THE ULTIMATE GUIDE TO
DRAWING

THE ULTIMATE
GUIDE TO
DRAWING

BARRINGTON BARBER

SIRIUS

SIRIUS

This edition published in 2021 by Sirius Publishing, a division of
Arcturus Publishing Limited,
26/27 Bickels Yard, 151–153 Bermondsey Street,
London SE1 3HA

ISBN: 978-1-83940-767-3
AD000450UK

Printed in China

Contents

Introduction

Learning to draw is not difficult. Everybody learns to walk and talk, and read and write at an early age. Learning to draw is less difficult than all that. Drawing is merely making marks on paper which represent some visual experience. All it takes to draw effectively is the desire to do it, a little persistence, the ability to observe and a willingness to carefully correct any mistakes. This last point is very important. Mistakes are not in themselves bad. Regard them as opportunities for getting better, and always correct them.

Many of the exercises in this book incorporate the time-honoured methods practised by art students and professional artists. If these are followed diligently, they should bring about a marked improvement in drawing skills. After consistent practice and regular repetition of the exercises, you should be able to draw competently, if not like Leonardo da Vinci – that takes a little longer. You will find that assessing your ability will help to make you more objective about your work. However, this new knowledge won't happen overnight, so be patient. And remember: the time you spend altering your drawings to improve them is never wasted – that is how you will improve your skills.

Making contact with other people who are also trying to become better artists will help your progress, too. Drawing is not a private exercise but a public one, so do show your work to other people. It may not be to everybody's liking and you may have to swallow criticisms that dent your pride. If this happens, look at your own work again with a more objective eye and see if those criticisms are justified. Of course, not all criticism is correct. But usually we know when it is, and

when it is we should act on it. Your best critics will be other students of art because they speak from their own experience. If you know any professional artists, talk to them about their work. You will find their advice useful. Go to art shows and galleries as often as you can and see what the competition is up to. The experience will help to push your work further in the right direction. Notice your own weaknesses, try to correct them, but don't ignore your strengths. And while you build on success, try to eliminate the gaps in your knowledge and expertise. Above all, don't give up. Steady, hard work often accomplishes more than talent.

In the following sections we will be looking at all sorts of drawing; with some you will be familiar, and some will be new to you. Many of my examples are close copies of the work of first-rate artists, who provide a wealth of ideas and methods from which to learn. Some of the drawings are my own and hopefully they will also teach you something. In considering the drawings of master artists and how they were done, I have tried to relate them to our experience of drawing and suggest ways of improving your abilities.

Topics such as anatomy and perspective are looked at in some detail, as is the difficulty of drawing movement. Detailed on the facing page are some of the major themes running through the book and how they can help you develop your drawing skills.

It is hoped you will have a great time with the suggestions in this book. Having taught art now for a long time – and practised it even longer – I can say with confidence that if you want to learn to draw well there is nothing to stop you.

Some of the styles and techniques will suit you instantly whereas with others you may find yourself having to work hard. Don't worry if you don't instantly get on with some of them. See them as a positive challenge. You will discover that just trying a new technique will help to improve the other methods you use. Seemingly difficult exercises firm up our talent. When you succeed at them, give yourself a pat on the back, because it means you are really getting interested. That, ultimately, is what counts and what improves levels of skill.

Above all, remember that the desire to draw and the use of your senses are all that are required to start the investigation into the visual world that this book hopes to encourage. Art is a marvellous part of life, and the more deeply you engage with it, the more you are adding to the cultural value of our society.

Finally, do not despair if your drawings are not masterpieces. If they were, you would not need this book, nor any other.

Major Themes

- Form and how to produce an effect of dimension, with shapes conditioned by light and shade, texture and volume – see pages 234–293.
- Devices and approaches that will help you to improve the accuracy of your drawing. We shall also consider how to analyse the mass of information gathered by the artist's retina in considering a composition.
- Ways of portraying an emotional state or mood in a picture. This is done by the composition, the choice of subject matter, or by the techniques and drawing medium. All work and all are valid.
- Practice – see pages 124–185. In this and other sections you will find exercises in drawing and analysis, to understand how to see a subject more clearly and how to represent what you see.
- Throughout you will see the work of artists who found ways of seeing the world anew. In their hands what might seem an ordinary situation or scene suddenly becomes full of promise and life, imaginative and unexpected.
- The importance of drawing what you can see. Not to draw what can't be seen might seem obvious, but it is a very precise discipline for the artist with lots of ideas in his head who sometimes attempts to invent without substance. It's easier – and the end result more convincing – to train yourself to see more, perceive more clearly and draw exactly what is seen. Anyway, try it out. You might be surprised.

PREPARATION

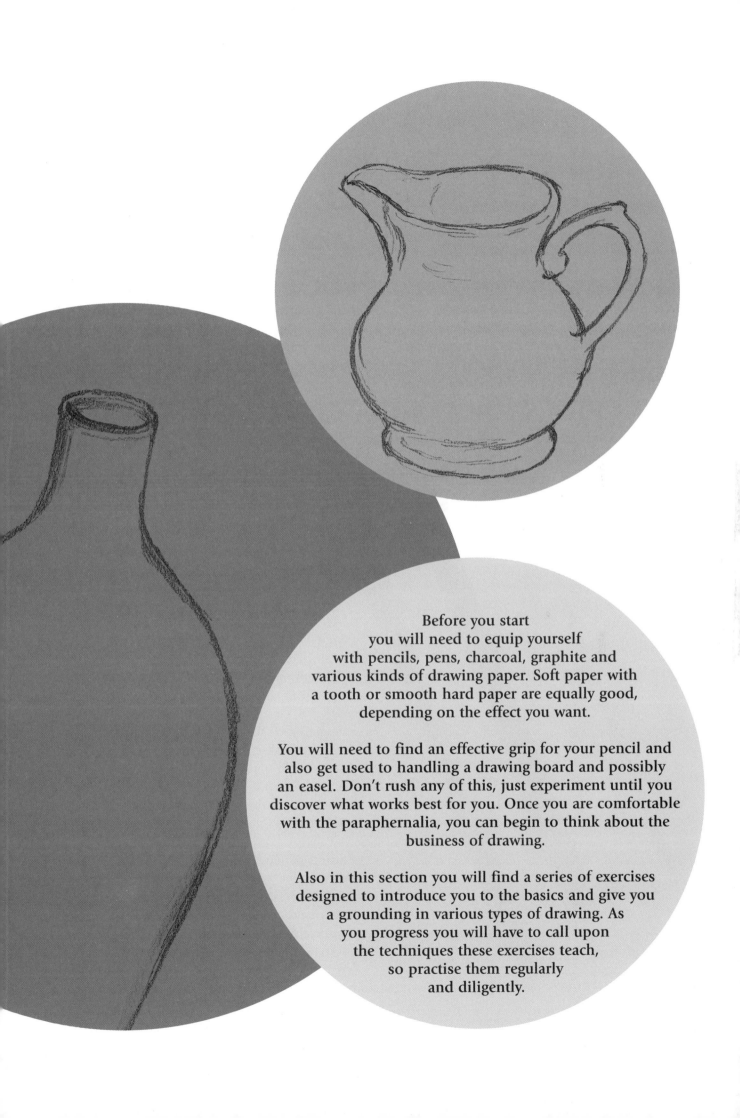

Before you start
you will need to equip yourself
with pencils, pens, charcoal, graphite and
various kinds of drawing paper. Soft paper with
a tooth or smooth hard paper are equally good,
depending on the effect you want.

You will need to find an effective grip for your pencil and
also get used to handling a drawing board and possibly
an easel. Don't rush any of this, just experiment until you
discover what works best for you. Once you are comfortable
with the paraphernalia, you can begin to think about the
business of drawing.

Also in this section you will find a series of exercises
designed to introduce you to the basics and give you
a grounding in various types of drawing. As
you progress you will have to call upon
the techniques these exercises teach,
so practise them regularly
and diligently.

DRAWING MATERIALS

Any medium is valid for drawing. That said, some media are more valid than others in particular circumstances, and in the main their suitability depends on what you are trying to achieve. Try to equip yourself with the best materials you can afford; quality does make a difference. You don't need to buy all the items listed below, and it is probably wise to experiment gradually as you gain in confidence.

Start with the range of pencils suggested, and when you feel you would like to try something different, then do so. Be aware that each material has its own identity, and you have to become acquainted with its individual facets before you can get the best out of it or, indeed, discover whether it is the right material for your purposes. So, don't be too ambitious to begin with, and when you do decide to experiment, persevere.

White carbon pencil

Pencils

HB B 2B 4B

Conté charcoal pencil

Pencil

The simplest and most universal tool of the artist is the humble pencil, which is very versatile. It ranges from very hard to very soft and black (H, HB, B, 2B, etc.) and there are differing thicknesses. Depending on the type you choose, pencil can be used very precisely and also very loosely.

You should have at least three degrees of blackness, such as an HB (average hardness and blackness), 2B (soft and black) and 4B (very soft and black).

Carbon pencil

This can give a very attractive, slightly unusual result, especially the dark brown or sepia, and the terracotta or sanguine versions. The black version is almost the same in appearance as charcoal, but doesn't offer the same rubbing-out facility. If you are using this type, start off very lightly because you will not easily be able to erase your strokes.

For working on a toned surface, you might like to try white carbon pencil.

Graphite pencils

Fine line pen

Fine nib push pen

Graphite

Graphite pencils are thicker than ordinary pencils and come in an ordinary wooden casing or as solid graphite sticks with a thin plastic covering. The graphite in the plastic coating is thicker, more solid and lasts longer, but the wooden casing probably feels better. The solid stick is very versatile because of the actual breadth of the drawing edge, enabling you to draw a line 6mm (¼in) thick, or even thicker, and also very fine lines. Graphite also comes in various grades, from hard to very soft and black.

Charcoal

Charcoal pencils in black and grey and white are excellent when you need to produce dimensional images on toned paper and are less messy to use than sticks of charcoal and chalk. However, the sticks are more versatile because you can use the long edge as well as the point. Drawings in this type of media need 'fixing' to stop them getting rubbed off, but if interleaved with pieces of paper they can be kept without smudging. Work you

wish to show for any length of time should be fixed with spray-can fixative.

Conté

Similar to compressed charcoal, conté crayon comes in different colours, different forms (stick or encased in wood like a pencil) and in grades from soft to hard. Like charcoal, it smudges easily but is much stronger in its effect and more difficult to remove.

Pen

Push-pens or dip-pens come with a fine pointed nib, either stiff or flexible, depending on what you wish to achieve. Modern fine-pointed graphic pens are easier to use and less messy but not so versatile, producing a line of unvarying thickness. Try both types.

The ink used for dip-pens is black 'Indian ink' or drawing ink; this can be permanent or water-soluble. The latter allows greater subtlety of tone.

Conté stick

Willow charcoal

White chalk

Pastel/chalk

Pastel/chalk

If you want to introduce colour into your still-life drawing, either of these can be used. Dark colours give better tonal variation. Avoid bright, light colours. Your choice of paper is essential to a good outcome with these materials. Don't use a paper that is too smooth, otherwise the deposit of pastel or chalk will not adhere to the paper properly. A tinted paper can be ideal, because it enables you to use light and dark tones to bring an extra dimension to your drawing.

White chalk

This is a cheaper and longer-lasting alternative to white conté or white pastel.

No 5 sable brush

No 2 nylon brush

Scraper-board tool

Clutch pencil with silver wire point

Brush

Drawing with a brush will give a greater variety of tonal possibilities to your drawing. A fine tip is not easy to use initially, and you will need to practise if you are to get a good result with it. Use a soluble ink, which will give you a range of attractive tones.

A number 0 or number 2 nylon brush is satisfactory for drawing. For applying washes of tone, a number 6 or number 10 brush either in sablette or sable or any other material capable of producing a good point is recommended.

Paper and board

Any decent smooth cartridge paper is suitable for drawing. A rougher surface gives a more broken line and greater texture. Try out as many different papers as you can.

You will find a good-quality cartridge paper most useful. Choose one that is not too smooth; 160gsm weight is about right. (If you are unsure, ask in your local art or craft shop, where they will stock all the materials you require.)

Drawing in ink can be done on smoother paper, but even here a textured paper can give a livelier

result in the drawing. For drawing with a brush, you will need a paper that will not buckle when wet, such as watercolour paper. Also see under Pastel/chalk.

Scraperboard

Scraperboard has a layer of china-clay which is thick enough to allow dry paint to be scraped off but thin enough not to crack off. It comes in black and white. White scraperboard is the more versatile of the two, and allows the ink to be scraped with a sharp point or edge when it is dry to produce interesting textures or lines. The black version has a thin layer of black ink printed evenly over the whole surface which can be scraped away to produce a reverse drawing resembling a woodcut or engraving. Try them out. Cut your first piece of board into smaller pieces so that you can experiment with a range of different approaches. (The more unusual techniques involving scraperboard are dealt with later in the book.)

The tools you need to work effectively with scraperboard can be obtained at any good art or craft shop.

Eraser

The best all-purpose eraser for the artist is a putty eraser. Kneadable, it can be formed into a point or edge to rub out all forms of pencil. Unlike the conventional eraser it does not leave small deposits on the paper. However, a standard soft eraser is quite useful as well, because you can work over marks with it more vigorously than you can with a putty eraser.

Drawing ink

Most artists try to use an eraser as little as possible, and in fact it only really comes into its own when you are drawing for publication, which requires that you get rid of superfluous lines. Normally you can safely ignore erasers in the knowledge that inaccurate lines will be drawn over and thus passed over by the eye, which will see and follow the corrected lines.

Stump

A stump is a tightly concentrated roll of absorbent paper formed into a fat pencil-like shape. Artists use it to smudge pencil, pastel or charcoal and thus smooth out shading they have applied, and graduate it more finely.

Sharpener

A craft knife is more flexible in its use than an all-purpose sharpener and will be able to cope with any medium. It goes without saying that you should use such an implement with care and not leave the blade exposed where it may cause harm or damage.

LINES INTO SHAPES

Before you begin any kind of drawing, it is necessary to practise the basics. This is essential for the complete beginner, and even for the experienced artist it is very useful. If you are to draw well you must be in control of the connection between eye and hand. There are many exercises to help you achieve this. The following are the simplest and most helpful I know.

Complete them all as carefully as you can, drawing freehand, at the sizes shown. The more you repeat them, the more competent and confident you will become – and this will show in your drawing.

Lines

As you draw, try to keep your attention exactly on the point where the pencil touches the paper. This will help to keep mind and hand synchronized and in time make drawing easier.

1. Begin with vertical lines, keeping them straight and the same length.

2. Produce a square with a series of evenly spaced horizontal lines.

3. Now try diagonal lines, from top right to bottom left, varying the lengths while keeping the spacing consistent.

4. Next, draw diagonals from top left to bottom right. You may find the change of angle strange at first.

5. To complete the sequence, try a square made up of horizontals and verticals crossing each other.

Circles

At first it is difficult to draw a circle accurately. For this exercise I want you to draw a series of them next to each other, all the same size. Persist until the circles on the paper in front of you look like the perfect ones you can see in your mind's eye. When you achieve this, you will know that your eye and mind are coordinating.

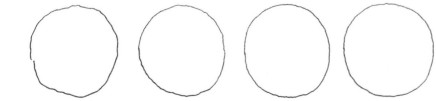

Variations

Paul Klee described drawing as 'taking a line for a walk'. Try drawing a few different geometric figures:

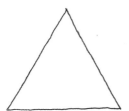

1. Triangle – three sides of the same length.

2. Square – four sides of the same length.

3. Star – one continuous line.

4. Spiral – a series of decreasing circles ending in the centre.

5. Asterisk – 16 arms of the same length radiating from a small black point.

Finish by practising a few S-shaped figures, which are formed by making two joined but opposing arcs. You will constantly come across shapes like these when drawing still life.

PENCIL & GRAPHITE: EXERCISES

The following technical practices should help you to ease your way into drawing in a range of different styles. There are, of course, many more than the ones we show, but **these will serve very well as a basis. You will discover all sorts of other methods through your own investigations and adapt them to serve your purpose.**

Pencil and Graphite

A pencil is the easiest and most obvious implement with which to start an exploration of technique. Try the following series of simple warming up exercises. They can be practised every day that you put aside time to draw. This practice is very useful for improving your technique.

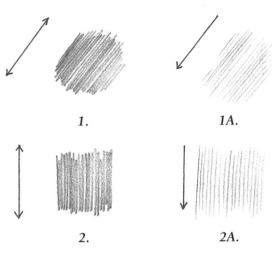

1. *1A.*

2. *2A.*

3. *3A.*

1. A backward and forward motion of the hand, always in an oblique direction, produces an even tone quickly.

2. The same motion vertically.

3. The same motion horizontally.

1A. 2A. and **3A.**
 Now try a slightly more careful method where the hand draws the lines in one direction only.

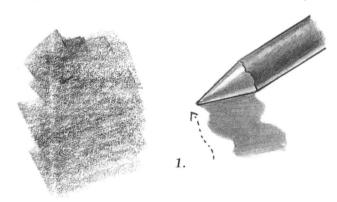

1.

Try using a graphite stick for the next two exercises; they can also be done with a well-sharpened soft pencil.

1. Lay the side edge of the point of the graphite or pencil onto the paper and make smooth, smudged marks.

2. Using the point as well in random directions works well.

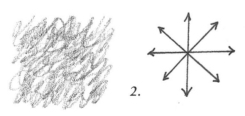

2.

Pencil Shading Test

When you are using pencil to add tone to your drawings it soon shows if you are not very expert. The only way you can develop this facility is to practise shading in various ways in order to get used to seeing the different tones achievable. This exercise is quite difficult but good fun and can be repeated many times over a period of weeks, just to help you get your hand and eye in. You will find the control it gives you over the pencil very valuable.

You will need a very dark pencil (4B), a slightly less dark pencil (2B) and a lighter pencil (such as a B). If you wish, you can always use a harder lighter pencil, such as an H or 2H.

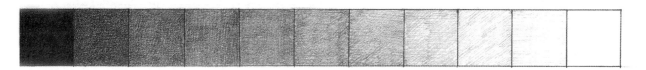

Draw out a long line of squares about 1in (2.5cm) square. Shade each square, starting with a totally black square. Allow the next square of shading to be slightly lighter, and so on, gradually shading each square as uniformly as possible with a lighter and lighter touch, until you arrive at white paper.

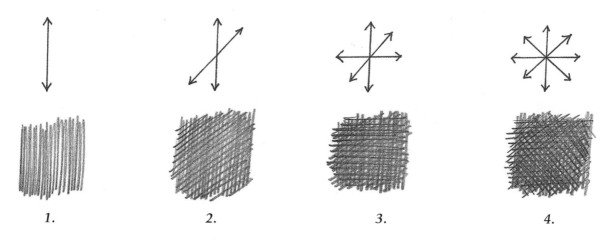

1. 2. 3. 4.

5.

Building up tones by crosshatching:

1. Vertical strokes first, close together

2. Horizontal strokes over the vertical strokes

3. Oblique strokes from top right to bottom left over the strokes shown in 1 and 2.

4. Then make oblique strokes from top left to bottom right over the strokes shown in 1–3.

5. Smooth and finely graduated tones can be achieved by working over your marks with a stub.

HOLDING THE PENCIL

Your inclination will probably be to hold the pencil like a pen. Try holding it like a brush or a stick. Keep the grip loose. You will produce better marks on the paper if your grip is relaxed and there is no tension in your hand or arm.

WORKING AT A BOARD OR EASEL

If you don't have an easel and are sitting with the board propped up, the pencil should be at about shoulder height and you should have a clear view of the drawing area.

The best way to draw is standing up, but you will need an easel for this.

There should be plenty of distance between you and the drawing. This allows the arm, wrist and hand to move freely and gives you a clearer view of what you are doing. Step back every few minutes so you can see the drawing more objectively.

Keep your grip easy and don't be afraid to adjust it. Don't have a fixed way of drawing.

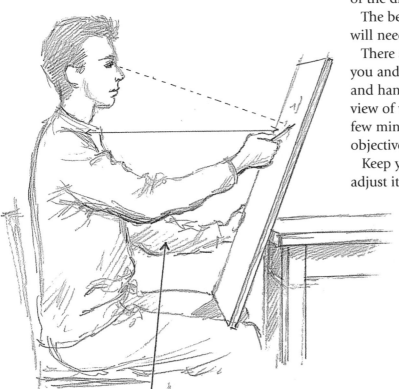

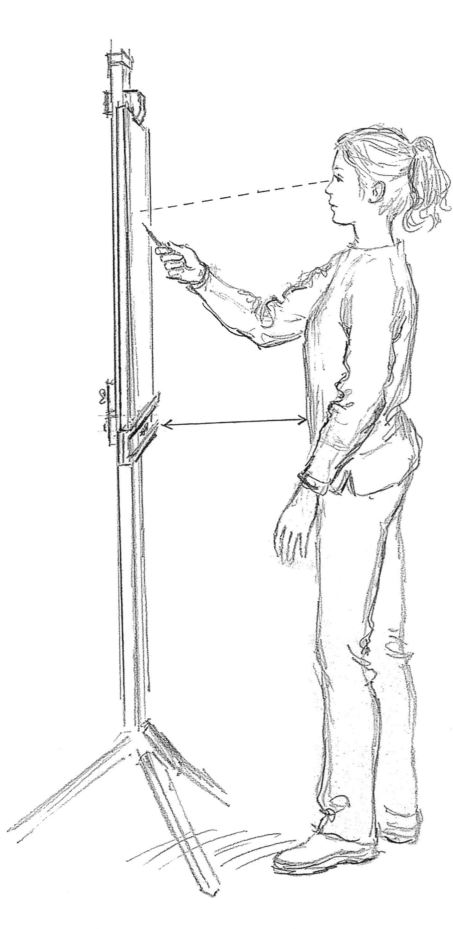

USING THE PAPER

Try to work as large as possible from the beginning. The larger you draw, the easier it is to correct. Aim to gradually increase the size of your drawing until you are working on an A2 sheet of paper and can fill it with one drawing.

You will have to invest in an A2 drawing board for working with A2 paper. You can either buy one or make one out of 6mm (¼in) thick MDF. Any surface will do, so long as it is smooth under the paper; masking tape, paper clips or Blu-tak can be used to secure the paper to the board.

PREPARATION

WORKING IN PENCIL

Versatile, easy to use and to erase, pencil can be used to good effect when drawing and lends itself to the creation of many different visual effects. Many artists favour it over other implements for its dual ability to produce realistic shapes and broader areas of tone by the simple expedient of smudging. The very versatility of the medium makes it excellent for experimentation, so try playing with the way you make lines and marks.

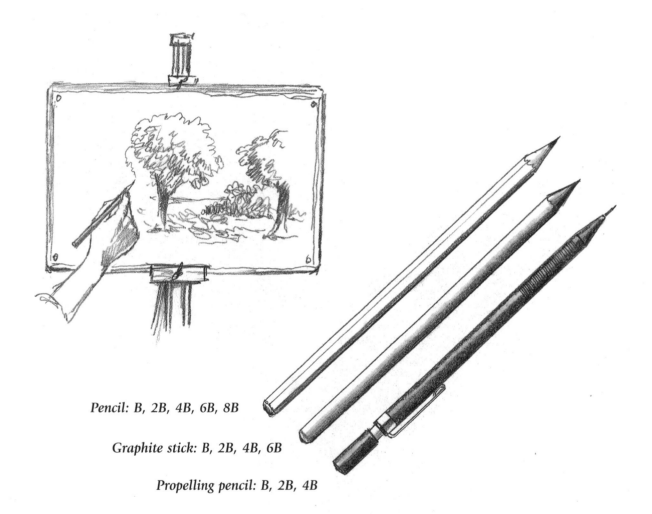

Pencil: B, 2B, 4B, 6B, 8B

Graphite stick: B, 2B, 4B, 6B

Propelling pencil: B, 2B, 4B

You will need to equip yourself with a range of fairly soft, dark pencils, ideally ranging from B through 2B, 3B, 4B, 6B to 8B. If buildings are high on your agenda of subjects, an HB can be useful. A propelling pencil will also help to give you a finer line and, unlike the traditional pencil, does not need constant sharpening. However, its range of expression is limited. Generally speaking, soft pencil gives a drawing many more attractive qualities than does hard pencil. A graphite stick pencil is very useful because of its versatility and the sheer range of options it offers in terms of thickness of line.

When you go out drawing, always take a range of pencils with you. This will enable you to vary your mark making, and also reduce the amount of time you spend sharpening lead.

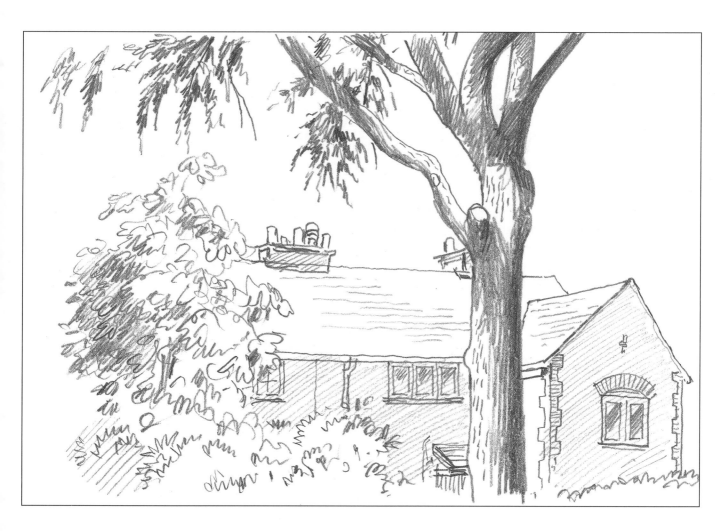

One of the characteristics of drawing with pencil is how widely the line varies depending on the grade you use. There is so much potential with pencil. All you need is a bit of imagination to give your drawing character.

WORKING IN PENCIL: TECHNIQUES

The pencil is, of course, easily the most used instrument for drawing. Often, though, our early learning of using a pencil can blunt our perception of its possibilities, which are infinite.

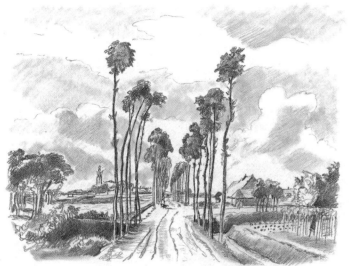

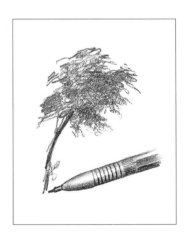

In 'Road to Middelharnis' (after Hobbema) we see a fairly free pencil interpretation of the original, using both pencil and stump.

The loose scribble marks used to produce the effect in this drawing will seem simple by comparison with our next example.

American artist Ben Shahn was a great exponent of drawing from experience. He advocated using gravel or coarse sand as models to draw from if you wanted to include a rocky or stony place in your drawing but were unable to draw such a detail from life. He was convinced that by carefully copying and enlarging the minute particles, the artist could get the required effect.

When you tackle a detailed subject, your approach has to be painstaking and unhurried. If you rush your work, your drawing will suffer. In this drawing, after putting in the detail, I used a stump to smudge the tones and to reproduce the small area of sea.

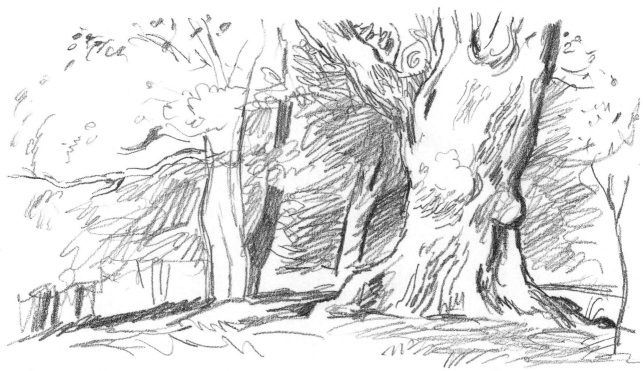

The pencil work used for this large old tree in a wood (after Palmer) is even looser in technique than that for the Hobbema. At the same time, however, it is very accurate at expressing the growth patterns of the tree, especially in the bark. It is best described as a sort of carefully controlled scribble style, with lines following the marks of growth.

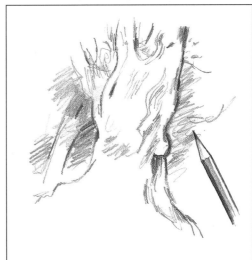

WORKING IN PENCIL: STYLES

Any technique can be learned, as you will know from the set of technical exercises you have completed. The test, though, comes in applying technique so that it does not take over your observational faculties or become a strait-jacket.

We are now going to look in detail at a selection of drawings in a range of styles using a range of media and incorporating many of the methods shown in the exercises. In these examples note how the technique or style is the servant of the artist.

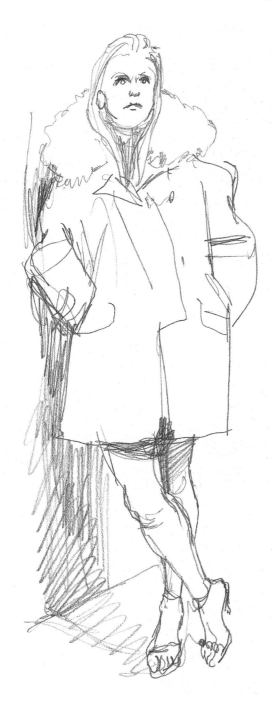

In this pencil drawing the line appears to wander at will to gradually produce an image that is both immediate and relaxed. The pose seems right for this particular method of drawing, looking casual and temporary. Drawing like this can be easily adapted by any artist when they have gained confidence in their ability to see and get the main shapes right. The rather exploratory feel of the wobbly line is very much used by art students as they gain in skill. It has both charm and a certain realism that allows mistakes to be corrected as the line develops without too much difficulty. It is also relatively quick as a method.

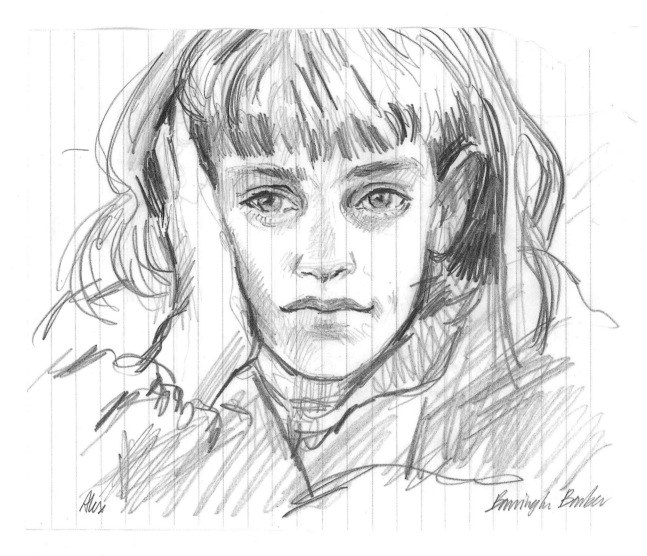

You don't need first-rate materials to produce an effective portrait, as this next example proves. Although I would always advise you to buy the best you can afford, don't make their absence a reason for not drawing something that catches your imagination. I was on a train journey with my family when I had an impulse to draw my youngest daughter. After borrowing a leaf from my wife's notebook and a battered old soft pencil from my daughter it took me about fifteen minutes to complete her portrait. The motion of the train prevented subtlety, forcing me to use slashing strokes. As a result the texture is quite strong, mitigated only by the few softer marks for the tonal areas around the eyes, nose and chin.

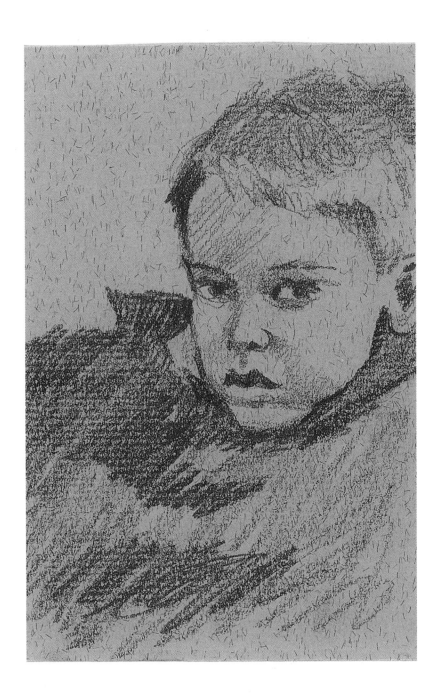

Another example using toned paper, this time with a 2B pencil that was not particularly sharp. I opted for the simplest exposition of form and let the paper provide much of the medium tone. After putting in the strongest dark tones I added a few in-between tones, particularly on the hair, and left it at that. The entire portrait took about six minutes. This sort of spontaneous drawing works best if you can see what you want to achieve in one glance and then put it down immediately without deliberation. The result may not be ideal, but taking a chance is what this kind of drawing is all about. It is akin to taking a snapshot with a camera. Practising drawing spontaneous portraits will increase your expertise enormously.

The details of the face are simplified and most of the tonal values dispensed with in this copy of a drawing of Aristide Maillol by fellow sculptor Eric Gill. The different emphasis in the outlines helps to give an effect of dimension, but it is more like the dimension of a bas-relief sculpture, which is perhaps what this study in pencil and stub was about.

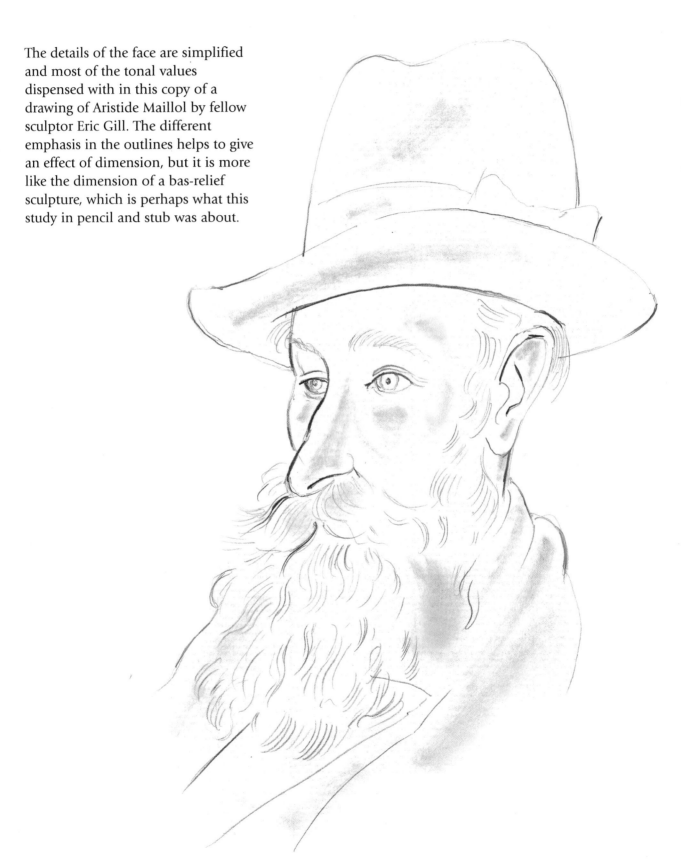

PREPARATION

WORKING IN PEN & INK: EXERCISES

There is a whole range of exercises for pen and ink. Pen is trickier than pencil to use for drawing and has to be put to paper rather more lightly and carefully so that its point does not catch and snag the surface.

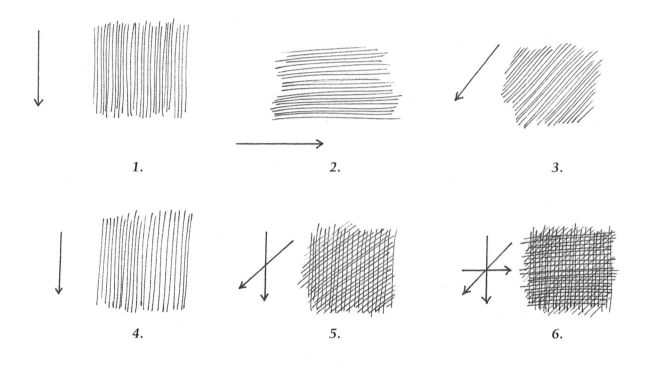

1. 2. 3.

4. 5. 6.

7.

1. Vertical lines close together in one direction.

2. Horizontal lines close together in one direction.

3. Oblique lines close together in one direction.

4. Draw vertical lines.

5. Draw oblique lines on top of the verticals.

6. Draw horizontal lines on top of the oblique and vertical lines.

7. Draw oblique lines at 90 degrees to the last oblique lines on top of the three previous exercises to build up the tone.

8. 9.

10.

8. Make patches of short strokes in different directions, each time packing them closer together.

9. Draw small overlapping lines in all directions.

10. Draw lines that follow the contours of a shape, placing them close together. For an additional variation, draw oblique lines across these contour lines.

11.

11. Build up myriad dots to describe tonal areas.

WORKING IN PEN & INK

The chief characteristics of pen and ink are precision, intensity and permanence. When using ink you have to make up your mind quite quickly and be sure of what you are doing – you can't change your initial decision halfway through. The medium can be used in a very decorative and formal way, in loose, flowing lines or scribbly marks. Any of these approaches can work well, but not if you mix them. The illusion you are trying to create will shatter if ink marks vary too greatly, with the formal lines becoming too rigid and the scribbled lines looking messy. In order to convince the eye and the mind, you have to decide whether your drawing is to be formal or loosely drawn.

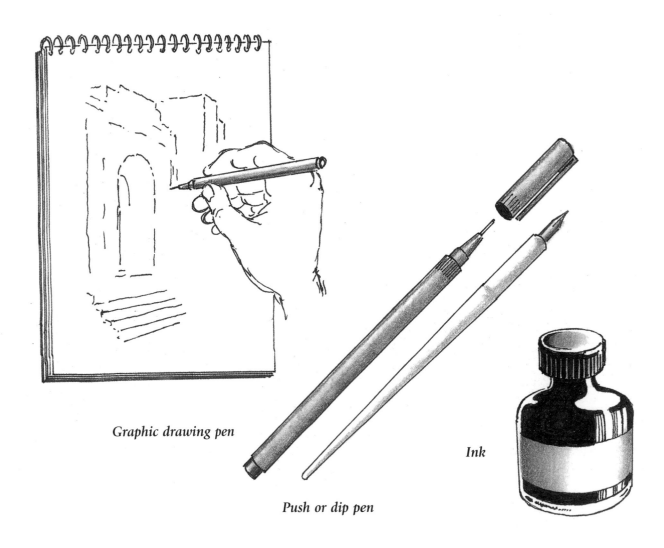

Graphic drawing pen

Push or dip pen

Ink

Pen and ink is an even more linear medium than pencil and particularly lends itself to the linear qualities of architecture. There are two main types of pen for the artist: the push or dip pen and the graphic drawing pen.

Graphic line pens give a consistent black line and come in varying thicknesses: 0.1, 0.5, 0.8 etc. Usually you will need only two line pens: one very fine and the other about twice that thickness.

The ordinary push or dip pen used with Indian ink is more flexible than the graphic drawing pen and allows you to vary your line width just by altering the pressure. Some pen nibs are very flexible, others stiffer, but you will need several different types, ranging from the finest point to a more flexible but rather thicker point.

There are various kinds of ink. The really black draughtsman's ink is consistent in quality and the non-waterproof Indian ink is easier to water down if you require lighter strokes. Art shops stock a range of inks; you just have to experiment to find out which you like best. I have found Chinese stick ink or that made from burnt oak apples most useful.

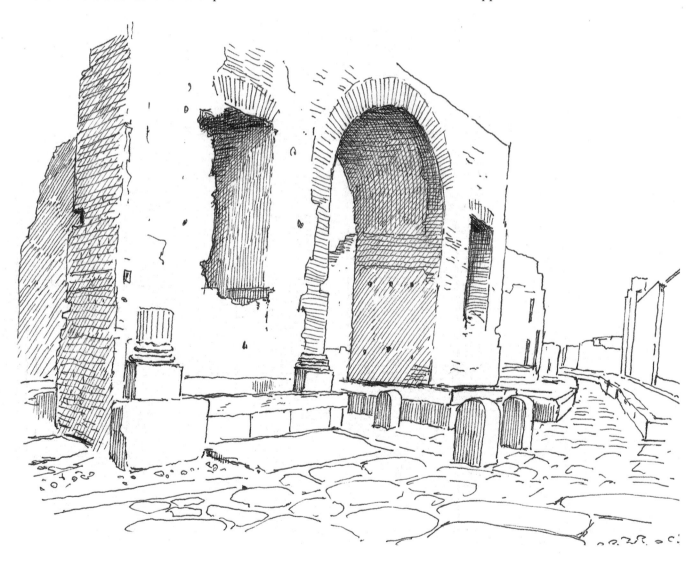

Pen-line is very good for hard-edged subject matter such as this Roman arch at Pompeii. Notice how the total areas are made up of cross-hatched lines drawn closely together to create an area of tone. The brighter areas you leave almost untouched.

WORKING IN PEN & INK: TECHNIQUES

Generally speaking any fine-pointed nib with a flexible quality to allow variation in the line thickness is suitable. Compare the two examples here and you will notice that the effects achieved are markedly different. For his original drawing the Japanese master would probably have used a pen that was smoother on the paper but not so flexible or finely pointed as the type used for the other example.

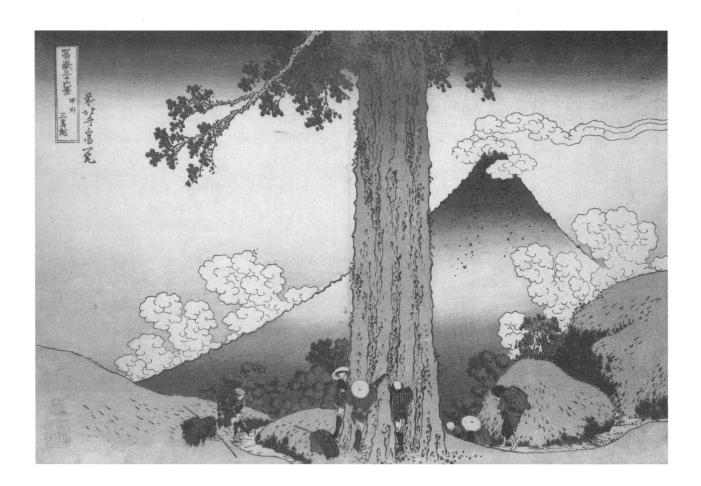

For his original of Mount Fuji the Japanese artist Hokusai probably made his marks with a bamboo calligraphic nib in black ink. We have made do with more conventional pen and ink in the version shown opposite, but even so have managed to convey the very strong decorative effect of the original.

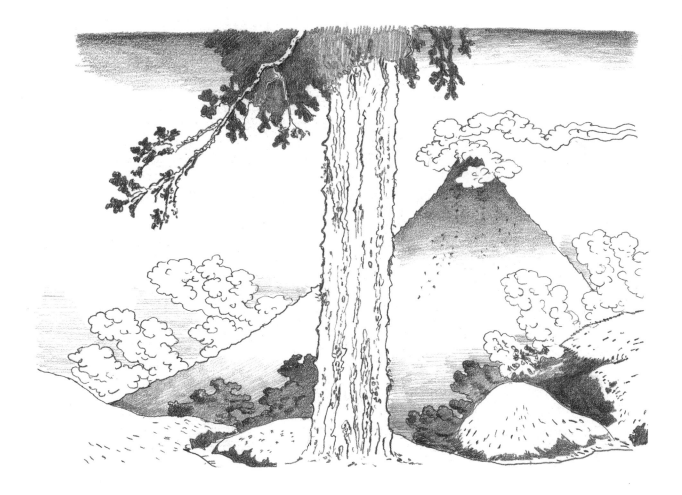

Note how the outline of the trunk of the tree and the shape of the mountain is drawn with carefully enumerated lumps and curves. Notice too the variation in the thickness of the line. The highly formalized shapes produce a very harmonious picture, with one shape carefully balanced against another. Nothing is left to chance, with even the clouds conforming to the artist's desire for harmonization. With this approach the tonal textures are usually done in wash and brush, although pencil can suffice, as here.

WORKING IN BRUSH & WASH

The best way to start with brush and wash is to try these simple exercises. Your brush should be fairly full of water and colour, so mix a generous amount on a palette or saucer first, and use paper that won't buckle.

1. With a brush full of ink or watercolour diluted in water, lay a straightforward wash as evenly as possible on water-colour paper.

2. Repeat but this time brushing the wash in all directions.

3. Load a lot of colour onto your brush and then gradually add water so that the tone gets weaker as you work. Keep working with the brush until it finally dries and you wipe out the last bit of colour.

4. Practise drawing soft lines with a brush and wash.

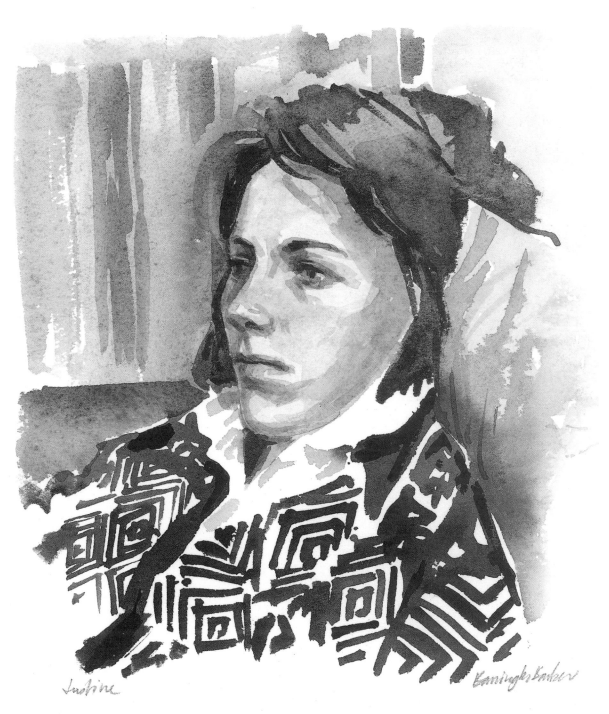

Plenty of water has been used to keep the tones on the face and the background soft in this example of watercolour on watercolour paper. The strength of colour on the jacket and hair is greater than elsewhere in the picture. The eyes, nose and mouth need touches of strong tone, especially the line of the mouth where it opens and the upper eyelashes, eyebrows and pupils of the eyes. This type of drawing can be built up quite satisfactorily, with the lighter tones put in first all over and then strengthened with the darks.

WORKING IN BRUSH & WASH

The medium of tonal painting in brush and wash is time-honoured and beloved of many landscape artists, largely because it enables the right effect to be created quickly and easily. It also enables you to cover large areas quickly and brings a nice organic feel to the creative process. The variety of brushstroke available enables the artist to suggest depth and all sorts of features in a scene. This imprecision is especially useful when the weather is a prominent part of the structure of your landscape and you want to show, for example, misty distance, rain-drenched trees or wind-swept vegetation.

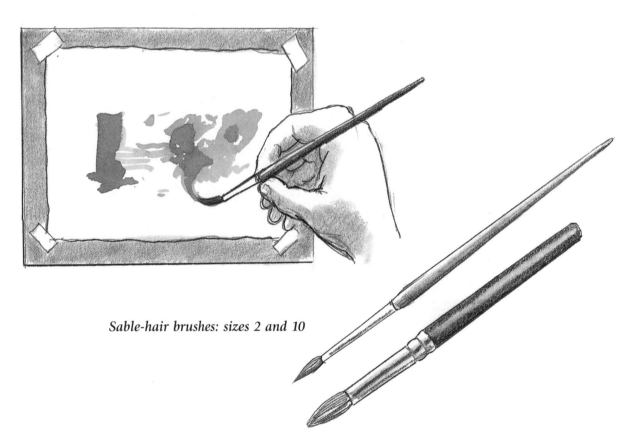

Sable-hair brushes: sizes 2 and 10

You need at least two very good brushes for this technique. Resist the temptation to buy cheap brushes: they don't last, they lose their ability to keep a point and the hairs fall out. Sable makes the best type of brush. You don't have to spend a fortune, and you certainly don't need to invest in a whole range of brushes. The largest brush you will need for anything of sketchbook size is probably a No 10. The No 2 is small enough to paint most subjects finely. These two are essential.

You can use either water-soluble ink or just some black watercolour. To go out sketching with this medium, you will need a screw-cap pot for water and some kind of palette to thin out your pigment. I use a small china palette that will go in my pocket or just a small box of watercolours with its own palette. You can get these in many sizes, but the smallest ones are very useful. As a water pot I generally use a plastic film roll canister with an efficient clip-on lid, or a plastic pill-bottle with a screw cap. These are small enough to put in a pocket and easy to use in any situation. Laying on a wash of tone is not always easy, so you will need to practise.

If you like this method of drawing, invest in a watercolour sketch book; its paper is stiff enough not to buckle under the effect of water, whereas regular heavy cartridge paper can buckle slightly.

A good-quality watercolour paper (such as Arches or Bockingford) makes it very easy to get an effective wash of tone without too many brush marks showing.

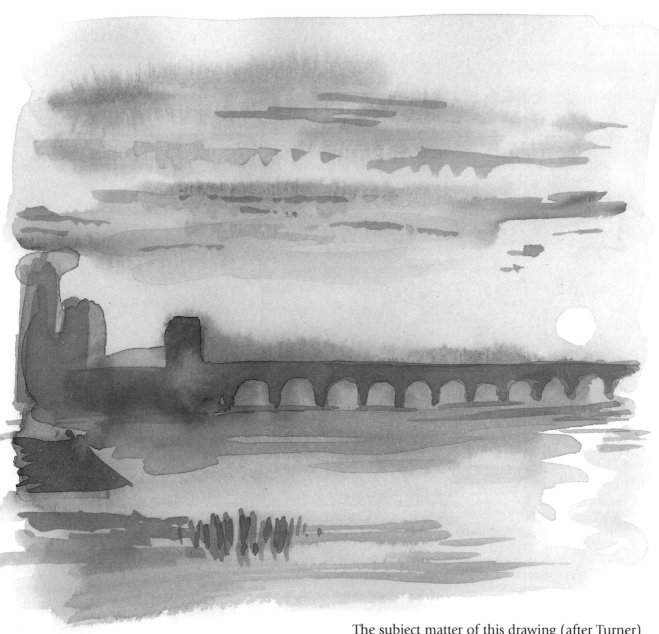

The subject matter of this drawing (after Turner) is very appropriate for the medium, being rather soft in tone and contrast and simple in shape.

BRUSH & WASH: TECHNIQUES

Beginners generally do not get on well with brush and wash. Watercolour, even of the tonal variety, demands that you make a decision, even if it's the wrong one. If you keep changing your mind and disturbing the wash, as beginners tend to do, your picture will lose its freshness and with it the most important quality of this medium.

I have chosen two contrasting examples, one very classical, the other very abstract.

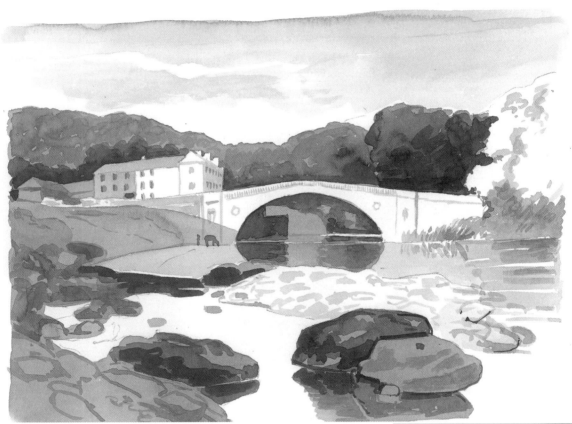

In 'Gretna Bridge' (after English watercolourist John Sell Cotman) the approach is very deliberate. The main shapes of the scene are sketched in first, using sparse but accurate lines of pencil, not too heavily marked. At this stage you have to decide just how much detail you are going to reproduce and how much you will simplify, in the cause of harmony in the finished picture. Once you have decided, don't change your mind; the results will be much better if you stick to one course of action. The next step is to lay down the tones, being sure to put in the largest areas first. When these are in place, put in the smaller, darker parts over the top of the first, as necessary. You might want to add some finishing touches in pencil, but don't overdo them or the picture will suffer.

'Les Martigues' (after de Stael) looks easy by comparison, but getting those large simple areas of tone down is harder than it looks. If you find they look less than smooth, don't worry – they might still work, so carry on regardless. The main difficulty for the beginner is lack of confidence. It is much better not to use pencil to put down the main shapes, but to go straight in with wash and brush. If you feel it is absolutely necessary to use pencil, keep it to a minimum.

EXERCISES IN CHALK

This series of exercises is similar to earlier ones but requires extra care not to smudge your marks as you put them down. The key in this respect is not to use a smooth paper. Choose one with a texture that will provide a surface to which the chalk can adhere.

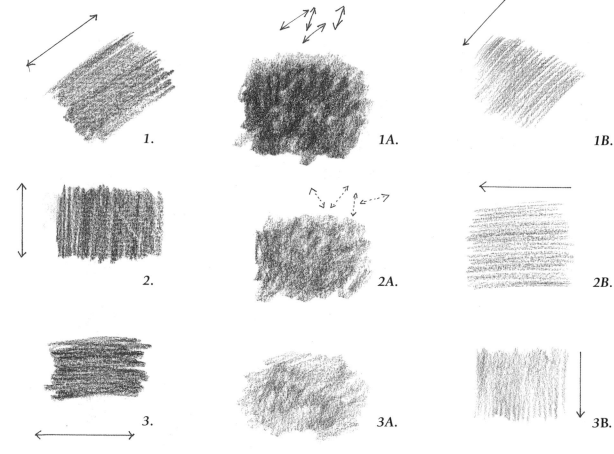

1.

1A.

1B.

2.

2A.

2B.

3.

3A.

3B.

1. Shading obliquely in two directions.

1A. Shading in various directions, heavily

1B. Shading in one direction obliquely.

2. Shading vertically in two directions.

2A. Shading in various directions, more lightly.

2B. Shading in one direction horizontally.

3. Shading horizontally in two directions.

3A. Shading in various directions, very lightly.

3B. Shading in one direction vertically.

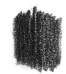 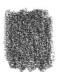 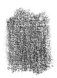

In a series of squares practise shading of various strengths, progressing from the heaviest to the lightest.

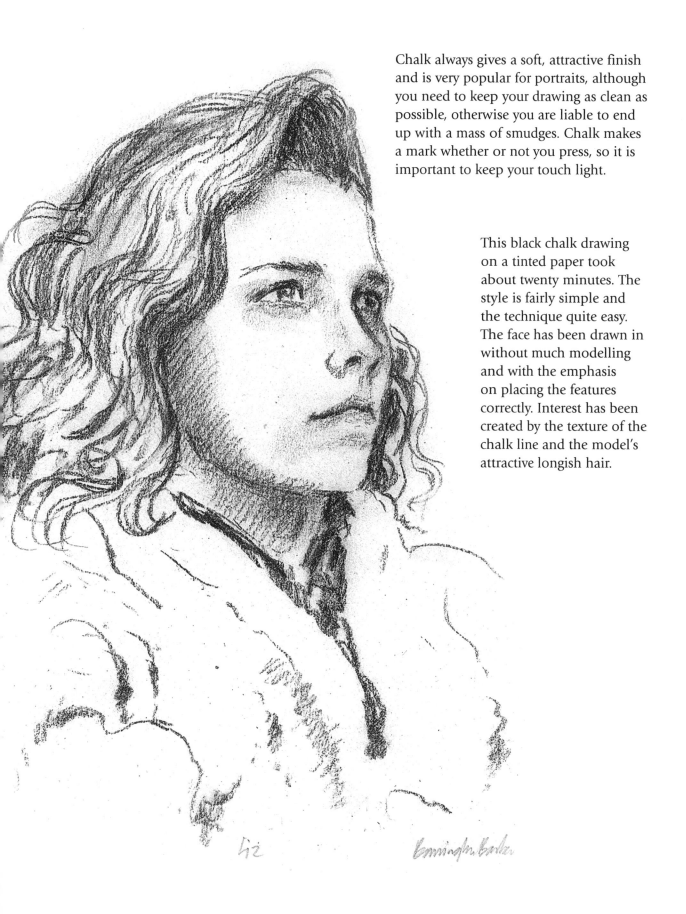

Chalk always gives a soft, attractive finish and is very popular for portraits, although you need to keep your drawing as clean as possible, otherwise you are liable to end up with a mass of smudges. Chalk makes a mark whether or not you press, so it is important to keep your touch light.

This black chalk drawing on a tinted paper took about twenty minutes. The style is fairly simple and the technique quite easy. The face has been drawn in without much modelling and with the emphasis on placing the features correctly. Interest has been created by the texture of the chalk line and the model's attractive longish hair.

WORKING IN CHALK: TECHNIQUES

Chalk-based media, which include conté and hard pastel, are particularly appropriate for putting in lines quite strongly and smudging them to achieve larger tonal effects, as you will see from the example shown, after Cézanne (below). Here the heavy lines try to accommodate the nature of the features and details they are describing.

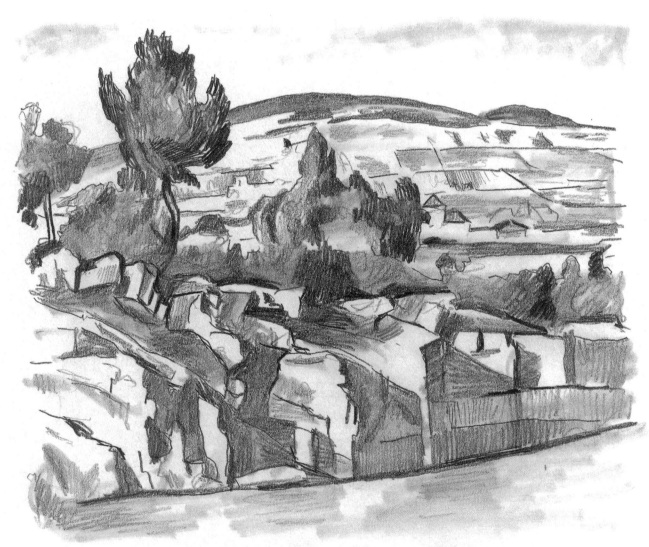

The similarity of style over the whole rocky landscape in this drawing (after Cézanne) helps to harmonize the picture. Compare the crystalline rock structures and the trees. Both are done in the same way, combining short, chunky lines with areas of tone.

SCRAPERBOARD

Take a fine pointed and a curved edge scraper and try your hand at scraperboard. The curved edge tool produces broader, thicker lines than the pointed tool, as can be seen from the examples shown below.

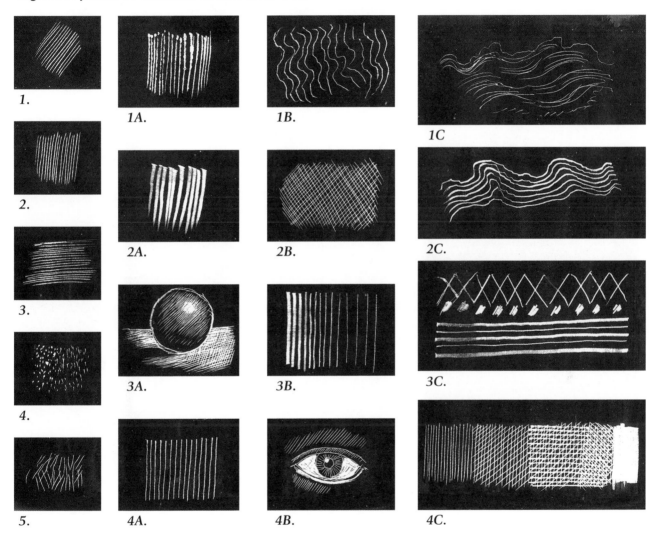

1. Oblique fine line
2. Vertical fine line
3. Horizontal fine line
4. Short pecks
5. Short pecks and strokes

1A. Thicker vertical lines
2A. Thicker oblique lines
3A. Draw a ball, then scrape away to reveal lighter side
4A. Thicker, measured vertical strokes

1B. Scraped wavy lines
2B. Crosshatching with fine lines
3B. Gradually reducing from thick to fine lines
4B. Draw eye shape and then scrape out light areas

1C. Lightly scraped wavy lines
2C. Thickly scraped wavy lines
3C. Criss-cross pattern
4C. Multiple cross-hatching increasing in complexity from left to right

Pointed tool

Curved-edge tool

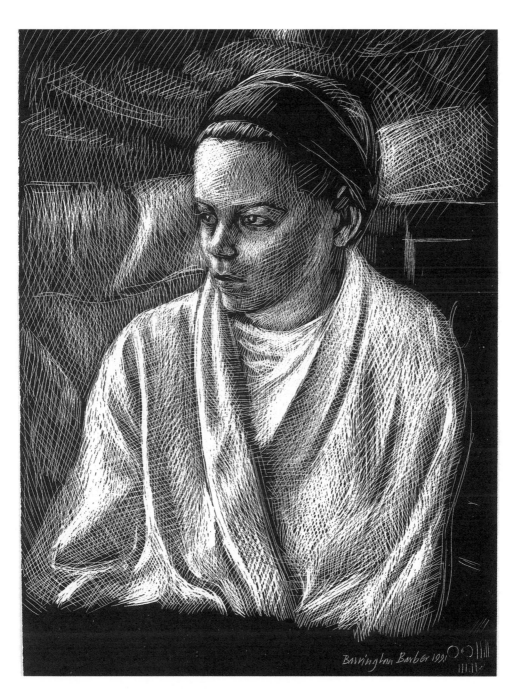

With scraperboard technique the artist has to draw back-to-front, revealing all the light areas and leaving the dark ones. Usually it is the other way round. This subject was ideal for the purpose, her white bath-robe ensuring there were plenty of light areas, although it was difficult to judge how much to work the face. The hair and hairband were made up of dark tones, and so required only the addition of highlights.

Similar effects to scraperboard can be obtained with white chalk on black paper. Try it as an exercise; it will teach you a great deal about gauging the balance of light and dark.

PREPARATION

MIXED MEDIA

The term mixed media simply means that an artist has used several different types of materials. For example, he might have drawn the basic shapes in pencil, sharpened up the foreground details with pen and then used chalk or brush and wash to soften parts of the work. There are many other types of mixed media, including cutting out paper shapes and drawing or painting over them. The example shown here (after Claude Lorrain) is straightforward and uses several common types of media in combination.

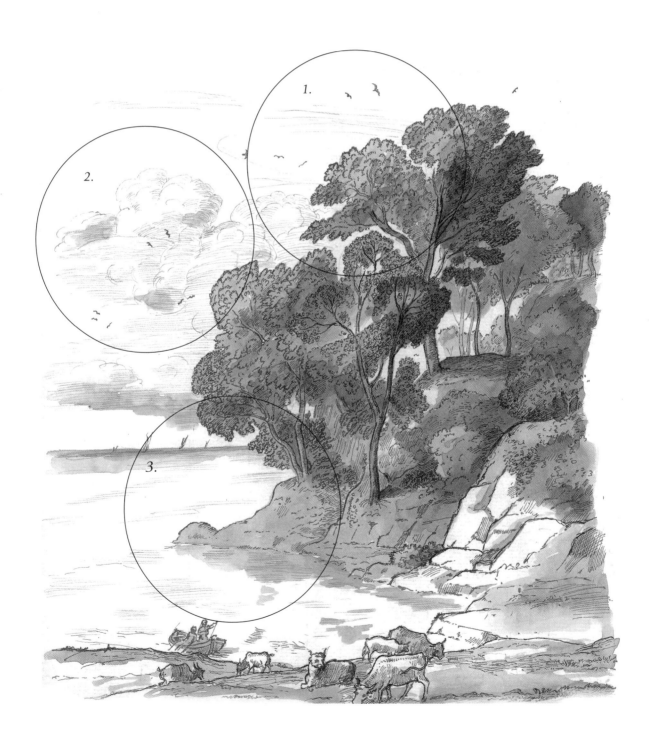

1.

1. Although Claude's treatment is fairly formal, it is not difficult. These leaves, for example, are quite easy to draw. Pen and ink were used to capture the required definition and then a tonal wash was applied to strengthen the effect of each clump.

2.

2. The mixture of media allowed Claude to graduate with great effect the softness of the clouds (here in graphite), which are sketched in very simply. They contrast with the wiry pen-line used for the trees and the soft, sombre shadows, in wash.

3.

3. The handling of rocks and coastline is again beautifully simple, with deft and appropriate touches of ink, chalk and wash.

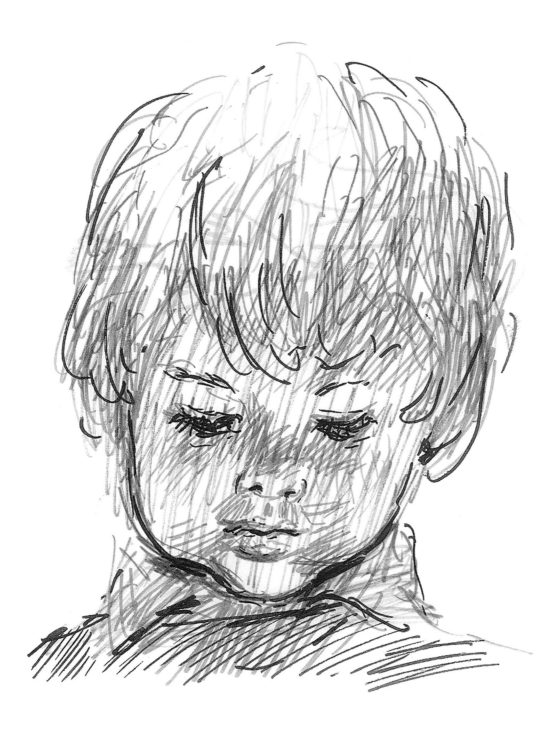

A range of coloured felt-tip pens were used for this spontaneous
drawing, hence the variation in tonal effect in the lines. Felt-tip is a
fairly coarse medium, so I was careful to leave space between the lines,
except in the outline.

This is a good example of how easy it can be to experiment with a range of different techniques in one picture. The various media – which include collage (sticking on paper), pen and ink, wash and brush, and pencil – add interest and colour to what is a simple subject of a young Cuban boy at a boxing training session. The style produces a quick, effective image and shows that you can get results without the need for a highly detailed drawing.

OBSERVATION

There is no substitute for observation. When you look long at something you want to draw, ask yourself what you are seeing. Look as an artist would – at colour, shape, form, texture, outline and movement. These will help you to analyze your impressions. Even when you think you know what you're looking at, keep looking. Nothing stays the same for more than a few seconds; the light changes, for example, giving you a new version of what you're looking at. You will find infinite variety, even in everyday scenes.

In this section we'll look at a range of subjects as they really are: agglomerations of shapes. As well as the shapes of objects, you will learn to notice the shapes between them and look at the whole image with interest and without preconceptions. Your aim will be to try to notice everything and avoid the common pitfall of regarding one part of the whole as superior to the rest.

DRAWING YOUR WORLD

Before we begin, I would like you to bear in mind a few points that I hope will stay with you beyond the period it takes you to absorb the contents of this book. It concerns methods of practice and good habits.

One invaluable practice is to draw regularly from life. That is, drawing the objects, people, landscapes and details around you. These have an energy and atmosphere that only personal engagement with them can capture.

Photographs or other representations are inadequate substitutes and should only be used as a last resort as reference (see caption on page 54).

Always have a sketchbook or two and use them as often as possible. Constant sketching will sharpen your drawing skills and keep them honed. Collect plenty of materials and tools – pencils, pens, rubbers, sharpeners, ink, paper of all sorts – and invest in a portfolio to keep all your drawings in.

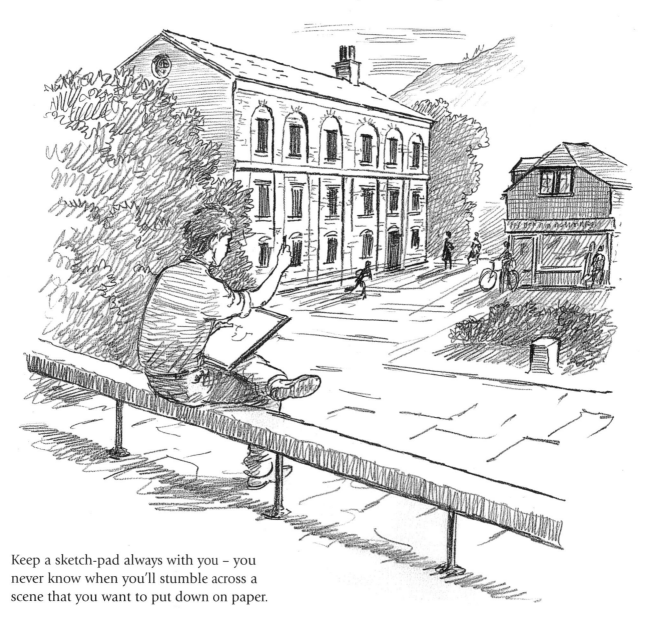

Keep a sketch-pad always with you – you never know when you'll stumble across a scene that you want to put down on paper.

These quick sketches of different parts of buildings are the result of drawing often and at any time. There is always the possibility of making a sketch of something seen out of a window. It's very good practice, too.

Don't throw away your drawings for at least a year after you've finished them. At that distance you can be more objective about their merits or failings, and have a clear idea of which ones work and which ones don't. In the white-hot creative moment you don't actually know whether what you've done is any good or not. You are too attached to your end result. Later on you'll be more detached and be clearer in your judgement.

Build a portfolio of work and sometimes mount your drawings. Then, if anyone wants to see your work, you will have something to show them. Don't be afraid of letting people see what you have done. In my experience, people always find drawings interesting. Have fun with what you are doing, and enjoy your investigations of the visual world.

When drawing from life is not possible, use your own photographs of objects or scenes of interest. This is better than relying on other people's shots, because invariably your visual record will remind you of what it was about that image you wanted to capture.

One of the most important lessons I hope
you will take from this book is the value of
simplicity. Successful drawing does not demand a
sophisticated or complex approach. Look at this
sketch. Its quality derives from a simple approach
to shapes and the assimilation of their graphic
effects into one picture. I had to make an effort to
keep those shapes basic and simple. Always try to
do the same in your drawings.

ENGAGING WITH LIFE

Good art contains an essential ingredient that has to be experienced directly from the work. For this ingredient to be present the artist himself almost certainly must have direct experience of what he is communicating. Drawing from life is therefore of paramount importance. When faced with real people, animals, objects, landscapes, townscapes, whatever, the artist has to assess and then render shape, proportion, tonal variation, perspective and anatomy without losing the verisimilitude of the experience. Obviously, there is some simplification and selection of what is exactly seen. Even so, this is a pretty tall order, and it is because talented artists try to do this all the time that their work is so good. Never forget: drawing from life will increase your ability to draw well. Drawing from drawings or photographs, or making up out of your head are valid, but if you don't return often to the natural visible world your drawings will never be convincing. Quite apart from the benefits it confers, it is the most interesting way to draw, and interest is what keeps art fresh and alive, both for the artist and the viewer.

ANALYZING SHAPES

Ordinarily when you look at a scene, object or person, your eyes will first register the shapes in an objective way and then your mind will supply information that enables you to recognize what you are seeing. The names, concepts or labels the mind supplies are not helpful to you as an artist, however, and you need to ignore them if you are to see objectively the shapes that are actually there.

One way of getting a more objective view is to analyze the shapes you are looking at in terms of their geometry. For example, a circular object seen at any angle forms an ellipse, and if you know how to draw an ellipse correctly you will get a good image of the object. Anything spherical is just a circle with toning to fool the eye into believing in the object's sphericality.

The spaces between objects are often triangles or rectangles. Objects within a group can be seen as being at different angles to each other: a leg may be propped up at an angle of 45 degrees from the upright torso, and the lower leg may be at right-angles to the thigh.

This sort of visual analysis is very useful for you, the observer, to undertake and will help the accuracy of your drawing. Once you recognize the angles you are drawing, you will find it difficult to draw them badly.

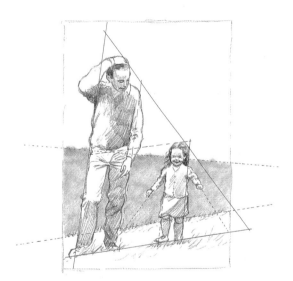

Observing a subject in almost geometric terms helps to simplify our approach to drawing. Look at this very simple picture. Both figures can be contained in a triangle. To the right of the little girl the space can be cut off along her right side so that she and her father's legs fit into a parallelogram. The space under her left arm, extending to her father's foot, makes another triangle.

Measuring proportions

Another useful form of analysis is to employ some common unit of measurement to get the proportions of different objects in your drawing right. For example, the shape and size of a door or window can give you a basic unit of measurement with which to measure the other units in a composition. In figure drawing, the head is a useful unit for measuring the human body. If you use a form of analysis, just remember that the unit has to remain constant throughout the composition, otherwise the proportion will not be right.

Rule of thumb is one of the most common units of measurement (see opposite page). The logic of this method is that your arm will not grow any longer during the time it takes to complete your drawing, so no matter how many measurements you take, your measuring device will remain at the same distance from your eye. Remember, though, that if you move your position you will have to start again because every proportion may alter.

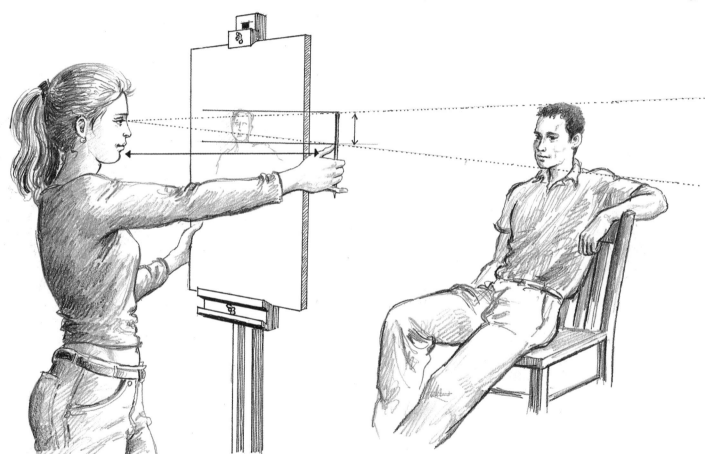

Using rule of thumb

Here the rule of thumb measurement is used to gauge the proportions of a figure. The arm is outstretched and the pencil held upright in line with the drawing board. The measurement taken (of the head, in this instance) is called 'sight-size'.

Once the measurement is taken it can be transferred to the paper. As long as you measure everything in your scene in this way, staying the same distance from the model and keeping

the pencil at arm's length when measuring, the method will give you a fairly accurate range of proportions.

This method is of limited value to beginners, however: the drawing will not be large and beginners really need to draw large in order to correct their mistakes more easily. Experienced artists will be able to translate the proportions into larger measurements when drawing larger than sight-size.

MAKING SPACES

An important part of composition that is often overlooked is the relationship of the shapes or spaces between objects and the objects themselves. These spaces must be taken into account when you are combining objects. Every artist has to learn that when it comes to drawing a group of objects there are no unimportant parts. The spaces or shapes between objects are known as negative shapes. In any composition they are as important as the objects themselves, irrespective of whether you are creating an 'ordinary' sort of picture or something you consider really interesting. Study the following examples.

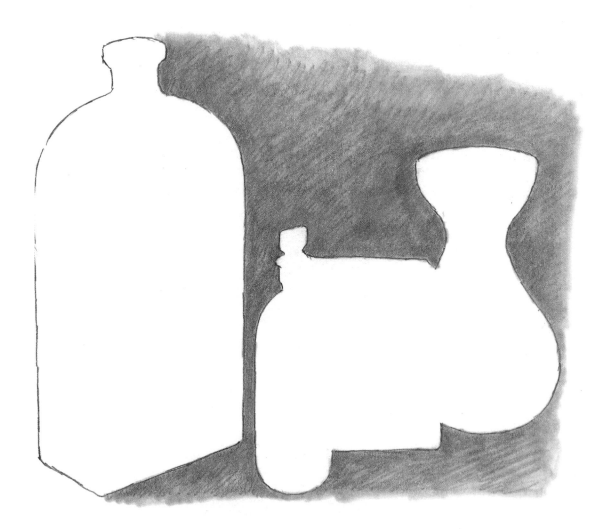

This drawing and that at the top of the facing page are of the negative spaces between objects in still life compositions. Try doing this with your own compositions and you will begin to appreciate how the shapes that make up an empty background have as much effect on your final drawing as does your choice of objects.

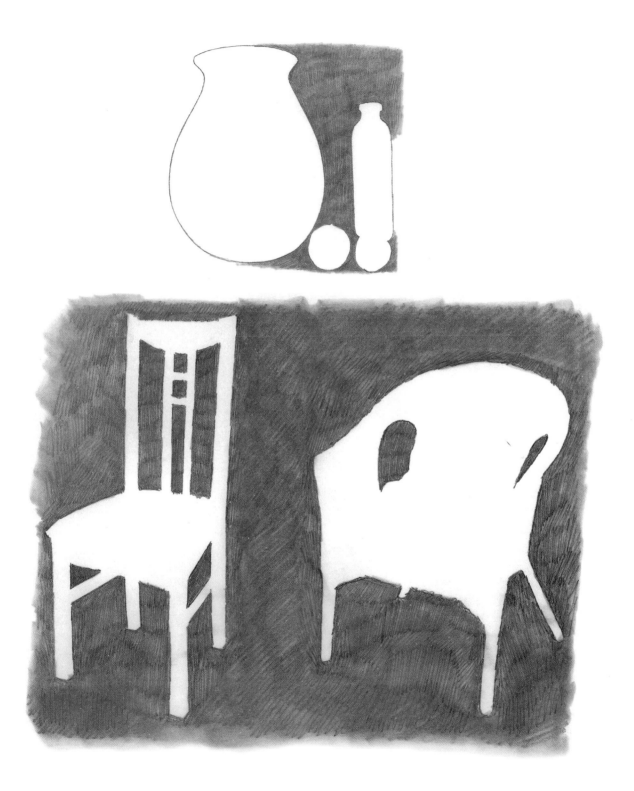

Objects like furniture clarify the lesson of negative space. Look at these two chairs and you will realize that the definition of the spaces between the legs and arms and the back of the chair describe the objects precisely. The negative spaces are telling us as much about the shapes of the objects as we could discover if they were actually solid.

LOOKING AND DRAWING EXERCISE

Now give yourself a break from regular drawing and try this experiment, which is a favourite art school test for new students. It will stand you in good stead for what comes later.

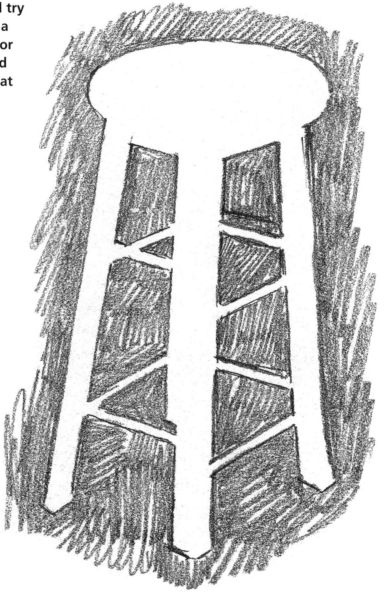

Place a chair or stool against a simple background; just wall and floor. Now draw the outlines of the spaces between the legs and the struts and fill them in with shading or tone. The trick is to see only the shapes in the spaces rather than the object itself. Just go for the shape of the spaces between the parts and around the object. When you have done enough you will see the object in negative between the shaded spaces. Don't worry if you go wrong – have another go.

This exercise shows there are no empty spaces in any view of the world; there is always something, even if it is only the sky. This realization gives us tremendous freedom from trying to make objects purely representations of themselves.

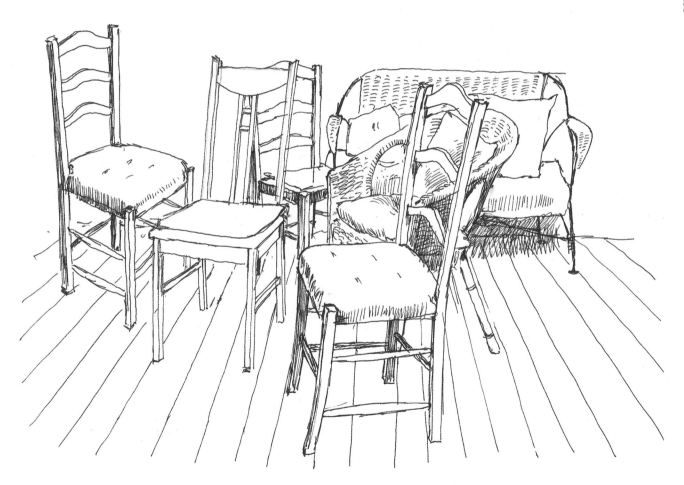

These chairs of various shapes and materials
scattered across the wooden floor in no apparent
order make interesting visual spaces in between
their forms. Large objects always force you to look
again at your efforts to compose well.

TECHNICAL AIDS

Photographs and slides can be used by artists to render a scene accurately. What they cannot give is a personal and thus richer view of a subject. This can only be achieved if the artist takes the time to go to the actual scene and look for himself.

The old masters used tools such as the *camera obscura* and *camera lucida* – literally, 'dark room' and 'light room' – to ensure the accuracy of their perspective and proportion. Another device used by artists of old to help this sort of technical analysis was a draughtsman's net or grid. This was a screen with crossed strings or wires creating a net or grid of exactly measured squares through which the artist could look at a scene. As long as the artist ensured that his eye was always in the same position each time he looked through the screen, and as long as a similar grid was drawn on his sheet of paper, the main composition could be laid out and each part related correctly.

These methods are not ends in themselves, however, and although they provide the main outlines of a composition, they cannot give the subtle distinctions that make a work of art attractive. To capture these, the artist has to use his own eye and judgement.

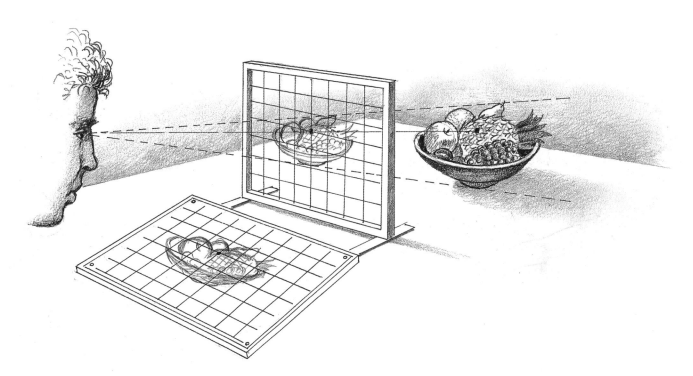

The draughtsman's net or grid is a construct for use in the Renaissance manner. Usually artists make them themselves or have them made by a framemaker. The squares can be either marked directly onto the glass or indicated by stretching thin cords or wires across a frame. The glass is then set in a stand through which the object is viewed.

Patience is required to transfer the image of a subject viewed in this way onto paper: it is very easy to keep moving your head and thus changing your view in relation to both the frame and the subject. The trick is to make sure that the mark on the object and the mark on the grid where two lines meet are correctly aligned each time you look.

Canaletto and Vermeer are just two of the artists who used the *camera obscura* in their work. It has the same effect as the *camera lucida*, although achieving it by different means. Used by painters for landscapes, cityscapes and interior scenes, the device was a tent or small room with a pin-hole or lens in one side which cast an image of the object onto a glass screen or sheet of paper, which could then be traced. It was an excellent device for architectural forms as long as one ignored the outer limits of the image, which tended to be distorted.

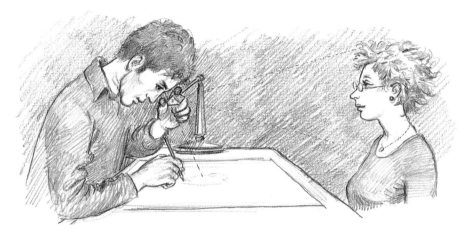

In a camera lucida or lucidograph a prism is used to transfer the image of a scene onto paper or board. This enables the artist to draw around the basic shape to get the proportions correct before he looks normally at the object.

The technique was well adapted for use in small areas of drawing and was probably favoured by illustrators and painters for portraits or still lifes. The lucidograph was used extensively by Ingres and possibly Chardin and Fantin Latour; David Hockney was encouraged to try it in his work after he detected the method in the drawings of Ingres.

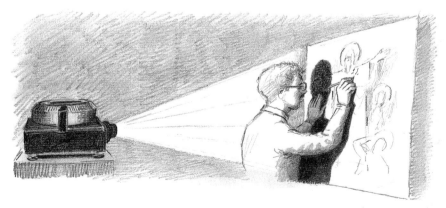

A slide-projector can give a similar effect to a lucidograph, although of course it allows you to use a much larger format and any kind of scene that can be photographed. It has been used extensively by artists who want to reproduce master paintings or enlarge their own work. Its only drawback is the difficulty of keeping your shadow out of the way.

ART APPRECIATION

An important part of observational drawing practice is getting into the habit of looking at the work of other artists. When viewing their work, try to analyze what makes it so attractive to you. Ask yourself questions. Don't be ashamed or coy if some of your answers suggest that your response is of a religious or spiritual nature. These are often the truest reasons why we like a work and should be acknowledged. Whatever the chord that is struck when you perceive a work, recognition of it will lead you towards understanding your own work and the direction it might take.

There is room for all sorts of artists and opinions about art. The freedom to find your own way towards art appreciation is of tremendous value.

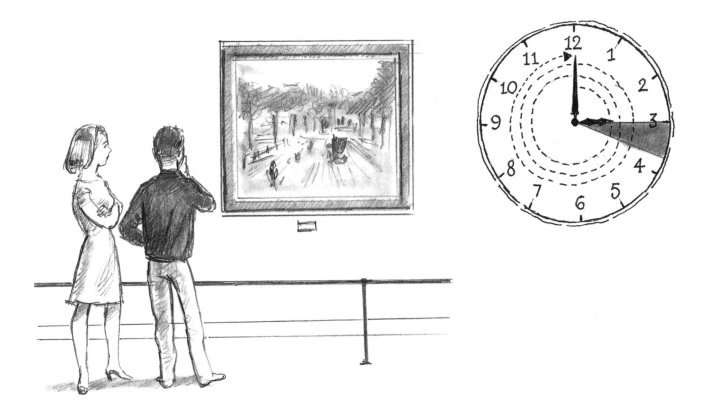

When looking at art you like, question your own perceptions. Is it the subject matter? Is it the technical brilliance of the artist? Is it the colour? Is it the form? Is it the medium used to produce the work? Is it the subtler ideas behind the form? Is it because it reminds you of someone? All these questions are valid. Many more will undoubtedly occur to you. The main point is to discover your true response to a picture that attracts you. Sometimes the answer is very simple, but sometimes the appreciation lies much deeper within yourself and will take some unearthing. Persevere and your reward will be considerable.

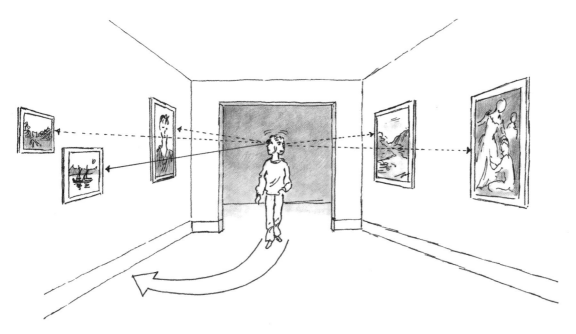

Don't try to look at everything. Wait until something really arouses your attention, and then give it your full attention. Spend at least three minutes just looking in detail at everything in the picture, without commenting. Then your questioning of what is in front of you will be very useful in clarifying your understanding.

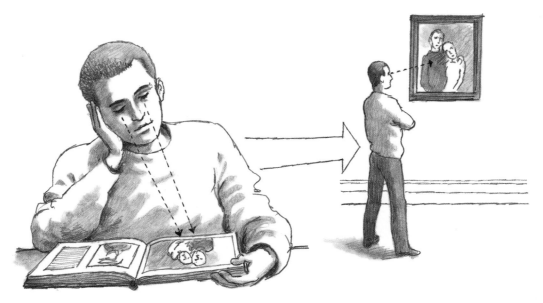

When looking at reproductions of famous works, notice where these works are held. If it is somewhere near enough for you to visit, do so. No matter how good the quality of a reproduction, the original possesses an extra dimension, and this will leap out at you as soon as you set eyes on the actual work. It is rather like discovering an old friend and seeing them totally afresh. First-hand knowledge of an original also helps to inform you of what is missing when you try to draw from a print of it. Without that knowledge you could not begin to make up for the lack.

So, let us now consider some drawings of the masters.

Peter Paul Rubens (1577–1640)

Before Rubens produced his rich, flowing paintings, full of bravura and baroque asymmetry, he would make many sketches to clarify his composition. These sketches are soft and realistic, with the faintest of marks in some areas and precise modelling in others.

The rather gentle touch of the chalk belies the powerful composition of the figures. When completed the paintings were full and rich in form. His understanding of when to add emphasis and when to allow the slightest marks to do the work is masterly.

Rubens was one of the first landscape painters, although he did this type of work only for his own satisfaction. His drawings of landscapes and plants are as carefully worked out and detailed as those of any Victorian topographical artist.

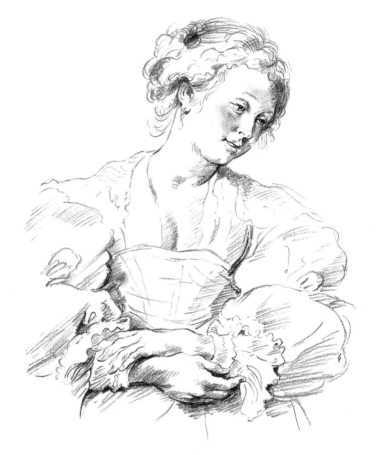

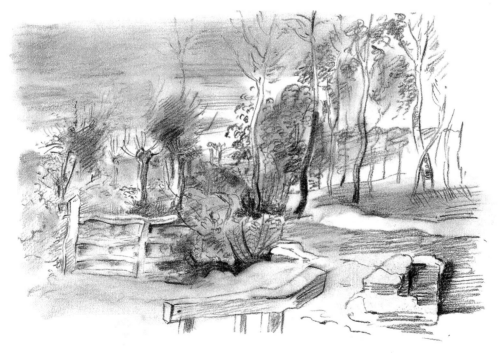

Hans Holbein the Younger (1497/8–1543)

Holbein left behind some extraordinarily subtle portrait drawings. These are worth studying for their brilliant subtle modelling. These subjects have no wrinkles to hang their character on, and their portraits are like those of children, with very little to show other than the shape of the head, the eyes, nostrils, mouth and hair. Holbein has achieved this quality by reducing the modelling of the form and putting in just enough information to make the eye accept his untouched areas as the surfaces of the face. We tend to see what we expect to see. A good artist uses this to his advantage. So, less is more.

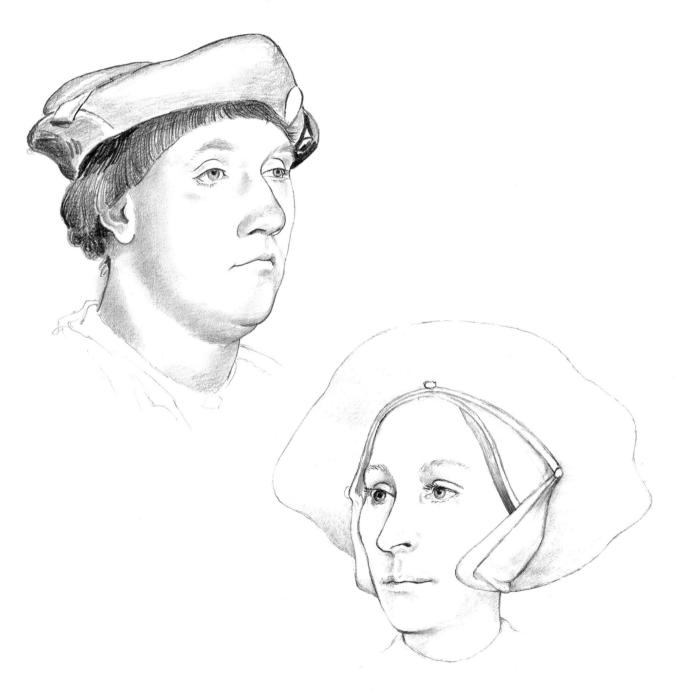

Jean-Antoine Watteau (1684–1721)

One of the most superb draughtsmen among the French artists of the 18th century, Watteau painted remarkable scenes of bourgeois and aristocratic life. Like all great artists he learnt his craft well. We too can learn to imitate his brilliantly simple, flowing lines and the loose but accurate handling of tonal areas. Notice how he gives just enough information to imply a lot more than is actually drawn. His understanding of natural, relaxed movement is beautifully seen. You get the feeling that these are real people. He manages to catch them at just the right point, where the movement is balanced but dynamic. He must have had models posing for him, yet somehow he implies the next movement, as though the figures were sketched quickly, caught in transition. Many of his drawings were used to produce paintings from. See page 524 for more on this drawing.

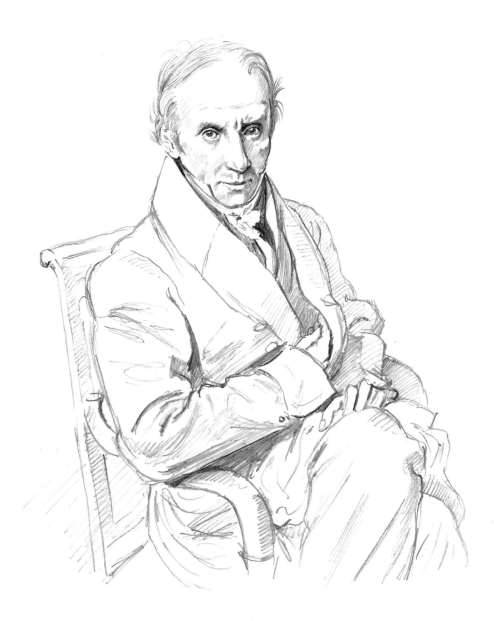

Jean-Auguste-Dominique Ingres (1780–1867)

Ingres' drawings are perfect even when unfinished, having a precision which is unusual. The incisive elegance of his line and the beautifully modulated tonal shading produce drawings that are as convincing as photographs. Unlike Watteau's, his figures never appear to be moving, but are held still and poised in an endless moment.

The elegance of Ingres was achieved by slow, careful drawing of outlines and shapes and subtle shading. If you would like to emulate this, try drawing from photographs to start with. When this practice has begun to produce a consistently convincing effect, then try using a live model. Your model will have to be prepared to sit for long periods, because this type of drawing can't be hurried.

Edgar Degas (1834–1917)

Degas was taught by a pupil of Ingres, and studied drawing in Italy and France until he was the most expert draughtsman of all the Impressionists. His loose flowing lines, often repeated several times to get the exact feel, look simple but are inordinately difficult to master. The skill evident in his paintings and drawings came out of continuous practice. He declared that his epitaph should be: 'He greatly loved drawing.' He would often trace and retrace his own drawings in order to get the movement and grace he was after. Hard work and constant efforts to improve his methods honed his natural talent.

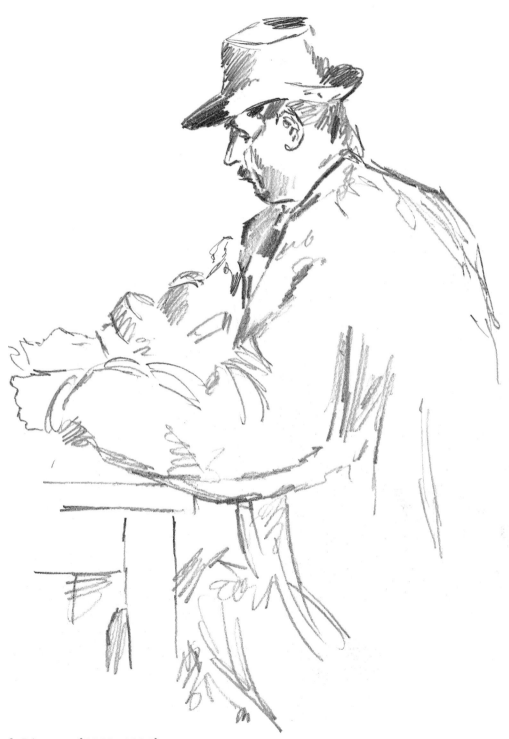

Paul Cézanne (1839–1906)

Cézanne attempted to produce art that was true to the reality of form as he saw it. He is the structural master-draughtsman without parallel in this section. All artists since his time owe him a debt of gratitude. He produced a body of work that saw the world from more than one viewpoint. The Cubists were inspired by his example to try to draw the objective world from many angles – whether or not they succeeded is arguable.

THE ARTIST'S EYE

OBSERVATION

We can learn a great deal from the compositions of professional photographers and painters and how they 'see' landscape.

Here are examples of different kinds of landscapes; two of the drawings are taken from photographs and the other two from paintings.

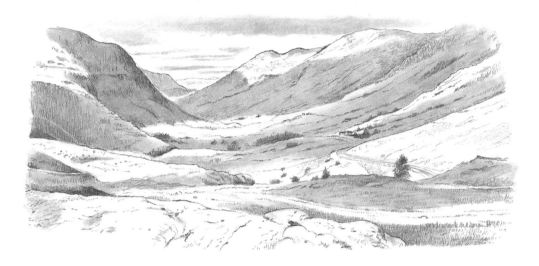

This marvellous open sweep of mountainous landscape shows the valley of Glencoe in the Scottish Highlands. The original photograph catches the effect of sunlight and cloud shadows flitting across the land. The drawing reflects this by showing one side of the valley much more clearly. The side with the sharper perspective has one large bluff or spur in the shadow of the cloud, which helps to create depth and drama.
A sense of scale is given by the road seen winding across the width of the valley and the minute cottage in the distance.

The second photograph-based scene is quite different, with a very localized view. Here we are close to trees and bushes viewed across an expanse of long grass and cow parsley. There is no distance to speak of and the interest lies in the rather cosy effect of a flattened path through the long grass, turning off suddenly with the luxuriant vegetation of summer hemming in the view. The effect is of a very English shire-like landscape; pleasant but without drama.

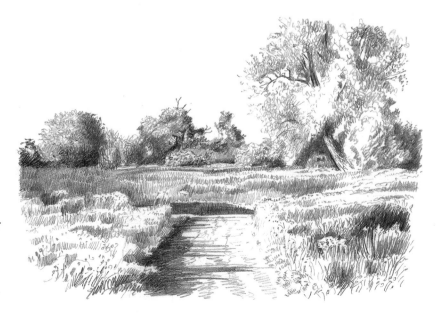

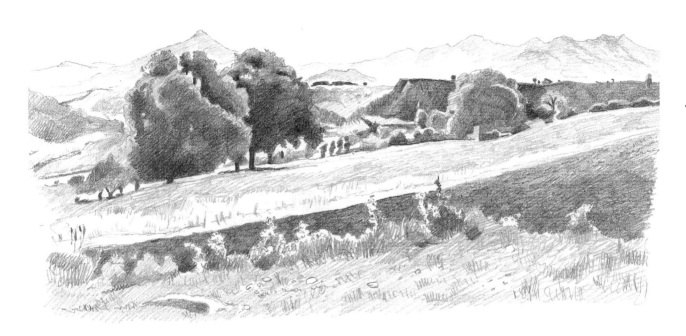

A beautiful sweep of landscape (after Corot) set in the Haute Savoie. The scope of the viewpoint is broad and shows mountain ranges in the distance. Closer up we see slopes and large trees in full foliage with, in the foreground, a large empty slope of grass, scrub and ploughed land. The broad movement from the high left towards the lower right side of the picture is balanced by the large group of trees at left of centre.

A view of Venice (after Monet) which combines compactness with a great effect of depth, thanks to the masterly handling of foreground details and distant buildings. Close up we see water and mooring poles rising out of the ripples to the left. Across the centre and right background, looking through mist, are the domes of Venetian churches caught in the light of the setting sun.

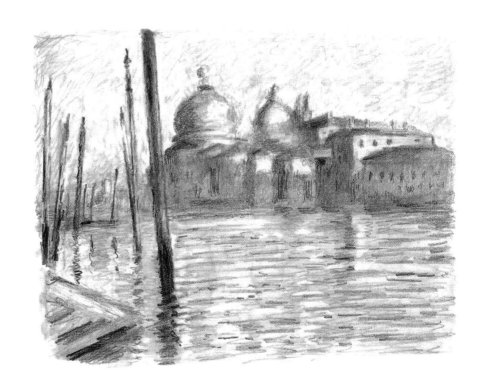

OBSERVATION

ELEMENTAL SHAPES

Elemental shapes are as expressive as they are defining, and offer many difficulties when it comes to drawing them. Whatever you do, don't retreat from the problems thrown up by your attempts. All are resolvable if you put in a bit of effort.

A good way to start is by selecting various symbols of the elements and studying them closely. Let's take them in order of difficulty, starting with earth and water.

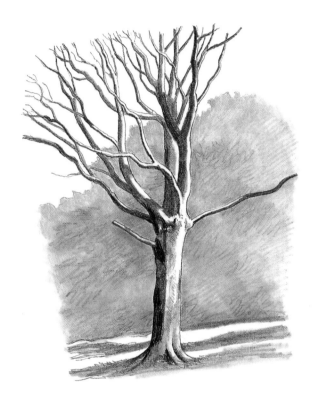

Earth can be shown by grains of soil or even a turf. Easier still is to choose a tree as your symbol, one whose branches can easily be seen. Winter is, of course, the best time to get a clear view of the architecture of deciduous varieties, which offer the most interesting shapes.

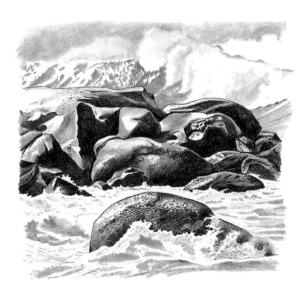

Water is an even harder form to understand than earth. First, try drawing some still water spilt onto a reflective surface, such as a mirror. Careful, detailed study will be necessary to really reveal its properties. Draw the outline edge of the shape first, look at the tonal qualities and then at the reflection in the water. This is not difficult as long as you draw everything you can see.

Moving water provides an even harder challenge. You will need to spend some time watching it and some time simplifying what you see. Eventually, though, you will begin to see the shapes it makes. Sometimes photographs can help in this respect. Don't be too subtle in your initial attempts.

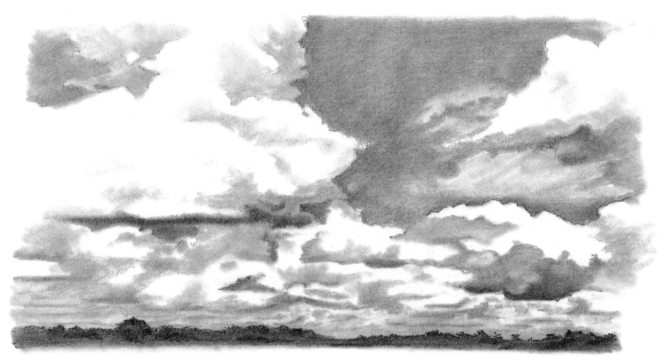

How do you draw what can't be seen? With air, the most obvious way is through the medium of clouds. Beautiful groups of water vapour hanging in the air, forming loose shapes, can describe air very effectively, especially when you see a whole procession of clouds stretching back to the horizon, as here. Try to draw a similar skyscape.

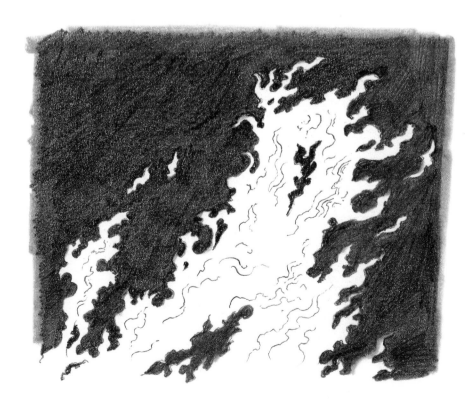

Fire is a really tricky subject. Start with a candle flame before you tackle the flickering flames of a big blaze. You can use photographs for reference, but unless you look closely at a real fire you won't get the feeling of movement or be aware of the variety of shapes. The early Japanese and Chinese artists had very good ways of drawing flames.

EARTH

When drawing the solid rocks that make up the surface of the world, it can be instructive to think small and build up. Pick up a handful or soil or gravel and take it home with you for close scrutiny, then try to draw it in some detail. You will find that those tiny pieces of irregular material are essentially rocks in miniature. You can get a very clear idea of how to draw the earth in all its guises by recognizing the essential similarities between earth materials and being prepared to take a jump from almost zero to infinity.

If we attempt to draw a rocky outcrop or the rocks by the sea or along the shore of a river, it is really no different from drawing small pieces of gravel, only with an enormous change of scale. It is as though those pieces of gravel have been super-enlarged. You will find a similar random mixture of shapes, though made more attractive to our eyes because of the increase in size.

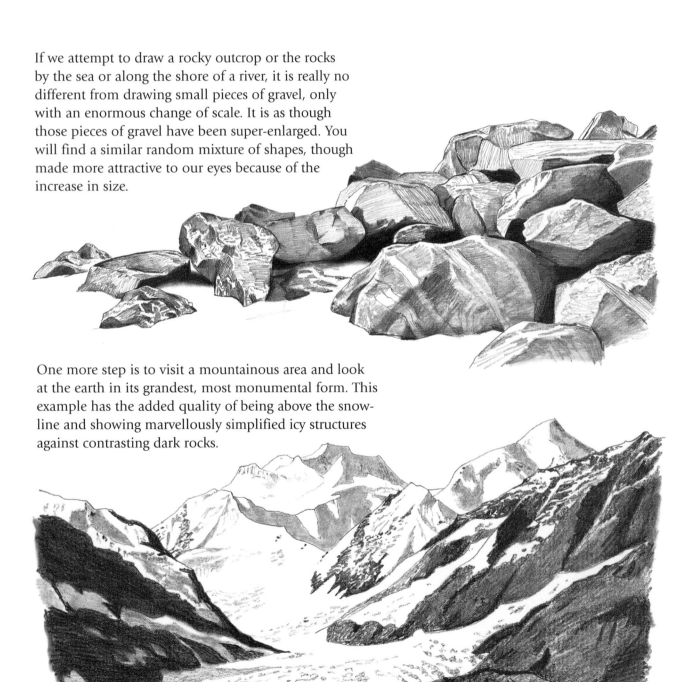

One more step is to visit a mountainous area and look at the earth in its grandest, most monumental form. This example has the added quality of being above the snow-line and showing marvellously simplified icy structures against contrasting dark rocks.

Now look at a large cliff-face, with its cleavages and striations of geological layering, some of it, no doubt, partially hidden by plants, but nevertheless showing the structure very clearly.

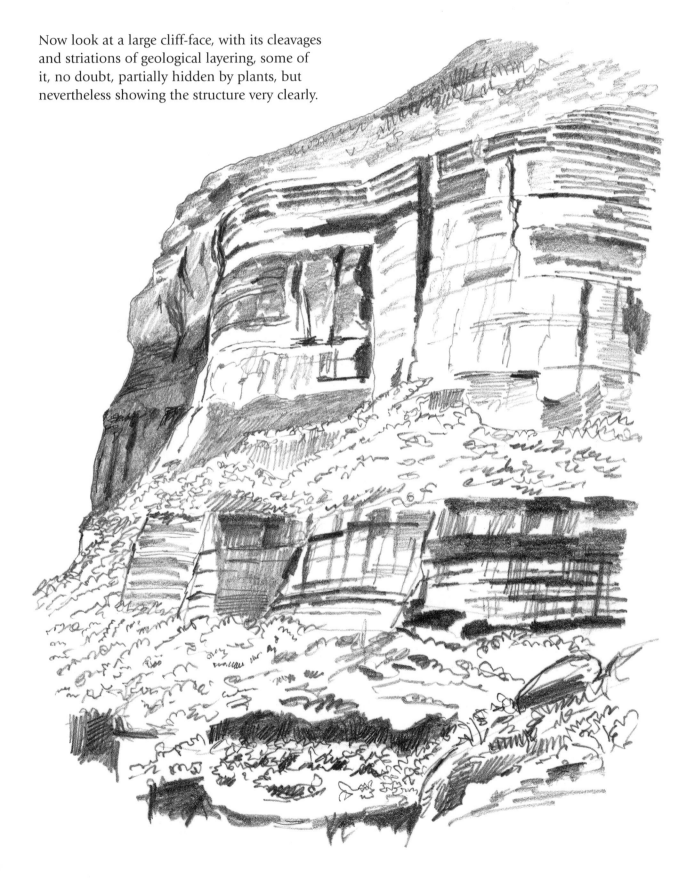

ROCKS

The visual nature of a mountain range will change depending on your viewpoint. Looked at from a considerable distance the details recede and your main concern is with the mountain's overall structure and shape.

The nearer you get, the softer the focus of the overall shape and the greater the definition of the actual rocks.

Below we analyze two examples of views of rocks from different distances.

In our first example, from a mountain range in Colorado, the peaks and rift valleys are very simply shown, giving a strong, solid look to the landscape. The main shape of the formation and the shadow cast by the light defines each chunk of rock as sharply as if they were bricks. This is partially relieved by the soft misty patches in some of the lower parts. The misty areas between the high peaks help to emphasize the hardness of the rock. Let's look at it in more detail.

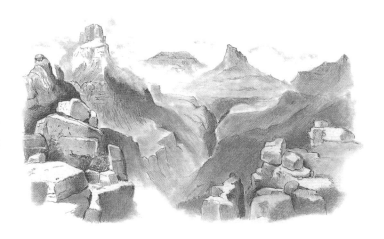

1.

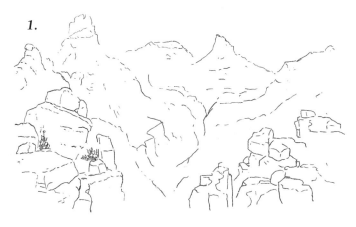

2.

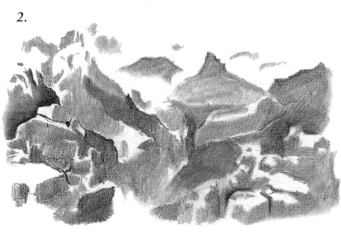

1. Sketch in with a fairly precise line the main areas of the mountain shapes, keeping those in the background very simple. For the foreground shapes, clearly show the outlines of individual boulders and draw in details such as cracks and fissures.

2. The real effect comes with the shading in soft pencil of all the rock surfaces facing away from the light. In our example the direction of the light seems to be coming from the upper left, but lit from the back. Most of the surfaces facing us are in some shade, which is especially deep where the verticals dip down behind other chunks of rock. The effect is to accentuate the shapes in front of the deeper shade, giving a feeling of volume. In some areas large shapes can be covered with a tone to help them recede from the foreground.

All the peaks further back should be shaded lightly. Leave untouched areas where the mist is wanted. The result is a patchwork of tones of varying density with the line drawing emphasizing the edges of the nearest rocks to give a realistic hardness.

You will find this next example, drawn exclusively in line, including the shadows, a very useful practice for when you tackle the foreground of a mountainous landscape or a view across a valley from a mountainside.

The cracks in the surfaces and the lines of rock formation help to give an effect of the texture of the rock and its hardness. The final effect is of a very hard textured surface where there is no softness.

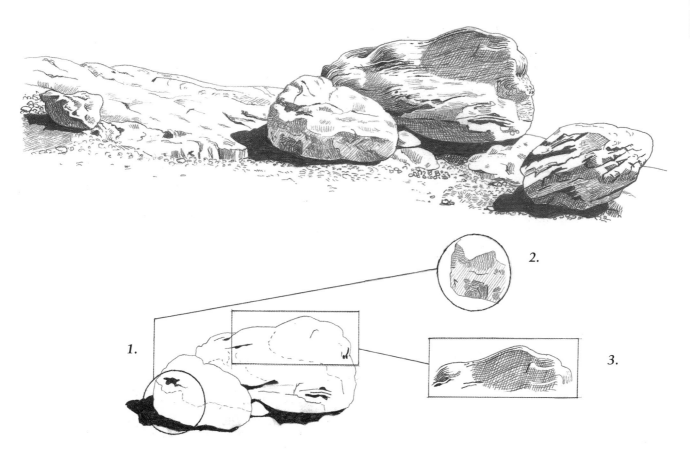

1. Draw in the outline as in the previous example, then put in areas of dark shadow as a solid black tone. Indicate the edges of the shaded areas by a broken or dotted line. Now carefully use cross-hatching and lines to capture the textured quality of the rock.

2. These particular rocks have the striations associated with geological stratas and as these are very clearly shown you can draw them in the same way. Be careful that the lines follow the bending shape of the stone surface and when a group of them change direction, make this quite clear in your drawing. This process cannot be hurried, the variation in the shape of the rock demanding

that you follow particular directions. Some of the fissures that shatter these boulders cut directly across this sequence of lines. Once again they should be put in clearly.

3. Now we come to the areas of shadow which give extra dimension to our shapes. These shadows should be put in very deliberately in oblique straight lines close enough together to form a tonal whole. They should cover the whole area already delineated with the dotted lines. Where the tone is darker, put another layer of straight lines, close together, across the first set of lines in a clearly different direction.

OBSERVATION

WATER

The character and mood of water changes depending on how it is affected by movement and light. Over the next few pages we look at water in various forms, which present very different problems for artists and very different effects to viewers. To understand how you can capture the effect of each of the forms shown here requires close first-hand study, supported by photographic evidence of what is happening, followed by persistent efforts to draw what you think you know.

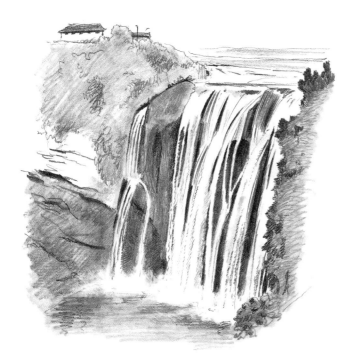

A waterfall is an immensely powerful form of water. Most of us don't see such grand works of nature as this magnificent example. Of course, you would need to study one as large as this from a distance to make some sense of it. This drawing is successful largely because the watery area is not overworked, but has been left almost blank within the enclosing rocks, trees and other vegetation. The dark tones of the vegetation throw forward the negative shapes of the water, making them look foaming and fast-moving.

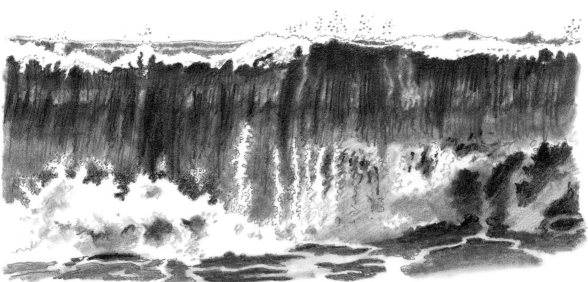

Unless you were looking at a photograph, it would be almost impossible to draw with any detail the effect of an enormous wave breaking towards you as you stood on a shore. Leonardo made some very good attempts at describing the movement of waves in drawings, but they were more diagrammatic in form.

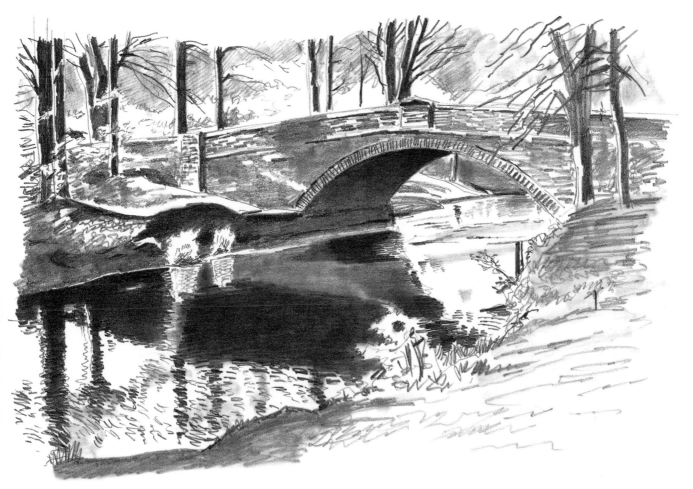

This is water as most of us who live in an urban environment see it, still and reflective. Although the surface of a stretch of water may look smooth, usually there is a breeze or currents causing small shallow ripples. Seen from an oblique angle these minute ripples give a slightly broken effect along the edges of any objects reflected in the water. When you draw such a scene you need to gently blur or break the edges of each large reflected tone to simulate the rippling effect of the water.

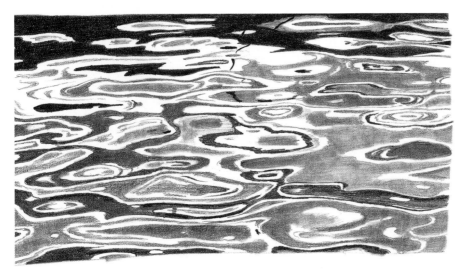

In this very detailed drawing of a stretch of water rippling gently, there appear to be three different tones for the smooth elliptical shapes breaking the surface. This is not an easy exercise but it will teach you something about what you actually see when looking at the surface of water.

TREES

Drawing trees has always been a favourite pastime of artists even when a commission is not involved. Trees are such splendid plants and often very beautiful but they are not that easy to draw well. Before you begin, consider the sketches on this page.

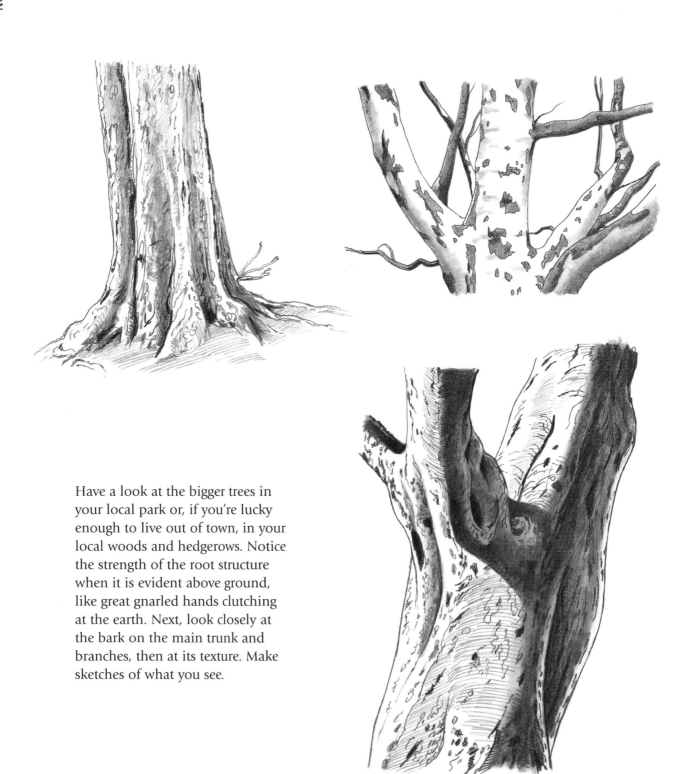

Have a look at the bigger trees in your local park or, if you're lucky enough to live out of town, in your local woods and hedgerows. Notice the strength of the root structure when it is evident above ground, like great gnarled hands clutching at the earth. Next, look closely at the bark on the main trunk and branches, then at its texture. Make sketches of what you see.

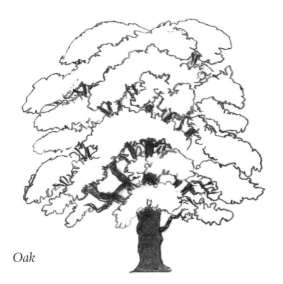

Oak

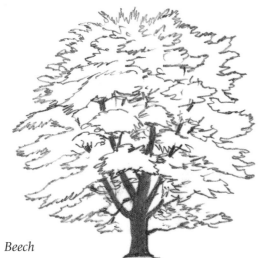

Beech

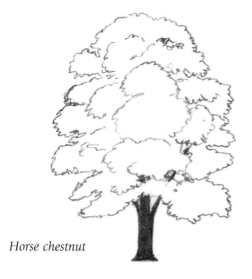

Horse chestnut

SHAPES

Getting a feel for the whole shape of the tree you want to draw is important. Often the best way to approach this is to draw in a vague outline of the main shape first. Then you need to divide this up into the various clumps of leaves and give some indication of how the main branches come off the trunk and stretch out to the final limit of the shape.

Of course, if your subject is a deciduous tree in winter the network of branches will provide the real challenge. The branches are a maze of shapes and success can only be achieved if you manage to analyze the main thrust of their growth and observe how the smaller branches and twigs hive off from the main structure. Luckily trees don't move about too much, and so are excellent 'sitters'.

These three types of deciduous tree present very different shapes and textures. Discover for yourself how different they are by finding an example of each, observing each one closely and then spending time drawing the various shapes. Note the overall shapes and the branch patterns – see accompanying drawings.

Outline of oak with branch pattern.

Outline of beech with branch pattern.

Outline of horse chestnut with branch pattern.

Drawing branches can prove problematical for even experienced artists. The exercise below is designed to get you used to drawing them. Don't worry about rendering the foliage precisely, just suggest it.

I drew this large tree in spring when its leaves were not completely out. It was an ideal subject for demonstrating the intricate tracery of branches because of its position on a wooded slope, which meant that its foliage was largely restricted to the tops of the branches.

When you first look at a tree like this, it is not at all easy to see how to pick out each branch. One useful approach is to draw the main stems without initially worrying whether they cross in front of or behind another branch. Only when you draw a branch that crosses the first one need you make a note of whether it crosses behind or in front.

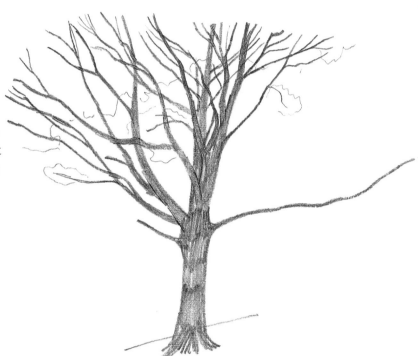

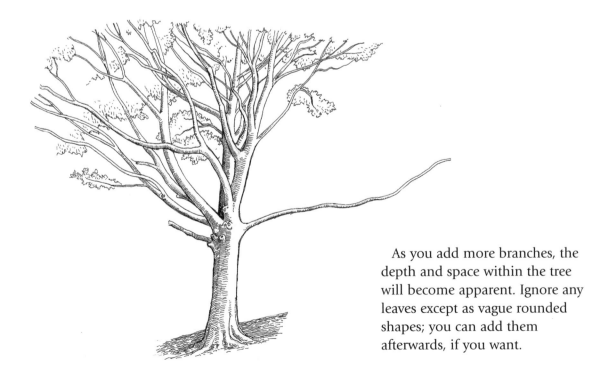

As you add more branches, the depth and space within the tree will become apparent. Ignore any leaves except as vague rounded shapes; you can add them afterwards, if you want.

When seen in silhouette every tree produces a distinctive web pattern. The point of this next exercise is to try to put in as much detail as you can, including leaves (if there are any) and twigs. To achieve this you have to draw the silhouette at a reasonable size; ie, as large as possible on an A4 sheet of paper.

One of the best varieties to choose for this exercise is a hawthorn, or may, tree. Its twisting, prickly branches and twigs make a really dense mesh, which can be very dramatic.

Try drawing it in ink, which will force you to take chances on seeing the shapes accurately immediately; you are committing yourself by not being able to rub out. It won't matter too much if you are slightly inaccurate in detail as long as the main pattern is clear.

Winter is the best time to do this exercise, although the worst time to be drawing outdoors. You could carefully copy a good photograph of such a tree in silhouette, but this would not teach you as much.

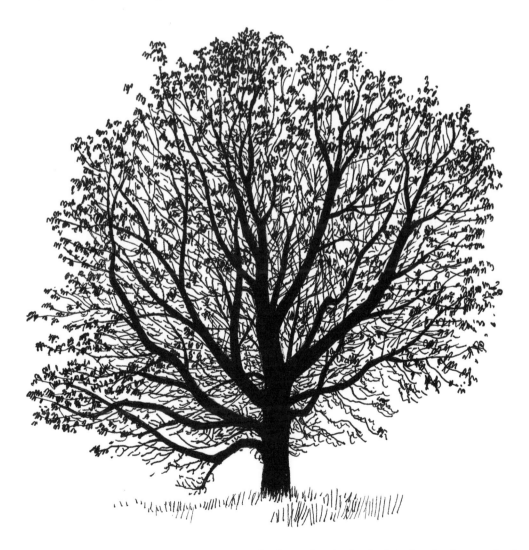

This silhouette is rather as you would see it against the sunlight and makes an extraordinary, intricate pattern. There is no problem with the branches being behind or in front of other branches, as there was in the example on the previous page.

PLANTS AND FLOWERS

The essential structure of a plant is not difficult to see if you study it for a time. Take a group of leaved plants: you soon notice how one type will have leaves in clusters that spring up at the points of the leaves, whereas in another the leaves will hang down around a central point.

Some plants have stalks coming off the branches evenly at the same point, others have the stalks staggered alternately down the length of the stem. Once you are familiar with a plant's characteristic shape and appearance, you will begin to notice it or similar properties in other plants. Observation will lend verisimilitude to even your most casual sketches. Look at the examples of plants on this spread, noting their similarities and differences.

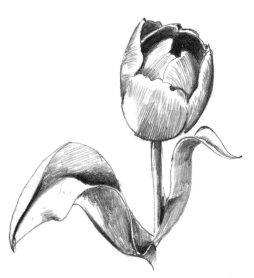

The appearance of the tulip is very formal and upright, with its closed cup-like flower and long stiff stalk and leaves.

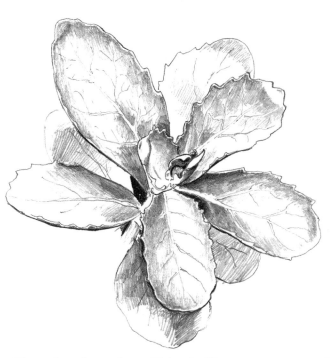

The sedum has a beautiful spiralling arrangement of leaves that curves up into a dish-like form. Rain must fill up the hollow of the leaf and run down the stalk to water the plant's roots.

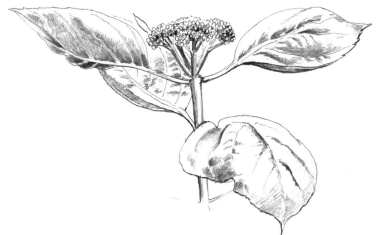

The leaves of the hydrangea come off the stem at opposite sides to each other in a symmetrical arrangment. Notice how they curve upwards and then how the curve is reversed, with the upper surface bulging out towards the tip.

The easiest way to study plants is by sketching them as often as you can. Before you begin to draw, look at the plant closely: at the bloom (if there is one), and note how the leaves grow off the stalk. Look at it from above, to see the leaves radiating out from the centre; and from the side to see the different appearance of the leaf shapes as they project towards you, away from you and to each side as they spiral round the stem. Note the texture of the leaves, and how it compares with that of other plants.

When your subject is a flower-head, draw it from an angle, where you can see the pattern of the petals around the centre of the blossom or a profile view of them. Notice the texture of the petals and how the centre of the flower contrasts with the main part of the bloom. When you draw the flower, include a leaf or two to show the contrast in tone or texture between the leaf and the petals.

The more you draw plants, the more details you will notice and the broader your vocabulary will become. After you have been drawing plants for a while, try drawing one from memory. This type of exercise helps to sustain the image that your senses have recorded and

The delicate blossom of the camellia looks so fragile. It contrasts beautifully with the solid, perfect shape of the leaves.

will help you to memorize shapes and textures. You will find drawing from memory gives a simpler result than drawing from life, because you tend to leave out unnecessary details. The ability to produce a conventional shape easily without reference is a great asset. Once you have this ability, you will be able to bring a greater sense of realism to your drawings.

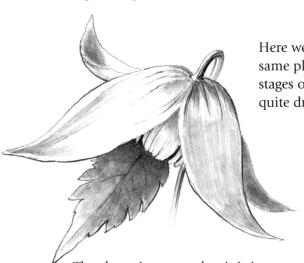

Here we have two blooms from the same plant (a clematis) at different stages of its growth. The difference is quite dramatic.

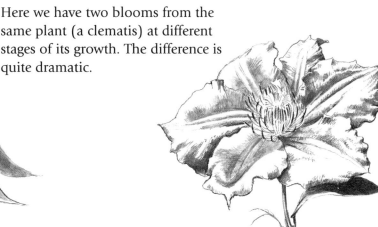

The clematis captured as it is just opening, with its smooth looking petals hanging down.

The fully open bloom, centre showing to the sun. By this stage the edges of the petals are quite crinkly.

GROWTH PATTERNS

Nature offers so much variety, as you will discover once you start studying it in earnest. Below you will find three very different effects in as many examples.

Compare them, and note the differences you observe. You will find these patterns of growth fascinating as you investigate them more fully and extend your experience.

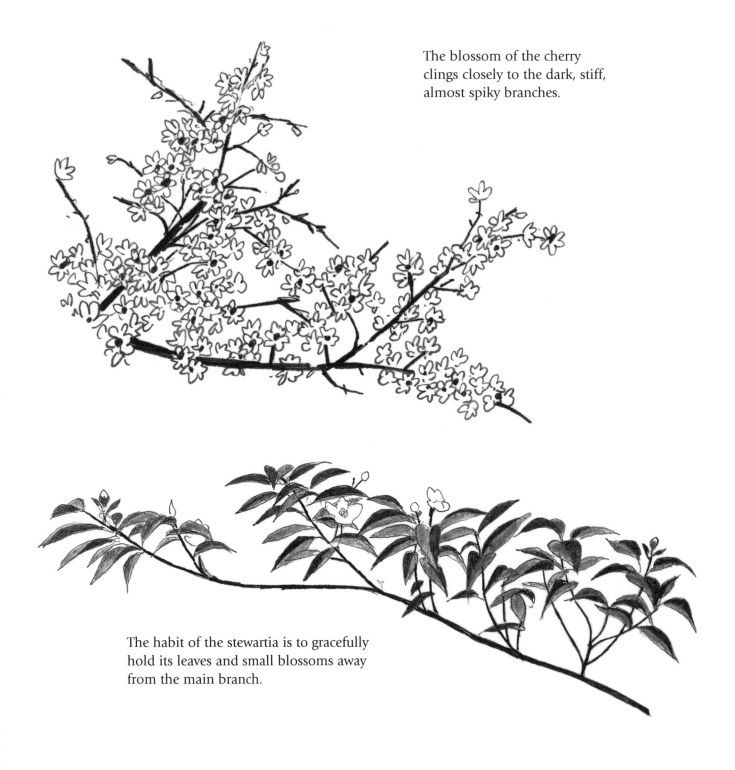

The blossom of the cherry clings closely to the dark, stiff, almost spiky branches.

The habit of the stewartia is to gracefully hold its leaves and small blossoms away from the main branch.

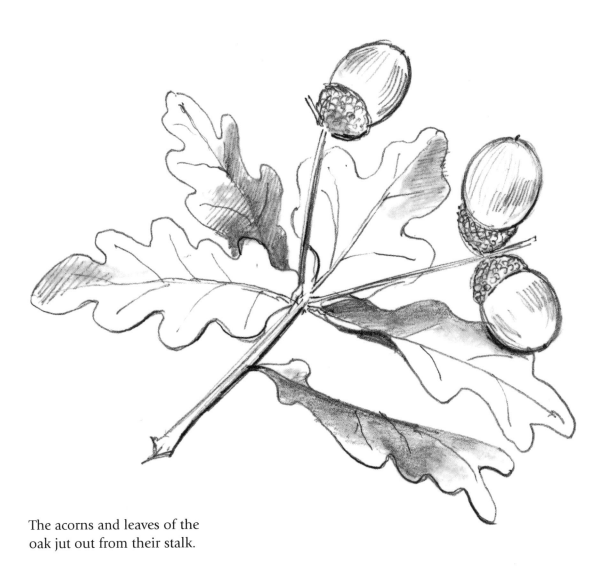

The acorns and leaves of the
oak jut out from their stalk.

Exercising Eye and Hand
It cannot be overemphasized that, in order to become a proficient artist, you need to get into
the habit of drawing every day. If you do, very soon you will become adept at handling almost
any shape. Keep trying different objects, and be adventurous, trying more difficult subjects once
you've got somewhere with easier ones.

BONES AND SHELLS

Skeletons are always interesting to draw because they provide strong clues as to the shape of the animal or human they once supported. They are often used in still-life arrangements to suggest death and the inevitable breaking down of the physical body that is its consequence. Some people may find them rather uncomfortable viewing because of this, but for the artist they offer fabulous opportunities to practise structural drawing, requiring all our skills to portray them effectively.

This old sheep's skull found on a hillside in Wales still retains a semblance of the living animal, despite the extensive erosion. The challenge for the artist is to get the dry, hard, slightly polished effect of the old weathered bone.

This is done by keeping the tones mainly light, with only a few very dark tones in the eye-socket or under the teeth. This, and the sharp edges of the tonal areas, help to show its hardness and smooth surface which catches the light.

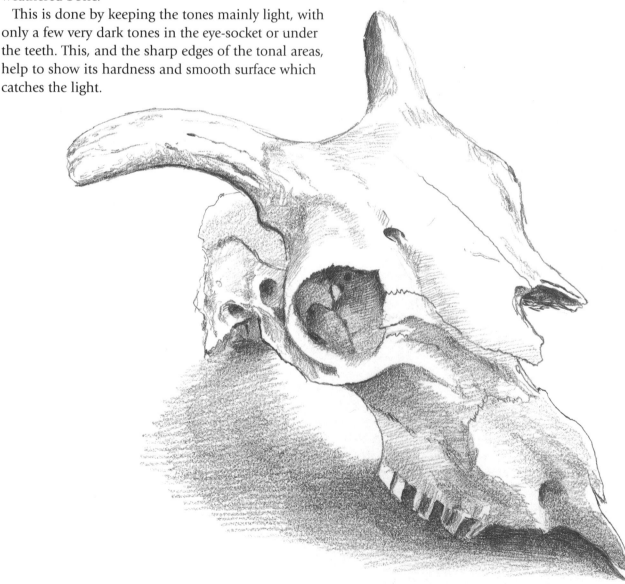

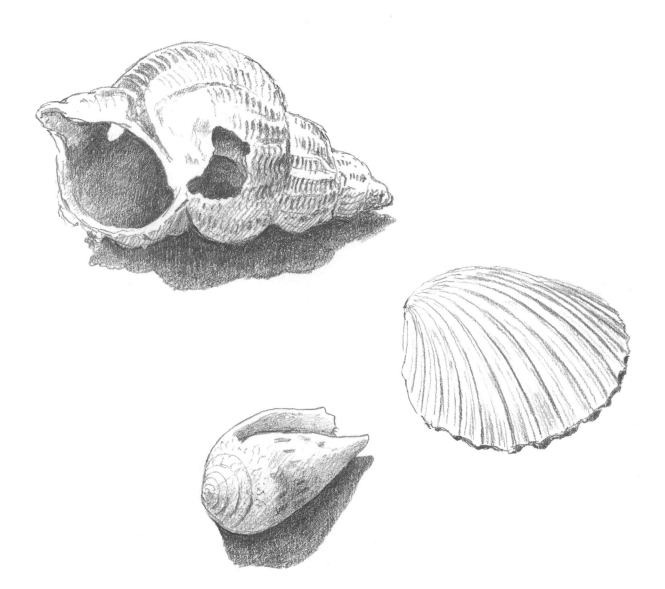

In contrast to the type of skeleton found in mammals and humans, the exoskeleton lies outside the body. These shells are all that remain of the molluscs they once shielded. As with the sheep's head, each one reveals the characteristic shape of its living entity.

Shells offer the artist practice in the drawing of unusual and often fascinating shapes, as well as different textures ranging from smoothly polished to craggy striations.

STONE

Natural materials such as rock offer a host of opportunities in terms of their materiality. All of the following are hard, solid objects, but that is about as far as the visual similarities go.

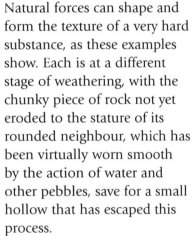

Natural forces can shape and form the texture of a very hard substance, as these examples show. Each is at a different stage of weathering, with the chunky piece of rock not yet eroded to the stature of its rounded neighbour, which has been virtually worn smooth by the action of water and other pebbles, save for a small hollow that has escaped this process.

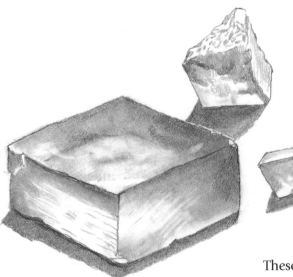

These pieces of feldspar present a different sort of smoothness, an almost glass-like surface in contrast to the opaque solidity of the previous examples.

WOOD

In its many forms, wood can make an attractive material to draw. Here the natural deterioration of a log is contrasted with the man-made construction of a wooden box.

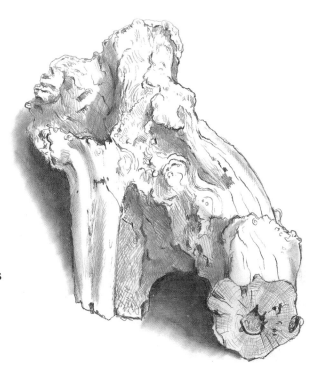

The action of water and termites over a long period has produced a very varied surface on the sawn-off log; in some places it is crumbling and in others hard and smooth and virtually intact apart from a few cracks. The weathering has produced an almost baroque effect.

By contrast, this wooden box presents beautiful lines of growth which endow an otherwise uneventful surface with a very lively look. The knots in the thinly sliced pieces of board give a very clear indication of the material the box is made of.

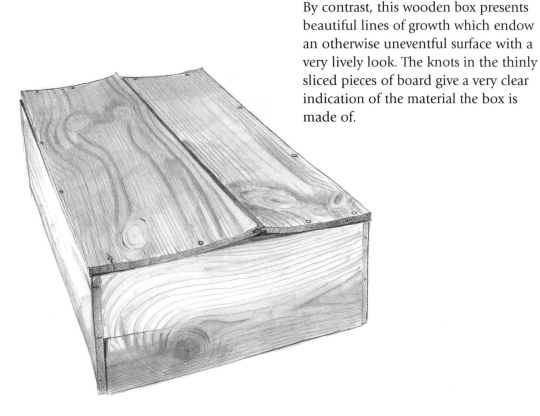

OBSERVATION

FIGURES: MAPPING

The greatest artists from the mid 1500s onwards were skilled in all areas of drawing and painting, but when the great art workshops (bottegas) of the Renaissance period were in full swing it was the master painter who would put in the figures, leaving the rest of the composition to be completed by his pupils. So be prepared for the most interesting and most difficult stage in your drawing career – but don't feel too daunted. The observational skills you are developing are crucial if you are to achieve a good level at figure drawing.

To begin mapping the figure, you could decide exactly where each point of the figure appears to be in relation to all the other points around it from your viewpoint. You could make a mark at the top of the head; then another at the back of the head, and another where the eyes are, all in relation to one to another. Most artists who use this method are assured of producing very accurate renderings of the form. Conversely, you can map the body very fast, delineating the form accurately but without much detail. Try both approaches to see which suits you better.

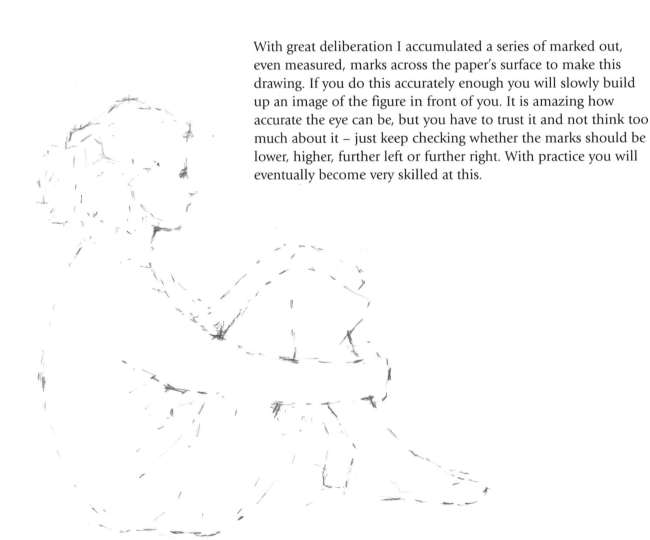

With great deliberation I accumulated a series of marked out, even measured, marks across the paper's surface to make this drawing. If you do this accurately enough you will slowly build up an image of the figure in front of you. It is amazing how accurate the eye can be, but you have to trust it and not think too much about it – just keep checking whether the marks should be lower, higher, further left or further right. With practice you will eventually become very skilled at this.

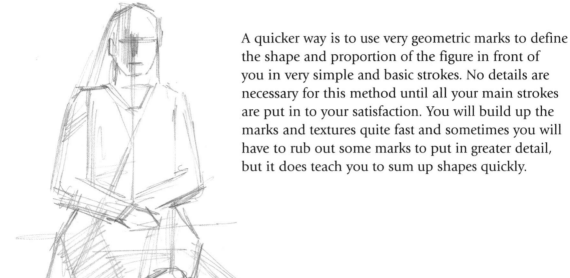

A quicker way is to use very geometric marks to define the shape and proportion of the figure in front of you in very simple and basic strokes. No details are necessary for this method until all your main strokes are put in to your satisfaction. You will build up the marks and textures quite fast and sometimes you will have to rub out some marks to put in greater detail, but it does teach you to sum up shapes quickly.

A fast way that can work very well if you are sketching people who are in motion is to draw with a scribble technique, hardly taking your pencil off the paper while you scrawl in marks that give some idea of the form in front of you without going into too much detail. What these drawings lack in details they often gain in vigour and liveliness.

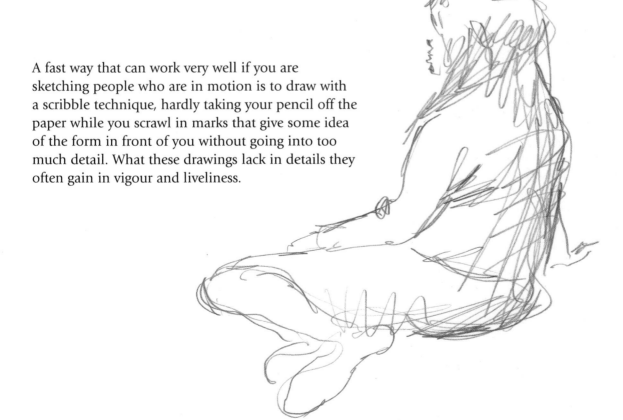

OBSERVATION

DRAWING FROM LIFE

Drawing from life is the foundation of all drawing, and particularly so in the case of figure drawing. The human body is the most subtle and difficult thing to draw and you will learn more from a few lessons in front of a model than you ever could by drawing from photographs.

In most urban areas, life drawing classes are not too difficult to find and if there is an adult education college or an art school that offers part-time courses it would be the best way to improve your drawing. Even professional artists will attend life drawing classes whenever possible, unless they can afford their own models. These classes are limited to people over the age of 16 because of the presence of a nude model.

One of the advantages of life classes is that there is usually a highly qualified artist teaching the course. The dedication and helpfulness of most of these teachers should enable you to gradually improve your drawing, and the additional advantage of the presence of other students will encourage your work by emulation and competition.

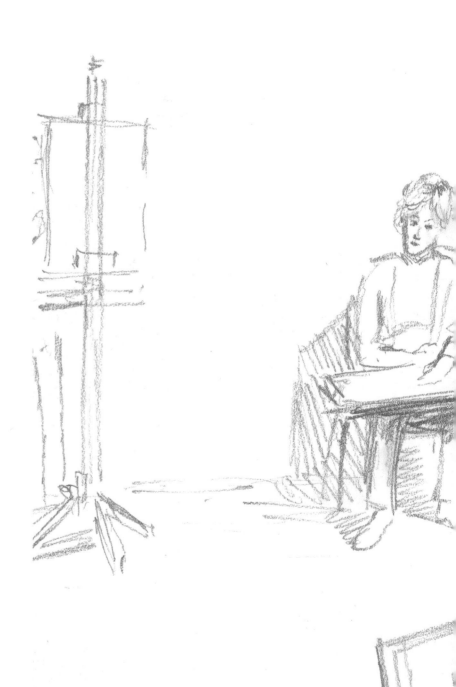

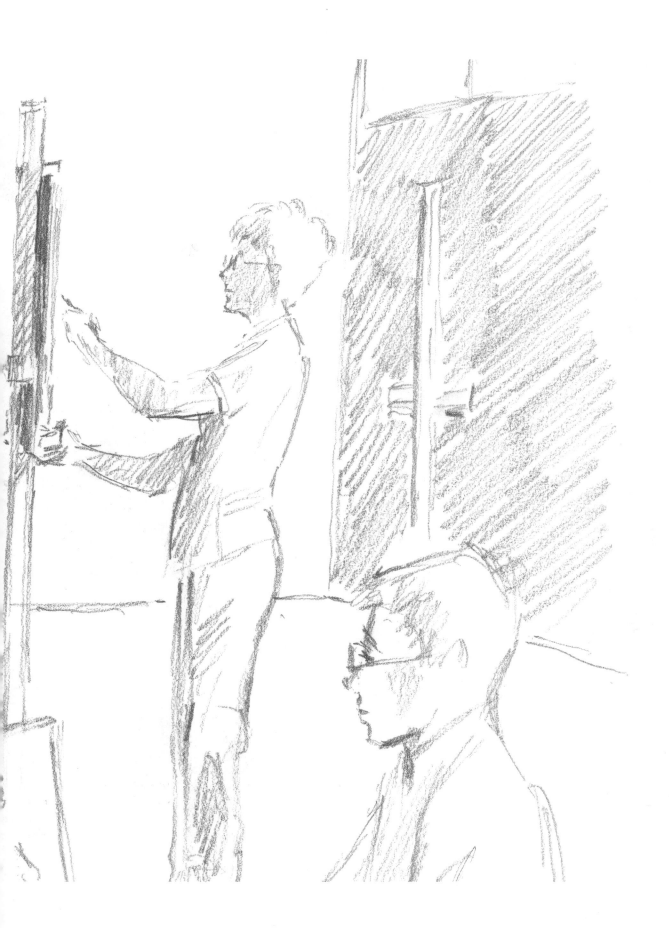

DRAWING FRIENDS

The greatest difficulty when drawing your friends is to persuade them to sit still for long enough. A professional model is accustomed to holding a pose for quite a while, but you may need to offer your friends some inducements to get them to do the same. Don't try to make them remain still for too long, though – even professional models get rests in between posing and someone not used to it may find it difficult to sit still for longer than 20 minutes. Nevertheless, in that time you should be able to take in the whole figure, even if it is not very detailed, and you will gain excellent drawing practice.

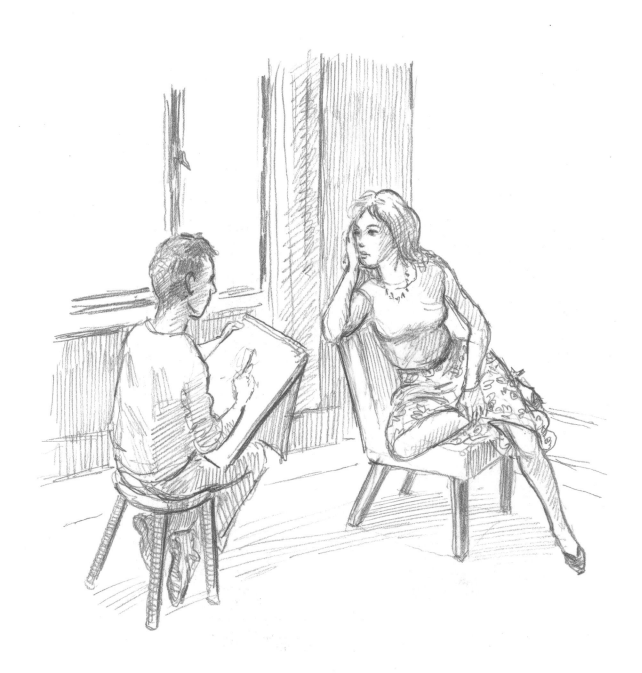

Indoors, make sure that you sit near a large window but without direct sunlight falling into the room. Place yourself side on to the window and get your friend to sit in an interesting but comfortable pose – not too complicated, or they will find it difficult to maintain the position.

Draw outdoors as well when you are able to because the light is different and you can often see much more clearly when the light is all around the figure. Try to do it on a day on which the sun is not strong: a cloudy warm day is best, because the light is even and the forms of the figure show more clearly.

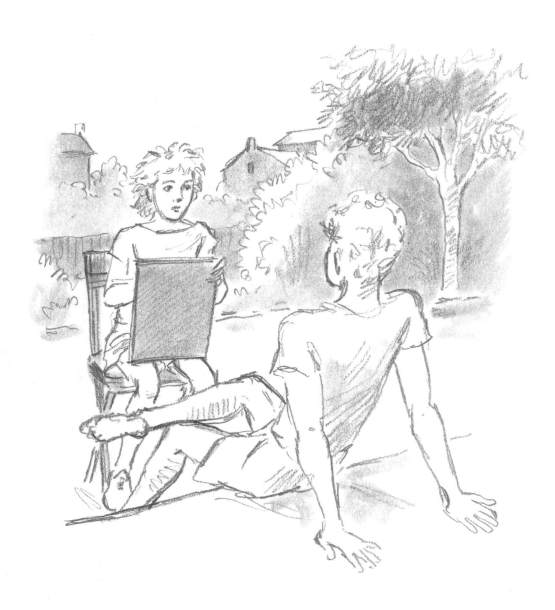

ARMS AND HANDS

Elbows and wrists are extremely important features but are often poorly observed by students. By paying extra attention to these joints when you are drawing the arms you will enormously increase the effectiveness of your drawing.

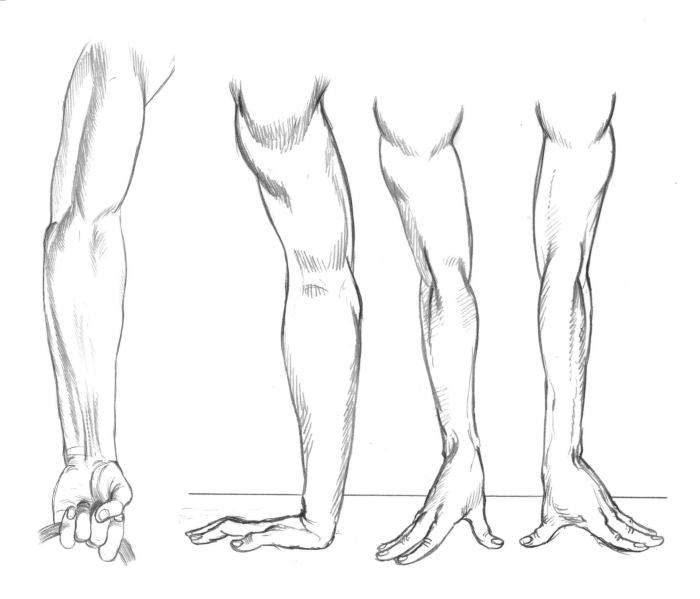

In these examples, notice how when the arm is under tension in the act of grasping an object or bearing weight, the muscles stand out and their tendons show clearly at the inner wrist.

As can be seen on the page opposite, when the arm is bent the larger muscles in the upper arm show themselves more clearly and the shoulder muscles and shoulder blades are seen more defined.

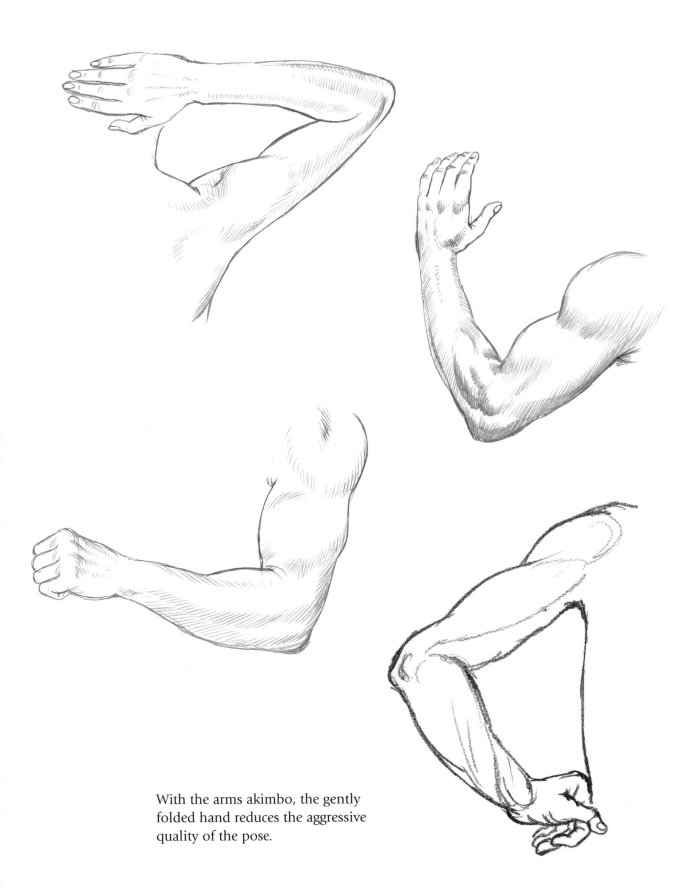

With the arms akimbo, the gently
folded hand reduces the aggressive
quality of the pose.

HANDS CLOSE UP

Hands are relatively easy to study, especially if you use your own as models. If you equip yourself with a mirror, you should be able to look at them from almost any angle. Of course, it will also be necessary to look at the hands of an older or younger person and also one of the opposite sex. You will find there are significant differences in shape depending on age and sex.

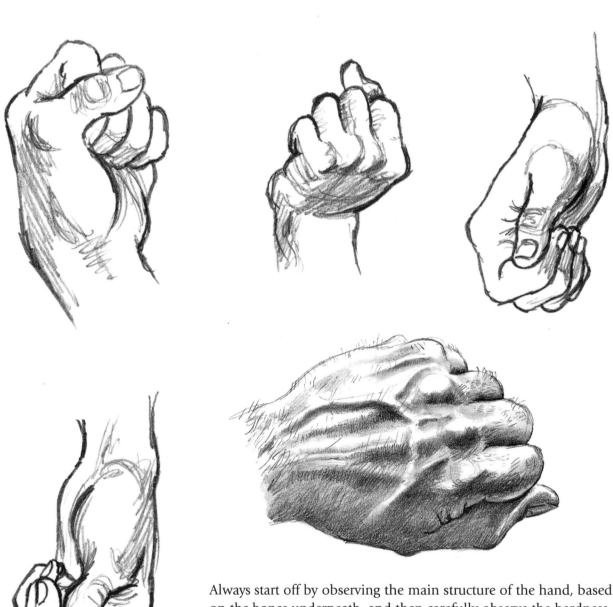

Always start off by observing the main structure of the hand, based on the bones underneath, and then carefully observe the hardness or softness of the flesh and skin.

The back of the hand gives the clearest indication of the age of your model. Older hands have more protuberant veins and looser, more wrinkled skin around the knuckles. The hands of small children seem smooth all over.

Many people find hands difficult to draw. You will never lack a model here because you can simply draw your own free hand, so keep practising and study it from as many different angles as possible. The arrangement of the fingers and thumb into a fist or a hand with the fingers relaxed and open create very different shapes, and it is useful to draw these constantly to get the feel of how they look. There is inevitably a lot of foreshortening in the palm and fingers when the hand is angled towards you or away from your sight.

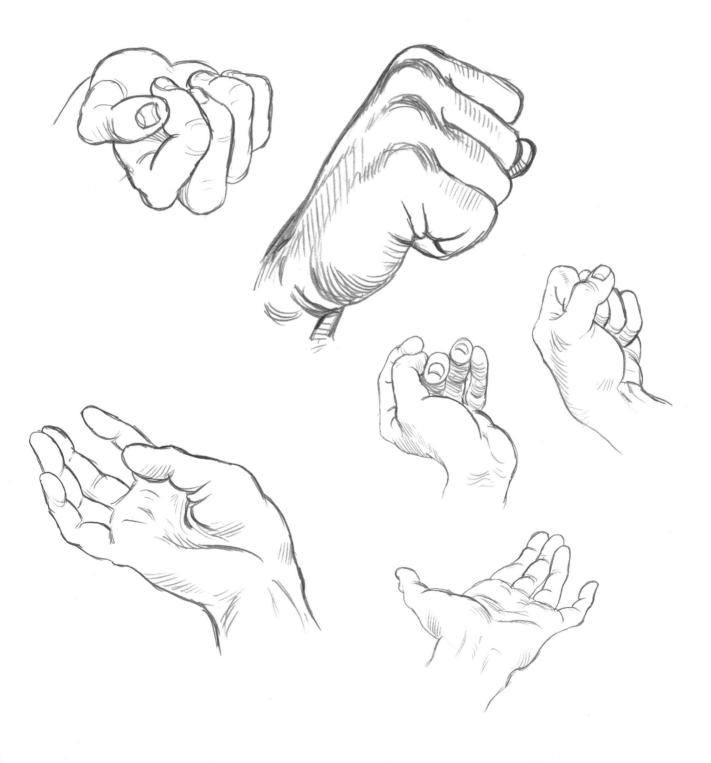

LEGS

The legs are not quite so flexible as the arms, but they are much more powerful, and so are much more powerfully built. The large muscles in the thigh and the strong, bony knee give the leg a similarity to the trunk of a small tree, so we understand connotations of strength and solidity. Remember that any part of the limb nearer to the torso is wider than the part further away, therefore calves are smaller than thighs and ankles are smaller than knees.

Notice how the foot compares in proportion with the length of the leg. Also note how easy it is to see the muscles on the leg because it has to support the weight of the body: the muscles are that much more powerful than those in the arm and so are more defined in the leg.

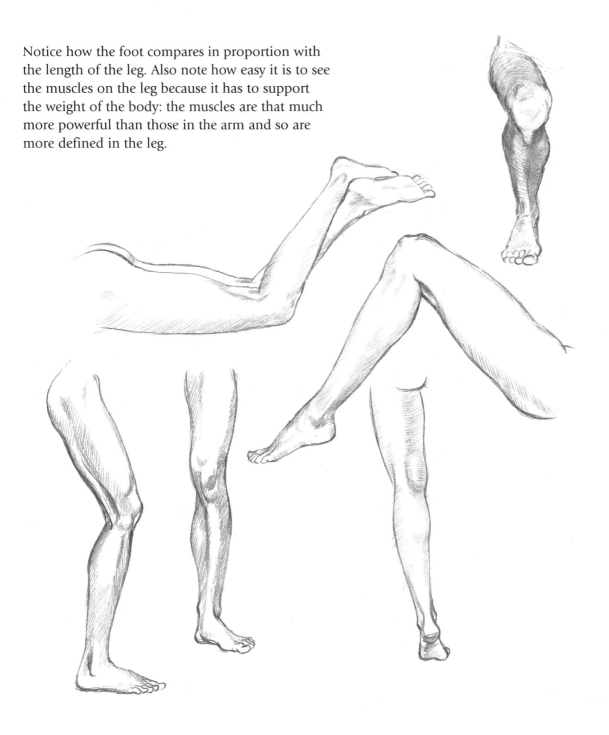

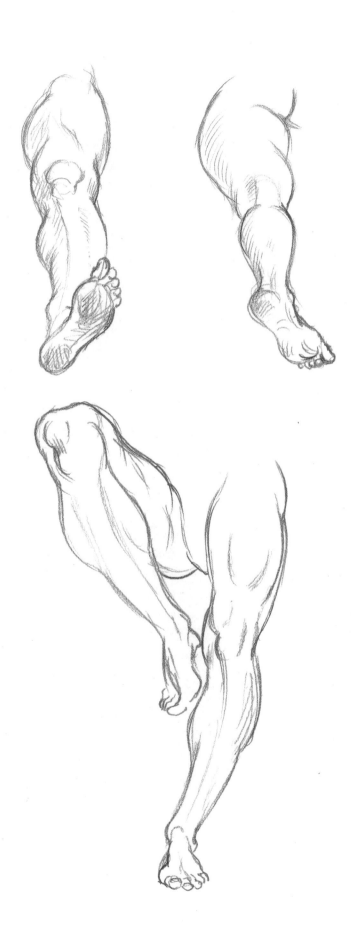

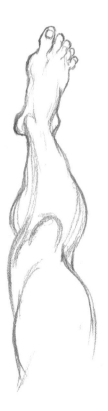

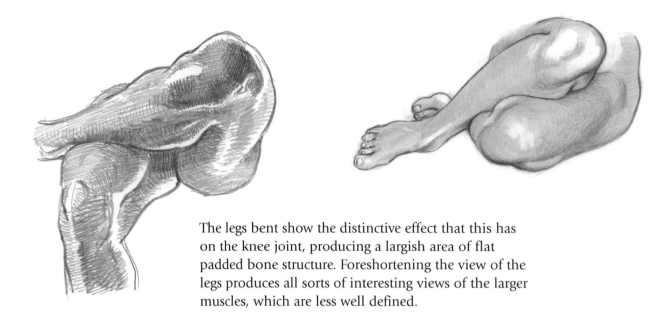

The legs bent show the distinctive effect that this has on the knee joint, producing a largish area of flat padded bone structure. Foreshortening the view of the legs produces all sorts of interesting views of the larger muscles, which are less well defined.

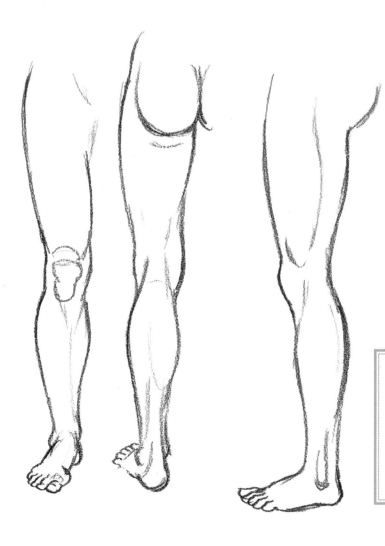

The shape of the leg is determined by how well the muscles are developed. In these drawings all the leg muscles are clearly delineated.

The joining of the leg to the foot can prove problematical for the novice and can let down an otherwise competent drawing. Pay particular attention to the relationship of the ankle to the instep and practise drawing this.

CLOSE-UPS OF FEET

Quite often, students of drawing tend to fudge the feet when drawing the body. They will, for example, produce a wedge-shaped extremity to the leg and this will, at best, look as though the model is wearing socks. It is worth making something of a feature of feet because the viewer's attention nearly always goes to the extremities of objects; thus the hands, feet and head are often noticed in a drawing. Sometimes artists leave them out altogether, but this is not good practice for a student.

Feet are not as difficult to draw as hands, but they can be tricky from some angles and this can result in awkwardness in your drawing. It's a good idea to practise drawing them from the front, back and both sides. To begin with, try drawing your own feet in a mirror. Feet do differ quite a lot and rarely conform to the classical model. Try to give yourself practice of drawing a female foot, a male foot and a small child's foot. Look at these examples, taking note of the major characteristics.

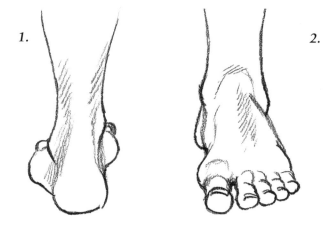

In these views you can see that the inner ankle bone is higher than the outer ankle bone.
1. Note the ball of the heel and the Achilles' tendon.
2. Looking from the front, notice how the line fluctuates to take in the large toe, the instep and the heel.

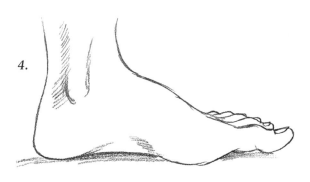

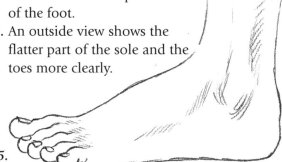

4. From this angle the large toe partly obscures the smaller toes. Note the instep and arch of the foot.
5. An outside view shows the flatter part of the sole and the toes more clearly.

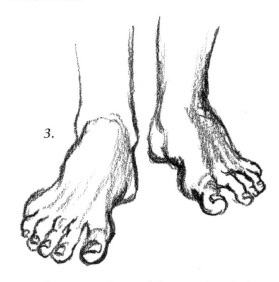

3. Note the proportions of the toes in relation to one another and in relation to the whole length of the foot.

OBSERVATION

FEET

The bone structure of the foot is quite elegant, producing a slender arch over which muscles and tendons are stretched.

The lower part of the foot is padded with soft subcutaneous matter and thicker skin.

Notice how the toes, unlike the fingers, tend to be more or less aligned although the smaller toes get tucked up into small rounded lumps.

The inner anklebone is higher than the outer, which helps to lend elegance to this slender joint. If the difference in the position of the ankle bones is not noted, the ankle becomes a clumsy shape. The small bump of the ankle bone is most noticeable from the front or back view, but it can show clearly as well from a side view if the source of light is right.

HEAD

The head is one of the most important components of the body and so deserves close attention. Study of its form and shape is necessary so that it will look natural on your drawings of figures. Here we look at it from all angles and get some idea of its dimensions and characteristics.

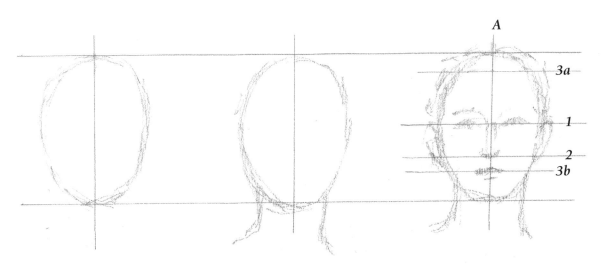

Getting the basic proportions of the head right is the starting point. These drawings show how the features are distributed. The eyes are placed halfway between the top of the head and the base of the chin (1); the end of the nose comes to about halfway down the lower half of the face (2), and the hairline and the mouth are roughly the same distance from the top edge and the bottom edge of the head (3 a and b). Draw a central line across which the features are balanced (A).

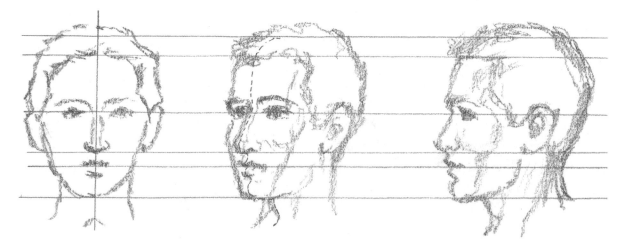

Looking at these views of the head as it moves round from full-face to profile, notice how the central line (dotted) maintains its position relative to the eyes, nose, mouth and chin. The proportional positions of the features down the length of the head remain the same as long as the head is not tilted backwards or forwards. For comparison, see the page opposite.

 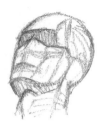

This trio of heads shows how you can reduce the complexities of the shape into simple blocked-out shapes. Notice that the eyes are just planes across the sockets. The nose and mouth don't really appear, but you have to make sure that the shape has the general prow-like look of the lower face. The forehead in contrast is broad and relatively flat, but be careful that you do not lose the roundness of the head.

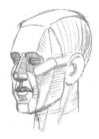 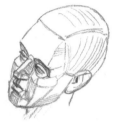 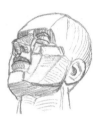

These are more detailed renderings, but still in a blocked-out style. Each shape on the head can be simplified into a block form so that the simpler version of the head gives a very solid look.

If you retain some of the blocking-out but just soften the edges of the blocked shapes, the head will easily begin to resemble that of a real person without losing its solidity.

These forms are more naturalistic and show the roundness of the head, making it seem to be more fleshy.

It is still a highly simplified form of drawing, but it describes the features very well and looks quite realistic. The different viewpoints given of the head are useful to get a fuller idea of how it is formed. Make a practice of drawing the parts of the figure from many angles in order to fix in your mind what it really looks like, then draw exactly what you see as accurately as you can, whether using formal techniques such as these or drawing more naturally. You will certainly begin to see your efforts pay off.

OBSERVATION

FACIAL FEATURES

The features are worth sketching many times from more than one angle until you begin to understand exactly what happens with every part. You can do this quite easily by just moving your point of view while the model remains still. However, sometimes the head needs to be tilted, the eyes moved and the lips flexed to get a better idea of the way these features change. Time spent working on this now means that your drawing will take on a new conviction in the future and you will begin to notice subtleties that were perhaps less obvious to you before.

Eyes

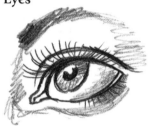
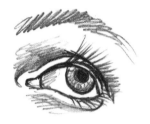

The eye seen from below looking up, and seen from above looking up, adds extra permutations to the variety of shapes.

You will quickly notice that the eye looking up and the eye looking down are vastly different in expression.

See how the eye seen from the side gives a much clearer view of the ball shape and how the lens seems to sit on the surface of the eyeball, the pupil appearing to recede into the shape of the lens.

When the eyes look down the upper eye-lid takes on the shape of the eyeball it is covering and the open part of the eye forms a sort of crescent shape. The upper lid increases and the lower one creases rather.

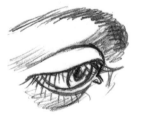
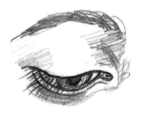

Ears

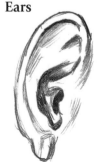
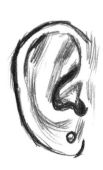
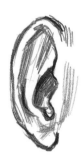

Not many people can move their ears, so they are less of a problem than any other feature. Their convolutions are unfamiliar because rarely do we look at them. Seen from the front or back most ears are inconspicuous. The shapes of ears do vary, but have several main shapes in common. Look at these examples.

Nose

The nose doesn't have a great deal of expression although it can be wrinkled and the nostrils flared. However, its shape often presents great difficulty to beginning students. Drawing the nose from in front gives the artist a lot of work to describe the contours without making it look monstrous.

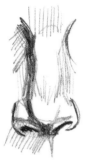

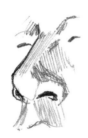

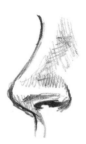

A clear dark shadow on one side helps a lot when drawing the nose from the front.

If you want to reduce the projection of the nose, a full facing light will tend to flatten it in terms of visible contours.

However, from the side it is clear how it is shaped. The nostrils are a well-defined part of the nose and from the front are the best part to concentrate on to infer the shape of the rest of the features.

Mouth

The mobility of the mouth ensures that next to the eyes it is the most expressive part of the face. Although there are many different types of mouth, these can be reduced to a few types once you begin to investigate them.

First of all, draw from the front, followed by three-quarter views from left and right, and then from the side.

Next draw from slightly above and slightly below; this gives you the basic shape of the mouth. Note the edge of the lips; some parts project and give a definite edge to the lip. On other parts, the colour of the lip is in the same plane as the surface of the face.

When you have a fairly clear idea of the basic form of the mouth, see what happens when it opens. First, try drawing it slightly open from at least two views (front and side) and then wider, and then wide open. Notice what happens to the lips when the mouth is open, how they stretch, and how creases appear in the cheeks either side and below.

Next, look at the mouth smiling; first with the mouth shut, and then more open.

PORTRAYING THE FEATURES

Once again looking at the work of other artists, we see the contrast is between emotional power and imagery and total objectivity. The copies of Gauguin and Van Gogh are marvellous examples of the portrait as self-investigation, whereas the Wadsworth and Fry epitomize the detached quality that comes out of a portrait where the artist is not concerned with personality but the exploration of technique.

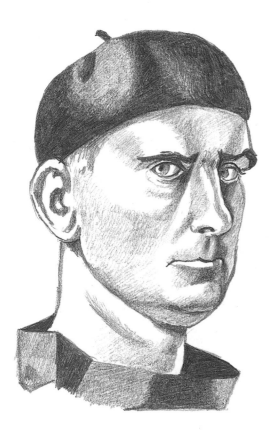

The rather wary expression in this self-portrait by Edward Wadsworth (1930) is partly due to the artist having had to look out of the corner of his eyes to see his reflection in the mirror while he drew. This is a good example of the often awkward poses artists have to adopt in order to portray themselves. Wadsworth has concentrated on volume rather than subtleties of outline, hence the rather solid look to the technique.

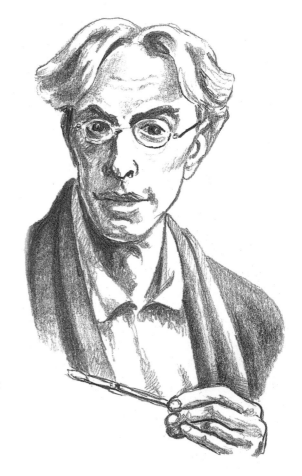

Roger Fry was the most famous artist to emerge from the Bloomsbury Group which dominated British artistic life in the early part of the 20th century. In this portrait (1926) he appears to look right through us, making a rather strange impression.

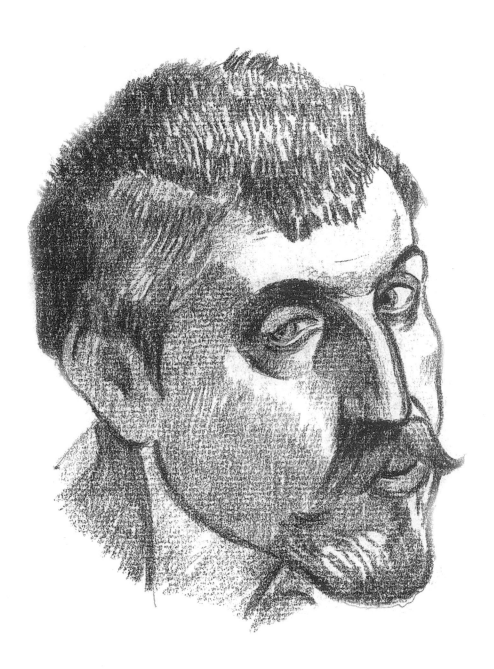

Gauguin gave the original of this chalk copy (1888) to Van Gogh as a gift. He called it 'les miserables', a reference not only to the traditional poverty of artists but also to their bondage to the quest for perfection.

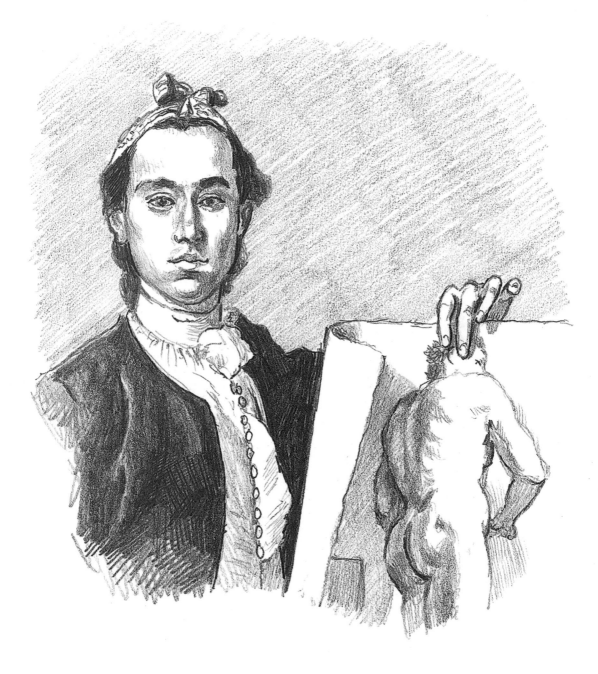

Luis Meléndez was a brilliant still-life painter in 18th-century Spain who never succeeded in reaching the heights of artistic achievement. This self-portrait (1708) looks like an attempt to convince his public that his drawing of figures is a good reason to let him move into the more lucrative and prestigious area of history painting where the human figure was the main feature. Notwithstanding the skill evident in this portrait, he was denied the chance by the Spanish Academy and went on painting mainly still-life subjects.

The great challenge to every portrait artist is how to achieve a well-drawn image that is never dull. This next series of examples demonstrates how even a slight oddity can bring freshness to a portrayal.

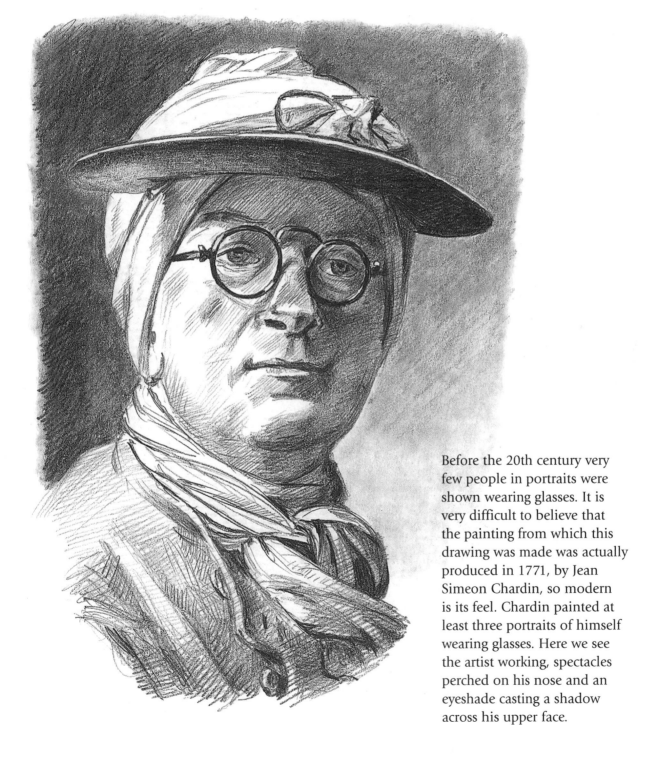

Before the 20th century very few people in portraits were shown wearing glasses. It is very difficult to believe that the painting from which this drawing was made was actually produced in 1771, by Jean Simeon Chardin, so modern is its feel. Chardin painted at least three portraits of himself wearing glasses. Here we see the artist working, spectacles perched on his nose and an eyeshade casting a shadow across his upper face.

APPROACHING SELF-PORTRAITURE

When an artist draws himself using a mirror, quite often he sets up the pose to enable him to make a detailed study of the face he is so familiar with. The serious practising artist will experiment with this set-up so that he comes to see himself in a new way. In the following series of examples, we suggest approaches that will give unusual views and the potential for producing interesting results.

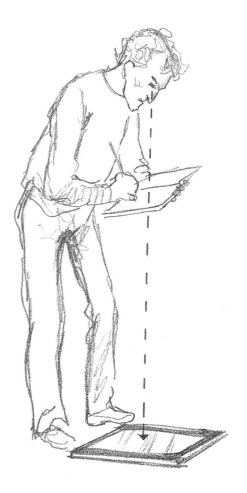

An obvious recourse would be to place the mirror in an odd position, for example on the floor.

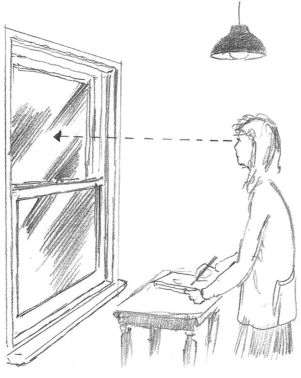

You know how sometimes you catch a glimpse of yourself in a shop window? Well, you can produce a similar image of yourself by, after dark in a well-lit room, drawing your reflection in a window. With this approach you can see objects through the glass at the same time as reflections in it, and this can make for very interesting compositions.

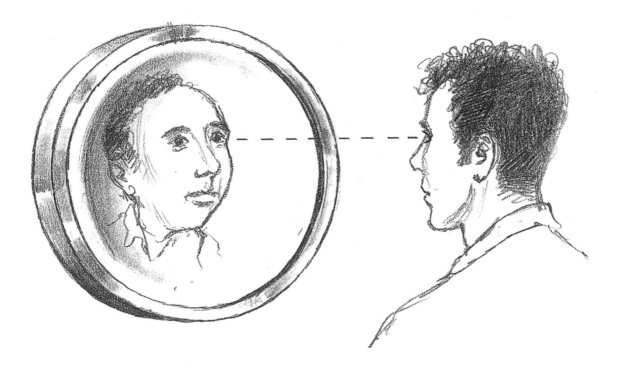

Artists have often had recourse to drawing their reflections in a convex mirror, which distorts what is seen in an interesting way.

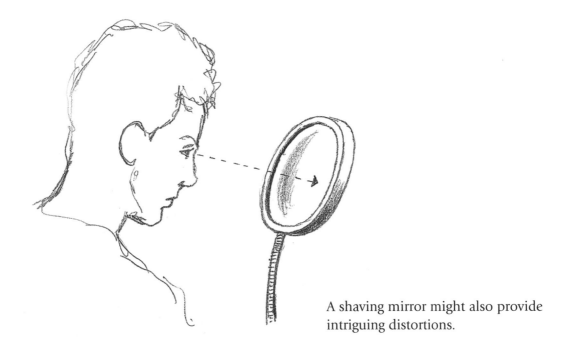

A shaving mirror might also provide intriguing distortions.

A full-length mirror will give another view of yourself and is useful because of this.

The typical dressing-table mirror could be a good way to get three different views of yourself at the same time. It is also invaluable for a profile view.

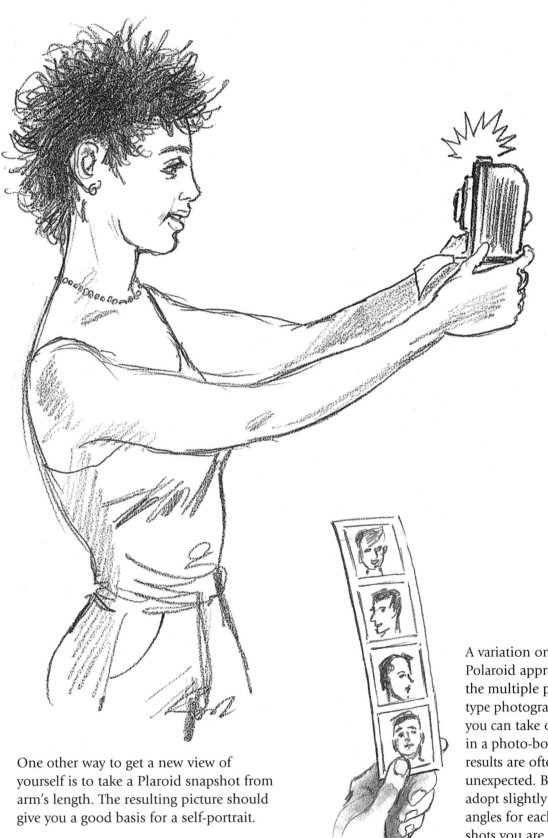

One other way to get a new view of yourself is to take a Plaroid snapshot from arm's length. The resulting picture should give you a good basis for a self-portrait.

A variation on the Polaroid approach is the multiple passport type photograph that you can take of yourself in a photo-booth. The results are often quite unexpected. Be sure to adopt slightly different angles for each of the shots you are allowed.

PRACTICE

In the last section you began to exercise
your artistic eye by observing a wide range of
drawing subject matter. Next you will be shown
in greater detail how to expand upon and practise
what you have learnt. In addition to consolidating your
technical ability, you will be encouraged to develop further
the art of looking.

When you have had plenty of practice you will find yourself
noticing all sorts of interesting details in the objects, scenes
and situations around you, not just in the ones you attempt
to draw. You will discover that, for an artist, the world is
never boring because there is so much to see. Each time
you look, you will discover something new, no matter
how many times you may have seen families,
things, views or people. This enhancement of
awareness will lead to a deepening of your
perception, enabling you to penetrate to
the essence of seeing.

PRACTICE

ADDING TO YOUR VOCABULARY

A practising artist must be ready to draw at any time. If you want to excel at drawing, sketching has to become a discipline. Get into the habit of seeing things with a view to drawing them. This means, of course, that you'll have to carry a sketch-pad around with you, or something that you can jot your impressions in. You'll find yourself making sketches of unrepeatable one-offs that can't be posed, as I did with some of the sketches shown here.

A quick note, even if not very accurate, is all you need to make a worthwhile addition to your vocabulary of drawing. Often it is impossible to finish the sketch, but this doesn't matter. Some of the most evocative drawings any artist produces are quick, spontaneous sketches that capture the fleeting movement, attitude, angle of vision or view of a movement. They are often the drawings you return to again and again to use in compositions or to remind yourself of an atmosphere or place.

When drawing scenes with large areas of building, it is useful to simplify the areas of light and shade to make it more obvious how the light defines the solidity of the buildings. In both these examples a large area of shadow anchors the whole composition and gives it depth and strength.

In the first drawing we are aware that the open area with buildings around it is a square; in the second we are in no doubt that the very dark area is an arch through a solid building. In both examples the light and shade help to convince.

DON'T FORGET YOUR SKETCHBOOK

A pocket-sized book with hard covers and thinnish paper is generally the best for most quick sketches, being simple to use and forcing you to be economic with your lines, tones or colours. A clutch pencil or lightweight plastic propelling pencil with a fine lead is ideal; preferably carry more than one. A fine line pigment liner is also very useful and teaches you to draw with confidence no matter how clumsy the drawing.

Continual practice makes an enormous difference to your drawing skill and helps you to experiment in ways to get effects down fast and effectively. If you're really serious you should have half a dozen sketchbooks of varying sizes and papers, but hard-backed ones are usually easier to use because they incorporate their own built-in drawing board. A large A2 or A3 sketchbook can be easily supported on the knees when sitting and give plenty of space to draw. Cover the pages with many drawings, rather than having one on each page, unless your drawing is so big that it leaves no room for others.

SKETCHING

Let's take a quick look at sketches by two acknowledged masters.

Rembrandt (Harmensz Van Rijn) (1606–69)

The drawings of Rembrandt probably embody all the qualities that any modern artist would wish to possess. To emulate him we have to carefully consider how he has constructed his drawings. His quick sketches are dashing, evocative and capture a fleeting action or emotion with enormous skill. His more careful drawings are like architecture, with every part of the structure clear. Notice how his line varies with intention, sometimes putting in the least possible and at other times leaving nothing to chance.

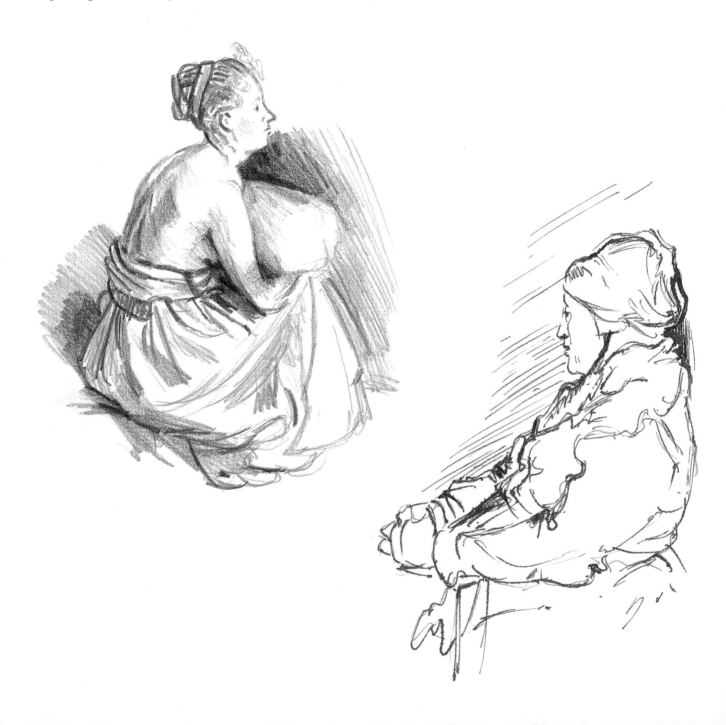

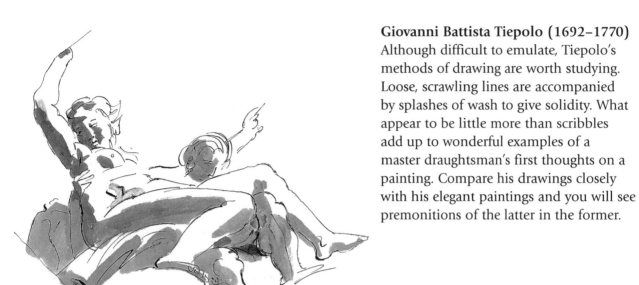

Giovanni Battista Tiepolo (1692–1770)
Although difficult to emulate, Tiepolo's methods of drawing are worth studying. Loose, scrawling lines are accompanied by splashes of wash to give solidity. What appear to be little more than scribbles add up to wonderful examples of a master draughtsman's first thoughts on a painting. Compare his drawings closely with his elegant paintings and you will see premonitions of the latter in the former.

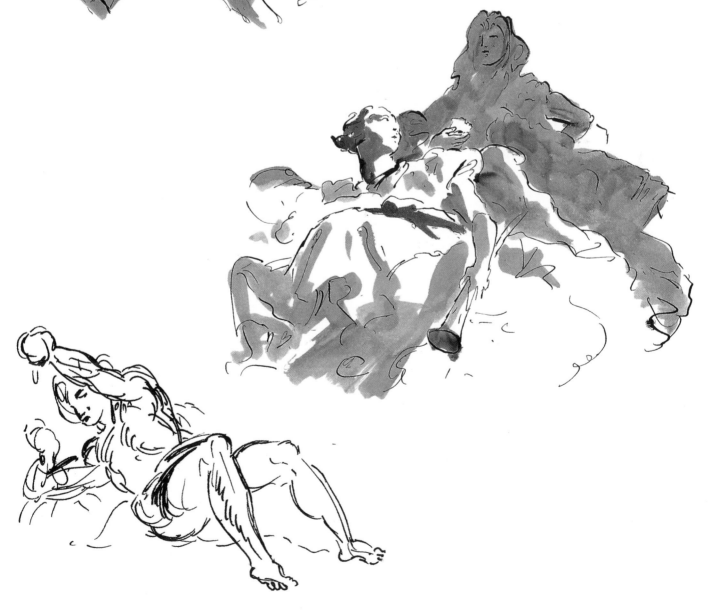

PRACTICE

MAKING QUICK SKETCHES

One of the best ways to learn to draw figures, for example, without worrying about the results is to take your sketchbook to a busy event in the summer where people are enjoying their leisure time. You will see all sorts of characters, both stationary and in motion, and if they are engrossed in their doings you will not feel self-conscious about sketching them.

Draw in as few lines as you possibly can, leaving out all details. Use a thick, soft pencil to give least resistance between paper and drawing medium and don't bother about correcting errors. Keep drawing almost without stopping. The drawings will gradually improve and what they will lack in significant detail they will gain in fluidity and essential form. Only draw the shapes that grab the eye. Don't make choices; just see what your eye picks up quickly and what your hand can do to translate this vision into simple shapes. This sort of drawing is never a waste of time and sometimes the quick sketches have a very lively, attractive quality.

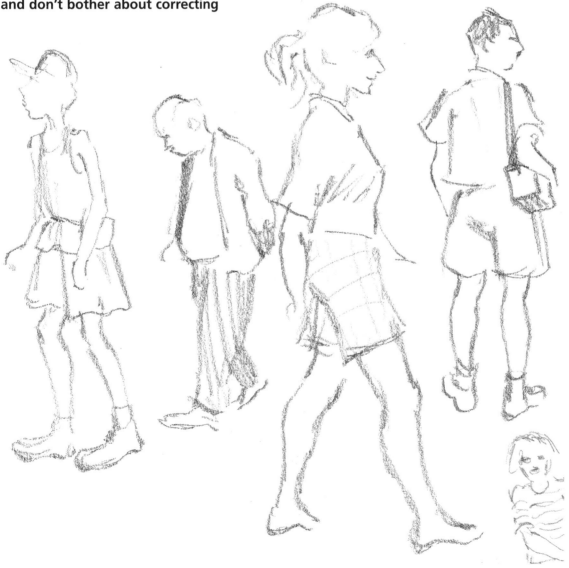

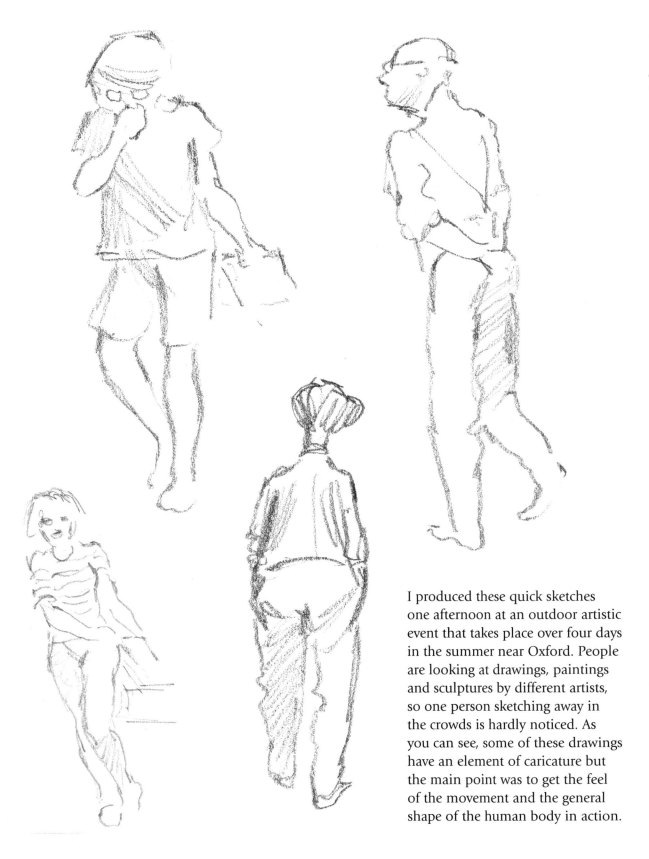

I produced these quick sketches one afternoon at an outdoor artistic event that takes place over four days in the summer near Oxford. People are looking at drawings, paintings and sculptures by different artists, so one person sketching away in the crowds is hardly noticed. As you can see, some of these drawings have an element of caricature but the main point was to get the feel of the movement and the general shape of the human body in action.

STARTING TO DRAW FIGURES

Now find pictures of people in various natural poses and try this exercise.

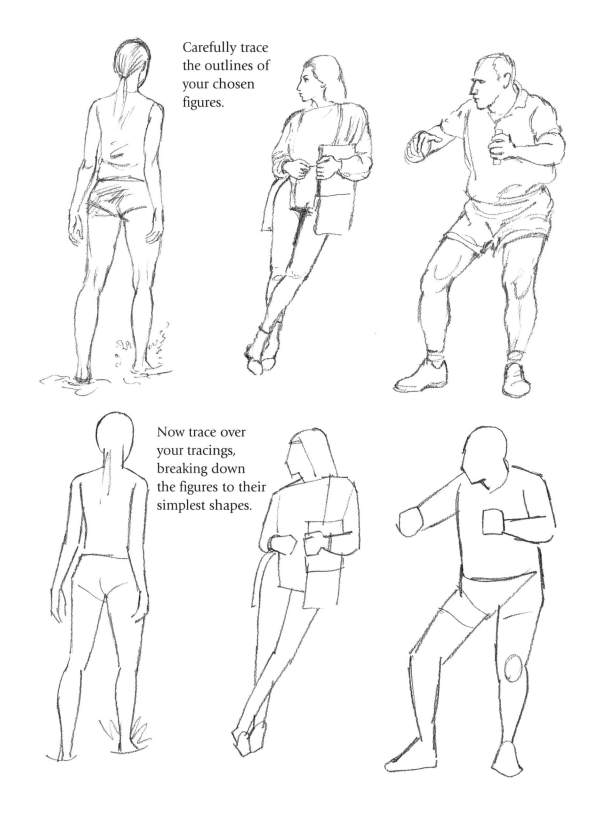

Carefully trace the outlines of your chosen figures.

Now trace over your tracings, breaking down the figures to their simplest shapes.

This way of drawing shows you how to tackle figure drawing using very basic lines to describe the position of the figure and **gradually building a more solid structure around these lines until you have got a complete figure.**

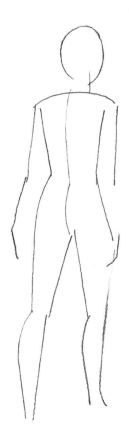

Now trace over your second tracings, putting in only the absolutely essential lines in order to show the movement of the figures. Take a central line through each figure, draw the main line of the shoulders and the main shape of the head and then make very simple lines to describe the arms and legs.

Don't include any other details. In my examples you can see that for each figure the head is given simply as a rounded shape, and a line running through the torso and legs serves to give the feel of the pose. Pare down your drawings to absolute essentials, as I have done.

When you have reduced your figures to these simple shapes, build them up again until you have worked back to the shapes of your original tracings. The method is exactly the same as that shown here. You simply reverse the process. Begin by tracing over your last drawing.

STUDYING DIFFERENT POSES

Now try working from photographs or models with a view to giving yourself experience of capturing different kinds of poses. If you can find good photographs of action poses or poses with some movement in them, use them first to trace and then to copy, keeping the original next to your drawing as reference.

Get used to looking at the whole shape, including the shapes enclosed by the limbs, in order to see the general outline. The more variety you can get in these sorts of sketches, the better. Get used to moving your hand quite fast, but observing closely the essential lines of the figures. Again, don't concern yourself with details. They are not important at this stage.

The sketches shown here are to give you ideas of the types of poses you might like to attempt.

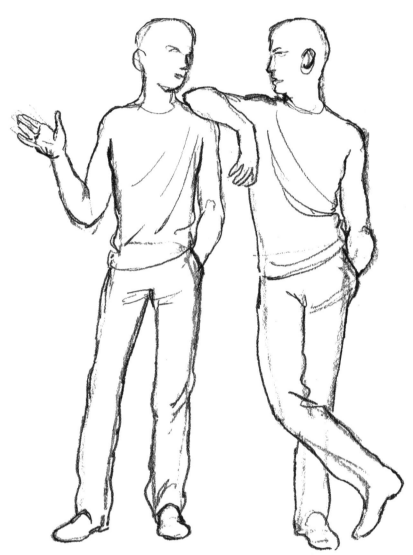

Young men talking.

A woman relaxing, probably talking or watching TV.

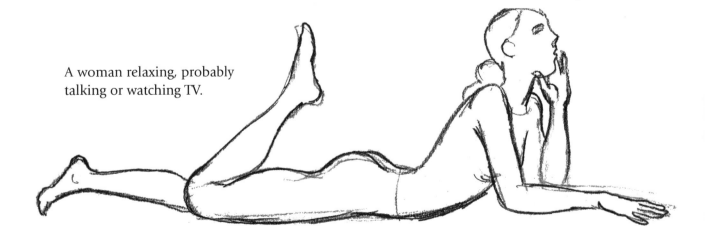

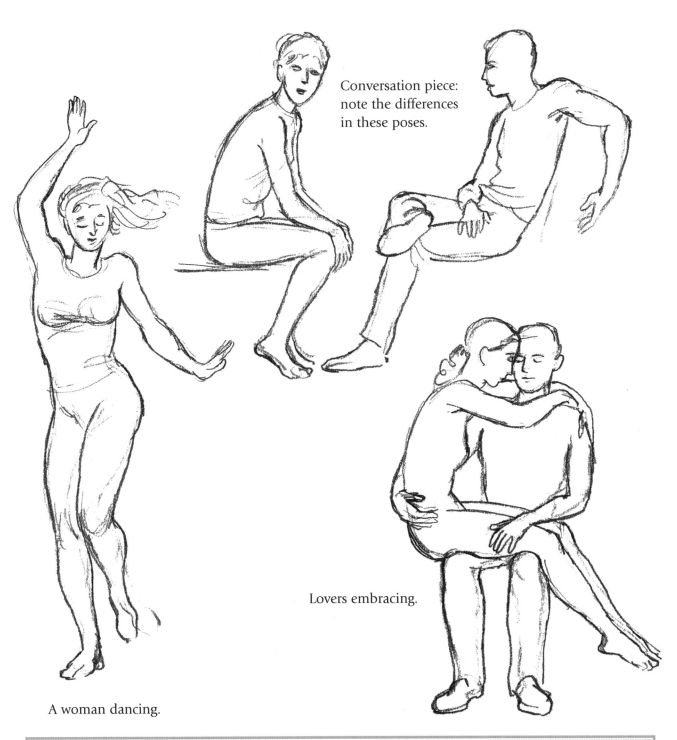

Conversation piece: note the differences in these poses.

Lovers embracing.

A woman dancing.

When you have traced a moving figure from a photograph, try to copy the same figure straight from the photograph. Place the tracing over the copy and note the differences. This exercise is useful for alerting you to inaccuracies. Repeat the exercise, using the same photograph, until it is difficult to tell the straight copy from the trace.

STARTING TO DRAW PEOPLE

Once you have practised the previous exercise a number of times and gained in confidence, you should be ready to tackle drawing people. Go to a life class, as we discussed earlier, or get a couple of different people to pose for you for about twenty minutes. Approach your subjects exactly as you were shown in the previous exercise.

Draw the essential shape, movement or pose first. Once you have the main shapes and made sure they resemble your model, try to fill out your drawing a bit, lightly blocking in areas of tone but not worrying about the detail. (If you want to try the last stage of this drawing, go to page 140.)

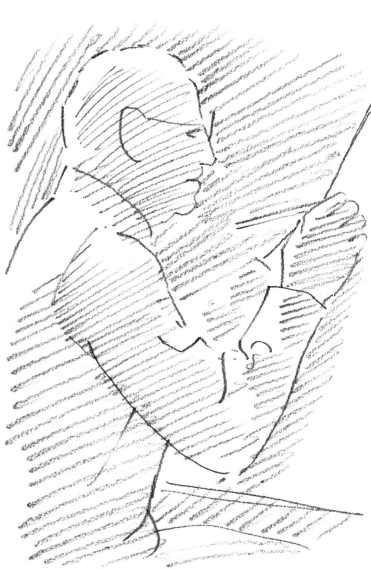

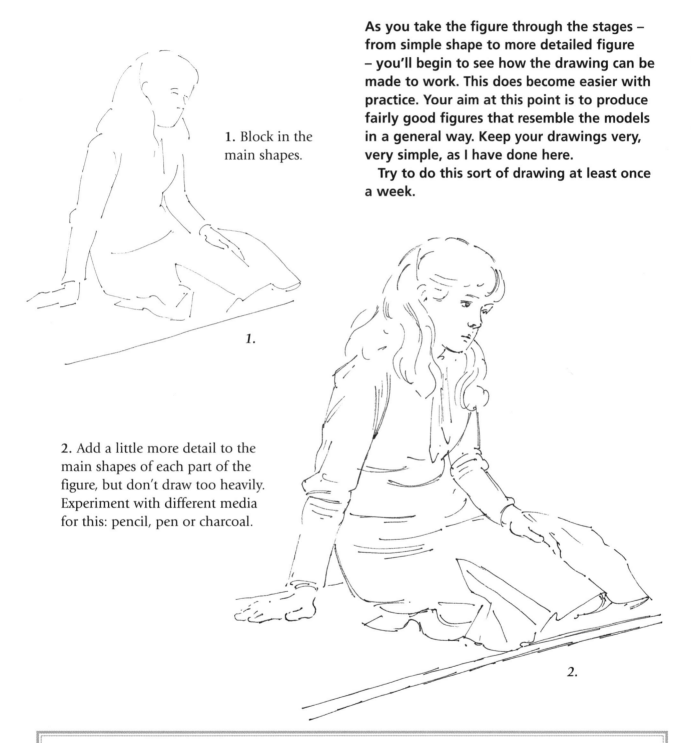

1. Block in the main shapes.

1.

As you take the figure through the stages – from simple shape to more detailed figure – you'll begin to see how the drawing can be made to work. This does become easier with practice. Your aim at this point is to produce fairly good figures that resemble the models in a general way. Keep your drawings very, very simple, as I have done here.

Try to do this sort of drawing at least once a week.

2. Add a little more detail to the main shapes of each part of the figure, but don't draw too heavily. Experiment with different media for this: pencil, pen or charcoal.

2.

Although you can be as thorough as you like, it is a good idea to stop before you have drawn every bump, wrinkle and indentation. The aim of simplifying is a very valuable part of learning to draw effectively.

PRACTICE

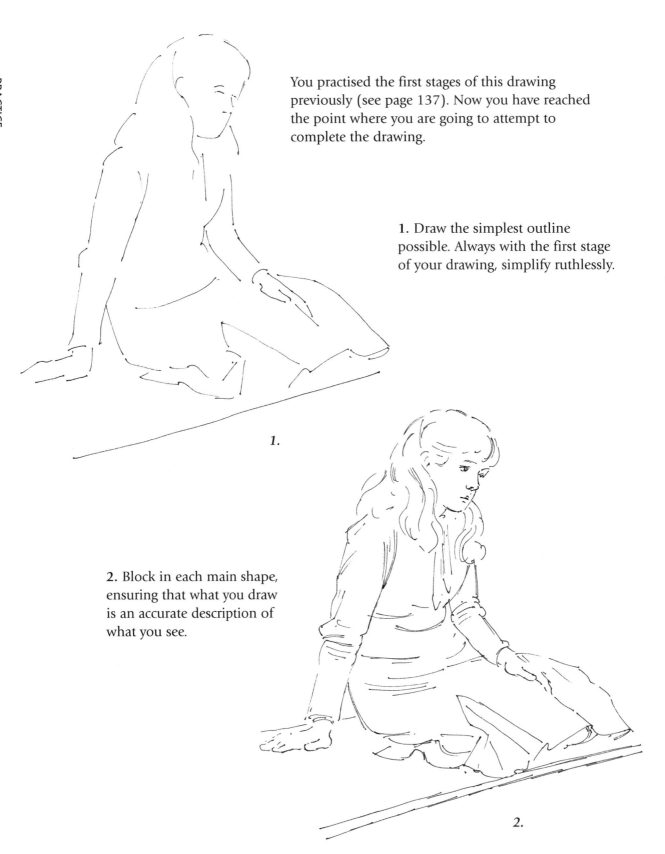

You practised the first stages of this drawing previously (see page 137). Now you have reached the point where you are going to attempt to complete the drawing.

1. Draw the simplest outline possible. Always with the first stage of your drawing, simplify ruthlessly.

1.

2. Block in each main shape, ensuring that what you draw is an accurate description of what you see.

2.

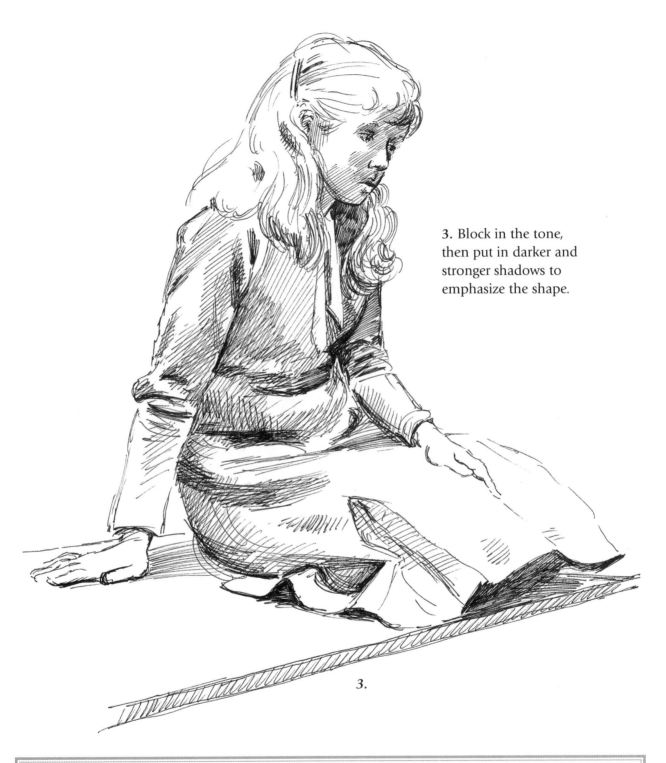

3. Block in the tone, then put in darker and stronger shadows to emphasize the shape.

3.

The drawings you have been studying so far have shown you many ways of drawing the human being. None of this information and guidance is of use unless you carefully and repeatedly practise. The best way is to draw from life. If this is not always available, regular practice using master-drawings will help a great deal. There is no substitute for continuous practice. Without it, you will not improve.

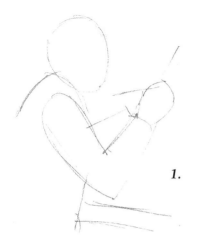

1.

You encountered the first two stages of this drawing on page 136; smaller versions of them are included here for reference. Now concentrate on completing the drawing.

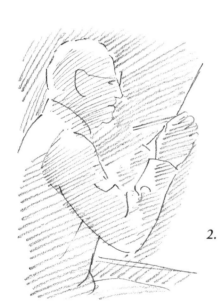

2.

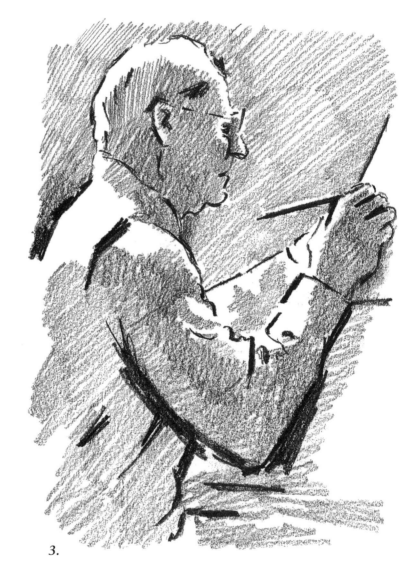

1. Make a basic outline.

2. Draw in the main shapes, then lightly block in areas of tone.

3.

3. The final stage of this portrait involves working more subtle variations into the main tone. Varying the strength of outlines brings dynamism to a subject; note the differences here. Note too how the large areas of tone contrast with the bright patches left on the man's head, shoulder and arm and make them stand out.

1.

Now try to do the same in this exercise, but in ink. The pose is similar to that of the model shown on pages 138–9, but there are important differences in the angle of the head and expression. From what you have learnt so far, see what you can do.

1. Repeat the exercise of blocking in the main area.

2. Elaborate each basic shape until it begins to resemble the model.

3. Add the tone. First draw your lines in the same direction. Now revisit some areas, going over them in a different direction to intensify the tone. Finally, add heavier tones still, in another direction, to emphasize the edges of the figure and her clothing.

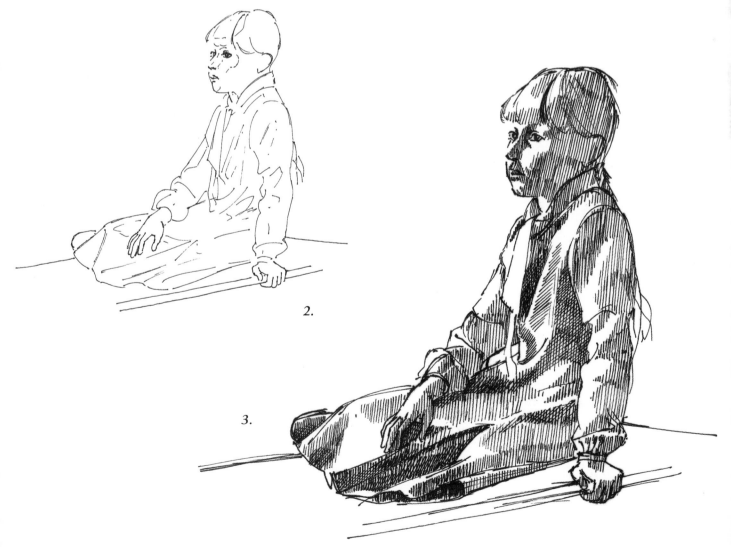

2.

3.

Capturing the likeness of a subject can be problematical, as can choosing the position from which to draw the face. This position gives some idea of the kind of person you are drawing. Gentler people tend to look down. Aggressive people look up or straight ahead, chin raised. The position for this type of forceful personality would be head on so they are looking straight at the viewer. Some people smile easily, others look darker or cooler. A profile is often the answer if the expression is less confident.

1.

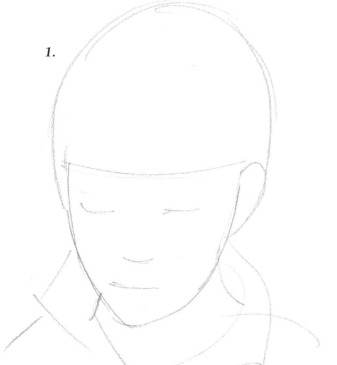

1. Before you start, look at the shape of the head as a whole. Study it; it is essential that you get this right.

Now draw an outline, marking the area of hair and the position of the eyes, nose and mouth.

2.

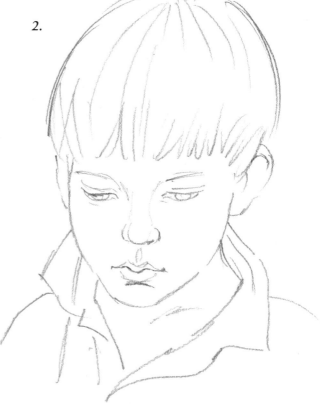

2. Build up the shapes of the ears, eyes, nose, mouth and a few more details such as the hair and neck.

3.

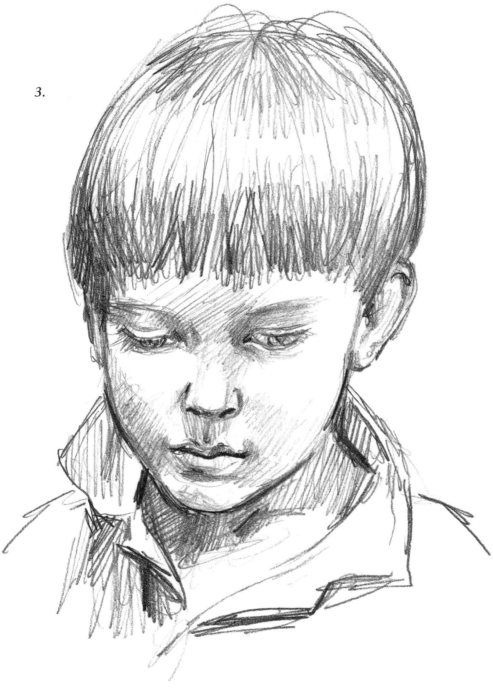

3. In the final drawing, effort has gone into the areas of tone or shadow, the quality of hair and shirt and the tonal variations of the shading around the eyes, nose and mouth in order to define the features. You'll notice that the lines of tone go in various directions. There is no single, 'right' way of doing this. In your own drawings you can try out single direction toning, multi-direction toning, shading around and in line with the contours and, where appropriate, smudging or softening the shading until it becomes a soft grey tone instead of lines. What you do – and what you think works – is simply a matter of what effect you wish to achieve. Softer, smoother tones give a photographic effect, more vigorous lines inject liveliness. Here the slight roughness of shading emphasizes a boyish unconcern with appearances.

MEASURING THE HEAD

The surest way of increasing your understanding of the head, and becoming adept at portraying its features accurately, is to practise drawing it life size, from life rather than from photographs. It is very difficult to draw the head in miniature without first having gained adequate experience of drawing it at exactly the size it is in reality, but this is what beginning artists tend to do, in the mistaken belief that somehow it will be easier.

Getting to know the head involves mapping it out, and this means taking measurements between clearly defined points. For the next exercise you will need a live model, a measuring device, such as a ruler or callipers, a pencil and a large sheet of paper.

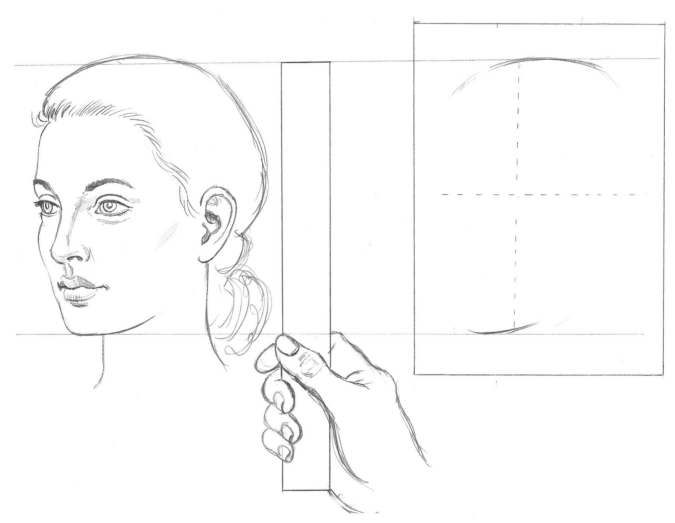

Measure the length of the head from the highest point to the tip of the chin. Mark your measurement on the paper. Measure the width of the head at the widest point; this is usually across the area just above the ears, certainly if viewed full on from the front. Mark this measurement on the paper. The whole head should fit inside the vertical and horizontal measurements you have transferred to your drawing paper.

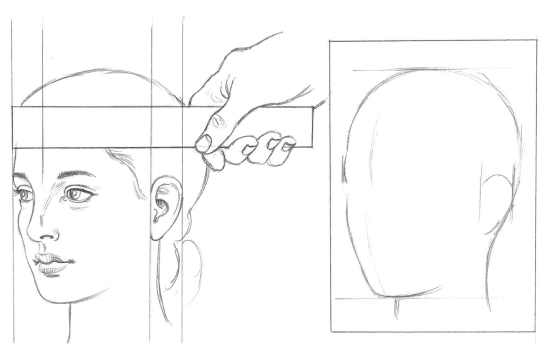

Measure the eye-level. This should be about halfway down the full length of the vertical, unless the head is tilted. Decide the angle you are going to look at the head. Assuming it is a three-quarter view, the next measurement is critical: it is the distance from the centre between the eyes to the front edge of the ear.

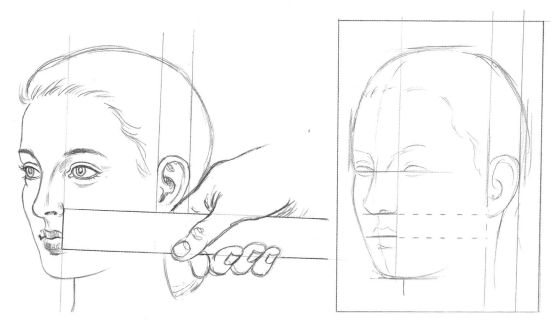

Measure the distance from the outside edge of the nostril to the front edge of the ear. Mark it and then place the shape of the ear and the position of both eyes. Check the actual length of the nose from the inside corner of the eye down to the base of the nostril. Next measure the line of the centre of the mouth's opening; you can calculate this either from the base of the nose or from the point of the chin. Mark it in. Now measure from the corner of the mouth facing you to a line projecting down the jawbone under the ear. Mark it.

DRAWING THE HEAD AND FEATURES

In this exercise we are going to practise drawing different views of the heads. You can either use the model shown or choose another to draw. Make sure the features line up horizontally across the three views, otherwise there will be discrepancies in their relationship. Before you begin you will find it helpful to define the form of the face by marking in the edges of the planes on the face, particularly the outlines of the eye sockets and eyelids, the mouth and the formation of the bridge, length and tip of the nose.

This exercise can also be used to practise getting the shapes of the features right. Detailed drawings of the principal features – eyes, nose and mouth – are on pages 114–115. Periodically check your effort against the drawings and the accompanying annotations.

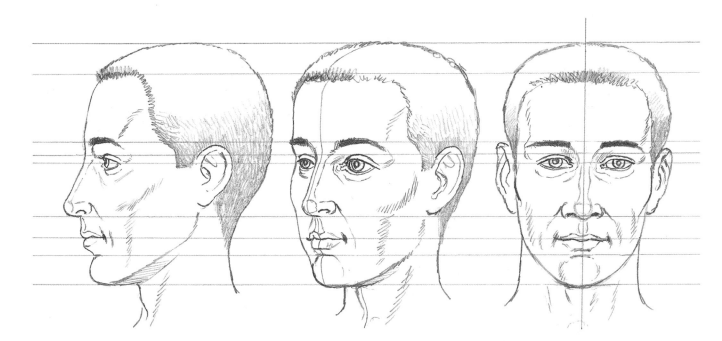

Profile view
- The nose projects much further than the rest of the face.
- The jaw projects no further than the forehead.
- The ear is positioned well back past the halfway mark of the profile.
- From this viewpoint the line of the mouth is quite short.
- Study the shape of the eye.

Three-quarter view
- The further eye has a slightly different conformation to the nearer eye, mainly because you can see the inside corner of the near eye, so the length of the eye is more obvious.
- The mouth shape is shorter on the far side of the central line and longer on the near side of the central line.
- The same observation applies to the eyebrows.

Full face view
- The eyes are one eye-length apart
- The two sides of the head tend to mirror each other.
- The widest part of the head is above the ears.
- The widest part of the face is at cheekbone level.
- The ears are less obvious from this perspective.

THE PROPORTIONS OF CHILDREN

There are significant proportional differences between the bodies of children and those of adults, which the artist has to bear in mind when undertaking a portrait. One of the most obvious differences is seen in the head, which in an adult is about twice as large as that of a two-year-old. The features, too, change with growth. In adults the eyes are closer together and are set halfway down the head. Nose, cheekbones and jaw become more clearly defined and more angular as we mature.

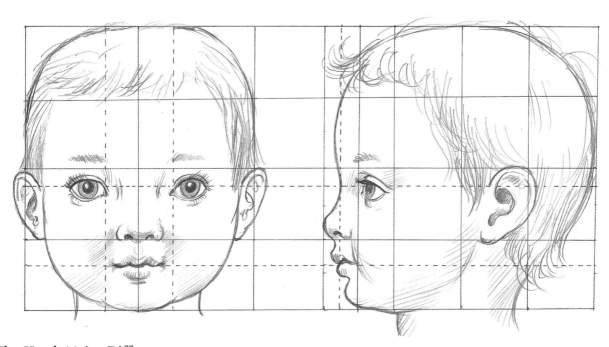

The Head: Major Differences

- In relation to its body, a child's head is much larger; this will be evident even if you can only see the head and shoulders. A child's head is much smaller than an adult's, but the proportion of head to body is such that the head appears larger.
- The cranium or upper part of the child's skull is much larger in proportion to the rest of the face. This gradually alters as the child grows and reaches adult proportions.
- The child's eyes appear much larger in the head than an adult's, whereas the mouth and nose often appear smaller. The eyes also appear to be wider apart. The nose is usually short with nostrils facing outward so that it appears upturned. This is because the nasal bones are not developed.

- The jawbones and teeth are much smaller in proportion to the rest of the head, again because they are still not fully developed. The rule with the adult that places the eyes halfway down the head does not work with a child, where the eyes are much lower down.
- With very young children, the forehead is high and wide, the ears and eyes very large, the nose small and upturned, the cheeks full and round and the mouth and jaw very small. Also there are no lines to speak of on the face.
- The hair is finer, even if luxuriant, and so tends to show the head shape much more clearly.

YOUR FIRST PORTRAIT STEP-BY-STEP

When you are confident of your ability to draw the features accurately, you are ready to try your hand at a full-scale portrait. If you are very lucky someone may commission you to draw a portrait, but it is more likely you will have to initiate the event yourself, especially in the beginning.

You will need to agree on a number of sittings with your sitter, and how long each of these should last; two or three sittings of between 30 minutes and one hour should be sufficient. It is advisable not to let your subject get too bored with sitting, because dullness may creep into their expression and therefore into your portrait.

Once the schedule has been decided, it is time to start work. First, make several drawings of your subject's face and head, plus the rest of the body if that is required, from several different angles. Aim to capture the shape and form clearly and unambiguously. In addition to making these drawings, take photographs: front and three-quarter views are necessary and possibly also a profile view.

All this information is to help you decide which is the best view of the sitter, and how much of their figure you want to show. The preliminary sketching will also help you to get the feel of how their features appear, and shape your ideas of what you want to bring out in the finished work. Changing light conditions and changing expressions will give subtle variations to each feature. You have to decide exactly which of these variations to include in the drawing.

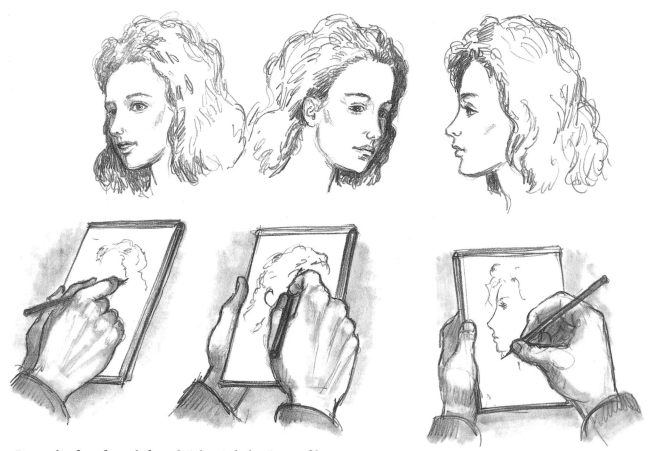

Draw the face from left and right and also in profile.

Take photographs from left and right.

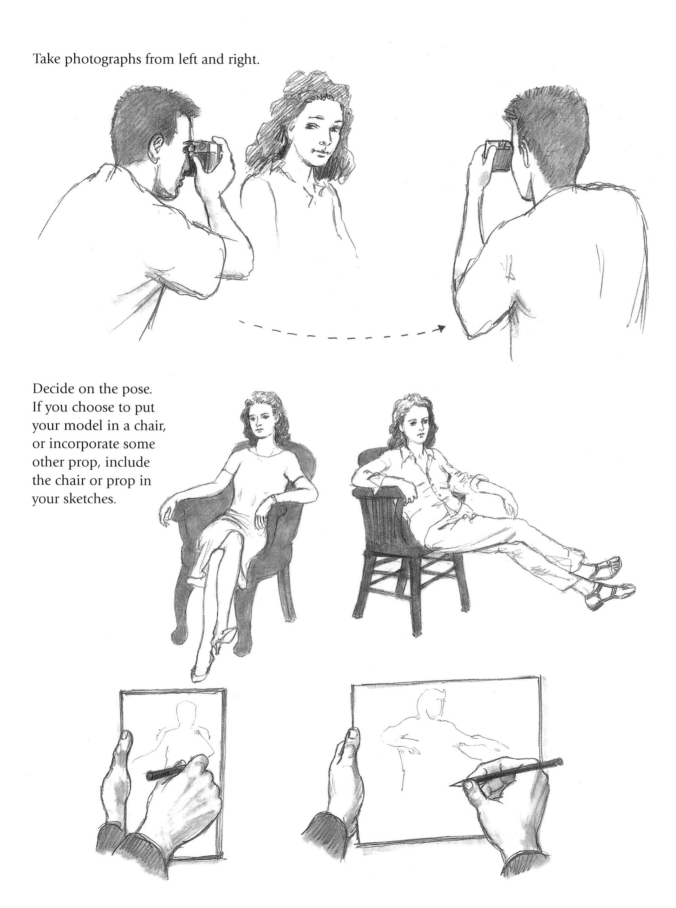

Decide on the pose. If you choose to put your model in a chair, or incorporate some other prop, include the chair or prop in your sketches.

THE HEAD AT DIFFERENT ANGLES

When the head is seen from either above or below, the lines of the mouth and eyes will curve round the shape of the head in a lateral direction, as you will have noted from some of the earlier examples. Seen from below, they will curve downwards at the outside corners. Seen from above, they will curve in an upwards direction at the corners. The forehead when seen from below will tend to disappear and the area under the nose and the chin appear much larger in comparison. The nose viewed from below shows like a triangle at right angles from the face with the nostrils clearly seen and often partially obscuring one of the eyes. Seen from above, the chin and upper lip tend to disappear while the length of the nose and forehead seems to increase. Try to simplify the angles shown here.

A three-quarter view emphasizes the angle of the chin and the back of the head. The eye farthest from the viewer is partially hidden by the bridge of the nose and almost appears to curve around the edge of the face.

Never forget that the central line from the top of the head through the centre of the eyes, nose and mouth and chin is of critical importance in constructing the shape of the face on the head (check back to pages 144–146 to refresh your memory of the proportions of the head).

The effect of the eyes curving round the head is also very evident here, as is the curve of the mouth for the same reason: the backwards tilt of the head. The nose appears to jut upwards out of the face. The area under the chin is greatly increased, altering the shape of the neck.

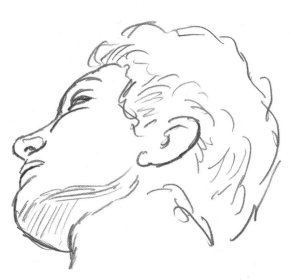

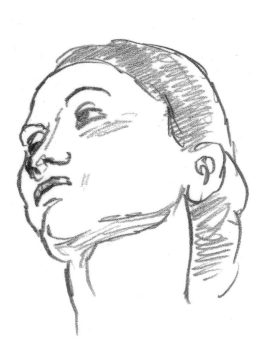

EXPRESSIONS

We also need to look at the different kinds of expression with which the face presents us.

These examples are all taken from classical paintings or photographs.

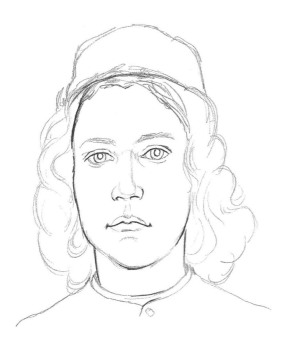

Taken from Botticelli, this gives a very simple, clear view of the features in relaxed, attentive mode.

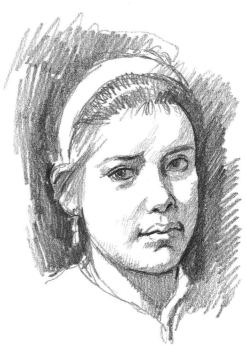

A slightly anxious or suspicious face with one eyebrow lowered, eyes to one side, mouth closed firmly; from Velázquez.

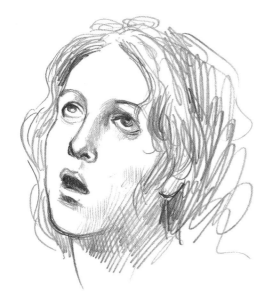

Religious awe, as depicted by Caravaggio.

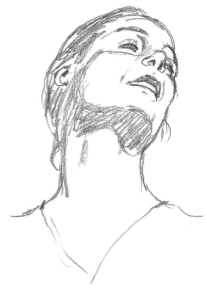

A joyous expression, with a contented open smile; from Riefenstahl's film of the 1936 Olympics.

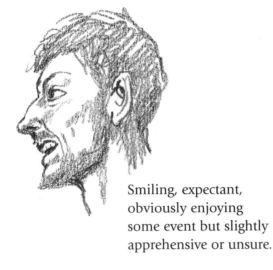

Smiling, expectant, obviously enjoying some event but slightly apprehensive or unsure.

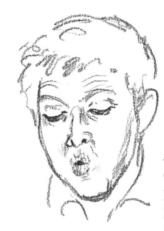

A surprised face, looking down at something with pursed lips, or perhaps just trying to blow out a candle.

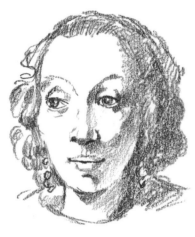

A wide-eyed gentle smile, eyebrows raised but eyelids half down.

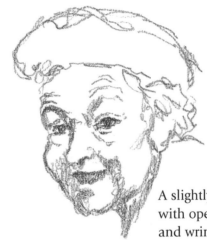

A slightly conspiratorial look with open-mouthed smile and wrinkled brow as though enjoying a good joke.

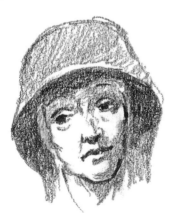

A dolorous face slightly inclined, with a faintly wry smile.

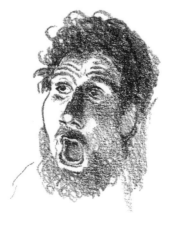

Mouth agape in a shout or gasp, eyes wide open, brow wrinkled in some astonishment or perhaps terror.

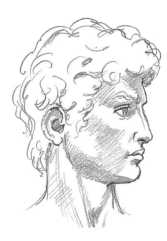

A head that seems to express defiance, alertness and power; taken from a Michelangelo statue.

PRACTICE

EXPRESSIONS: PRACTICE

The faces on these pages show more extreme expressions than those on the preceding spread and have an almost caricaturist quality.

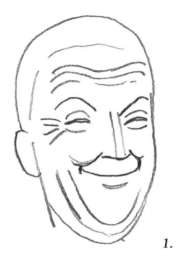

1.

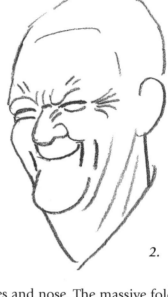

2.

1–2. The main lines are of primary importance when drawing very expressive faces. Here I put in sharply and clearly all the wrinkles around the eyes and nose. The massive folds of skin and muscle on the forehead, cheek and chin are also emphasized.

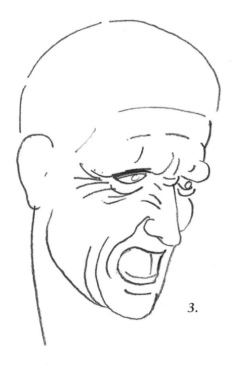

3.

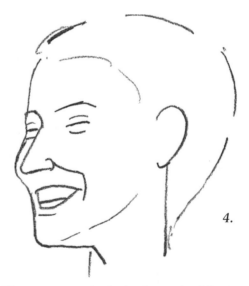

4.

3–4. Here note particularly the pad of flesh under the eyes, and the large crease from the corner of the nostril down to the corner of the mouth. In the man there is a web of creases at the outside corner of the eyes and also parallel lines on the forehead.

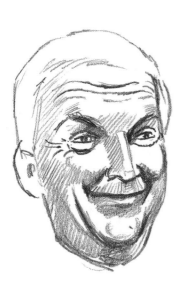

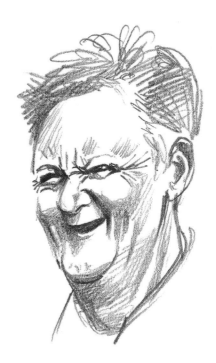

5–6. For the final stage I added tone to the folds and wrinkles to give them more solidity. However, in all these examples a successful outcome hinged on the accuracy, clarity and strength of the lines. These lines are the key to expression.

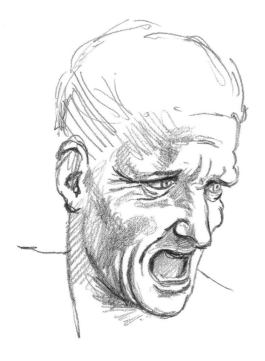

The easiest way to practise these sorts of facial qualities is to make faces at yourself in the mirror. All good cartoonists do this. If you're too inhibited to act out expressions, take photographs of your friends pulling faces and then carefully copy those.

POSING FOR YOURSELF

We looked at self-portraits in the previous section. Now we need to take a more considered approach to the subject. The most difficult aspect of self-portraiture is being able to look at yourself in a mirror and still be able to draw and look at your drawing frequently. What usually happens is that your head gradually moves out of position, unless you have some way of making sure it always comes back to the same position. The easiest way to do this is to make a mark on the mirror, just a dot or tiny cross with felt-tip pen, with which you can align your head. You might ensure the mark falls between the centre of your eyes, corner of an eye or your mouth, whichever is easiest.

You can only show yourself in one mirror in a few positions because of the need to keep looking at your reflection. Inevitably, the position of the head is limited to full-face or three-quarters left or three-quarters right of full face. In these positions you can still see yourself without too much strain.

If you want to see yourself more objectively you will have to use two mirrors, one reflecting the image from the other. This will give a complete profile view, although it does make repositioning the head after it has wandered out of position slightly more awkward. However, this method is worth trying at some point because it enables us to see ourselves the right way round instead of left to right as in a single mirror. It will also give you a new view of yourself.

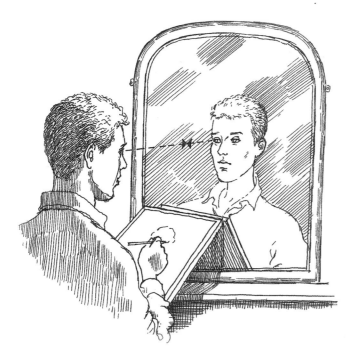

The angles of looking are restricted and the eyes will look straight at you whichever way you turn. This means there will be a similar effect in your finished drawing whatever the angle.

Drawing your own reflection in a mirror is not too difficult, but you have to learn to keep your head in the same position. It is very easy to move slightly out of position without noticing it and then finding your features don't match up. Use a marker spot on the mirror and line up something on your face with it.

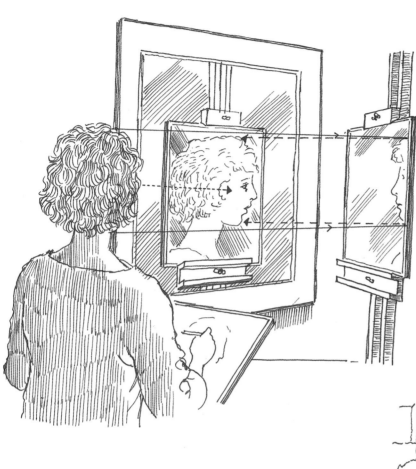

Use two mirrors in order to draw your own profile image. Rarely do we see ourselves in this perspective, so it can be quite interesting visually.

Although a self-portrait is often just an exercise for the artist to learn how to draw, it can also be useful in pictures of large groups. Many Renaissance artists painted themselves into their large-scale figure compositions, partly because they wanted to include a signature but more importantly because a face shown looking out at the viewer – as in this detail from a Botticelli – helped to draw the viewer into the picture.

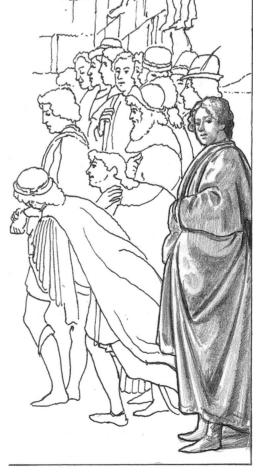

INDIVIDUAL VIEWPOINTS

On the next two spreads you will find a further selection of artists' views of themselves. As before, a mix of artists is included, but all have taken a particular attitude and in some cases give very unusual images of their personality.

They play with different methods both in the actual handling of the portrait and in their attitude to its meaning. Some are very honest and straightforward, others more symbolic and mysterious.

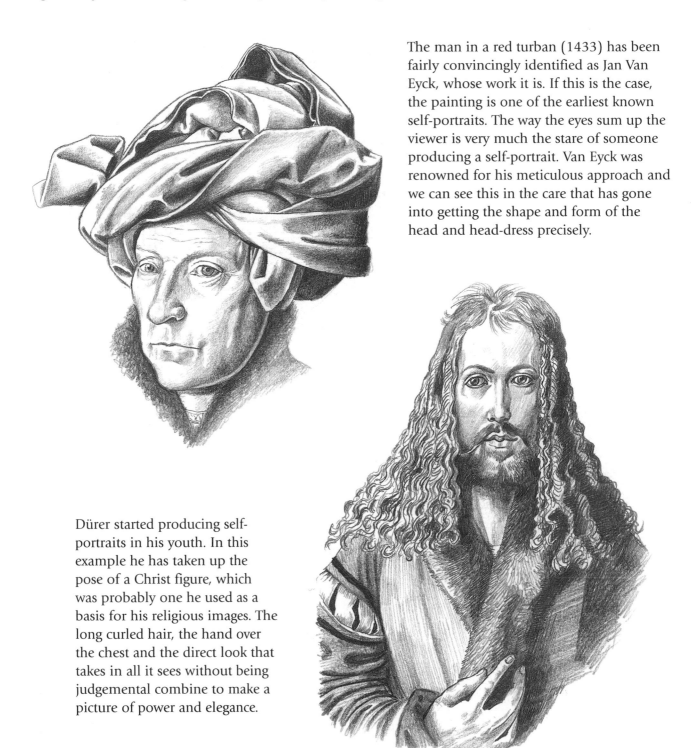

The man in a red turban (1433) has been fairly convincingly identified as Jan Van Eyck, whose work it is. If this is the case, the painting is one of the earliest known self-portraits. The way the eyes sum up the viewer is very much the stare of someone producing a self-portrait. Van Eyck was renowned for his meticulous approach and we can see this in the care that has gone into getting the shape and form of the head and head-dress precisely.

Dürer started producing self-portraits in his youth. In this example he has taken up the pose of a Christ figure, which was probably one he used as a basis for his religious images. The long curled hair, the hand over the chest and the direct look that takes in all it sees without being judgemental combine to make a picture of power and elegance.

Gian Lorenzo Bernini (1624) shows himself in sombre mood. The rather shadowy soft look to the picture suggests that he is taking a romantic view of himself, but it is beautifully observed and the use of light and shade masterful.

In this rapid and lyrical drawing the artist, John Vanderbank (1750), is almost looking back at us over his shoulder. Although it may seem a difficult pose it is quite common in self-portraiture where, if the artist is using a drawing board on an easel, he has to look across his shoulder in order to see his reflection in the mirror.

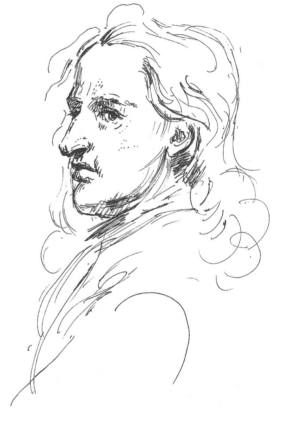

The original of this penetrating self-portrait by Goya (1771) was produced fairly early in his career and is a good example of his 'no holds barred' approach. Here he was not afraid to reveal every defect of his own physiognomy – the slightly pudgy, pale complexion and slightly disgruntled expression – and point them up by providing a contrasting dark background.

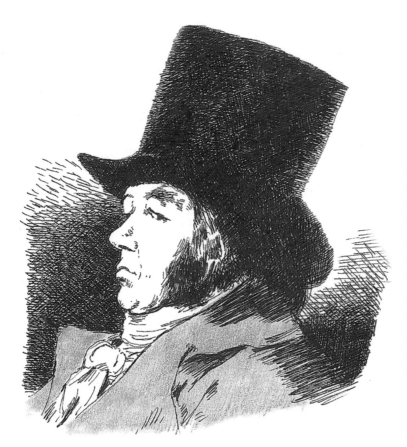

Goya again, in this example looking sideways at himself (1799). The original etching on which this copy is based was produced much later in the artist's life and gives a very clear idea of his rather quizzical and wary personality, although not of the deafness which was besetting him with difficulties. The inclusion of the hat is interesting because its sheer size must have caused problems when he was drawing himself.

The First President of the Royal Academy, Sir Joshua Reynolds (1747), is shown here peering from under a raised hand, shielding his eyes from the light. This is not an easy pose for the self-portraitist to draw, but it probably appealed to Reynolds as an opportunity to show how expert an artist he was. It certainly makes an unusual portrait.

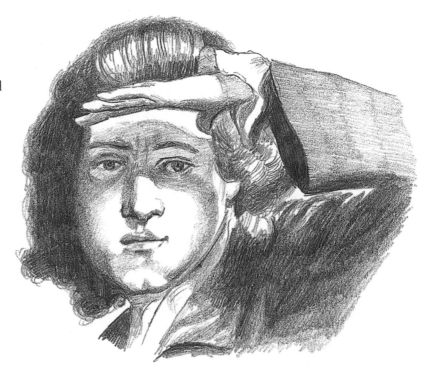

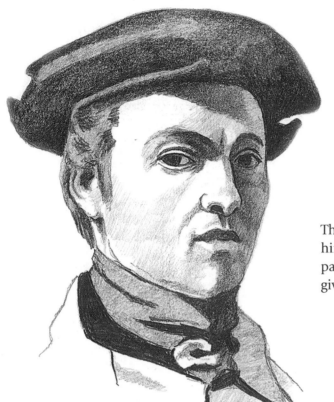

The young Camille Corot (1835) here portrays himself in a dark hat as though poised for painting. His vigorous and economical style gives a very clear and direct view.

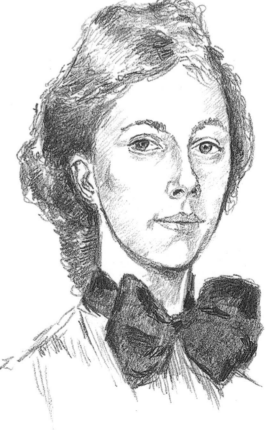

Gwen John produced the original of this while she was a student at the Academie Carmen in Paris (1899). She comes across as very self-possessed and confident, even challenging. At the time of this portrait she remarked that 'shyness and timidity distort the very meaning of my words in people's ears. That is the one reason why I think I am such a waif.' So does this self-portrait represent bravado or the real woman?

PRACTICE

DRAWING ON THE HOOF

Now comes the stimulating, if more difficult, exercise of taking your sketchbook and going out to find an animal subject to draw, preferably one that is relatively static. A horse gently grazing, or farm animals, which tend to be relatively calm when close to people, will provide good opportunities for you to practise your drawing skills. If you live near a farm, or zoo, you could take a half-day out to draw just one or two animals several time, from as many angles as possible. Don't worry about them moving, just keep starting new drawings. Don't worry either if your shapes don't come out well. Keep drawing and trying. The results aren't important. Sketchbooks are meant to be experimental, and the more often you do this type of practice, the better you will get at it.

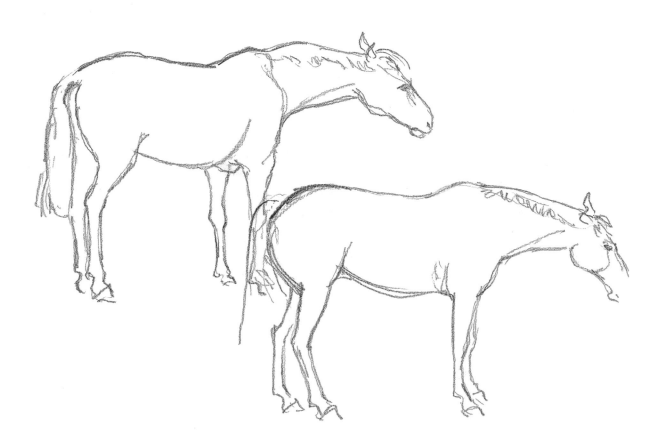

I sketched the shapes in loose flowing lines and didn't concern myself about the finished article. As soon as the horse changed position, I started again, sometimes for a few seconds, sometimes for a few minutes.

The pictures shown here are taken from a sketchbook in which I used up about ten pages on drawing a horse that was loose in a field. I didn't manage to finish any of the drawings, but that wasn't the point. I drew the horse as he wandered around me. Each time he moved and took up another position I'd begin another drawing.

This exercise is brilliant for practising the coordination of eye and hand. More importantly, it doesn't allow you time to evaluate what you are doing.

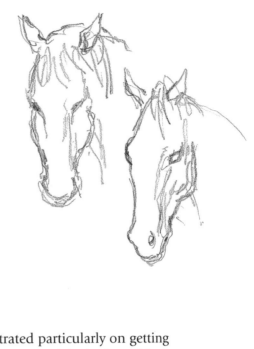

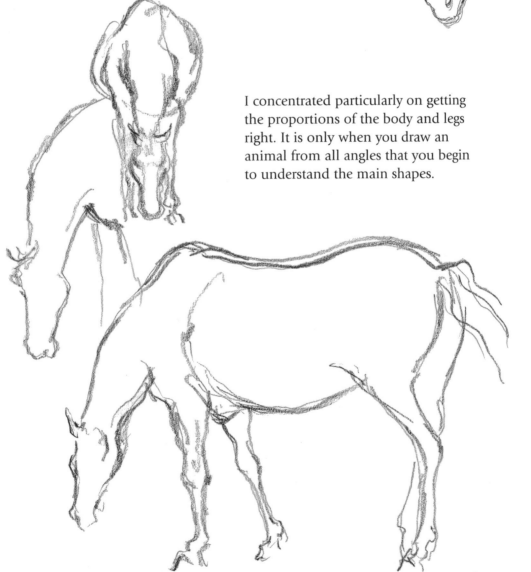

I concentrated particularly on getting the proportions of the body and legs right. It is only when you draw an animal from all angles that you begin to understand the main shapes.

VIEWPOINTS

Finding a landscape to draw can be very time-consuming. Some days I have spent more time searching than drawing. Never regard search time as wasted. If you always just draw the first scene you come to, and can't be bothered to look around that next corner to satisfy

yourself there is nothing better, you will miss some stunning opportunities. Reconnaissance is always worthwhile.

Let's look at some different kinds of viewpoint and the opportunities they offer the artist.

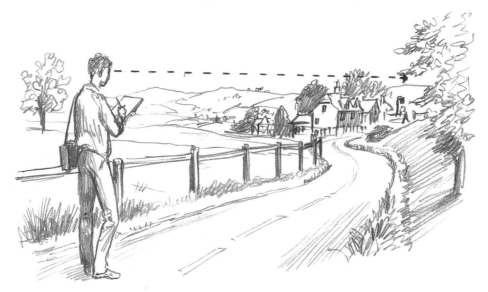

A view along a diminishing perspective, such as a road, river, hedge or avenue, or even along a ditch, almost always allows an effective result. The change of size gives depth and makes such

landscapes very attractive. Well-drawn examples of this type suggest that we, the onlookers, can somehow walk into them.

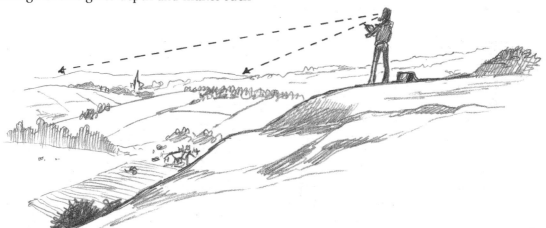

A landscape seen from a high point is usually eye-catching, although not always easy to draw. Look for a high point that offers views across a valley to other high points in the distance. From such a perspective the landscape is somehow revealed

to the viewer. If you try this approach, you will have to carefully judge the sizes of buildings, trees and hillsides to ensure the effect of distance is recognized in your picture.

EDITING YOUR VIEWPOINT

A good artist has to know what to leave out of his picture. You don't have to rigorously draw everything that is in the scene in front of you. It is up to you to decide what you want to draw. Sometimes you will want to include everything, but often some part of your chosen view will jar with the picture you are trying to create. Typical examples are objects that obscure a spacious view or look too temporary, or ugly, for the sort of timeless landscape you wish to draw. If you cannot shift your viewpoint to eliminate the offending object, just leave it out. The next two drawings show a scene before and after 'editing'.

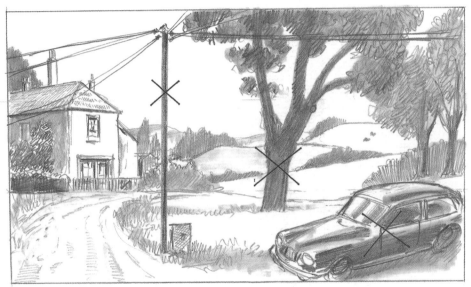

In this view a telegraph pole and its criss-crossing wires, a large tree and a car parked by the road are complicating what is an attractive landscape.

Eliminate those offending objects and you are left with a good sweep of landscape held nicely between the country cottage and unmade road, and the coppice of trees over to the right.

VIEWING THE GROUND

All landscapes have, at most, three layers of depth or vertical development: background, middleground, and foreground.

How well you manipulate the space occupied by these areas is very important.

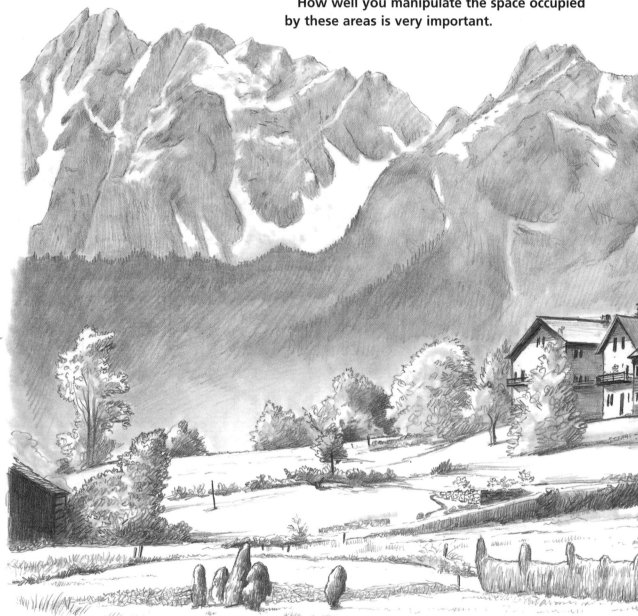

FOREGROUND

The foreground is important to the overall effect of a composition, its details serving to lead the eye into a picture, and also to the observation of the more substantial statement made by features in the middleground. Intentionally there is usually not much to hold the attention. The few features are often drawn precisely with attention given to the textures but not so much as to allow them to dominate the picture.

BACKGROUND

The background is the most distant part and is usually less defined, less textured and softer in effect.

MIDDLEGROUND

The middleground forms the main part of most landscapes, and gives them their particular identity. The structure of this layer is important because the larger shapes produce most of the interest. However, any details can vary in clarity.

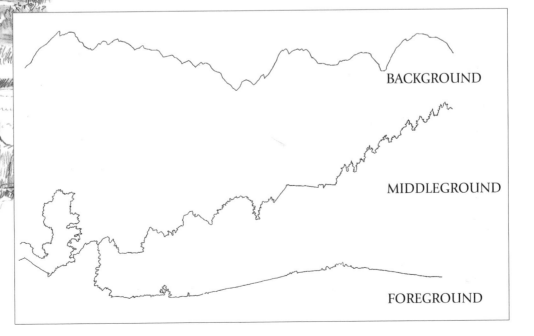

BACKGROUND

MIDDLEGROUND

FOREGROUND

HILLS AND SKIES

Any landscape will be made up of one or more features: sky, hills, water, rocks, vegetation, such as grass and trees, beach and buildings. Each grouping offers enormous scope for variation. For the moment look at each set of comparative examples and note how the features are used.

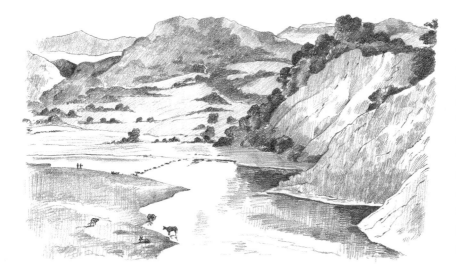

Here the high viewpoint allows us to look across a river valley to rows of hills receding into the depth of the picture. The tiny figures of people and cattle give scale to the wooded hills. The drawing of the closer hills is more detailed. Contrast their treatment with that used for the distant hills, which seem to recede as a result.

In this example of myriad layers of features, notice the way details are placed close to the viewer and how the distance is gradually opened up as the valleys recede into the picture. Buildings appear to diminish as they are seen beyond the hills and the distant mountains appear in serried ranks behind.

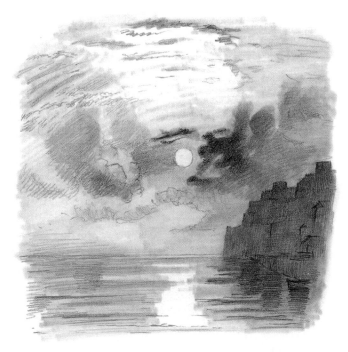

A very simple landscape/seascape is brought to dramatic life by the contrast of dark and light tones. The moon shines through clouds that show up as dark smudges around the source of light. The lower part of the picture features calm water reflecting the light, and the dark silhouette of a rocky shore.

A halcyon sky takes up almost three-quarters of this scene and dominates the composition, from the small cumulus clouds with shadows on their bases to the sunlight flooding the flat, open landscape beneath.

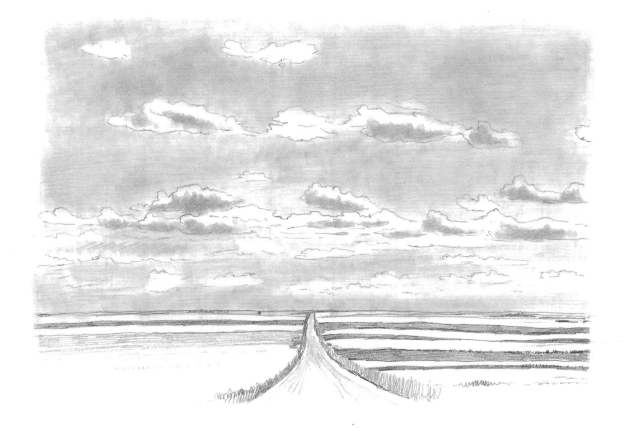

A DRAMATIC SKY: PRACTICE

Here is a large dramatic sky, after Constable, depicting a rainstorm over a coastal area, with ships in the distance. The sweeping linear marks denoting the rainfall give the scene its energy. The effect of stormy clouds and torrential rain sweeping across the sea is fairly easily achieved, as long as you don't mind experimenting a bit. Your first attempt might not be successful, but with a little persistence you will soon start to produce interesting effects, even if they are not exactly accurate. This type of drawing is great fun. Keep going until you get the effect you want.

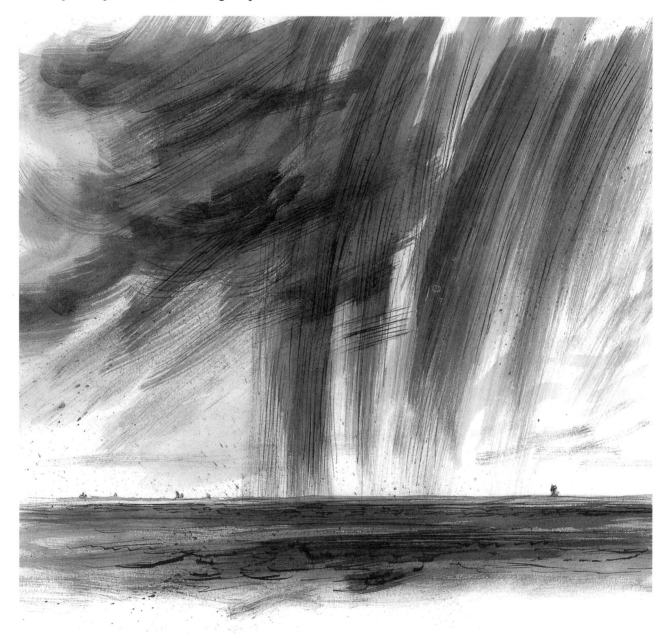

For the first stage use a fine pen with a bit of flexibility in the nib and black ink. Scribble in vertical and wind blown lines to suggest heavy rainfall. The sea can be marked in using both fine horizontal strokes and more jagged, fairly strong wave-like marks. To complete the effect, dip a hogs-hair brush into dark watercolour paint and splatter this across areas of the picture. This produces a more uneven texture to suggest agitated sea and rain.

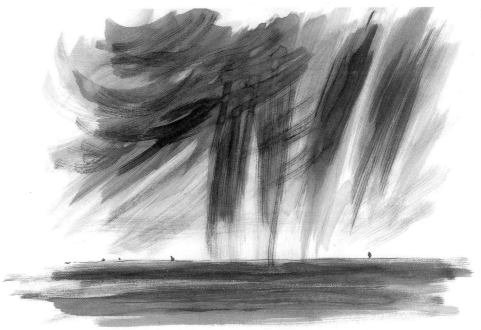

Then, using a large and small (size 12 and smaller) hogs-hair brush, put in pale washes of watercolour across the sweep of the rain and horizontally across the sea. Repeat this with a darker tone until you get the effect you require in the sky and sea. Allow the brush to dry out periodically and then apply almost dry brush marks to accentuate the effect of unevenness or patchiness.

WATER: CONTRASTING MOODS

The contrast in moods between the choppy sea depicted in the first drawing and the glassy looking water in the second couldn't be more extreme. Pay particular attention to the absence of any reflecting light in the first example, and the fact that the second drawing comes across as all-reflection.

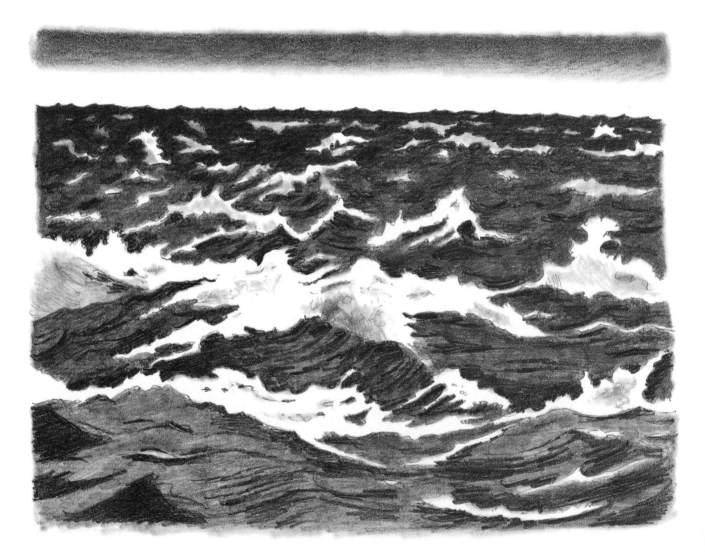

In this view of a choppy inky sea, with breaking crests of foam, the skyline is dark and there is no bright reflection from the sky. The shapes of the foaming crests of the wind-blown waves are very important. They must also be placed carefully so that you get an effect of distance, with large shapes in the foreground graduated to smaller and smaller layers as you work your way up the page towards the horizon.

Observe how foam breaks; take photographs and then invent your own shapes, once you've seen the typical shapes they make. No two crests of foam are alike, so you can't really go wrong. But, if you are depicting a stormy sea, it is important to make the water between the crests dark, otherwise the effect might be of a bright, albeit breezy, day.

This whole drawing is made up of the sky and its reflection in the river below. The lone boat in the lower foreground helps to give a sense of scale. Although the trees are obviously quite tall in this view, everything is subordinated to the space of the sky, defined by the clouds, and the reflected space in the water. The boat and a few ripples are there to tell the viewer that it is water and not just air. The effect of this vast space and mirror is to generate awe in the viewer.

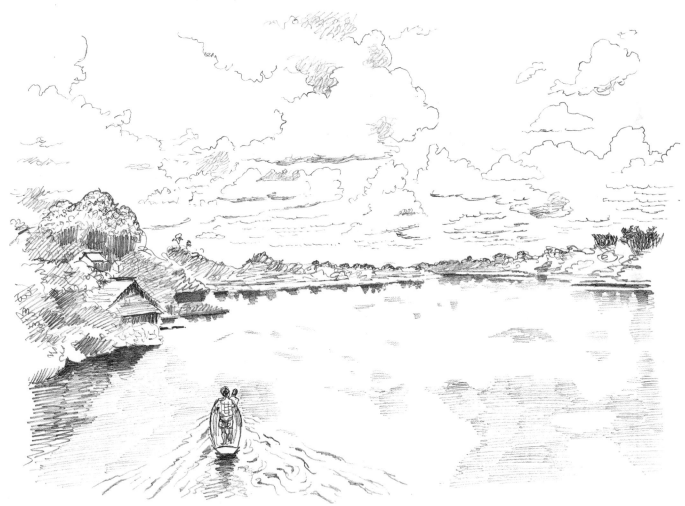

PRACTICE WITH WATER

Water is one of the most interesting of subjects for an artist to study and certainly adds a lot to any composition. As you will have noticed, the different shapes it can make and the myriad effects of its reflective and translucent qualities are quite amazing. Over the last few pages we've looked at various ways of portraying water but by no means all of them. The subject is limitless, and you will always manage to find some aspect of it that is a little bit different. Go out and find as many examples as you can to draw.

FALLING WATER: PRACTICE

High Force waterfall in the Pennines is narrow, with rocks interrupting the flow of the water that rushes down its steep sides. The strong tones of the banks provide contrast with the almost white strip of the waterfall.

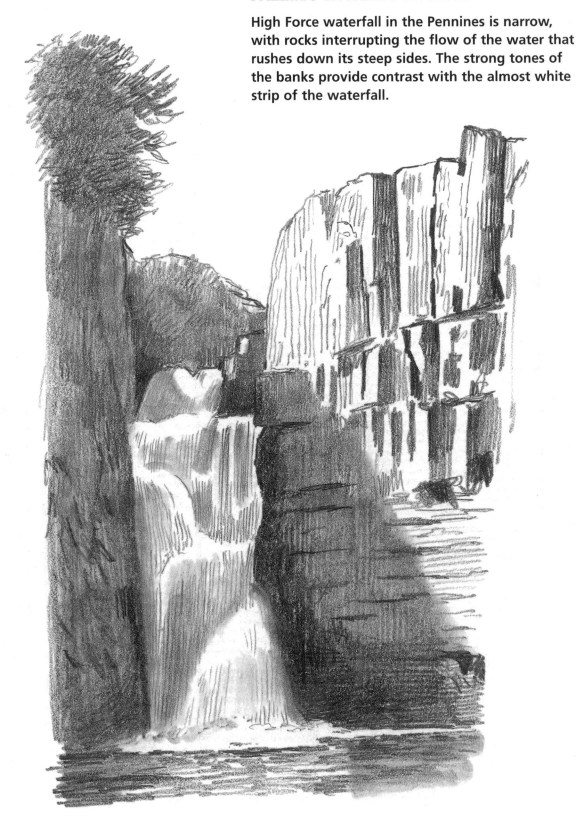

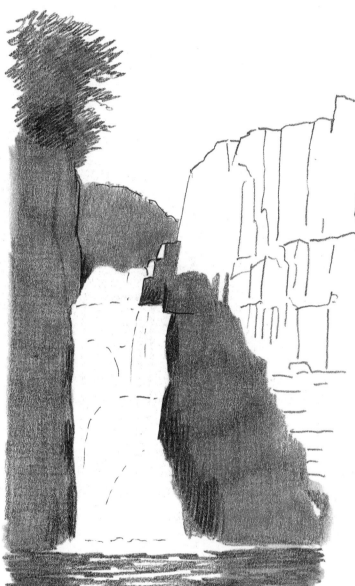

1. Start with the cliffs on either side. Where they are in shadow, use dark tone to block them in. Where they are not, draw them in clearly. In our view the area all around the falls is in shadow and it is this deep tonal mass that will help to give the drawing of the water its correct values. Leaving the area of the falls totally blank, put in the top edges of each ledge in the cliff face. Draw in the plunge pool and the reflection in the dark water at the base of the falls.

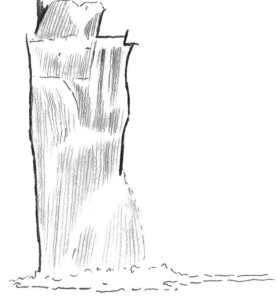

2. Leaving a clear area of white paper at the top of the ledges, indicate the downward fall of the water with very lightly drawn closely spaced vertical lines. Don't overdo this. The white areas of paper are very important in convincing us that we are looking at a drawing of water.

PRACTICE

INDICATING DISTANCE

In most landscapes you visit there will be man-made objects that can work in your picture as an instant pointer to the distance beyond or the distance between the viewer and the object. In this next series of drawings the subtler aspects have been purposely left out in order to show how foreground objects give definite clues as to size and distance

A picket fence looks simple enough but to draw it is quite an exercise if you are to get the structure correct and capture its tones and texture. Placed in the foreground of a picture, it can be used as an

indicator for the rest of the view, enabling us to relate to the size of the pickets and so judge the distances behind.

Now let's look at a fence alongside a country road with an open field and trees behind it. The fence must stand at waist-height at least, so giving the trees and spaces behind it a sense of distance, although these are drawn without any real effort to show distance variations. The croquet hoop in front of the fence provides another size indicator, but it is the fence that shapes our idea of depth in the picture.

A little way past the fence in this drawing you will notice three trees which act as a sort of frame for the landscape behind. We can tell by the line of the turf in which the trees are standing that they are a few yards from the fence and so we get some idea of their size. The field and simple depiction of tree lines behind the trees in the foreground give an indication of not only the space behind the fence and trees but also the slope of the landscape, dipping away from us and then rising up again towards the horizon.

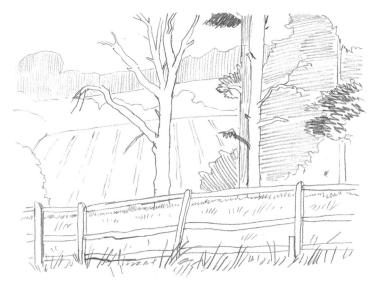

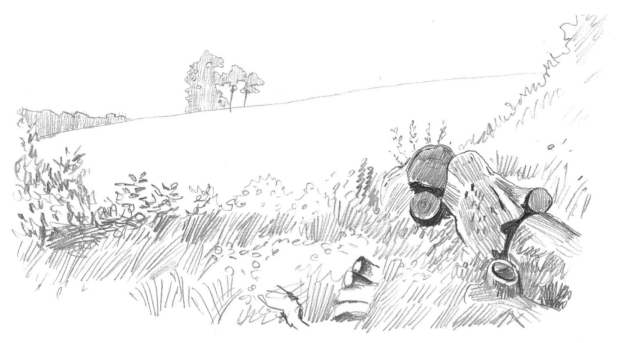

This example doesn't actually show a man-made object, but does reveal traces of human activity. The large chunky logs, half hidden in the long grass next to a low hedge, give a very clear indication of how close we are to them, and also how far we are from the stretch of hillside with its isolated trees on the skyline. The log offers a simple yet effective device to give an impression of open space.

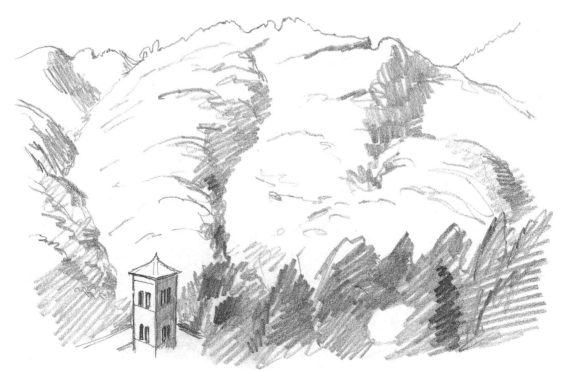

Our next scene is quite unusual and one I happened upon in an old village called Boveglio, near Lucca in Italy. The view is across a steep valley. On the opposite side thickly wooded hills sweep up to the skyline. The rather diminutive looking tower below belongs to a church in Boveglio and is in fact large enough to house a couple of bells.

PRACTISING FOREGROUND FEATURES

Urban environments offer opportunities for practising drawing all sorts of objects you may want to include in your compositions as foreground details. A garden table and chairs or machinery such as a bicycle are found in most households and can be used creatively to make satisfying mini-landscapes. It is amazing how ordinary objects can add drama to a picture.

The houses to one side of this village green in southern England are useful visual indicators of size, but even more effective is the lone car parked on the pathway, because this tells us something about the distance between it and us. It also gives us a good idea of the space behind the trees in the middle distance and the hedges and house behind.

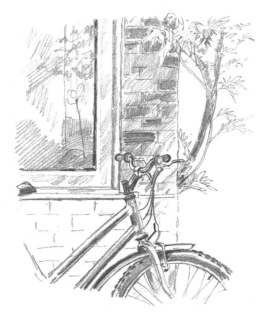

The bicycle lends an air of habitation to the blank corner on which it is balancing, with the vine curving around and up the brickwork. If part of the landscape could be seen past the corner, it would give a very sharp contrast between our position as viewers and whatever was visible behind. Even a small garden would give an effect of space. If the landscape were a street, the contrast would be even more dramatic.

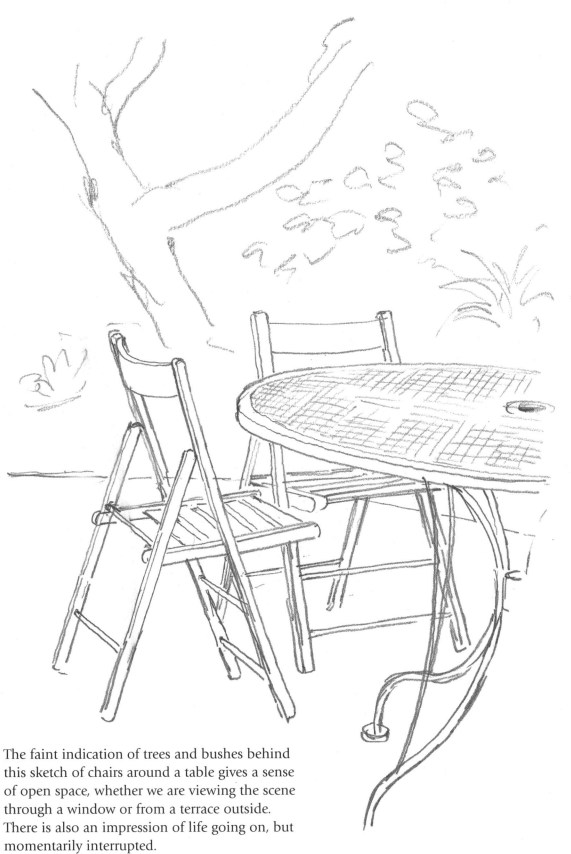

The faint indication of trees and bushes behind
this sketch of chairs around a table gives a sense
of open space, whether we are viewing the scene
through a window or from a terrace outside.
There is also an impression of life going on, but
momentarily interrupted.

PRACTICE

MIDDLEGROUND

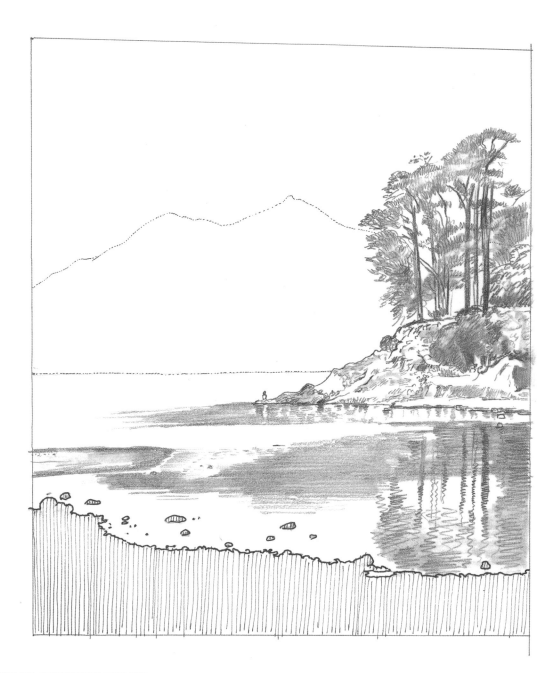

POINTING OUT THE SPACE

This view of Derwentwater in the Lake District offers a very simple yet effective way of highlighting the importance of the middleground. The majority of this area is taken up with one feature – water. However, as this might prove too bland to arrest the eye, a jutting spur of rock to the right acts as a focal point and keeps our attention well into the centre of the lake. The spur is almost like a finger pointing to the water to make sure we don't miss it.

The reflections in the water also give the expanse of lake a little more liveliness, although the smooth surface is uneventful.

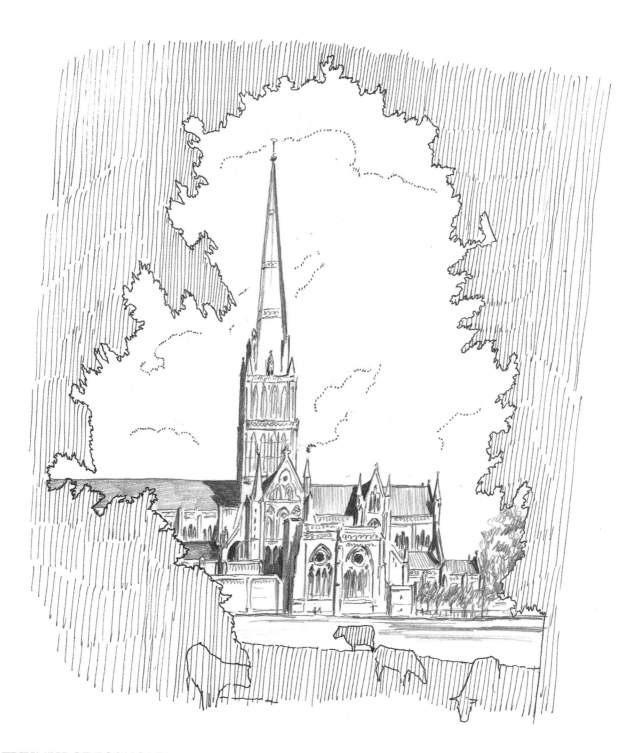

A TRIUMPH OF ECONOMY

This picture is after John Constable, that master of landscape, from his later years. The subject of the picture is Salisbury Cathedral, and that is just what you get. The foreground is a frame of leaves and a few cows grazing, brilliantly vignetting the building. The background is all sky, but a lively one. The magnificent spire and long nave of the Cathedral account for the whole of the middleground.

BACKGROUND

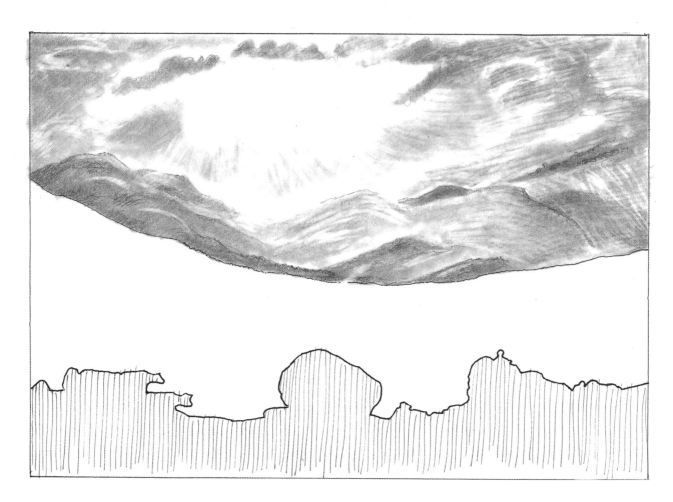

INCIPIENT DRAMA

Simmer Lake (after Turner) begins to show that great artist's interest in the elemental parts of nature. The background of sky and mountains does not have the restlessness we associate with much of his work but is nevertheless fairly dramatic. The great burst of sunlight coming through swirling clouds and partly obscuring the mountains gives a foretaste of the scenes Turner would become renowned for, where the elements of sunlight, clouds, rain and storms vie for mastery in the picture.

A KNOCKED BACK FOCAL POINT

In this view of Whitby (after Turner) the background is dramatic and prominent in shape while reduced in intensity. The Abbey on top of the cliff with the sun flooding through its arches creates a marvellous soft focal point above the buildings of the main part of the town. The clear bright sky helps to silhouette the background feature while also diminishing its strength in the picture by making it look almost insubstantial against the darker and more solid buildings in the town.

REDUCED EFFORT

This example (after Monet's picture of a small cabin on the rocky coast at Varengeville) does away completely with the middleground and places the foreground against an immense, serene space of sea and sky that merge into each other. The curve of the edge of the coast frames this rich-looking tone with just a couple of tiny spots of white that we read as sails. The overall texture of the background makes a very effective surface on which to place the rocks, vegetation and cabin of the foreground.

BACKGROUND PRESSING IN

Here, in a scene of a wet Paris street (after Caillebotte), is a strange arrangement of foreground, middleground and background. Large buildings or busy streets often make up the backgrounds in pictures of town- or cityscapes. These backgrounds often seem much closer than those of open landscapes. Caillebotte reduced his foreground effectively to one side of the picture and made his middleground form a deeper frame around the picture. The large blocks of apartments become very strong statements, but are still very much a background to the people and activity in the streets. In effect the background is brought much closer to us as viewers and yet does not take our attention away from the figures. The background has the effect of showing us what cities do to humanity.

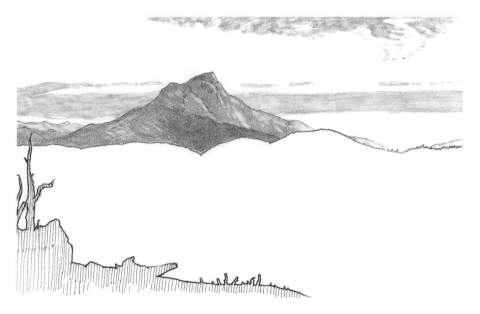

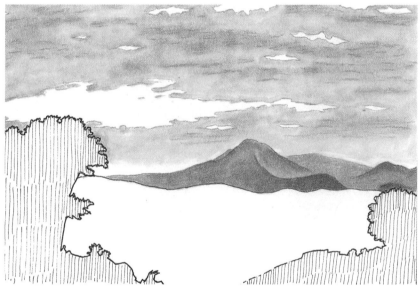

SIMILAR BACKDROPS, DIFFERENT EFFECTS

Here we have two backgrounds to American landscapes that appear similar in space but are focusing your attention in different ways to get their effect. The more you study landscape paintings and drawings the more interesting these subtle effects become.

The first picture (after S. R. Gifford) is of a lake at twilight. It just so happens that behind the lake is a large mountain peak that dominates the area. The calm sky and remote peak provide focal points but they don't hold the attention, which will keep returning to a hunter and his boat in the middleground (not shown). The middleground takes up almost half of the area, whereas the background of sky and mountain account for about one-third, accentuating the distance separating them and our sense of what is the most important feature in the picture: the man and his boat.

The second picture (after F. E. Church) is very much of its subject, Mount Ktaadn. The artist has kept the background landscape rather diminished but with an enormous expanse of sky with clouds reflecting the sunset. The darkness of the mountain makes it almost a silhouette, thus increasing its air of mystery. The middleground and foreground are reduced in size, between them only taking up one third of the picture.

PERSPECTIVE AND SPATIAL AWARENESS

Including some perspective in your drawings is a natural result of opening up your viewpoint. Diagrams can help you to understand what you are seeing. Obviously they are not quite true because in real life the eye moves around and looks up and down; the view as seen through a fish-eye lens would probably be more correct. However, the mind interprets the view seen and supplies the knowledge that, for example, the walls are really vertical and that the lines are really straight, and so the eye adjusts to accept this reality.

In this section we shall be looking at various methods of perspective and showing you how to demonstrate their validity for yourself. Perspective involves a good deal of visual deception and you need to know the rules if you are to use it effectively in your drawings. Perspective exercises can help you to understand what is happening to your view. However, only the direct experience of drawing from observation will make you aware of how perspective actually works.

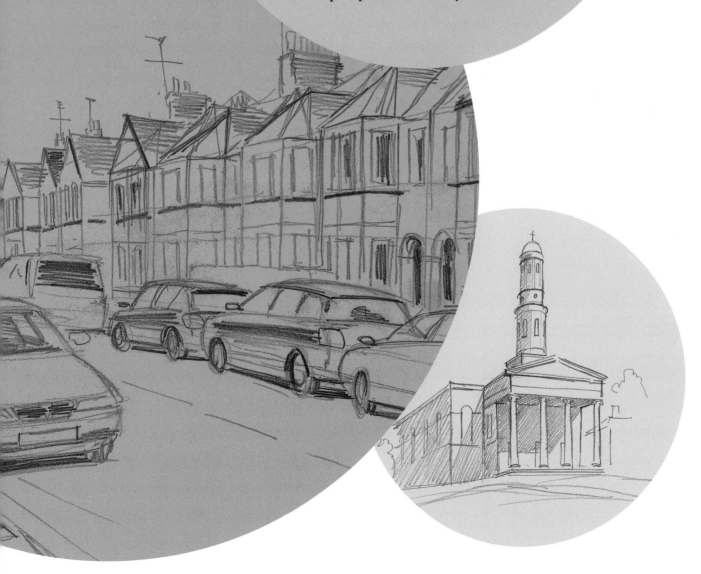

THREE DIMENSIONS

To give the impression of depth and solidity in drawing, you have to use perspective, or shading, or both. This series of exercises has been designed to show you how to achieve the basic illusion of three dimensions. We begin with a series of cubes and spheres.

1. Draw a square.

2. Draw lines that are parallel from each of the top corners and the bottom right corner.

3. Join these lines to complete the cube.

This alternative method produces a cube shape that looks as though it is being viewed from one corner.

1. Draw a diamond shape or parallelogram elongated across the horizontal diagonal.

2. Now draw three vertical lines from the three angles shown; make sure they are parallel.

3. Join these vertical lines.

Shading

Once you have formed the cube you are halfway towards producing a realistic three-dimensional image. The addition of tone, or shading, will complete the trick.

 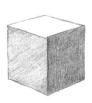 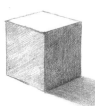

There is only one way of drawing a sphere. What makes each one individual is how you apply tone.

In this example we are trying to capture the effect of light shining on the sphere from top left.

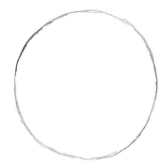

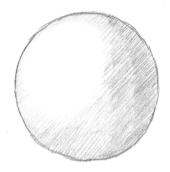

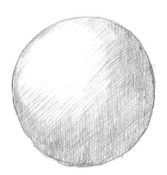

1. Draw a circle as accurately as possible.

2. Shade in a layer of tone around the lower and right-hand side in an almost crescent shape, leaving the rest of the surface untouched.

3. Subtly increase the depth of the tone in much of the area already covered without making it uniform all over.

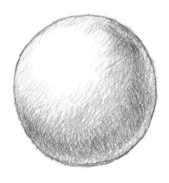

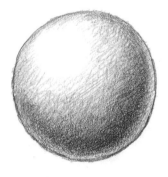

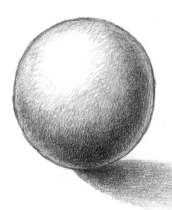

4. Add a new crescent of darkish tone, slightly away from the lower and right-hand edges; ensure this is not too broad.

5. Increase the depth of tone in the darkest area.

6. Draw in a shadow to extend from the lower edge on the right side.

PERSPECTIVE AND SPATIAL AWARENESS

ELLIPSES

One shape you need to learn to draw if you are to show a circular object in perspective is an ellipse. This is a curved figure with a uniform circumference and a horizontal axis longer than the perpendicular axis.

An ellipse changes as our view of it shifts. Look at the next series of drawings and you will see how the perspective of the glass changes as its position alters in relation to your eye-level.

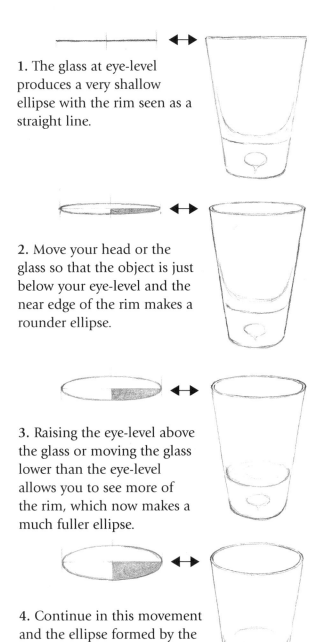

1. The glass at eye-level produces a very shallow ellipse with the rim seen as a straight line.

2. Move your head or the glass so that the object is just below your eye-level and the near edge of the rim makes a rounder ellipse.

3. Raising the eye-level above the glass or moving the glass lower than the eye-level allows you to see more of the rim, which now makes a much fuller ellipse.

4. Continue in this movement and the ellipse formed by the rim becomes deeper. Despite this shift the length of the horizontal axis does not alter.

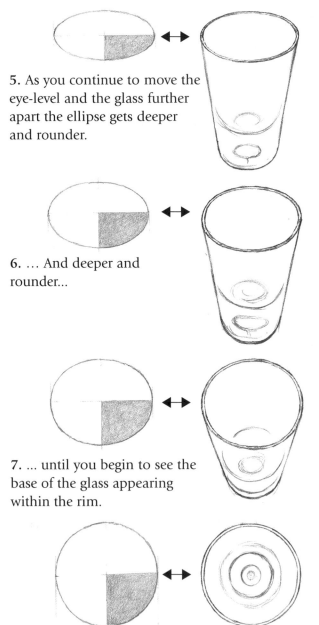

5. As you continue to move the eye-level and the glass further apart the ellipse gets deeper and rounder.

6. … And deeper and rounder...

7. ... until you begin to see the base of the glass appearing within the rim.

8. When the glass is so far below your eye-level that you are looking straight into it, the rim of the glass makes a complete circle and the base of the glass appears in the centre of the circular rim.

ELLIPSES PRACTICE: CYLINDERS

Ellipses come into their own when we have to draw cylindrical objects. As with our previous examples of making shapes appear three-dimensional, the addition of tone completes the transformation.

1. Draw an ellipse.
2. Draw two vertical straight lines from the two outer edges of the horizontal axis.
3. Put in half an ellipse to represent the bottom edge of the cylinder. Or, draw a complete ellipse lightly, then erase the half that would only be seen if the cylinder were transparent.
4. To give the effect of light shining from the left, shade very lightly down the right half of the cylinder.
5. Add more shading, this time to a smaller vertical strip that fades off towards the centre.
6. Add a shadow to the right, at ground level. Strengthen the line of the lower ellipse.

UNDERSTANDING PERSPECTIVE

The science of perspective is something with which you will have to become acquainted in order to produce convincing depth of field. This is especially important if you want to draw urban landscapes. The following diagrams are designed to help you understand how perspective works and so enable you to incorporate its basic principles in your work.

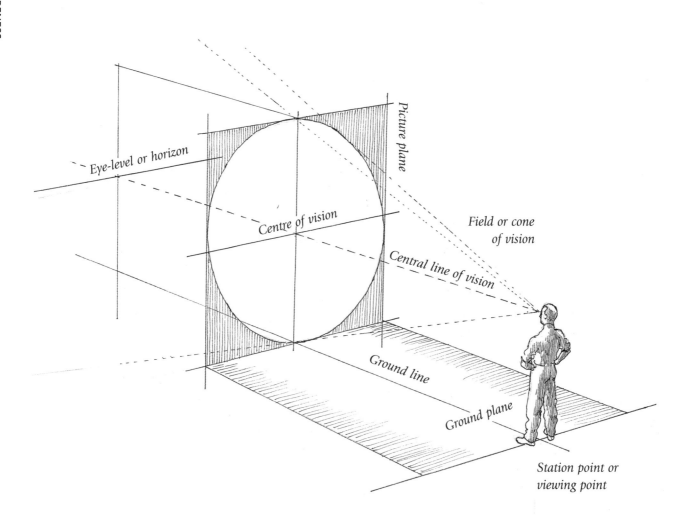

Eye-level or horizon

Picture plane

Centre of vision

Field or cone of vision

Central line of vision

Ground line

Ground plane

Station point or viewing point

RELATIONSHIPS IN THE PICTURE PLANE

In the example shown here we look at the relationships between the tree, post and flowers and the horizon line. As you can see, the height of the tree in the picture appears not as high as the post, although in reality the post is smaller than the tree. This is due to the effect of perspective, the tree being further away than the post. There is also an area of ground between the bottom of the tree and the flower. The horizon line is the same as the eye-level of the viewer.

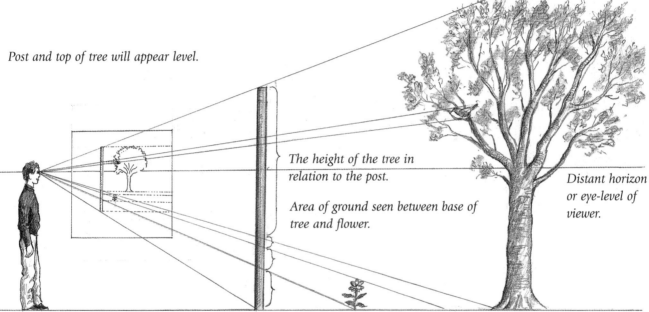

Post and top of tree will appear level.

The height of the tree in relation to the post.

Area of ground seen between base of tree and flower.

Distant horizon or eye-level of viewer.

Distance between bottom of tree and bottom of post.

AERIAL PERSPECTIVE

When you are drawing scenes that include a distant landscape as well as close up elements, you must give the eye an idea of how much air or space there is between the foreground, middle ground and background. In this drawing these areas are clearly delineated. The buildings and lamp-posts close to the viewer are sharply defined and have texture and many tonal qualities. The buildings further away are less defined, with fewer tonal variations. The cliffs behind this built-up area are very faint, with no detail or texture and without much variation in tone.

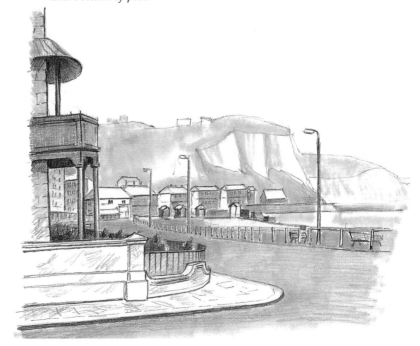

SIMPLE PERSPECTIVE

Perspective is very important if you wish to make a drawing appear to inhabit a three-dimensional space. The rules are fairly simple, but there are many ways of contrasting the lines of perspective to give the right effect. Drawing from observation will help you to see how perspective works in fact. Here we look at three devices which help explain the theory.

Rule number one of perspective is that objects of the same real size, look smaller the further away they are from the viewer.

Therefore a man of 6ft who is standing about 6 feet away from you, will appear to be about half his real height. If he is standing about 15 feet away, he will appear about 8 inches high. Stand him one hundred yards away and he can be hidden behind the top joint of your thumb, and so on.

The first diagram gives some idea of how to construct this effect in the picture plane. The posts apparently become smaller and thinner as they approach the vanishing point. The space between the posts also appears to get smaller. This image gives a good semblance of what happens in the eye of the viewer, and one can see the use that can be made of it to create apparent depth on the flat surface of the paper.

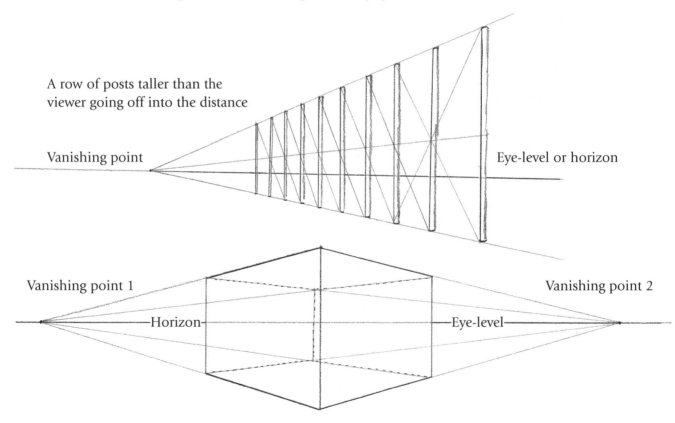

A row of posts taller than the viewer going off into the distance

Vanishing point

Eye-level or horizon

Vanishing point 1

Horizon

Eye-level

Vanishing point 2

In the constructed cube above the size is inferred by the height above eye-level, which makes this appear to be the size of a small house. The dotted lines show the far side of the cube, invisible to the eye (unless the cube is of glass). It is noticeable that not all the lines are parallel to each other, as they are in the cubes drawn on page 188, but actually follow the rules of perspective which takes the lines to the two vanishing points. This device is very convincing to the eye, and was the great rediscovery of the Renaissance artists (particularly Brunelleschi), which had been lost as an aid to drawing since Roman times.

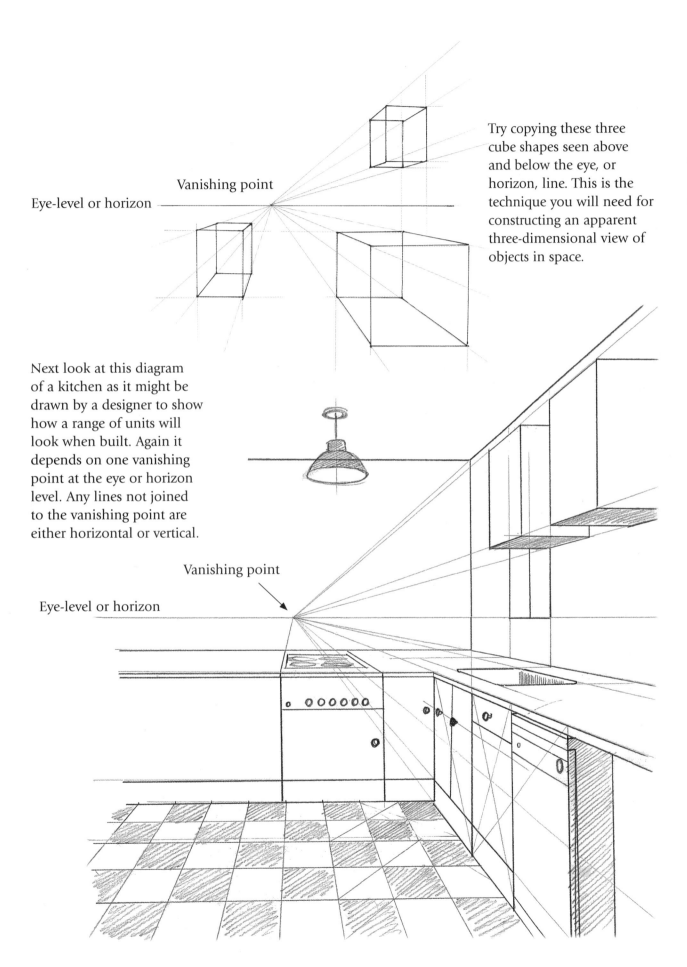

Vanishing point

Eye-level or horizon

Try copying these three cube shapes seen above and below the eye, or horizon, line. This is the technique you will need for constructing an apparent three-dimensional view of objects in space.

Next look at this diagram of a kitchen as it might be drawn by a designer to show how a range of units will look when built. Again it depends on one vanishing point at the eye or horizon level. Any lines not joined to the vanishing point are either horizontal or vertical.

Vanishing point

Eye-level or horizon

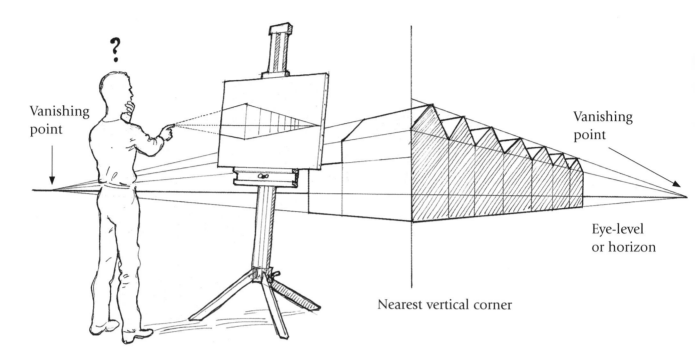

Vanishing point

Vanishing point

Eye-level or horizon

Nearest vertical corner

These drawings are to give you some idea of how to construct a drawing to show a building in perspective. The key lines are the eye-level or horizon line and the lines along the top and bottom edges of the building. Both top and bottom lines converge at a vanishing point on eye-level, although on the other side of the perspective the converging lines would not meet until they had come off the paper.

Now try drawing either a long building or a short street from one end. Again, this can be set up by drawing guide lines to mark eye-level (your eye-level), the nearest vertical corner, and lines converging on the eye-level above and below it to represent the base and the top edge of the building. The vanishing point on one side of the vertical should be fixed on your eye-level line even if the one on the other side is too far away to make it onto your paper.

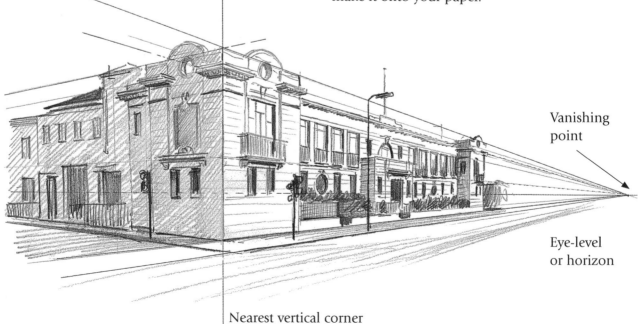

Vanishing point

Eye-level or horizon

Nearest vertical corner

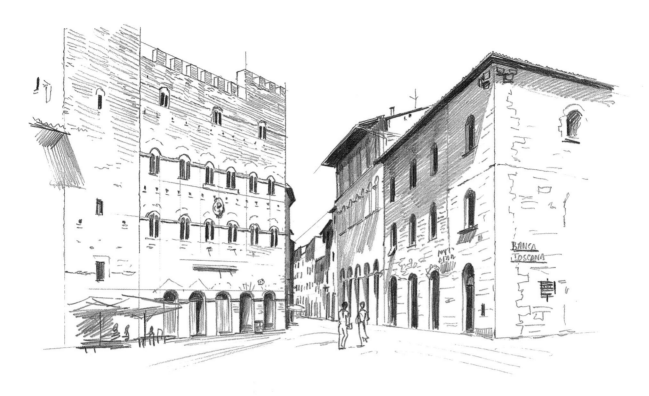

Here one building is set at an angle from the main street. This means that although the horizon line will be the same for the other buildings in the drawing, the vanishing point for this particular building will be much further to the right on the horizon. The vanishing point of the main part of the street is just behind one of the doors at the right-hand side of the oblique building.

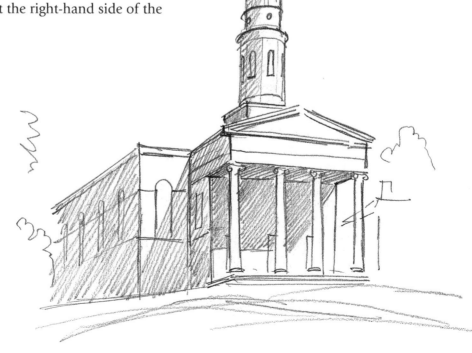

This church with a pepper-pot tower is set up on a rise in the ground, so the horizon is very low in the picture, just below the level of the steps.

IRREGULAR PERSPECTIVE

We now look at a large piece of architectural work in which the perspective is not entirely regular, in this instance because of the sloping ground and the slightly odd type of fortification. The horizon line is very low and so the line of the top of the arch is at about 60 degrees from vertical. Because very few of the lines are horizontal or vertical, such a drawing does not demand that you organize the perspective to perfection. When faced with a view like this, it is better to forget perspective and trust that your eye will give you all the information you need.

Interesting here are the massive areas of wall and the chunky simplified masses of building which give a very strong combination of shapes. The handling of the shadows is important too, because they increase the impression of simplicity and the building's monumental size.

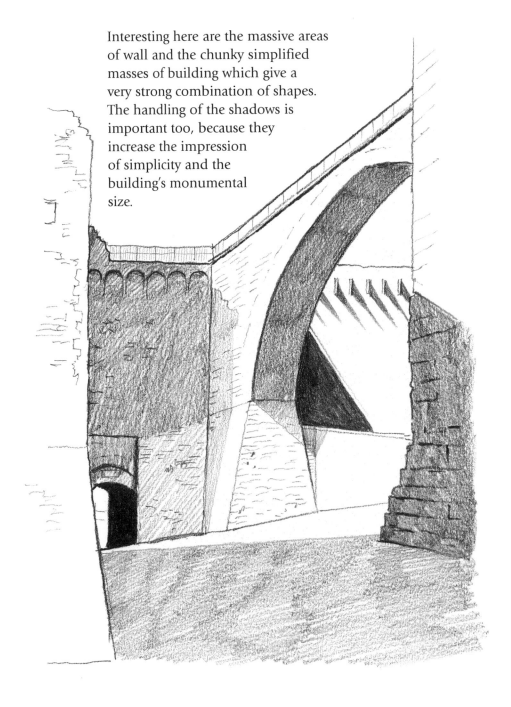

The next sketch shows how to handle a very large building which has multiformed decorative details all over it. Start by trying to draw the very simple shapes of the main construction of the building; what you will get is a picture that looks like a cardboard cutout, as here. Once this main block of the building has been worked out, and you have made sure that the perspective makes sense visually, only then should you begin drawing the proliferation of details that are on the exterior. These details will mostly be too small to draw accurately, but you can try to get the right effect by using marks that give an impression of the shapes.

With large, complex buildings it is important not to try to draw every detail at first. Aim to get down on paper simplified block shapes to give the effect of the architecture. When you have done this you can then put in as much detail as you can manage, but don't worry if some parts end up as scribbles or smudge-like marks. The eye allows the imagination to fill in the features that are only roughly indicated. Try to bear in mind that buildings are mostly vertical and have horizontal layers of structure.

USING A COMMON UNIT OF MEASUREMENT

A large subject such as a street scene, in which proportions and perspective have to be taken into account, can be difficult to draw accurately unless you use some system of measurement.

For the urban scene shown below, I chose an element within the scene as my unit of measurement (the lower shuttered window facing out of the drawing) and used it to check the proportions of each area in the composition. As you can see, the tall part of the building facing us is about six times the height of the shuttered window. The width of the whole building is twice the height of the shuttered window in its taller part and additionally six times the height of the shuttered window in its lower, one-storey part near the edge of the picture.

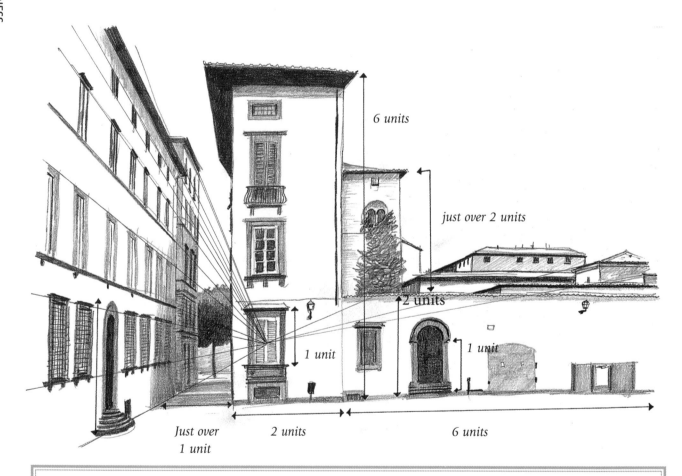

6 units

just over 2 units

2 units

1 unit

1 unit

Just over 1 unit

2 units

6 units

Keeping Measurement in Perspective

A unit of measurement enables us to maintain the accuracy of our drawing, but it is only meant to provide a rough guide. Once you are used to drawing, you will find the eye an extraordinarily accurate instrument for judging proportion and size. Sometimes we just need to check to make sure we've got them right, and at such times units and the like come into their own.

PERSPECTIVE: FIELD OF VISION

The system we look at next is quite easy to construct. You don't require training in mathematics to get it right, just the ability to use a ruler, set square and compass precisely.

Although the picture does not have depth in actuality, the eye is satisfied that it does, because it sees an area of squares which reduces geometrically as it recedes into the background.

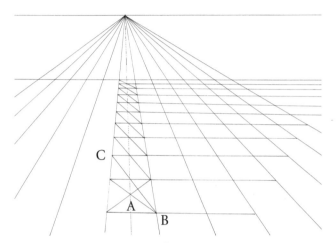

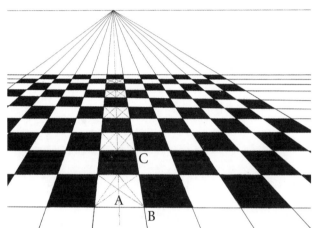

Constructing an area of squares

Any square portions, such as paving slabs, tiles or even a chequerboard of fields, can be used to prove the illusion of depth in a picture.

Take one slab or square size (A), draw in diagonal lines and from the crossing point of these diagonals mark a construction line to the vanishing point. In order to get the next rows of paving slabs related to the first correctly and in perspective, draw a line from the near corner (B) to the point where the construction line to the vanishing point

cuts the far edge of the square. Continue it until it cuts the next line to the vanishing point (C) and then construct your next horizontal edge to the next paving slab. Repeat in each square until you reach the point where the slabs should stop in the distance. Having produced a row of diminishing slabs, you can continue the horizontal edges of the slabs in either direction to produce the chequerboard of the floor. Notice the impressive effect you get when you fill in alternate squares.

More About Chequerboard

The sort of chequerboard floor or pavement you have been learning about has often been used in paintings to help the illusion of depth. In pictures painted during the early Renaissance period it was thought to be amazingly realistic. These days we are a bit more used to seeing such devices and so other effects have been brought into play to help us accept the illusion of dimensionality. However, do experiment with the chequerboard ground – it's very simple and very effective. And don't forget that if you place figures or objects on it, make sure that as they recede into the picture – standing on squares that are further back – they diminish in size consistent with your eye-level.

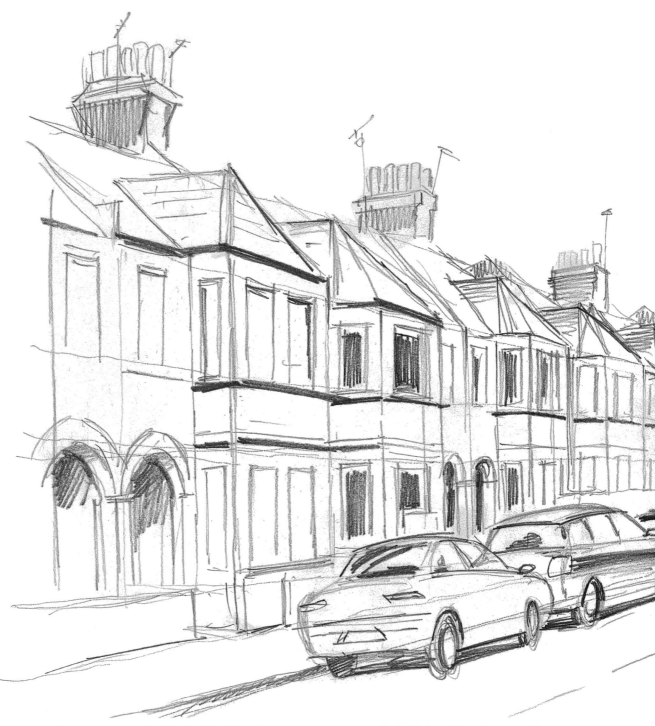

Drawing architecture is probably the hardest thing to do other than the human figure and face. It is great fun if you persevere and produces hours of intense investigation in pursuit of the sort of impression that looks something like the view in front of you.

It is good practice to take a photograph of the view that you are drawing and compare the two. You will find that the photograph is not necessarily more correct than the drawing, because the perspective in a photograph may be slightly exaggerated, depending on the lens. Nevertheless, the comparison of the two can show how the perspective works. The correct perspective will probably be somewhere between your drawing and the photograph.

CONSTRUCTING A VIEW ALONG A STREET

The best possible subject to give you a lot of practice of perspective drawing is a view along a corridor or a street, particularly if the street is narrow. If you set yourself up to draw looking down the length of the street, you will notice how the lines of the roofs and lines of the base of the buildings converge towards the distance. Not only that, but any structure on the surface of the buildings, such as ledges, door frames or window frames, gives the same effect. If you can get the angle of the convergence of these lines accurate enough, the street will appear to recede into the depth of the picture.

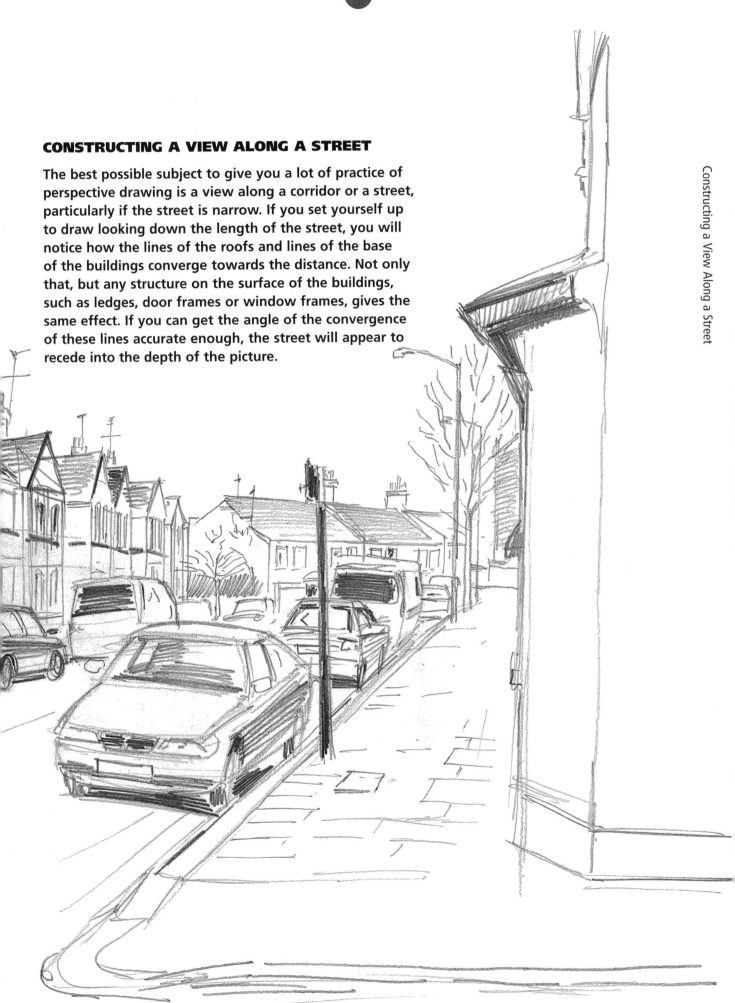

TYPES OF PERSPECTIVE

The eye being a sphere, it comprehends the lines of the horizon and all verticals as curves. You have to allow for this when you draw by not making your perspective too wide, otherwise distortion occurs.

We looked at the concept of 'vanishing points' earlier in this section. Let's consider this further, as it applies to aspects of the outside world, beginning with the simplest type of perspective.

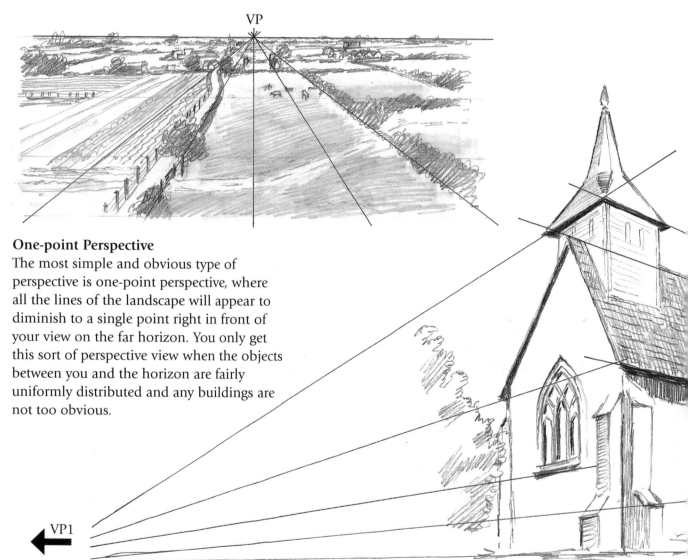

One-point Perspective
The most simple and obvious type of perspective is one-point perspective, where all the lines of the landscape will appear to diminish to a single point right in front of your view on the far horizon. You only get this sort of perspective view when the objects between you and the horizon are fairly uniformly distributed and any buildings are not too obvious.

Two-point Perspective
Where there is sufficient height and solidity in near objects (such as houses) to need two vanishing points at the far ends of the horizon line, two-point perspective comes into play. Using two-point perspective you can calculate the three-dimensional effect of structures to give your picture convincing solidity and depth. Mostly the vanishing points will be too far out on your horizon line to enable you to plot the converging lines precisely with a ruler. However, if you practise drawing blocks of buildings using two vanishing points you will soon be able to estimate the converging lines correctly.

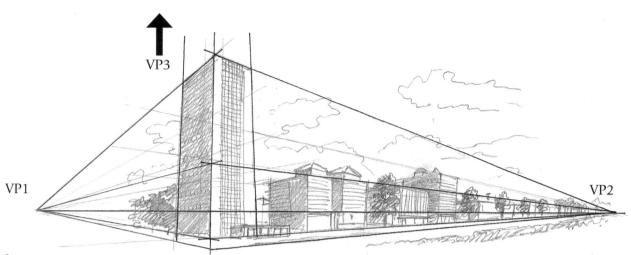

VP3

VP1

VP2

Three-point Perspective

When you come to draw buildings that have both extensive width and height, you have to employ three-point perspective. The two vanishing points on the horizon are joined by a third which is fixed above the higher buildings to help create the illusion of very tall architecture. Notice in this example how the lines from the base of the building gently converge to a point high in the sky. Once again, you have to gauge the rate of the convergence. Often, artists exaggerate the rate of convergence in order to make the height of the building appear even more dramatic. When this is overdone you can end up with a drawing that looks like something out of a comic book.

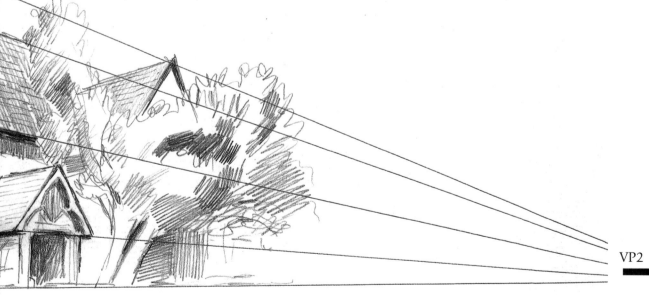

VP2

USING PERSPECTIVE

After you have absorbed the terminology and theory of perspective, it is time to look at how this knowledge is used by artists to give an impression of depth when they are confronted by a real landscape. In the following examples, we identify the various features and objects that have been used to give space and depth to the picture plane.

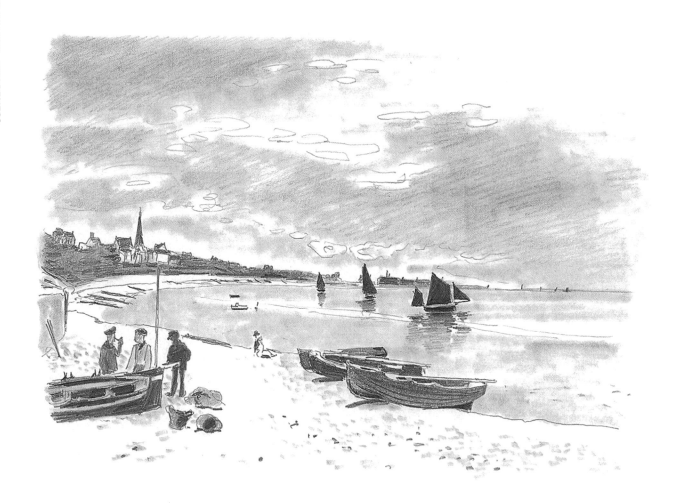

Size and light give clues to the depth of this picture, of the Bay of St Ardresse (after Monet). In the foreground, human figures and small fishing boats give us the proportion of the close-up foreground. Across the expanse of water are dotted sailing vessels, which diminish in scale as they recede from our point on the beach. Note the curve of the beach moving away to the left and then curving around to the right, behind the fishing vessels in the middle ground. The buildings on the shoreline diminish as they recede into the distance around the curve of the bay. On the far horizon we see very small marks denoting vessels and buildings. The lines of clouds in the sky also help to support the illusion of depth. Lastly, note how silhouette has been used, especially in the fishing boats, to proclaim their closeness to us in relation to the far distant shore.

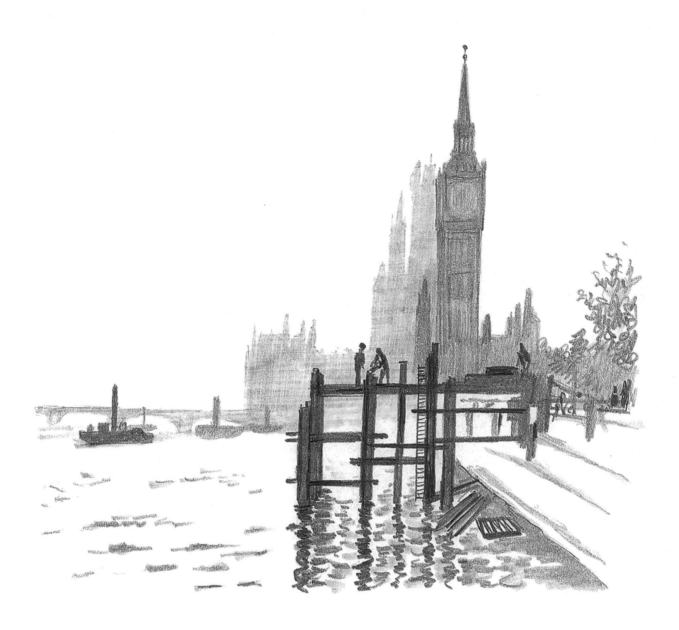

In this second scene (also after Monet), of the River Thames near Westminster, there are various clues to distance including, most tellingly, clever use of layers of tone. The contrast between the differently sized objects tells us clearly that the jetty is closer to us than Big Ben and that the steam tug is closer to us than the bridge. However, most persuasive is the change in tonal values of the buildings and objects as they recede into the background, aided by the misty quality of the atmosphere. In the near foreground the jetty is strongly marked in dark tone, contrasting with the embankment wall and the dark and light surface of the water. Behind this is the rather softer tone for the bulk of the tower of Big Ben and the small tugboat on the bright water. Beyond, other buildings are faintly outlined against a pale sky.

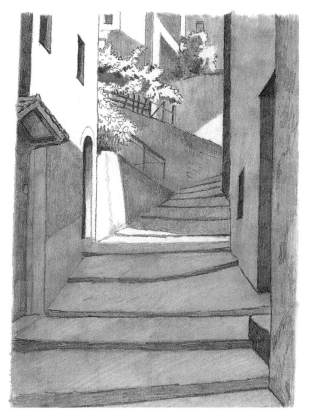

This drawing of the entrance to the mountain town of Boveglio in Tuscany gives many clues to our position and that of the buildings in front of us. The angle of the steps upwards and the change in the size of the windows provide information that helps us to detect how the path winds up into the old town.

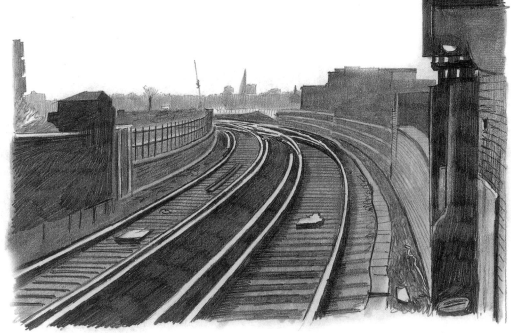

A classic image of perspective is instantly shown in this drawing of railway lines. The drama of the curve as the rails sweep around to the left where they merge and disappear takes us into the picture and shows us the clarity of perception of the viewer. All that we see beyond the rails are softly silhouetted buildings about 500m (547yd) away.

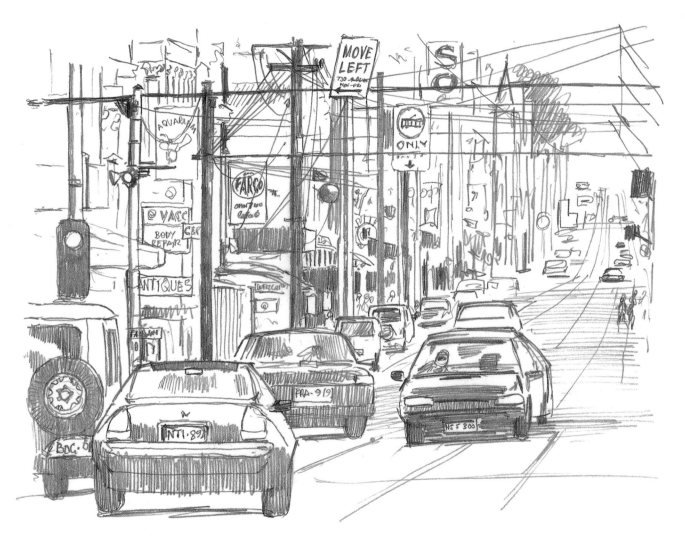

The chaos of signs and telephone wires along a
Melbourne street give us a sense of the texture
of Australian city life. The sweep of the road and
the diminishing sizes of the vehicles certainly
convince us of the distance observed, and yet the
signs and posts flatten out the depth, making it
difficult to judge distances.

In the three examples shown here formal perspective is conspicuous by its absence. In all cases the effect the artist is after does not rely so much on perspective.

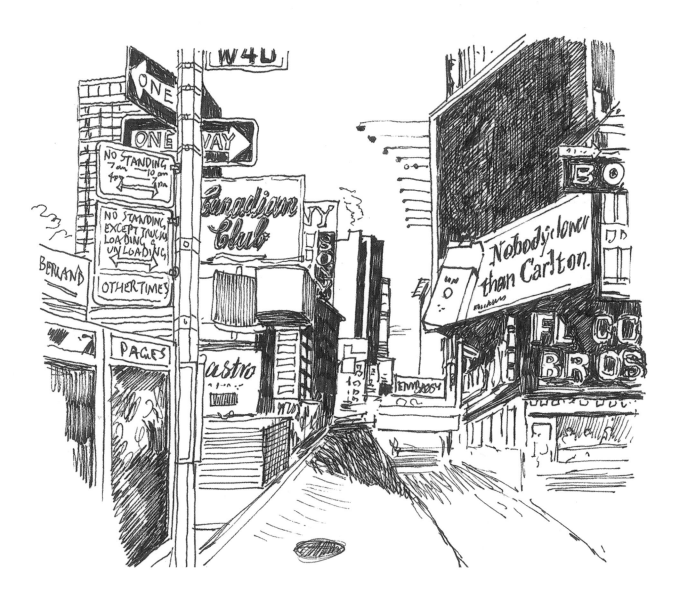

The complex artificial surface of city life is the point of this picture of information clutter, as sign vies with sign to confuse the eye. The only nod to the idea of perspective is the variation in the size of the lettering.

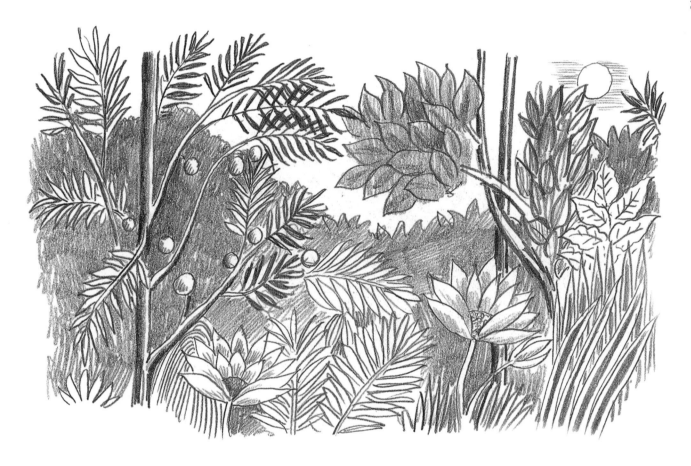

This close up of plant life (after primitive painter Henri Rousseau) is a huge jump stylistically from the first drawing. All the emphasis is on the pattern of jungle-like plants which have been rendered very painstakingly. There is no real depth in the picture, although each plant has its own solidity of form. What we have is a network of plant shapes that present a texture to the eye without any attempt to describe depth of perspective. See another example, also by Rousseau, on page 573.

LANDSCAPES FROM DIFFERENT PERSPECTIVES

It is a good exercise to try drawing the same landscape from two or three different viewpoints. It is always worth walking about after you have picked on your area of landscape to find the best place to work from.

Here you see three different points of view of the same seaside bay with cliffs, distant headland, village, coastguard hut with flagpole and wooden jetty.

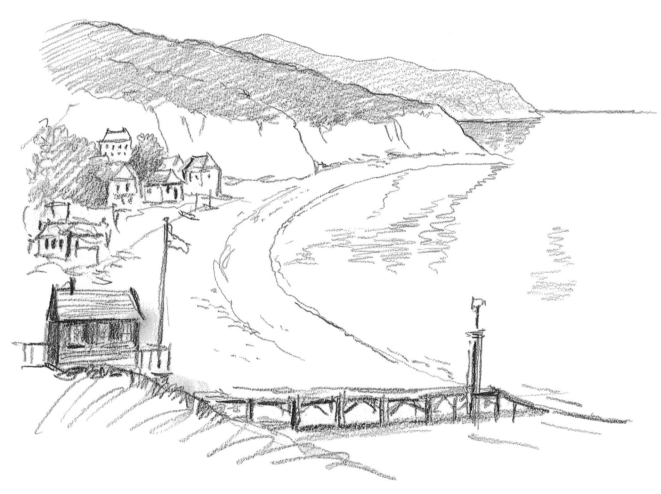

This view is from fairly high above the scene and, as a result, the sea's horizon is high in the picture and the distant headland is clearly seen beyond the cliffs at the end of the bay. The coastguard hut and jetty act as nice complements to the cliffs framing the village and the bay between them.

Now you see the same view from lower down, on about the same level as the coastguard hut. From this perspective the distant headland is almost obscured. The village is mostly hidden behind the hut, and the hut and jetty act as a setting for the cliff on the far side of the bay.

In this view, seen from even lower down, the hut is above eye-level. The village has disappeared and now the hut and jetty are the most important elements in the picture. By adjusting our perspective, we have redefined the area of the landscape and completely changed the nature of the drawing.

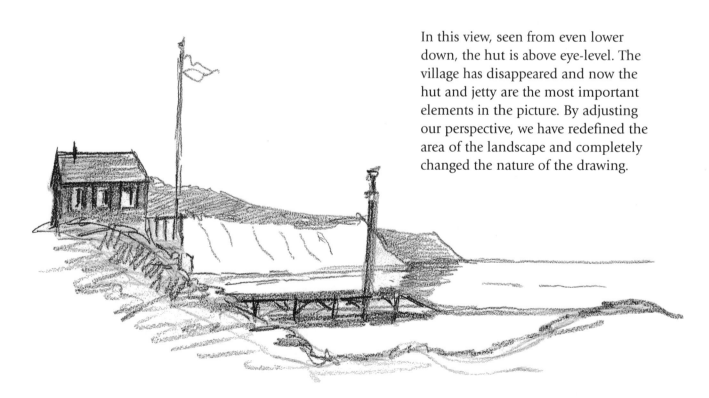

Again a landscape is viewed from three different positions to get three different compositions. In the next three drawings we view the landscape across the valley of the River Stour (after Constable). Compare the three and note how the change in position alters the balance of the elements as well as the overall appearance of the scene.

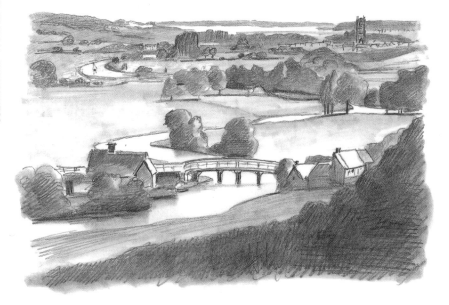

This is quite literally taking the highest viewpoint, which was where Constable chose to position himself to record the scene. From here we get a very broad, expansive view.

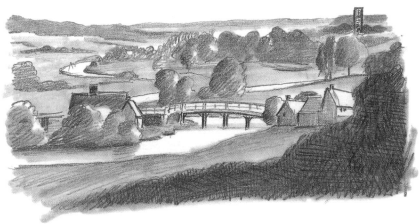

If we come down the hill a short way, although we still get quite a broad view, the land in the distance is greatly compressed. Our eye is drawn to the dominant nearer and middleground.

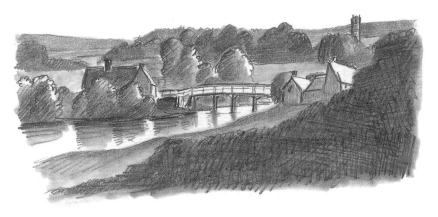

Lower still, and the distant horizon is almost completely blocked out by the houses and trees in what is now the middleground. The only distant feature visible is the tower of the church.

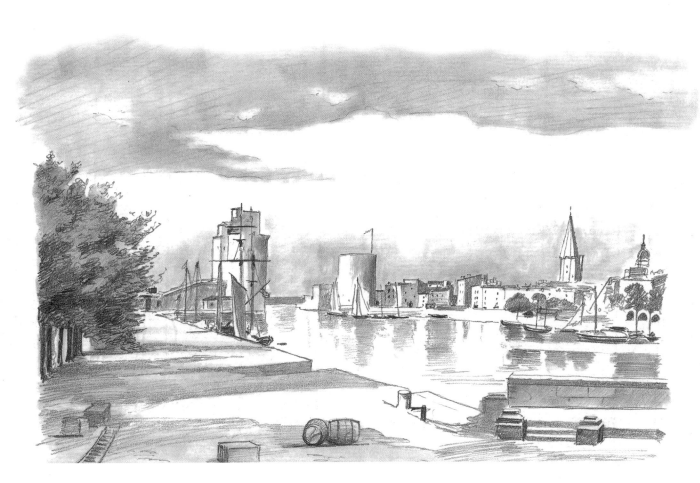

The effect in this landscape of the port of La Rochelle (after Corot) is of a vast space across the centre of the picture, nicely defined by the brightly lit buildings, but suggesting there is much more space beyond them and out to sea. The length of the quay recedes in perspective off to our left. The row of trees helps this effect by drawing our eye in this direction. (I have purposely left out a group of figures with horses dotted around this space, to allow us to concentrate on the spatial effect.) At the far end of the quay is a tower jutting out into the harbour with the masts of boats and ships projecting up to obscure part of the building. An expanse of water fills the middleground. Stretched out along the far right side of the harbour is a row of buildings including a church steeple and a small dome. A large round tower acts as a focus point marking the end of the quayside. Along the length of the far side of the harbour ships and boats are moored, and buildings are brightly lit by the sunlight, which reflects in the limpid water.

SEA: LITTLE AND LARGE

When you want to produce a landscape from different perspectives with the sea as part of it, you have to decide how much or little of the sea you want to show. The viewpoint you choose may mean you have to draw very little sea, a lot of sea, or all sea. In the next series of drawings we look at ways of using the sea in proportion to the land.

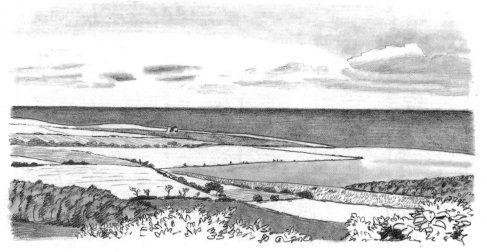

In our view of the Norfolk coast the sea takes up about one-eighth of the whole picture. Because the landscape is fairly flat and the sky is not particularly dramatic, the wide strip of sea serves as the far distant horizon line. The result is an effective use of sea as an adjunct to depth in a picture. The calm sea provides a harmonious feel to the whole landscape.

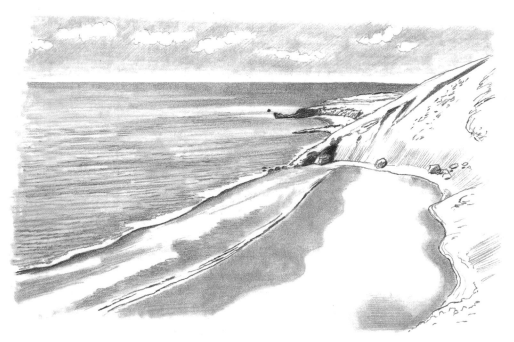

In the next scene the sea takes up two-thirds of the drawing, with sky and land relegated in importance. The effect is one of stillness and calm, with none of the high drama often associated with the sea. The high viewpoint also helps to create a sense of detachment from everyday concerns.

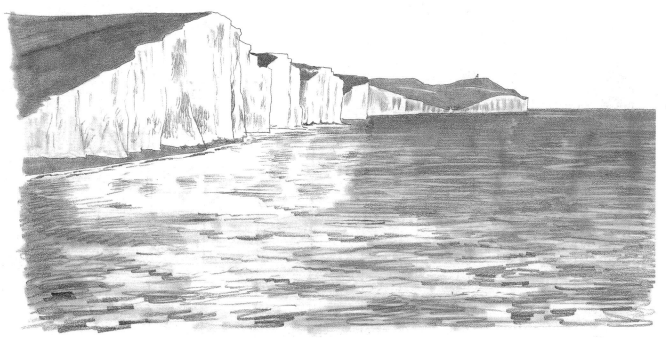

Such a large expanse of sea could be boring unless it was turbulent. What makes the scene interesting is the bulk of solid earth jutting into the picture and dividing the sea from the sky. This transforms the sea into a foil for the rugged cliffs.

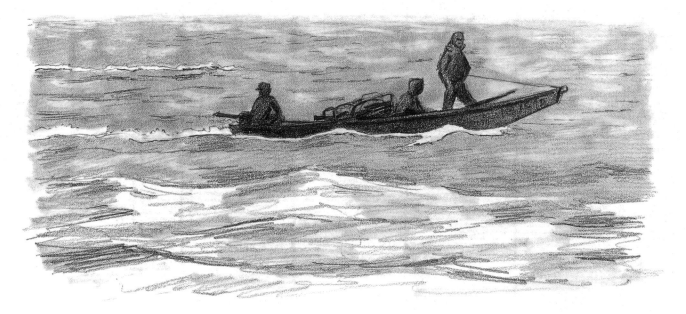

When the sea is the whole landscape, the result is called a seascape. The boat with the three fishermen is just a device to give us some idea of the breadth and depth of the sea. If the sea is to be the whole scope of your picture, a feature like this is necessary to give it scale.

THE EFFECT OF DIFFERENT EYE-LEVELS

These three drawings show how the effect of a picture is altered by the relationship of figures to the horizon or eye-line. In the first two pictures the viewer is standing and in the last picture the viewer is seated. This change in the relationship of the figures to the horizon-line has had quite an effect on the composition, and has indeed changed its dynamic.

You can see in galleries of paintings how artists have used this dynamic, particularly the Impressionists – look at examples of the work of Degas and Monet.

In the first picture the eye-level is considerably higher than the people reclining on the beach. The viewer has a sense of looking down on the figures, which appear to be part of the overall scene and are not at all dominant.

The eye-level of these two standing figures is the same as ours, making them appear more active. We are standing, as are they. (Note that the line of the horizon is at the same level as their eyes.) Here the eye-level is much lower than that of the two figures; even the woman bending down is still head and shoulders above our eye-level. The figures now appear much more important and powerful in the composition.

RECTANGULAR OBJECTS

Unlike some other types of drawing, you don't need to know a great deal about perspective to be able to produce competent still lifes.

You will, however, find it useful to have a basic grasp of the fundamentals when you come to tackle rectangular objects.

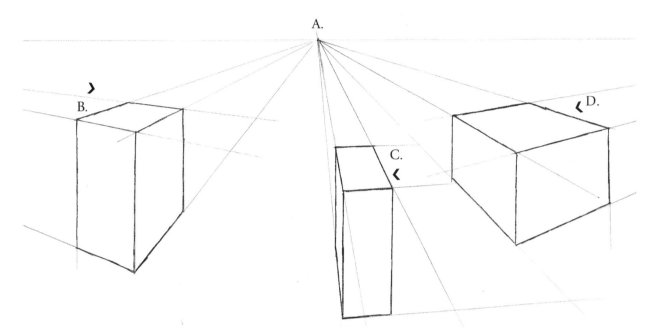

Perspective can be constructed very simply by using a couple of reference points: eye-level (the horizontal line across the background) and (A.) one-point perspective lines (where all the lines converge at the same point).

The perspective lines relating to the other sides of the object (B. C. D.) would converge at a different point on the eye-level. For the sake of simplicity at this stage, they are shown as relatively horizontal.

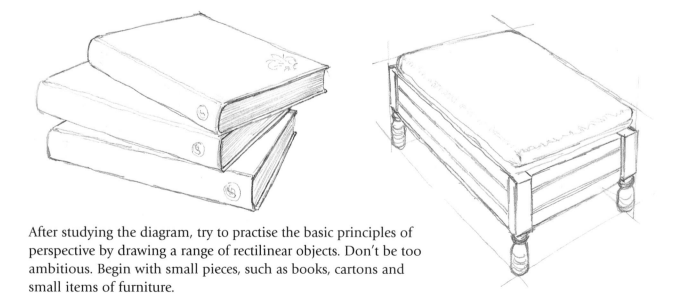

After studying the diagram, try to practise the basic principles of perspective by drawing a range of rectilinear objects. Don't be too ambitious. Begin with small pieces, such as books, cartons and small items of furniture.

You will find that different objects share perspectival similarities – in my selection, compare the footstool with the pile of books, and the chair with the carton.

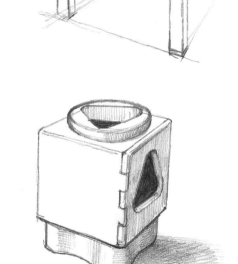

The wicker basket and plastic toy box offer slightly more complicated rectangles than the blanket box. With these examples, when you have got the perspective right, don't forget to complete your drawing by capturing the effect of the different materials. Part of the fun with drawing box-like shapes comes in working out the relative evenness of the tones needed to help convince the viewer of the solidity of the forms. In these three examples, use tone to differentiate the lightest side from the darkest, and don't forget to draw in the cast shadow.

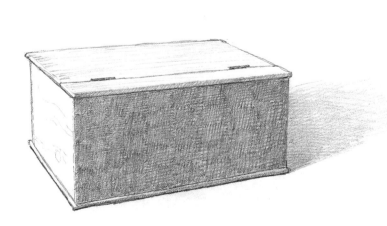

ROUNDED OBJECTS

When you are drawing rounded objects it can be tricky to get the sides symmetrical. To begin, I have chosen a couple of simple examples: a tumbler and a bottle. Glass objects are particularly appropriate at this stage because their transparency allows you to get a clear idea of their shape.

In pencil, carefully outline the shape. Draw the ellipses at the top and bottom as accurately as you can. Check them by drawing a ruled line down the centre vertically. Does the left side look like a mirror image of the right? If it doesn't, you need to try again or correct your first attempt. The example has curved sides and so it is very apparent when the curves don't match.

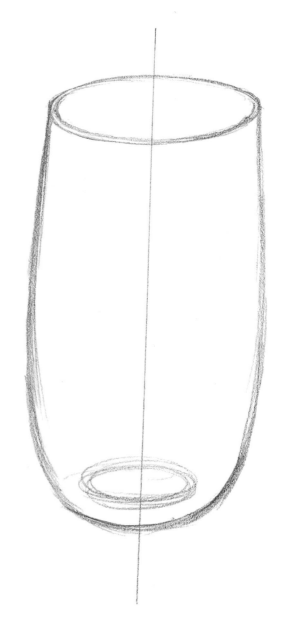

Now shift your position in relation to the glass so that you are looking at it from higher up. Draw the ellipses at top and bottom, then check them by drawing a line down the centre. You'll notice this time that the ellipses are almost circular. Shift your position once more, this time so that your eye-level is lower. Seen from this angle the ellipses will be shallower. Draw them and then check your accuracy by drawing a line down the centre. If the left and right sides of your ellipses are mirror images, your drawing is correct.

You have to use the same discipline when drawing other circular-based objects, such as bottles and bowls. Here we have two different types of bottle: a wine bottle and a beer bottle. With these I want you to start considering the proportions in the height and width of the objects. An awareness of relative proportions within the shape of an object is very important if your drawings are to be accurate.

After outlining their shapes, measure them carefully, as follows. First, draw a line down the centre of each bottle. Next mark the height of the body of the bottle and the neck, then the width of the body and the width of the neck. Note also the proportional difference between the width and the length. As you can see, in our examples the proportions differ a lot.

The more practice at measuring you allow yourself, the more adept you will become at drawing the proportions of objects accurately. In time you will be able to assess proportions by eye, without the need for measuring. To provide you with a bit more practice, try to draw the following objects, all of which are based on a circular shape although with slight variations and differing in depth.

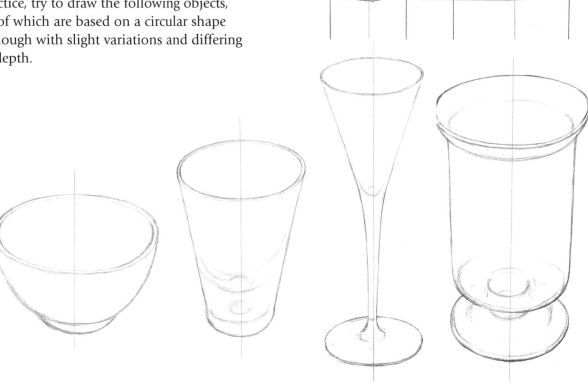

Here is an apparently casual arrangement of a basket of vegetables seen
from above on a tiled floor. The composition turns out to be not so
casual when you study the disparate shapes of the vegetables, which must
have been chosen to make a good picture using an aerial perspective.

PERSPECTIVE VIEWS OF THE BODY

One of the most difficult problems with drawing the human figure (or any other figure for that matter) arises when the body or the limbs of the figure being drawn are foreshortened by perspective; an example might be when a leg or arm is projecting towards your viewpoint. Instead of the expected shape of the limb you get an oddly distorted proportion that the mind often wants to correct. However, if you are going to draw accurately, you have to discount what the mind is telling you and observe directly, measuring if necessary to make sure that these rather odd proportions are adhered to. In this way, a limb seen from the end on (as in the illustration right) will carry real conviction with the viewer.

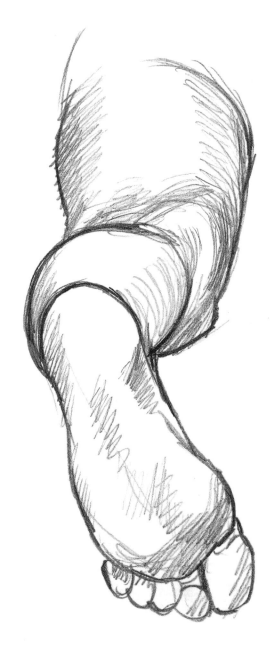

When viewing the leg from the foot end, notice how large the sole of foot looks in comparison with the apparent length of the leg. The muscles and the knee project outwards, their roundness and angularity very pronounced, while their length is reduced to almost nil. If you observe the shapes produced by this view, you shouldn't have any problem. Don't tell yourself that it looks wrong, because it's not; it's just an unusual point of view.

The same situation is evident with the arm, where the size of the hand will often appear outrageously large, practically obscuring the rest of the arm. Seen in this perspective the bulge of any muscle or bone structure becomes the paramount shape of the arm.

It will help you make visual sense of a foreshortened hand if you view the limb as though it is one of a group, with the fingers coming off a body (the palm). Take notice of the shapes of the tips of the fingers and the knuckles particularly, because these too will be the dominant features of the fingers seen from end-on. The shape of the fingernail provides another good clue to seeing the finger as it really is. The main part of the hand loses its dominance in this position but still needs to be observed accurately.

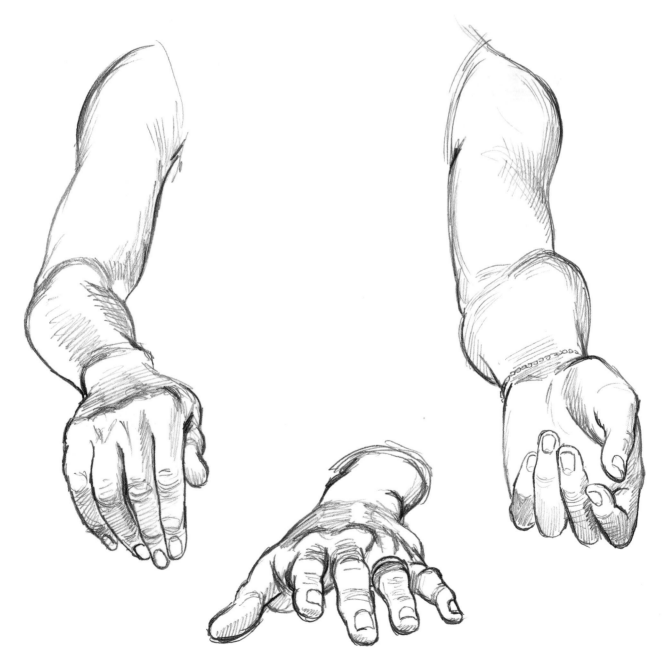

THE FORESHORTENED SKELETON

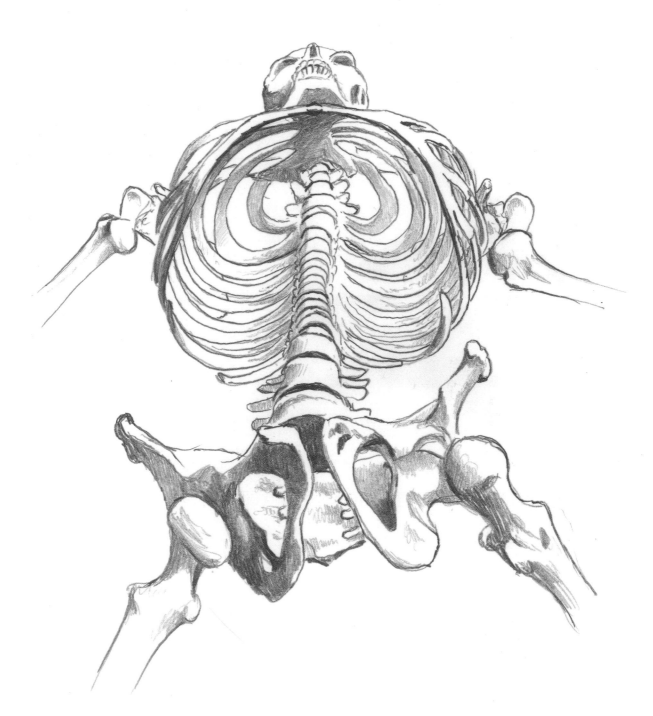

To underline the effect of perspective, let us look at the skeleton seen from either end as well. Here we have the pelvis and ribcage and the skull seen from the feet end of the figure, and it is obvious how the curve of the rib cage becomes such a dominant feature of this view. Notice how large the pelvic bone looks in relation to the rib cage and how tiny the skull appears.

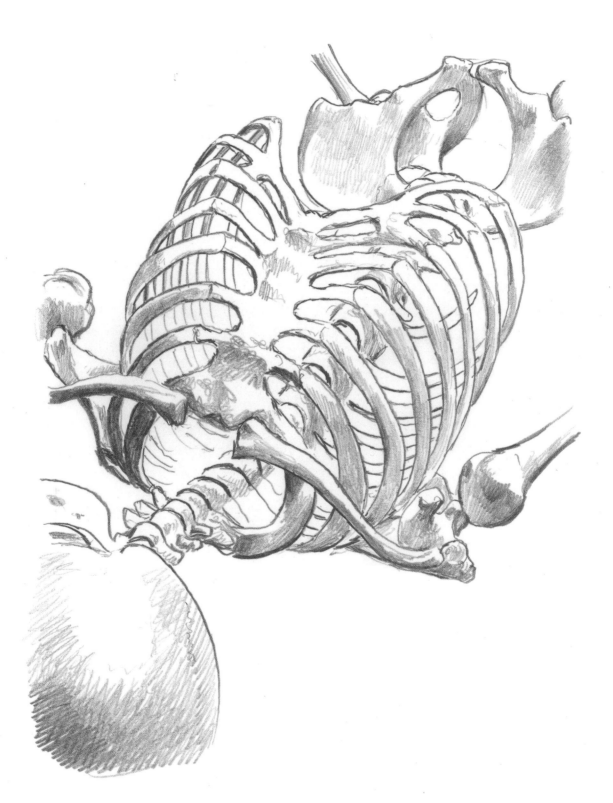

In this drawing I have drawn the skeleton from the head end: the skull is so large it is mostly out of the picture and the ribcage is a massive curving latticework. In both of these drawings I have left out the legs and arms in order to show the structure of the torso more clearly. Once again the width is proportionately larger than the length of the ribcage.

SPATIAL AWARENESS

These images demonstrate variations on a setting where the sitter is placed in a space that seems to define something about him. As you will notice, the way the space is inhabited has a very different effect.

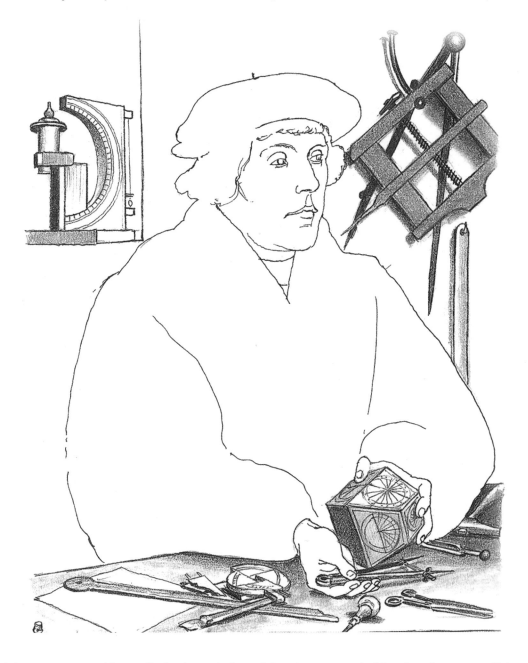

In 'The Astronomer' by Holbein (1528) the subject is surrounded by the elements of his science. His desk is covered with the tools that he works with, and on the wall behind are more astronomical instruments. The props in this example give us obvious clues to the man's identity and his profession. At this time there was prestige in being identified as an astronomer but also a risk because of the antipathy of the Church towards science.

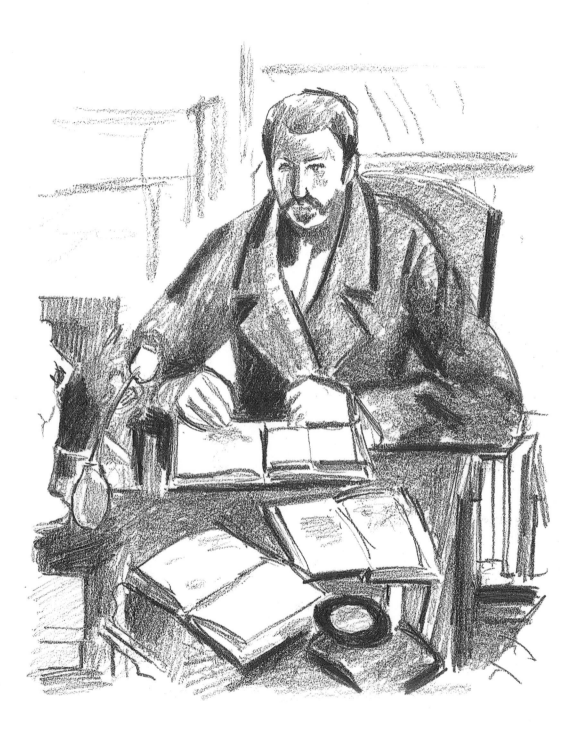

Cézanne has placed the writer Gustave Geffroy at his desk, surrounded by books, his writing materials and a few personal mementos (1895). He looks completely at home, in his element, whereas we, the viewers, are kept at arm's length by the furniture and the props which act as a barrier.

MEANING IN BACKGROUND

Whereas a room can be both a setting and a background, a distant landscape is very much a background feature. In these examples there is a contrast in the use of background, although at first glance you might be forgiven for thinking the idea behind them was very similar.

The setting of the Mona Lisa is a puzzle. Why it was thought appropriate to place the wife of a wealthy Florentine merchant in front of such a landscape is not known. Whatever the truth of the matter, the background comprises all the naturalistic features Leonardo was so good at producing in new combinations. It also reinforces the air of mystery that is evoked by this extraordinary portrait, and so validates his reason for choosing it.

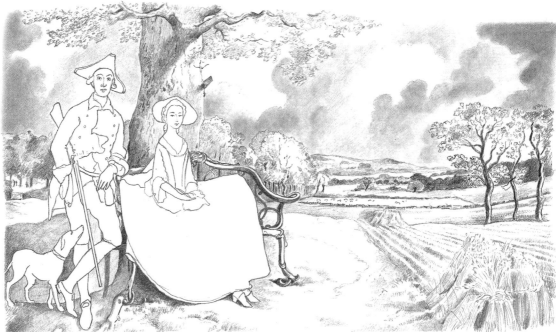

Gainsborough's portrait of Mr and Mrs Andrews is an interesting development of the 'swagger' portrait. The placement of the couple suggests that the landscape may be more the point of this picture than the couple themselves. The Suffolk landscape stretches out on the right side of the composition, bathed in warm sunlight which highlights the clear traces of agricultural activity. Andrews was a forward-thinking landowner, keen to use the latest farming techniques, and to the right we see the marks left by a seed drill, which in the 18th century was a great innovation.

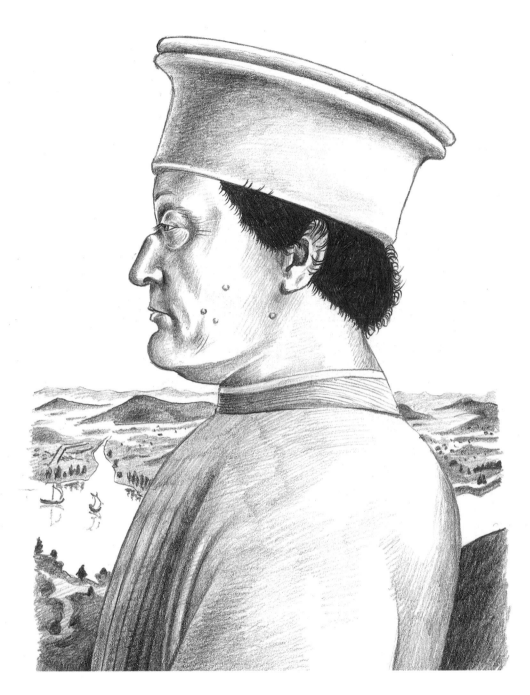

In this copy of Piero della Francesca's portrait of his friend and patron, Federico da Montefeltro, the background provides a rich context for the subject. Montefeltro, ruler of Urbino, was a famous condottiere, and the ships and fortifications shown along the river are indications of his military prowess. The Duke was also a leading patron of the arts and learning, and in times of peace he occupied himself in the pursuit of Renaissance ideals.

The artist presents us with an apparently simple profile which tells us that Federico is benign, powerful and wise. The eyes are far-seeing, fixed on a point beyond our gaze. Also hidden from us is the war wound on the other side of the duke's face. Della Francesca has not, however, hidden his subject's personality. The head sits above the background, with nothing to distract the eye. This is a sympathetic yet revealing portrait of a man who is clearly both a thinker and doer.

LIGHT, FORM AND TEXTURE

The eye sees shape, colour, light
and shade. The mind relates that to other
experiences and translates the shape and form into
something we can recognize.

Shape is the outline visual impression we have of an
object. Because we get used to seeing certain objects our minds
develop visual templates and we tend to see what we expect rather
than what is actually there. Shape changes constantly, depending on
our position in relation to it, and this can cause us problems as artists.

Form is the three-dimensional appearance of an object or body; in
other words, the spatial area it inhabits. Form is more difficult to draw
than shape because of the problems of representing three dimensions
on a flat surface. To make our representations realistic, we have to find
ways of expressing advancing or receding shapes, and we need to
know how to render different textures to make those shapes live.

The artist has to experiment with both seeing and drawing
in order to come to an understanding of the language
of shape and form and how to manipulate it. This
section is intended to help you use your eyes more
experimentally, to look beyond your expectations
and your normal process of recognition.

LIGHTING

The quality and nature of the light with which you work will have a large bearing on your finished drawing. A drawing can easily be ruined if you start it in one light and finish it in another. There is no way round this unless you are adept enough to work very quickly or you set up a fixed light source. In this spread we look at the visual implications of adopting different kinds of lighting, starting with the range of effects that you can obtain by placing a series of objects around a single source of even light.

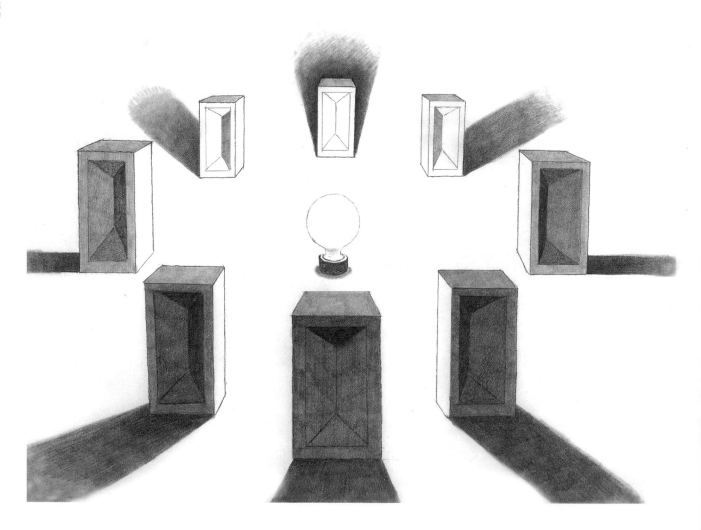

The most interesting point to take from this exercise is how different the same object can look when light shines on it from different positions. Note how the light plays on the surfaces, and how the effects range from a total absence of shadow to complete shadow, depending on the position of each object in relation to the light. In each case the cast shadow appears to anchor the brick to the surface it is resting on, an effect that is often usefully employed by artists to give atmosphere to their drawings.

Here we show the same three objects arranged in the same way in different lighting versions. Each one also shows the nature of the lighting, in this case a single lamp with a strong light which shows the direction that the light is coming from.

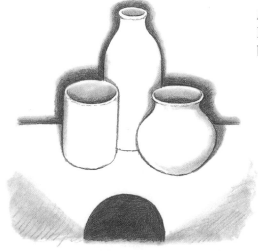

Left: These three pots are lit entirely from the front – the light is coming from in front of the artist. The shadows are behind the pots and the impression is of flatter shapes.

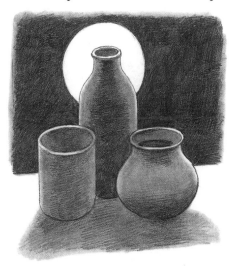

Right: Here the light is right behind the objects. Therefore the pots look dark with slivers of light around the edges. Except for the circle of the lamp the background is dark.

Left: Lighting from one side gives the best impression of the three-dimensional quality of the pots. The cast shadows and the areas of shadow on the pots both help to define their roundness.

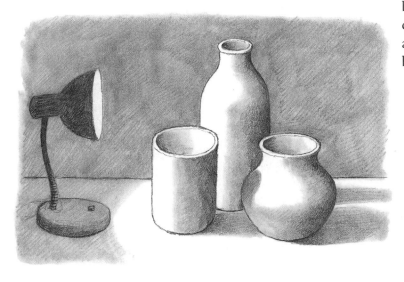

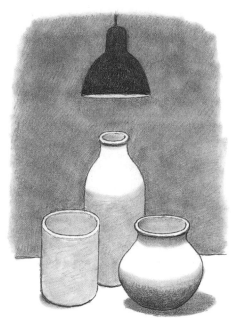

Right: Lighting from above is similar to side lighting but the cast shadows are smaller and the shadow on the pots is, on the whole, less obvious.

Many an art student has been put out by the discovery that the natural light falling on their still-life arrangement has changed while they have been drawing and that what they have ended up with is a mish-mash of effects. You need to be able to control the direction and intensity of the light source you are using until your drawing is finished. If this can't be done with a natural light source, use an artificial lighting set up.

Lit directly from the side; this produces a particular combination of tonal areas, including a clear-cut cast shadow.

Lit from above; the result is cooler and more dramatic than the first example.

Lit strongly from the side; the strength of the light and the fact that the arrangement is set against such a dark background produces the effect of spotlighting, attracting our attention to the picture and giving a rather theatrical effect.

Right: A small table lamp lighting a lidded glass jar from directly above. The upper surfaces are very bright. The cast shadows are simple and encircle the bases of both object and lamp. The glass jar catches the light from all around, as we can see from the small reflections in it. The darkest areas are behind the light, around the lamp and especially the lampshade.

Above: Directing light from below and to one side is traditionally the way to make objects look a bit odd, unearthly or sinister. Mainly this interpretation is down to our perception; because we are not used to viewing objects lit from below, we find it disturbing when we do. Seen in an ordinary light this cherub's expression looks animated, but lit from below, as here, it appears to have a malign tinge.

Now a more traditional form of lighting, although still unusual. The bowl of fruit and the bottle of water are backlit from the large windows with the sun relatively low in the sky; I made this sketch in the evening, but you can get a very similar light in early morning. The effect is to make the objects look solid and close to us, but also rather beautiful, because of the bright edges.

CREATING FORM

Our fairly sophisticated recognition system has to be persuaded to interpret shapes as three-dimensional form. One way of doing this is to produce an effect that will be read as form, although in reality this may only comprise an arrangement of lines and marks. Let's look at some examples.

A diagrammatic form is often given in atlases to represent the world. Why is it that this particular arrangement of lines inside a circle makes a fairly convincing version of a sphere with its latitude and longitude lines? We don't really think it is a sphere, but nevertheless it carries conviction as a diagram.

Let's go a stage further. In this drawing of a bleached-out photograph of an onion the reduced striations or lines make the same point. We recognize this kind of pattern and realize that what we are looking at is intended to portray a spherical object which sprouts. We can 'see' an onion.

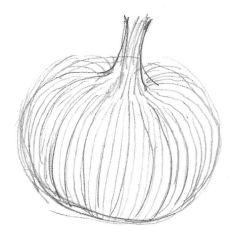

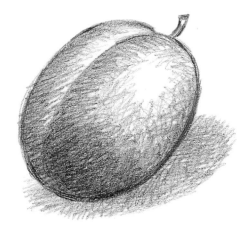

So is this a round fruit? No, of course not. But the drawn effect of light and shade is so familiar from our study of photographs and film that we recognize the rotund shape as a piece of fruit.

Visual Conditioning

We have been educated to accept the representation of three-dimensional objects on a flat surface. This is not the case in all parts of the world. In some areas remote from modern life, for example, people cannot recognize from photographs three-dimensional objects that are familiar to them.

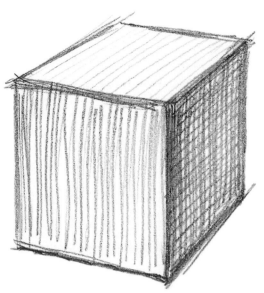

When we look at this hexagonal divided into parallelograms of light, dark and medium tones, we want to interpret it as a cube or block shape.

These rather scribbled lines and marks can be seen as a leaping cat-like creature and a human form engaged in sporting activity. Of course they are not really those things, but there are enough clues to prompt our ever-ready memory to remind us of forms we have seen. The mind quickly fills in the details even when a form is rudimentary.

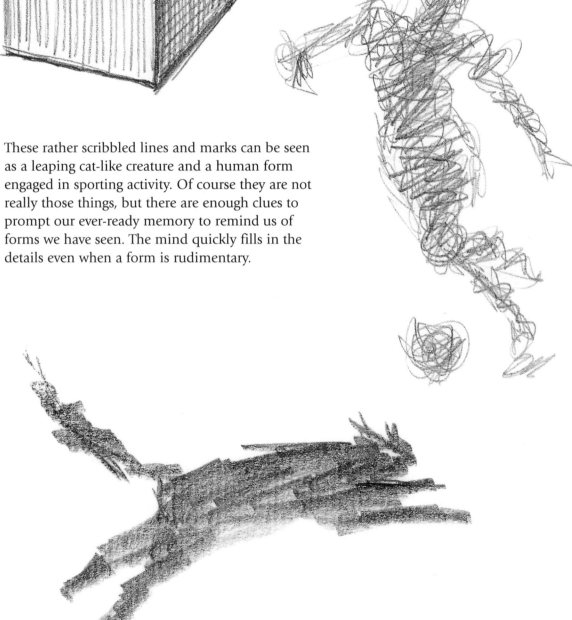

EXERCISES: REALIZING FORM

We now look at the sort of exercises that will help you to begin to see how to realize form with some power. They are all difficult but extremely useful and very satisfying when you begin to make them work. It will require repeated practice, of course, but if you want to be an effective artist there is no avoiding hard work.

A geometric pattern on a three-dimensional shape is a marvellous exercise for the draughtsman, and shows how a linear device on a surface can describe the form of that surface.

This tartan-patterned biscuit tin presents various problems. First is drawing the outline with its elliptical top and cylindrical sides. Secondly is the pattern, which proceeds round the curved edge of the tin, but is shown flat on the lid with some perspective.

Draw your outline with the basic pattern inscribed, as shown. Even without the addition of tone or detail, this gives some idea of the roundness of the sides and the flatness of the top.

With this cup and saucer the printed landscape is tricky but interesting. You have to get the details of the printing exactly marked around the curve of the cup, otherwise the cup will look flat. One thing that makes it a bit easier is the fact that some of the details in the pattern are not clear, and so a few mistakes won't necessarily make much difference. The main point to observe is the way the picture reduces in width as it curves around the cup.

The general outline gives the basic shape and some indication of the scene around the curved surfaces of both cup and saucer. But it is not until more detail is added with variations in tone that the roundness of the cup becomes evident.

EXERCISES: REALIZING FORM

You shouldn't find it difficult to practise drawing spherical objects. Start by looking in your fruit bowl, and then scanning your home generally for likely candidates. I did this and came up with an interesting assortment. You will notice that the term spherical covers a range of rounded shapes. Although broadly similar, none of the examples is identical. You will also find variations on the theme of surface texture. Spend time on these practices, concentrating on getting the shapes and the various textural characteristics right.

For our first practice, I chose an apple, an orange and a plum. Begin by carefully drawing in the basic shape of each fruit, then mark out the main areas of tone.

The orange requires a stippled or dotted effect to imitate the crinkly nature of the peel.

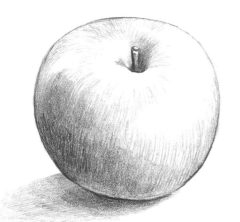

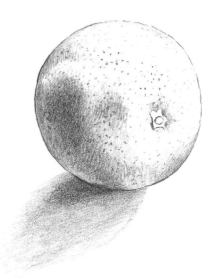

Take the lines of tone vertically round the shape of the apple, curving from top to bottom and radiating around the circumference. Gradually build up the tone in these areas. In all these examples don't forget to draw the cast shadows.

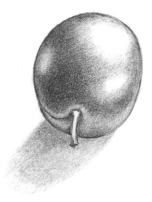

To capture the silky-smooth skin of a plum you need an even application of tone, and obvious highlights to denote the reflective quality of the surface.

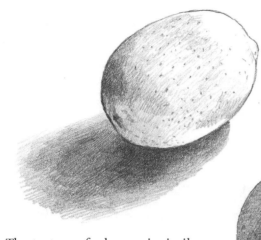

The surface of an egg, smooth but not shiny, presents a real test of expertise in even tonal shading.

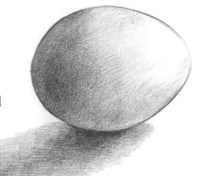

The texture of a lemon is similar to that of the orange. Its shape though is longer.

The shading required for this round stone was similar to that used for the egg but with more pronounced pitting.

The perfect rounded form of this child's ball is sufficiently shiny to reflect the light from the window. Because the light is coming from behind, most of the surface of the object is in shadow; the highlights are evident across the top edge and to one side, where light is reflected in a couple of smaller areas. The spherical shape of the ball is accentuated by the pattern curving round the form.

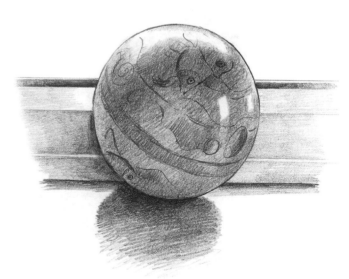

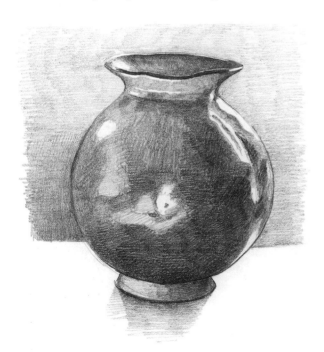

The texture of this hand-thrown pot is not uniform and so the strongly contrasting dark and bright tones are not immediately recognizable as reflections of the surrounding area. The reflections on the surface have a slightly wobbly look.

LIGHT, FORM AND TEXTURE

OBJECTS OF DIFFERENT MATERIALITY

After you have learnt to draw simple shapes with tone, you can then tackle a variety of objects of different materiality with a view to making still life compositions. Over the next few spreads, we will look at a range of such objects and the different approaches you might consider when you come to organize your own arrangements and subject matter.

First, try drawing this fir cone, which is quite simple in essence but complex in detail. You will need to use your powers of observation and your ability to see an object as a whole to get this right.

1.

1. Look hard at the object and see the whole shape. Draw the outline as simply and as accurately as possible.

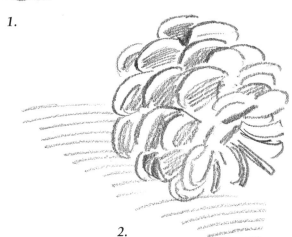

2.

2. Now look at the various parts within the whole. Sketch in each shape within the overall shape you have already outlined.

3. Once you have a sort of diagram of the object, you can draw in the details of light and shade, the exact shapes of each part and give dimension to your drawing.

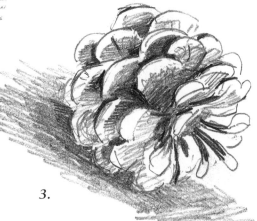

3.

Now try an object like a wineglass.

1. Draw the main shape, paying special attention to the proportion of height to width and the proportion of the stem to the cup (bowl).

2. Sketch in the main shapes of the reflections very simply as outlines.

1.

2.

3.

3. Put in the very darkest tones and then work in lighter and lighter tones; the white of your drawing paper should be the colour of the brightest highlights.

You'll find the approach outlined here quite effective. One point to watch: don't be confused by the subtleties of the tones, just simplify them. Make sure that the very strongest edges and shadows are vigorously put in, but be aware of the areas where they don't occur. In other words, the lines around the objects will not be even because some will be strong and clear and others soft and indistinct. If you observe this difference and get it right, your drawing will have much greater depth and dimension.

MIXING MATERIALS

The first arrangement shown is one of the tests that has traditionally been set for student artists to help them develop their skill at portraying different kinds of materials in one drawing. Such exercises are an excellent means of honing ability. As well as trying this exercise, use your own imagination to devise similar challenges for yourself.

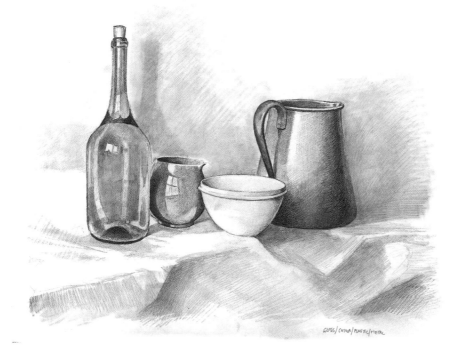

GLASS/CHINA/PLASTIC/METAL

In this still-life group we have a mixture of glass, china, plastic and metal. Note that the glass bottle is filled with water and that the metal jug has an enamelled handle. All the objects are placed on blocks hidden under a soft hessian cloth draped across the background and over the foreground.

This still life after Chardin is of a dead rabbit lying across a game bag on a shelf. The soft furry rabbit, the soft smooth bag and the hard-edged background make a good test.

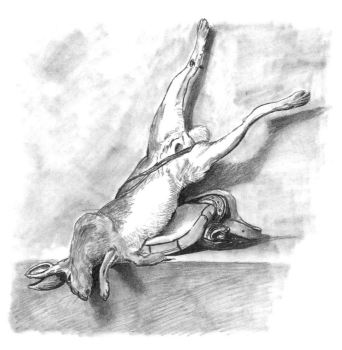

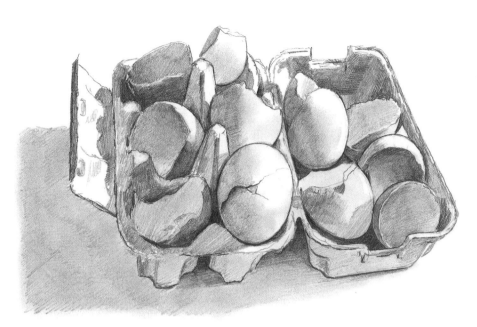

This exercise was quite fortuitous. I came across this egg-box full of broken egg-shells after one of my wife's cooking sessions. She had replaced the broken shells in the box prior to throwing them away. The light on the fragile shells with their cracks and shadowed hollows made a nice contrast against the papier-maché egg-box; a cruder manufacture with similar use to the subtle natural package.

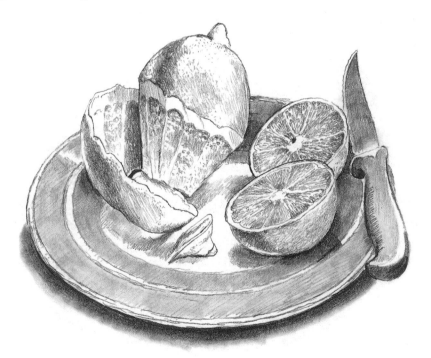

This is an interesting exercise, though it is a fairly difficult one. Here is an orange sliced in half and a partially peeled lemon, the knife resting on the plate beside them. The picture's charm comes from the fact that it is of work in progress, a standard preparation for a meal or drinks. The real difficulty of this grouping is to get the pulp of the fruit to look texturally different from the peel. The careful drawing of contrasting marks helps to give an effect of the juice-laden flesh of the orange and lemon.

SURFACE TEXTURE

Solid objects present a particular challenge and can seem daunting, whether man-made or natural, shiny or dull. This gives a clue to an important characteristic that could actually have been designed to help the artist out: surface texture. In the beginning you might find the following practices a bit tricky, but if you persevere you will find them immensely rewarding.

The two darkly glazed objects presented here, for example, appear almost black with bright highlights and reflections. Begin by putting in the outlines correctly, then try to put in the tones and reflections on the surface as carefully as you can. You will have to simplify at first to get the right look, but as you gain in confidence you will have a lot of fun putting in detailed depictions of the reflections.

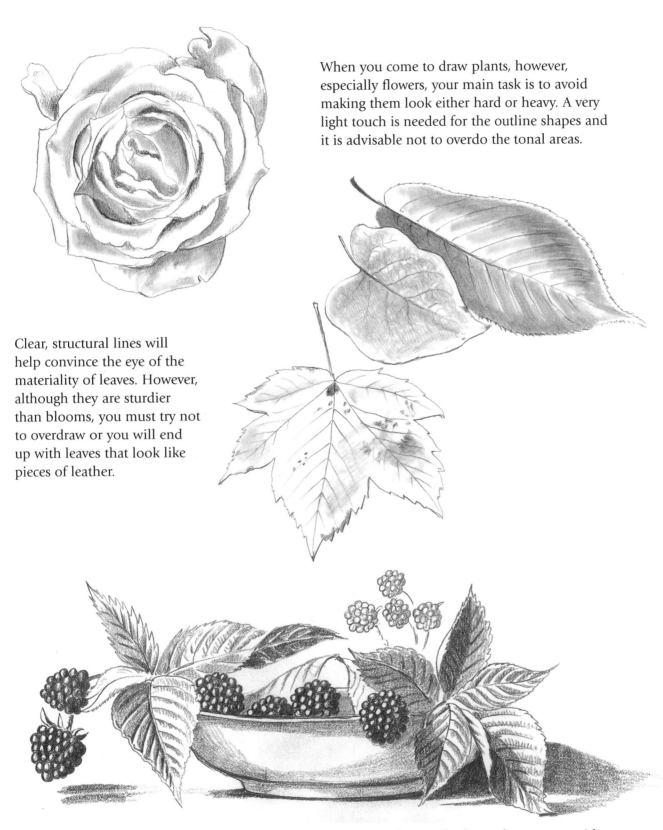

When you come to draw plants, however, especially flowers, your main task is to avoid making them look either hard or heavy. A very light touch is needed for the outline shapes and it is advisable not to overdo the tonal areas.

Clear, structural lines will help convince the eye of the materiality of leaves. However, although they are sturdier than blooms, you must try not to overdraw or you will end up with leaves that look like pieces of leather.

The shiny, dark globes of the blackberries and the strong structural veins of the pointed leaves make a nice contrast. The berries are just dark and bright whereas the leaves have some mid-tones that accentuate the ribbed texture and jagged edges.

Food is a subject that has been very popular with still-life artists through the centuries, and has often been used to point up the transience of youth, pleasure and life. Even if you're not inclined to use food as a metaphor, it does offer some very interesting types of materiality that you might like to include in some of your compositions.

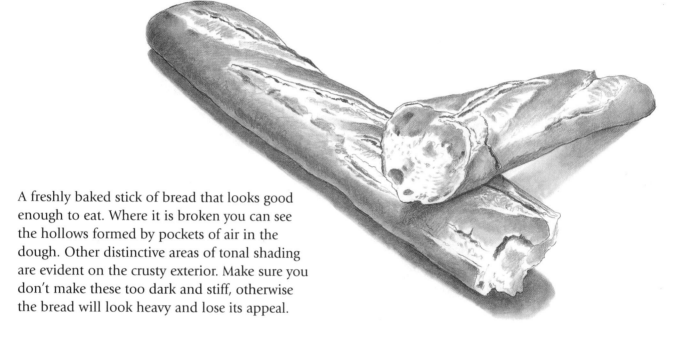

A freshly baked stick of bread that looks good enough to eat. Where it is broken you can see the hollows formed by pockets of air in the dough. Other distinctive areas of tonal shading are evident on the crusty exterior. Make sure you don't make these too dark and stiff, otherwise the bread will look heavy and lose its appeal.

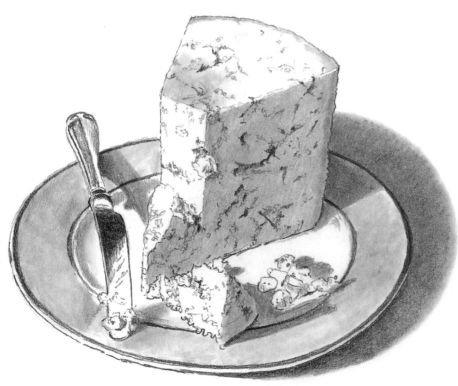

A piece of Stilton cheese, slightly crumbly but still soft enough to cut, is an amazing pattern of veined blue areas through the creamy mass. To draw this convincingly you need to show the edge clearly and not overdo the pattern of the bluish veins. The knife provides a contrast in texture to the cheese.

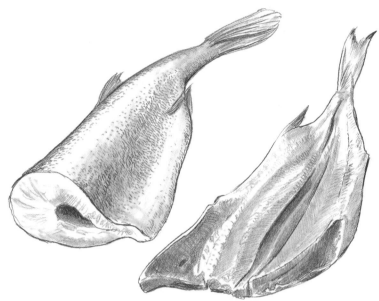

Two views of fish with contrasting textures: scaly outer skin with bright reflections, and glistening interior flesh. Both shapes are characteristic, but it is the textures that convey the feel of the subject to the viewer.

This large cut of meat shows firm, whitish fat and warm-looking lean meat in the centre. Although the contrast between these two areas is almost enough to give the full effect, it is worth putting in the small fissures and lines of sinew that sometimes pattern and divide pieces of meat.

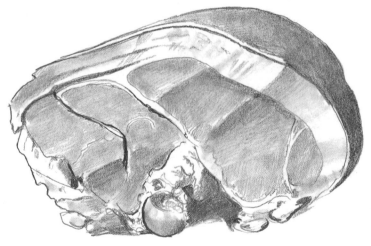

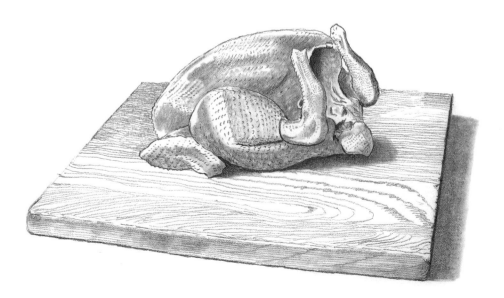

A marked contrast in textures, with a plump chicken appearing soft against the grained surface of a wooden chopping board. Careful dabbing with a pointed bit of kneadable eraser has given a realistic goose-bump look to darker areas of the chicken's skin and where there are shadows.

CONTRASTING TEXTURES

If we succeed in capturing an object's surface, it is very likely we will also manage to convey its presence. Our two man-made objects here, a glazed vase and a teddy bear, offer different types of solidity, while the matt bottle and shiny decanter shown on the facing page test our ability to describe the variation in smooth surfaces. The artist should always aim to alter his approach to suit the materiality of the object he is drawing.

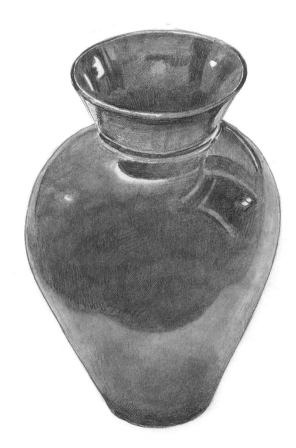

The effects produced by the brilliant glaze on this rather beautiful vase are not so difficult to draw. The reflections are strong and full of contrast, giving us glimpses of the light coming through surrounding windows. They do not, however – as is the case with metallic objects – break the surface into many strips of dark and light.

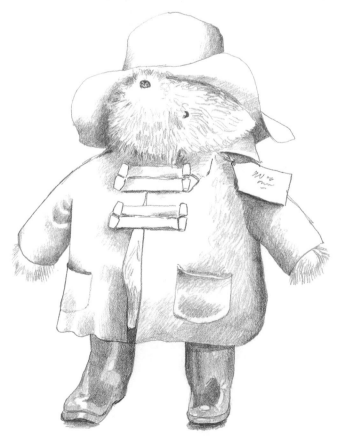

Teddy bears are very attractive to young children and Paddington Bear is particularly so because of the many stories told about him. This particular soft toy incorporates various textures and qualities: the cuddly softness of the character himself, the shiny surface of the plastic boots, the hardness of the wooden toggles and the rather starchy material of the floppy hat and duffle coat.

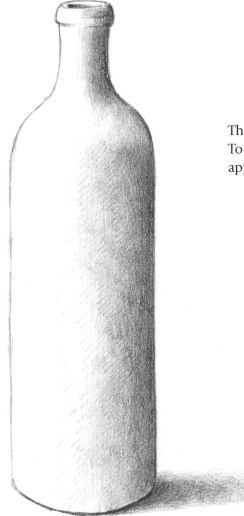

The surface of this matt bottle is non-reflective. To get this right you have to take a very subtle approach with the application of tone.

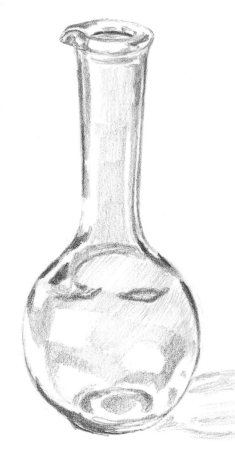

The problem with clear glass is how to make it look like glass. In this example the bright highlights help us in this respect, so put them in. Other indicators of the object's materiality are the dark tones, which give an effect of the thickness of the glass.

NATURAL STRUCTURES

Now we turn to the rock formations that lie under the vegetation and help form the bone-structure of the landscape. First of all, find a few chunks of rock from wherever you can, from a garden, a beach or a park. My examples are actually geological samples, but you don't need to go to the same trouble. Most well tended flower-beds will have a few stones in them. If you are really stuck, dig a hole in a piece of wasteland or your backyard. You won't have to dig very deep before stones show themselves.

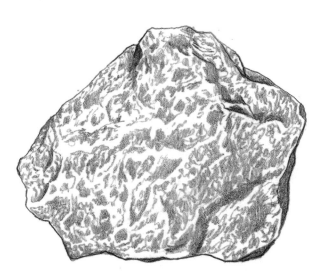

Dunite

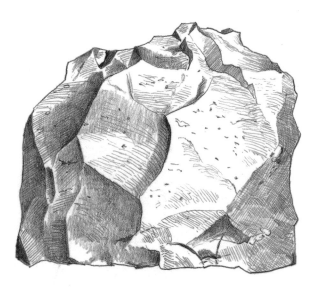

Comendite

Pumice

These shining examples of rock were obtained from the geological section of a museum where they sell small pieces of rock to help you learn to identify the various types. They were chosen for their clearly defined differences. Note the differences in regularity and holes in the surface.

Even in relatively tame landscapes quite magnificent pieces of rocky structure can be found, such as the one shown. Practise drawing the main shapes and how the texture repeats or contrasts in different areas.

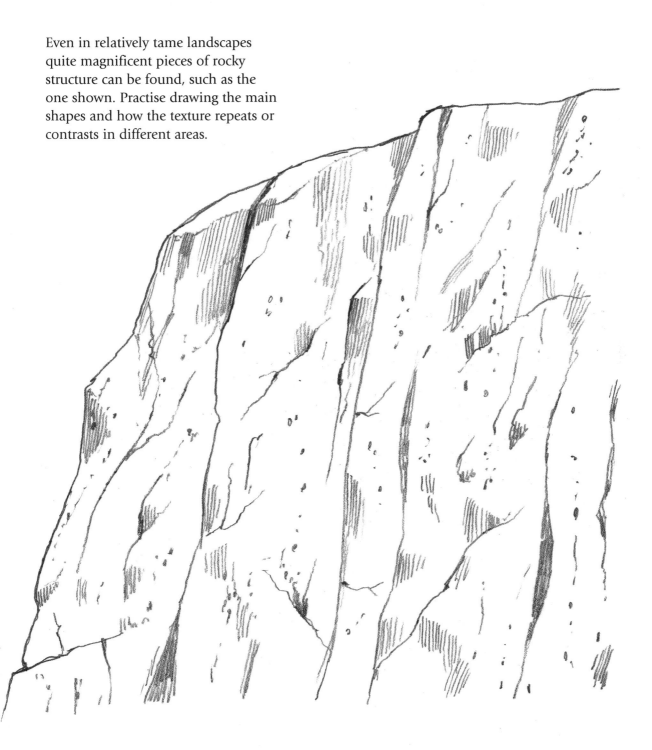

WATER AND ROCKS

The reflective qualities of water make it a very useful addition to a landscape. It can also introduce movement to contrast with stiller elements on view. Below we look at two of the possibilities given by the addition of water. On the opposite page we consider the raw power that the inclusion of rocks can bring to a picture.

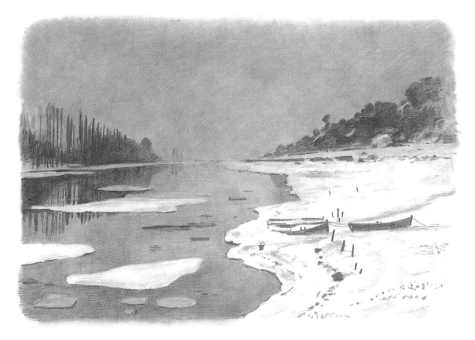

The impact of this wintry scene (after Monet), is made by the contrasts in darks and lights. These are noticeable between the principal features and especially within the river. Contrast the dark of the trees on either bank of the river with the white of the snow-covered banks; the inky blackness where the tall poplars on the far bank reflect in the water; the grey of the wintry sky reflecting in other areas of the river; and the brilliance of the white ice floes. On the bank a few smudgy marks help to define the substance of the snowy landscape.

The River Oise in summer (after Perrier) looks more inviting than Monet's depiction of the Seine. The leafy trees are presented as a solid mass, bulking up above the ripples of the river, where the shadowed areas of the trees are strongly reflected. The many horizontal strokes used to draw these reflections help to define the rippling surface of the calmly flowing river.

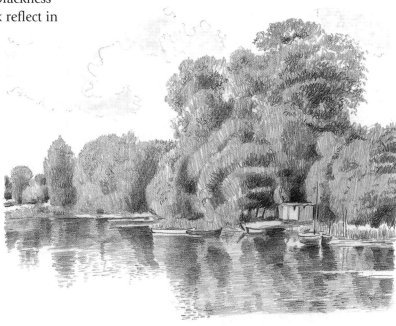

The turbulence of the water and its interaction with the static rocks is the point of this small-scale study. Note how the contrast between the dark and light parts of the water intensifies nearer to the shore. As the water recedes towards the horizon the shapes of the waves are less obvious and the tonal contrast between the dark and light areas lessens.

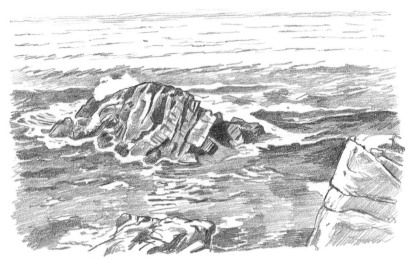

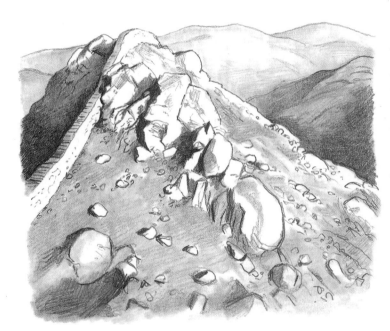

This close-up of a rocky promontory shows starkly against a background of mountaintops drawn quite simply across the horizon. The rock wall effectively shadows the left-hand side of the hill, creating a strong definite shape. In the middleground large boulders appear embedded in the slope. Smaller rocks are strewn all around. Note how the shapes of the rocks and the outline of the hill are defined by intelligent use of tone.

The main feature in this landscape is the stretch of rocky shoreline, its contrasting shapes pounded smooth by heavy seas. Pools of water reflect the sky, giving lighter tonal areas to contrast with the darker shapes of the rock. This sort of view provides a good example of an important first principle when drawing landscapes: include more detail close to the viewer, less detail further away.

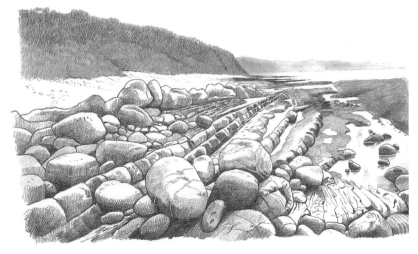

GRASS AND TREES

Grass and trees are two of the most fundamental elements in landscape. As with the other subjects, there are many variations in type and in how they might be used as features.

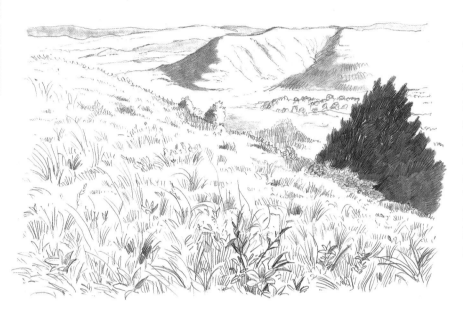

Tufts and hummocks of grass mingle with flowers in this close-up of a hillside. The foreground detail helps to add interest to the otherwise fairly uniform texture. The smoothness of the distant hills suggests that they too are grassy. The dark area of trees just beyond the edge of the nearest hill contrasts nicely with the fairly empty background.

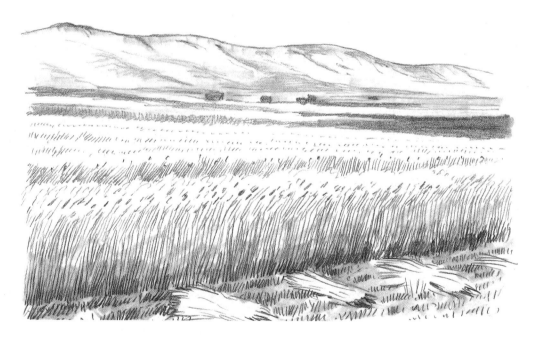

Cultivated crops produce a much smoother top surface as they recede into the distance than do wild grasses. The most important task for an artist drawing this kind of scene is to define the height of the crop – here it is wheat – by showing the point where the ears of corn weigh down the tall stalks. The texture can be simplified and generalized after a couple of rows.

BEACHES

Beaches and coastline are a rather specialized example of landscape because of the sense of space that you find when the sea takes up half of your picture.

Our first view is of Chesil Bank in Dorset,

which is seen from a low cliff-top looking across the bay. Our second is of a beach seen from a higher viewpoint, from one end, and receding in perspective until a small headland of cliffs just across the background.

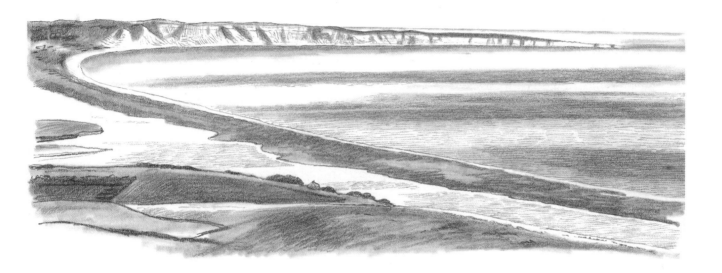

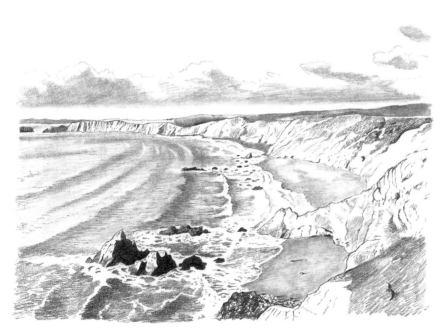

Here the dark, grassy tops of the cliffs contrast with the lighter rocky texture of the sides as they sweep down to the beach. The beach itself is a tone darker than the cliff but without the texture. The hardest part of this type of landscape is where the waves break on the shore. You must leave enough white space to indicate surf, but at the same time intersperse this with enough contrasting areas of dark tone to show the waves. The tone of the rocks in the surf can be drawn very dark to stand out and make the surf look whiter. The nearest cliff-face should have more texture and be more clearly drawn than the further cliff-face.

EXERCISES WITH PAPER

Now let's try something completely different. In the days when still-life painting was taught in art schools the tutor would screw up a sheet of paper, throw it onto a table lit by a single source of light, and say, 'Draw that.' Confused by the challenge, many students were inclined to reject it. In fact, it is not as difficult as it looks. Part of the solution to the problem posed by this exercise is to think about what you are looking at. Soon you will realize that although you have to try to follow all the creases and facets, it really doesn't matter if you do not draw the shape precisely or miss out one or two creases. The point is to make your drawing look like crumpled paper, not necessarily achieve an exact copy.

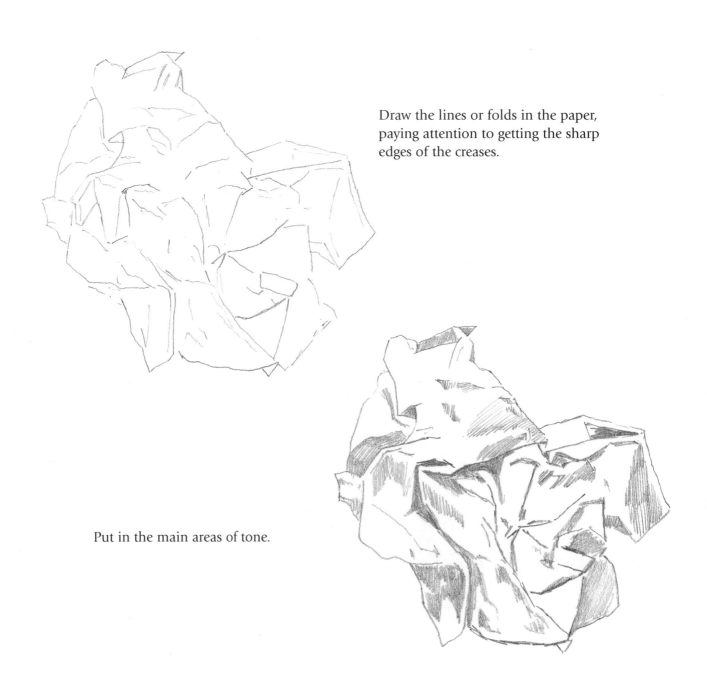

Draw the lines or folds in the paper, paying attention to getting the sharp edges of the creases.

Put in the main areas of tone.

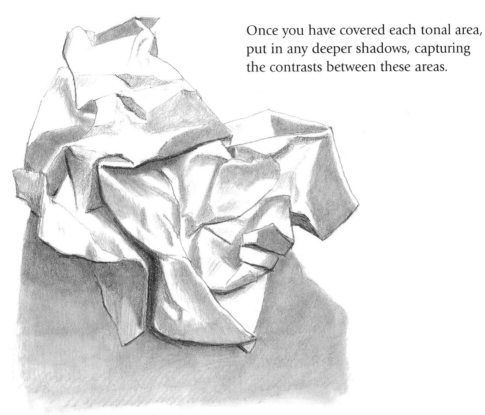

Once you have covered each tonal area, put in any deeper shadows, capturing the contrasts between these areas.

When you have completed the last exercise, try a variation on it. Crumple a piece of paper and then open it out again. Look at it and you will see that the effect is rather like a desert landscape. Before you try to draw it, position the paper so that you have light coming from one side; this will define the facets and creases quite clearly and help you.

Follow the three steps of the previous exercise, putting in the darkest shadows last.

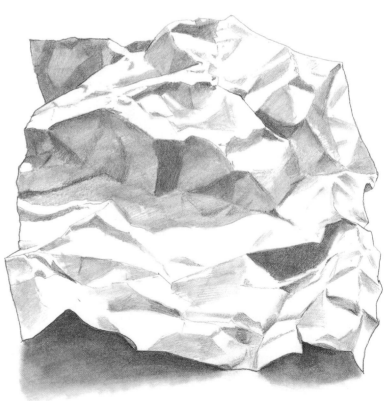

GLASS

Glass is a great favourite with still-life artists because at first glance it looks almost impossible to draw. All the beginner needs to remember is to draw what it is that can be seen behind or through the object. The object is to differentiate between the parts that you can see through the object and the reflections that stop you seeing straight through it. You will find, as with this example, that some areas are very dark and others very bright and often close up against each other. The highlights reflect the brightest light, and whatever is behind the glass is a sort of basis for all the brighter reflections.

Make sure that you get the outside shape correct. When you come to put in the reflections, you can always simplify them a bit. This approach is often more effective than over-elaborating.

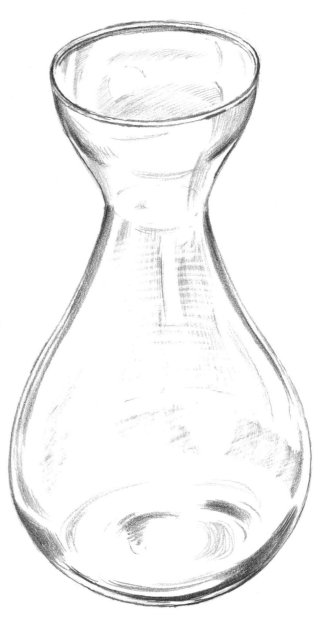

A glass vase, set in front of a white area of background. This allows you to see the shape of the glass very clearly. The tonal areas here will be minimal. If you are not sure whether to put in a very light tone, leave it out until you have completed the drawing, then assess whether putting in the tone would be beneficial.

You'll remember this glass from earlier in the section. We are now going to try a more detailed approach. The delicacy of this kind of object demands increased precision in this respect.

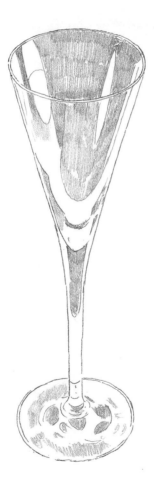

When you are satisfied you have the right shape, put in the main shapes of the tonal areas, in one tone only, leaving the lighter areas clear.

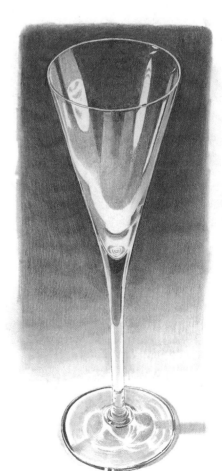

Finally, put in the darkest tones quite strongly. Each of these three drawings should inform anyone seeing them very precisely about the object and its materiality.

METAL

Now we look at metal objects. Here we have a brass lamp and a silver candlestick, which gives some idea of the problems of drawing metallic surfaces. There is a lot of reflection in these particular objects because they are highly polished, so the contrast between dark and light tends to be at the maximum. With less polished metalware the contrast won't be so strong.

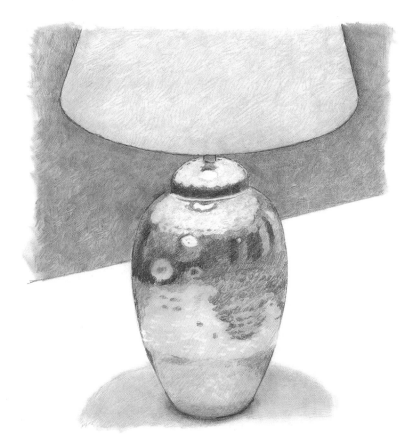

The beaten surface of this brass lamp gives the object many soft-edged facets. Because the light is coming from above, the darkest tones are immediately next to the strong, bright area at the top. The area beyond the darker tones is not as dark because it is reflecting light from the surface the lamp is resting on.

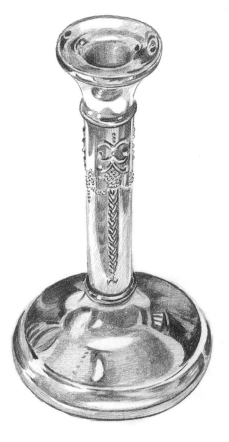

A silver candlestick does not have a large area of surface to reflect from. Nevertheless the rich contrast of dark and light tones gives a very clear idea of how metal appears. Silver produces a softer gleam than harder metals. Note how within the darker tones there are many in-between tones and how these help to create the bright, gleaming surface of our example.

Take your time with this sort of object. It requires quite a bit of dedication to draw all the tonal shapes correctly, but the result is worth it. Your aim must be for viewers to have no doubt about the object's materiality when you have completed the drawing.

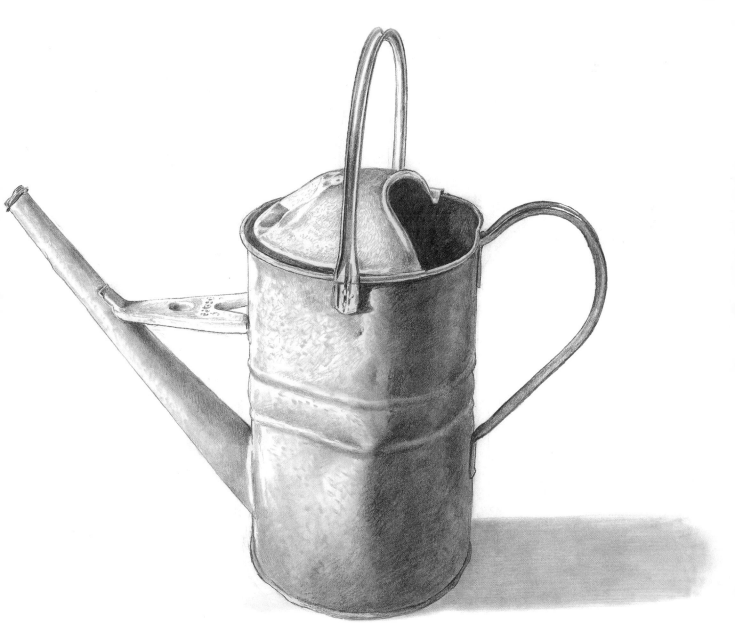

This battered old watering can made of galvanized metal has a hammered texture and many large dents. The large areas of dark and light tone are especially important in giving a sense of the rugged texture of this workaday object. No area should shine too brightly, otherwise the surface will appear too smooth.

TEXTILES

The best way to understand the qualities of different textures is to look at a range of them. Here we examine different kinds of textiles: viscose, silk, wool and cotton. Key with each example is the way the folds of cloth drape and wrinkle. You will need to look carefully too at the way the light and shade fall and reflect across the folds of the material, because these will tell you about the more subtle qualities of the surface texture.

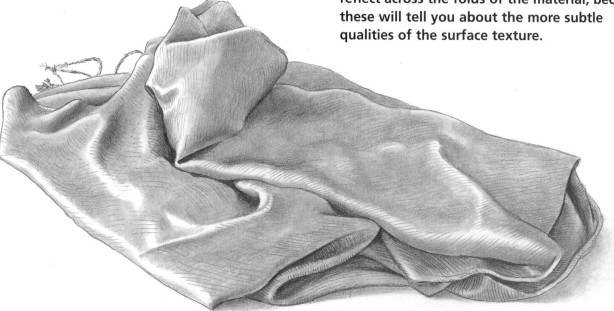

This scarf or pashmina made of the synthetic material viscose is folded over upon itself in a casual but fairly neat package. The material is soft and smooth to the touch, but not silky or shiny; the folds drape gently without any harsh edges, such as you might find in starched cotton or linen. The tonal quality is fairly muted, with not much contrast between the very dark and very light areas; the greatest area of tone is a medium tone, in which there exists only slight variation.

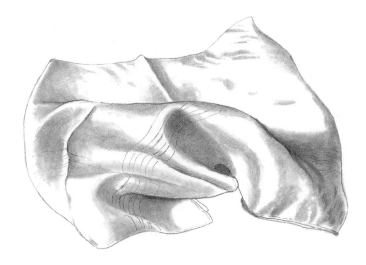

A silk handkerchief which, apart from a couple of ironed creases in it, shows several smooth folds and small undulations. The tonal qualities are more contrasting than in the first example – the bright areas ripple with small patches of tone to indicate the smaller undulations. We get a sense of the material's flimsiness from the hem and the pattern of stitched lines.

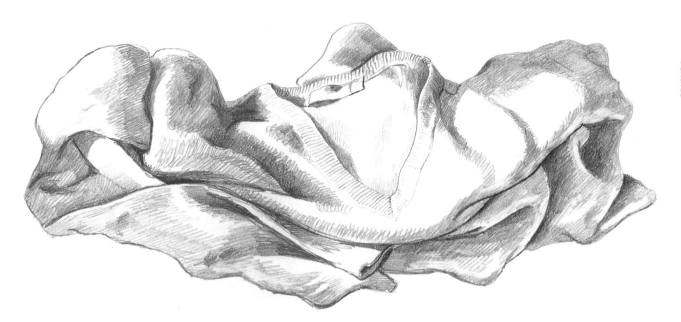

The folds in this large, woolly jumper are soft and large. There are no sharp creases to speak of. Where the two previous examples were smooth and light, the texture here is coarser and heavier. The showing of the neckline with its ribbed pattern helps to convince the eye of the kind of texture we are looking at.

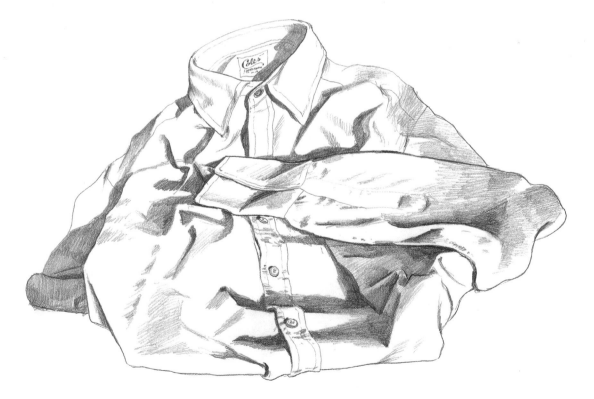

This well-tailored cotton shirt is cut to create a certain shape. The construction of the fabric produces a series of overlapping folds. The collar and the buttoned fly-front give some structure to the otherwise softly folded material.

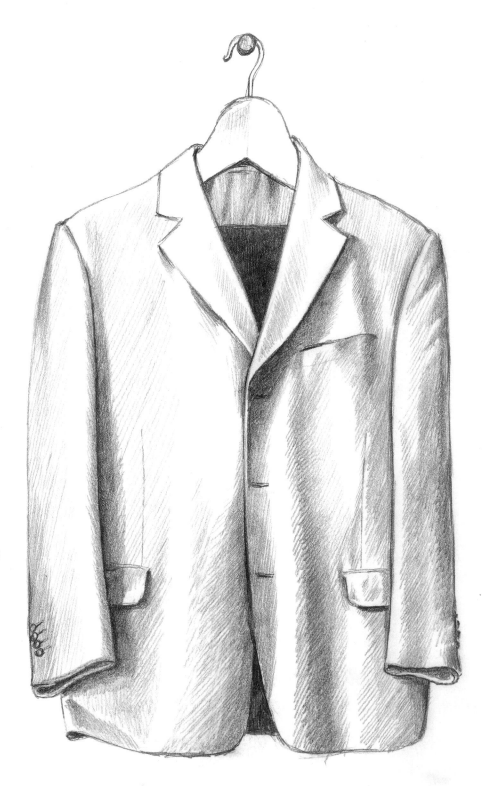

A wool jacket, tailored like the shirt on the previous page. Its placement on a hanger gives us a clear view of the object's shape and the behaviour of the material. The few, gentle folds are brought to our attention by the use of tone.

A deck shoe in soft leather, with soft edges and creases across the toe area, has none of the high shine of formal shoes. The contrast between the dark inside of the shoe and the lighter tones of the outside help to define the overall texture.

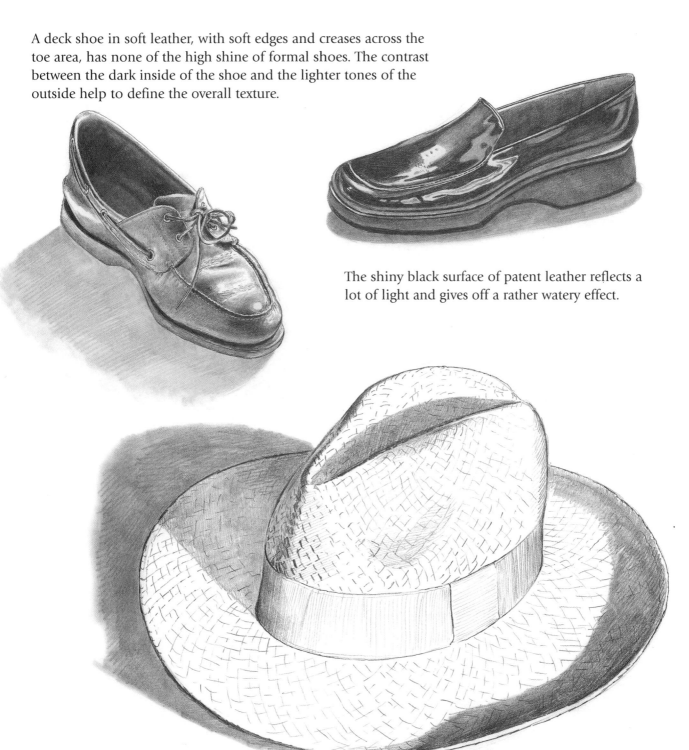

The shiny black surface of patent leather reflects a lot of light and gives off a rather watery effect.

A straw hat produces a clear-cut form with definite shadows that show the shape of the object clearly. The texture of the straw, woven across the structure, is very distinctive. Well-worn hats of this kind tend to disintegrate in a very characteristic way, with broken bits of straw disrupting the smooth line.

HANDLING FORM AND CLOTHING

The handling of drapery and clothing is not particularly difficult, but it does require some study in order to be clear about how materials behave and what happens when they are covering the body. The main purpose of these exercises is to teach you how folds work. How materials behave depends largely on the type of fabric. With practice you will come to understand those differences.

1.

A useful exercise for learning about the behaviour of clothing is to choose an item in a soft fabric – such as wool or silk – and drape it over something so that it falls into various folds. Now try to draw what you see.

1. Draw the main lines of the large folds. When you have got these about right, put in the smaller folds.

2. In order to capture the texture of the material, put in the darkest tones first, and then the less dark. Make sure that the edges of the sharpest folds contrast markedly in tone from the edges to the softer folds. In the latter the tone should gradually lighten into nothing.

2.

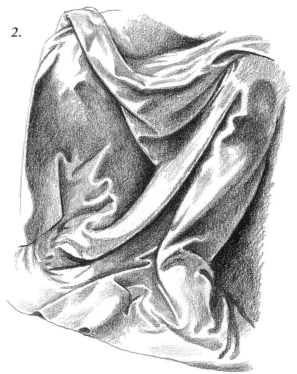

Try drawing an arm in a sleeve or a leg in trousers and carefully note the main folds and how the bend in the arm or leg affects them. In sleeves, the wrinkles can take on an almost patterned look, like triangles and diamond shapes alternating.

1. Start by very simply putting in the main lines of the creases. Note how on the jacket the folds and creases appear shorter and sharper across the sleeve, whereas on the tracksuit they appear longer and softer down the length of the leg.

2. Shade in where necessary to give the drawing substance.

3. The patterns on these sleeves look almost stylized, partly because the material is a bit stiff.

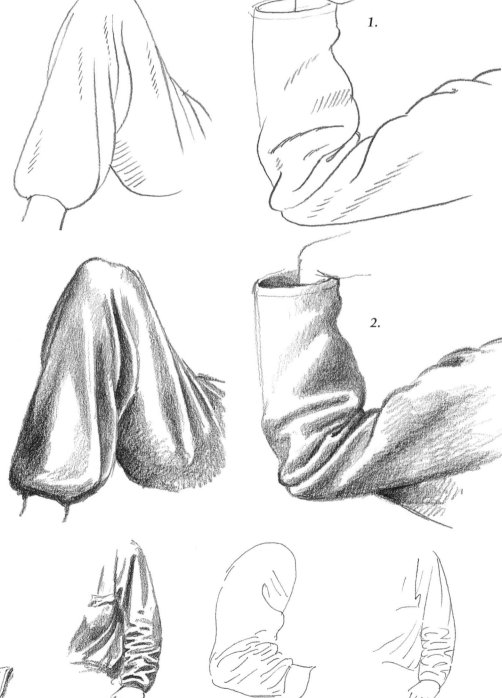

EVERYDAY CLOTHING

Your main source of models for figure studies will probably be clad in loose modern garments such as skirts, trousers and loose coats. These do not reveal the figure underneath in quite the same way as the rather more draped clothing seen in classical paintings, but nevertheless there are clues in the shapes. Unless the subject is rather stout, the characteristic shapes shown by clothing tend to be the bony parts of the figure.

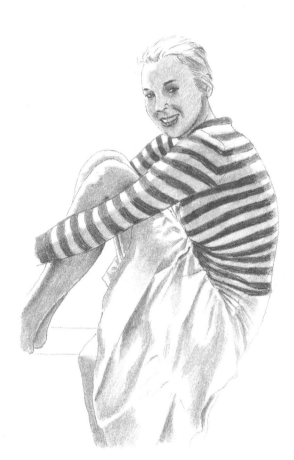

This drawing of a girl sitting on a window sill with her knees clasped up to her chest shows the effect of a loose lightweight skirt rucked up in small folds and then hanging in open undulations down over the wall. You can see how the legs join to the torso, but only by inference. The upper close-fitting garment is also very interesting in that the horizontal stripes curving round the arms and torso give a very clear idea of the shape of the body underneath.

The loose lightweight coat hugged around the figure of the girl with her hands deep in her pockets creates a tent-like shape, with the sharp, narrow folds giving some indication of the shoulders, the bend of the arms and a slight curve indicating the chest.

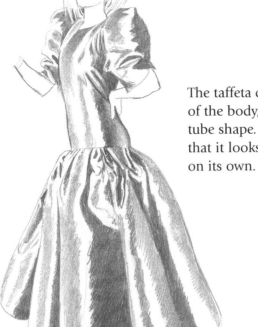

The taffeta dress shows only the upper part of the body, but this is almost reduced to a tube shape. The skirt is so bouffant and stiff that it looks almost as if it could stand up on its own.

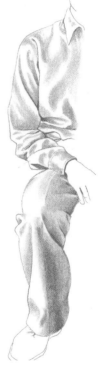

With the shirt and trousers, the lateral folds give a clear indication of the fairly bony arms under the shirtsleeves while the loose flopping folds of the lower part of the trousers define the knee. The thigh is shown because the leg is bent and the trouser leg is stretched across its muscles.

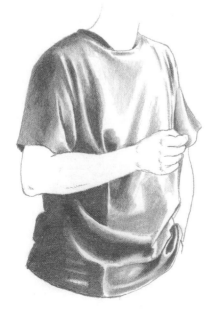

The more masculine garments here are two very typical pieces of materiality, part-disguising and part-revealing the shape underneath. The T-shirt shape is loose and floppy, and the solidity of the shoulders and chest is obvious. The way the folds hang down round the lower part of the torso leaves very little to go on to discover the figure underneath. The only noticeable feature is the slight curve of the edge of the shirt around the hips.

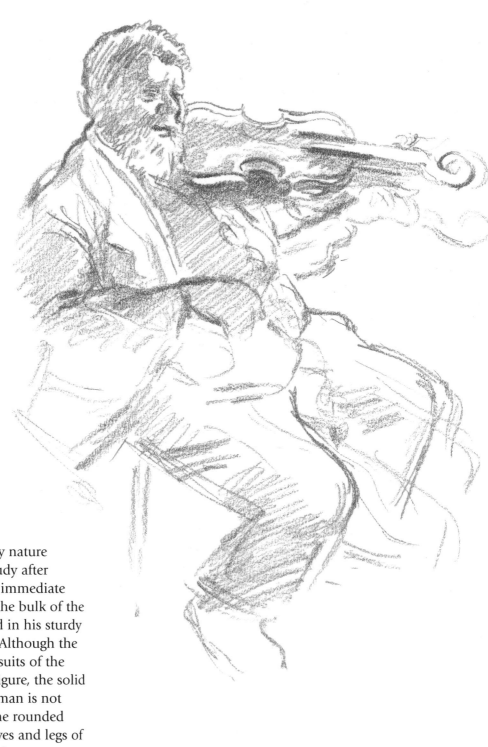

Despite the sketchy nature of this charcoal study after Degas, we gain an immediate understanding of the bulk of the violinist enveloped in his sturdy 19th-century suit. Although the suit is cut, like all suits of the time, to hide the figure, the solid dimension of the man is not hidden from us; the rounded quality of the sleeves and legs of the garments and the generous protuberance in front make it very obvious that the clothing is covering a sizeable body.

DESCRIBING AND DISGUISING

The two drawings (here and overleaf) show the contrast of how the human body can be represented quite graphically, by the way the form is dressed or, at the opposite extreme, can be disguised to appear very different to its real form. This interesting variation on the use of clothing to portray or distort the figure has been noticeable throughout history, with costume moving from one extreme to the other over the centuries.

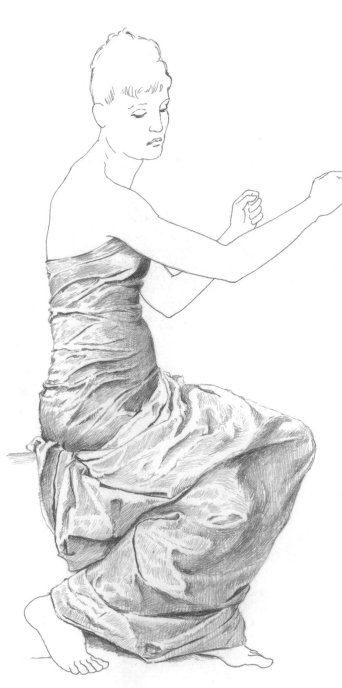

In this example the artist Otto Greiner dressed his model in such a way as to show clearly how the female figure looks wrapped in thin cloth which accentuates the shape. The lateral wrinkles and folds pulled tightly around the body give a very sharply defined idea of the contours of the torso, while the softer, larger folds of the cloth around the legs show their position but simplify them into a larger geometric shape so that the legs form the edges of the planes of cloth.

This Indian official is dressed in an elegant costume that seems to be designed to hide the real shape of its wearer. The turban gives extra height, but the close fit of the jacket around the shoulders opening up to a wide skirt, accentuated by the folds of cloth hanging down the back from the turban and the very wide trousers, produces a figure that is widest at the knees and narrowest at the shoulders. This is almost the reverse of the masculine figure underneath.

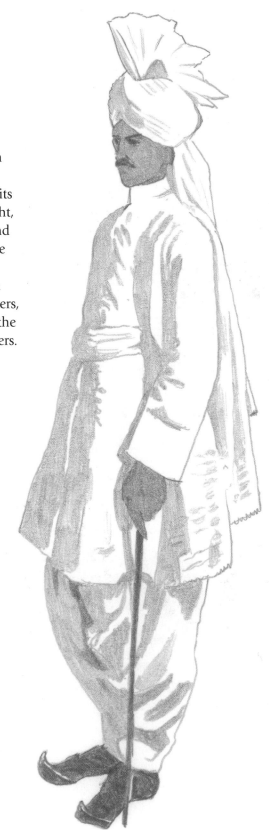

HAIR

Here is another material associated with the body – hair. We look at two examples and the technical problems involved when trying to draw them. This particular material comes in thin strands that can either curl, tangle or lie smoothly against each other, and these characteristics allow very different qualities to be shown in a drawing. You will find all of these challenging but fascinating to attempt.

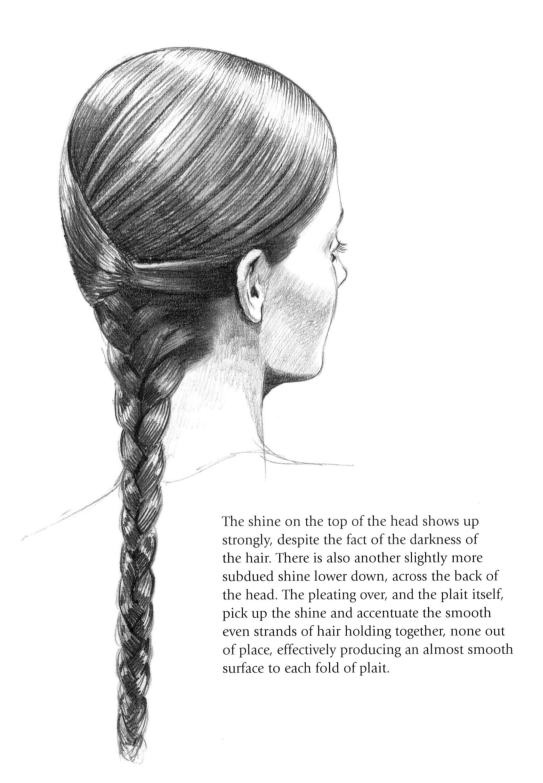

The shine on the top of the head shows up strongly, despite the fact of the darkness of the hair. There is also another slightly more subdued shine lower down, across the back of the head. The pleating over, and the plait itself, pick up the shine and accentuate the smooth even strands of hair holding together, none out of place, effectively producing an almost smooth surface to each fold of plait.

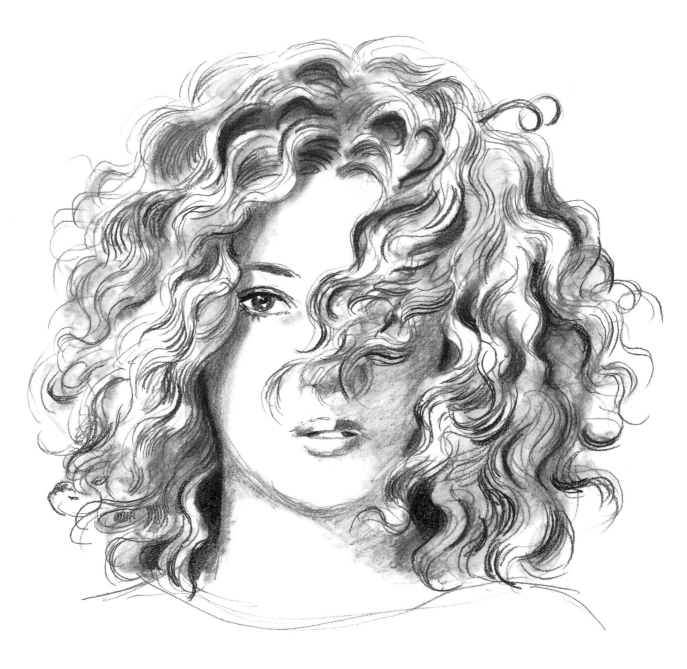

A lot of effort has gone into this hairstyle, with every seemingly
wayward strand beautifully arranged. Contrived it may be, but
it does show to good effect how hair can wave and corkscrew in
ringlets. Notice the many highlights on the bends of the curls and
the darker richer tones underneath. It's not easy to make this style
look natural in a drawing, but this is a good attempt.

LIGHTING A PORTRAIT SUBJECT

Natural lighting is usually the softer of the two types and is the better if you want to see every detail of the face. However, this can have its downside, especially if you want to draw a sympathetic portrait and not highlight the sitter's defects.

Leonardo said that the ideal set-up was in a sunlit courtyard with a muslin sheet suspended above the sitter to filter the daylight and give a diffused light. This type of arrangement will be beyond most of us. However, we can aim to get a similar effect with a cool, diffused light through a large north-facing window.

The artist Ingres described the classical mode of lighting as 'illuminating the model from an almost frontal direction, slightly to above and slightly to the side of the model's head'. This approach has great merit, especially for beginners in portraiture, because it gives a clear view of the face, but also allows you to see the modelling along the side of the head and the nose, so that the features show up clearly.

Artificial lighting is, of course, extremely flexible, because you can control the direction and amount of light possible and are not dependent on the vagaries of the weather.

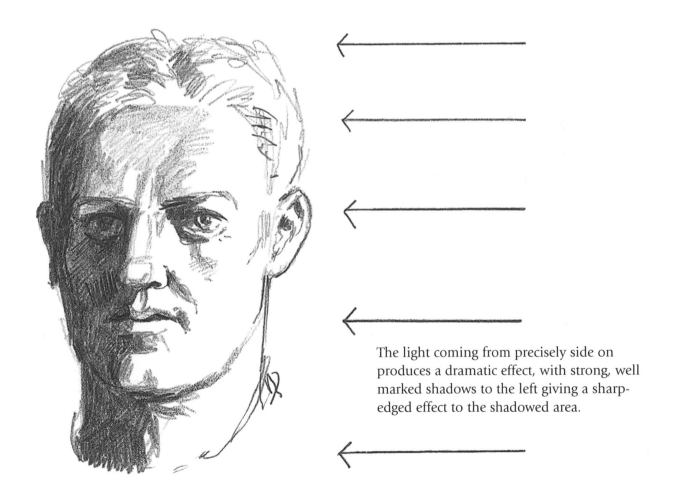

The light coming from precisely side on produces a dramatic effect, with strong, well marked shadows to the left giving a sharp-edged effect to the shadowed area.

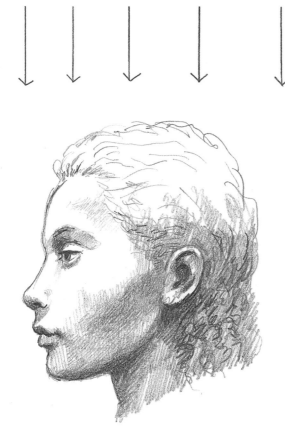

The three-dimensional aspect of the girl's head is made very obvious by lighting coming from directly above, although the whole effect is softer than in the previous example. The shadows define the eyebrows and cheekbones and gently soften the chin and lower areas of the head.

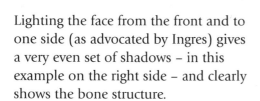

Lighting the face from the front and to one side (as advocated by Ingres) gives a very even set of shadows – in this example on the right side – and clearly shows the bone structure.

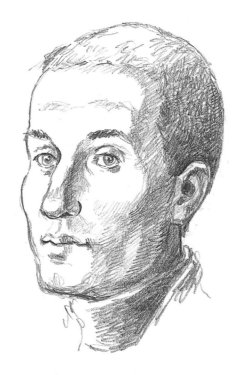

You don't have to invest in expensive equipment to achieve satisfactory results: several anglepoise lamps and large white sheets of paper to reflect light will do very nicely.

Lighting from behind the subject has to be handled very carefully and while it can produce very subtle shadows there is a danger of ending up with a silhouette if the light is too strong. Usually some sort of reflection from another direction creates more interesting definitions of the forms.

The only directional lighting that is not very useful is lighting from beneath the face, because light from below makes the face unrecognizable, which rather defeats the point of a portrait.

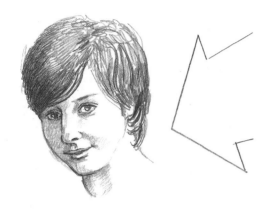

Lit frontally and from above this example also owes a debt to Ingres. The slight tilt of the head allows the shadows to spread softly across the far side of the face.

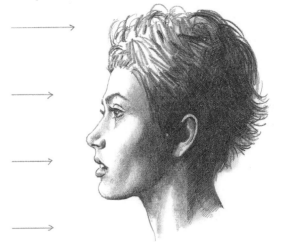

Lighting the model from directly in front shows the features strongly, subsuming the areas of the hair and the back of the head in deep shadow.

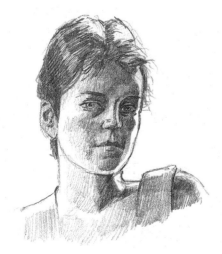

Lighting from behind is not usual in portraiture although it has been done quite effectively. The trick is not to overdo it and end up with your subject in silhouette.

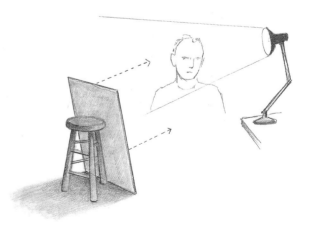

Reflected light can be used to flatten out too many shadows cast over the face. If you want to try this, place a large white sheet of card or similar opposite your light source.

1.

1. Lit from directly above, producing dark shadows around the eyes and under the nose and chin.

2.

3.

2. Lit from the front, flattening the shape, resulting in loss of depth but there is increased definition of the features.

3. Lit from beneath. Everything is reversed and it is difficult to believe this is the same boy as in the first picture. The shadows are now under the eyes but not the brow, and on top of the nose instead of under it. This lighting technique gives the drawing a decidedly eerie feel.

EXPERIMENTING

Here we look at the effect of different lighting on the same subject. Different lighting teaches a lot about form, so don't be shy of experimenting with it. Try the following options with a subject of your choosing.

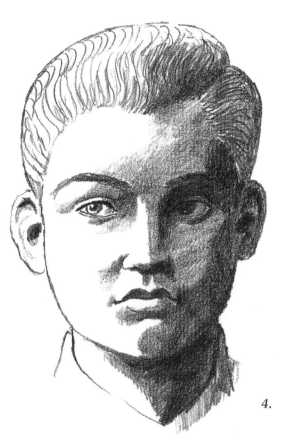

4.

4. Lit directly from the side. Here, half of the face is in shadow and the other half is strongly lit.

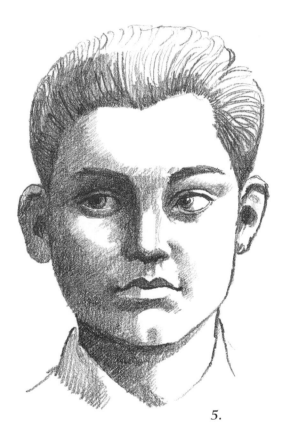

5.

5. Lit from above and to one side. The lighting evident here is fairly standard. The shadows created define the face in a fairly recognizable way.

As this series of images shows, directional lighting can make an immense difference to a face. The same principles apply equally to figures and objects. Experiment for yourself, using a small lamp or candles. Place objects or a subject at various angles and distances from a light source and note the difference this makes. When you have an effect that interests you, try to draw it.

PORTRAIT EXERCISES

The lighting lends a special quality to this portrait, accentuated by the three-quarter view. Although the light is coming from above, the face is not directly lit, apart from the nose. With this type of view, care has to be taken to align the central line of the head and face and correctly position the features across this line. If the subject had been looking straight at the viewer, the centre line would have been much more obvious. However, that view would not have given the atmosphere of gentleness and peacefulness intended.

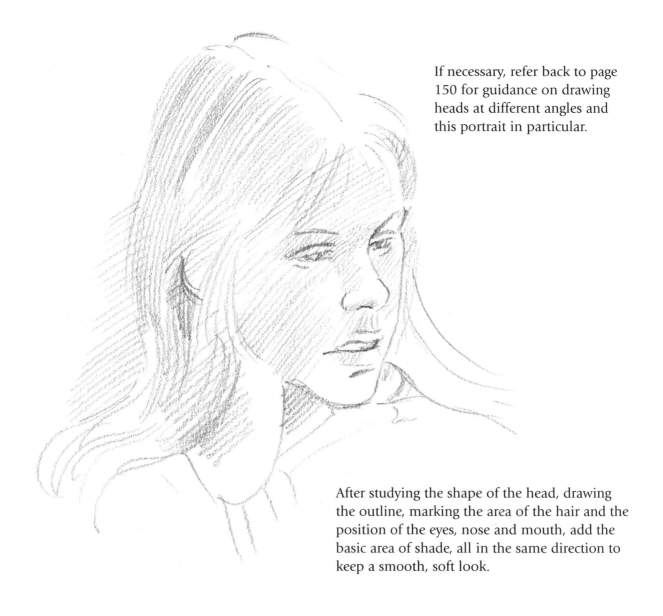

If necessary, refer back to page 150 for guidance on drawing heads at different angles and this portrait in particular.

After studying the shape of the head, drawing the outline, marking the area of the hair and the position of the eyes, nose and mouth, add the basic area of shade, all in the same direction to keep a smooth, soft look.

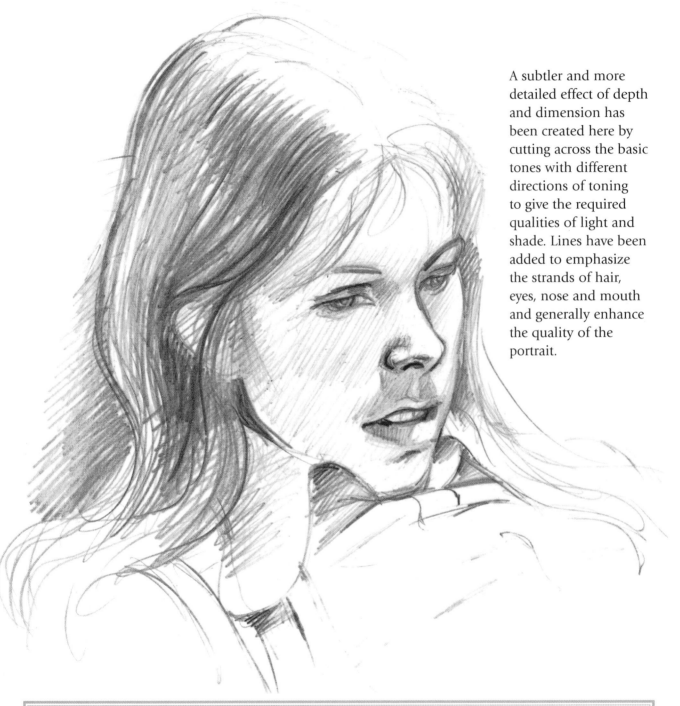

A subtler and more detailed effect of depth and dimension has been created here by cutting across the basic tones with different directions of toning to give the required qualities of light and shade. Lines have been added to emphasize the strands of hair, eyes, nose and mouth and generally enhance the quality of the portrait.

It is essential in a portrait to place the features exactly right and then make sure that the basic shapes of mouth, nose and eyes and the outline of the head and jaw are as close to your original as you can get. Don't worry if this doesn't happen the first time, but be mindful of it as an important aim. Always try to reproduce exactly what you see and not what you don't see. Trust your eyes. They are very accurate.

In this portrait you are faced with a very unusual position of the head. The degree of difficulty accentuates the necessity of correctly drawing the outline of the head. If you don't spend time getting this stage right, the result will be unsatisfactory, no matter how beautiful your detailed drawing. Generally, the first few minutes of a drawing determine how good or bad it will be.

Because of the unusual angle don't expect the shapes to be conventional or even what you know. Observation here is the real key, and if you observe keenly there is more chance of a powerful drawing resulting from your efforts.

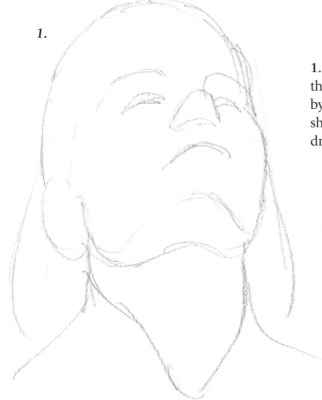

1.

1. The key to this drawing is understanding the construction of the shapes caused by the lifted head. Make sure that the shapes you can see are reproduced in your drawing as precisely as you know how.

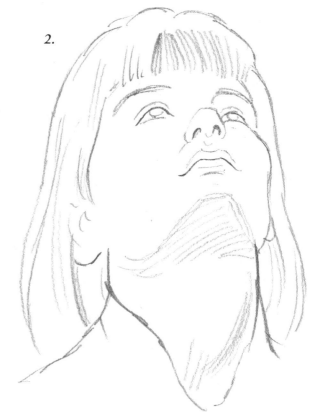

2.

2. Pay special attention to the shape under the jaw and how it combines with the neck to make a large, open shape. The features – eyes, nose and mouth – are all pushed together in a smaller space than is usual, because of the angle.

3.

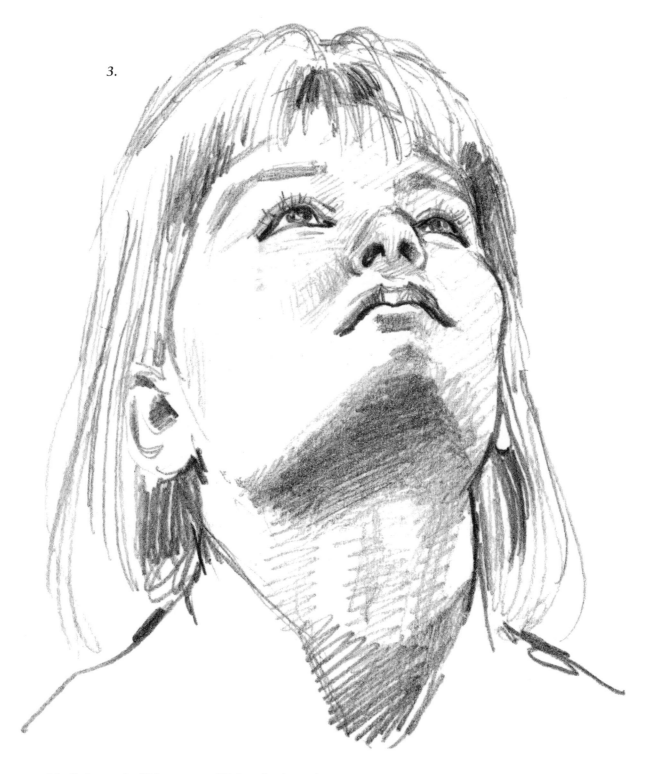

3. Add all the embellishments of light, shade and detail, using emphasis accurately to create both a good line and a convincing portrait.

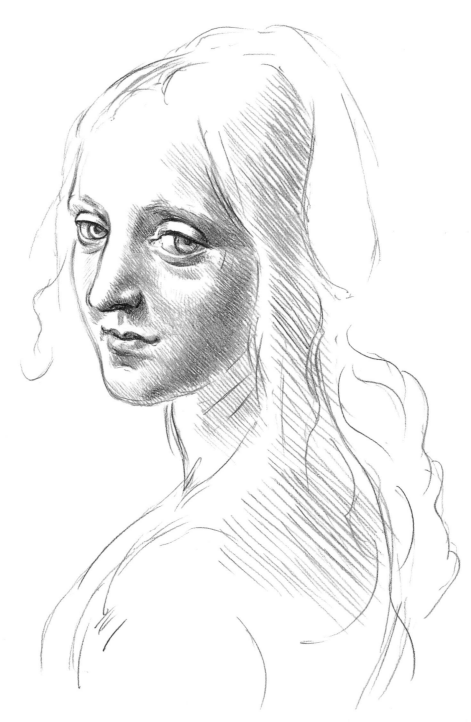

MASTERS OF LIGHT AND SHADE

LEONARDO DA VINCI (1459–1519)

Leonardo regulates light and shade by means of his famous sfumato method (Italian for 'evaporated'), a technique by which an effect of depth and volume is achieved by the use of dark, misty tones. The careful grading of the dark, smudgy marks helps us to see how the graduations of tone give the appearance of three dimensions.

The effect of dimension is also shown with very closely drawn lines that appear as a surface, and are so smoothly, evenly drawn that our eyes are convinced. There is elegance in the way he puts in enough tone but never too much.

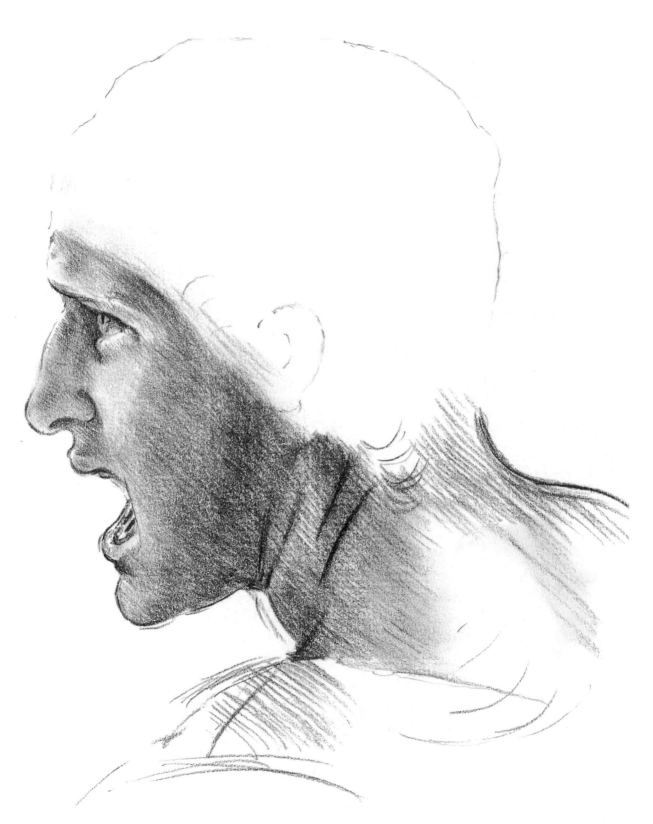

Whereas on a face all the surfaces move smoothly into each other, even on the craggiest visage, on a building each surface is distinct from the next. Most buildings are rectilinear, cuboid or cylindical and do not have ambiguous curves.

The challenge of making a structure that remains upright and lasts in time means that the edges of its surfaces are more sharply defined and the shapes much simpler than those found in natural form. As a consequence it is much easier to show mass.

Here we have two examples of drawings of buildings in which the aim is to communicate something of the materiality and form of these buildings. The first, of a tower by Christopher Wren, follows the shapes almost as if the artist is constructing the building anew as his pencil describes it.

The approach taken for a famous London landmark, Battersea Power Station, is very different, as befits a great monument to an industrial age.

A very powerful three-dimensional effect has been achieved here by vividly portraying the massive simplicity of the building's design with sharply drawn shadows and large light areas.

This drawing captures the elegant balancing forms of classical architecture as practised by Christopher Wren, with spaces through the form and much articulation of the surfaces to create a lightness in the stone structure as well as visual interest.

TECHNIQUE

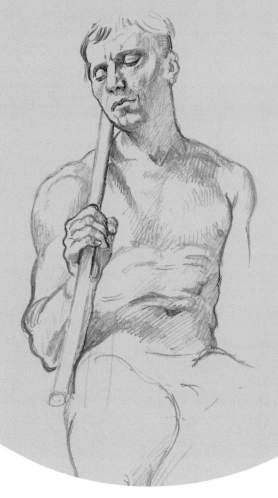

To develop an individual style and method of working, you have to experiment. This is quite easy, given the wide range of materials and implements available. Next, we consider different implements and papers and the effects that can be achieved with them – for example, various types of pencil, as well as pen and ink, line and wash, chalk, pastel and charcoal. We also look at scraper-board and some rather interesting if labour-intensive ways of making marks on paper.

In addition we look at some of the approaches to the art of drawing taken by different artists at different times. Some of these may seem alien or too different from the way of working you are used to. Don't be concerned if this is the case. Experimentation gives us the opportunity to discover new techniques and approaches, and to incorporate them in our work. Do try your hand at all of them, and see if you can invent a new style. The main point is to have some fun!

PENCIL DRAWING

A drawing can function in several ways: as a sketch that acts as a preliminary stage for a painting, as an underdrawing on top of which you then put colour, as a finished piece in itself, or just as a piece of information to use for later work.

Try out this loose-line technique, in which there is very little in the way of careful tone or sometimes none at all. The questing, wobbling line, which almost looks as though the point of the pencil never leaves the paper, is a very expressive medium for quickly and elegantly stating the form of the objects it is describing.

Notice how the line varies from one side of an object to the other, sometimes heavy and bold, sometimes slight and varying. To help this transition in definition you have to hold the pencil loosely as shown, more like a wand than a fountain pen. This of course takes a bit of practice but it is amazing how quickly the method can be mastered.

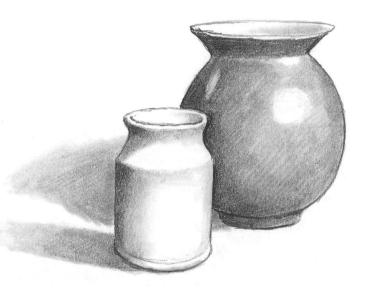

Shown here is the more careful and deliberate method of drawing quite fine and precise outlines and then carefully shading in the tone until it graduates from dark to light with great subtlety. For this method, the pencil has to be kept finely sharpened at the start, but allowed to become softly blunt when shading.

The graduation of tone can be further enhanced by the use of a stump (a rolled, pressed, solid paper stick with a pointed end) which smudges the pencil from heavy to faint shading very effectively.

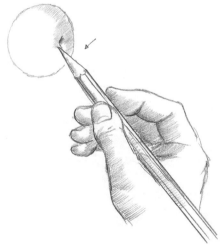

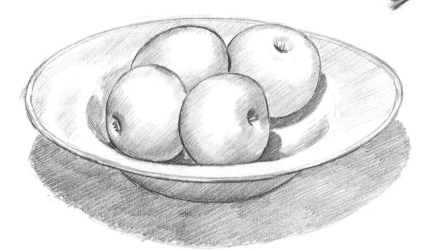

Another, even more classical approach is to draw similar clear, sharp outlines and then use a diagonal hatching system of closely drawn lines which build up large areas of tone very effectively and which, with just a change in pressure, increase the depth of tone. Leonardo da Vinci was a great exponent of this system of hatching, which he apparently did with great speed and precision. It may take you a bit longer than him and you may not have his brilliant control of the pencil, but you will learn by practice. The hatched lines are drawn only in one direction, and the results are very attractive.

TECHNIQUE

THE SIMPLE OUTLINE

The drawing on this page actually uses simple outlines. Such simplicity serves to 'fix' the main shape of the drawing, ensuring the effect of the additional detailed shading.

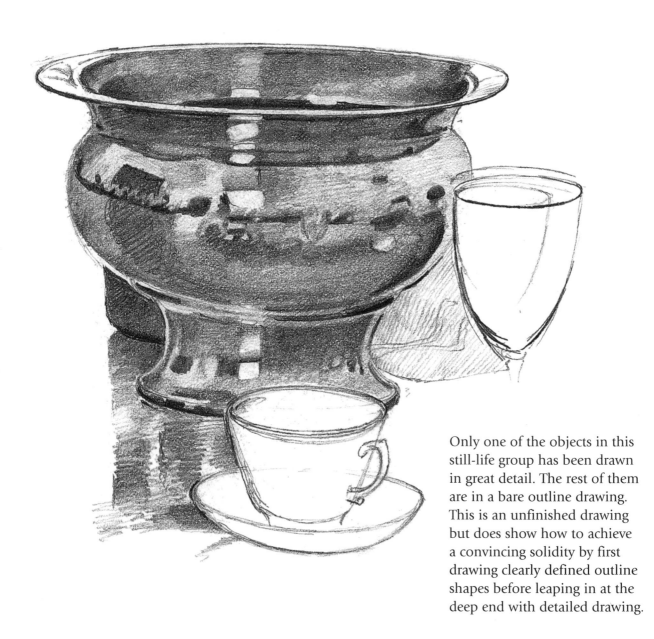

Only one of the objects in this still-life group has been drawn in great detail. The rest of them are in a bare outline drawing. This is an unfinished drawing but does show how to achieve a convincing solidity by first drawing clearly defined outline shapes before leaping in at the deep end with detailed drawing.

Clarity of definition is very important when drawing objects that have been designed to do a job. If your outline drawings are not accurate the addition of tone will not make them any better. Assuming that your outlines are spot-on, proceed to put in the tones, denoting differences between the various materials of which the tools are made: for example, the sharp contrasts between dark and light in metallic parts and the more subdued tones for parts made of rubber, plastic or wood.

LINE VERSUS TONE

Each of the following drawings has been given different treatment with regard to line and tone. Different effects can result from the balance between these two technical elements.

1. This is primarily a line drawing, showing the outline of the form with only minimal shading to reinforce the shapes. The outline is sharp and definite, and even without the cross-hatching shading it would still make sense.

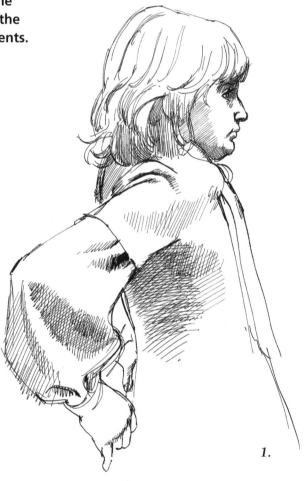

1.

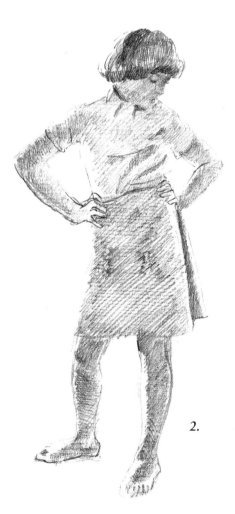

2.

2. In this figure the outside edge is much less sharply defined but the impression of solidity is much greater. Standing with the light coming from behind, this figure was drawn almost without an outline. Blocks of pencil toning of various strengths give the main shape of the figure and only some details are outlined to give emphasis. The small areas of light which creep around the edges of the arms, legs and skirt point up the round solidity of the figure and stop it being just a silhouette.

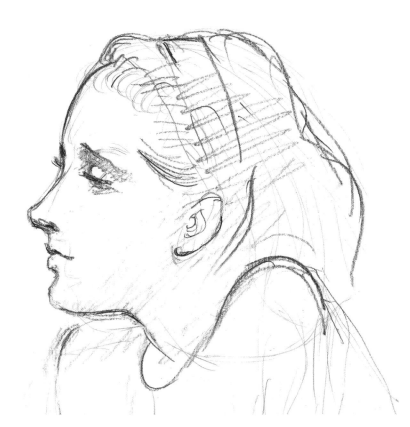

This profile is very loosely drawn with hardly any tonal work and not even a very firm outline. The lines of her head are a lyrical expression of her youthful enjoyment of life.

Contrast this technique with that used in the drawing below, where the head is heavily pencilled in with shadows.

Here the head is heavily pencilled in with shadows and vigorous tonal values. The dark tonal marks underline the atmosphere of brooding and the apprehension evident in his concentrated gaze. He appears to be considering something we cannot see.

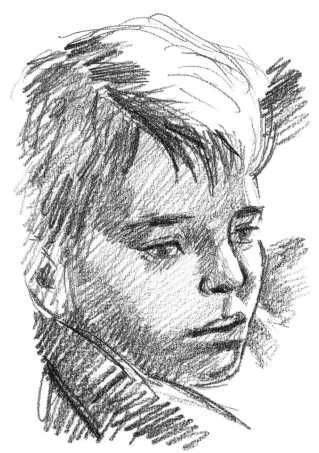

TRYING OUT DIFFERENT MEDIA

The benefits of ink are clarity, simplicity and boldness of effect. You will have to be daring and commit yourself with every mark, using highly simplified, blocked-out shapes for the main elements.

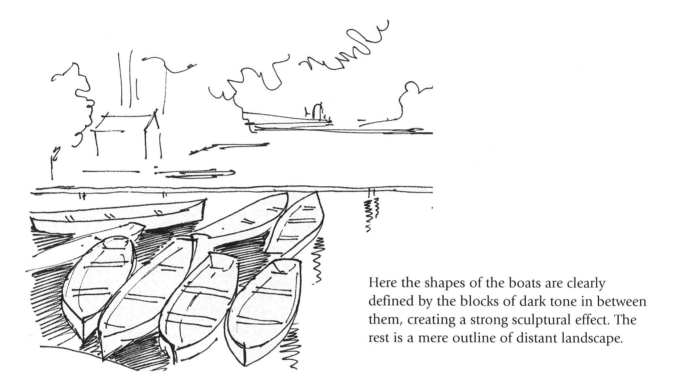

Here the shapes of the boats are clearly defined by the blocks of dark tone in between them, creating a strong sculptural effect. The rest is a mere outline of distant landscape.

This is almost a map of what your final drawing might be; simple outlines with blocks for the buildings, the line of the hills and the bay, an extensive patch of shadow across the beach and small marks showing boats and people on the beach and in the water. Drawing like this gives sculptural value to a scene, providing a sort of skeleton on which you can build your picture.

This Greek vase drawing, one of the earliest known (dating from c. 510 BC), is so sophisticated and elegant that it might have been drawn by a modern-day Picasso or Matisse, except that Matisse would not have been as exact and Picasso would probably not have been as anatomically correct. The simple incised line appears to have been done easily and quickly and yet must have been the result of years of practice. Yet more remarkable is that the drawing was not done on flat paper but on the curving surface of a vase or crater. The economy of line is a lesson to all aspiring artists.

Joseph Mallord William Turner (1775–1851) started his career as a topographical painter and draughtsman and made his living producing precise and recognizable drawings of places of interest. He learnt to draw everything in the landscape, including all the information that gives the onlooker back the memory of the place he has seen. This ability stayed with him, even after he began to paint looser and more imaginative and elemental landscapes. Although the detail is not so evident in these canvases, which the Impressionists considered the source of their investigations into the breaking up of the surface of the picture, the underlying knowledge of place and appearance remains and contributes to their great power.

The outline drawing of the abbey (shown left) is an early piece, and amply illustrates the topographic exactitude for which the artist was famous in his early years. The second example is much more a painter's sketch, offering large areas of tone and flowing lines to suggest the effect of a coastal landscape.

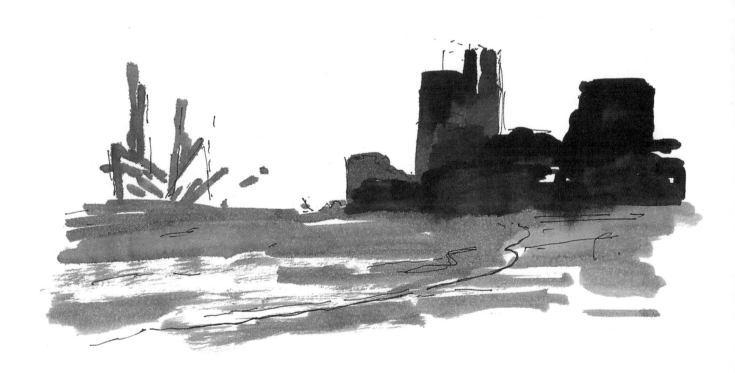

PORTRAITURE WITH A DIFFERENCE

Both of the examples shown here are unusual approaches to portraiture and stand almost at opposite ends of the spectrum: the first showing the effect of simplified outline treatment, and the second the visual impact of detail and texture.

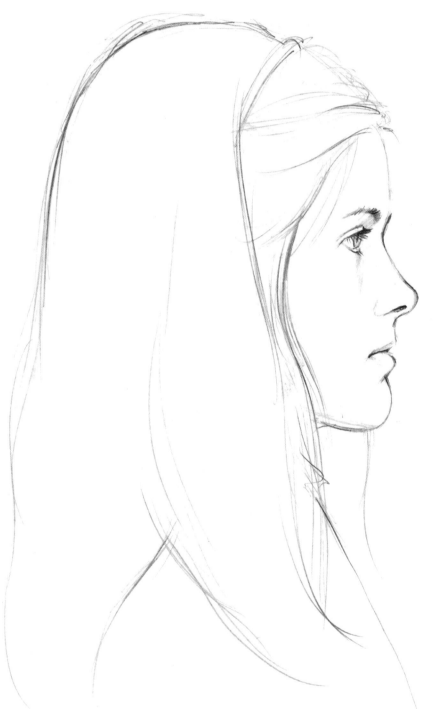

The effect of this drawing derives purely from the outline shape of the basic features and hair. For this approach to work well you have to succeed in getting the profile accurate, in proportion and shape. Although time-consuming, this is not as difficult as it might seem.

The technique of ink drawing was rather useful here to emphasize the dark richness of the young woman's luxuriant head of hair. You'll notice that the lines are not continuous from top to bottom and that white areas have been left between the breaks in the line. The impression, though, is of a mass of long, shiny hair.

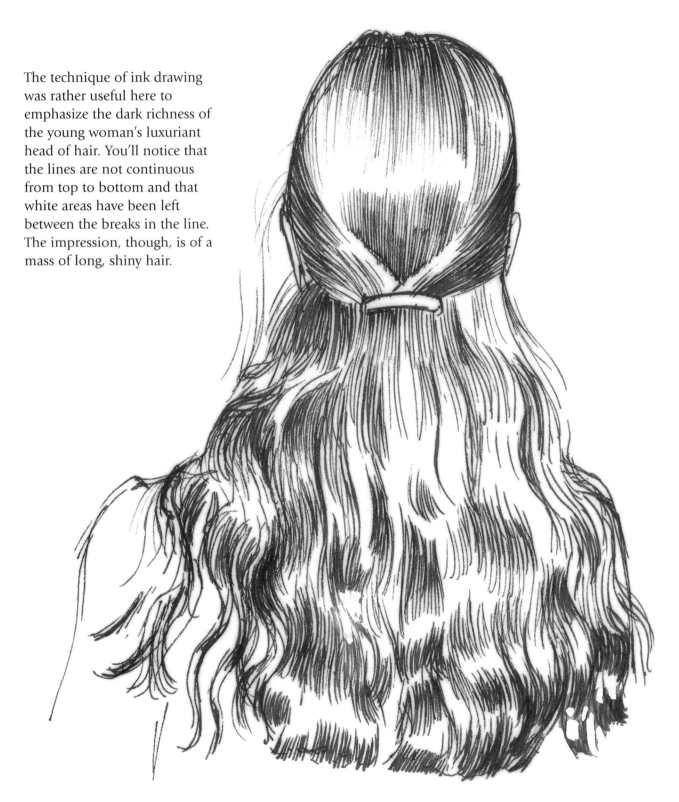

PEN AND INK

There are many types of pen that can be used for drawing in pen and ink. The techno-graphic pens with fine fibre tips produce lines of uniform thickness and weight. If you use these you will sometimes need more than one calibre, or thickness. Then there is a range of fine-pointed nibs available that are pushed into an ordinary dip pen holder. Some of these are pointed and rigid, while others are flexible to allow variations in thickness of line. They tend to have a few more variable lines than the techno graphic pens. You can also vary the kind of ink you use with them to get a blacker or greyer tone.

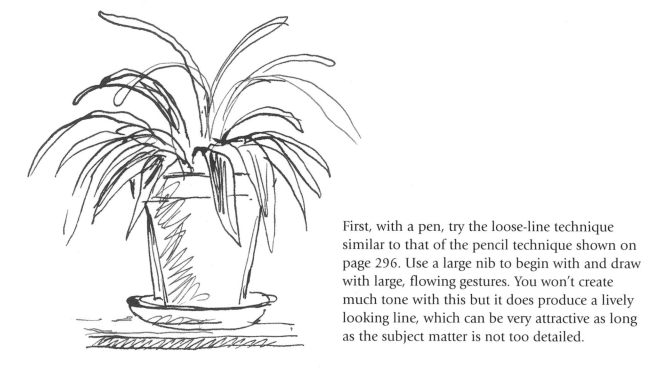

First, with a pen, try the loose-line technique similar to that of the pencil technique shown on page 296. Use a large nib to begin with and draw with large, flowing gestures. You won't create much tone with this but it does produce a lively looking line, which can be very attractive as long as the subject matter is not too detailed.

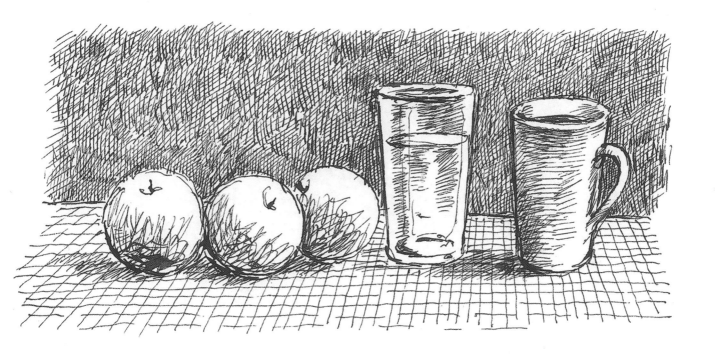

The same approach with a finer nib demands a more tightly controlled scribble effect, which can build up very varied tonal areas, helping to produce more depth and substance in the drawing. Always keep the strokes smaller with a fine pen, because it is the build-up of tiny wavering marks that produces an attractive quality to the drawing.

TECHNIQUE

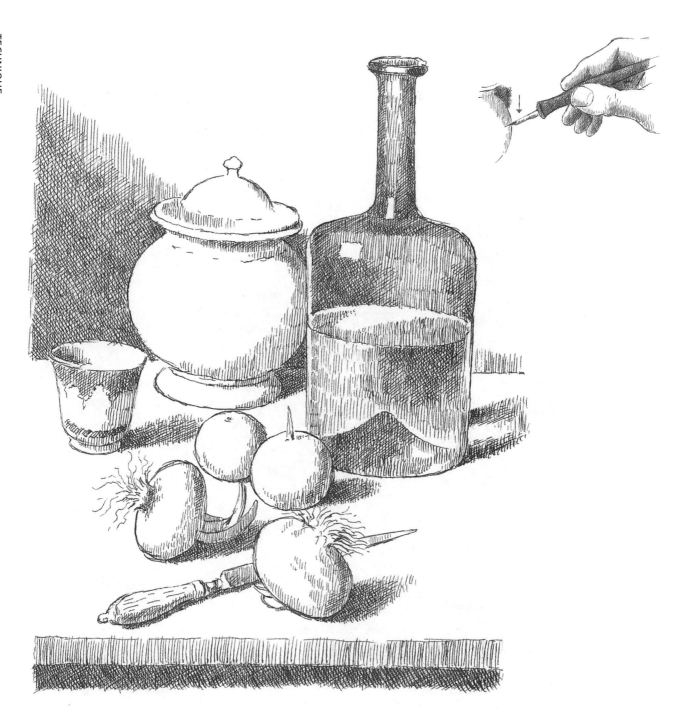

You can use a much more carefully organized system of hatching with multiple hatching, layered to build up significant areas of darker tone. This demands more precision in the outline shapes and you need to control the way the pen strokes butt onto these finely drawn outlines. Carried out with patience and perseverance, this can produce beautiful velvety textures that seem to create real depth and solidity.

Pen and ink is special in that once you've put the line down it is indelible and can't be erased. This really puts the artist on his mettle because, unless he can use a mass of fine lines to build a form, he has to get the lines 'right' first time. Either way can work.

Once you get a taste for using ink, it can be very addictive. The tension of knowing that you can't change what you have done in a drawing is challenging. When it goes well, it can be exhilarating.

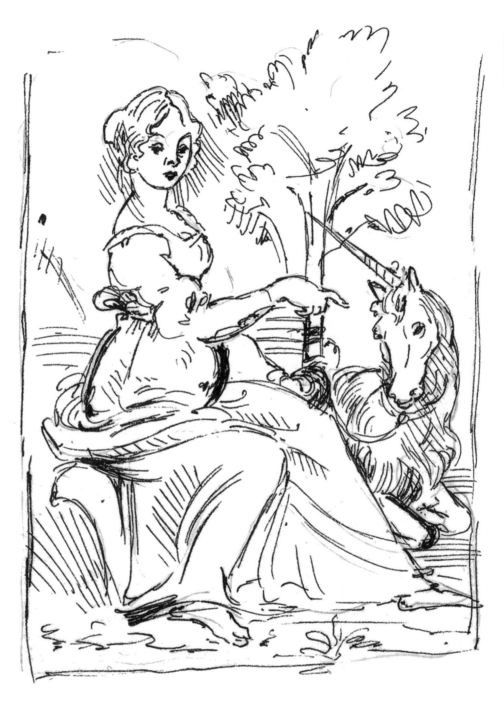

Leonardo probably did the original of this as a study for a painting. Drawn fairly sketchily in simple line, it shows a young woman with a unicorn, a popular courtly device of the time. The lines are sensitive and loose but the whole hangs together very beautifully with the minimum of drawing. The curving lines suggest the shape and materiality of the parts of the picture, the dress softly creased and folded, the face and hand rounded but firm, the tree slightly feathery looking. The use of minimal shading in a few oblique lines to suggest areas of tone is just enough to convey the artist's intentions.

This copy of a Raphael is more heavily shaded
in a variety of cross-hatching, giving much more
solidity to the figures despite the slightly fairy-
tale imagery. The movement is conveyed nicely,
and the body of the rider looks very substantial
as he cuts down the dragon. The odd bits of
background lightly put in give even more strength
to the figures of knight, horse and dragon.

DIFFERENT STYLES OF TREATMENT

The treatment you choose for your subject will dictate the look of your final drawing.

The materials used have a considerable effect, as does the artist's approach.

In 'Fountain in the Garden of St Paul's' (after Van Gogh), there is graphic emphasis on the lines of the various trees and stones and the handling of textural effects to create tone and weight. The mixture of large slashing marks and fine hatched lines builds a convincing and vigorous picture that packs quite a punch.

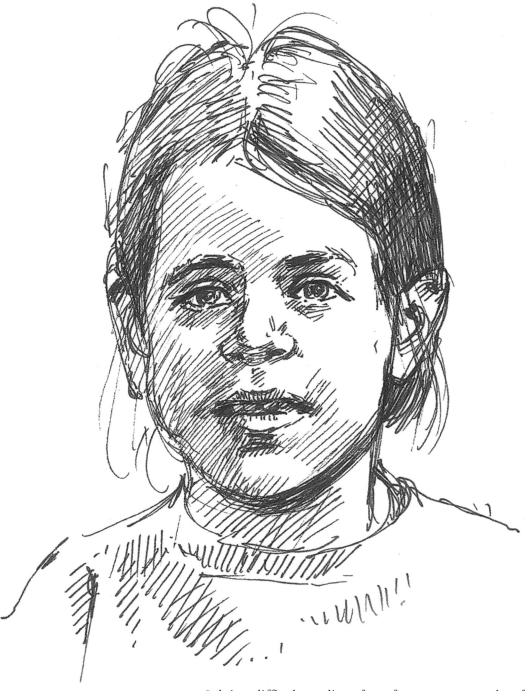

Ink is a difficult medium for a face as young and unformed as this and so the style had to be fairly loose and fluid. I used sweeping lines to prevent them looking too dry and technical. Ink does not allow a lot of subtle variations but its very simplicity can give a drawing great strength.

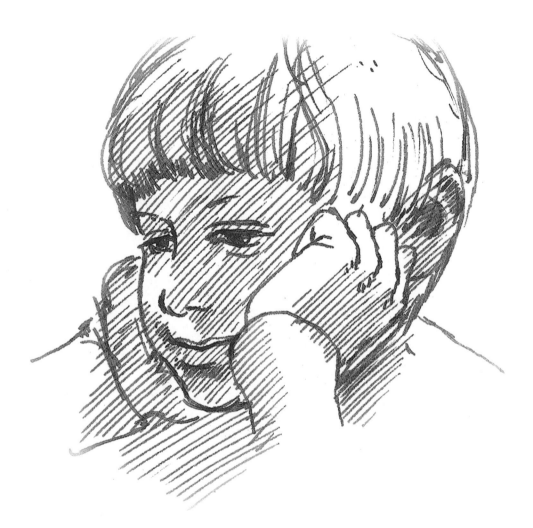

In this small sketch with a ball-point pen I was interested in capturing the shape of the head and the dimensional effect of the large area of shadow and the bright areas catching the light. The features are drawn simply in line to show through the overall texture of shadow. At this age the features are becoming better defined, allowing the use of a stronger line.

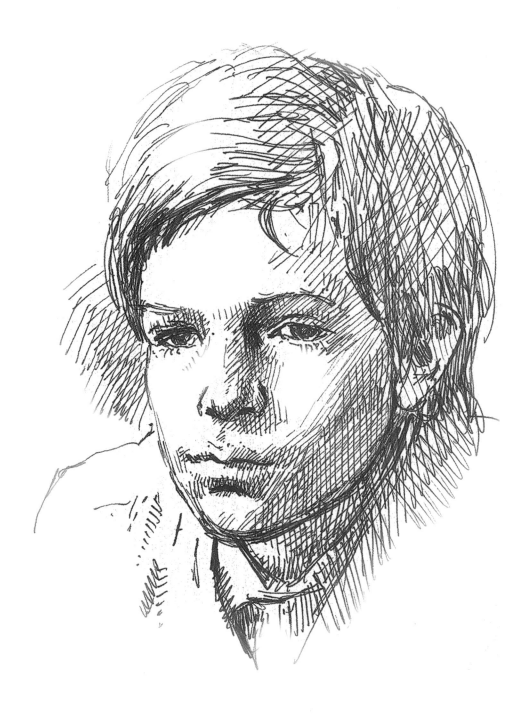

Here the toned paper gives a slightly heavy
look to the face which, although still soft and
relatively unmarked by experience, has a slightly
stronger bone structure and a dour uncertain
look expressive of the mood swings that beset
youngsters approaching the early teenage years.

SUBTLE VOLUME

Shown here and overleaf are two drawings after Thomas Gainsborough and Camille Pissarro. Both were master draughtsmen capable of showing form with very little in the way of significant marks; they managed to convey bulk and solidity without having to labour the point with highly detailed contour hatching.

The Gainsborough is of a fashionable lady drawn at Richmond, glancing back at the artist as she walks past in her beautiful floating silk dress and big black hat. The solidity of the body under the garments is implied by little touches of chalky lines, smudged tones and white body colour, which tells us of the fascinating form of this rather coquettish young woman. What is very obvious is that this is a human body, youthful and light-footed but also substantial.

TECHNIQUE

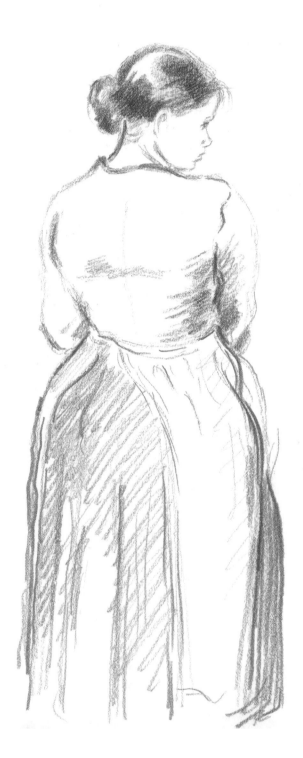

Pissarro's young peasant woman is drawn with the maximum of economy and the minimum of marks on the paper. Although the lines are very sparse, there is no doubt in our minds that this is a solid, earthily substantial young woman with sturdy limbs and torso. The shoulders look strong and the waist solid. Although there are probably layers of petticoats under the skirt, it looks as though she is probably well developed in the hip area as well. Despite the scarcity of marks to depict it, this body looks firm and strong; our eyes fill in all the spaces to see her as the artist did.

The great Romantic French painter **Eugène Delacroix (1798–1863)** could draw brilliantly. He believed that his work should show the essential characteristics of the subject matter he was portraying. This meant that the elemental power and vigour of the scene, people or objects should be transmitted to the viewer in the most immediate way possible. His vigorous, lively drawings are more concerned with capturing life than including minuscule details for the sake of it. He would only include as much detail as was necessary to convince the viewer of the verisimilitude of his subject. As you can see from these examples, his loose powerful lines pulsate with life.

DRAWING WITH TONE

So far we have been examining different ways of drawing with line, so it is quite a departure to think about creating an object almost entirely from tone. Instead of following an outline, you will need to consider instead laying down tones that will not only describe volume but also define edges. You can use a range of media to do this, ranging through soft pencil smudged with a stump, charcoal, crayon, ink and wash, and an eraser to define some of the lighter areas by going over the tones and reducing them.

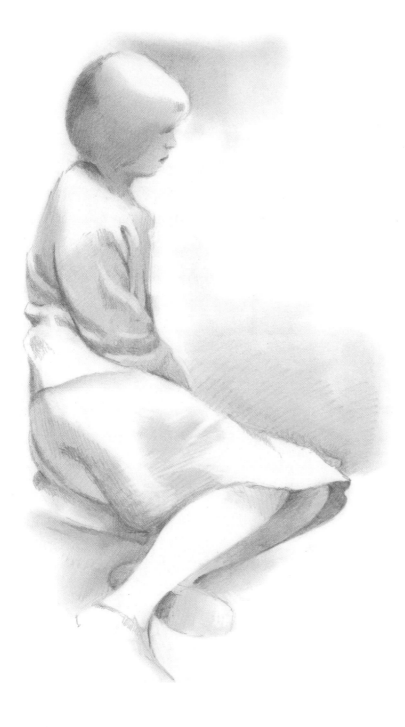

Here I built up areas of tone, leaving areas of light where necessary, so that the figure arrived on the paper by a series of soft smudgy areas of tone. The edges were defined without my having to draw a line.

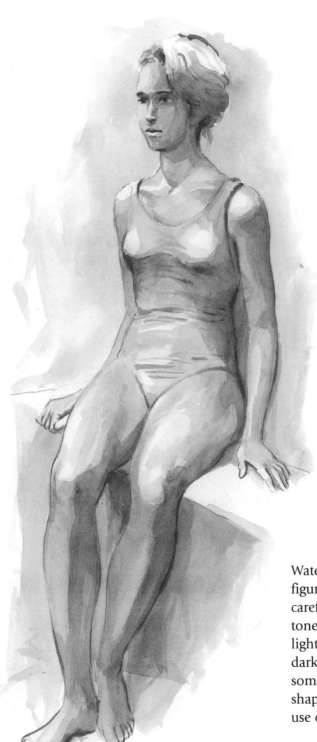

Watercolour or ink and wash for the figure requires a more deliberate and careful technique, laying areas of tone with a brush and working from light tones, building them up with darker and darker layers of tone. It is sometimes better to draw an outline shape first if you feel unsure of your use of the brush.

When using line and wash in landscape
drawing, the handling of the wash is
particularly important, because its different
tonal values suggest space receding into the
picture plane.

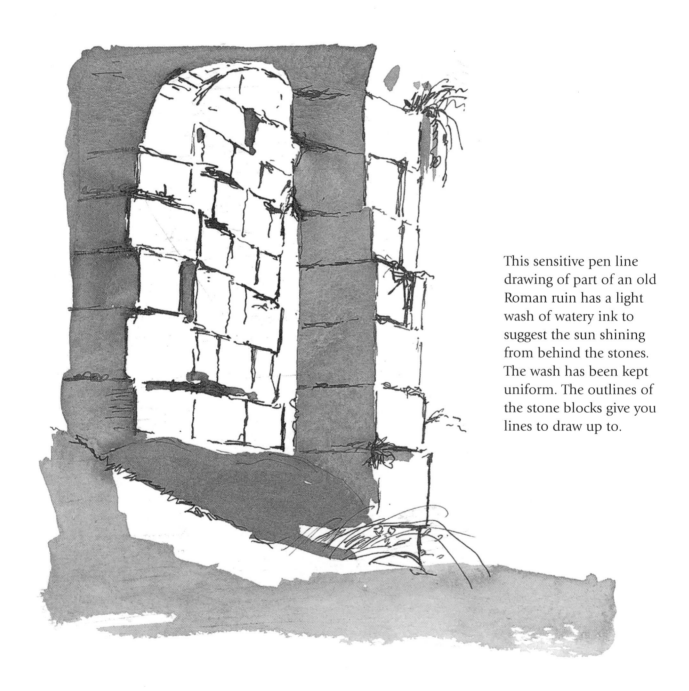

This sensitive pen line
drawing of part of an old
Roman ruin has a light
wash of watery ink to
suggest the sun shining
from behind the stones.
The wash has been kept
uniform. The outlines of
the stone blocks give you
lines to draw up to.

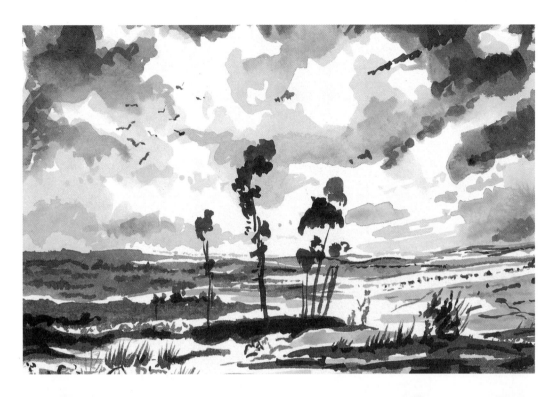

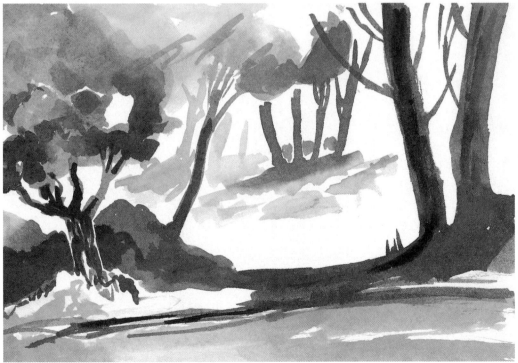

Different effects with brush and ink: These two landscapes give very different effects although a very similar technique was used for both.

Here we look at three drawings after Claude Lorrain.

These two deer are fairly loosely drawn in black chalk. A variety of tones of wash has been freely splashed across the animals to suggest form and substance.

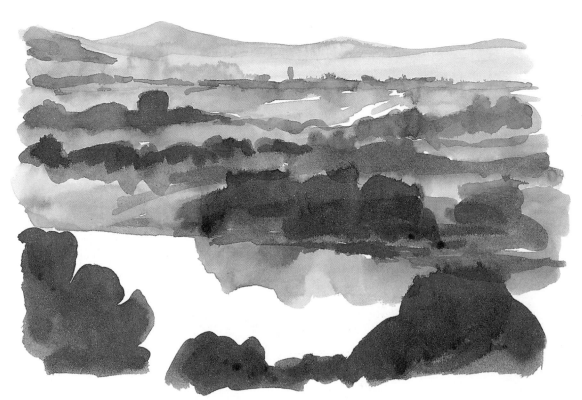

In this wash drawing of the Tiber at Rome the tones gradually darken as we approach the foreground. The dark tone is relieved by the white patch of the river, reflecting the light sky with a suggestion of reflection in a softer tone.

Lorrain gives a lesson in how to draw nature in this study of a tree. Executed with much feeling but great economy, the whole drawing is done in brushwork.

To try this you need three different sizes of brush (try Nos. 0 or 1, and 6 and 10), all of them with good points. Put in the lightest areas first (very dilute ink), then the medium tones (more ink less water), and then the very darkest (not quite solid ink).

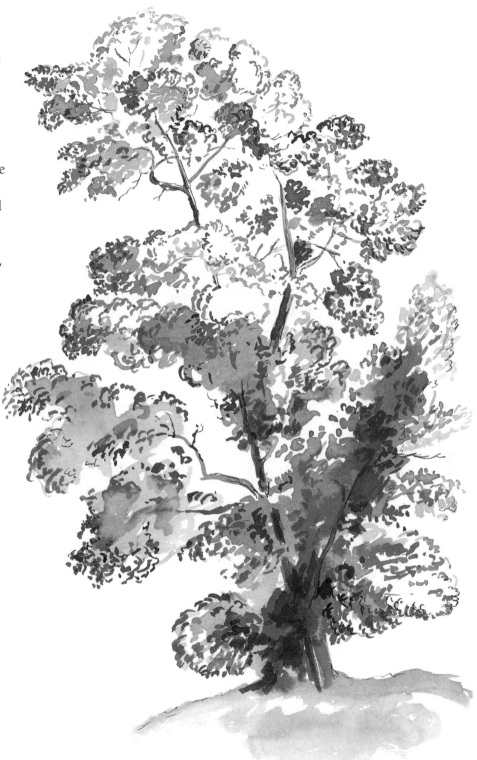

Notice how Lorrain doesn't try to draw each leaf, but makes interesting blobs and scrawls with the tip of the brush to suggest a leafy canopy. With the heavier tones he allows the brush to cover larger areas and in less detail. He blocks in some very dark areas with the darkest tone and returns to the point of the brush to describe branches and some clumps of leaf.

PRACTICE WITH BRUSH AND WASH

One of the most effective, and fun, ways of capturing tonal values is to do them in brush and wash. In this view of the Venetian lagoon in early morning, looking across from the Guidecca to the island of San Giorgio, its Palladian church etched out against the rising sun, the use of wash makes the task of producing a successful result much simpler. Getting the areas of tone in the right places is the key to success. It doesn't matter if your final picture is a bit at variance with reality. Just make sure the tones work within the picture. More confidence is needed for this kind of drawing, and it is advisable to practise your brush techniques before you begin to

make sure the wash goes on smoothly. Don't worry if you make a mistake. You certainly won't get it right first time, but over time you will come to appreciate the greater realism and vividness this technique allows.

Begin by sketching out very lightly the outline shape of the background horizon and the buildings. Don't overdo the drawing; keep it to a minimum. If you are feeling very confident, use the brush for this first stage.

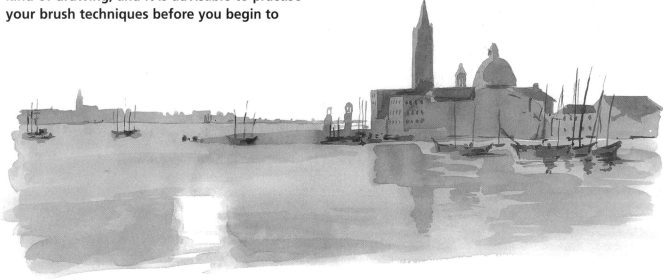

1. The first tone to put in is the lightest and most widespread, which shows us the horizon line and the basic area of the buildings with differentiation except where they jut up above the horizon and are outlined against the sky. Leave a patch of white paper to indicate the lightest reflection in the water. Don't worry if your patch doesn't quite match the area that you can see.
2. Your second layer of tone should be slightly heavier and darker than the first. This requires more drawing ability, because you have to place everything as close as possible to effectively show

up the dimension of the buildings. Also with this tone you can begin to show how the reflections in the water repeat in a less precise way the shapes of the buildings. Once again, try to see where the reflections of light in the water fall.
3. The third layer of tone is darker still. With this you can begin to sharply define the foreground areas. The parts of the buildings strongly silhouetted against the sky are particularly important. Now put in the patches showing the boats moored near the quay and the dark, thin lines of their masts jutting up across the sky and buildings.

First the main shape of the island and its church was brushed in with a medium tone of wash. Then, while it dried, the far-distant silhouette of the main part of Venice was brushed in with the same tone. Then the darker patches of tone on the main area were put in, keeping it all very simple. Now it was possible to wash in a fairly light all over tone for the water, leaving one patch of white paper where the reflected sun caught the eye. Even darker marks could now be put in with a small brush to define the roofs, the windows and the boats surrounding the island. The reflections in the water are put in next. After that, when all is dry, add the very darkest marks such as the details of the boats, to make them look closer to the viewer than the island and background.

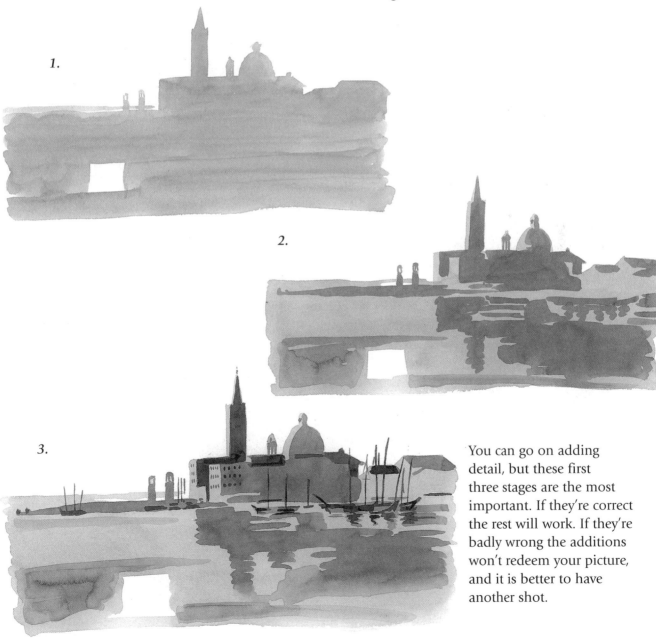

1.

2.

3.

You can go on adding detail, but these first three stages are the most important. If they're correct the rest will work. If they're badly wrong the additions won't redeem your picture, and it is better to have another shot.

TECHNIQUE

WASH AND BRUSH EXERCISE

For this exercise I have chosen a shiny saucepan. As you will have already discovered when carrying out some of the practices on the earlier pages, obtaining a realistic impression of a light-reflecting material such as metal can only be achieved if you pay particular and careful attention to the tonal contrasts.

Begin by outlining the shape of the saucepan. The critical proportion you have to get right is the relationship between the object's cylindrical body and its long, tubular handle. I chose to place the handle slightly angled towards me to get an effect of it jutting out of the saucepan.

When the outline is in place, use a larger brush to put in the main areas of tone; in our example they are in a mid-tone of grey. The highlights were denoted by leaving the paper bare.

For the final stage, take a smaller, pointed brush and work up the detail, applying darker and darker tones. If you inadvertently cover the bright areas, go over them with white gouache to re-establish the highlights.

TECHNIQUE

PEN AND WASH AND PASTEL

The use of different media is very much a question of choice by the artist working, but it is a good idea to try out different media to give you an idea about which techniques you may want to use when confronted by decisions in drawing.

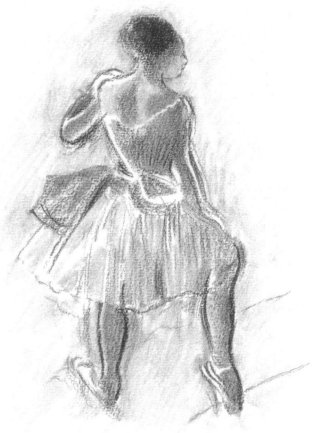

Degas's pastel drawing of a ballet dancer practising point exercises is one of many he produced during the 1860s. His brilliant use of pastel gives great softness and roundness to the form and his masterly draughtsmanship ensures that not a mark is wasted. This is a very attractive medium for figure studies because of its speed and the ability to blend the tones easily.

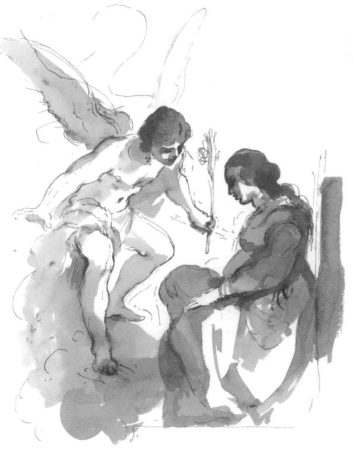

This drawing made by the Italian master Guercino in 1616 was a sketch for a small devotional picture of the Annunciation with the Archangel Gabriel descending from heaven bearing a lily, symbol of Mary's purity. The line in ink which Guercino uses to trace out the figures is very attractive, because although it is sensitive it also has a confidence that shows his great ability. The drawing has areas of tone washed in with watered-down ink and the wet brush has also blurred some of the lines, as the ink is not waterproof. His handling of dark areas contrasting with light is brilliant, and shows why his drawings are so much sought after by collectors.

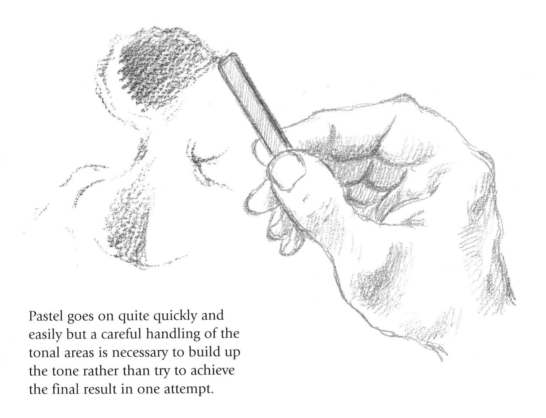

Pastel goes on quite quickly and easily but a careful handling of the tonal areas is necessary to build up the tone rather than try to achieve the final result in one attempt.

This illustration shows the use of pen with wash, alternating the fine line of the pen with the floating on of tone which blurs some of the areas where roundness is needed.

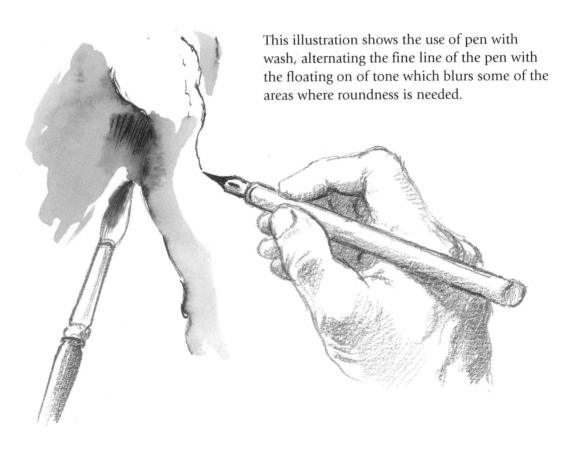

TECHNIQUE

CHALK

A copy in chalk of a portrait of
Jean Edouard Vuillard's mother,
done when she was in her eighties,
describes age in a most economical
way. Echoing the original, I was
sparing with the tone and detail,
and allowed the wavering lines to
follow the gentle loosening form of
flesh on the ageing face.

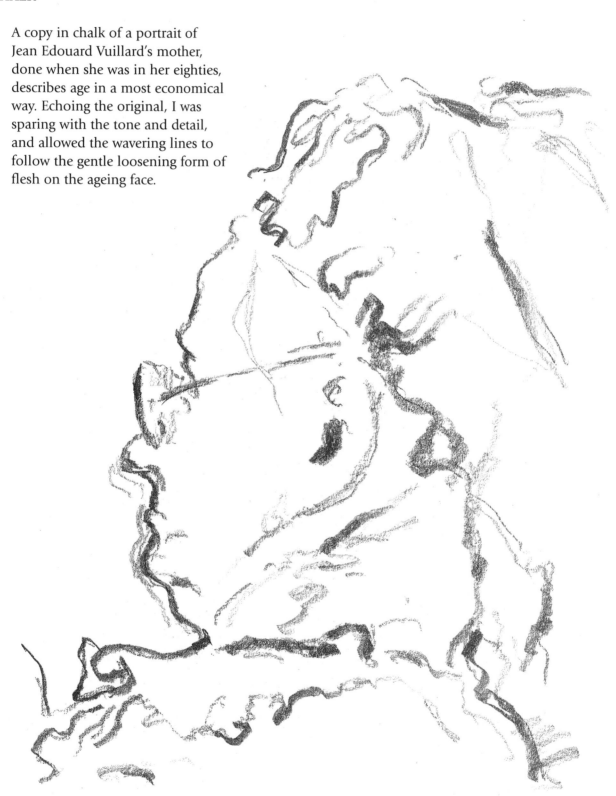

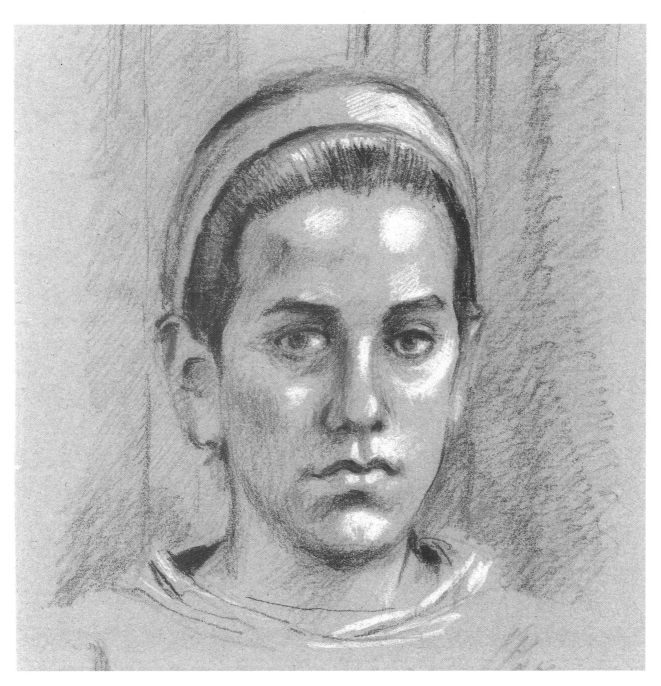

The most dimension is achieved for the least effort in this example. The reason is the use of three materials in combination: brown and terracotta conté pencil, white chalk and toned paper. These give such a range of tones that they obviate the need to work a drawing too heavily. Notice how the strong emphasis provided by the darker of the conté pencils is kept to a minimum, sufficient to describe what is there but no more. Similarly the

chalk is used only for the strongest highlights. The mid-tone is applied very softly, with no area emphasized over-much. The toned paper is a great asset and does much of the artist's work, enabling rapid production of a drawing but one with all the qualities of a detailed study. Often you will find it effective to include some background to set off the lighter side of the head, which in this example is the right side as we look at it.

TECHNIQUE

CHALK ON TONED PAPER

The use of toned paper can bring an extra dimension to a drawing and is very effective at producing a three-dimensional effect of light and shade. Whether you are drawing with chalk, pastel or charcoal it is very important to remember that the paper itself is in effect an implement, providing all the tones between the extremes of light and dark. You must resist the temptation to completely obliterate the toned paper in your enthusiasm to cover the whole area with chalk marks. Study the following examples.

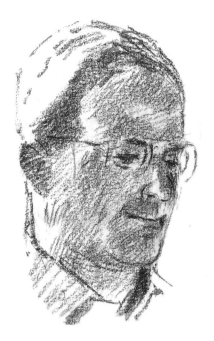

This head is drawn simply in a medium toned chalk on a light paper. Here the challenge is not to overdo the details. The tones of the chalk marks are used to suggest areas of the head, and definite marks have been kept to a minimum.

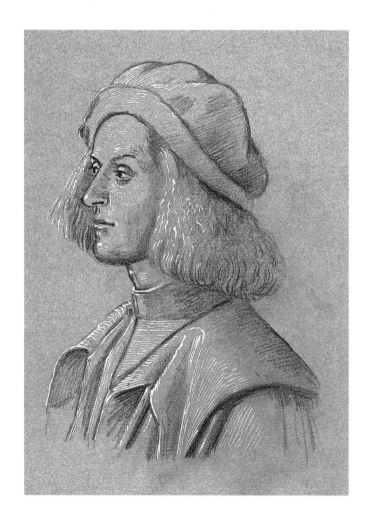

The mid-tone of the paper has been used to great effect in this copy of Carpaccio's drawing of a Venetian merchant. Small marks of white chalk pick out the parts of garments, face and hair that catch the light. No attempt has been made to join up these marks. The dark chalk has been used similarly: as little as the artist felt he could get away with. The medium tone of the paper becomes the solid body that registers the bright lights falling on the figure. The darkest tones give the weight and the outline of the head, ensuring that it doesn't just disappear in a host of small marks.

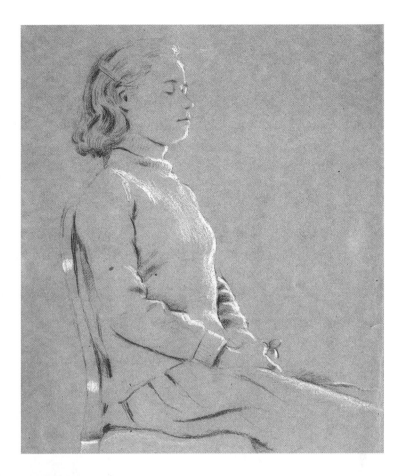

These two drawings were executed in white and dark chalk on medium toned paper. The approach taken with the first is about as economical as you can get. The form of the surface of the girl's face and figure is barely hinted at down one side, with just the slightest amount of chalk. A similar effect is achieved on the other side, this time in dark chalk. The uncovered toned paper does an awful lot of the rest of the work.

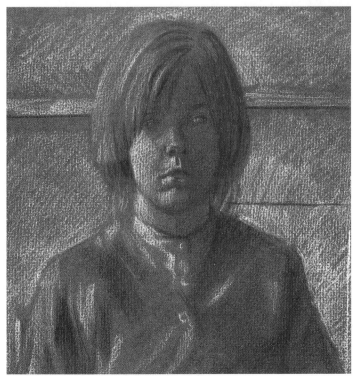

The second drawing takes the use of dark and light much further, creating a substantial picture. In places the white chalk is piled on and elsewhere is barely visible. The dark chalk is handled in the same way. More of the toned paper is covered, but its contribution to the overall effect of the drawing is not diminished for that.

TECHNIQUE

CHALK

The method used for chalk is quite varied and also depends upon the quality of the chalk. Some are quite hard and wear down slowly; others are very soft or crumbly. They demand slightly different handling, so try a variety of them to discover which type you prefer to work with.

The easiest way to use chalk is on a tinted paper, especially one that has a slightly rough or matt surface; a smooth surface refuses the chalk sometimes, so paper with some texture produces a better quality of line. You will be able to buy some good papers for this medium from your local art shop.

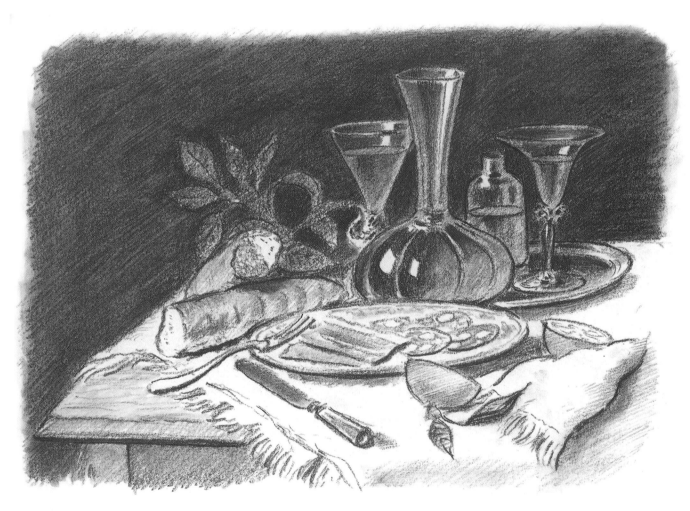

You can take the classical method (similar in some respects to the pencil technique) of building up your picture with layers of hatched chalk lines, all in the same direction, which creates areas of uniform and variable tone to describe the form of the objects on show. Here you have to be very careful not to smudge the lines, because their effectiveness depends on their beauty of gradation

from one tone to the next. Nothing is left to chance in this method, and it has to be carefully planned to get the well-tempered effect.

Two shades of tone go a long way to help make this still life work, but don't use white chalk here, where the paper is white. You must allow the white of the paper highlights to show, or you will lose half the brilliance.

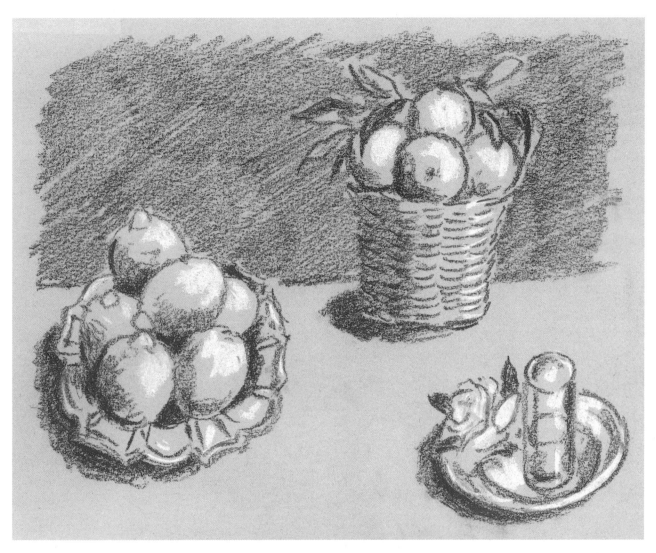

This still life is on tinted paper in a dark and a white chalk. The paper produces the half tones, the dark chalk the deeper shadows and outlines and the white chalk the highlights and bright spots. It is a very effective method, with economical amounts of drawing to be done; you let the tone of the paper do the work, with you just putting in the more extreme shadows and highlights. You will probably have to fix the final result with a good fixative spray, available from any art shop.

Use the chalk as shown, very lightly stroking the surface of the paper. A carefully sharpened end will give you finer lines. Never apply heavy pressure, which will always give a coarse effect.

TECHNIQUE

SCRAPERBOARD TECHNIQUE

Scraperboard drawing evolved during the early days of photographic reproduction in newspapers as a response to the needs of advertisers, who wanted to show their wares and products to best advantage but were limited by the poor quality of the printing processes then available. The technique gave very clear, precise definition to photographs, and so became the means of rendering advertisements for newsprint. Over time, of course, the screen printing of photographs improved so much that it has become just another art technique. Scraperboard does have some qualities of its own, however. It is similar in some respects to wood engraving, wood cuts or engraving on metal, although because of the ease of drawing it is more flexible and less time-consuming.

In this drawing the boatman appearing across a misty lake or river was first sketched in pencil, then blocked out in large areas of ink. The figure of the man, the oars and the atmospherics were done in diluted ink to make a paler tone. The boat was drawn in black ink. Using a scraperboard tool, lines were carefully scratched across the tonal areas, reducing their tonal qualities further. Some areas have few or no scratched lines, giving a darker tone and an effect of dimensionality.

You can see in the two examples below how scraperboard technique lends itself to a certain formalized way of drawing. The scratch marks can be made to look very decorative. The Christmas Card drawing and lettering is in a very similar technique and has been produced using both scraper-board and pen and ink. The main effort is taken up with making the shapes decorative and giving the main lines a textural quality; this is achieved by using either a brush or the side of a flexible nib.

The top illustration was first drawn in black ink. The areas of ink were then gone over using the scraper tool to reduce the heaviness of the shaded areas and clean up the edges to achieve the shape required.

The Xmas card drawing is mainly thick line in brush with a few lines in pen added afterwards to provide details. The scraper tool was then used to sharpen up the outline and the spaces between the areas of black.

Using the Technique
Scraperboard technique is similar to cross-hatching with a pencil, although of course with the former you are drawing white on black. The china clay surface of the board can be scratched over several times if it is not cut too deeply. Any areas requiring strengthening or correction can be filled in with ink. Correcting lines using this technique is very easy: you just scratch out the wrong bits and redraw.

MERRY CHRISTMAS

SAME SCENE, DIFFERENT TECHNIQUE

There is more than one way of drawing landscapes. People often think, erroneously, that everything has to be drawn exactly as it would be seen by the eye or lens of a camera, and if a high degree of verisimilitude is not achieved a drawing is worthless. Here are two different approaches to the same landscape. Beginners who are not confident of their drawing skills might find the technique used in the second of these worth considering.

The difference between distant and close-up objects is made obvious by means of texture, definition and intensity. The weight and thickness of line varies to suggest the different qualities of features and their distance in relation to each other and the viewer.

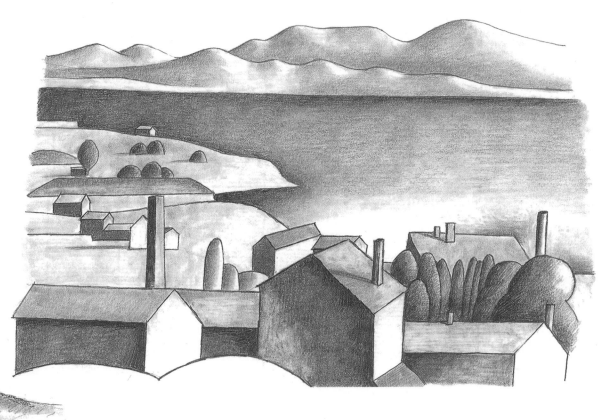

Here an attempt has been made to create an extremely simple scheme of solid forms. The only difference between the treatment of nearer forms and further ones is in intensity. Every detail has been subsumed in the effort to describe the solidity of the forms in a very simple way. The result is a sort of sculptural model universe where the bulk of the form is clearly shown but the differences in texture or detail are greatly reduced. The effect is of a very strong three-dimensional landscape, albeit one that is rather detached from the way our eyes would really see it. Nevertheless many artists have used this increase in total form successfully.

SAME OBJECT, DIFFERENT MEDIA

Taking an object and drawing it in different types of media is another very useful practice when you are developing your drawing skills. The materials we use have a direct bearing on the impression we convey through our **drawing. They also demand that we vary our technique to accommodate their special characteristics. For the first exercise I have chosen a cup with a normal china glaze but in a dark colour.**

Drawn in pencil, each tonal variation and the exact edges of the shape can be shown quite easily – once you are proficient, that is.

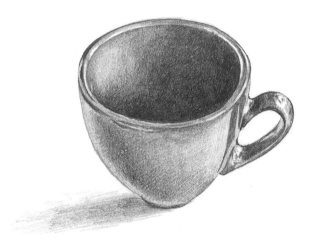

Attempt the same object with chalk (below) and you will find that you cannot capture the precise tonal variations quite so easily as you can with pencil. The coarser tone leaves us with the impression of a cup while showing more obviously the dimension or roundness of the shape. A quicker medium than pencil, chalk allows you to show the solidity of an object but not its finer details.

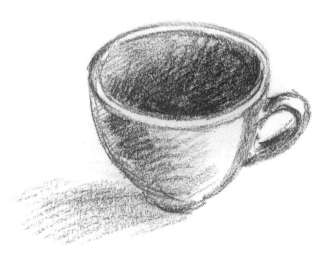

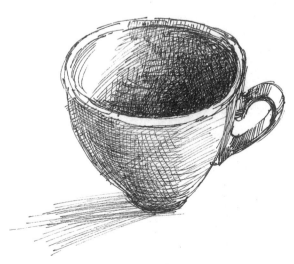

Although ink (left) allows you to be very precise, this is a handicap when you are trying to depict the texture of an object. The best approach is to opt for rather wobbly or imprecise sets of lines to describe both the shape and texture. Ink is more time-consuming than either pencil or chalk but has the potential for giving a more dramatic result.

If you want to make what you are drawing unmistakable to the casual viewer, you will have to ensure that you select the right medium or media. Unfortunately for the beginner, in this respect the best result is sometimes achieved by using the most difficult method. This is certainly the case with our next trio, where wash and brush succeed in producing the sharp, contrasting tones we associate with glass.

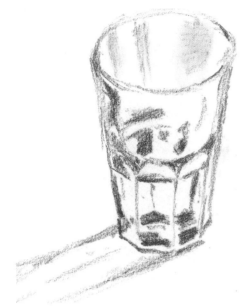

Although this example in chalk is effective in arresting our attention, it gives us just an impression of a glass tumbler.

The quality of the material is most strikingly caught with wash and brush, which produces hard, bright surfaces and the illusion of light coming from behind the object.

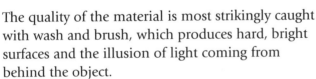

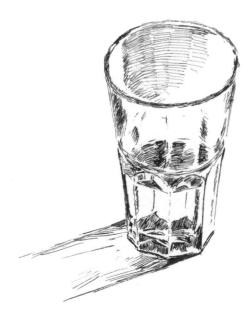

Pen and ink is a very definite medium to work in. Here it allows the crispness of the glass edges to show clearly, especially in the lower half of the drawing.

Now, looking at a still-life arrangement of some objects gathered together in a Morandi-like arrangement, let us try out different methods of expression in different mediums.

Here we have a group of precious objects from Persian civilization arranged in a simple composition. The group does not have a great deal of depth and is set on a well-lit surface against a dark background. I've tried it out in two ordinary media: pencil and brush and wash, for which you can use either ink or watercolour. The arrangement remains the same but, as you can see, the change of medium creates a different look.

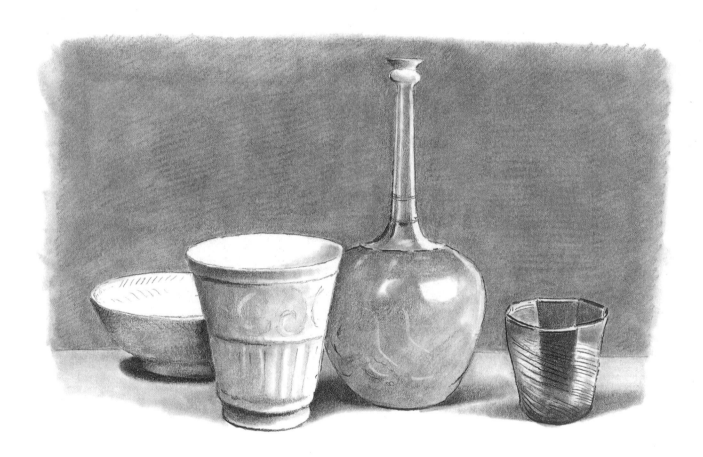

First, a fairly soft pencil (2B) gave me clearly defined edges and grey tones, producing an effect of light and shade and textural surfaces such as glass, porcelain and so on.

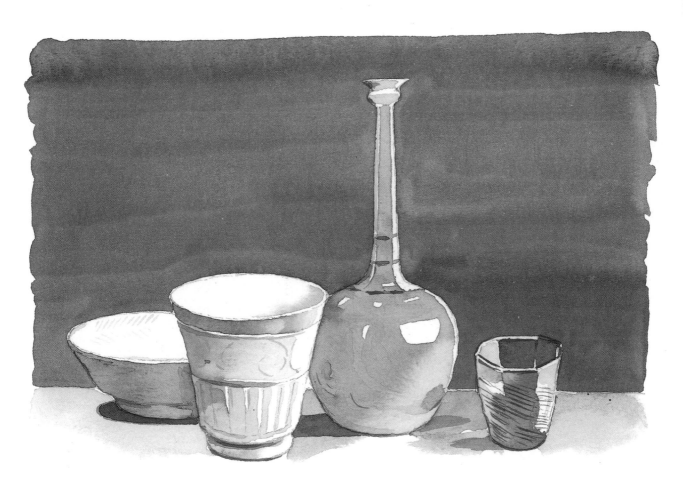

In this watercolour version of the same composition, grey tones have been washed on in large areas. This doesn't give quite the same surface effect as pencil, but is a more dynamic medium that creates an instant attraction. Both versions rely on fairly accurate outlines to start with. In this example you can see how the same picture can be made to look very different simply by a change of medium.

For more on Morandi, see pages 516–517.

EFFECTS WITH TECHNIQUE

There are various ways of producing an effective picture by varying the technique you use. Here are a few variations in the treatment of the head of a young man to show you some of the stylistic possibilities.

The tones have been worked over with a stub, smudging the pencil to produce a softer, more gradual tonal effect on the areas of shadow. This approach requires fairly vigorous handling of the pencil and the production of strong lines to ensure that the smudging is effective.

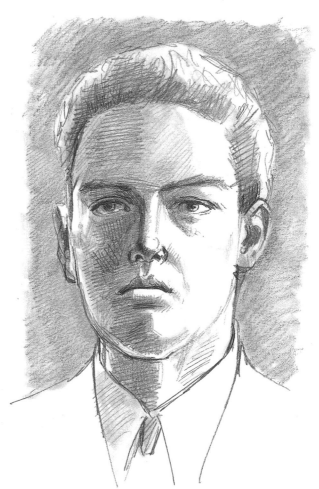

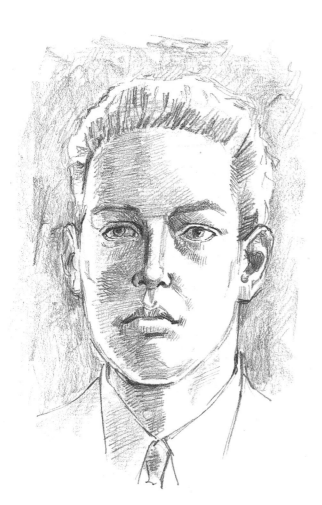

Two grades of pencil (B and 2B) have been used to create texture within the tone. The softer tonal areas, such as the background and hair, were achieved by means of a graphite pencil stick.

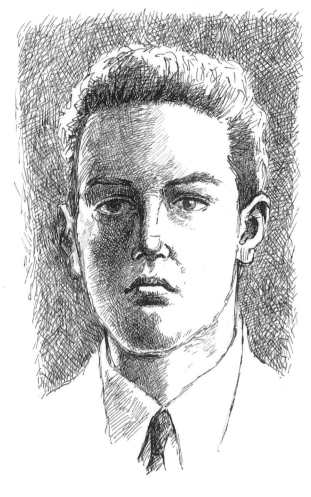

The method used here, in ink, is time-consuming. The tonal areas have been carefully built up with different kinds of cross-hatching and random strokes, giving a solid feel to the head and allowing an exploratory approach to the shape and form.

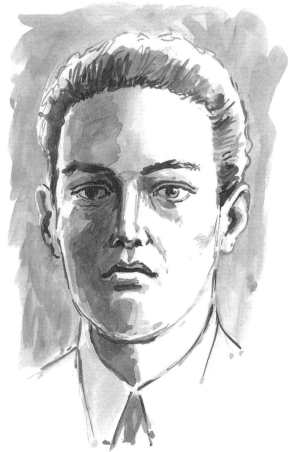

Using a brush and ink or watercolour in one colour will give a painterly feel to your portrait. When attempting this approach, don't be too exact with your brush-strokes. Build up the outlines with fairly loose strokes and then fill in the large areas of tone, initially with very pale washes and then with darker washes.

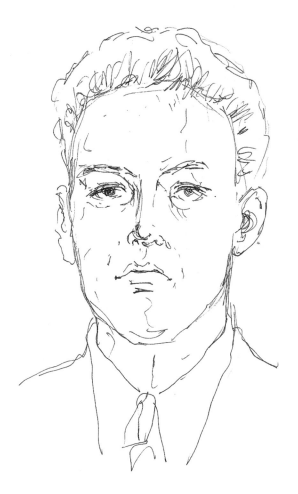

There has been no attempt to build up tone in this example in ink. Open and loosely drawn, it is a very rapid method requiring confidence and facility with the pen. You need to feel your way with your strokes and, as with the previous example, resist the temptation to be too precise.

Up to this point the examples given have been explorations of what you see. This next method is all about using technique to capture form, not likeness. For this approach the initial drawing of the shapes of the head and features has to be very accurate, otherwise the simplification and smoothing out that is the essence of this method will render the final result a bit too perfect in form. You may find that your first swift drawing has captured more of a likeness of the sitter than has your finished drawing. Once you have got the features and tonal areas down, you begin the technical exercise of making the outlines very smooth and continuous so there are no breaks in the line. Then, with a stub, work on the tonal areas until they grade very smoothly across the surface and are as perfect in variation and as carefully outlined as it is possible to make them.

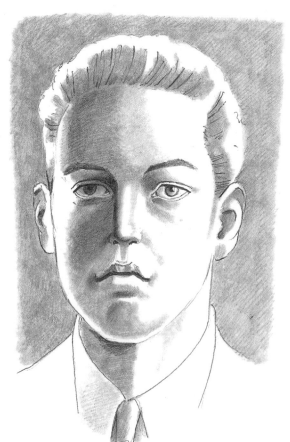

UNCONVENTIONAL TECHNIQUES

The last and probably for most people the least likely technique to be attempted is silverpoint drawing, the classic method used in the times before pencils were invented. Many drawings by Renaissance artists were made in this way. Anybody interested in producing very precise drawings should try this most refined and effective technique.

First you have to buy a piece of silver wire (try a jeweller or someone who deals in precious metals) about a millimetre thick and about three inches long. This is either held in a wooden handle taped to it or – the better option – within a clutch-action propelling pencil that takes wire of this thickness.

Then you cover a piece of cartridge paper (use fairly thick paper because it is less likely to buckle) with a wash of permanent white gouache designer paint; the coat must cover the whole surface and mustn't be either too thick or too watery. When the white paint has dried, you draw onto it with the silver wire; ensure that the end of the wire is smooth and rounded to prevent it tearing the paper. Don't press too hard. The silver deposits a very fine silky line, like a pencil, but lasts much longer. Silver point is a very nice material to draw with. I thoroughly recommend that you make the effort to try it. It's very rewarding as well as instructive.

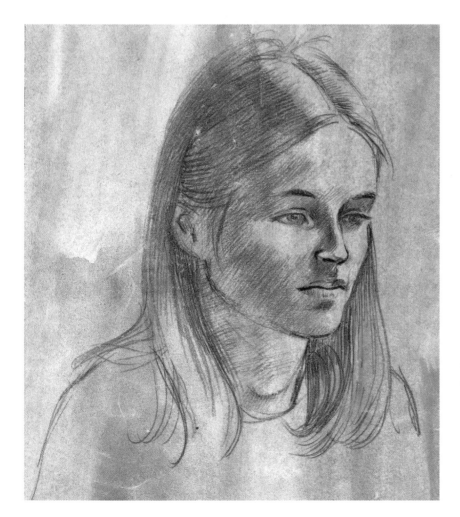

To use silver point you need to prepare a background to draw onto. I drew this example onto white paint with a bit of reddish-brown mixed in.

TECHNIQUES THROUGH THE AGES

TECHNIQUE

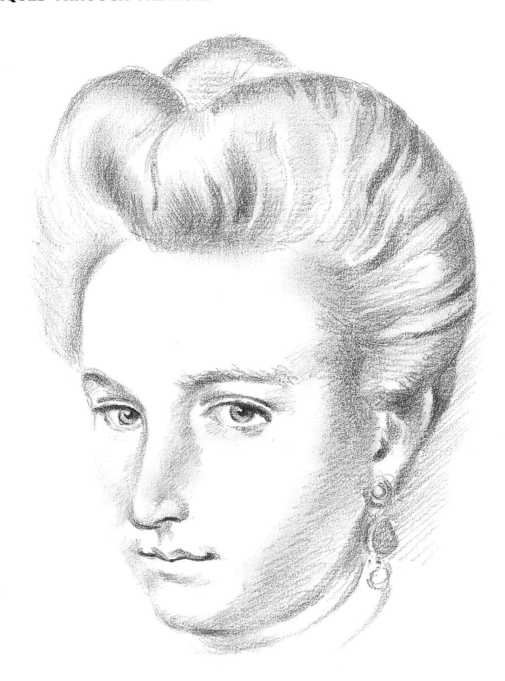

This copy of a portrait of Gabrielle d'Estrées by a follower of
François Clouet was executed by carefully stroking on lines of soft
B and 2B pencil. In some areas chalk was carefully put in. Sharp
lines have been applied only around the eyes, nostrils and mouth.
Clouet reveals her as wary and self-composed beyond her eighteen
years, and yet we are not convinced this is more than a pose.

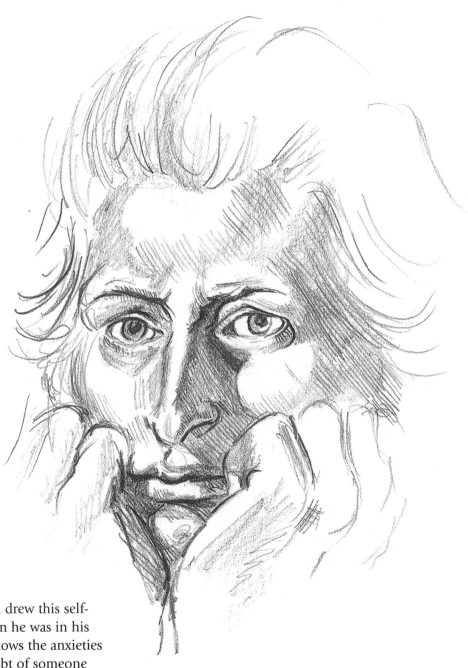

Henry Fuseli drew this self-portrait when he was in his thirties. It shows the anxieties and self-doubt of someone mature enough to be aware of his own shortcomings. B and 2B soft pencils were used for this copy to capture the dark and light shadows as well as the sharply defined lines depicting the eyes, nose and mouth.

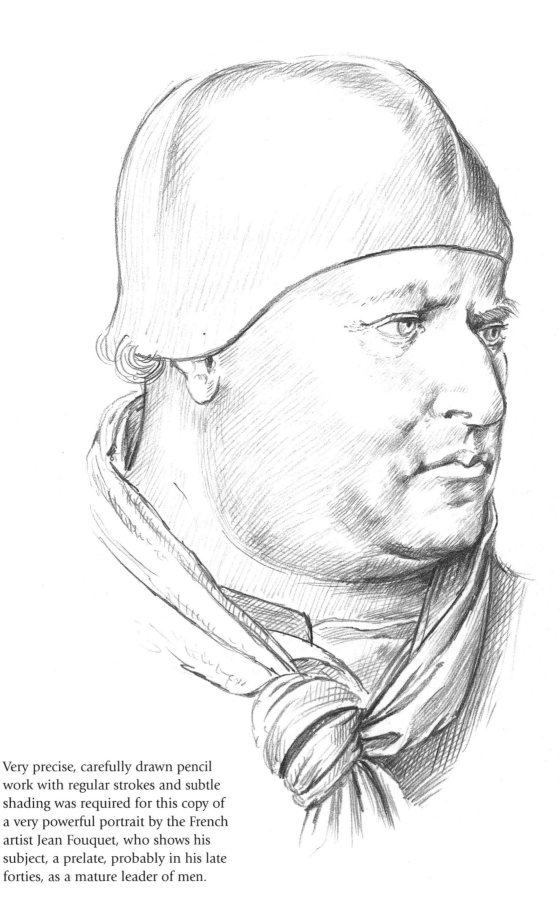

Very precise, carefully drawn pencil
work with regular strokes and subtle
shading was required for this copy of
a very powerful portrait by the French
artist Jean Fouquet, who shows his
subject, a prelate, probably in his late
forties, as a mature leader of men.

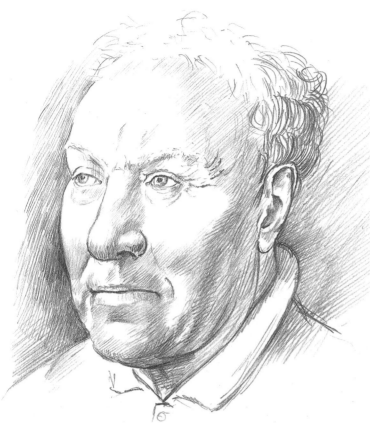

We happen to know that the sitter of this portrait by Jan Van Eyck, the Cardinal of Sante Croce, Florence, is fifty-six years old. The lines of the eyes, ears, nose, mouth and outline of the face are precise and give clear signs of the ageing process. The technique is generally smooth and light with some cross-hatching in the tonal areas. Although Van Eyck portrays his subject as still powerful, there is also a sense of resignation.

Rembrandt drew himself throughout his life, from early adulthood until just before his death, and has left us an amazing record of his ageing countenance. In this copy of a self-portrait done when he was about sixty years old, a smudgy technique with a soft 2B pencil was used in imitation of the chalk in the original.

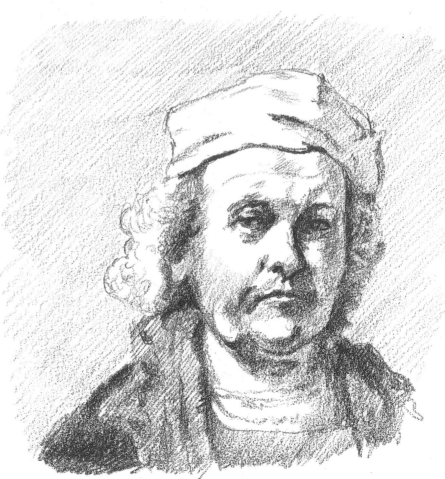

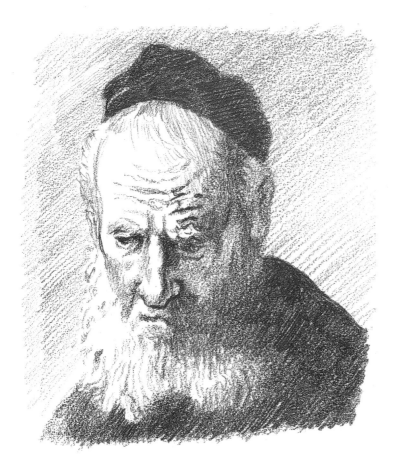

The definition in this copy of Rembrandt's portrait of his father, who was in his early seventies, derives from the use of tonal areas instead of lines. The technique with the pencil is very smudgy and creates an effect that is very similar to one you would get with chalk.

Drawn in pen and ink, after Guercino, these two examples are graphic depictions of the ravages of age, although there is no record of how old the men were. I tried to emulate Guercino's methods, using bold strokes in some places (hair and hood) with tentative broken lines.

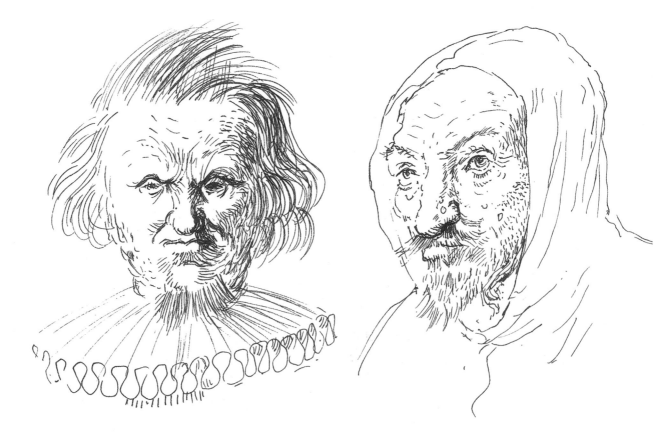

The original of this portrait of a dreamy ten-year-old boy, by Antonella da Messina, was done in silverpoint. In this copy a B pencil was used throughout, producing closely grouped lines with a little cross-hatching on the face and very sharp, clear lines around the eyes, mouth and for the main strands of hair.

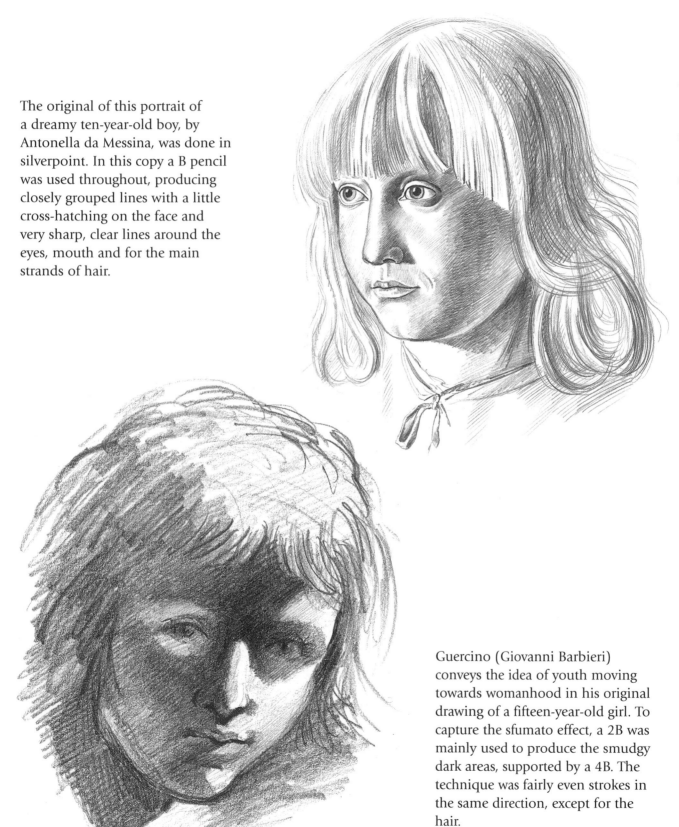

Guercino (Giovanni Barbieri) conveys the idea of youth moving towards womanhood in his original drawing of a fifteen-year-old girl. To capture the sfumato effect, a 2B was mainly used to produce the smudgy dark areas, supported by a 4B. The technique was fairly even strokes in the same direction, except for the hair.

COMPOSITION

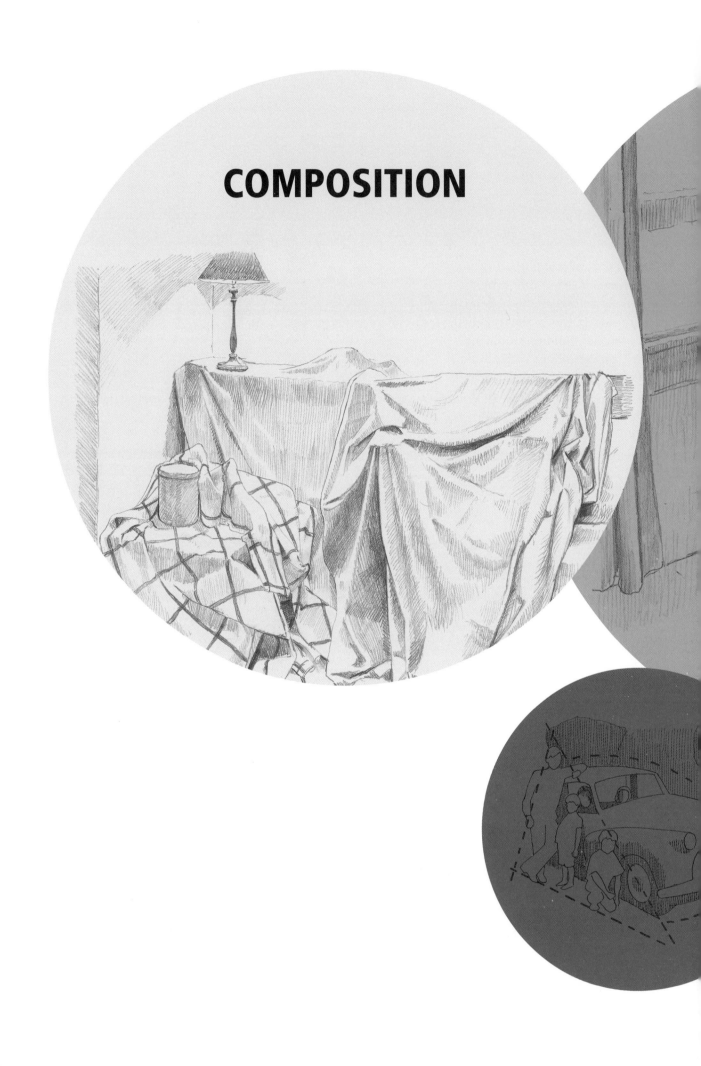

With practice, anyone can learn to draw the basic parts of a picture, but composing or designing the whole effect is a different matter altogether. This is the most interesting and rewarding stage of an artist's work, and also the most difficult. Both intellectually and emotionally challenging, composition reveals either an artist's vision or his lack of it.

When we embark on designing a composition, we instinctively look for the best way to express our experience. If we are drawing from nature, we may arrange our subject or our own viewpoint in order to get the best possible view. A landscape obviously can't be moved around in reality, but most artists adjust parts of it graphically to suit their composition. If a tree is in the 'wrong' place it can be left out of the picture or moved around on the canvas without too much difficulty.

When it comes to portraits, apart from getting the best light, background and profile, you can also look at clothes, hairstyle and accessories to make a difference to your composition. The decision to draw just the head, or head and shoulders, half-length or full-length can also greatly affect the final result. Many compositions are produced simply by means of using geometric principles. The discipline of geometry is often used by artists to create harmony and balance.

Every picture needs careful consideration to bring out its full potential. Sometimes you'll find yourself changing your approach at least once to get a drawing right.

EMPHASIS AND LOCATION

In this section we look at compositional methods over a range of genres, from landscape to still life. The examples included are in different styles and in time extend from the Renaissance to the 20th century. All of them contain devices designed to draw you in and ensure you understand the point of the drawing. The diagrams are included to indicate the narrative flow and show you how the visual attention is attracted from one part of a picture to another.

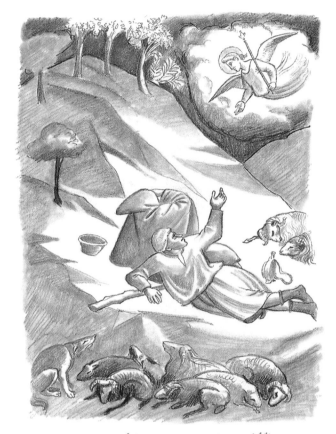

In this straightforward narrative (a copy of Taddeo Gaddi's mural of the Annunciation to the shepherds, in Santa Croce, Florence), we see the shepherds reacting to a bright light in the middle of the picture, on a steeply sloping hill with some trees at the top. In the top right-hand corner there's an area of dark sky and an angel floating out of a brightly lit cloud, indicating to the shepherds. Down at the bottom, there's a small flock of sheep with a dog looking on. The position of the angel swooping downwards and the shepherds angled across the centre of the picture give an unambiguous, almost strip-cartoon version of the story. The brightness of the angel tells us of his importance, and the position and actions of the shepherds mark them out as central characters. Everything else in the picture is just a frame to convince you that this is outdoors and a fitting context for the shepherds.

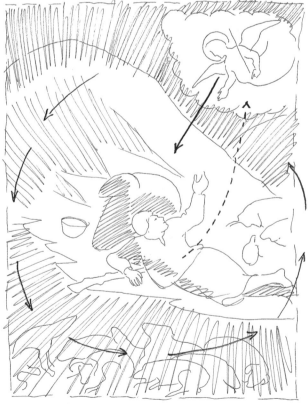

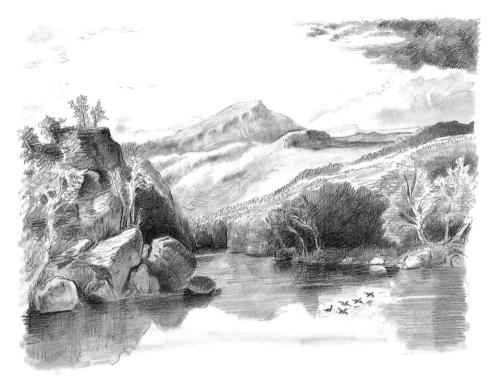

This is a copy of a landscape by the 19th-century American painter John Kensett. Rocky wooded banks curve into the picture at about centre-stage. To help the viewer Kensett has included a group of wildfowl just about to take off from the water. The viewer's attention is immediately grabbed by this movement, and by the detail of the foreground rocks. The inward curve of the water pulls your eyes to the distant mountain peak, rearing up above the surrounding hills. Even the cloudscape helps to frame the rather distinctive mountain, which is on the centre line. Kensett uses these very precise devices to get us to look at the whole landscape and appreciate the singularity of its features.

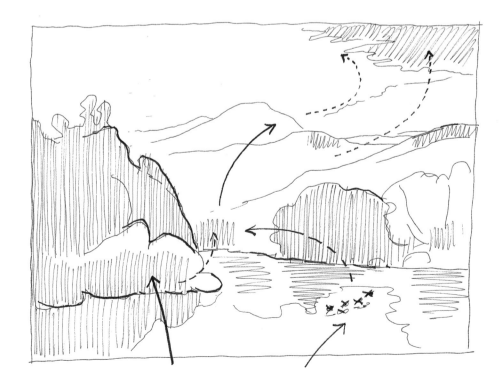

COMPOSITION

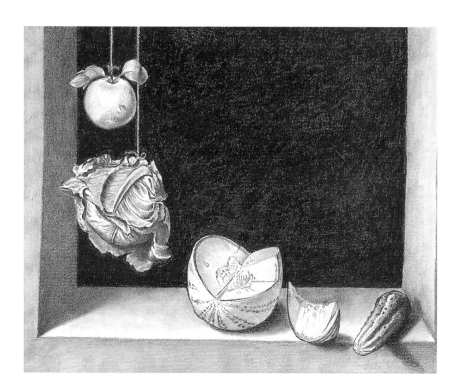

The Spaniard Juan Sánchez Cotán found an effective, dramatic way to arrange and light quite ordinary objects in this still life. The dark background, the dangling fruit and cabbage, the cut melon and aubergine on the edge of the ledge produce an almost musical sweep of shapes, all highlighted dramatically. Would Cotán have seen fruit and vegetables arranged like this in late 16th/early 17th century Spain, or did he create this design himself specifically for his painting? Either way, the arrangement is very effective and a brilliant way of injecting drama into quite ordinary subject matter.

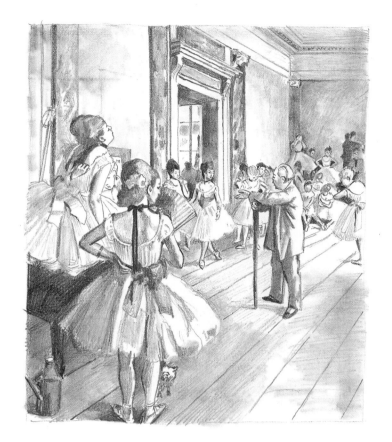

We return to Degas to finish this section. We are in a 19th-century dance studio, with a master continuing to instruct his pupils as they rest. All the attention is on the master with his stick, which he uses to beat out the rhythm. The perspective takes you towards him. The way the girls are arranged further underlines his importance. The beautiful casual grouping of the frothy dancers, starting with the nearest and swinging around the edge of the room to the other side, neatly frames the master's figure. He holds the stage.

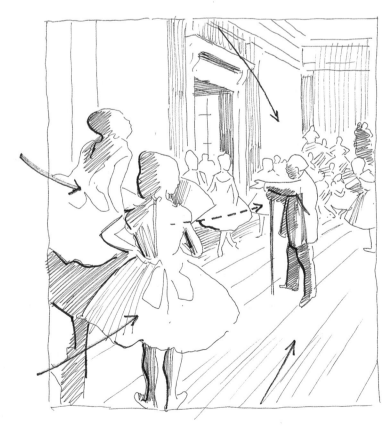

FRAMING THE PICTURE

A very useful tool to help you to achieve interesting and satisfying compositions is a framing device such as is shown here. It can be made cheaply by cutting it out of card to any size and format that you wish to work on. Holding it in front of you to look through it and moving it slightly up and down and from left to right will allow you to examine the relationship between the figure and the boundaries of the paper and visualize your composition before you actually begin to draw. It will also help you to see the perspective of a figure at an angle to you, as the foreshortening becomes more evident. Dividing the space into a grid will assist you in placing the figure accurately within the format when you draw it.

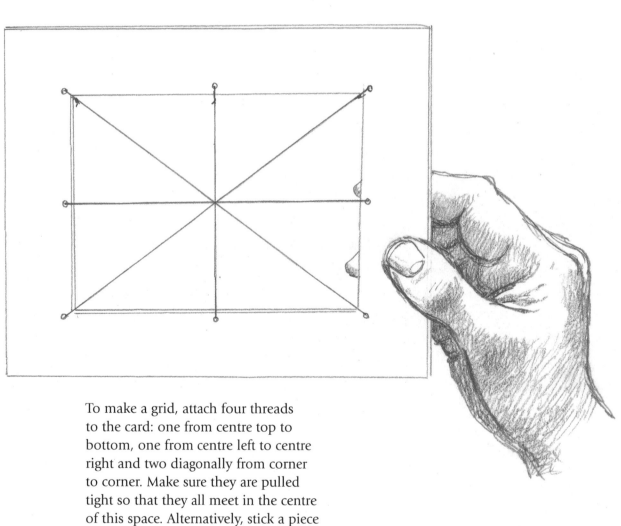

To make a grid, attach four threads to the card: one from centre top to bottom, one from centre left to centre right and two diagonally from corner to corner. Make sure they are pulled tight so that they all meet in the centre of this space. Alternatively, stick a piece of acetate across the central space with black marker lines drawn in the same way. Either method works, although the latter device sometimes reflects the light, which stops you seeing your model so easily.

USING SPACE

Think about the areas of paper around your figures; they should fulfill a purpose rather than appearing by default. Space in your composition can suggest as much about the **mood of the piece as the pose of figure itself. Planning ahead is what transforms a drawing of a figure into a complete composition that affects the emotion of the viewer.**

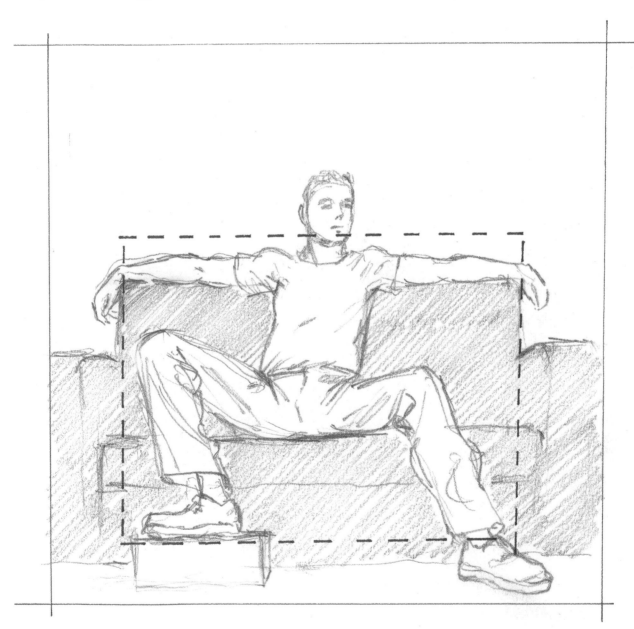

In this rather static pose, a young man is stretched out on a sofa. The pose is very foursquare, so that he looks extended to the rectangular shape of the seat. The only elements that slightly disrupt this solid pattern are his slightly raised leg and his head, which juts up above the main shape. He is set across the bottom half of the space with a significant area of space above him, creating a very steady, immobile composition. He not only inhabits the space, he takes it over.

WHEN THE RIGHT SIZE
IS THE WRONG SIZE

The drawings of objects and figures produced by beginners are usually rather small. This is due to the phenomenon of drawing what is called 'sight-size': the size a subject or object appears to your eye. As you can see from the illustrations here, if you let this be your guide, the size of that subject or object on the paper will be remarkably small. The margin for error at this size is equally small. Sight-size does have its uses, though, and the beginner may use it for measuring the shapes of very large objects, buildings or landscapes.

So, to start with, always draw to the largest size possible. On your sheet of paper, the objects or figures should take up most of the space. This is true whether you are drawing in a sketchbook at A4, on a sheet at A2 or on a large board at A0. If you draw large you can see your mistakes easily and are able to correct them properly because there is plenty of space to manoeuvre.

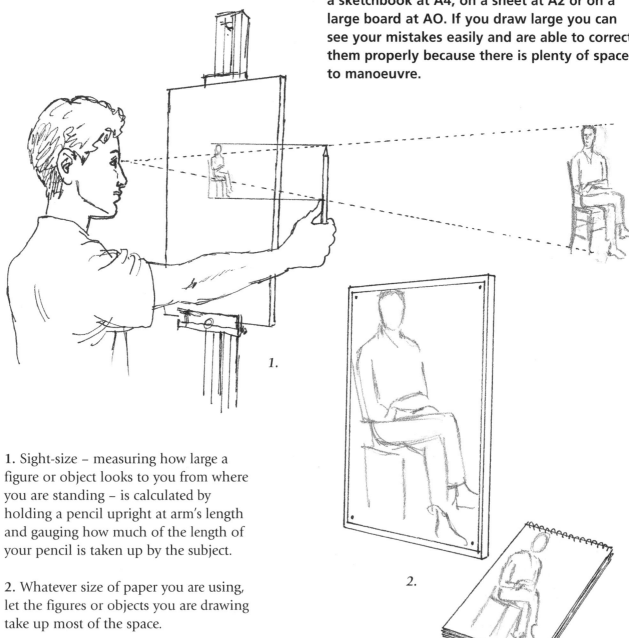

1.

2.

1. Sight-size – measuring how large a figure or object looks to you from where you are standing – is calculated by holding a pencil upright at arm's length and gauging how much of the length of your pencil is taken up by the subject.

2. Whatever size of paper you are using, let the figures or objects you are drawing take up most of the space.

The bigger the paper you use, the bigger your drawing has to be. This may seem daunting but it will give you more confidence when you get used to it. When you draw large, you begin to worry less about mistakes and have more fun correcting them. Eventually, of course, you can learn to draw any size: from miniature size to mural size is all part of the fun of learning to draw.

When you begin to feel more confident, fix several strips of underlay wallpaper to a wall and draw heroic size – that is, larger-than-life size. You will find the proportion goes a bit cock-eyed sometimes, but don't let that worry you. Drawing at larger-than-life size can be a very liberating experience. It can also show you where you are going wrong technically. Once you have identified your particular tendency for error, you will find that correcting it is relatively easy, enabling your skill to take a further step in the right direction.

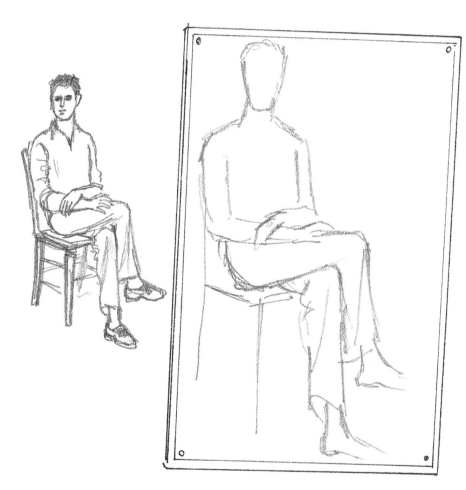

Drawing at larger-than-life size is both liberating and instructive. Errors are more easily seen and more easily corrected.

To start with you will probably find it difficult to draw large and will have to keep reminding yourself to be bolder and more expansive. It seems so natural to draw at sight-size in the beginning, but this has more to do with our natural self-consciousness and a mistaken belief that the smaller the drawing, the smaller the error. Once you discover how much easier it is to correct a large drawing, you will not want to go back to drawing at sight-size.

STARTING A COMPOSITION

For a landscape the easiest way to start a composition is with what is outside. What you see will be helpfully framed by the window, saving you the task of deciding on how much or little to include. Going out into the countryside will give you greater scope.

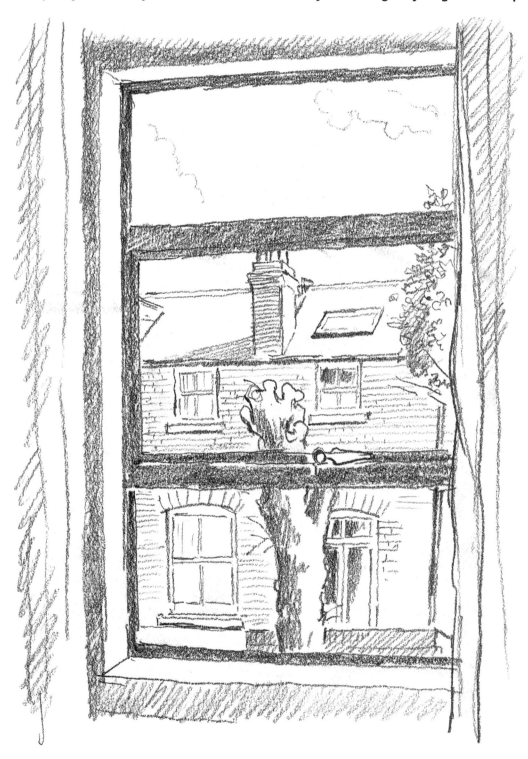

Once a scene is chosen, the main areas are drawn very simply. Noting where the eye-level or horizon appears in the picture is very important.

Attending to these basics makes it much easier to draw in the detail later.

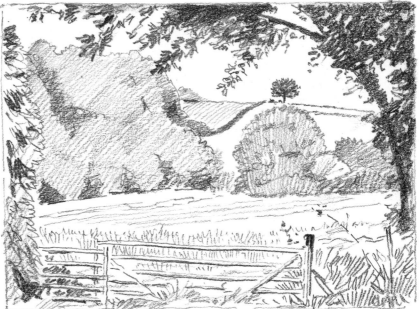

The hands can be used to isolate and frame a chosen scene to help you decide how much landscape to include.

FRAMING A VIEW

As discussed on page 362, one way to get a better idea of what you are going to draw is to use a frame instead of your hands. Most artists use a frame at some time to limit the borders of their vision and so help them to decide upon a view, especially with large landscapes.

In the first example below a very attractive Lakeland view has been reduced to a simple scene by isolating one part of it. With landscape drawing it is important to start with a view you feel you can manage. As you become more confident you can include more. You will notice how the main shapes are made more obvious by the framing method.

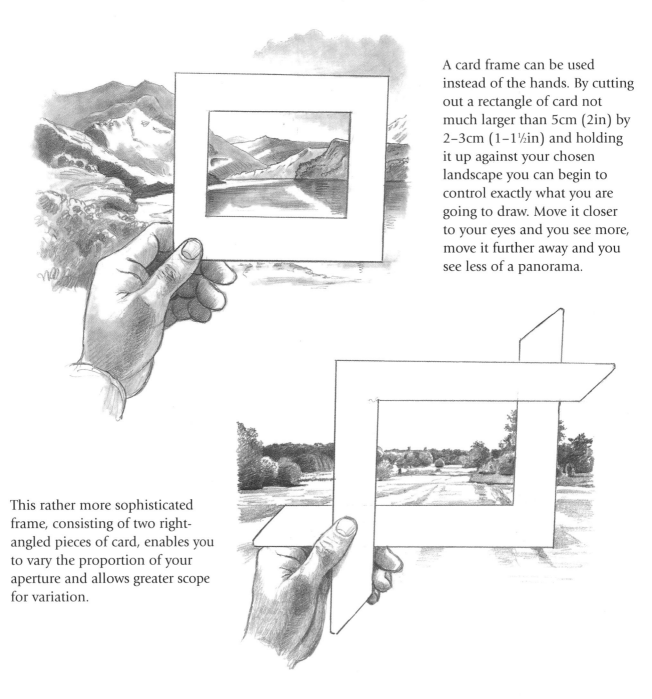

A card frame can be used instead of the hands. By cutting out a rectangle of card not much larger than 5cm (2in) by 2–3cm (1–1½in) and holding it up against your chosen landscape you can begin to control exactly what you are going to draw. Move it closer to your eyes and you see more, move it further away and you see less of a panorama.

This rather more sophisticated frame, consisting of two right-angled pieces of card, enables you to vary the proportion of your aperture and allows greater scope for variation.

THE WORLD AROUND US

To begin to draw landscapes, you need a view. Look out of your windows. Whether you live in the countryside or in the town, you will find plenty to interest you. Next go into your garden and look around you. Finally step beyond your personal territory, perhaps into your street. Once we appreciate that almost any view can make an attractive landscape, we look at what lies before us with fresh eyes.

The two views shown here are of the area around my home.

When I look out of the window, I see a graceful Mediterranean pine tree. It is so large it obscures most of the rooftops of the houses backing onto the garden. The window frame usefully restricts my angle of vision so that I have an oblique view of the fencing with its climbing ivy. Across the back of the garden is a fence with some small bushes. Plants grow under the window, their stalks cutting across my view. Apart from a few details of another house, this landscape is mostly of a large tree and a fence, and a few smaller plants.

In this view we are looking away from the pine. Behind the fence can be seen the roof of a neighbour's house and some trees. In the corner of my own garden there is a small shed with two small fir trees in front of it with a large log at their foot. The flowerbed to the right includes a large potted shrub, with ivy growing over the fence. Closer in is the edge of the decking with flowerpots and a bundle of cane supports. A small corner of the lawn is also visible. The main features in view are a fence, two trees and a garden hut.

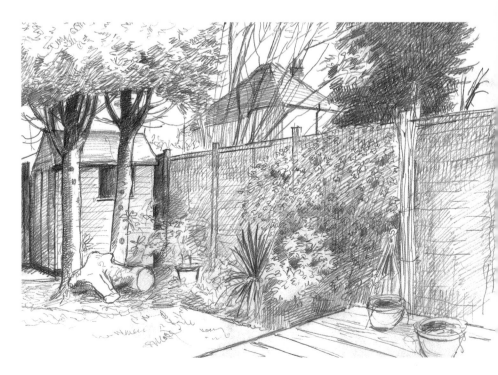

CHOOSING A SIZE

At some point you will have to decide how large your picture is going to be. In the beginning you may only have a small pad at your disposal, and this will dictate your decision. Starting small and gradually increasing the size of your picture is advisable for the inexperienced, but you will quickly get beyond this stage and want to be more adventurous.

Ideally you should have a range of sketchbooks to choose from: small (A5), medium (A4) and large (A3). If this seems excessive, choose one between A5 and A4 and also invest in a larger A3. A5 is a very convenient size for carrying around but isn't adequate if you want to produce detailed drawings, so a hybrid between it and A4 is a good compromise. The cover of your sketchbook should be sufficiently stiff to allow it to be held in one hand without bending while you draw.

It is not too difficult to draw a landscape on an A5 pad, but it does limit the detail you can show.

When you are more confident, try a larger landscape on an A2 size sheet of paper. This can be placed on a board mounted on an easel or just leant against a convenient surface.

The grade of paper you use is also important. Try a 160gsm cartridge, which is pleasant to draw on and not too smooth.

When it comes to tools, soft pencils give the best and quickest result. Don't use a grade harder than B; 2B, 4B and 6B offer a good combination of qualities and should meet most of your requirements.

When you are really confident, it is time to look at different types of proportion and size. One very interesting landscape shape is the panorama, where there is not much height but an extensive breadth of view. This format is very good for distant views seen from a high vantage point.

COMPOSITION

GEOMETRIC CONNECTIONS

The structural strength of your composition will depend on you making geometric connections between the various features you decide to include. These connections are vital if your picture is to make a satisfying whole. Look at any picture by a leading landscape artist and you will find your eye being drawn to certain areas or being encouraged to survey the various parts in a particular order. Below are two examples where the connections have been made for you. Study them and then try to incorporate their lessons in your own compositions.

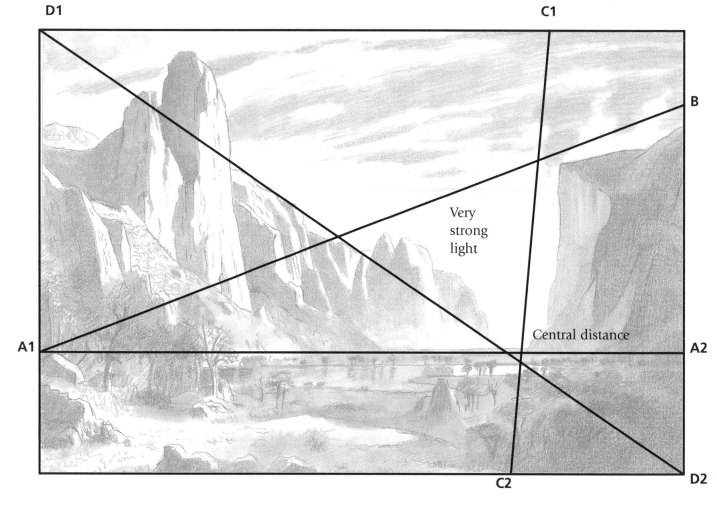

A very interesting geometric analysis can be made of this drawing of a valley in what is now Yellowstone Park (after American wilderness painter Albert Bierstadt).
- A1–A2 follows the line of a stretch of water running through the valley and makes a very strong horizontal across the composition. Note that it is slightly below the natural horizon.

- D1–D2 traverses the composition diagonally from the top left corner to bottom right, cutting across the horizontal A where the sunlight shines brightly in reflection on the water. The line also gives a rough indication of the general slope of rocky cliffs on the left as they recede into the distant gap in the mountains.

- A1– B makes a sort of depressed diagonal from the top of the mountain on the right side.
- The near vertical C1–C2 describes the almost perpendicular cliff on the right side.

- The very brightest part of the picture, where the sun glows from behind the cliff (right), resides in the triangle described by the lines A1–B, the diagonal D1–D2 and the vertical C1–C2.

In this example (after John Nash) the eye is taken from all directions (lines A1–A10) to the light shape in the dark area slightly off-centre where the stream and the building converge onto an area of trees. This large solid clump of trees is set about two-thirds from the left-hand side of the composition and just below the horizon level. The stream winds its way from the central foreground towards the deep dark shape in the central middleground. Note also how the tree in the left foreground acts as a balance to the building and vegetation.

GEOMETRIC PERSPECTIVE

The design of your composition can be based on a number of geometric configurations. Here we look at two contrasts: an almost centrally based design and one that relies for its movement on a dramatic thrust across the picture plane.

In this composition (after Sisley) of a footbridge over the Seine at Argenteuil, we are immediately struck by its off-centre geometric construction and the dramatic movement across the picture, carried by the perspective lines which show the thrust of the bridge (at B1 raying out to B2, B3 and B4). The main line of the horizon makes a shallow saucer-like curve (A1–A2) broken in the centre by a vertical lamppost and continued by the central standing figure (C). A simple vertical denoting the edge of the pier of the bridge, cutting the line of the river at right angles (D), defines the lower left-hand eighth of the picture.

Pissarro's composition of a lane seen along an avenue of slender trees gives an almost classic perspective view, where the main lines subtly emphasize movement into the distance.

The lines A1 radiating to A2 and A3 give the heights of the avenue of trees. Lines B1 to B7 similarly indicate the lower ends of the trees and the edges of the path and roadway. Everything radiates out or converges inwards to B1. At this point in the picture observe the strong line at the edge of the building behind the horse and cart. Note too how the two rows of trees are linked by means of the curving shadows thrown across the roadway. The wavy horizon line C1–C2 denotes the various heights of trees in the distance.

THE GEOMETRY OF COMPOSITION

Artists use geometry to harmonize their compositions. Often merely by dividing the parts of a picture formally into halves, quarters, thirds and so on, and placing figures and objects where these lines divide or intersect, an artist can balance a scene. The pictures shown here are classic examples of the use of geometry. Both Leonardo and Piero della Francesca were great mathematicians and their handling of geometry in their works reflects this facility. If you want to test the effect of the systems they used, go and look at the originals of these drawings (you'll find the Leonardo in the Uffizi in Florence and the Piero della Francesca in the National Gallery, London).

3 units 2 units 3 units

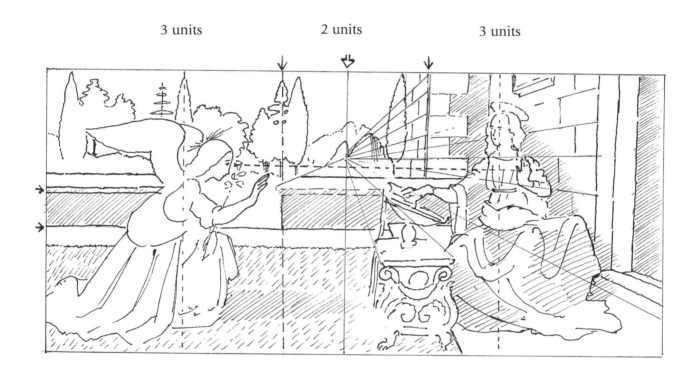

'The Annunciation' by Leonardo is centred on a 'cleft' (the mountain in the background) to which point all the perspective lines converge. (This symbol of the cleft earth is often used in paintings in conjunction with God's incarnation in human form.) The picture is divided vertically into two halves by this point and horizontally by a long, low wall dividing the foreground garden from the background landscape. The angel's head is about central to the left half of the picture and the Virgin's head is about central with the right half of the picture.

The scene seems to be divided vertically into eight units or areas of space: the angel takes up three of them, as does Mary, and two units separate them.

The angel's gaze is directed horizontally straight at the open palm of Mary's left hand, about one third horizontally down from the top of the picture.

All the area on the right behind Mary is manmade. All except the wall behind the angel is open landscape or the natural world.

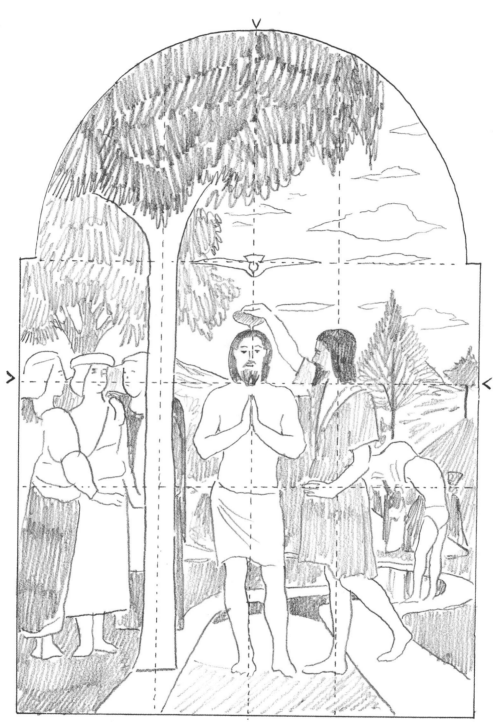

In Piero della Francesca's 'Baptism of Christ' (above) the figure of Christ is placed centrally and his head comes just above the centre point of the picture. The figure is divided into thirds vertically, by a tree trunk and the figure of St John the Baptist. The horizon hovers along the halfway line in the background. The dove of the Holy Spirit is about one third of the way down the picture, centrally over Christ. His navel is about one-third above the base of the picture. The shape of the bird echoes the shape of the clouds and because of this doesn't leap out at us. The angels looking on in the left foreground, and the people getting ready to be baptised in the right middle ground, act as a dynamic balance for each other.

DIVIDING A PANORAMA

A large panorama of landscape can be very daunting to the inexperienced artist who is looking at it with a view to making a composition. There can appear to be so much to handle.

The first point to remember is that you don't have to draw all you see. You can decide to select one part of the landscape and concentrate on that area alone. This is what I have done with the drawing below, dividing it into three distinct and separate compositions.

See the next spread for assessments of the individual drawings.

C

I have extracted three views from the large landscape on the previous spread, each of them equally valid. Read the captions to find out how they work compositionally.

A

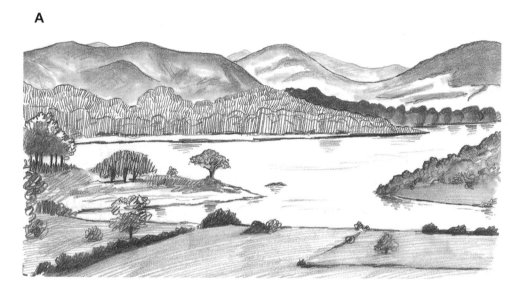

A: The main feature in this part of the landscape is a large area of water sweeping across the whole composition. The large hills in the background provide a backdrop to the more open landscape on the near side of the water. Two small spits of land jut out from either side just above the foreground area of open fields with a few hedges and trees.

B

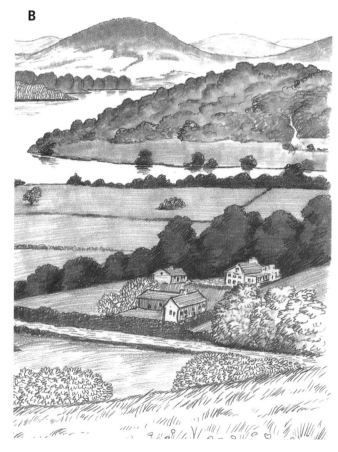

B: With its more vertical format this composition gives just a hint of the open water beyond the stretch of river in the middle ground. The extensive fore-ground contains hedges, trees, bushes and cottages. The wooded hill across the river provides contrast and the slope of hillside in near foreground also adds dimension. The distant hills provide a good backdrop.

C

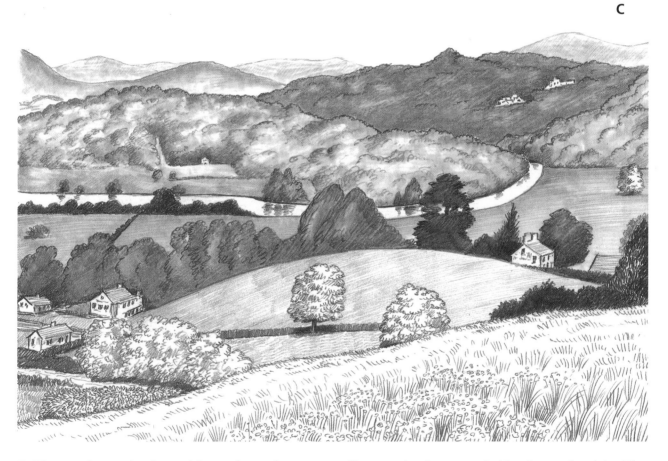

C: Here we have a horizontal layered set of features receding back into the picture plane. In the foreground is a close-up of hillside sloping across from right to left. Just beyond is a low rounded hill-form surrounded by trees and in the left lower corner some houses. Beyond the low hill is the river curving around a large bend and disappearing into wooded banks on the right. The banks slope up either side into wooded hills, and beyond these into another layer showing a larger darkly wooded hill with a couple of villages or properties to the right. At upper left is layer upon layer of hills disappearing into the distance.

INTERIORS

On these two pages we look at what happens when a viewpoint is changed, and how much the narrative of a picture owes to the positioning of figures within a scene. In each of these pictures there is a strong sense of containment.

First, we compare two versions of Caillebotte's 'The Floorscrapers' and consider

what happens to a composition when the viewpoint changes from side on (top) to head on (below). The men in the picture are working in an empty room on the first floor of an apartment in Paris, scraping a floor to renew its surface. In both pictures one window is the sole source of light.

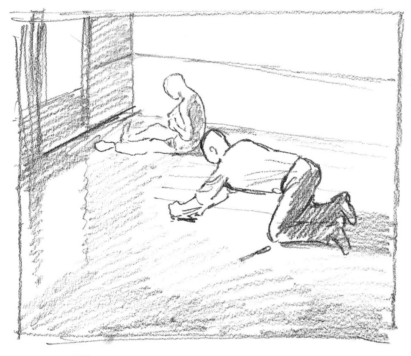

In the top picture the light reflects off the wall in the background, and the bodies of the men are highlighted. In the second version the background wall appears dark and shadowed and the bodies of the men blend in with this. The change of viewpoint changes the whole dynamic of the picture, from one of calm and almost lazy activity to hard, intense industry. The darker tones in the bottom picture accentuate the pace of activity, and the fact that all three are stripped to the waist underlines the elemental feel. The space between the men isolates them within their labour. They do not share the easy companionship of the men in the top picture whose physical proximity emphasizes their 'at oneness' within the task.

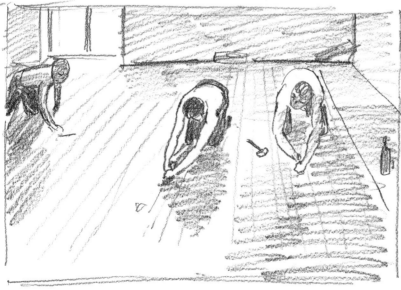

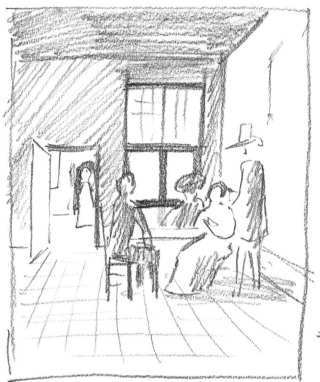

This copy of a Pieter de Hooch is less intimate than the von Menzel below by virtue of the fact that the viewer is kept at some distance from the group sitting in the room. The area above them is dark except for the light coming in through the window at the back. The doorway to the left allows us to see even further into the picture. If you ask a child or an adult unpractised in art to draw a scene, they tend to set the action in distant space, as here.

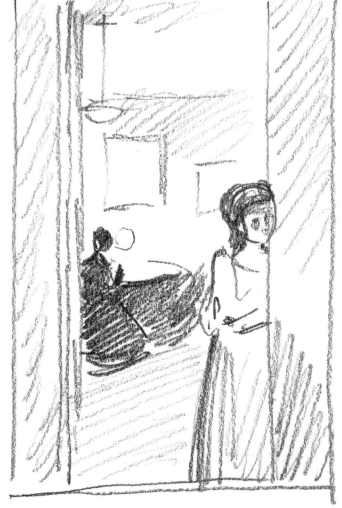

The advent of the camera and the influence of techniques evident in the work of Japanese printmakers encouraged Western artists to cut off large areas of foreground so as to increase dramatic effect and bring the viewer into the scene. This interior by Adolphe von Menzel ('Living Room with the Artist's Sister') is like a cinema still: the viewer is standing the other side of the lit open doorway, looking into the room where someone sits in front of a light. We are confronted by two contrasting images – of an inner world from which we are cut off by the door and the anonymity of that lone figure in the background, and of the girl who is looking expectantly out towards us. We wonder what this girl is waiting for and we wonder about her relationship with that other figure.

BALANCING A COMPOSITION

Both of these examples show an unusual way of composing a picture. Gustave Caillebotte was as good at composing exterior scenes as interiors. His rainy day on the streets of Paris epitomizes a view of 19th-century France as it is imagined by many people. Its composition is similar to that of the Velázquez opposite. In both success is achieved through the use of dramatic contrast.

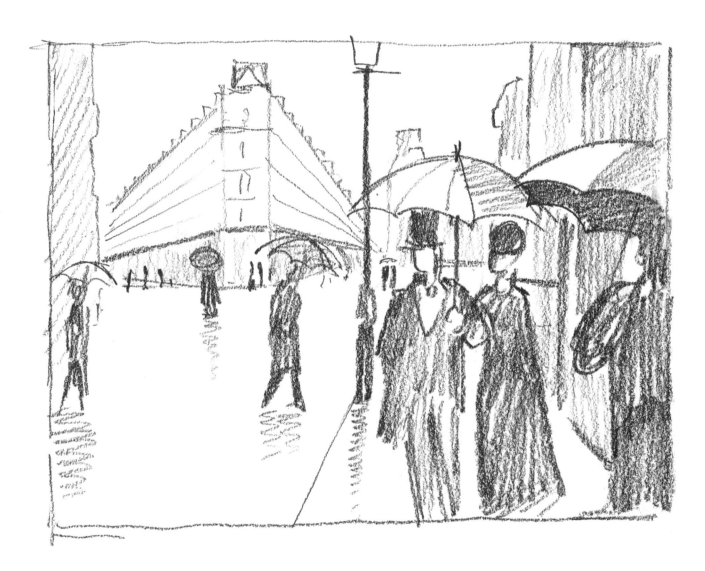

The left side of this picture is mostly empty, with the distant wedge-shaped block of apartments thrusting towards us. The right half of the picture is packed with three figures under umbrellas, a couple coming towards us and a single figure who is entering the picture from the right edge. The two halves of the picture are neatly divided by the lamp post. The scene is played out between tall buildings which bleed off the side of the picture, and the viewer is made to feel part of it. As in the next picture we are about to look at, the balance is quite brilliant.

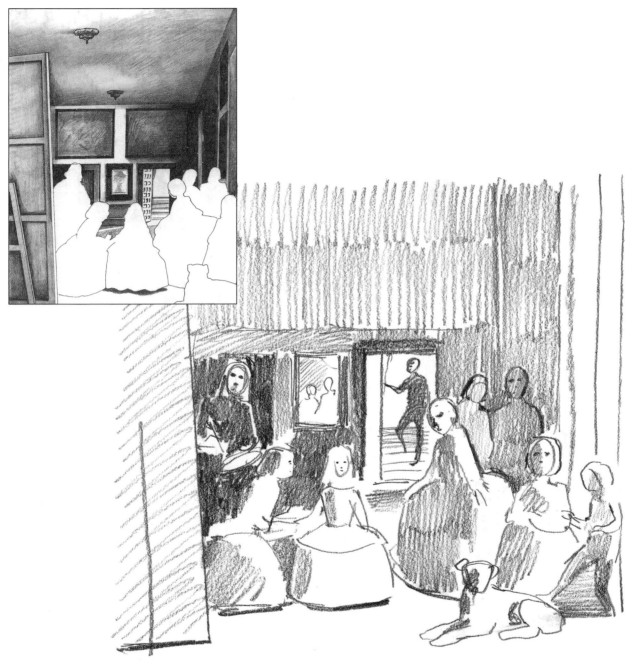

Here the contrast between the dark upper half of the picture and the lit figures in the lower half works brilliantly. Velázquez himself makes an appearance. He stands at the left, palette in hand, looking out at us. In the front of the picture are the Infanta of Spain and her maid. To the right are grouped in depth the members of her entourage, including a dwarf and a dog. At the back of the painting, just off centre, is an open doorway through which we can see a man looking in. To the left of this door is what appears to be a mirror with the reflections of the couple being painted by the artist. Three of the figures in the foreground are gazing at us, as is the artist, so perhaps we are that couple. Psychologically, as well as compositionally, this is a very interesting picture: a case of the viewer being viewed.

FIGURES IN INTERIORS AND EXTERIORS

When you are drawing figure compositions the scene has to be set in some location, either inside or outside, or your figures will be appear to be floating in limbo. Two of the most famous Dutch painters of the 16th century were Vermeer and de Hooch, both of whom excelled at interiors that depicted the orderly calm of the households occupied by the bourgeoisie. The main difference for the artist between interior and exterior scenes is that the former tend to have more directional light, often from just one window. Studying the work of Vermeer and de Hooch, two masters, will help you to consider ways to use light to explain your composition to the viewer. Even with very few objects to set the scene, the way the light falls on your figure will indicate whether it is set inside or outdoors.

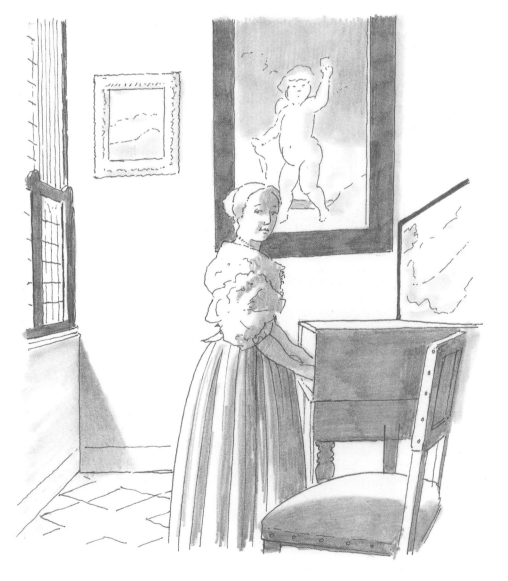

Vermeer always placed his figures very carefully in a specific interior with light coming from a window and musical instruments or other appurtenances of the household included in the composition. He would place large pictures or maps on the wall to act as a foil to the human figure. The furniture was arranged to make the spatial element in the picture more evident.

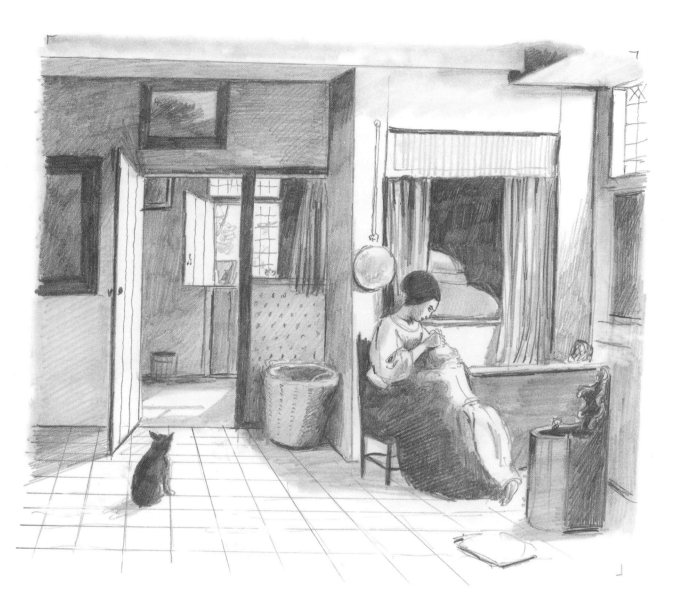

De Hooch often included quite a large area of the inside of a house, particularly the family rooms. In this example, his interior spaces are very considered and help to create an aspect that goes through the room into the next and then out of the window to the outside world. The little dog sitting opposite the doorway draws the eye through to the larger space. The mother and daughter placed well over to one side sit in front of a cupboard in which the bed is set, making a dark, enclosed interior area. This juxtaposition of light open space and dark inner space gives the composition a lot of interest, apart from the presence of the figures.

ARRANGING OBJECTS

To practise some still-life compositions, spend some time placing objects into groups. The idea is not to draw them – just arrange them, look at them carefully, see the shapes and patterns they make and then rearrange them into different compositions.

The arrangement of shapes within shapes gives interest to this composition, as does a sense of confinement of the major elements of this meal in the making. The glassy eyes of the fish fix the viewer reproachfully.

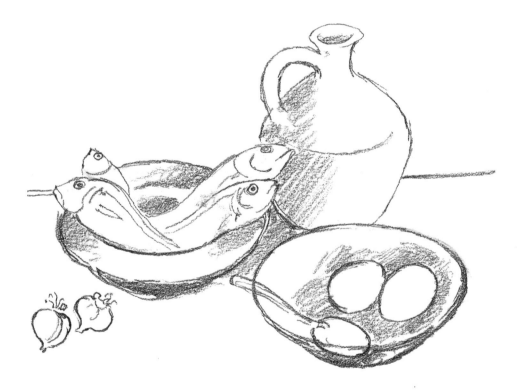

You will find still life arrangements all around you, wherever you go. Someone has thrown a coat over a chair. Someone has laid a table for dinner. The shapes of glasses, plates, cutlery, not to mention details such as flowers, napkins or groups of condiments, form different patterns and designs, depending on whether you are seeing them from above or from sitting position or even from table level. Once you become aware of such possibilities, your eye will start to look for composition as it happens naturally.

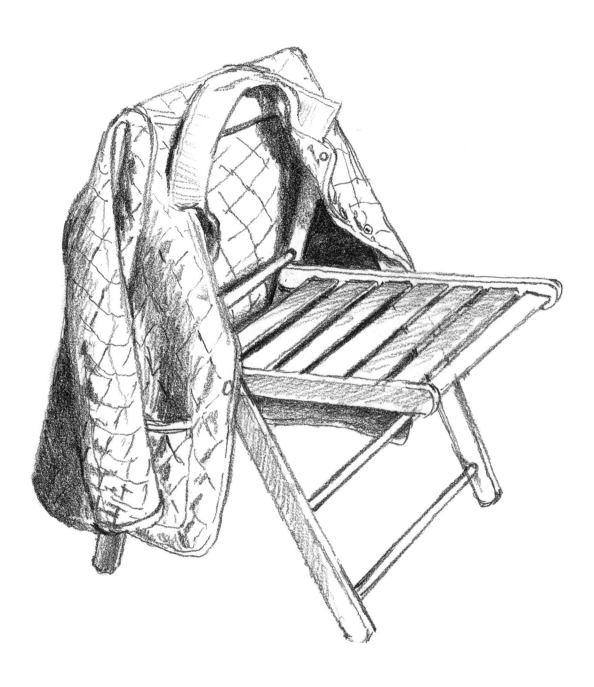

Objects placed in close proximity look different as a consequence, as in this example of a jacket placed over the back of a chair.

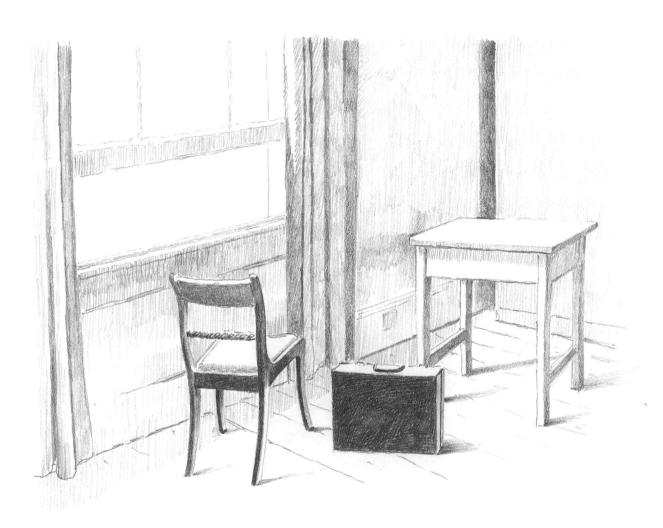

I saw this group of briefcase, chair and table in front of a large open window when I was visiting a school. While the pupils were drawing other things, I had a go at this because the summer sunlight not only gave a strong structural form to the objects, but also gave a look of a waiting empty room, silent and peaceful. Lighting can often conjure up an atmosphere as well as define space.

This next composition is, again, a very simple but effective arrangement. Both elements contribute to the strong effect of the contrast between the rigid angularity of the chair and the soft, fluid lines of the material of the overcoat.

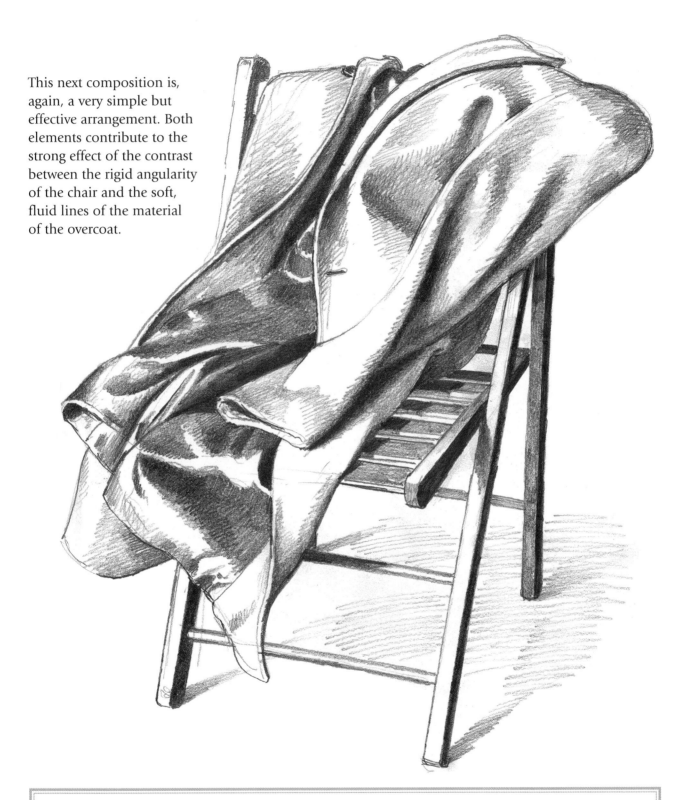

The more you try to draw objects and constantly make the effort to correct your work, the keener your own perception will become. In time you will draw with something approaching the quality that a practised artist appears to achieve with ease.

ENCOMPASSED GROUPS

Sometimes the area of the objects you are drawing can be enclosed by the outside edge of a larger object which the others are residing within. Two classic examples are shown here: a large bowl of fruit and a vase of flowers.

With this type of still life you get a variety of shapes held within the main frame provided by the bowl.

A large vase filled with flowers can be a very satisfying subject to draw. These sunflowers in a large jug make quite a lively picture: the rich heavy heads of the blooms contrast with the raggedy-edged leaves dangling down the stalks, and the simplicity of the jug provides a solid base.

If you were to take the same jug of flowers seen in the previous arrangement and place it among other objects of not too complicated shape, you would get an altogether different composition and yet one that is just as lively. Particularly noteworthy is the relationship between the smooth rounded shapes in the lower half of the picture and the exuberant shapes of the flowers and leaves in the upper part of the composition.

MEASURING UP

One of your first concerns when you are combining objects for composition will be to note the width, height and depth of your arrangement, since these will define the format and therefore the character of the picture that you draw. The outlines shown below – all of which are after works by masters of still-life composition – provide typical examples of arrangements where different decisions have been made.

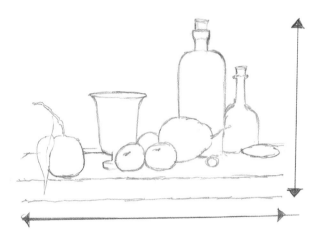

In our first example (after Chardin) the width is greater than the height and there is not much depth.

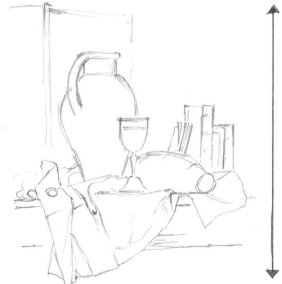

The height is the dominant factor in our second example (also after Chardin). The lack of depth gives the design a pronounced vertical thrust.

In his original, Francisco Zurburan put the emphasis solely on width. The objects, which divide neatly into three sub-groups, align themselves across our view horizontally, allowing us to take in one sub-group at a time or all three simultaneously.

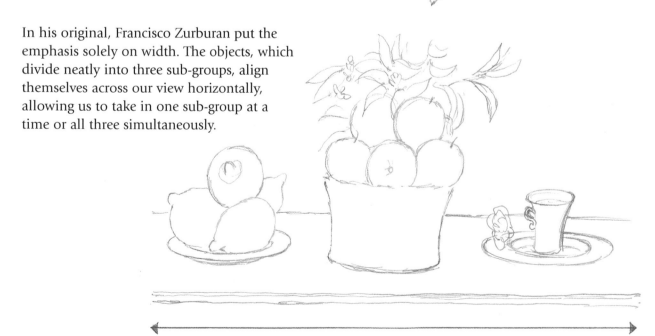

Now for something entirely different, this time after Samuel van Hoogstraten. This sort of still life was a great favourite in the 17th and 18th centuries, when it provided both a showcase for an artist's brilliance and a topic of conversation for the possessor's guests.

Almost all the depth in the picture has been sacrificed to achieve what is known as a 'trompe l'oeil' effect, literally meaning 'deceives the eye'. The idea was to fix quite flat objects to a pinboard, draw them as precisely as possible and hope to fool people into believing them to be real.

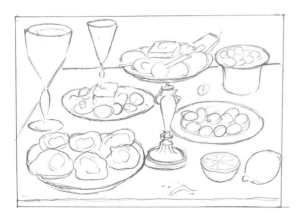

Depth is required to make this kind of arrangement work (after Osias Beert). Our eye is taken into the picture by the effect of the receding tabletop, the setting of one plate behind another and the way some of the objects gleam out of the background.

COMPOSITION

FRAMING

Every arrangement includes an area that surrounds the group of objects you are drawing. How much is included of what lies beyond the principal elements is up to the individual artist and the effect that he or she is trying to achieve. Here, we consider three different 'framings', where varying amounts of space are allowed around the objects.

1. A large area of space above the main area, with some to the side and also below the level of the table. This treatment seems to put distance between the viewer and the subject matter.

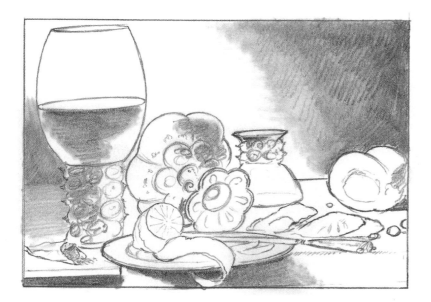

2. The composition is made to look crowded by cropping into the edges of the arrangement.

3. This is the framing actually chosen by the artist, Willem Claesz. The space allowed above and to the sides of the arrangement is just enough to give an uncluttered view and yet not so much that it gives a sense of the objects being left alienated in the middle of an empty space.

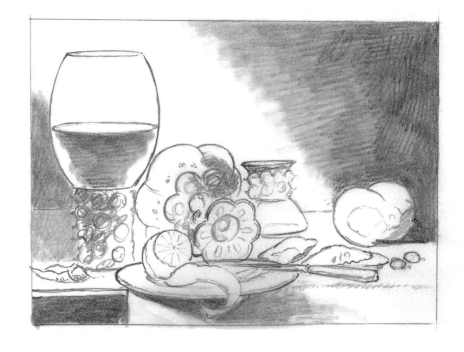

COMPOSITION

COMPOSING A STILL LIFE

Place on a large table as many unrelated objects as will fit on it, then take a large sheet of paper and start drawing the objects, working your way across from one side of the paper to the other. When you have covered this first sheet, take another, move round the table and draw the objects you see, again starting at one edge of the paper and moving across.

Each time you complete a page and move round to a new viewpoint, you will find that you have to relate the size of each object to the one next to it and include all objects in the background. Don't worry if you lose the composition, just keep observing and drawing. Don't concern yourself with the results, either. The idea of this exercise is to keep you drawing for as long as possible, so that what you are doing becomes second nature.

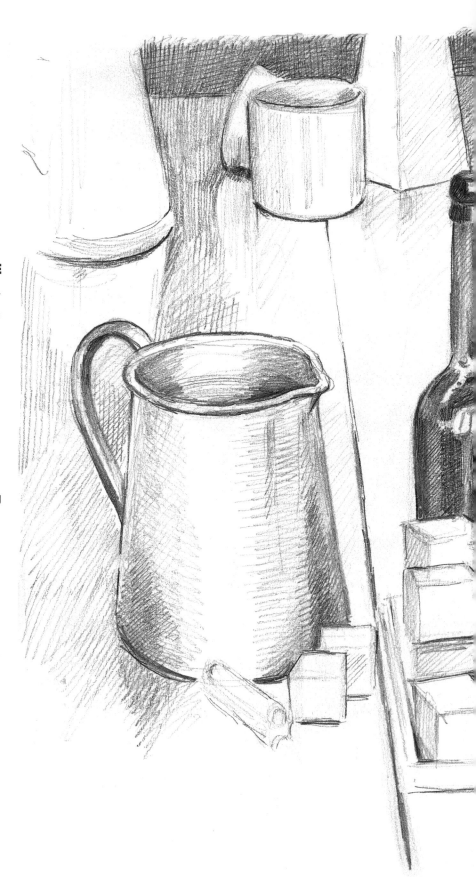

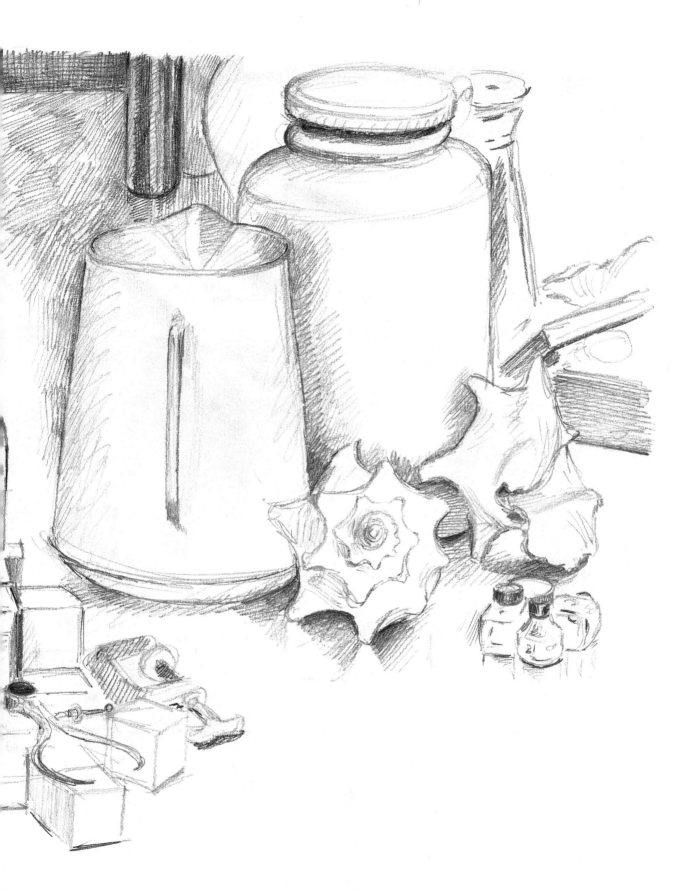

A ROUGH COMPOSITION

The next few pages show you how to work up a composition. Here I have drawn a very rough composition of the arrangement of these different objects which I decided I liked. I settled upon the angle of the light and what sort of background the composition should have.

Here, I have the light coming from the left, fairly low and casting a shadow on some of the objects on the side wall. Behind the main part of the composition is the darkness of the room behind, so the arrangement is well lit but against a dark space. I covered the side table with the cloth but allowed the jug and bowl of fruit to rumple it up a little. The heavy dark pot and the spiky plant are at the base of the foreground. The hamper and the large copper pan act like a backdrop on the left-hand side.

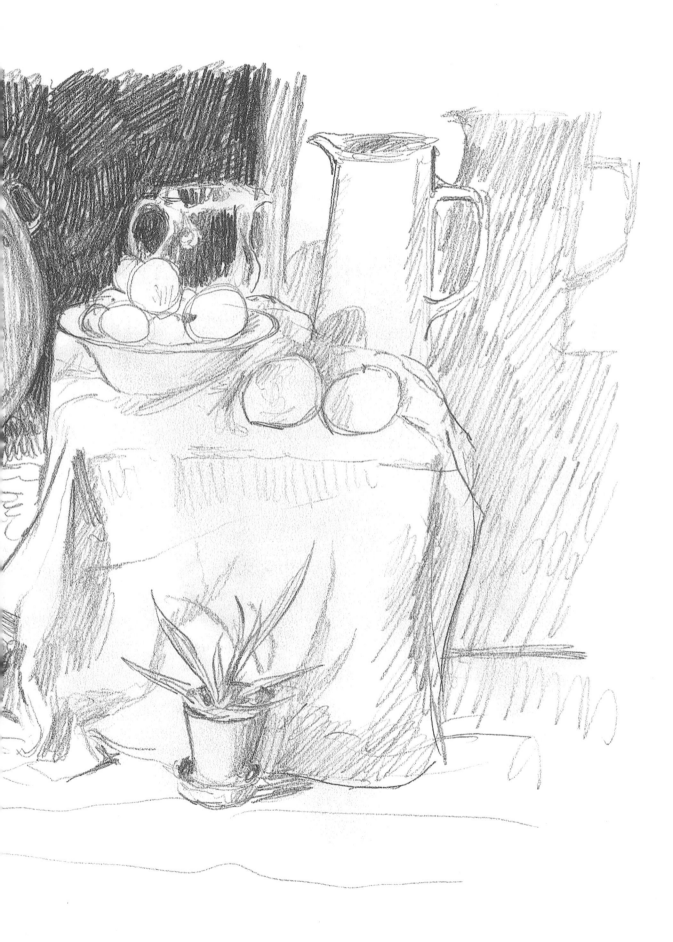

OUTLINE DRAWING

Having decided on my arrangement and made
a fairly quick sketch of it, I now knew what
I was going to do. The first thing I needed
to establish was the relative positions and
shapes of all the articles in the picture, so
I made a very careful line drawing of the
whole arrangement, with much correcting and
erasing to get the accuracy I wished to convey
in the final picture. You could of course use a
looser kind of drawing, but for this exercise I
was being very precise in getting all the shapes
right and their dispositions carefully related.
This is your key drawing which everything
depends on, so take your time to get it right.
Each time you correct your mistakes you are
learning a valuable lesson about drawing.

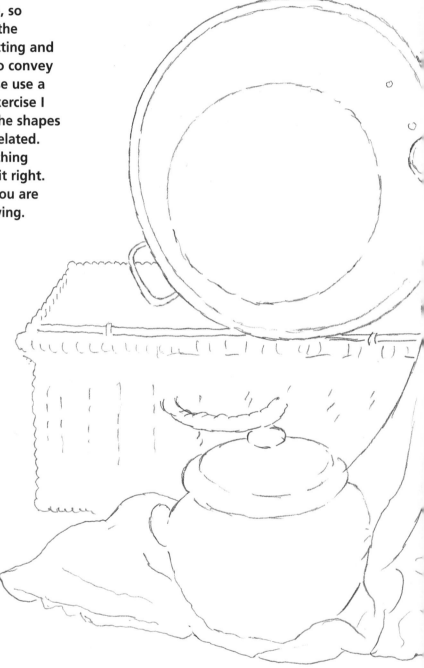

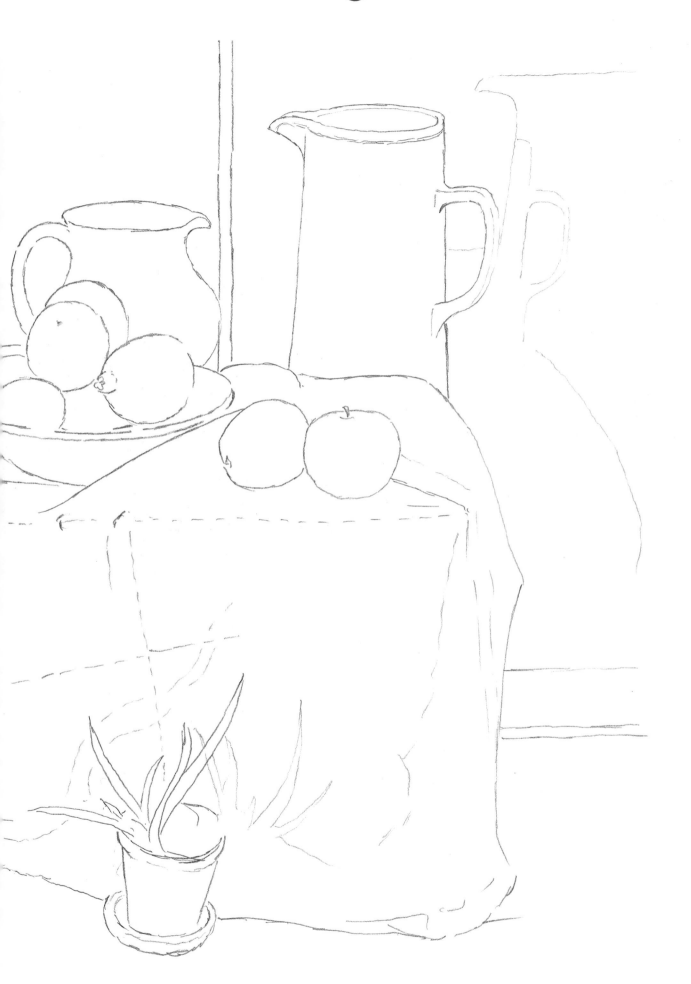

BLOCK IN THE TONE

After that I blocked in all the areas of the main shadow. Do not differentiate between very dark and lighter tones at this stage; just get everything that is in some sort of shadow covered with a simple, even tone. Once you have done this you will have to use a sheet of paper to rest your hand on, to make sure you do not smudge this basic layer of tone. Take care to leave white all areas that reflect the light.

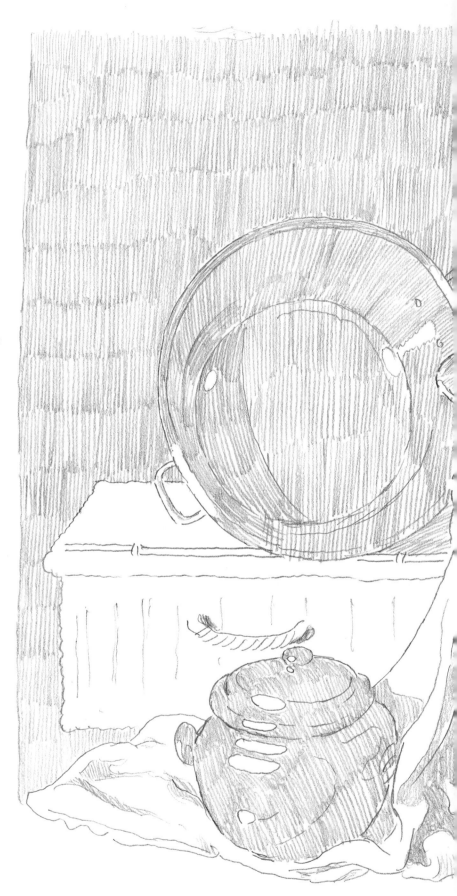

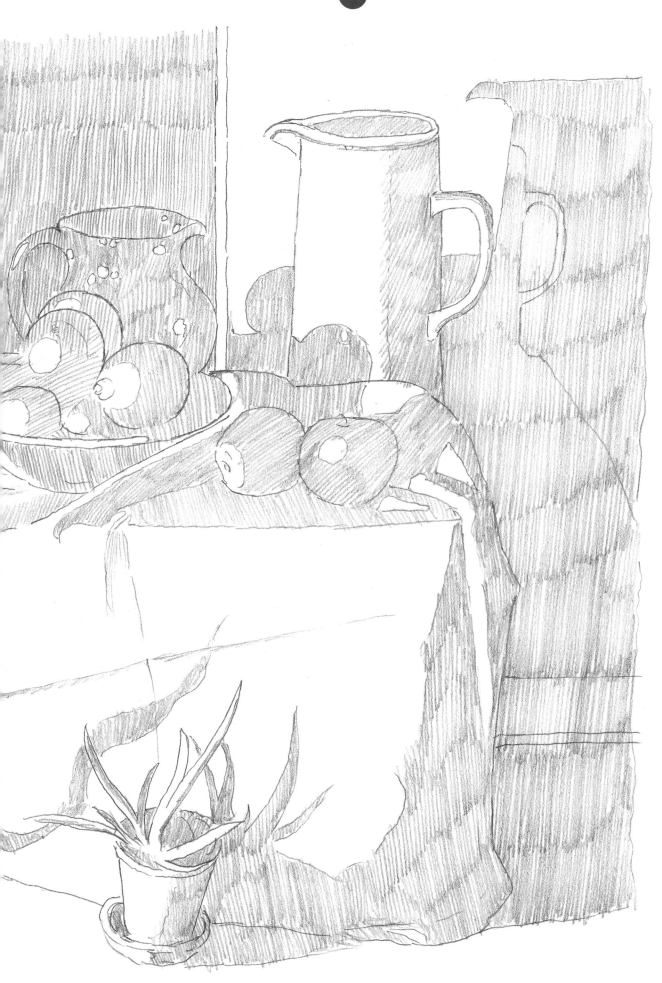

THE COMPLETED PICTURE

Finally, I did the careful working up of all the areas of tone so that they began to show all the gradations of light and shade. I made sure that the dark, spacious background was the darkest area, with the large pan, the glass jug and the fruit looming up in front it. The cast shadows of the plant and where the cloth drapes were put in crisply, and the cast shadow of the jug on the side wall required some subtle drawing.

Before I considered my drawing finished, I made sure that all the lights and darks in the picture balanced out naturally so that the three-dimensional aspects of the picture were clearly shown. This produced a satisfying, well-structured arrangement of shapes with the highlights bouncing brightly off the surfaces.

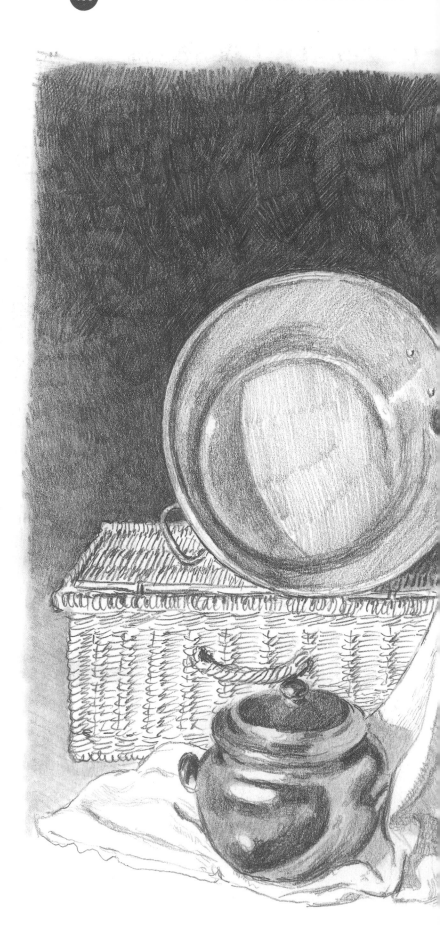

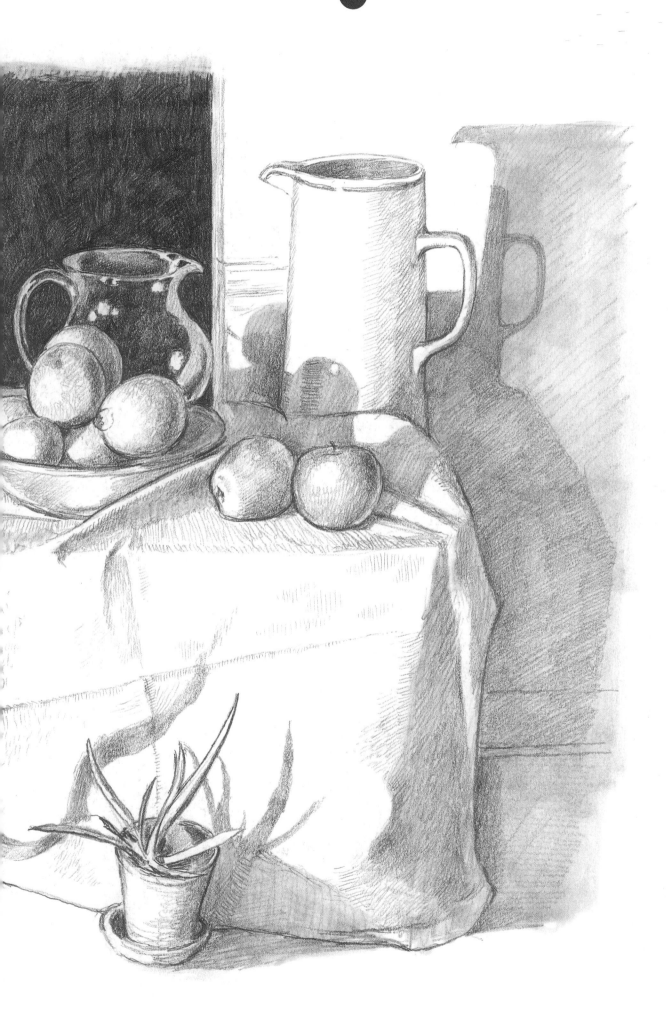

LEARNING FROM THE MASTERS

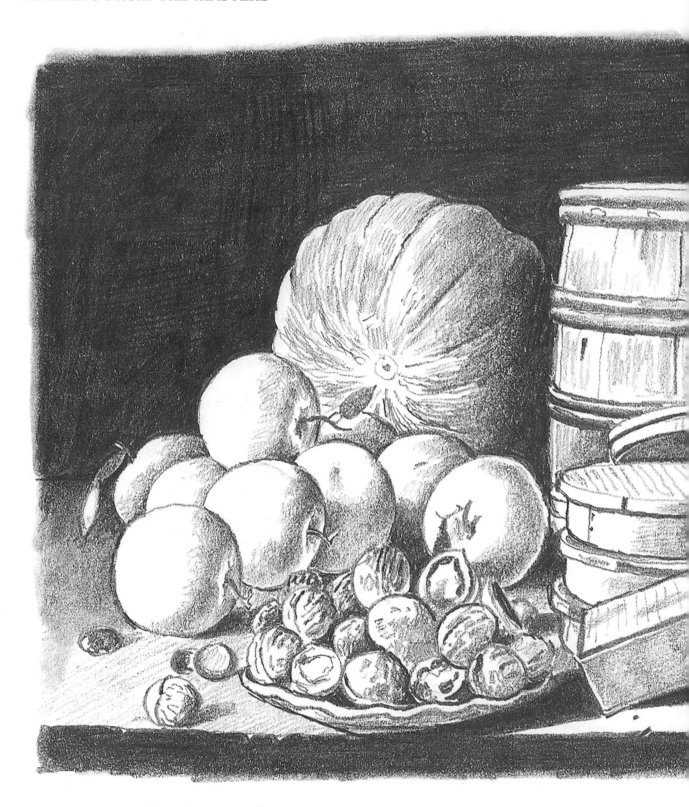

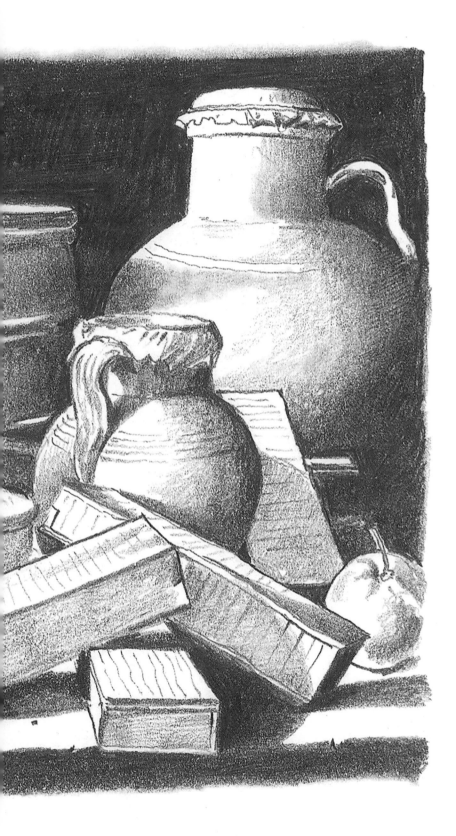

This beautiful piece by the famous Spanish artist Luiz Meléndez (1716–80) is a full and even crowded arrangement, but because of its simple workaday subject matter gives a very solid and complete-looking group of objects. The pots, packets and loose fruits and nuts both contrast and harmonize with each other at the same time.

This sketch of a still life by Spanish artist **Juan Van der Hamen y Leon (1596–1631)** is carefully composed and gives a formality to the composition. The placing of the pots, baskets, plates and packages could not be accidental; it is well prepared and thought out. This formal arrangement creates an almost abstract, spatial quality to the composition.

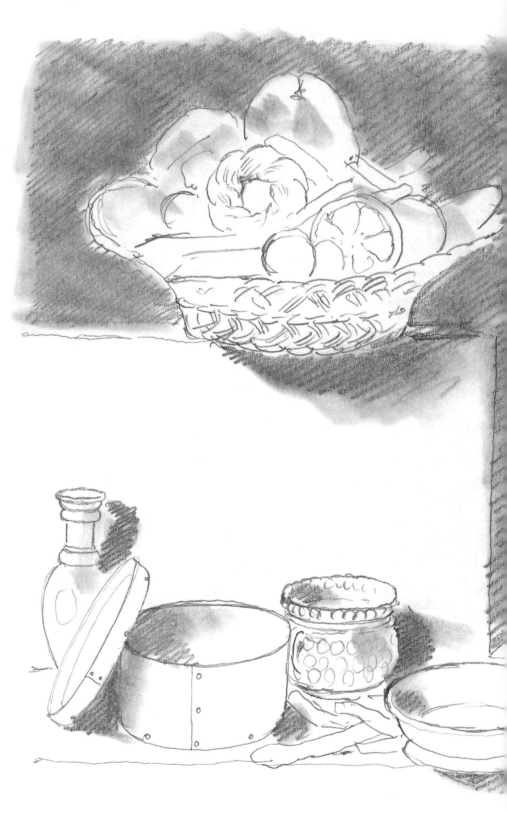

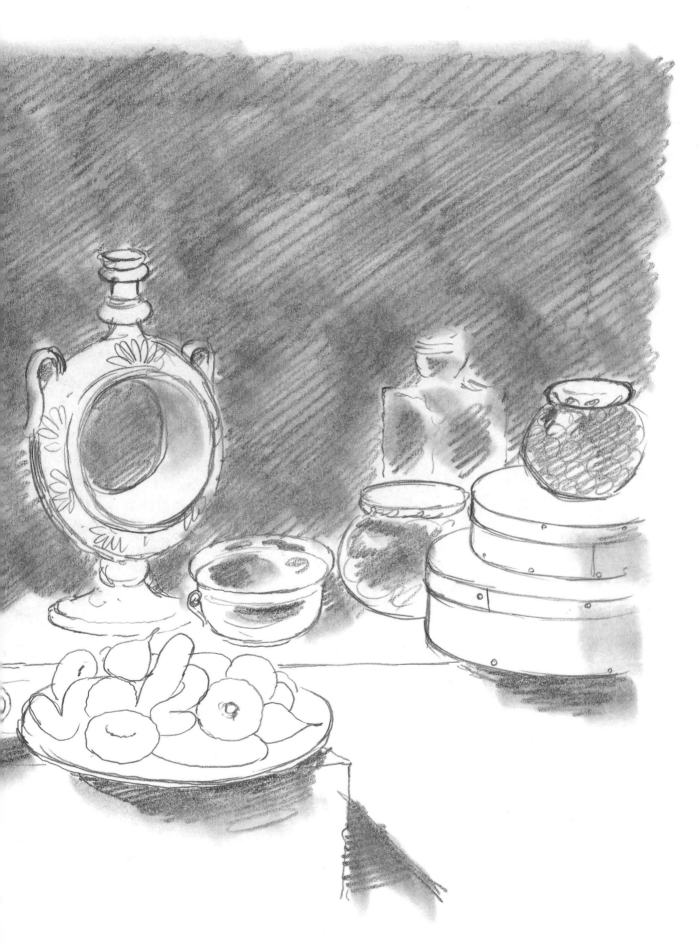

DIFFERENT ASPECTS OF STILL LIFE

All successful still-life arrangements exploit different aspects of the genre. In this series of copies of the works of professional artists, note how the objects are used either to repeat and reinforce the feeling of the group or, conversely, to interrupt and contrast the various elements. Either of these ways works depending on the effect you want to achieve.

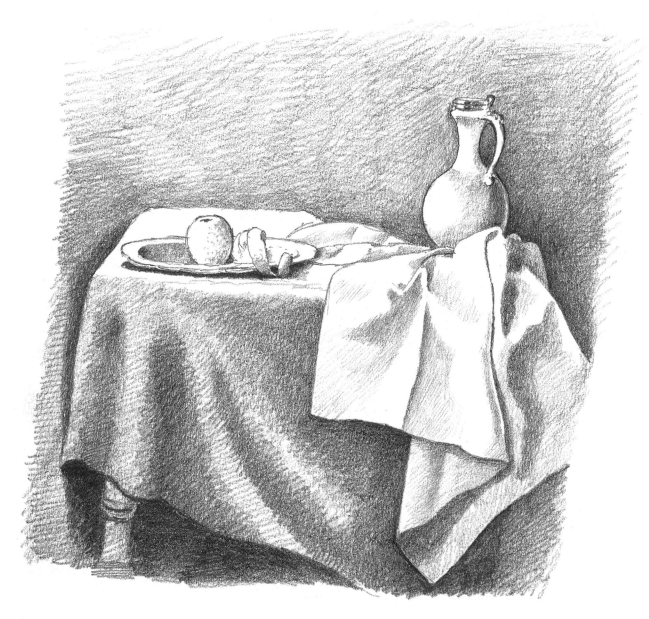

This cunningly arranged still life, a copy of a Vermeer, is given its effect by the large light cloth folded over and draped across the corner of the table with the uneven tablecloth acting as a darker foil. The plate with a peeled fruit and the elegant jug contrasting against the soft shapes of the cloth add drama to the composition.

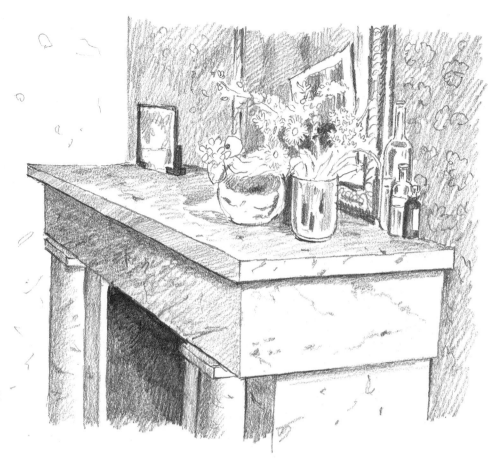

This copy of a Vuillard takes a very ordinary situation and produces an extraordinary piece of art out of it. It is a brilliant exercise in form and tone. The interest comes from the ephemeral objects set apparently accidentally on the solid, permanent chimneypiece.

In this copy of a Cézanne, the bottle and folds in the tablecloth give assistance as a vertical element to the spilled abundance of fruit in the centre of the picture. The relationship of the structure of each object is submerged into the main shape and yet runs through the whole picture to make a very satisfying composition.

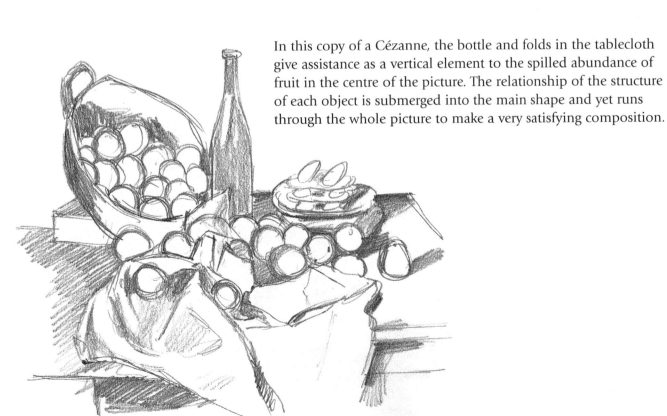

COMPOSITION

STILL LIFE IN A SETTING

On this spread we look at still-life compositions that incorporate the room in which they are set. This is a natural progression but, of course, involves you in more decision making. How much of the room should you show? How should you treat the lighting? Probably the best lighting is ordinary daylight and I would advise you to use it whenever possible. The extent of room area that you show depends on your confidence.

The interest in this drawing of one end of a room is with the objects set in the window and in various places around the room.

With an extended still life it is important to observe the details of the furniture and other main elements, such as the window frame. If your picture is to be a success, you must also be very aware of the source of light and make the most of how the shadows fall.

This arrangement makes more of a feature of
the window, allowing the viewer to see outside
and gain some sense of the garden beyond the
window. Most of the objects shown are confined
to the area of the table.

PORTRAIT SETTINGS

One of the most difficult aspects of the preliminary stage of producing a portrait is the setting. Quite often you will see the face and features of your subject very clearly and yet have little idea of the sort of background or setting in which to pose them. Sometimes the background that ends up in a portrait is the one that just happened to be behind the person when the artist first drew them. However, that situation is less than ideal. The background is part of the effect you are trying to create, and contributes to the visual and metaphorical picture you are constructing, so it demands your attention and is worth putting a great deal of thought into.

When the whole figure is in the portrait, the background and setting become especially important. It may be that you decide to have a blank or empty background behind the head, to ensure that the viewer concentrates solely on the figure. Even a simple background can have dramatic effect; for example, a dark tone behind and around the head can make it project out of the background, whereas a light tone will isolate the head without projecting it forwards.

Hans Holbein's 'The Ambassadors' was painted to record the visit of Georges de Selve (a bishop) to his friend Jean de Dinterville in 1533. The setting consists of a two-tier table on which are placed items associated with the interests and affairs of the two men. On the top level are instruments used for mapping the heavens and making calculations of time, date and the movements of the sun, all activities of interest to gentlemen of a humanist persuasion. On the lower shelf we see a lute and a book of Lutheran hymns. The latter says something for the Catholic bishop's pragmatism; as ambassador to the English court and the strongest Protestant nation in Europe at the time, he would have had to show tolerance in matters of religion. The carpet on the upper shelf and the background curtain give evidence of the richness of the household.

Holbein often produced carefully invented settings. For this example, it is very doubtful whether the ambassadors sat for any longer than it took to draw and paint their faces. A servant would probably have stood in for them, and the still life on the table would have been painted in the studio when the sitters were absent.

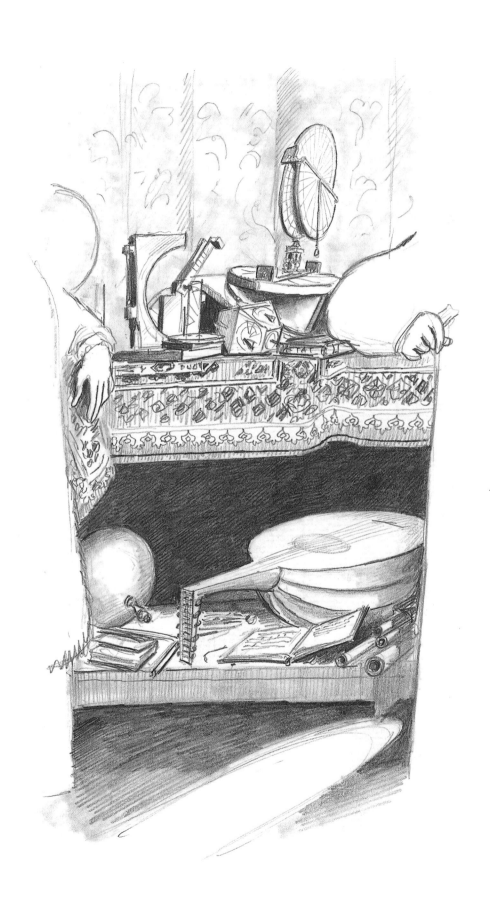

PLACEMENT IN THE FRAME

When focusing on figures or portraits the most basic compositional consideration is how you arrange the subject in the frame of the picture. The pose or attitude you choose will have a large bearing on this. There are many compositional permutations that can be brought to a portrait, as you will quickly discover when you start to look at the work of other artists. Each of the arrangements shown here conveys an idea or mood associated with the subject. Before choosing a composition, you must be sure it is right for your purposes. Good composition is never accidental.

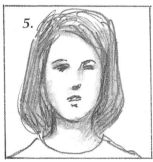

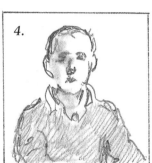
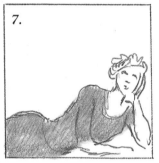
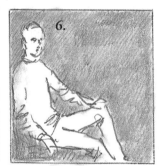

1. This figure is set well back in a room with lots of space around him. In order for the sitter to be clearly recognizable the picture would have to be huge. There would be a reason for choosing this degree of detachment from the viewer.

2–5. In this series of viewpoints the onlooker gets a progressively closer picture of the sitter. Generally longer views give a more detached picture. A tight close-up of the head demands that the artist achieve an accurate likeness, both physically and in terms of psychological insight.

6–8. An off-centre position can produce a dramatic, unpredictable effect. The picture becomes more than just a recording of someone's likeness, and we begin to consider it as an aesthetic, artistic experience. The space in the picture acts as a balance to the dynamic qualities of the figure or face. It can also be used to indicate qualities about the sitter, especially if they have a retiring personality.

9. Not many faces can stand such a large, detailed close-up and not many people would be comfortable with this approach. However, it is extremely dramatic.

10. In this unusual and interesting arrangement, enough is shown of this figure turning away from the viewer for him to be recognizable.

11. Showing a half figure to one side of the picture with a dark background is a good approach for colourful characters or if you want to add some mystery to a portrait.

12. Firmly placed centre stage in an uncompromising pose, this sitter comes across as very confrontational. The well-lit background and foreground ensure that nothing is left to the imagination, accentuating the no-nonsense direct view of the subject.

13. This head and shoulders view is evenly lit with little or no tonal values and absolutely no decorative effects. As such it demands a very attractive face.

14. The rather indirect positioning of the figure suggests a diffident character, and an almost reluctant sitter.

15. The figure takes up only one quarter of the frame, with most of the space given up to the sitter's domestic surroundings. The emphasis here is on lifestyle and the ambience of home.

16. This sitter is made mysterious and moody by the device of posing him so that he is not looking at the viewer.

17. A soft, slightly out of focus effect can be very flattering, and in this example gives a sympathetic close-up of an elderly woman.

18. This close-up of a face floating in a dark void gives a dream-like effect.

19. An off-beat dramatic twist has been brought to this portrait by placing the sitter at the bottom of the picture, as though she is about to sink from our view.

20. This sitter is presented as playful, almost coquettish, by placing her along the lower half of the picture in a relaxed lying-down pose.

CLASSIC RULES

At one time portrait painting was exclusively the preserve of the well-heeled, the well-connected and the powerful, and for this reason there were very set conventions regarding composition. It went without saying, for example, that a portrait should include devices that pointed up the subject's social standing or worthiness. Over the centuries this would change, but very slowly, and in the meantime people got used to 'reading' paintings and understanding their content through the composition.

The background of a portrait often told the viewer a clear story connected with the subject's lifestyle. The props or clothing as well as the amount of the figure shown, and the style of showing the figure, would be understood in the context of the social life of the period. If a portrait was of a ruler, emperor or king, then the size would be large, the figure would be shown in a decidedly heroic stance and often all the clothing and objects depicted would indicate the power of the sitter. Most leaders would be shown with such objects as maps, legal documents, military headgear etc. to indicate their area of status. However, although there were clearly understood rules of composition, these were always open to radical interpretation. The great artists would restate or completely change the composition, their powerful aesthetic understanding producing a new way of looking at their society. Once the master had set a new mode of portraiture, lesser artists could quickly follow suit and so whole schools of artists would set the fashion for an age.

The portraits we look at next are examples from historical pictures which in their different ways define the sitter from clearly understood rules of composition. The background is everything seen behind or around the figure but not advanced in front of it. The setting could be anything from furniture to animals or props.

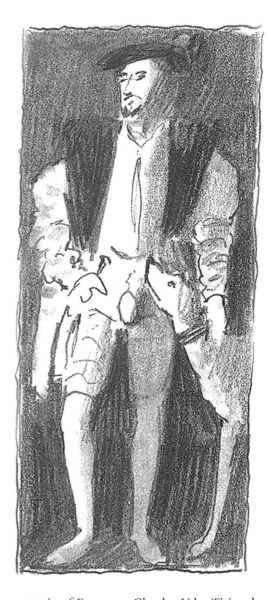

The portrait of Emperor Charles V by Titian leaves us in no doubt as to the sitter's importance and that this man is a leader. The stance and dress give a complete feeling of ease with his role. The background has been left as a dark shadowy space, as if there was no point in trying to define this man's role. Even without background clues, Titian is saying that his society, knowing the unusually powerful role of this monarch and that he is a charismatic and able warrior, will be impressed enough by the man himself. Charles was indeed an unusual ruler and this judgement by Titian was not misunderstood at the time.

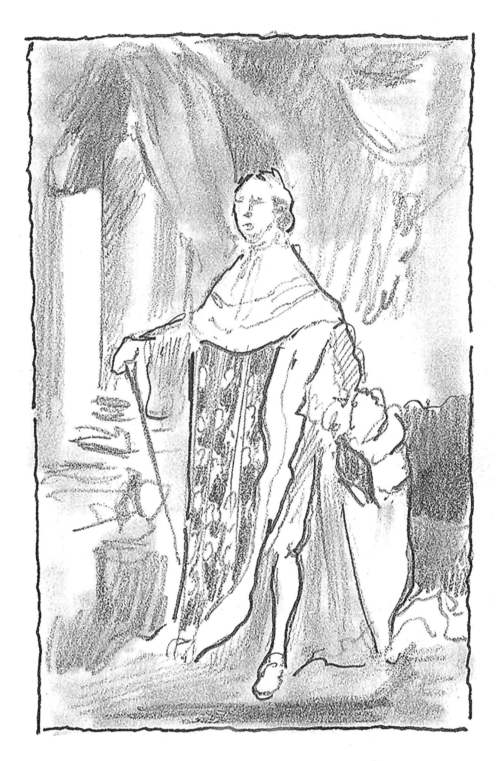

This is a copy of a typical ruler's portrait, in this instance of Louis XVI of France. However, although the court painter knew the system of representation for such a figure, his artistry and the character of the monarch are not powerful enough to give us an impressive painting of a great man. The breadth and depth of the scene, with its gorgeous coronation robes and background hangings, and the classical allusions to dignity and status in the architectural details, only serve as scenery for a splendid but empty pageant.

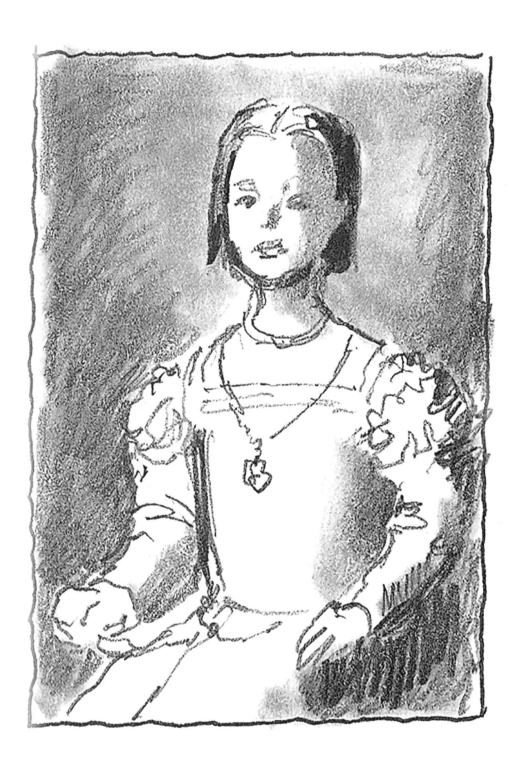

Bronzino has produced a charming piece in his depiction of a young princess, sitting upright as befits her status, and yet still very tenderly portrayed as a favourite child. The background is almost non-existent; we are merely aware of the chair upon which she is formally placed, which almost dwarfs her but at the same time sets her up in a position of potential power.

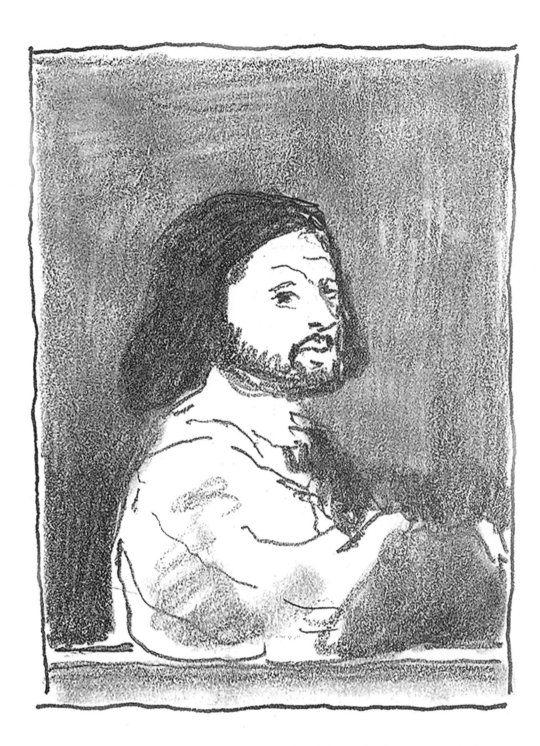

Another Titian masterpiece, of the poet Ariosto, set the fashion for future portraits by showing a simple head and shoulders. The composition convinces us of the importance of the sitter merely by the bravura stance of the pose, plus the extraordinary power in the intelligence of the face. The mere fact of being painted by a great master in itself conferred a degree of importance on a sitter.

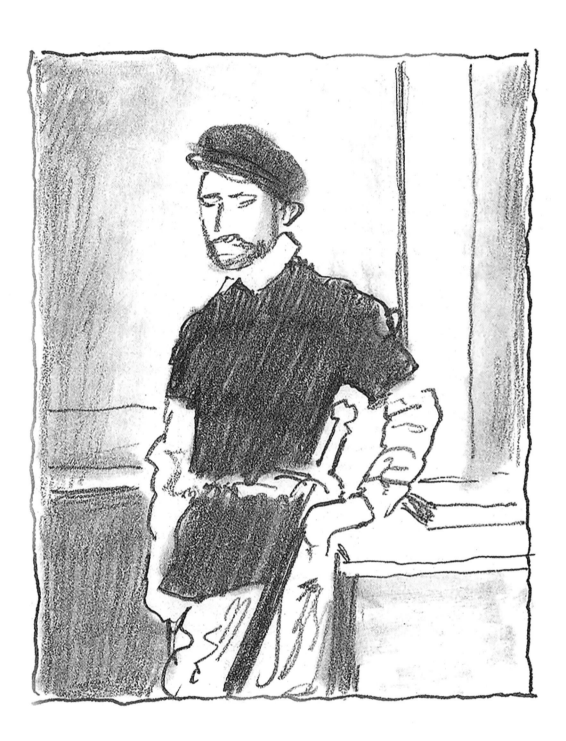

Moroni's portrait of the Duke of Alberqueque shows something of the man's humanity and awkwardness in his pose as a gallant of the Spanish court. The pillar on which he leans is a good classical adjunct to an otherwise bare background wall, which helps to suggest that he is a man of consequence. A full-figure depicted a ruler, a half-figure a lesser, but still powerful, being and so on down to just a head.

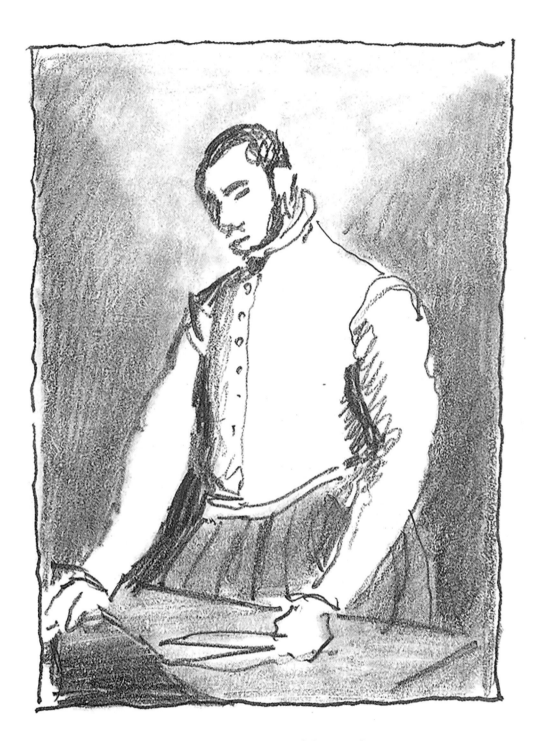

This second Moroni portrait tells us about the nature of the sitter's trade. The customer for this picture was probably a tailor who wanted a composition that said something about his employees. It's very unusual to find portraits of ordinary working people and there may be a moralistic or didactic motivation behind the picture.

GEOMETRIC GROUPS

The use of geometric shapes to compose and 'control' a group of figures is a well-tried method of picture composition. It can become a straitjacket if it is taken too seriously, but it is a good method to use as a guide because it puts a strong underlying element into the picture. All the obvious geometric shapes can be used – a circle, a triangle, a rectangle, a parallelogram – although it can lead to a rather forced composition if you are not careful.

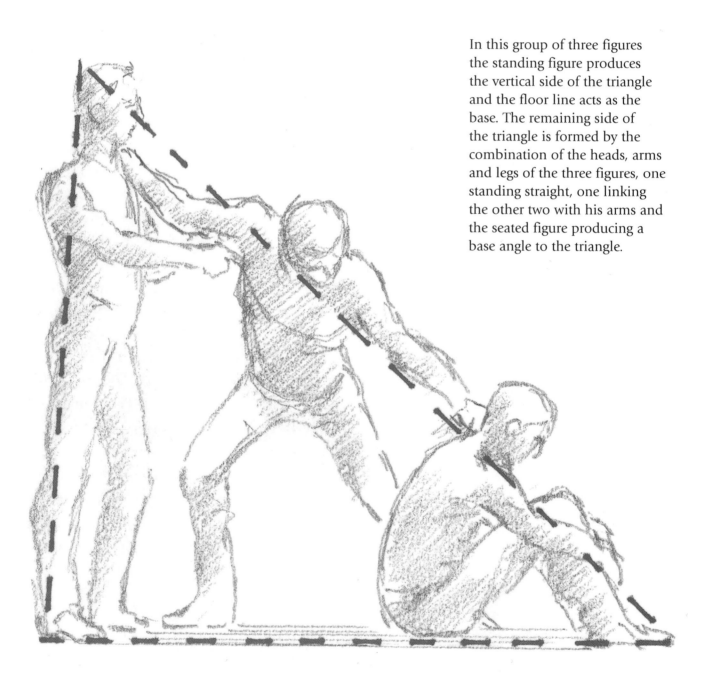

In this group of three figures the standing figure produces the vertical side of the triangle and the floor line acts as the base. The remaining side of the triangle is formed by the combination of the heads, arms and legs of the three figures, one standing straight, one linking the other two with his arms and the seated figure producing a base angle to the triangle.

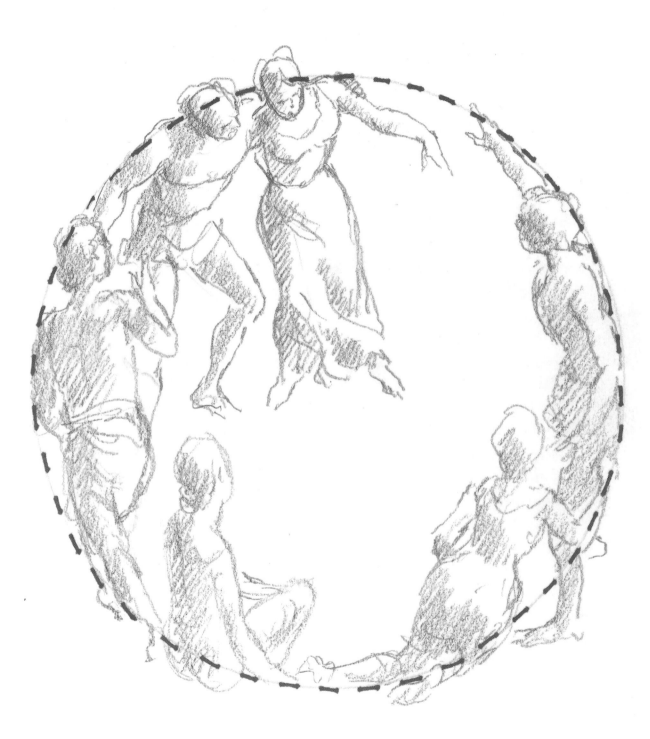

A circular composition is unusual and lends itself mostly to dance movements of groups of figures. This group of three couples suggests some formal movement which could develop into a dance, with the lower edge of the circle indicated by two females about to stand up but still sitting or kneeling. The gestures of two of the male and female figures with their outstretched arms help to create the circle and the beginning of a dynamic, dancing movement.

RELATING TRIANGLES AND RECTANGLES

The lines in the next drawing may look complex but they are in fact a way of simplifying a grouping by pinpointing the extremities of the figures. Adopting this method will also help you to hold the composition in your mind while you are drawing.

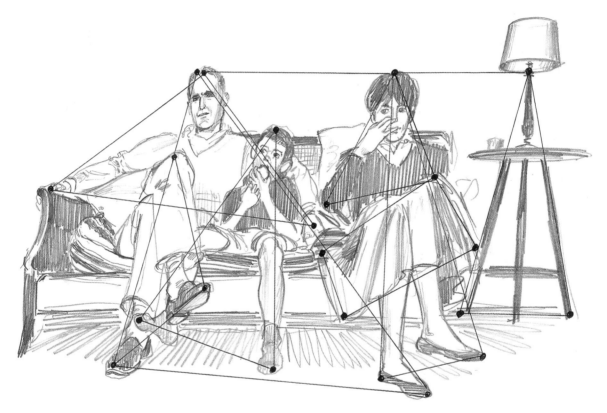

Let's identify the triangular relationships in this fairly natural composition: the father's head to his lower foot and to the mother's lower foot; also his head to his hands; the boy's head with his feet; the father's knees and feet; the mother's skirt shape and the relationship of head to elbow to knee. The table and lamp form a ready-made triangle.

Triangles and Angles Simplified

You don't have to be a great geometrician to understand systems based on angles and triangles. When it comes to triangles, just note the relative sizes of their sides: in an equilateral triangle all three sides are equal (and all angles are equal); in an isoceles triangle one side is shorter than the other two; and in a parallelogram (which is four-sided) the opposite sides are equal in length and parallel.

Angles are even simpler. An angle of 90 degrees looks like the corner of a square. Half a right-angle is 45 degrees, and a third is 30 degrees. These are the only angles you'll need to be able to recognize. All the others can be related to them, and thought of in terms of more or less than 30, 45 or 90 degrees.

TAKING YOUR COMPOSITION FORWARD

Once you decide on an arrangement for your figures, you then need to consider their dress (formal or informal); the background (inside or outside, dark or light; detailed or plain); the lighting (from above or the side, strong or diffused); or props (pets, favourite toys, hats, books, musical instruments). And so it goes on; the list is unending. But that is half the fun. From this, you can imagine that you might arrive at an infinite variety of groupings.

Don't exhaust your sitters by trying out too many variations at once. When you've hit on the idea you want to pursue, make a quick sketch of your group in position, without worrying about likeness, and then draw each face in the right position separately, before putting the faces and the group composition together to produce your finished work.

Don't expect your subjects to hold the pose for long periods, especially when children are involved. You won't be in the same position as the great Roman painter of groups of figures, Caravaggio, who, at the height of his fame, paid his models so well that they'd sit, stand and pose for him for days on end.

CENTREPIECES

For a group portrait it can be very effective to include a focal point around which the sitters can gather. This might be something that relates to their interests or profession.

In this 18th-century group by Carl Marcus Tuscher, the two adult figures and the lifted top of the harpsichord give a stable effect. The curved line that links the position of the heads pulls the eye smoothly across the composition.

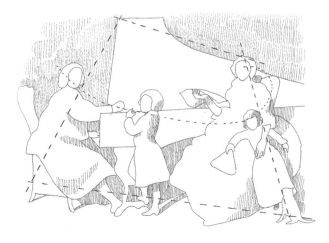

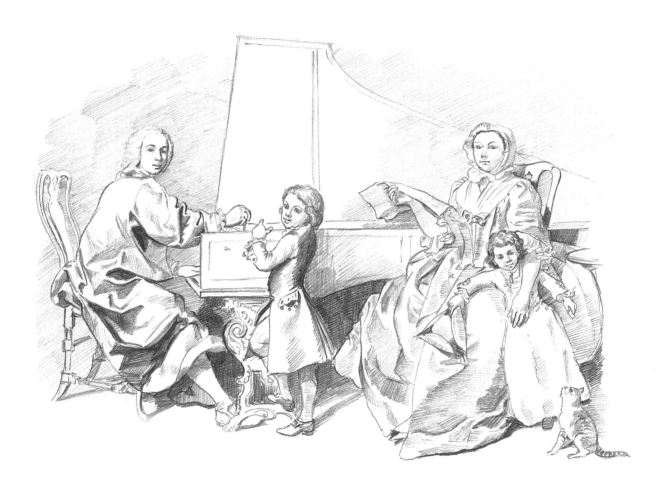

Like many 18th-century portraits this one is carefully posed to include plenty of visual clues to the sitters' social position. The artist wants to show us that these people are comfortably off – note the care that has gone into the detail of their clothing. The head of the family is Burkat Shudi, a well known harpsichord manufacturer and friend of the composer Handel. The harpsichord is centrally positioned but set behind. If we were not sure that the family owes its good fortune to the instrument, Tuscher underlines the connection by posing Shudi at the keyboard with a tuning fork in his right hand, and has the eldest son indicating to the viewer what his father is doing. The arrangement is balanced but relaxed. It is as though we have dropped in on the family unexpectedly at home and found them at leisure.

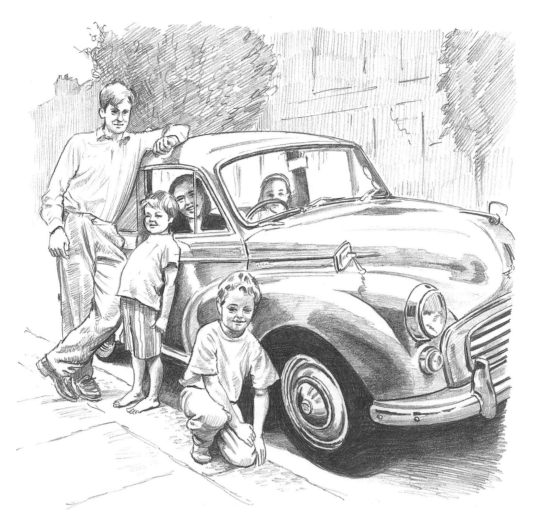

This example might almost be a portrait of the car as much as it is of the family. Obviously very well looked after, polished and shining, it is the centrepiece of the arrangement, if not quite the head of the household. The pride of possession is very evident among the males. The females inside the car are less obvious, although the mother is in the driving seat. This sort of casually posed arrangement is more often found in photo-portraiture. The style makes the drawing of the figures more difficult than it might have been in a different arrangement.

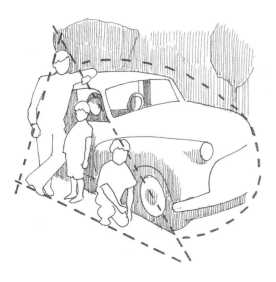

This composition is unusual and rather dynamic, partly due to the position of the car. The three figures outside the car form an acute angled triangle which also gives perspective. The bulge of the car against the longer side of the triangle produces a stabilizing element.

FORMAL ARRANGEMENTS

In this example there is an attempt to create a formal pose, but of the kind you get when people have gathered for a snapshot. The father is sitting, as is the mother, who has the youngest child in her lap. The two daughters are perched either side of their parents. It seems the oldest boy is standing only because there is not enough room for him on the same bench, and he is obviously the only one tall enough to look over the top of his father's head.

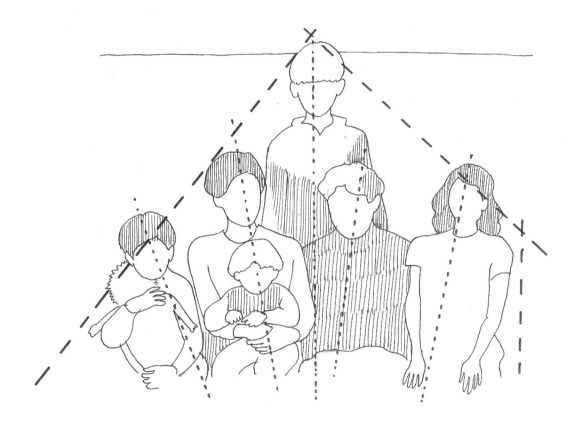

Another simple enough composition, with
a large triangular shape like a pyramid, with
the individual figures radiating outwards
from the wide base, like the arms of a fan.
Very static and symmetrical.

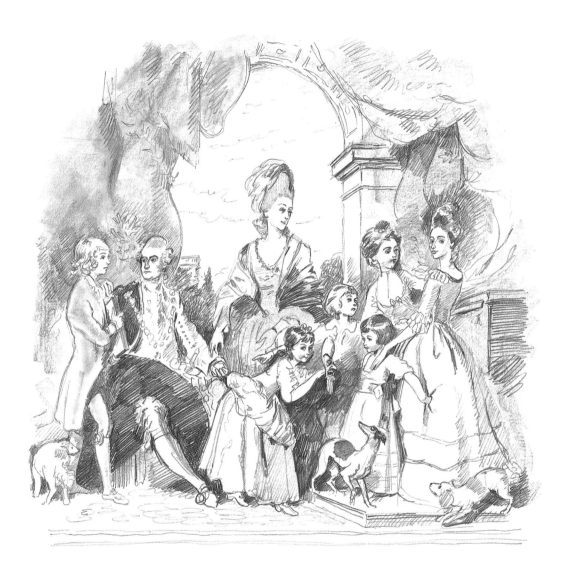

The Duke of Marlborough's family portrait was done by Sir Joshua Reynolds in his best classical manner. We see the father seated in the grandeur of the robes of the Order of the Garter, his hand resting on the shoulder of his eldest son. The mother stands at the back of the group under the triumphal arch, her fingers gently resting on her husband's cuff as she casts an amused glance at her children. They are grouped along the space in front of her, dogs weaving around their feet. One young girl is holding a mask, trying to frighten her sister, who is leaning back against an older girl's dress. Reynolds has lightened the formality with this humorous touch to bring out the characters of his sitters. This may be a great family, but there is a human dimension.

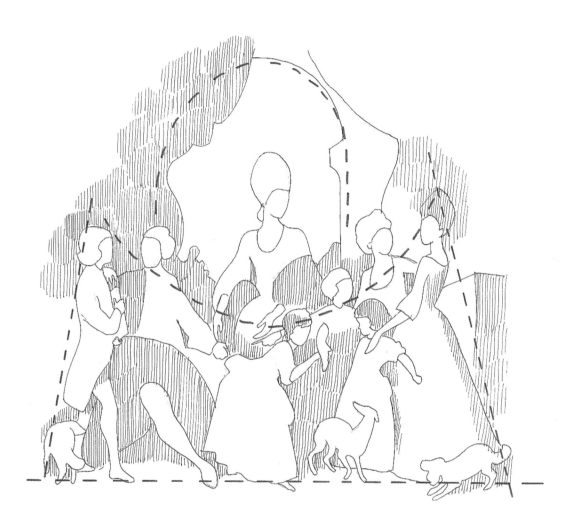

The drawing style for this copy is loose and tonally sparse. Areas of tone are either heavily scribbled lines, meandering lines following the form or smudged pencil to make the texture as unobtrusive as possible. The outlines are correct but not detailed. Simplification is a good rule here.

Note the nicely balanced wedge shape with the wide curve of the heads of the family. The exception is the Duchess who is centred under the tall arch in the background. Mobile, but restful at the same time.

COMPOSITION

VARIATIONS ON A THEME

The use of a basic activity like eating and drinking is a very good way of connecting with the viewer. This situation can be shown in many different ways, and can say many different things. In the Van Gogh the family at table is at a fairly low level of subsistence, their attention concentrated on getting fed as quickly as possible. The Breughel tells us about the earthy enjoyment that can be had from drinking. At the Duc's banquet, restraint is the watchword. We are kept at arm's length, surveyors from afar, in contrast to the Metsu where we are taken into the scene as though we are one of the family. Here the familial connections are made obvious through look and gesture.

Eating and drinking as necessity are clearly shown in Van Gogh's 'Potato Eaters'. The evening meal is a serious business for these gritty peasants. The drawing is full of darkness and shadows, the gloom punctuated by telling shafts of light which catch on tired faces, gnarled hands and what little there is to be consumed.

'The Peasant Dance' by Breughel shows a more cheerful if just as intense eating and drinking scene. The peasants greet each other, talk with their mouths full and embrace with gusto. The characters' enjoyment of the table is well illustrated by the composition, which gives us a close-up of what's going on. Each shape is pushed together and overlaid, much as you would find with a photograph taken at close range. This creates a feeling that we might be watching people we know, perhaps neighbours. We are catching them unawares.

The composition of the Limbourg Brothers' illumination for the 'Tres Riches Heures du Duc de Berry' is formal and courtly, the food and clothing sumptuous. Each of the feasters is aware of his status in society. Only the Bishop and the Duc himself are seated. The lateral spread of the composition lends detachment to the scene. Unlike the other pictures here, we don't know these people.

In Gabriël Metsu's fluid composition of the Epiphany feast in a Dutch home, we are onlookers at a relaxed family gathering. An old man drinks a yard of ale, to the amazement of the little boy and the old servant or wife, while the younger woman is disapprovingly unable to believe her eyes.

ANALYSIS

Compositionally, Renoir's 'Boating Party' is a masterly grouping of figures in a small space. The scene looks so natural that the eye is almost deceived into believing that the way the figures are grouped is accidental. In fact, it is a very tightly organized piece of work.

Notice how the groups are linked within the carefully defined setting – by the awning, the table of food, the balcony – and how one figure in each group links with another, through proximity, gesture or attitude.

Let's look at the various groups in detail.

Group A: In the left foreground is a man standing, leaning against the balcony rail. Sitting by him is a girl talking to her dog and in front of her is a table of bottles, plates, fruit and glasses. It is obviously the end of lunch and people are just sitting around, talking.

Group A

Group B: Just behind these two groupings are a girl, leaning on the balcony, and a man and woman, both seated.

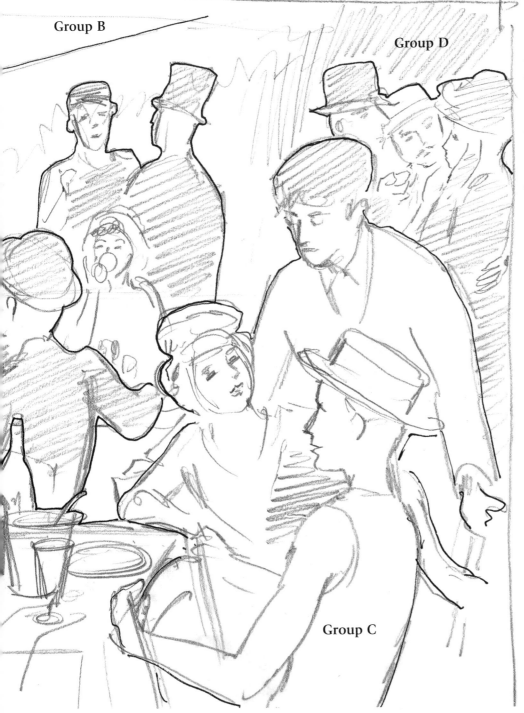

Group B

Group D

Group D: Behind this trio, two men are talking earnestly, and to the right of them can be seen the heads and shoulders of two men and a young woman in conversation.

Group C: In the right foreground is a threesome of a girl, a man sitting and a man standing who is leaning over the girl, engaging her in conversation.

Group C

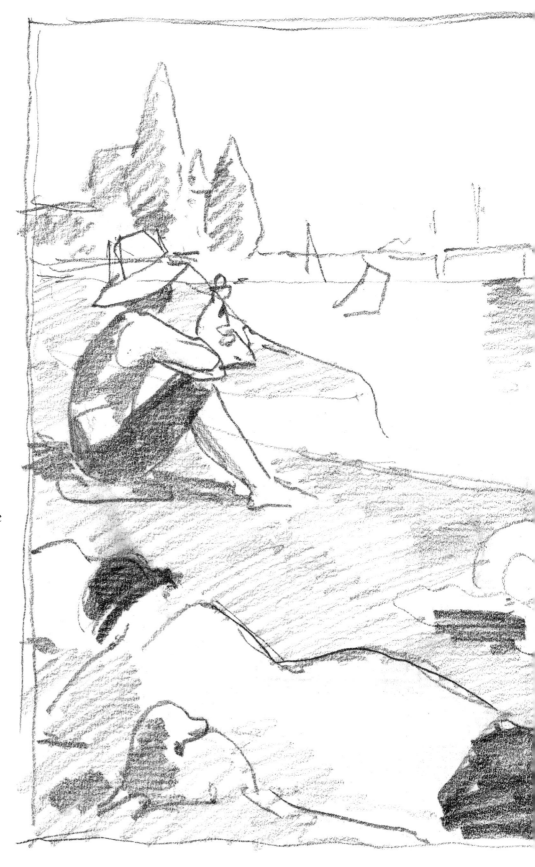

In Seurat's large, open air painting of 'The Bathers', the composition is effectively divided in two: the horizon line with factories along it comes about two-thirds above the base of the picture, and the diagonal of the bank runs almost from the top left of the picture down almost to the bottom right corner. The larger figures are grouped below this diagonal. The picture is drawn as though the viewer is sharing the quiet calm of the day with them, surveying the people sitting on the grass and in the boat on the river and the scene beyond.

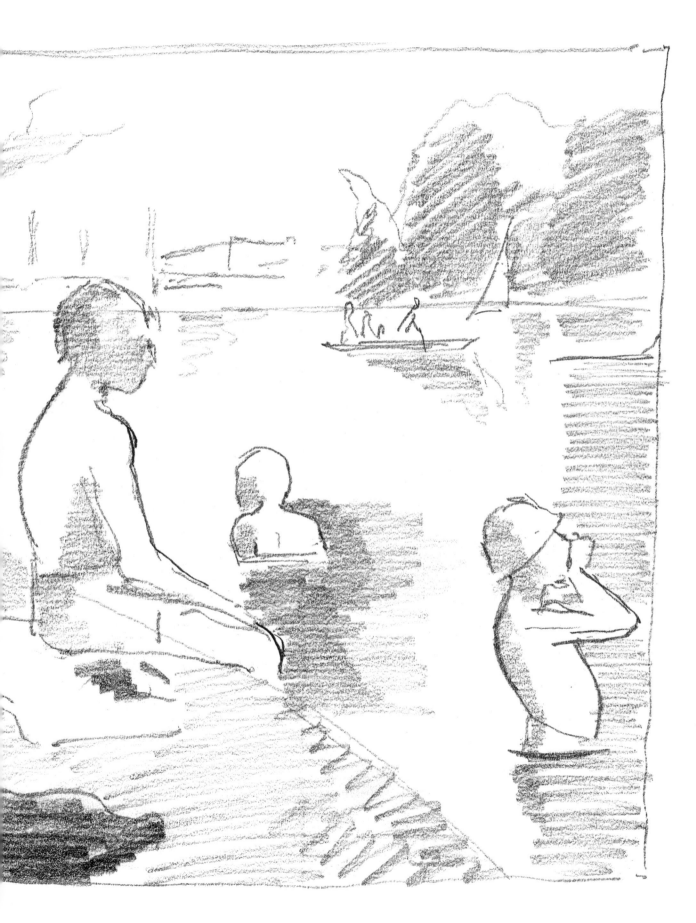

PRACTICE: CREATING A COMPOSITION

Most artists draw or paint the elements in their compositions piecemeal and then fit them together in the studio. Here I have deconstructed a Manet by separating out the individual parts of his picture and then reassembling them as he did. Try this system yourself. Manet arranged the elements shown here to produce a rather intriguing picture. Let's discover why it works so well compositionally.

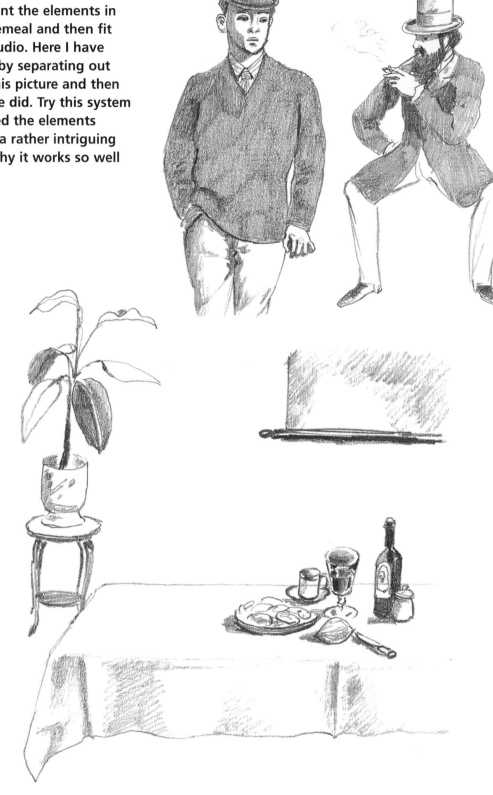

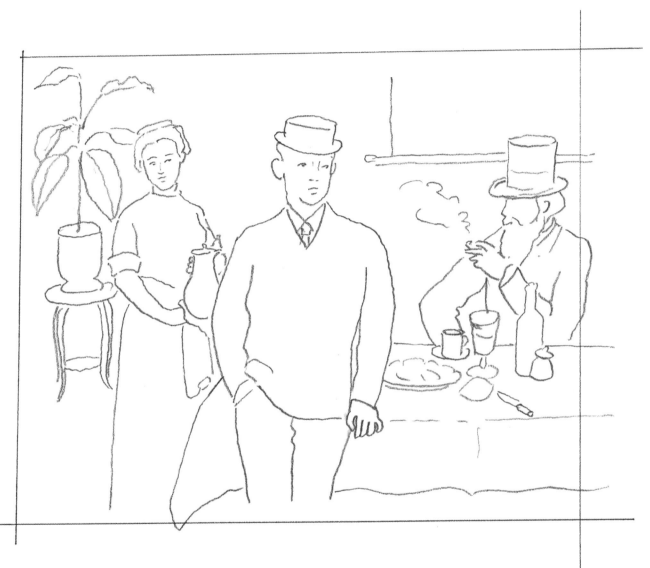

A cursory glance tells us that we are witnessing the end of a meal enjoyed by two men, whether alone or separately we are not sure. Neither is communicating with the other. The woman with the jug has been placed in the background with the pottted plant to the left of her, thus acting as a frame and serving to make her part of the narrative. The older man looks in the direction of the woman, the woman looks questioningly at the younger man and he looks beyond, out of the picture.

When you create a composition have in mind the poses you want to put together, then draw them separately. Afterwards draw in the background, including still-life objects, to make the scene convincing. If you decide that you want an outdoor setting, draw the background first and then decide how you will fit the figures in before you draw them separately. Some artists look for backgrounds to suit the figures they want to draw. The important point is to match the shapes and sizes carefully so that the proportions work.

Now try your own hand at a picture. The following pages offer a practical exercise in ways of producing an effective figure composition. We begin by looking at arranging models.

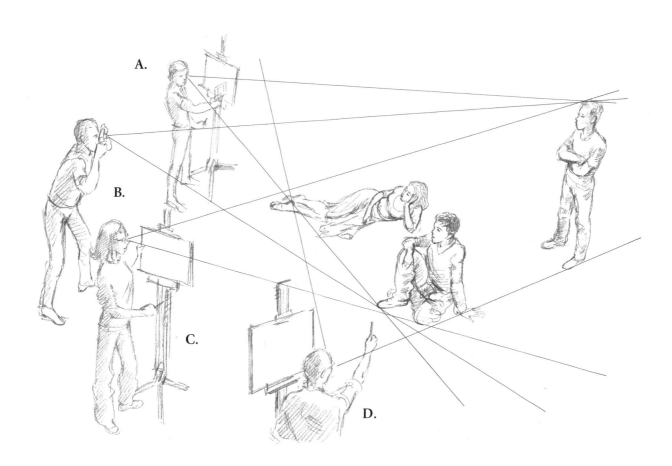

A.

B.

C.

D.

Viewing different angles

Get three models together to sketch them in some sort of relationship with each other, with space and depth around them. It doesn't matter about the scenery yet, but you need to know how the figures will look together in reality. Either get them to pose while you do a quick sketch, or take a photograph (B) to give you an idea of how the composition might work. Even now it doesn't have to be set in stone and if necessary you can still change them around, but a good drawing of how the figures relate is now essential. You might use a card framing device (A), or do it by eye (C) or measure it by judging with your pencil (D).

A.

B\C.

D.

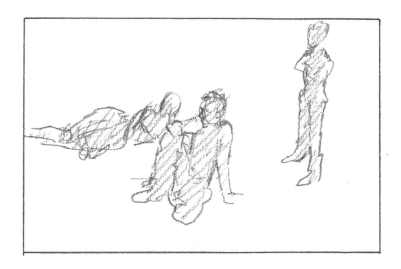

Exploring the setting

Relaxing in the park in summer is the theme, so you will need to make some drawings of background scenes in your nearest parkland or gardens. With your drawings of the three characters to work on, place them in the scene in as many ways as you think fit to get the best effect you require. When you have considered some options, make a choice. All these stages are about making decisions that gradually limit your picture to a pattern that you find aesthetically satisfying.

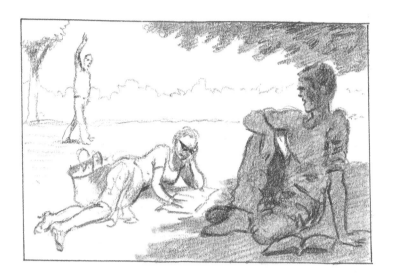

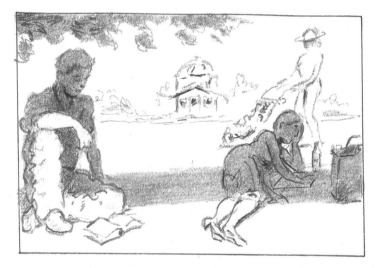

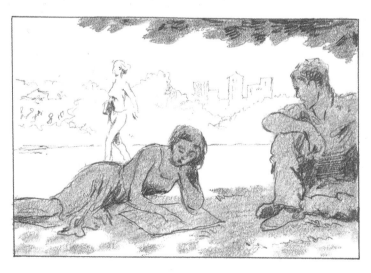

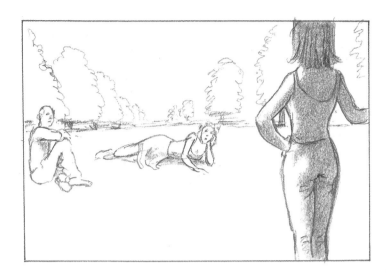

In all these scenes the dynamics are different although the scene is similar. Each could work. My choice (left) is just that I liked the contrast between the woman lit up in the foreground and the man sitting in the shade behind.

COMPOSITION

Detailed figure drawings

Having chosen your composition you will now have to do detailed drawings of your three figures. This time you can take them one at a time and make a more careful drawing that will have all the information you want in it. This means that now you have to notch up the level of your drawing to something more developed and finished. Take your time at this stage; it is worth getting these drawings absolutely right. It doesn't matter if it takes several days or even weeks to complete them, it will be worth it in the long run and the end result will be all the better for it.

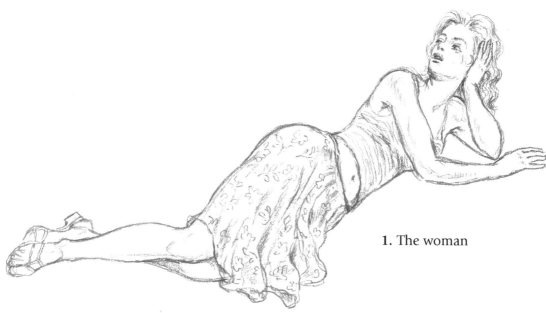

1. The woman

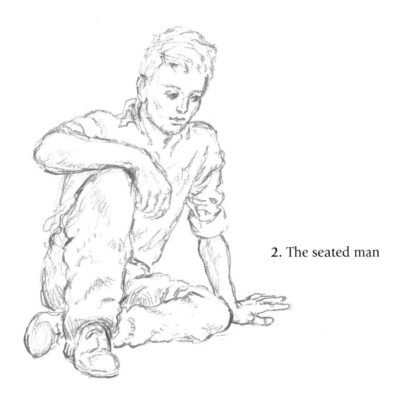

2. The seated man

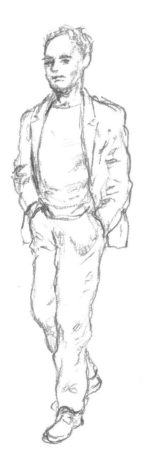

3. The strolling man

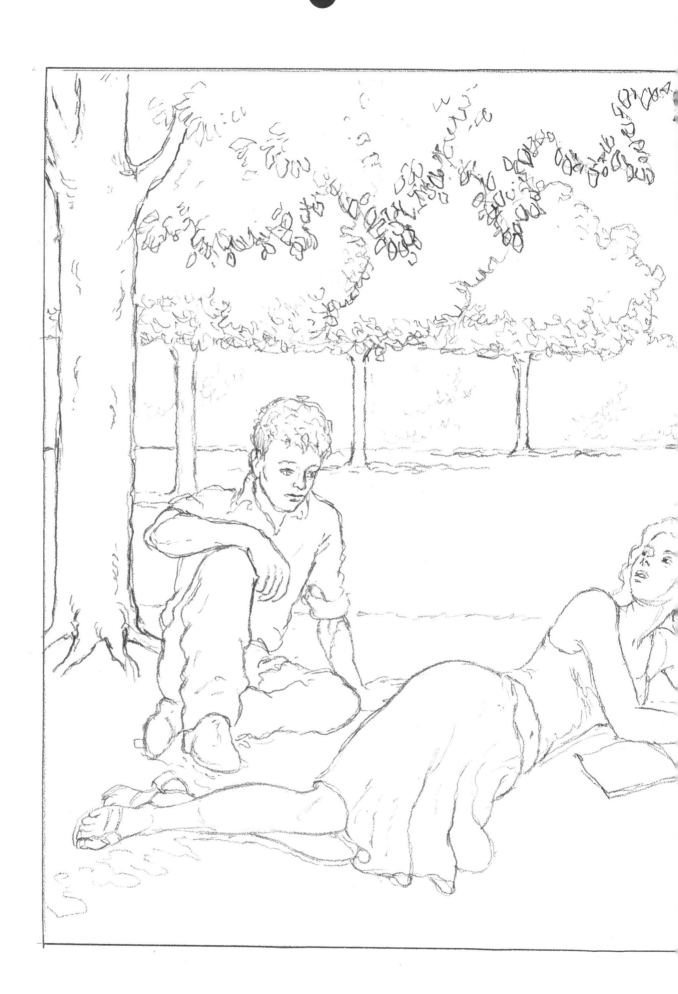

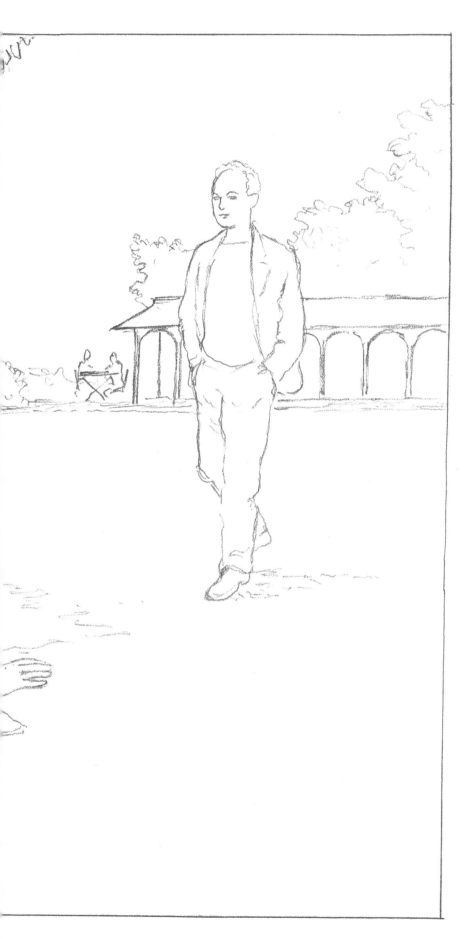

Putting it all together

Now you have three excellent drawings of your characters, you have to fit them convincingly into your scene. You may have to reduce or increase their size as you set the relationship of the three figures for the final piece. Draw them up very carefully, tracing them off in line, and placing them in an outlined drawing of the setting. This is your 'cartoon' in which everything is going to be drawn as the final picture requires. It has to be the same size as the finished drawing and everything should be in it except for tone and texture. At this stage what is required is a full-size complete line drawing in pencil of your composition.

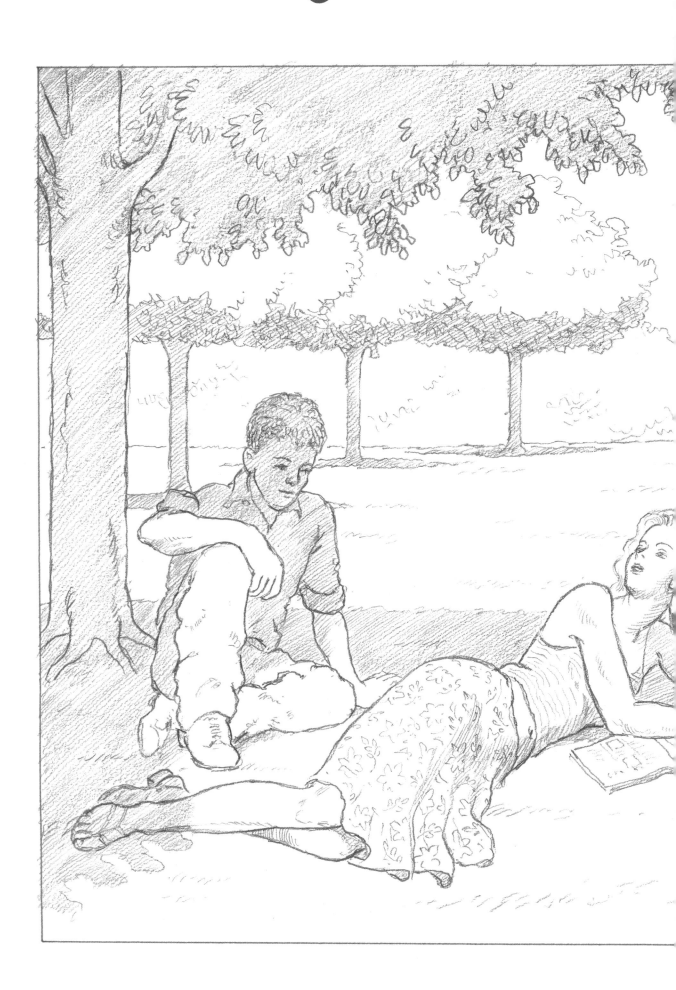

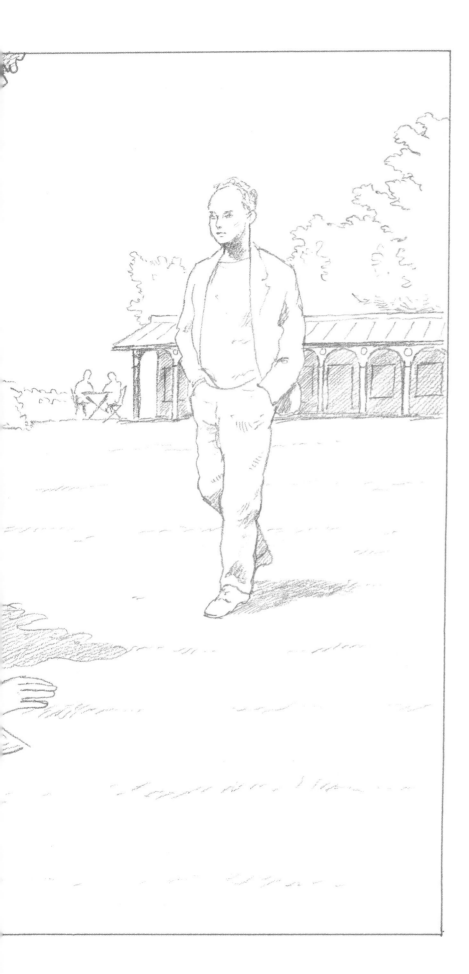

Blocking in the tone
The next stage is to put in every bit of tone, but in one tone only – the lightest you are going to use. At this stage you can also begin drawing in your final technique (for example pen and ink, or line and wash). All heavier tones can be worked in later and even the texture of each area can be left until after this stage. So you should at the end of this stage have a complete drawing in line and tone, but only one bland tone.

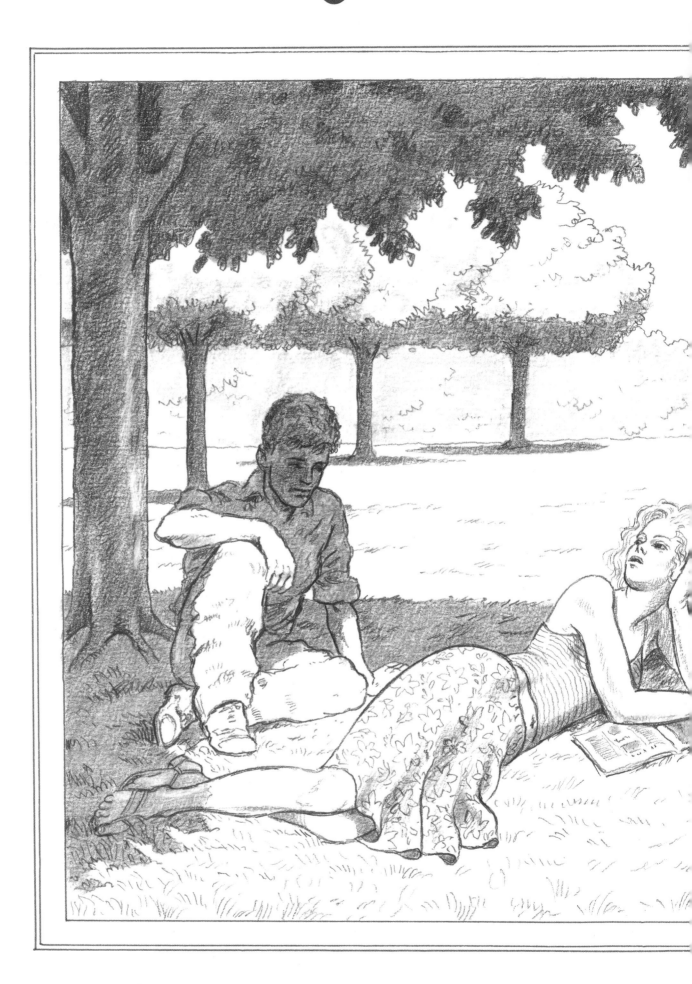

The complete picture

Having made all the necessary decisions which have produced a convincing picture, you can now let rip with light and shade, the textural qualities of the scene and the subtleties of outline. Work into your shaded areas so that darker, bigger areas of shade have more variety of tone from very dark to light. The objects and people further away should have lighter and less varied tones to give a feeling of recession. Show the textural qualities such as grass and leaves, again making those in the foreground more textured and more obvious. The figures themselves are dealt with in a similar fashion, the further figures being less strongly toned and textured while the nearer ones are more varied and stronger in detail. Even the outlines of the foreground figures should be stronger in the front of the picture and fainter as they recede.

Now you have accomplished a complete figure composition on the theme of summer in the park with three figures. Well done! You will no doubt have realized how necessary it is to have a system of working your way through a picture, and while you may wish to adapt it, this system has stood the test of time.

SUBJECT

We have
included in this section
various approaches to a wide range
of potential subject matter for you to
consider. You will find yourself confronted by
similar problems whatever your choice of subject.
Whether you are looking at a plant or a horse, a
seascape or a person, the first objective is to look at
the shape and movement that runs through your subject
and to simplify it. Each different object, person, or place
on which you focus is composed of shapes which can be
simplified in order to see how your subject works as form
in space and as part of your overall composition. Different
subjects naturally have different characteristics and all you
have learned so far will come into play when deciding
how to interpret your chosen area of study. How you see
your subject, the material you use to define it and the
positioning of it within the frame of your page all
combine to make your approach unique to you.
Be brave and try subjects unfamiliar to you
– you'll learn that this is the best way to
develop your skills and increase
your confidence.

SUBJECT

PLANTS

Plants are very accommodating subject matter when you are learning to draw. They don't keep moving; they remain the same shape while you are drawing them; a great many of them can be brought indoors to observe and draw at your convenience; and they offer an enormous variety of shapes, structures and textures.

To begin with, choose a flower that is either in your house, perhaps as part of an arrangement, or garden. In the series of exercises here we concentrate on the principal focal point, the head in bloom, although it is instructive to choose a plant with leaves because they give an idea of the whole. Study the shape of your plant, its fragility and how it grows. Now attempt to draw what you see, following the approach outlined below.

Using a well-sharpened pencil, which is essential when drawing plants, outline the main shape of the bloom and the stalk.

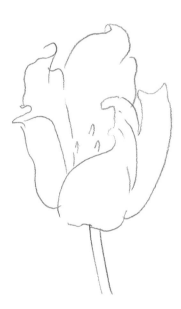

Draw in the lines of the petals carefully.

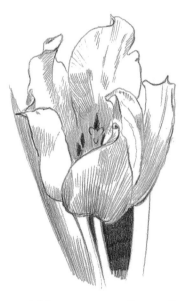

Add any tone or lines of texture.

What you may notice in this exercise is how exquisite the texture and structure of the petals and stamens are and how carefully you need to trace the line. Don't use heavy lines because the effect they produce will contradict the delicacy of the plant.

In some places around the petals you will need to emphasize the sharpness of the line, while elsewhere your touch will need to be very light, the line almost invisible.

The type of pencil you use for drawing plants should be no different from your usual choice, but it must be kept sharpened to a good point. A blunt point will deaden the characteristic elegant edge of flowers. Any shading you attempt with a blunt pencil will produce a similarly coarse result.

1. Ensure that the ellipse for each floret is angled in the right direction, otherwise the shape of the plant won't be correct.

Now try drawing a more complex plant with several blossoms or florets on one stalk, as here. This time, the construction lines at the beginning have to be more exact in order for all the flowers to fit together on the stalk in the right proportion. After that, carry on as before.

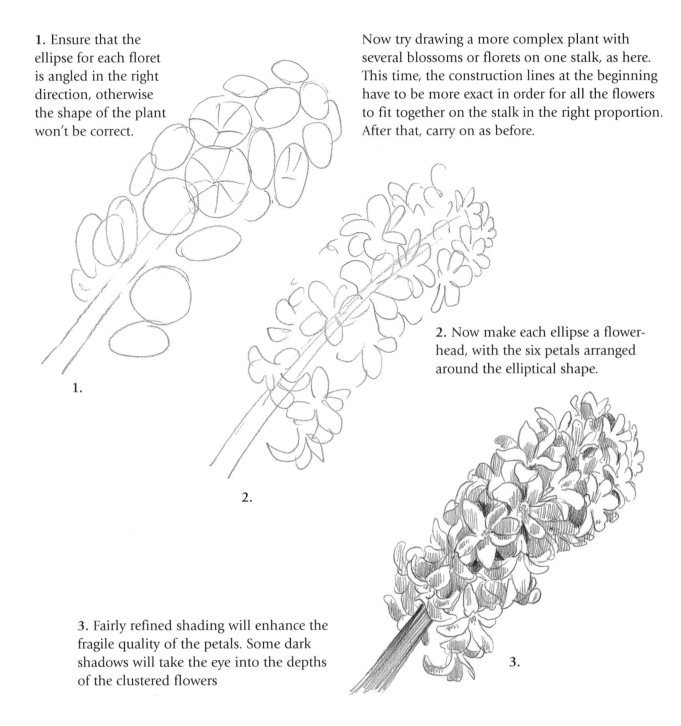

1.

2. Now make each ellipse a flower-head, with the six petals arranged around the elliptical shape.

2.

3. Fairly refined shading will enhance the fragile quality of the petals. Some dark shadows will take the eye into the depths of the clustered flowers

3.

When drawing flowers it is tempting to try to indicate colours by using different tones. This is not a good idea because it tends to destroy the clarity of the form. It won't achieve the result you intended either. As in other types of drawing, concentrate on using well the effects that can be applied successfully.

By contrast with the other examples, this lily is a very sculptural looking flower. It is shown in three stages of bloom; as it is just opening, almost fully extended, and at full bloom just before it begins to die off.

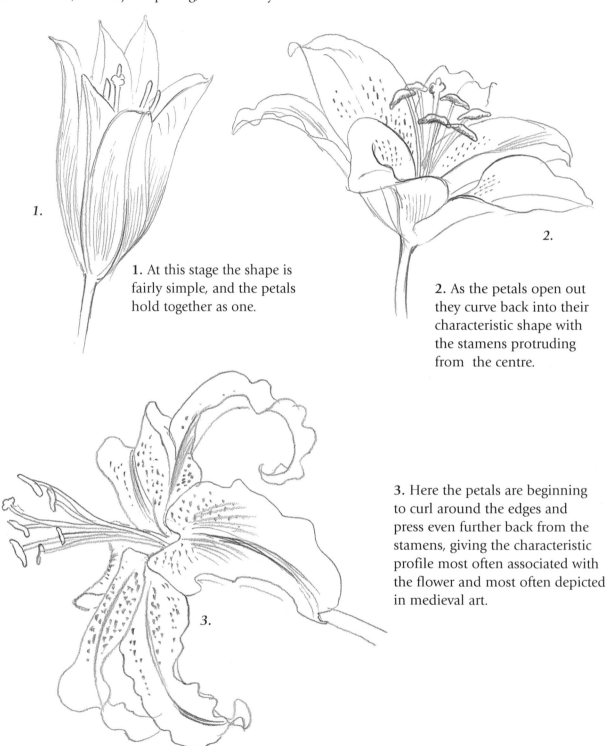

1.

1. At this stage the shape is fairly simple, and the petals hold together as one.

2.

2. As the petals open out they curve back into their characteristic shape with the stamens protruding from the centre.

3.

3. Here the petals are beginning to curl around the edges and press even further back from the stamens, giving the characteristic profile most often associated with the flower and most often depicted in medieval art.

Now experiment with a range of different shapes and find slightly different ways of drawing them. As you can see from this selection, each subject has been approached from a different viewpoint. I did this because I wanted to get a better idea of the plants' form and habit and what gives them their individual character. Try this for yourself. You will find your method adapting to the requirements of the subject and that you are perhaps drawing only an outline or making a more detailed line drawing but without adding the tonal areas indicated. Sometimes you might find yourself adding tone to enhance the feeling of the shape.

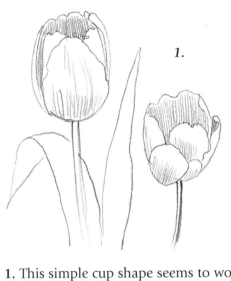

1.

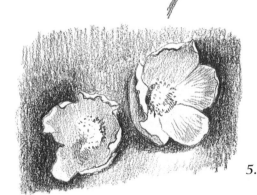

2. The linear effect of the curled rose petals tightly spiralling around the centre is very characteristic of this flower, and it is unnecessary to add any tone except to the leaves.

2.

1. This simple cup shape seems to work best with the inside space shaded.

3. The soft cushiony centre of the sunflower can be described with just enough tone to give it texture.

3.

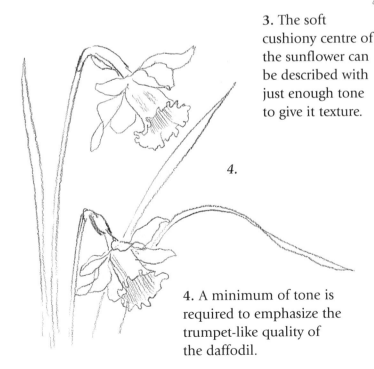

4.

4. A minimum of tone is required to emphasize the trumpet-like quality of the daffodil.

5.

5. Adding tone around the blossom, in the space against which the plant is shown, can have the effect of making the flowers look brighter or more delicate.

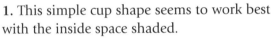

FLOWERS IN CONTAINERS

One of the most popular themes of all time in still-life pictures has been those depictions of flowers in vases which remind people of their own homes. The simple, delicate beauty of the blossoms, combined with an attractive container, can be handled in many ways to convey their growth and fragrance.

This theme is one of the oldest of all, with many of the early Flemish and Dutch still-life pieces being abundant arrangements of flowers painted with almost botanical precision. However, since the Impressionists the theme has moved on to more loosely painted pictures of great tactile beauty.

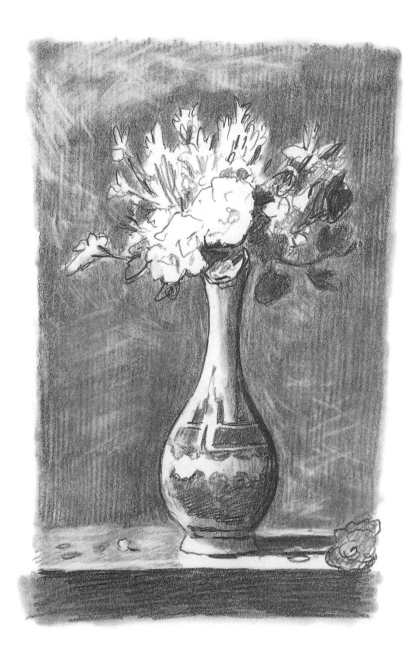

The vase of flowers by the master Chardin has both delicacy and strength, while also offering depth and structural complexity.

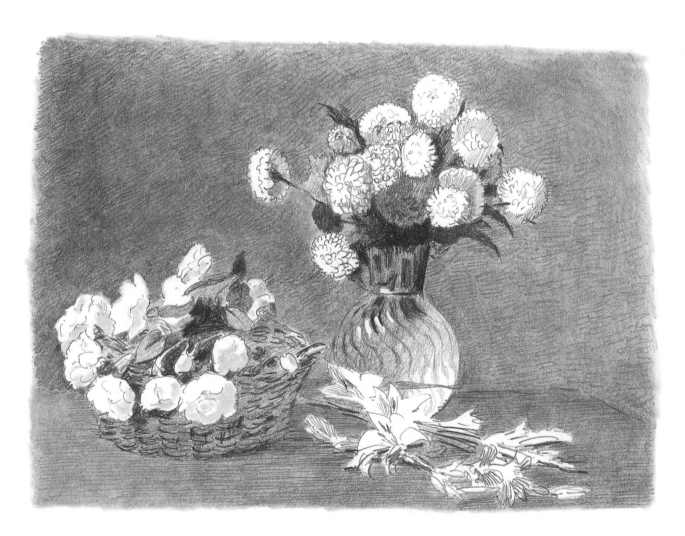

The rich bunches of dahlias in this picture after Henri
Fantin-Latour (1836–1904) have an almost tactile
feeling of the creamy plush blossoms. They are lit
with a soft light against a shadowy background that
helps to produce a strong effect of depth and texture.
Fantin-Latour's flower paintings are some of the most
admired in the genre.

SUBJECT

LARGE PLANTS

Large plants are ideal practice for drawing trees. They display many similar characteristics and they ease you into upping the size at which you draw. Potted plants are ideal subjects and give plenty of opportunity for practising the growth of the leaves and how this growth is repeated throughout the plant. The same pattern of leaf growth can look quite different when viewed from other angles. It is worth experimenting: drawing the plant from beneath, from above, and also side on just to give yourself experience of how the shapes alter visually.

As with smaller plants, attention to detail is important. You need to investigate how each leaf stalk connects to the main stem and be scrupulous about the number of leaves you put in each clump: don't put in more than are actually there, or too few.

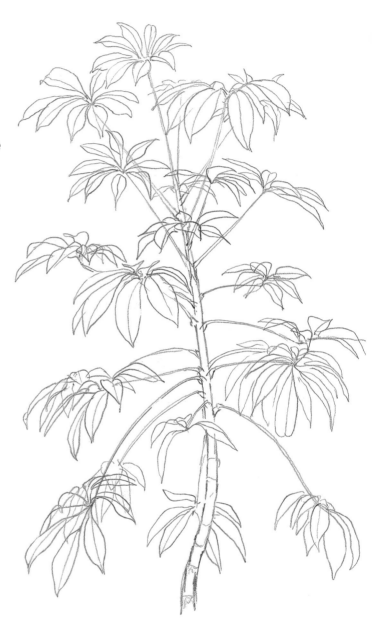

In this example each leaf has a characteristic curl. Once you see the similarities in the pattern of the plant, the speed at which you draw will increase. It is important to feel the movement of the growth which the shape shows you through the plant and how it repeats in each stalk.

Once you start drawing larger plants, you realize that drawing every leaf is very time-consuming. Some artists do just this, but most devise a way of repeating the typical leaf shape of the plant and then draw in the leaves very quickly in characteristic groups. It is not necessary to count all the leaves and render them precisely; just put in enough to make your drawing look convincing.

Be very aware of the overall shape and construction of the branches and how the size of the leaves will vary. Look closely at this example and you will understand.

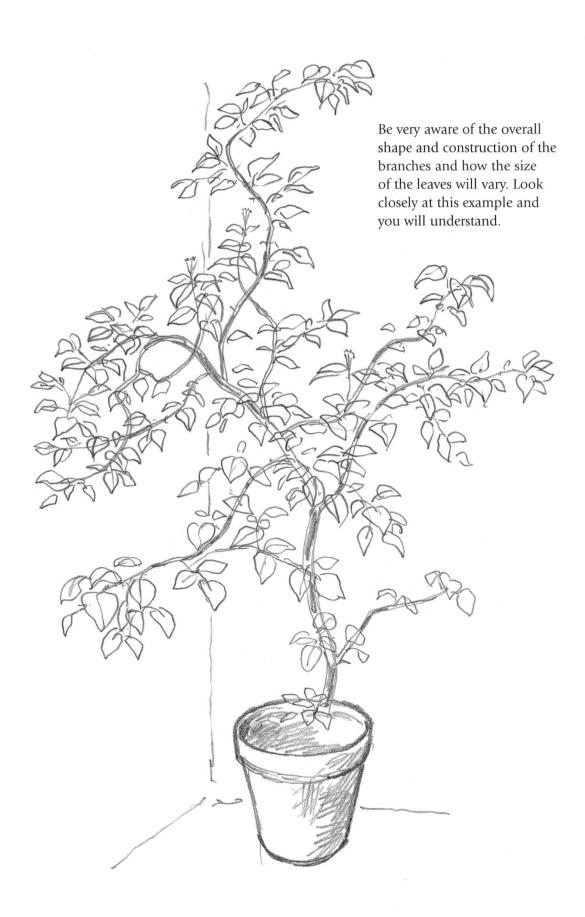

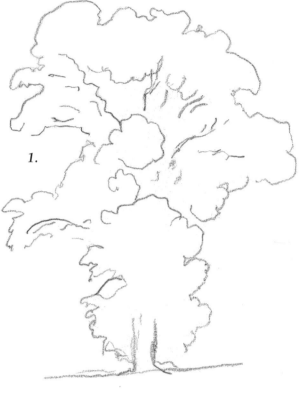

1.

TREES

The idea of drawing trees can be a bit daunting because there seems to be so much to them. To begin with, just concentrate on capturing the overall shape by looking at the outline of the whole mass of the tree. Draw a line around the extremities of the branches and the twigs. Contrast that with your line for the trunk. Don't concern yourself with the details of leaves or even branches.

1. This oak has cloud-like branches of leaf growth projecting from the trunk to form the main shape. The sun was shining from behind the viewer, hence the absence of shadow.

2. The central poplar, with its vertical, elongated, cone-shape construction of leaves and branches, was well lit.

3. The sun was directly overhead here, and I have indicated this by leaving a very light area at the top and adding tone towards the bottom, to create the effect of branches overhanging the lower parts, creating shadows.

2.

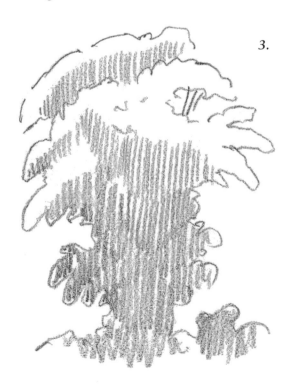

3.

4.

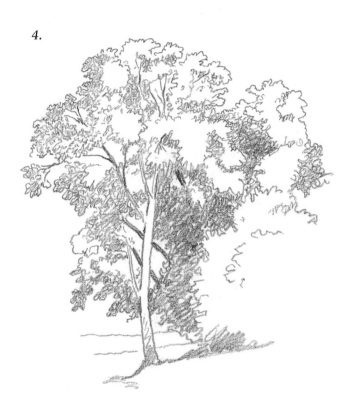

4. When you have had more practice with tree shapes, look for examples that will enable you to have a go at using the pencil to capture an indented and more detailed outline, as here. You can add some textural marks to give the effect of leaves, particularly in the shady areas. Also make sure that some of the large branches are visible across the spaces within the main shape of the tree.

5. When you look at a tree with the light mostly behind it, you get the effect of a silhouette which gives a nice simplicity to the overall shape.

6. In this small group of cedar trees the feathery layers of leaves and branches contrast well with the vertical thrust of the rather simple trunks. Again, the sun was behind the subject.

5.

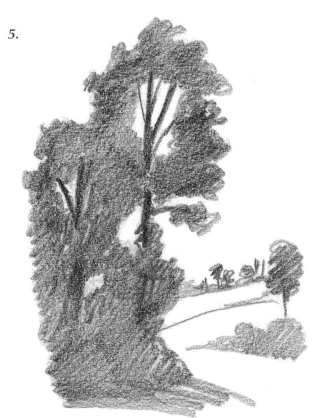

6.

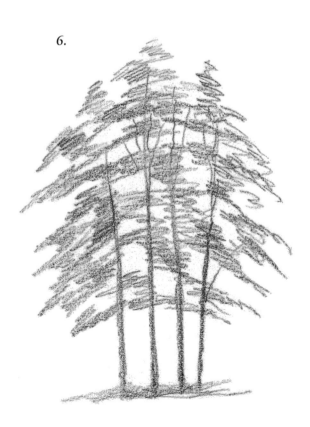

TREES IN THE LANDSCAPE

This loosely drawn copy of a John Constable composition shows you one way of simplifying your approach to landscape drawing. Here the areas of trees and buildings have been executed very simply. However, great care has been taken to place each shape correctly on the paper. The shapes of the trees have been drawn with loosely textured lines. The areas of deepest shadow show clearly, with the heaviest strokes reserved for them.

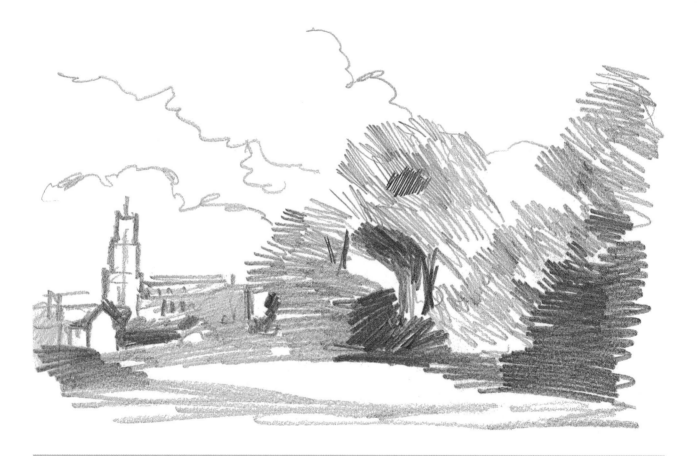

When producing landscape drawings it is very easy to be daunted by the profusion of leaves and trees. Do not attempt to draw every leaf. Draw leaves in large clumps, showing how the brightly lit leaves stand out against darker clumps of leaves in the shadow. Each group of leaves will have a characteristic shape which will be repeated over the whole of the tree. Obviously these will vary somewhat, but essentially they will have a similar construction. Find a method of drawing the textures of leaves in large areas. It looks a bit like loose knitting, as you can see from the examples here. You can do no better than to look at Constable landscapes and notice how well he suggests large areas of leaves with a sort of abstract scribble. He also suggests the type of leaf by showing them drooping or spraying out, but he doesn't try to draw each one. The only part of your landscape where you need to draw the leaves in detail is in the nearest foreground. This helps to deceive the eye into believing that the less detailed areas are further back.

When you are more confident, start trying to draw the trees in your landscape in more detail. Take care over your placement of various emphatic points, such as buildings, reflections in water, darkly shaded tree trunks and the clarity of the horizon. If you misplace them, this will have consequences for your drawing. It is very easy to understate emphatic areas like shadows and overstate the sharpness of man-made objects.

The horizon line may be lightly drawn but it needs to be clear.

Don't forget that all you are doing here is making marks with a pencil on paper. You are not really drawing leaves and trees. You are putting down pencil marks to create an impression in the eyes of the viewer, to communicate the effect of a landscape.

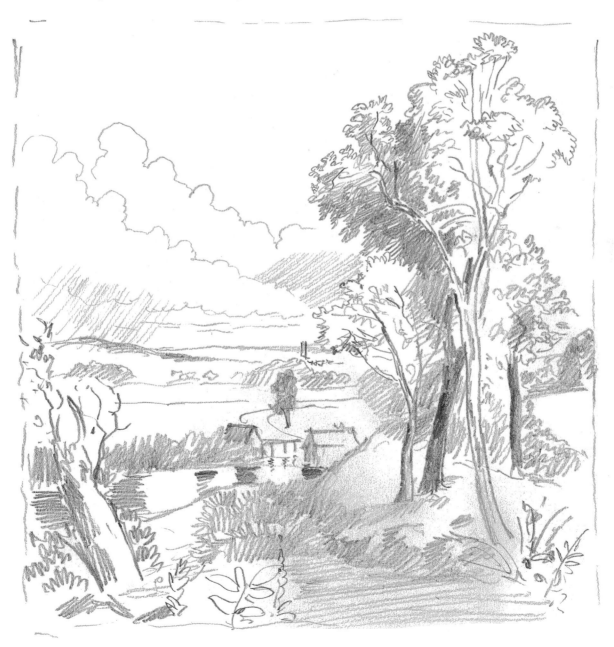

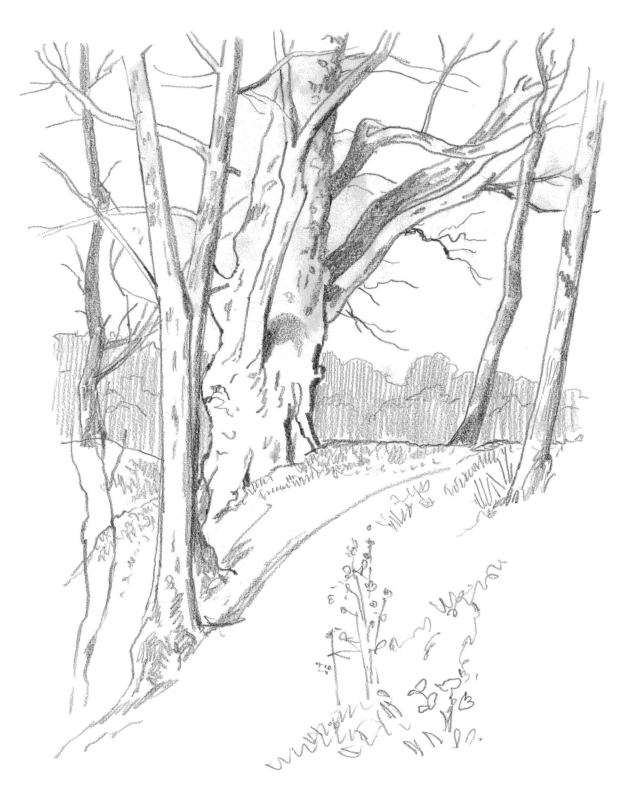

A slightly closer view of trees in a landscape can create an unusual arrangement, as here where the landscape is seen fairly indistinctly through the trunks of the trees. You will find that different species of trees can have quite different shapes.

Some are smooth branched with flowing shapes, while others writhe and bend dramatically. If the trees are varied, their shapes can create a very interesting study of patterns against the sky.

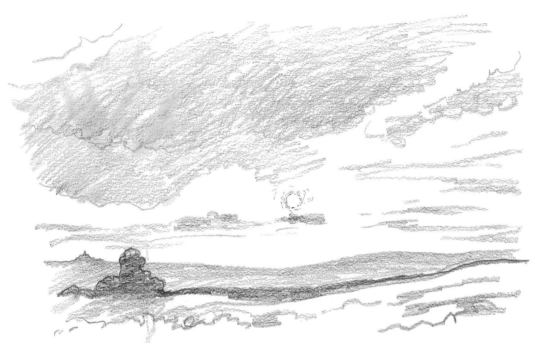

The structure of this landscape is not difficult but you have to vary the texture of your pencil marks in order to get the misty softness of the clouds and the effect of the sun making the landscape itself disappear into a hazy distance.

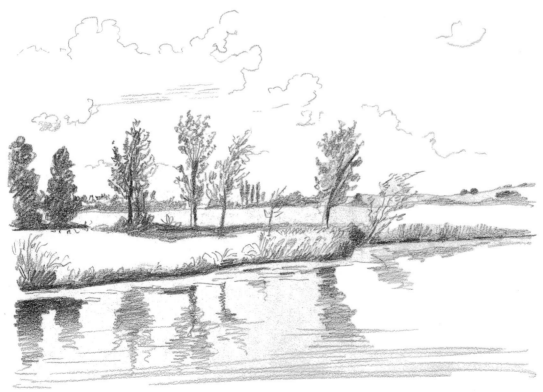

There is a variety of challenges here, but none too difficult. The main interest is in the reflections in the water, which give a sort of reversed picture. To render such reflections, simply draw shapes that are similar to the originals but less definite and slightly broken up to suggest the effect of the water.

GARDEN LANDSCAPES

The tamed landscape of a garden can sometimes seem a rather limiting space for the artist. However, if a garden has been designed with some flair, you will notice that the division of spaces in it create a new proportion of landscape. This may be smaller but it can be just as interesting to draw as a more open, spacious view.

In these three examples, the gardeners have brought a clever aesthetic quality to the manipulation of plants, walls, hedges, etc., which is very rewarding to draw.

Here the hedges and bushes have been carefully trimmed to produce edges to pathways and more open spaces. The effect created is of an enclosed paradise garden. Seen from under an overhanging vine, the formal bushes clipped into large cushions define a route towards the end of an old wall, behind which stand tall clipped hedges. Planted among all this formality are clumps of flowers, potted plants, bushes and places to sit. Rather like a beautiful room without a roof, it offers the artist options for drawing from many angles.

One of the main features to catch the eye here is the topiary, which appear like chess pieces set out in rows around a lawn with larger trees seen behind and a terrace with steps leading up to it. More formal than the first example, the garden is carefully contrasted against the larger trees gathered around in the background. The total effect is of a sort of natural sculpture.

In both these drawings, the rows of clipped bushes give a good effect of perspective and make the space look larger than it is.

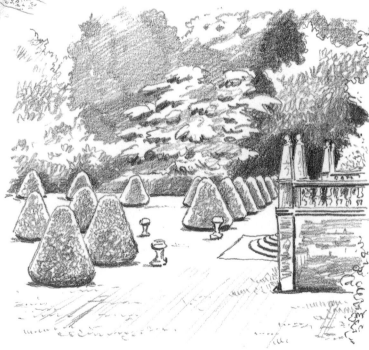

INDUSTRIAL MONUMENTS

Industrialization resulted in the building of quite interesting artefacts. Although there to serve a purpose, some of them are design features in themselves. Places such as factories and power stations, while not built for their aesthetic values, are nevertheless very powerful statements of architecture. The very functionalism of such buildings usually gives them interesting shapes. They represent a rewarding challenge for artists interested in portraying the urban landscape. The examples I have chosen reflect their time in terms of the materials and aesthetic perceptions they embody.

Clifton suspension bridge. The two solidly constructed brick towers give the structure a sort of Egyptian style. The beautiful curve of the suspending cable and the vertical cables joining it to the bridge itself produce a monumental and geometrical effect; an aspect I found very interesting to draw. Generally to get a good view of such a vast structure you have to move around until you get its best angle. A bridge such as this, however, is so impressively designed that you can get a good view from many different angles.

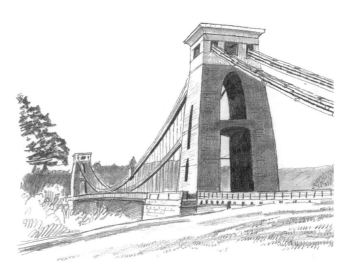

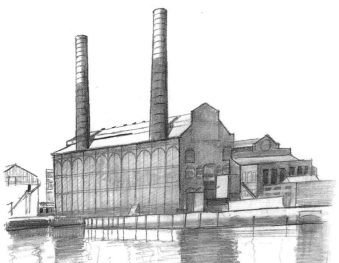

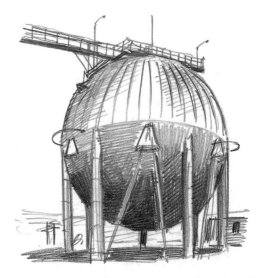

Set on the edge of the River Thames, Chelsea power station stands out as a landmark among the rest of the buildings in this area. Its brickwork looks very dark against the other buildings around it and its two chimneys are very unusual in London today.

This gas tank is an obsolete piece of engineering, although I find its shape and size particularly interesting. Almost futuristic in appearance, it looks good from almost any angle and both close-up or from further away gives a very satisfying shape to the usual urban environment.

SKY – ITS IMPORTANCE

The next series of pictures brings into the equation the basic background of most landscapes, which is, of course, the sky.
As with the sea in the landscape, the sky can take up all or much of a scene or very little.

We consider some typical examples and the effect they create. Remember, you control the viewpoint. The choice is always yours as to whether you want more or less sky, a more enclosed or a more open view.

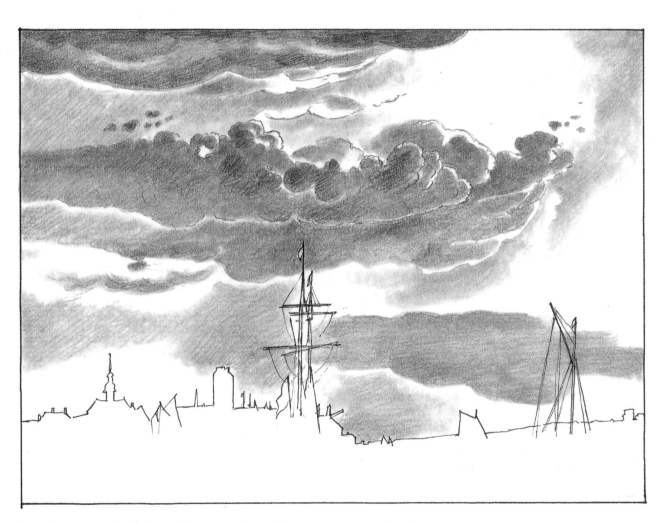

Our first example (after Albert Cuyp) is of a dramatic sky with a chiaroscuro of tones. Very low down on the horizon we can see the tops of houses, ships and some land. The land accounts for about one-fifth of the total area, and the sky about four-fifths. The sky is the really important effect for the artist. The land tucked away at the bottom of the picture just gives us an excuse for admiring the spaciousness of the heavens.

This country scene (after Pissarro) is a very different proposition. The downs behind the village, which is screened by small trees of an orchard, allows us a glimpse of only a small area of sky beyond the scene. The fifth of sky helps to suggest space in a fairly cluttered foreground, and the latticework quality of the trees helps us to see through the space into the distance. It is important when drawing wiry trees of this type to capture their supple quality, with vigorous mark-making for the trunks and branches.

John Constable's view of East Bergholt church through trees shows what happens when almost no sky is available in the landscape. The overall feeling is one of enclosure, even in this copy. Constable obviously wanted this effect. By moving his position slightly and taking up a different viewpoint, he could have included much more sky and banished the impression of a secret place tucked away.

THE SKY: CONTRASTS

Air is invisible, of course, so cannot really be drawn, but it can be implied by looking at and drawing clouds and skyscapes. Whether fluffy, ragged, streaky or layered, clouds give a shape to the movements of the elements in the sky and are the only visible evidence of air as a subject to draw.

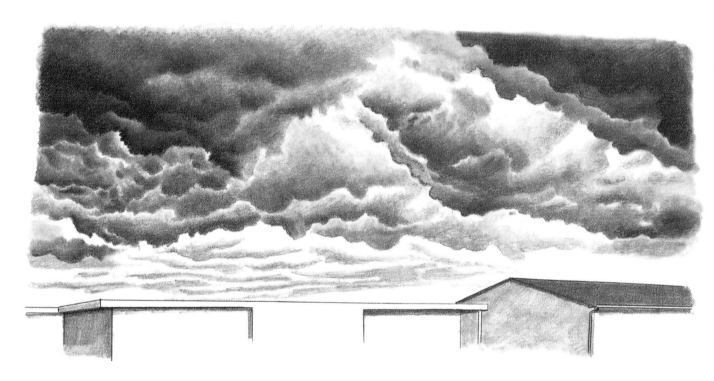

Here we see dark, stormy clouds with little bits of light breaking through in areas around the dark grey. The difficulty is with the subtle graduations of tone between the very heavy dark clouds and the parts where the cloud cover is thinner or partly broken and allows a gleam of light into the scene. Look carefully at the edges of the clouds, how sometimes they are very rounded and fluffy and sometimes torn and ragged in shape. If you get the perspective correct, they should be shown as layers across the sky, flatter and thinner further off and as fuller more rolling masses closer to. You can create a very interesting effect of depth and space across the lower surfaces of the cloudscape with bumps and layers of cloud that reduce in depth as they approach the horizon.

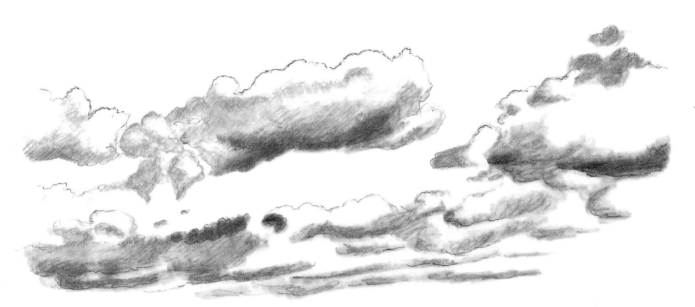

When the clouds allow more sun to shine through, they look much less heavy and threatening and often assume quite friendly looking shapes. Essentially, though, it is the same vapour as in the stormy sky but with more light, enabling us to see its ephemeral nature.

The effect of beams of sunlight striking through clouds has a remarkable effect in a picture, and can give a feeling of life and beauty to even a quite banal landscape.

A lot has been achieved here with very simple means. The clouds are not complicated and it is the sun's rays (marked in with an eraser) and the aircraft that do much of the work, giving the illusion of height and also limitless space above our view. The broken light, the light and dark clouds, and sunlight glinting against the wings and fuselage of the aircraft give the drawing atmosphere.

SUBJECT

THE SKY: USING SPACE

The spaces between clouds as well as the shapes of clouds themselves can alter the overall sense we get of the subject matter in a drawing. The element of air gives us so many possibilities, we can find many different ways of suggesting space and open views. Compare these examples.

This open flat landscape with pleasant soft-looking clouds gives some indication of how space in a landscape can be implied. The fluffy cumulus clouds floating gently across the sky gather together before receding into the vast horizon of the open prairie. The sharp perspective of the long, straight road and the car in the middle distance tell us how to read the space. This is the great outdoors.

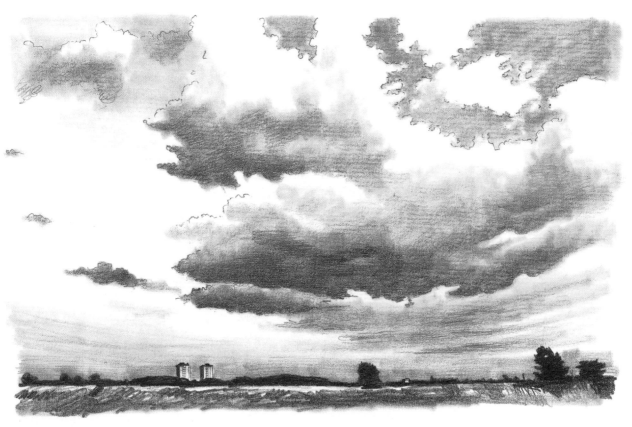

Another vision of air and space is illustrated here: a sky of ragged grey and white clouds, and the sun catching distant buildings on the horizon of the flat, suburban heathland below. Note particularly the low horizon, clouds with dark, heavy bottoms and lighter areas higher in the sky.

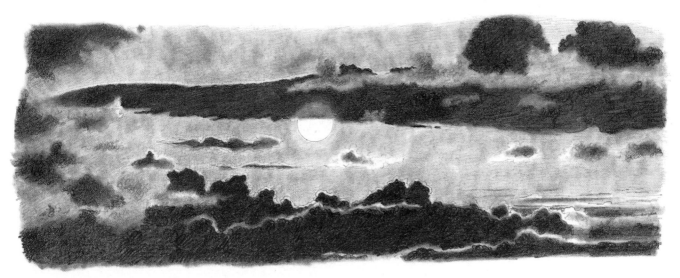

Despite the presence of dark, dramatic clouds in this scene at sunset, the atmosphere is not overtly gloomy or brooding. The bright sun, half-hidden by the long flat cloud, radiates its light across the edges of the clouds, which tell us that they are lying between us and the sun. The deep space between the dark layers of cloud gives a slightly melancholic edge to the peacefulness.

SUBJECT

CLOUDS

The importance of clouds to suggest atmosphere and time in a landscape has been well understood by the great masters of art since at least the Renaissance period. When landscapes became popular, artists began to experiment with their handling of many associated features, including different types of skies. The great landscape artists filled their sketchbooks with studies of skies in different moods. Clouded skies became a significant part of landscape composition with great care going into their creation, as the following range of examples shows.

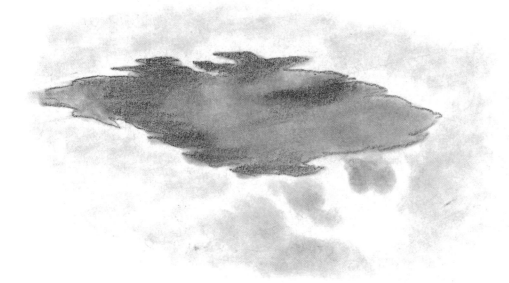

After a follower of Claude Lorrain
This study is one of many such examples which show the care that artists lavished on this potentially most evocative of landscape features.

After Caspar David Friedrich
One of the leading German Romantic artists, Friedrich gave great importance to the handling of weather, clouds and light in his works. The original of this example was specifically drawn to show how the light at evening appears in a cloudy sky.

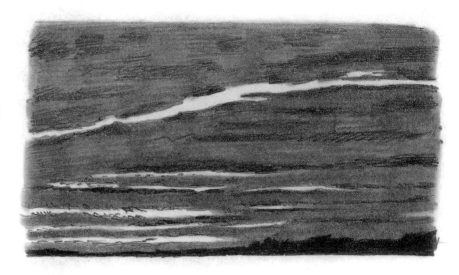

Clouds

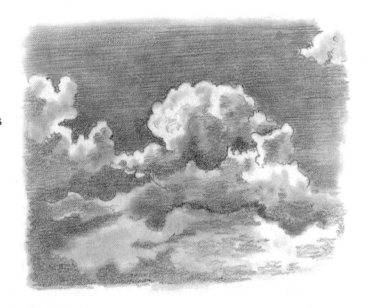

After Willem van de Velde II
Some studies were of interest to scientists as well as artists and formed part of the drive to classify and accurately describe natural phenomena.

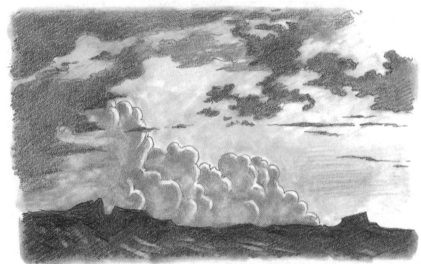

After Alexander Cozens
The cloud effects are the principal interest here. The three evident layers of cloud produce an effect of depth, and the main cumulus on the horizon creates an effect of almost solid mass.

After J. M. W. Turner
Together with many other English and American painters, Turner was a master of using cloud studies to build up brilliantly elemental landscape scenes. Note the marvellous swirling movement of the vapours, which Turner used time and again in his great land- and seascapes.

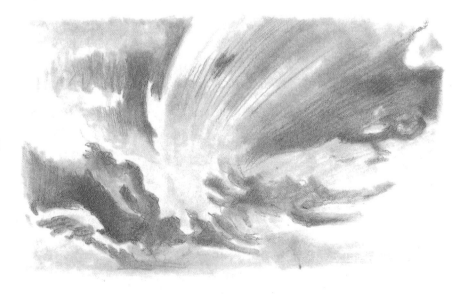

SKY: EXPRESSIVE CLOUDS

The sky plays a very dramatic role in these two examples of landscapes: copies of Van Gogh's picture of a cornfield with cypress trees, and of Van Ruisdael's 'Extensive Landscape'. Although different in technique, both types of landscape are easier to do than they look.

The Van Gogh copy is characterized by strange, swirling mark-making for the sky, trees and fields. The feeling of movement is potently expressed by the cloud shapes which, like the plants, are reminiscent of tongues of fire. Somehow the shared swirling characteristic seems to harmonize the elements. The original painting was produced not very long before the artist went mad.

Draw in the main parts of the curling trees and clouds and the main line of the grass and bushes. Once you have established the basic areas of vegetation and cloud, it is just a case of filling in the gaps with either swirling lines of dark or medium tones or brushing in lighter tones with a stump. Build up slowly until you get the variety of tones required.

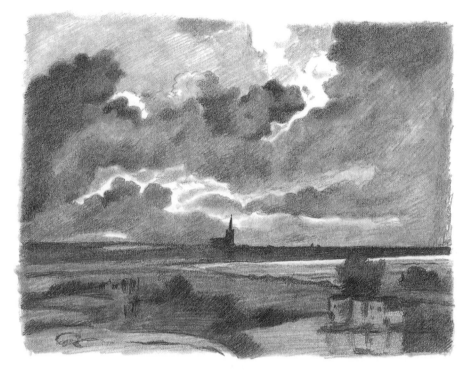

Ironically the land referred to in the title 'Extensive Landscape' only takes up a third of the space. The clouds, drawn in contrasting dark areas with a few light patches, create an enormous energetic sky area in which most of our interest is engaged. The land by comparison is rather muted and uneventful.

First, mark in with light outlines the main areas of cloud, showing where the dark cloud ends and the lighter sky begins. Draw in the main areas of the landscape, again marking the lines of greatest contrast only.

Next, take a thick soft pencil (2B–4B) and shade in all the darker and medium tones until the sky is more or less covered and the landscape appears in some definition. Finish off with a stump to smooth out some of the darker marks and soften the edges of clouds. The more you smear the pencil work, the more subtle will be the tonal gradations between dark and light. Afterwards you may have to put in the very darkest bits again to increase their intensity.

SUBJECT

THE SKY AT NIGHT

One difficulty of drawing at night is the dark. For this reason a townscape is a more obvious choice because you can position yourself under a lamp post and draw from there. In the first of our two examples, light provided by the moon is spread across the scene by the expedient device of the reflective qualities of a stretch of water. In the second, moonlight also comes into play, although less obviously. Night scenes are always about the lit and the unlit, the reflective and the non-reflective.

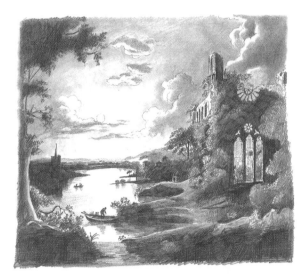

The classic picturesque scene was for many years the whole point of landscape painting. Artists would find a rugged, untamed spot that would appeal to Romantic sensibilities and draw it at a dramatic moment. In this copy of a Harry Pether painting of Anglesey Abbey, a ruin in

the best Gothic taste is shown against gleaming water and moonlit sky. The clouds are almost as carefully designed as the position of the ruins. All elements in the picture combine to create an atmosphere of delight in the airy qualities of the nocturnal scene.

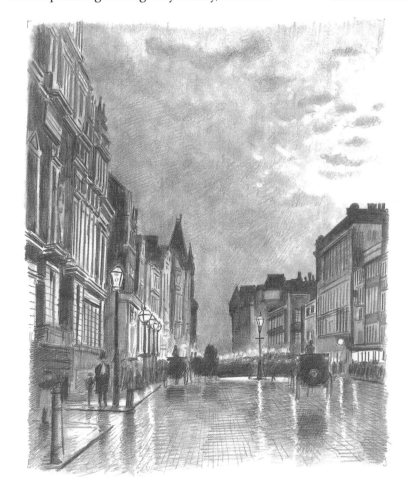

British artist John Atkinson Grimshaw was known for his depictions of the city after dark. His 'Piccadilly at Night' captures the effects of a dark cloudy sky with the hint of moonlight and dark, looming buildings lit by street lamps, windows and cab lights. A recent downpour helps to emphasize the brilliance of the light.

Study the two stages opposite leading up to the final drawing.

As you draw in the main elements, be aware of the perspective effects of the buildings along the street. Leave white paper to show where the lamps are and also their reflections on the wet street. Put in very strongly with dark lines the pillars, cornices, window ledges, etc., of the buildings.

The light and dark areas in the sky should appear softer in contrast to the lines used for the buildings. The lighter areas can be smudged across with a stub to keep them looking lighter but not as bright as the lamps. The only white paper showing should be to denote the source of light and the reflections of it. The whole of the sky area should be softened with the application of the stub. When you have uniform greys and darks over the whole area, take a putty eraser and lighten up the clouds nearest the moon's glow.

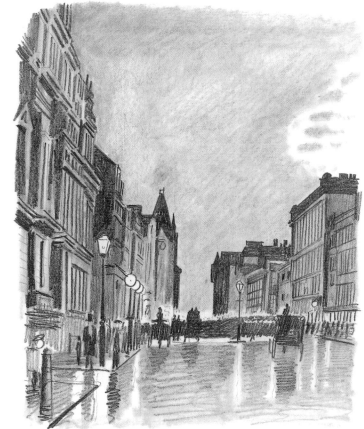

ANIMALS SIMPLIFIED

SUBJECT

Drawing animals can be difficult. Rarely will they stay still long enough for careful study, although occasionally this can be achieved when, for example, a cat or dog is sleeping. Probably the best way to approach this subject is to find really clear photographs or master-drawings and carefully copy the basic shapes from these. Reducing the animal to simple shapes takes you halfway to understanding how to draw them. Once you have the outline, more careful study is required to draw in the details of texture and pattern.

Try copying the drawings of animals on these pages. When you have done this, try applying the same simple analysis of shapes to illustrations of other animals.

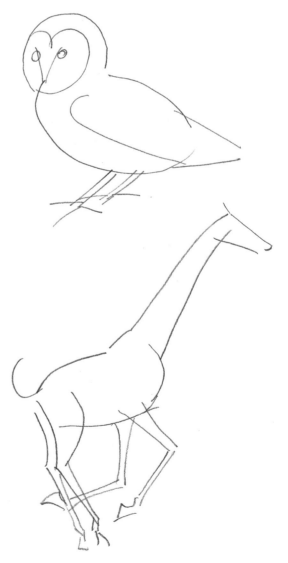

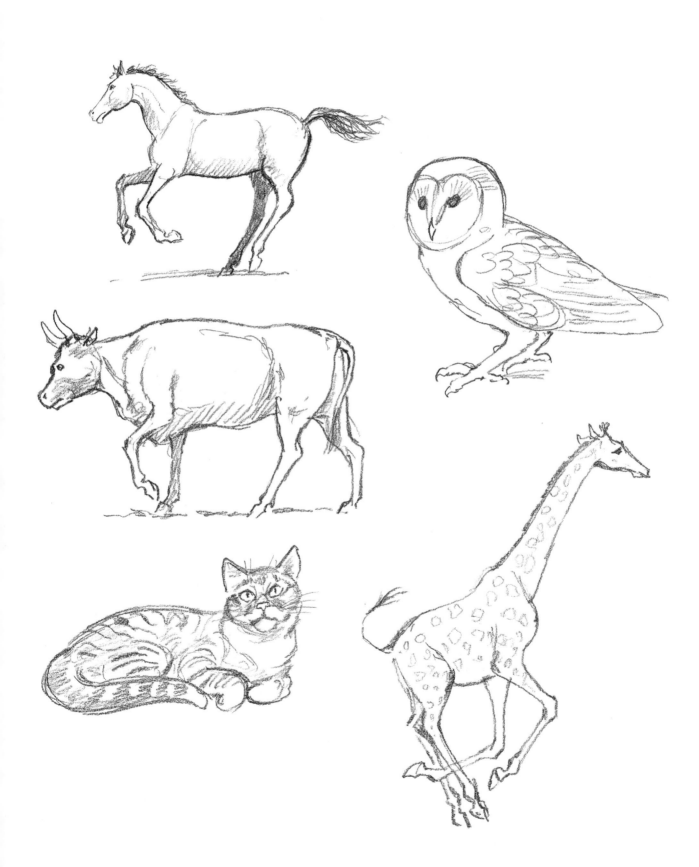

ANIMALS

When drawing animals, start with the simplest, such as insects. Most insects have a very simple structure, with their skeleton on the outside (an exoskeleton), so you can draw them almost diagrammatically. Sometimes if they have furry bodies or delicate wings, it becomes more complicated. Note the examples here and how relatively simple the shapes are. Moving onto birds, frogs and animals like snakes, again the basic shape is very simple. Careful observation of these shapes from photographs, drawings or from life will show you how straightforward the structures of these creatures are.

1.

1. The frog has a blunt, triangular shape when seen from the side, a view that allows you to see its large back legs clearly.

2.

2. Side views often show the characteristic shapes of birds more clearly.

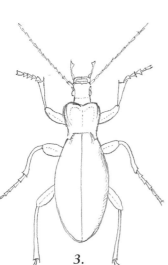

3. The shape of the beetle is often best displayed from above – which is usually the view we get.

3.

4. The furry body of the bee contrasts with its delicate wings and thread-like legs.

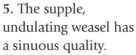

4.

6. The snake is quite simple except for the head, which needs to be shaped carefully. Note the gradual thickening and thinning along its length.

5. The supple, undulating weasel has a sinuous quality.

5.

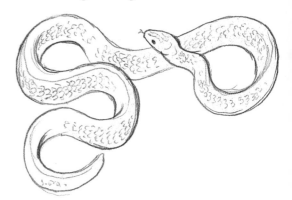

With larger animals, the skeleton is hidden, so you have to judge the structure from the outside shape, which may be covered in fur. However, with careful observation you can simplify the basic shapes of heads, bodies, ears and legs, not to mention tails. With a little practice, you will soon get the feel of your subject.

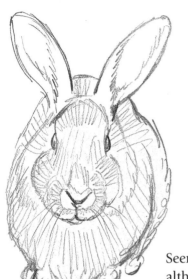

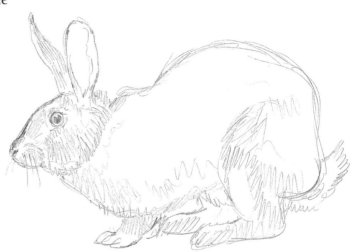

Seen from the front and side, the rabbit makes very different shapes, although both views are fairly characteristic. Make sure the proportions of the head and body are correct – and don't make the ears too long.

Two important points to remember with the kangaroo: the large ears and the rather small front legs.

The crab is another example of an exoskeletal creature but is more complex than the insects shown here.

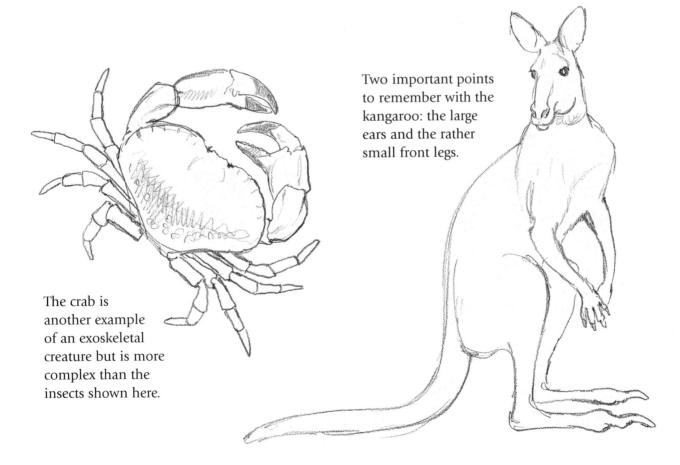

SUBJECT

ANIMALS IN MOVEMENT

Trying to capture the movement of animals is a different proposition altogether. Fortunately, there are plenty of excellent photographs and drawings of animals in action to help you gain the necessary practice. Pictures of birds on the wing, animals eating or startled give a very clear idea of characteristic movements.

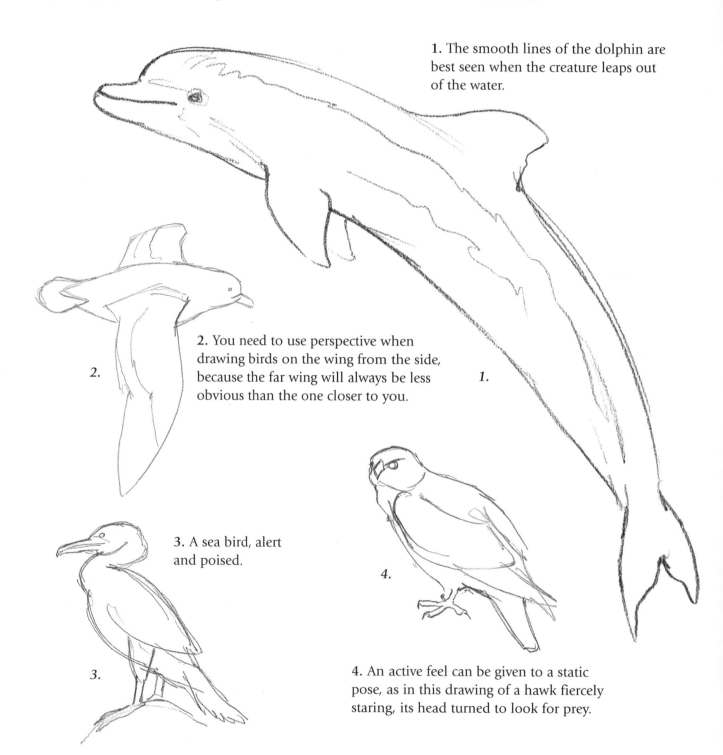

1. The smooth lines of the dolphin are best seen when the creature leaps out of the water.

2. You need to use perspective when drawing birds on the wing from the side, because the far wing will always be less obvious than the one closer to you.

2.

1.

3. A sea bird, alert and poised.

4.

3.

4. An active feel can be given to a static pose, as in this drawing of a hawk fiercely staring, its head turned to look for prey.

It is not always easy to bring the effect of movement into a drawing, even when copying from a photograph of a moving creature. Try to suggest a taut or fluid look to the structural lines. Don't hesitate to simplify if that will communicate the illusion of movement. I used this technique with the drawing of the hare below, using a slightly nervous scribble to suggest the creature's agitation and readiness to run.

1. A hawk coming into land, its wings upright. Points to emphasize are the size of the wings in comparison with the body, the short, vicious beak, the rudder-like tail and the dangling talons.

2. The hare, nervously grooming itself, ready to flee at the hint of threat.

3. The mouse, with its twitching nose and whiskers and small beady eyes, looks ready to move in any direction.

Don't be afraid to simplify the basic shapes of the creatures you are drawing. Consider them as other types of objects whose form you are trying to capture on paper. Choose a line that is sympathetic to their materiality; for example, soft, fluid lines for fur and broken lines for birds' feathers.

LARGE ANIMALS

SUBJECT

When you come to draw large animals, try to convey a sense of what each type represents. I envisaged the animals depicted here in very different ways. The very distinctive pattern of the tiger makes him into a sort of dandified ruffian, despite his status as a ruthless killer.

The elegant horse with his smooth, muscled shape and sensitive head has a poetic, heroic quality. The great elephant is solid but slightly shambling with his strangely creased hide and rather coarse-looking trouser legs – all power but also gentle, rather like a favourite grand relation.

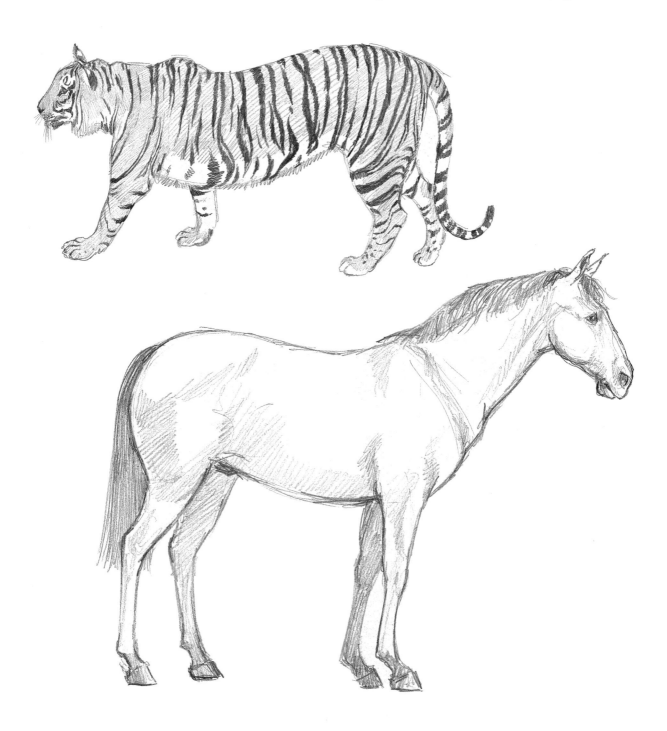

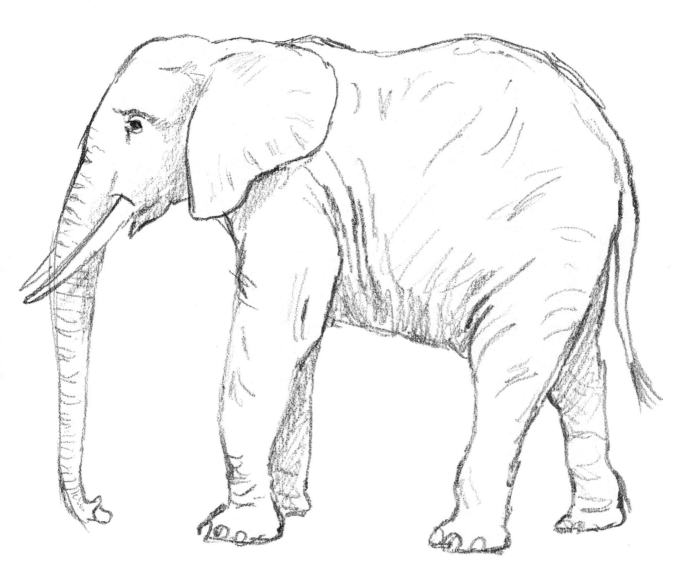

With larger, more statuesque animals you need to make sure that the proportions of legs to bodies and heads to bodies are carefully worked out. The examples here show the variations you can encounter. The low-slung, heavy body of the tiger, with its sinuous shape and patterned stripes, is very different from the rather elegant shape of the horse, for example, with its long head, long neck and slim elegant legs. The elephant has a much looser unstructured look: large sack-like body, loose-trousered legs, long curling trunk and large flat ears.

The way you use the pencil will help enormously to get across the effects of the different textures. Sharp clear-cut lines work well for the horse, soft, wobbly lines for the elephant. The tiger requires an approach that lies somewhere between these two extremes.

SUBJECT

LARGE OBJECTS

Now we come to objects whose size normally excludes them from being considered as still life objects. You will have to step into the wider world in order to draw them.

Let's begin with this bicycle. There is very little cosmetic design to a bicycle and the interest for the artist is in the unambiguous logic of its construction.

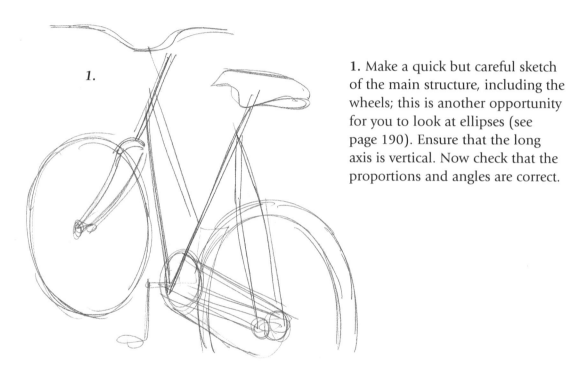

1.

1. Make a quick but careful sketch of the main structure, including the wheels; this is another opportunity for you to look at ellipses (see page 190). Ensure that the long axis is vertical. Now check that the proportions and angles are correct.

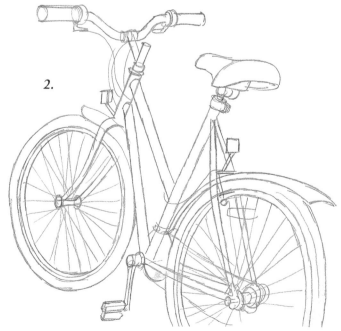

2.

2. Begin to build on this skeleton, producing a clear outline drawing showing the thickness of the metallic tubes and tyres and the shapes of the saddle, handlebars and pedal and chain areas. Be careful to observe the patterns of the overlapping spokes on the wheel.

3. Add a bit of toning and some lines to emphasize the shapes.

3.

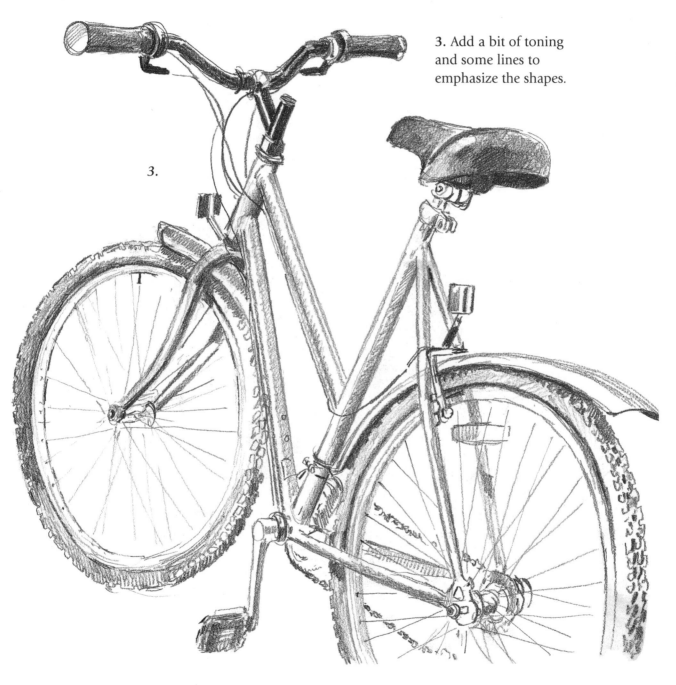

The main problem the artist encounters when drawing machines such as bicycles, motorbikes or cars is how to retain a sense of the complete structure without losing the proportions of each part. Don't try to be too exact with the details. Concentrate first on simply sketching the main structure of the machine. You will find this structure has a sort of logic to it, which is why it works as a machine. To get such a drawing to work visually, you have to see the object as its designer might have envisaged it.

I have deliberately drawn this motorcycle quite graphically. The style is intentionally slightly awkward, to convey a mechanical feeling. There is no need to produce a perfectly measured designer's drawing.

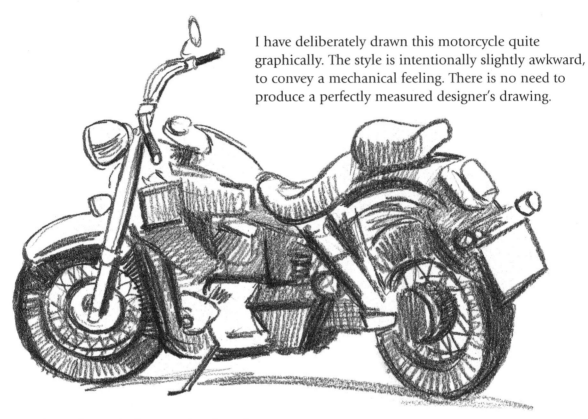

By comparison, the car is drawn rather loosely to allow the shine of the surface to work for the picture. Although you would never confuse this drawing with a photographically exact picture, it has enough consistency and attention to detail to allow the viewer to recognize the make and type of car.

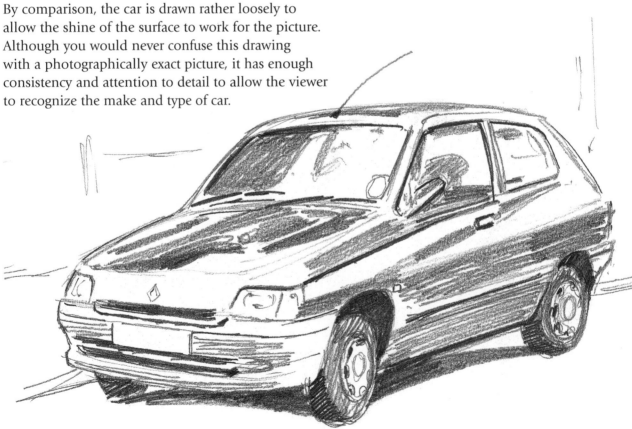

Here we have two large dynamic objects. The Jeep has a chunky sleek look and a soft line actually enhances the shiny but solid look of the vehicle. Cars are, of course, plentiful and do keep still, as long as the owner doesn't suddenly jump in and drive off while you are in full flight of creative work. The boat has a sharper profile and more elegant line.

Here, the overall light colour contributes to the illusion of sleekness. Tone has been used sparingly; some is needed to indicate the shapes but the reflected light from the water and the white-painted hull and super-structure call for brightness and well defined lines.

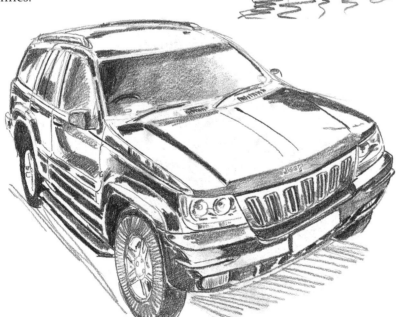

The slightly bulging shape of this rugged vehicle is given even more prominence by the angle. This viewpoint emphasizes the machine's strength and power, without making it look threatening.

An item of machinery can dominate a still-life composition, so long as the setting you choose seems right for it. A backdrop for a bicycle might be a hallway, a backyard or a garden, for example, or even the front of a house. A car would look at home as part of a street scene or centre stage in a garage with the door open. Such a scenario would give some interesting lighting, especially if there were other related objects close by. The possibilities are endless.

STILL-LIFE OBJECTS

Before you tackle a group of objects as a still life, it's a good idea to draw them as individual items but close enough on the paper to relate them. When you have done this, repeat the exercise, only this time with the objects grouped; you might want to arrange them so they overlap, as in the examples shown on the next page.

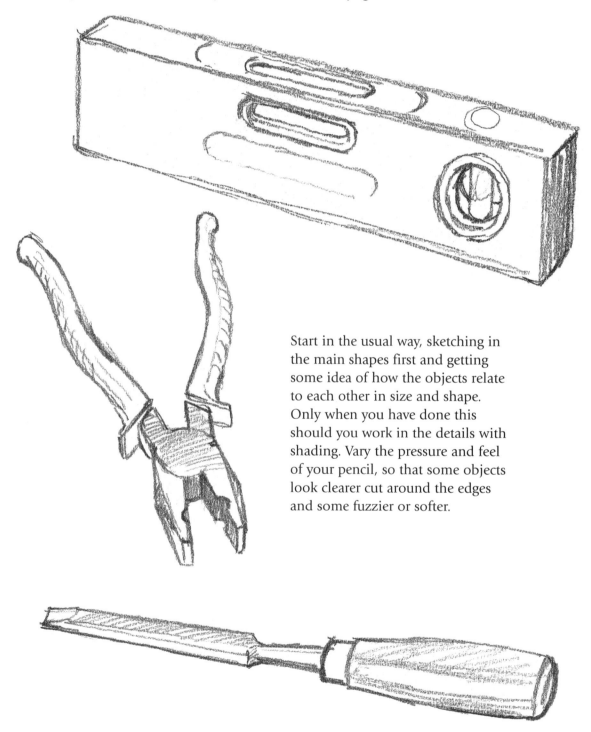

Start in the usual way, sketching in the main shapes first and getting some idea of how the objects relate to each other in size and shape. Only when you have done this should you work in the details with shading. Vary the pressure and feel of your pencil, so that some objects look clearer cut around the edges and some fuzzier or softer.

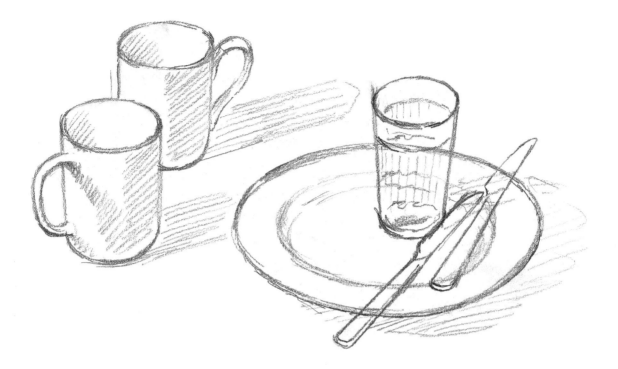

There are various ways of grouping objects. You might choose objects for their aesthetic qualities or because they contrast well in terms of their shape or materiality, as in the drawing to the right. On the other hand, you might choose to draw a group of related objects, such as the items left on a draining board (above).

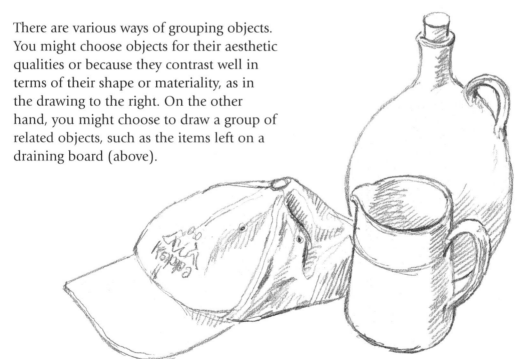

Continually experiment with how you draw lines and use hatching, and try to discover which approach produces the most effective result. No two objects require the same treatment. Try drawing the same objects first in very clean-cut lines and then in very soft wobbly lines. Now compare the results. There is no absolutely right way of drawing. Trust your own judgement: if a result interests you, that's fine.

SUBJECT

USING SIMILAR OBJECTS

The great still-life painters – such as Chardin, Cézanne and Morandi – often made use of similar objects time and time again. Here are copies of three of Chardin's still lifes for you to consider.

Notice how all three arrangements use very similar objects with variations in their balance and composition. The contrast between the height of one object and the rest, the variation in size of objects, the grouping of shapes to counterbalance and contrast to create interest

to the eye – these elements show the master touch of Chardin.

These jugs and glasses and pots and pans look deceptively simple, but Chardin's great talent with soft and hard edges, brilliant reflections and dark soft shadows creates a marvellous tone poem out of quite ordinary objects. Really there is no such thing as an 'ordinary' object. When the subtle perception of an artist is present in a work, everything becomes extraordinary.

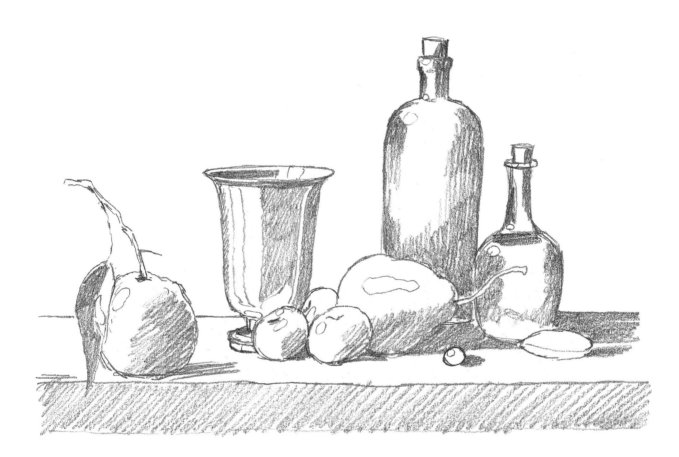

This composition relies for its effect on the different sizes of the objects and the spaces between them. The objects are almost in a straight line, but there is enough variation in depth to hold the viewer's interest.

The pestle and mortar seem to be standing alone in opposition to the overwhelming, almost open-jawed presence of the pan.

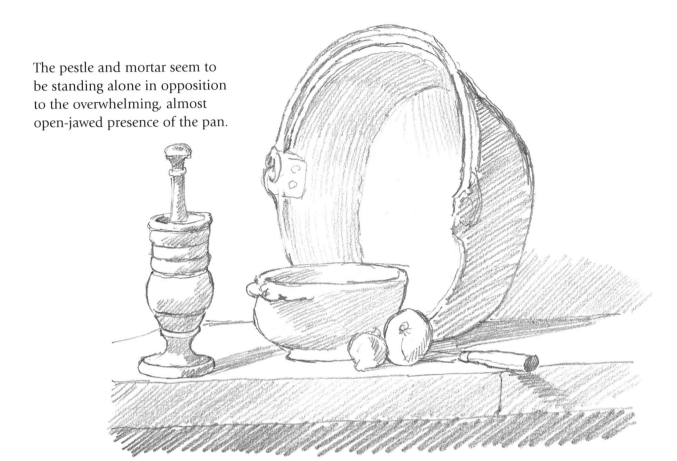

Here the handles act as extra dynamic shapes, defining the intervening space. The distance between these items, the eggs nestling against them as if seeking protection and the pepper mill at the edge of the table produce an interesting tension.

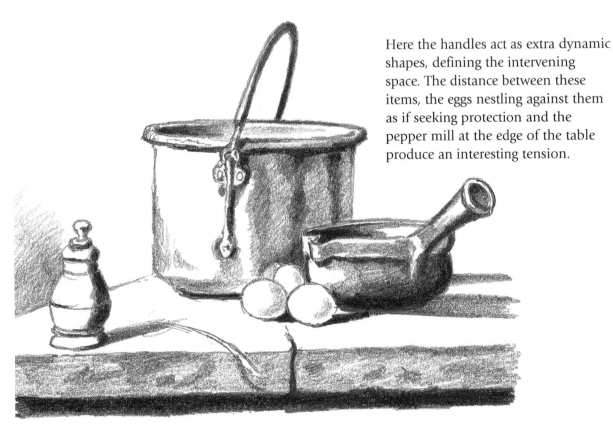

THE FIVE SENSES

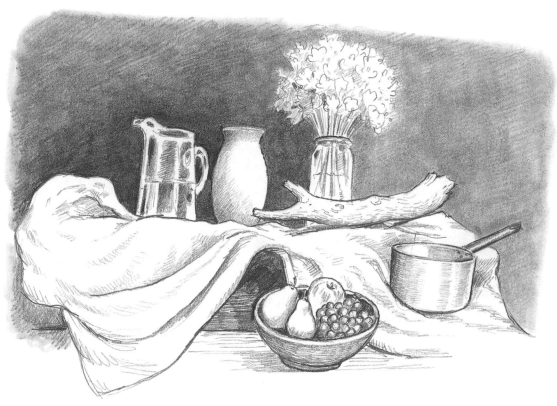

Taking a group of objects, each of which is made from a different material, is a time-honoured way for a still-life artist to show his skill in depicting the texture of things. Here we have glass, pottery, flowers, wood, metal, fruit and cloth, all of which need to be drawn differently in order to bring out their texture.

In this composition of a warm drink, a sugar bowl, a glass of wine, some olives, some oranges and a nice rich-looking cake, all the items refer to taste.

A vase of lilies, which have a strong scent, and a bottle of perfume put across the idea of smell.

Here there is a group of objects such as a lamp, a camera, a pair of binoculars, a book, a magnifying glass and spectacles, all of which are referring to sight.

Taking a theme of the five senses allows us to try to show something that everyone experiences through the medium of drawing.

The drawing above refers to touch, showing silk, pearls, water and fur, all of which have great tactile values.

Finally, a group of musical instruments puts across the idea of sound and hearing – a classical subject.

FOOD AND DRINK

Representations of food and drink are a popular form of still-life drawing. The traditional pictures of this subject often show food ready for the preparation of a meal, rather than the completed dish. This has the effect of creating a more dynamic picture.

Our first picture is of a classic 17th-century still life, by the Italian artist Carlo Magini (1720–1806), of bottles of wine, oil pots, a pestle and mortar and the raw ingredients of onions, tomatoes, pigeon and sausages. This is a very traditional picture of the basic preparation for some dish. Note the balance achieved between the man-made objects and the vegetables, bird and sausages. The hardware is towards the back of the kitchen table and the food is in the front.

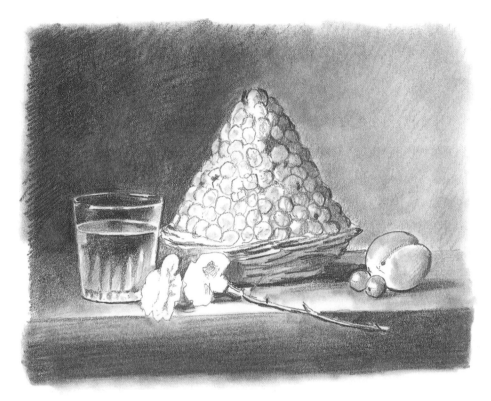

Next we look at a very simple picture by that master of French still life Chardin (1699–1779), who was so renowned in his own lifetime that many collectors bought his works rather than the more complex figure compositions by the artists of the Paris Salon. This picture shows fruit, water and a flower. The heap of strawberries on a basket is unusual as a centrepiece, and the glass of water and the flower lend a sensitive purity to the picture.

This is an accidental still life come upon by chance in my own kitchen, where a few apples put down on a marble slab were backed by a bottle of water, a bottle of wine and a roll of kitchen towel. The formality of the composition caught my eye and I drew it quickly before it became disarranged.

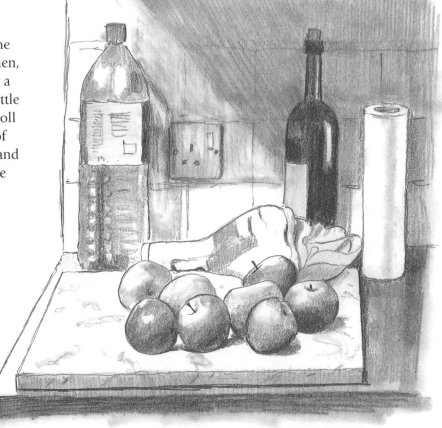

RARITIES

This picture may not seem unusual in itself, but if you look through the history of still life there is very little that deals with a table prepared for a meal. One reason for this might be that table arrangements can be so complex and full of different objects that a depiction of them can end up looking a muddle. As you can see, in this example of what is really only three places set at the end of a table, the mixture of tall items such as bottles, candlesticks and glasses and flat objects such as plates and cutlery does make for a forest of shapes.

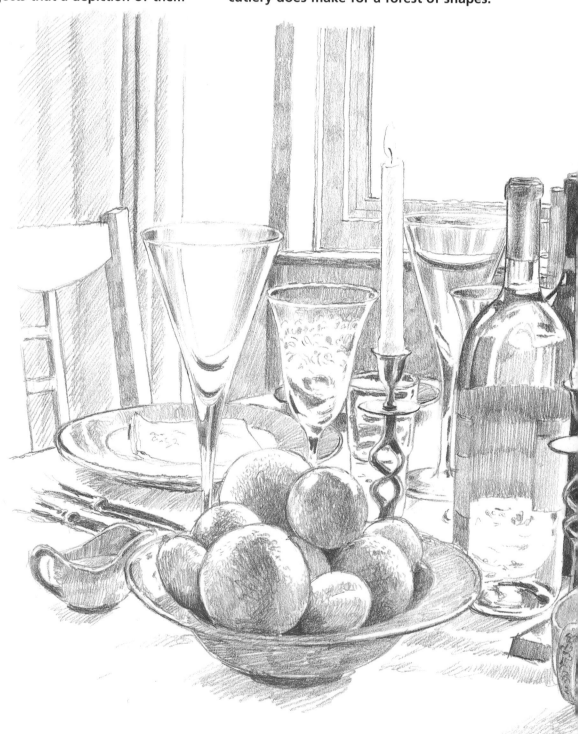

However, the intermediate height of the bowl of fruit and sauceboats helps to bridge the gap between them. If you have ever looked at an old edition of Mrs Beeton's cookery book, you may have found in it drawings of place and table settings that appear remarkably like a doll's house tea party, with everything very small on expanses of white tablecloth.

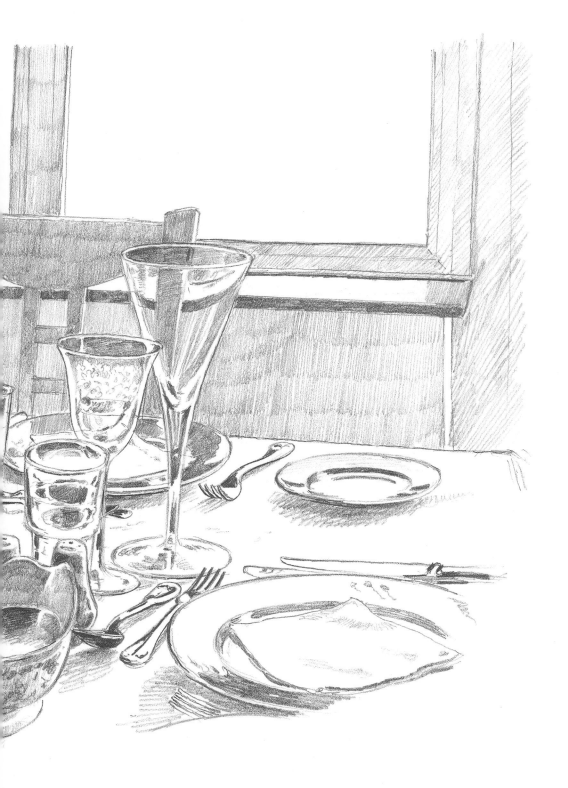

UNUSUAL COMBINATIONS

Here we look at less usual types of composition, where we take something which is not usually considered to be an aesthetically pleasing object, but which, when drawn well and clearly defined, nevertheless produces an interesting result.

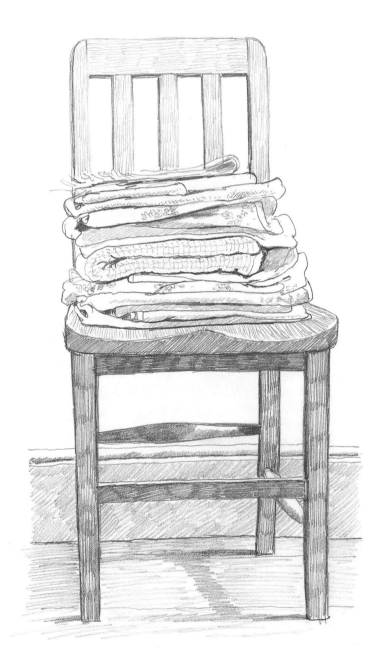

With clean laundry of towels, bathmats and tea towels piled neatly on the seat, this ordinary kitchen chair from the last century is as square and simple as is possible. The simple, flat wall background, and the fact that the whole scene is lit sharply with very little light and shade, produces a strong, plain image.

This artistic theme is rather complicated by the fish in the foreground. As the fish is not cooked it cannot be linked with a meal, so the picture must be concerned with an artist's palette and brushes together with items from a still life that is to be painted.

This group of stuffed animals and teddies with a couple of books seems as though they might be on a nursery shelf. Perhaps they are old toys that a girl grown into a woman has refused to part with because of their sentimental value.

TRAVEL THEMES

These examples of the theme of travelling take two moments in time. The first is before the journey starts and the second is at the time of return when unpacking begins, showing **not only clothes but also souvenirs and presents. Together they bracket the travelling experience.**

The arrangement of two suitcases accompanied by a hat, umbrella, coat and boots gives an idea of someone about to leave on holiday. It is a compact composition and relies on the solidity of the cases to act as the framework for whatever else is placed with them. The suitcases make the statement but the accessories give a season to the theme.

In this second sketch on a travel theme the case is opened and suggests its owner has come back from somewhere interesting or even exotic. The clothes are half revealed in the case and the packages carelessly spilled around, with souvenirs of statuettes, dolls, bottles, travel guides and presents giving a narrative element of someone returning from abroad. Obviously this theme could be adjusted for any country or continent to suit it to the person commissioning the picture.

MUSICAL THEMES

Musical themes have always been very popular, usually shown by the casual deployment of **musical instruments, musical scores and so forth across a table, chairs or the floor.**

A musical still life was a very popular theme in the 17th and 18th century. This one, after Baschens, is rather arbitrary but works mostly because the shapes of the instruments are so interesting that it almost doesn't matter how they are arranged. The great beauty of this sort of theme is that you can't really produce a bad picture if the objects themselves are so satisfying to look at.

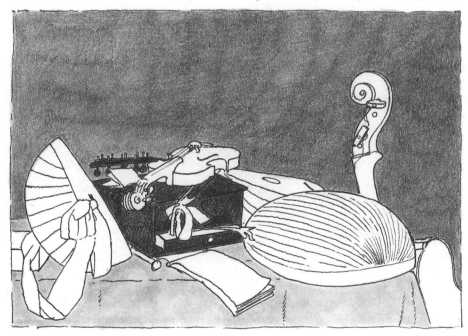

I've shown this group of instruments depicting a musical theme in simple outline forms to classify the dramatic possibilities of rounded, flattened and cuboid forms contrasted with each other. Notice how all the objects are mostly heaped in the lower half of the composition, contrasting with the blank space above. The rounded shapes of the lutes, the flatter angularity of the violin and bass, the open music score and the cubic black box which presumably holds music paper, pens and ink – these create a variety of clearly defined shapes, which in a way mirrors the musical possibilities of contrast and harmony.

PAPER AND BOOKS

A theme of paper and books was very popular in the 18th century. Images of books, packages or rolls of paper and envelopes were used to create a very specific type of picture, which suggested a literary or business style of life.

This interest in books was part of life for the enlightened members of civilized society at this period, and of course this was a time when the production of printed works on paper had become a significant key to the dissemination of literature and art, in the form of texts, etchings and prints. Consequently, anyone who was anyone in society would draw attention to their interest in literary production by commissioning pictures that echoed this idea. The artists producing them were also keen to shown off their technical expertise in showing paper as a textural object.

The neatly tied bundle of paper in the background suggests a setting for legal documents or business papers of some sort, spread across a desk waiting for attention.

The rather battered-looking books give a more literary look. These well-used tomes imply a close connection with the importance of the written word.

This composition showing shelves of music books again refers to a musical theme, but this time has a more scholarly look because this is where the composer is working to produce the raw material that instruments will eventually play.

THE SEA

These pictures, redolent of life lived close to the sea, bring the atmosphere of the ocean into a piece of still life. The first is a collection of things found on the beach and the second is an arrangement of nautical instruments that points out the interests of the person who commissioned it. The third, more simple in composition, relies on shells for its message.

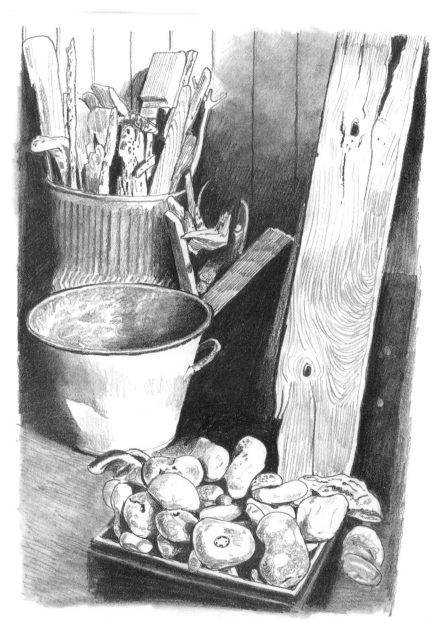

This still life hints at the outdoors, with its piles of driftwood and box of large stones. It gives the impression of a corner of the garden shed, with the collected minerals and wood shoved into battered pails and dustbins. The effect of worn wood and stones brings home the idea of time passing, with the wearing down of natural objects by natural forces. There is a strong suggestion of the sea, even though we can't see it anywhere.

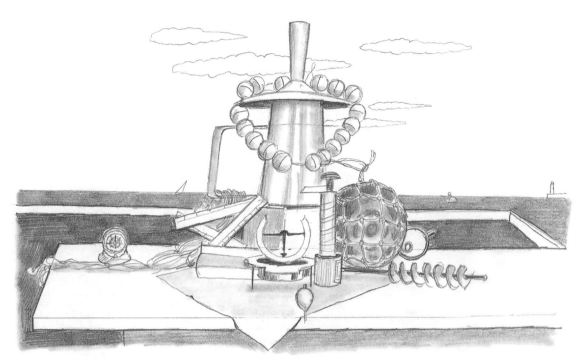

The next picture, after British artist Edward Wadsworth (1889–1949), is a deliberate effort to bring the world of boats and the sea into a symbolic composition which is almost monumental. The objects work as abstract shapes and textures and it is only after noting the satisfying arrangement that the theme of the sea comes across strongly.

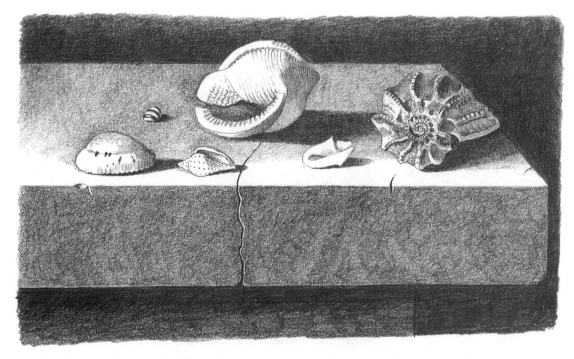

In the still life of seashells on a shelf by Adrian Coorte (1685–1723), the sea is nowhere to be seen. The elegant beauty of these sea creatures' exoskeletons makes an attractive picture in its own right, apart from the pleasing connotations of the ocean.

SUBJECT

AN OBSESSION WITH A THEME

Some artists are famous for producing still-life pictures that repeat the same theme over and over again. The Italian artist Giorgio Morandi (1890–1964) spent most of his working life making pictures of pots, bottles and similar ordinary objects grouped together against a plain background. (Other drawings after Morandi can be seen on pages 344–345.)

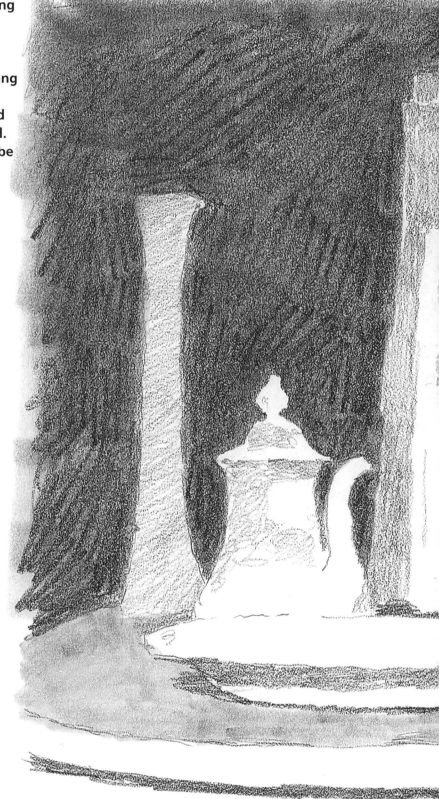

Here we have a large group of bottles and pots against a dark background with a couple of plates in the foreground. This monumental still life suggests much bigger objects but still has the same constituents that Morandi always used.

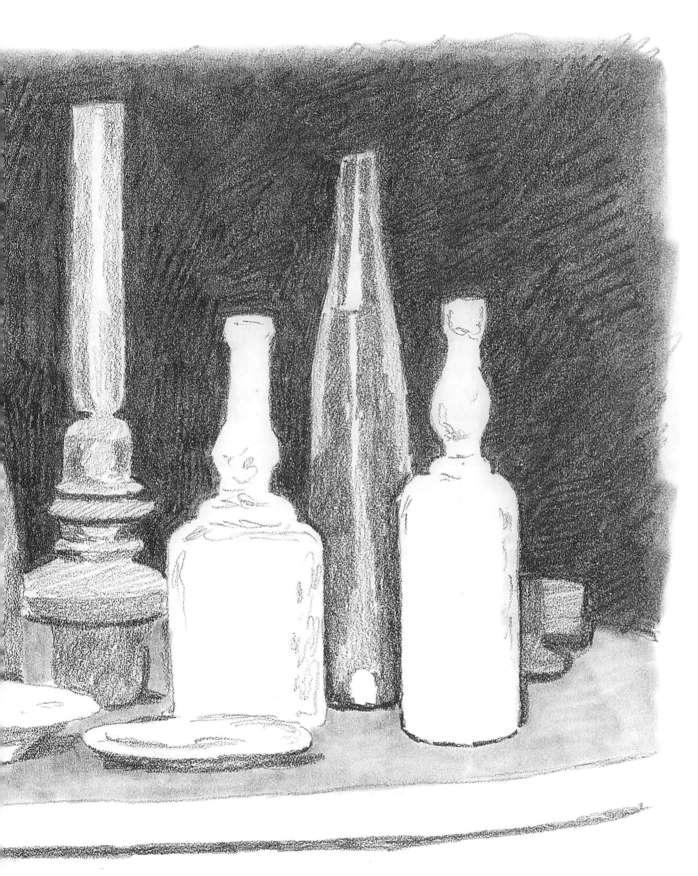

CONNECTING WITH THE VIEWER

The aim of all portrait artists is to engage the interest of an audience beyond the relative few who actually know the subject of their drawing or painting. The really great ones manage to lift any subject out of the ordinary rut of existence and invest him or her with a humanity that we viewers connect with. The features, especially the eyes and mouth, are what draw us in. In both examples shown here a fleeting expression has been captured which we cannot read with any certainty. It is worth trying to practise drawing difficult expressions, such as these, and the subtlety of tone they require.

Leonardo's 'La Giaconda', or Mona Lisa, is probably the most famous painting in the world. The wife of an important Florentine, the sitter has become a symbol of the mystery of womanhood and the epitome of subtle charm. The whole portrait is of great power, but it is her mysterious smile that is the focus of most interest, and of this pared-down copy. The effect is created by Leonardo's famed sfumato technique in which soft, shadowy tones gently melt one form into another without any jarring notes. Every other artist since da Vinci has employed sfumato. Very few, though, have been able to equal his handling of it.

The original of this drawing of William Shakespeare, by John Taylor, is believed to have been taken from life, and is perhaps the only record we have of the playwright's likeness. Taylor was little known, but he must have learnt his trade well to be able to produce a portrait of such depth. The intensity of the gaze and the shadows around the face are very well drawn devices. Shakespeare was a man of mystery, and Taylor's handling of the tone helps to create this effect. The direct gaze seems to hold both humour and wisdom, and the earring beneath the curtain of black hair lends the subject an air of bohemianism.

A testing exercise is to draw an elderly human face in detail, with all the lines, textures and marks produced by old age. If this is too difficult with a human model (it does take rather a long time and your model may get restless), try drawing from a detailed close-up photograph.

My drawing of the famous pioneer of photography Alfred Stieglitz was done from a photograph taken by one of his pupils. The detail in that original is brilliant and it is quite a tour-de-force to produce it in pencil or ink. When you try it, you'll find that you have to discipline yourself to produce every mark, every little ripple of flesh and tuft of hair with many small careful marks. Allow yourself plenty of time for this exercise.

Human anatomy is perhaps the ultimate test for the draughtsman. If you want to excel at portrait drawing, it's worth trying to acquire a skull or the use of one from a medical person or another older artist who probably has access to one.

Carefully draw it from different angles in great detail. Don't hurry, be precise, rub out any mistakes, redraw ruthlessly and don't be satisfied until the drawing is almost photographic in detail.

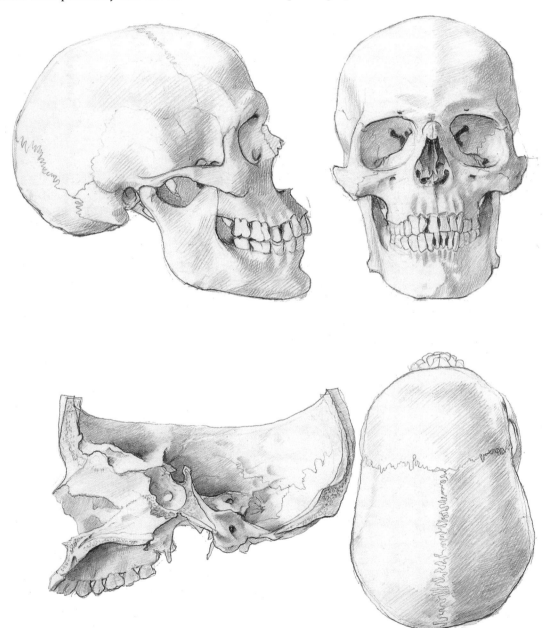

The example shown is a skull that can be taken apart, although in the complete view the lines of division and the hooks that hold the parts together have been left out. The interior of the skull is a particularly tough challenge because it is unfamiliar to most of us. Keep the drawing precise and clean-looking, so that you have no difficulty in seeing where you go wrong. This will make your mistakes easier to correct.

LOOKING AT THE HEAD

When a person is presented as a subject, the obvious approach is to sit them down in a good light, look at them straight on and begin to draw. However, there's much more to the head than mere features, as you will know from the earlier exercise we did on pages 150–151, where you looked at it from different angles, excluding the obvious one.

The aim of this next exercise is to encourage you to look at the head as a whole and engage with the most important and most interesting aspects of drawing portraits.

The head leaning back. This angle gives a clear view of underneath the chin and the nose, areas we rarely notice ordinarily. Seen from this angle the person is no longer instantly recognizable, because the forehead has disappeared and the hair is mostly behind the head.

Notice the large area of neck and chin, and the nostrils, which are coming towards the viewer. See how the nose sticks up out of the main shape of the head. When seen at this angle the ears seem to be in a very odd position, and their placement can be quite tricky. Notice that the eyes no longer dominate the head.

The head looking downwards. This allows a good view of the top of the head, which tends to dominate the area in view. Notice how the eyes disappear partly under the brow; how the eyelashes stick out more noticeably; how the nose tends to hide the mouth and the chin almost disappears.

Once you have looked at various heads of different people you will begin to classify them as whole shapes or structures and not just as faces. This approach teaches that although there are many different faces, many heads share a similar structure. The individual differences won't seem half so important once you realize that there are only a few types of heads and each of us has a type that conforms to one of these.

If you want to investigate this phenomenon fully, get your models to pose with their heads at as many different angles as possible, and explore the structure of what you see. You can use the poses I have provided or create your own.

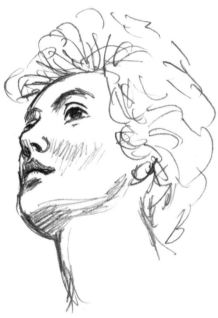

Mostly when we look at people our attention is too easily captured by the appearance of their eyes and mouth, because these are the principal determiners of facial expression. Once you ignore the facial expression, you will begin to notice in more detail the shapes of the features. When drawing the head focus your attention on these features: forehead, jaw, cheekbones and nose. They give the face its structure and thereby its character.

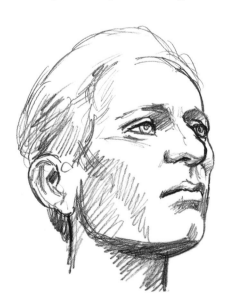

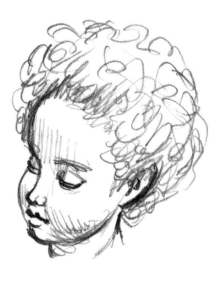

CLOTHED FIGURES AT REST

This collection shows figures that are all resting, in either a seated or prone position. Dating from the 18th century to the present day, the paintings are less classical in nature and the attire of the figures is less formalized. Nevertheless, the same rules apply as to the formation or gathering of cloth around the torso and limbs.

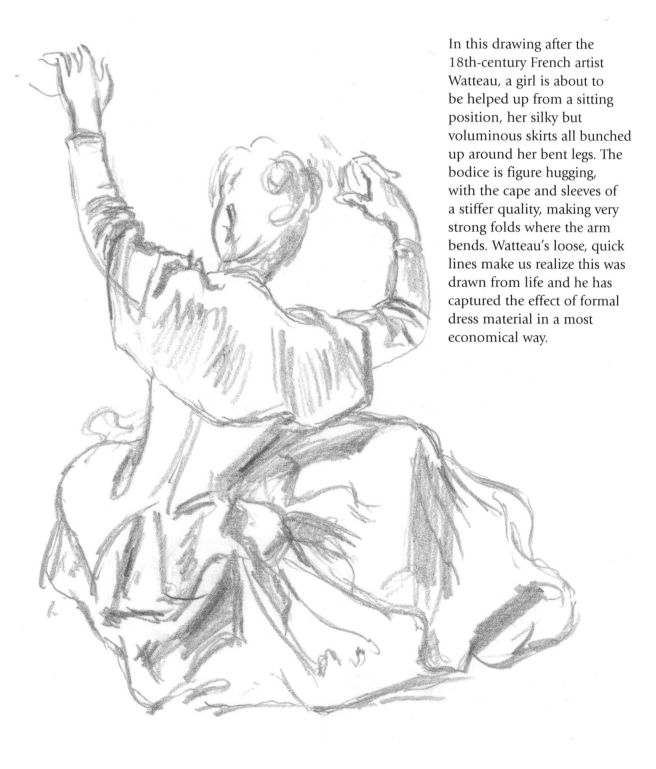

In this drawing after the 18th-century French artist Watteau, a girl is about to be helped up from a sitting position, her silky but voluminous skirts all bunched up around her bent legs. The bodice is figure hugging, with the cape and sleeves of a stiffer quality, making very strong folds where the arm bends. Watteau's loose, quick lines make us realize this was drawn from life and he has captured the effect of formal dress material in a most economical way.

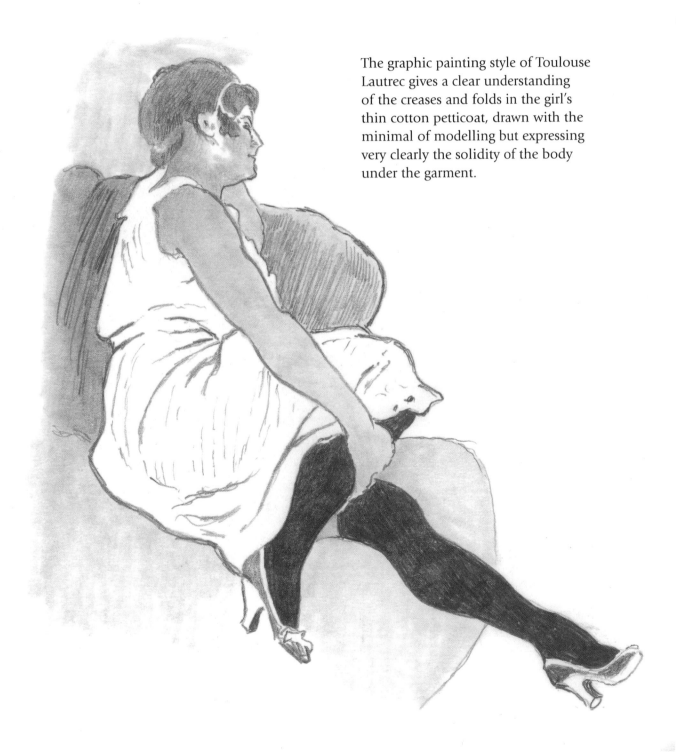

The graphic painting style of Toulouse Lautrec gives a clear understanding of the creases and folds in the girl's thin cotton petticoat, drawn with the minimal of modelling but expressing very clearly the solidity of the body under the garment.

MOVEMENT

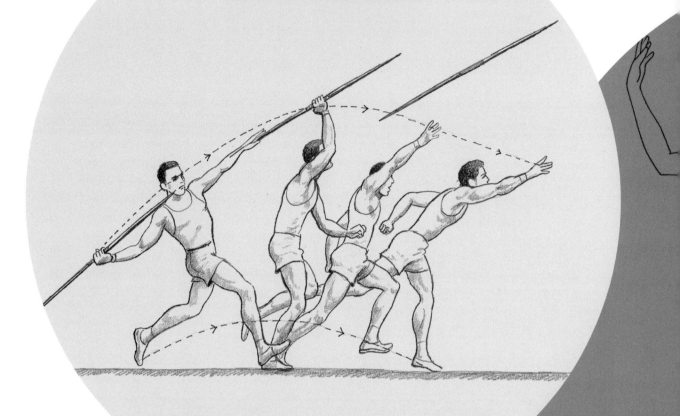

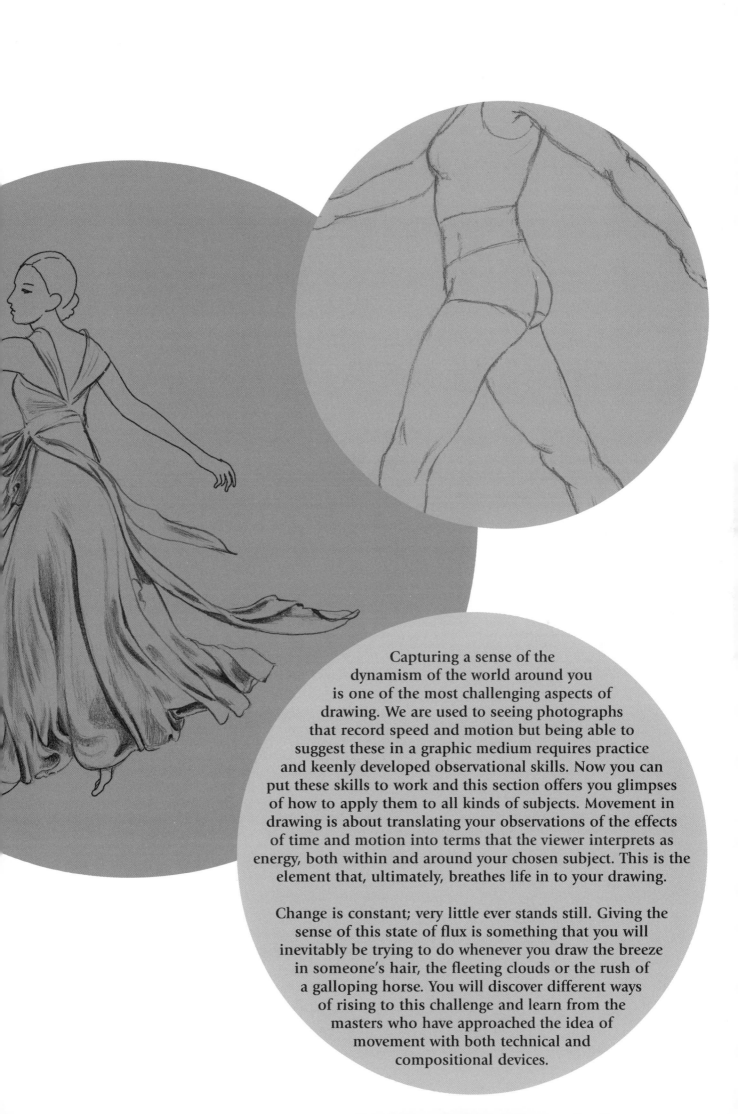

Capturing a sense of the
dynamism of the world around you
is one of the most challenging aspects of
drawing. We are used to seeing photographs
that record speed and motion but being able to
suggest these in a graphic medium requires practice
and keenly developed observational skills. Now you can
put these skills to work and this section offers you glimpses
of how to apply them to all kinds of subjects. Movement in
drawing is about translating your observations of the effects
of time and motion into terms that the viewer interprets as
energy, both within and around your chosen subject. This is the
element that, ultimately, breathes life in to your drawing.

Change is constant; very little ever stands still. Giving the
sense of this state of flux is something that you will
inevitably be trying to do whenever you draw the breeze
in someone's hair, the fleeting clouds or the rush of
a galloping horse. You will discover different ways
of rising to this challenge and learn from the
masters who have approached the idea of
movement with both technical and
compositional devices.

EXPRESSING MOVEMENT

We can now look at how artists draw figures which express some emotional or sculptural movement. As you get more into drawing, you will begin to notice how other artists create different effects. There is nothing like doing it yourself to understand how brilliantly some artists have solved the problems associated with producing those effects.

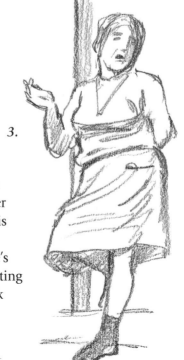

1.

1. The geometric shaping of figures gives a picture great power and a satisfying stability. When Degas drew the original of this he must have seen the simplicity of the triangular pyramidal shape of the ballet dancer pulling on her shoe. The shadow emphasizes this by being mainly all on one side, giving a dark triangular shape against a bright triangular shape with a slight fuzzing over near the apex where the shadows on the face and hair are reversed. The shape of the dress hides most of the lower figure but the arm is very clearly shown thrusting through the middle of the triangle.

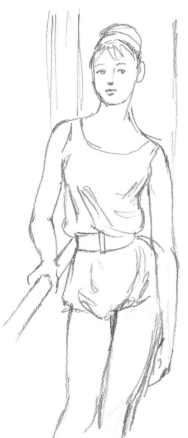

2. A beautiful expression of the classical contra-posto attitude by a young ballerina at the barre. Her shoulder tilts one way and her hips in the opposite direction, throwing the weight onto one leg, the head tilting to compensate. Many artists have used this complex, balanced shape, especially when representing Goddesses or the Three Graces.

2.

3.

3. This drawing – taken from a photograph of a shopkeeper gossiping on her doorstep – is redolent in gesture of small-town interest in other people's problems: a wry look, the jutting knee and weight pushed back against the folded arm.

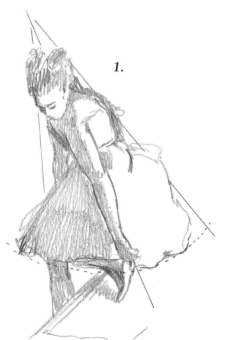

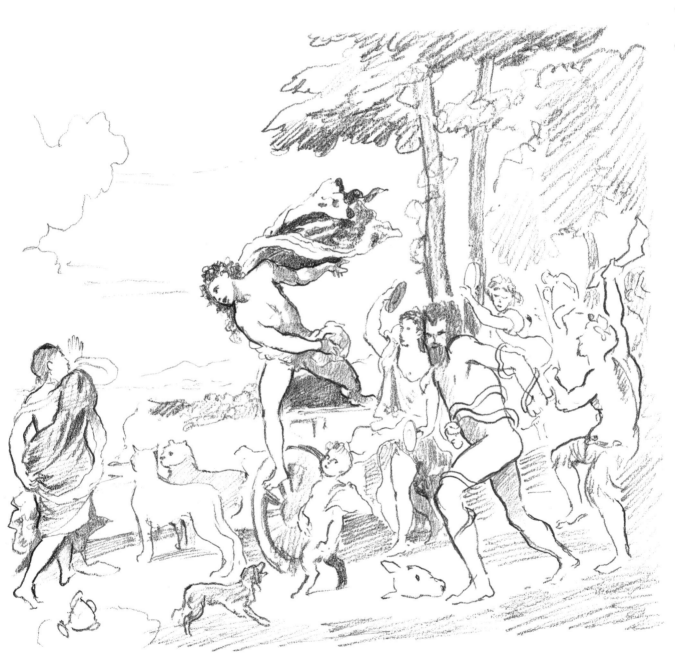

In Titian's painting of Bacchus and Ariadne, there is great dynamism. The airy space in the left half of the picture contrasts with the unruly procession of figures emerging from a grove of dark trees and moving across from the right. In this group are disporting maenads, satyrs and the drunken Silenus, all belonging to the boisterous entourage of Bacchus, god of wine and ecstatic liberation. Both aspects of this god's personality are represented here. Bacchus is centre stage, creating the major drama by flinging himself from his chariot, eyes fixed on the startled Ariadne, whom he has come to claim as his bride.

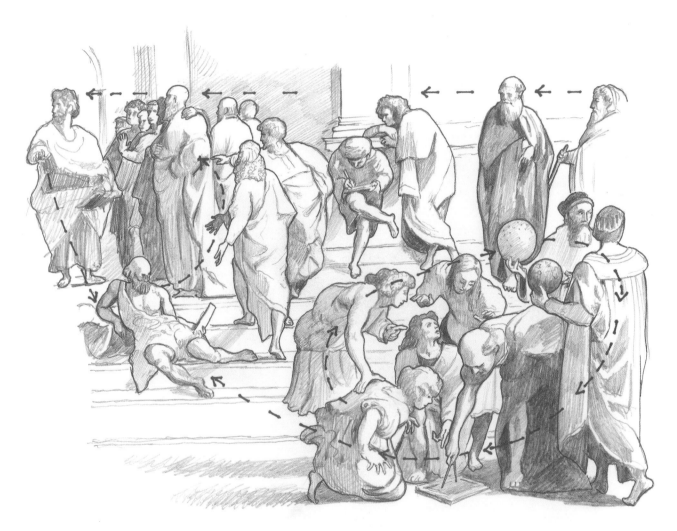

This scene is taken from Raphael's fresco in the Vatican of the School of Athens. Here, set on a staircase, are two loosely related groups of figures which are part of a much bigger composition. In order to make a crowd scene work so that it is not just a random dotting of figures over the setting, Raphael carefully produces closer groups of figures within the large crowd. He helps them to adhere as a composition by using the direction of the individuals' sightlines. For example, note how the uplifted face of the youth in the centre of the group at the bottom right of the picture starts the flow of movement as denoted by the arrowed

line. Similarly, one figure by a gesture links one or two figures with another group – see how a double-handed gesture includes the slumped, reclining figure; sometimes figures face in towards each other to produce a centre to a composed set of figures. Raphael also uses the kneeling, sitting and reclining figures to set off the overall standing figures to stop them becoming too vertically dominant. Raphael was a master of this sort of composition, and it is worth studying just parts of large paintings by masters to spot these internal groupings within larger groups and discover how the whole dynamic of the composition works.

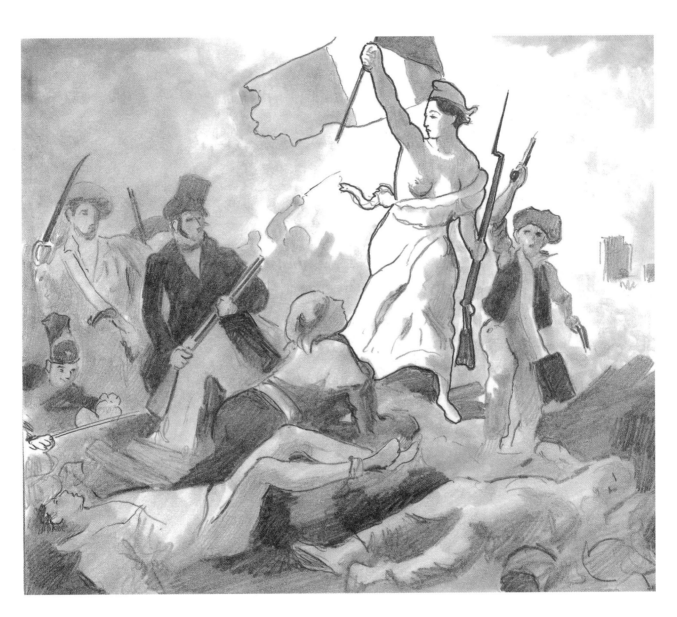

In Delacroix's 'Liberty Leading the People', a revolutionary fervour is emphasized by the main character, Liberty, thrusting up across the top of the picture and moving from the dark masses on the left of the picture to the clearer but devastated emptiness of the right-hand side. Her position seems to take everything forward towards the viewer and onwards past the right shoulder.

DRAWING MOVEMENT

Drawing movement is not as difficult as it might seem at first, although it does need quite a lot of practice. You'll find it helpful if you can feel the movement you are portraying in your own body, because this will inform the movement you are trying to draw. The more you know about movement the better. It's a good idea to observe people's movements to check out how each part of the anatomy behaves in a range of poses and attitudes.

Photographs of bodies in action are very useful, but limited in the range they offer. It is noticeable that action shots tend to capture moments of impact or of greatest force. Rarely do you find an action shot of the movements in-between. With a bit of careful observation, watching and analyzing, you should be able to see how to fill in the positions between the extremes.

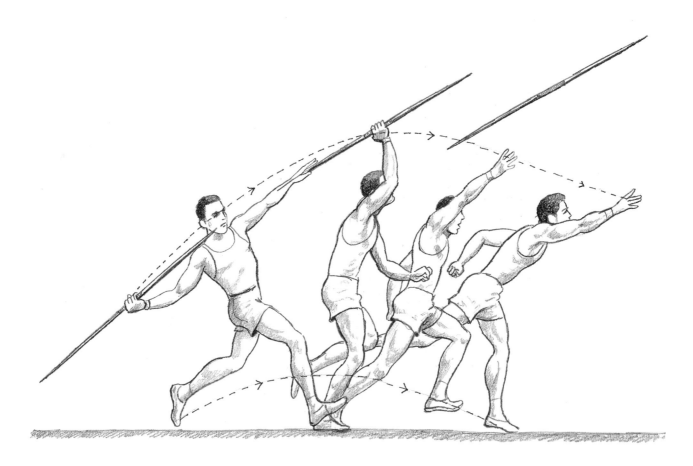

Here we see a man in the various stages of throwing a javelin. The point at which he is poised to throw and the moment when the javelin is launched are the two extremes of this process. However, you may find that drawing the man in a position between these extremes gives you a composition with more drama and tension.

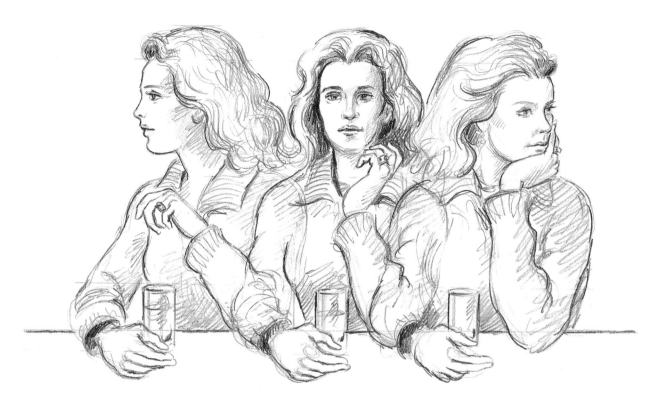

Similarly here, the point between the head completing its turn from one side to the other offers a different quality and perhaps a more revealing perspective on the subject.

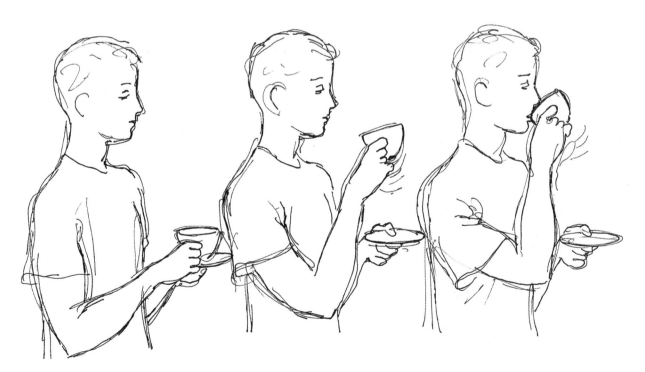

In these examples the only really obvious movement is the hand lifting the cup to drink. The first drawing sets the scene; the second shows the intent; and the third completes the action. The loose multiple line used in the second and third drawings helps to give the effect of movement.

MOVEMENT: CONTROLLED AND UNCONTROLLED

The most effective drawings of people falling accidentally capture the sheer unpredictability of the situation. In this example the arms and legs are at all sorts of odd angles and the expression is a mixture of tension, fear and surprise. He is wondering where and how he's going to land. Deliberately I made the line rather uncertain to enhance the effect of the uncertainty in the situation.

In this example, the odd angle of the viewer's vision provides a contrast with the lines of the water and side of the pool, creating tension although it's obvious what is happening. This is not drama in the making but a moment frozen in time. The slight strobe effect of the diving-board also helps to give the impression that we are witnessing something first-hand.

I used a clip from a newspaper as my model for this rugby player kicking a ball. My version is slightly amended from the original to accentuate the 'fuzz' of the out-of-focus kicking foot. The speed of this movement contrasts with the rest of the figure, which is much more clearly defined. The balance of the position is very important, to accentuate the force of the kick and the concentration of the kicker on those distant goal-posts.

MOVEMENT

DYNAMIC ENERGY

When you are deciding on your composition you will have some theme in mind that will influence the way you pose and draw the model. Generally, the pose falls into one of two types: the dynamic, energetic pose or the relaxed, passive pose. Shown here are four examples of ways to produce the former, showing power, energy or movement.

We understand the message they carry partly because of the associations we have with particular movements of the body and partly because of the activities the figures are engaged in; the drawings of a footballer kicking a ball and of the runner starting from the starting blocks immediately inform the eye of the dynamics involved.

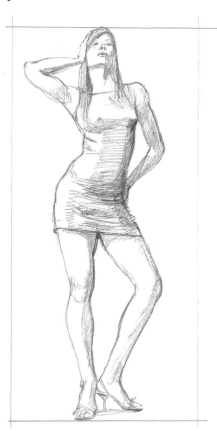

The runner exploding off the starting blocks is a sharp diagonal towards the edge of the picture, also helped by the hand and feet being right on the frame. The man with the starting gun gives a strong, stretched form from top to bottom of the picture from which the runner is angled off in a very dynamic shape.

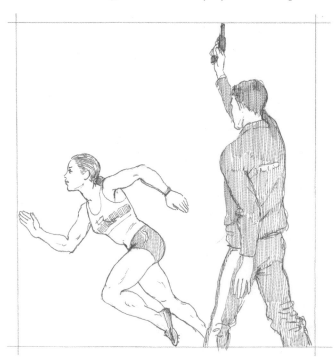

In a classic fashion pose, the model is thrusting out one hip and both her elbows and bent knee are also pushed out to create strong angles all along the length of the body. Although we are aware that this is a static pose, it has the movement implicit in the angled, arched torso, the uneven bending of the arms, one to the head, one to the hip, and the attitude of head, feet and shoulders. It has the look of a dance movement, which helps to maintain the dynamic. Again the framing of the figure helps by being as close in as seems effective.

These two figures are apparently startled, turning to see something that may be alarming or surprising. They are looking above the head of the artist, bending towards each other, their arms seeming to indicate disturbance. There is some feeling of movement about to take place, but there isn't a real source of activity; it is just a pose. However, the movements of the bodies, their juxtaposition to each other and the apparent focus of their attention outside the picture frame helps to produce a dynamic, energetic set of forms, which we read as movement. The way the figures are framed also helps this feeling, with the outstretched arm of the man almost touching the top edge and their legs being out of sight below the knees. The diagonal forms of the two torsos, leaning in towards each other away from the lower corners of the frame, also help this appearance of action.

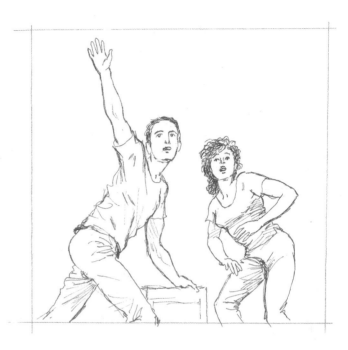

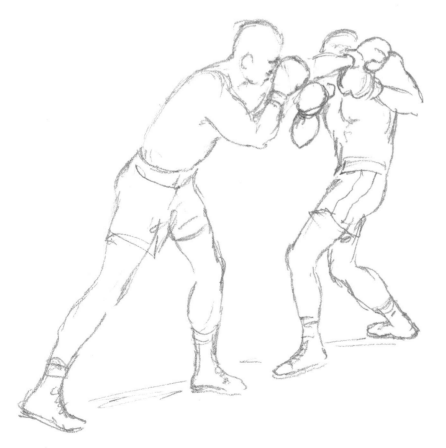

With the two boxers the balance relates to both figures but each fighter is also in balance himself. The one striking the blow is extended but both feet are on the floor and his guard is up. The other has moved to the side with both hands up to defend himself from the incoming fist and be ready to strike back. His feet are also firmly on the floor and his body weaves in order to retain both balance and hitting power.

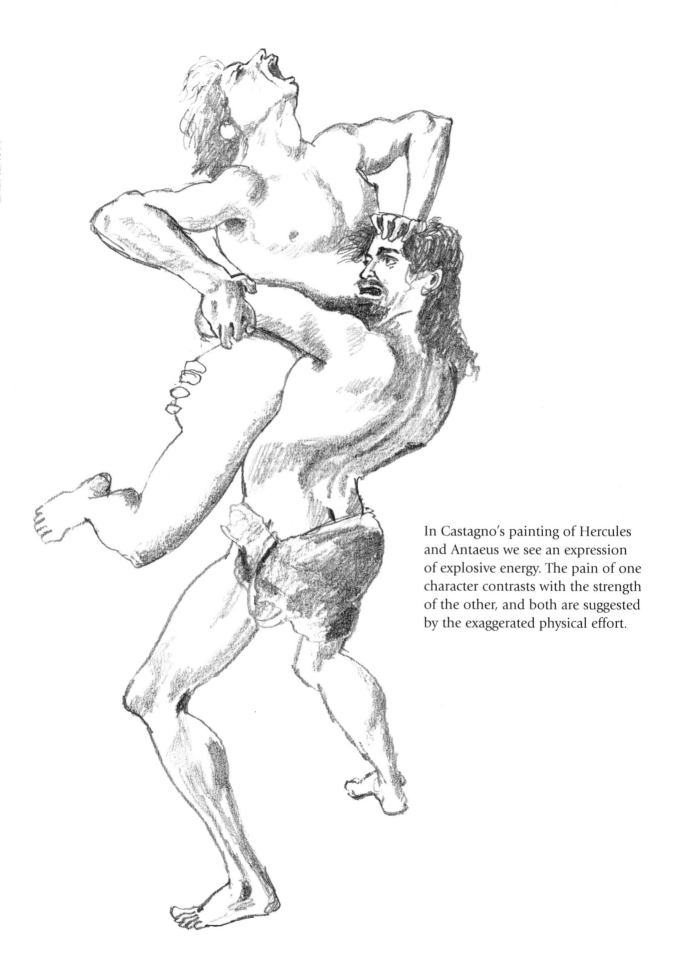

In Castagno's painting of Hercules and Antaeus we see an expression of explosive energy. The pain of one character contrasts with the strength of the other, and both are suggested by the exaggerated physical effort.

RELAXED POSES

Here the basis of the pose is more relaxed, without the active dynamism of the poses on pages 536–8. This is of course a much easier way to pose a model, because most people can keep still in a comfortable reclining or sitting position. When you want to do longer, more detailed drawings you will always have to rely on more static poses.

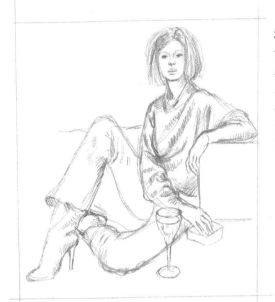

Sitting upright on the floor, the model has her legs bent, one tucked underneath the other. Her fashionable appearance and the wine glass on the floor in front of her helps to give a static easy-going composition which looks as if she is engaged in a conversation at a party. The arrangement of the legs crossing each other and the arms bent around the torso help to give a fairly compact appearance to the arrangement.

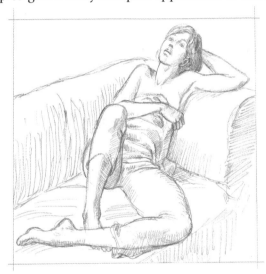

The second figure is even more relaxed and literally laid back, with the head supported on one bent arm resting on the side of the couch and the other arm bent across the torso, holding a garment across the body. The legs are tucked around each other in a way similar to the previous pose but even more loosely arranged. The viewpoint from the foot end of the body does give a certain dynamic, but the energy is reduced to give an effect of rest. The head bent back onto the hand and the arm of the couch helps this passivity.

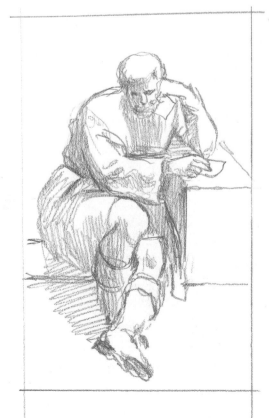

This sitting figure, taken from a Raphael design in the Vatican, is in a pose that looks both thoughtful and relaxed. The figure is of a philosopher about to write his thoughts, a pose that is obviously going to be static for some while.

CLOTHING AND MOVEMENT

Next we look at clothing and how the movement and actions of the wearer affect it. Of course, how an item of clothing behaves will depend on the type of material of **which it is made, so you need to be aware of different properties and characteristics and how to render them realistically in various situations.**

A very simple movement of a girl pulling on her jacket produces all sorts of wrinkles and creases in a rather stiff material. The creases at the bend of the arm are relatively soft, however, which generally indicates an expensive material. As the American Realist painter Ben Shahn remarked, 'There is a big difference between the wrinkles in a $200 suit and a $1,000 suit.' (This was said in the 1950s, so the prices are relative.) What he was remarking on was the fact that more expensive materials fold and crease less markedly and the creases often fall out afterwards, whereas a suit made of cheaper materials has papery-looking creases that remain after the cloth was straightened.

The clothing worn by this figure (right) hangs softly in folds and suggests a lightweight material such as cotton. The shape of the upper body is easily seen but the trousers are thick enough to disguise the shape of the leg.

This drawing (left) was made from a picture of a dancer playing a part. The baggy cotton-like material has a slightly bobbly texture and its looseness in the sleeves and legs serves to exaggerate his movements. Both the action and costume reinforce the effect of floppy helplessness.

A bit of clever posing by a fashion photographer was responsible for the original from which the drawing below was made. The model was actually photographed lying on the floor with the dress spread out to make it look as though she was moving in a smooth-flowing dance. The photograph was taken in the 1930s, before the benefits of high-speed cameras and film, and represents an imaginative way round a technical problem. It proves that you can cheat the eye.

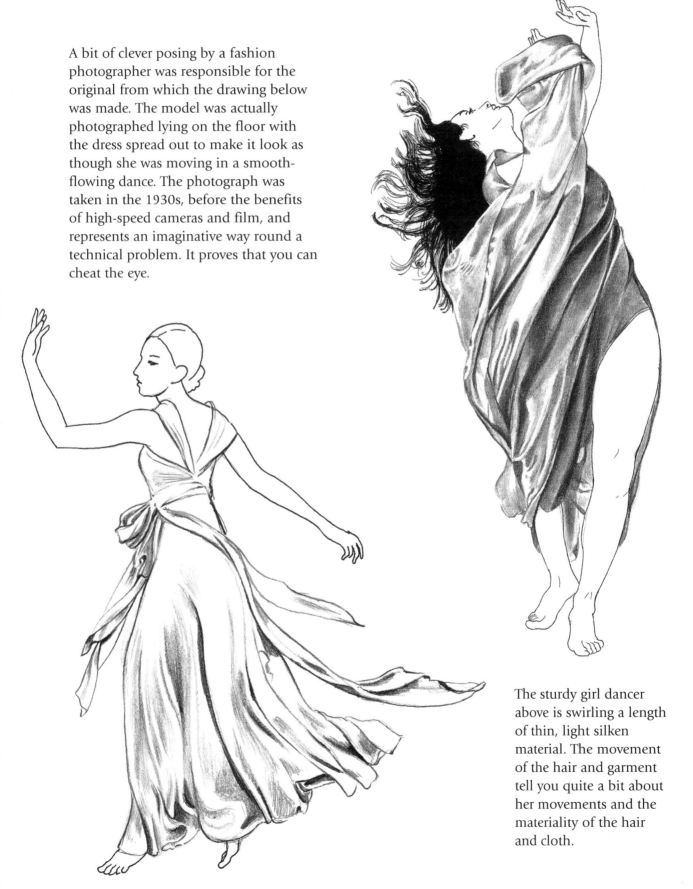

The sturdy girl dancer above is swirling a length of thin, light silken material. The movement of the hair and garment tell you quite a bit about her movements and the materiality of the hair and cloth.

Here are three drawings of different clothes that exhibit vastly different effects of folds and creases, mainly because the particular type of material used in each case.

These jeans, made of tough hard-wearing cotton, crease easily and characteristically, and the creases remain even when the cloth is moved.

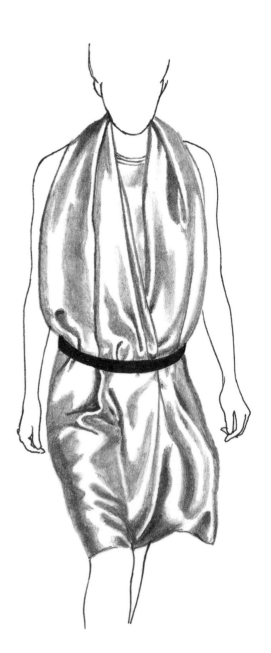

A couture garment made of heavy satin and tailored to keep the folds loose and mainly vertical. The movement is not extreme and so the weight and smoothness of the material ensure an elegant effect.

When you come to draw this type of material, be sure to get a strong contrast between dark and light to capture the bright reflective quality of the garment.

The raincoat sleeve shown below is similar in character to our first example: a stiffish material but one made to repel water and so has a very smooth sheen. The folds are large, the sleeve being loose enough to allow ease of movement. Even in this drawing, they look as though they would totally disappear when the arm was straightened.

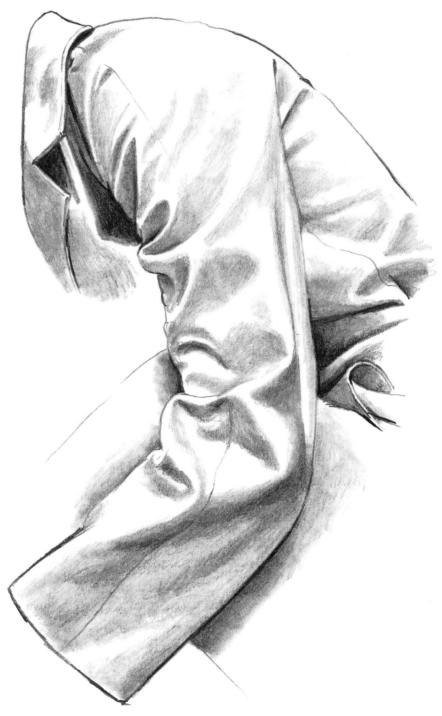

MOVEMENT

Studying classical drapery in museums and books will give you a range of subjects to consider. Taking specific works, set yourself the task of noting how the artists have used drapery to describe the form and motion of the human figure beneath it. Your own drawings will benefit greatly from such close analysis of the work of artists from earlier eras.

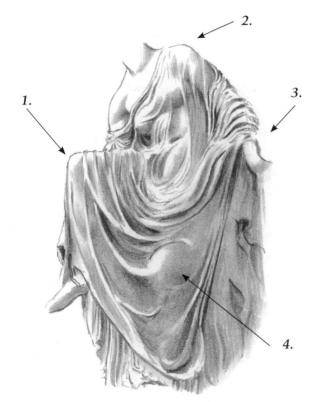

This example taken from an Athenian sculpture (410 BC) of a Nike, or Victory, figure shows how the folds of the thin cloth reveal the figure underneath. At point 1, the raised knee of the figure projects outwards as the female figure leans over to fix her sandal. This knee creates a series of large folds across the whole width of the figure from the opposite elbow (point 3) and produces the main curve of the drapery. Notice also how the cloth draped over the shoulder at point 2 folds and reveals the upper part of the torso showing both breasts and the curve of the stomach area. At point 4, the other knee creates a large area of cloth pushed outwards with sharp folds created either side and above. The cloth falls in many close, narrow folds around the arm and elbow point 3.

This example of another active Greek figure, dating from 160 BC, shows how the tie around the waist of the figure (point 1) pulls in many small sharp folds in the draped cloth, both above and below the waist. The figure's backward-thrust leg (point 2) disturbs the heavier, longer folds of the main swirl of the skirt, which then produces a rhythmic curve of folds hiding the other leg.

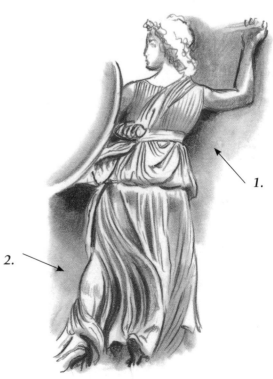

1.

2.

In the Giotto figure (AD 1305) the material is draped in a similar way to our first draped figure, hanging off the shoulders (point 1), in simple, heavy, long folds. The way the hands are holding the cloth bunched towards the front of the figure (point 2) creates the deep pulled-in fold under the forearm and the shorter, tighter folds hanging down from the hands at the front of the figure.

1.

2.

4.

3.

The Roman figure (430 BC) shows a toga draped around the shoulder and pushed out by the right hand which projects over the edge of the cloth (point 1), creating strong, lateral curves almost like a balcony. The hand on the hip under the cloth (point 2) pulls the folds around the forearm and creates several sharply folded pieces of drapery below along the more relaxed leg (point 3). The hip pushed outward (point 4) creates the more open folds down the figure's right side.

This famous trio of goddesses from Botticelli's Primavera shows a variant on the clothing where, instead of hiding the limbs, the flimsy chiffon-like garments show quite clearly the shape of the body. I have simplified the picture by making the hair one tone and outlining the figures in black.

The folds of the robes are drawn in very lightly, as they are in the painting. A good reproduction of this will give you a better idea of the subtlety of the concept, but the drawing here does give some idea of the way the fine folds float around the limbs and are formed by their substance.

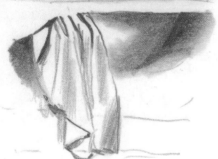

The drawing from a Greek statue (4th century BC) shows how the folds of cloth drape down from the head to the neck and then around the shoulders and back. You can see how the bent arm pulls the folds across the body.

The man from Ghirlandaio's Stories of the Virgin fresco is a much more substantial piece of materiality, the heavy, probably woollen, cloak hanging in large solid folds that swing from side to side across the stalwart figure of the man. It is easy to conceive of the three-dimensional figure under the substantial material.

MOVEMENT

WALKING, RUNNING AND DANCING FIGURES

Photographs are a great boon to the artist wanting to discover just how the parts of the body relate to each other as the model moves, but they should be used with caution: copying from a photograph can produce sterile results. An artist should be looking not just to make an accurate drawing of lines and shapes but also to express the feeling of the occasion in a way that can be understood by the viewer: look particularly at the styles of depiction chosen here. Study photographs, but stamp your own mark as an artist on your drawings.

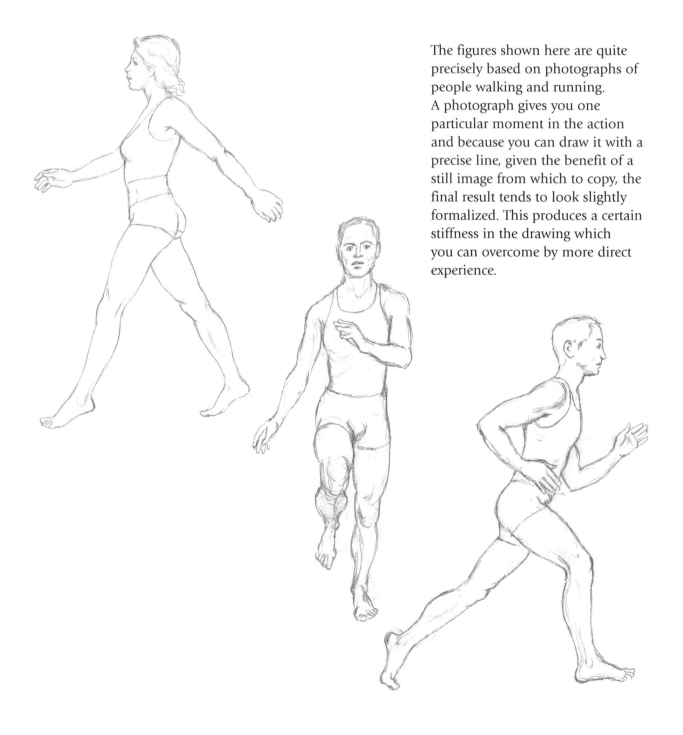

The figures shown here are quite precisely based on photographs of people walking and running. A photograph gives you one particular moment in the action and because you can draw it with a precise line, given the benefit of a still image from which to copy, the final result tends to look slightly formalized. This produces a certain stiffness in the drawing which you can overcome by more direct experience.

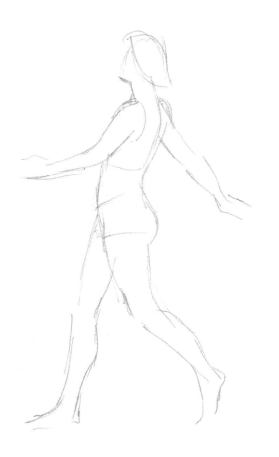

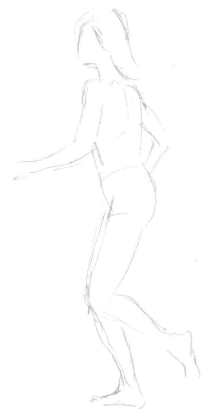

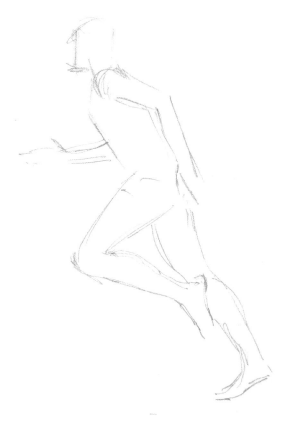

The next three figures, drawn much more loosely without the aid of photographs, give an impression of the movement. The type of line used helps to produce an image which looks as though it is in motion; none of the lines are exact and in some cases there are several lines, which create a blurred effect. Notice how the shoulders and hips work in opposition; the torso is sometimes vertical but is quite often tilted forward or back at different parts of the movement.

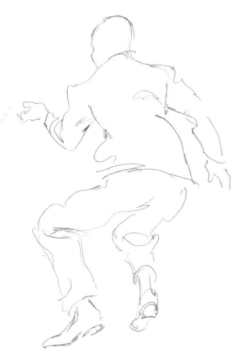

The drawing of a male dancer leaping shows his suit wrinkled and thrown upwards as his body is projected into the air. He maintains a balanced position because as a dancer he keeps control of his movement so that he will always land on his feet.

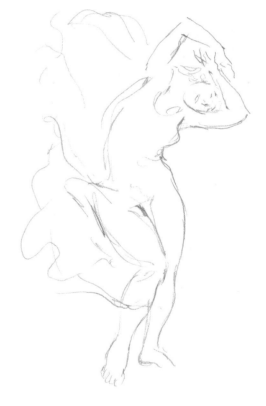

The sinuous shape of this girl indicates a slower sort of dance, which is accented by the movement of the dress blowing up in the wind. Notice how the lines of the drawing follow the flow of the figure, with no attempt at an exact rendering of her form.

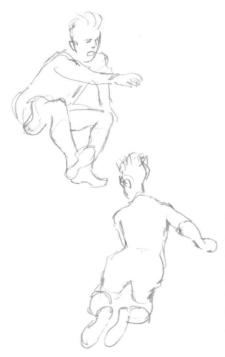

The two men jumping in the air have pulled their knees up high and are using their arms to maintain their balance and produce a highly energetic leap. The figures are drawn with minimal lines so that although you can tell they are male figures the main point of the line is to show movement.

This figure is based on footage of Fred Astaire dancing, engaged in vigorous, balanced and elegant movement. The body is turned, the feet are tapping and the arms are swinging. The turning of the body is balanced by the disposition of the legs and arms and head.

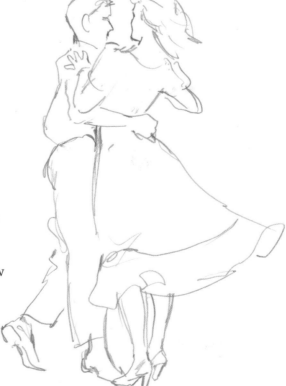

In a classic version of simple ballroom dancing, the girl leans back slightly, the man's arm round her waist. Her skirts and hair swing out while his stepping feet direct the movement of the dance. Again the drawing is kept minimal with just enough movement in the clothing to show its type, but with no details evident.

MOVEMENT

BALANCE AND IMBALANCE

It is an interesting exercise to try to draw someone at the point where they have lost their balance and begun to fall over. It is not easy to do, because even if the occasion presents itself your reaction will probably be to try to help rather than take advantage of the situation. However, an accident such as this is often clearly imprinted on your memory for a short time, so you can sometimes remember enough to make a sketch shortly afterwards. Asking someone to adopt a falling pose is never quite the same, but it is worth trying.

Conversely, people engaged in an activity such as throwing a ball or climbing rocks and trees are usually in a state of perfect balance. Here the body is under tight control, with deliberate movements – note how careful pencilling reflects this control.

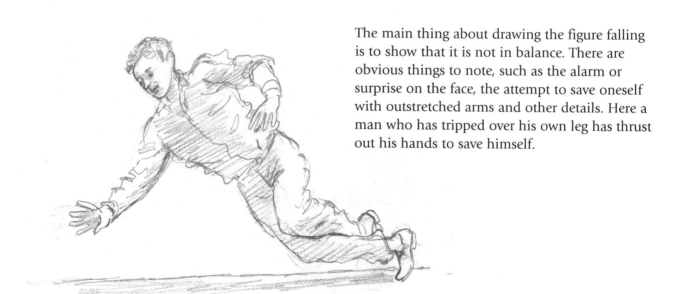

The main thing about drawing the figure falling is to show that it is not in balance. There are obvious things to note, such as the alarm or surprise on the face, the attempt to save oneself with outstretched arms and other details. Here a man who has tripped over his own leg has thrust out his hands to save himself.

A woman who has slipped over is trying to turn to protect herself from a bruising. Again, there is an instinctive attempt to cushion the fall with the arms, and her untidy hair and alarmed face reinforce the message that she has temporarily lost control of her body.

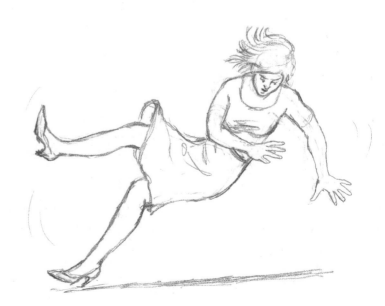

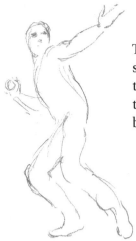

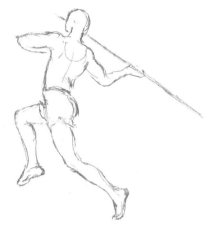

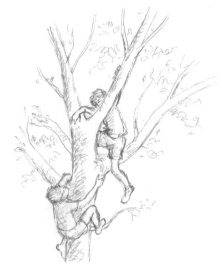

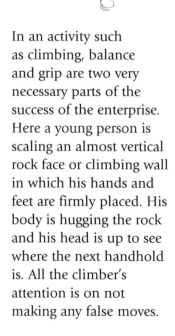

The action of throwing something is quite a dynamic subject for a drawing. In this figure throwing a ball, the body is drawn back, with the free arm stretched to help with the aim. You can see that when the body is unleashed the ball will go far.

Here an athlete is in the run-up for the casting of his javelin. His arm is back, his body is turned and his legs are poised for the final twist as the object is sent flying.

This young woman is throwing a ball underarm with a sudden twist of the body. The effort is more gentle than the previous two and suggests that she hopes the recipient, perhaps a child, will catch the ball.

In an activity such as climbing, balance and grip are two very necessary parts of the success of the enterprise. Here a young person is scaling an almost vertical rock face or climbing wall in which his hands and feet are firmly placed. His body is hugging the rock and his head is up to see where the next handhold is. All the climber's attention is on not making any false moves.

With the two figures climbing a tree the emphasis is on effort and a certain sense of risk, where the youngsters seem to be taking chances. The lower boy is in a rather tricky position from which he might have to drop down or wait for the upper boy to help him. The upper boy is climbing up quite fast and looks agile and strong. The balance is there but less deliberate than with the rock climber.

SWIMMING AND DIVING

Swimming is a very difficult activity to draw because the water partially hides the body and distorts the shape of it beneath the surface of the water because of the surface movement and refraction of light. In the case of a diver, you have about one second to catch the position and you might have to make many attempts before you catch the exact point that you wish to draw. Here again, visual memory is all-important. Of course you can take photographs, but you will get a better result if you observe and draw on the spot as well.

The overarm swimmer is making so much splash on the surface of the pool that all that can be seen of his body is limited to the parts out of the water. Compare the effects to the calm rock pool and gentle swimming opposite.

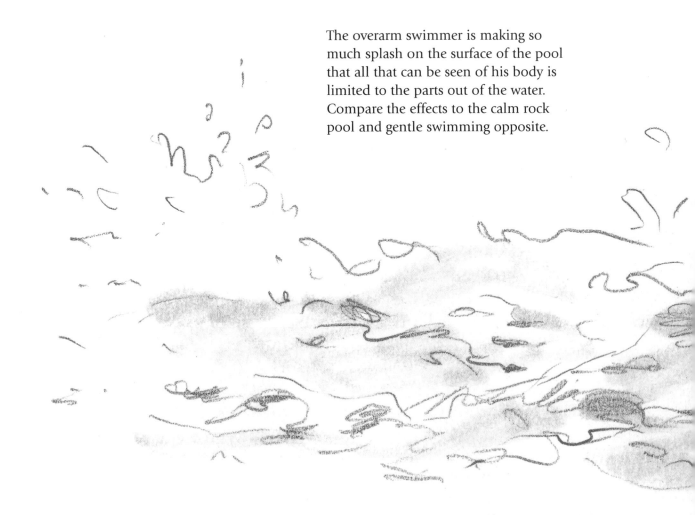

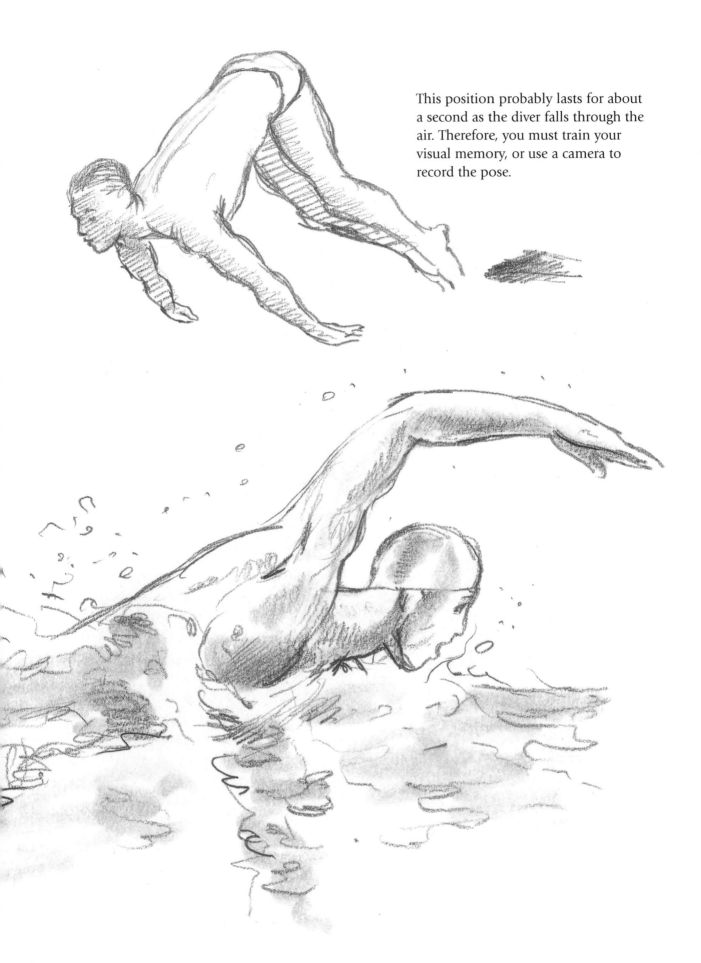

This position probably lasts for about a second as the diver falls through the air. Therefore, you must train your visual memory, or use a camera to record the pose.

MOVEMENT

SOCIAL SETTINGS

Figures in social settings are much simpler to draw than those engaged in energetic sports. Their movements are slower and calmer and they will stay in one spot for longer. Their gestures and body language will tend to be repeated again and again, giving you plenty of time to observe them and draw them accurately. Notice how they may change as people begin to relax in the company of someone they have only just met.

These three figures engaged in conversation look relaxed and are fairly still. The animation tends to be in the hands and faces while the bodies take on poses of comfortable balance rather than energetic shapes.

A group around a table at a meal is even more static and here you will probably see only the upper half of the bodies with any clarity. Again all the animation will be in the faces and it is the glances and direction of the turning heads that help to create the dynamic. Lighting helps here and drama can be enhanced by candlelight, which tends to obscure details.

Social settings outside tend to be more dynamic in terms of body movements and poses. Here, at a garden party, a group of young people are seen eating and talking. One leans aside to replenish his plate, while the woman with her back towards us gestures to the table. The man opposite her is partially obscured but one can get the effect of some rather direct expression from him. The other woman points to herself with hand on hip, all this against the background of foliage and roofs.

Street scenes are less easy to draw because people don't tend to linger much and it is difficult to find places where you can obtain a good view. However, the dynamics of this group of shoppers as they pass each other, commenting on their purchases, makes an interesting balance of figures across the pavement with other figures lightly indicated in the background.

IMAGINATION, ABSTRACTION AND SYMBOLISM

Not all pictures pretend to be real in the sense of portraying an observed incidental scene. Imaginary landscapes, for example, are an attempt to produce something that is real in a metaphysical sense. Sometimes they are skilfully blended so as to resemble a scene that we might recognize, but sometimes not even this attempt is made. The intentions of the artist are often worked into a scheme that demands certain ways of showing the world in order to teach a doctrine or lesson about life, religion or the next world. Most pictures of the Garden of Eden or Paradise are of this nature.

Although they can be very naturalistic in theme, such pictures don't resemble any particular place, object or person but are a representation of an ideal or the supernatural. Many cultures have been quite clear that the images they produce are not of the world as it appears, but as it ought to be, or is in its true perfection. Many artists are trying to capture the essence of the subject, and consider this to be much more important than producing a mere facsimile of some aspect of the real world. This is not to say they don't use natural forms – they do, but carefully rearranged to show the underlying qualities of reality and to convey something of the artist's philosophy of life. So the artist's interpretation of a subject may be real, super-real or even surreal. Let's now have a look at a range of good examples of this exciting and stimulating area of artistic activity.

ABSTRACT DESIGN IN COMPOSITION

In the 20th century there was much discussion in artistic circles about the respective merits of naturalistic and abstract art. However figurative a picture, it still needs an understanding of abstract design to make a satisfying composition. In these examples, although the world is portrayed naturalistically, their power derives from the arrangement of one shape against another within the confines of the picture.

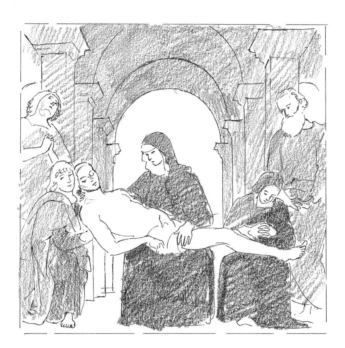

In this 'Pieta' by Pinturicchio, a colleague of Raphael, the dark shape of the mother of Christ supports her son's pale corpse, represented as a strong horizontal shape cutting across the arch which frames the scene. The dark shape of the Virgin and her central position serve to balance the picture. The dark areas above and to the sides contribute to the power of the composition.

You can see these relationships very clearly in the simplified version.

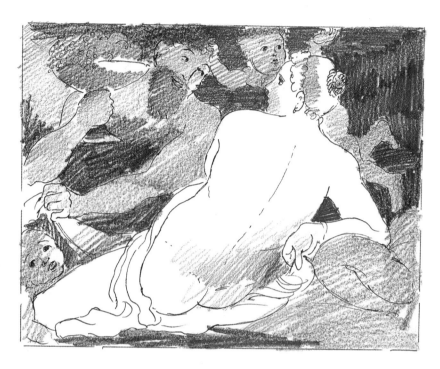

In these two sketches of Veronese's 'Venus with Satyrs and Cupid', a very simple compositional device has been used to give sensual potency to the work. The bare back of Venus is revealed to us as she stretches across the picture plane, sharply lit against the dark, chaotic space in front of her where the moving shapes of the satyrs and Cupid can just about be made out.

ABSTRACT AND NATURALISTIC DESIGN IN COMPOSITION

Some pictures, while appearing to be purely abstract in conception, are in fact naturalistic and portray actual things. These few examples show how easy it is to move from a naturalistic to an abstract approach, and back again. The abstractionists can teach us different, but equally valuable, lessons about composition.

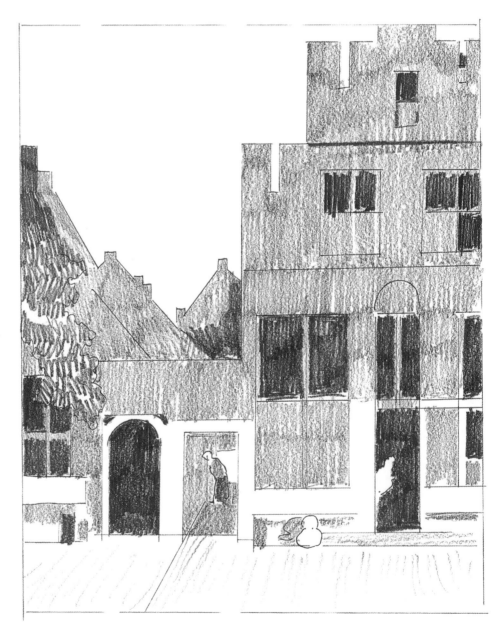

Vermeer's 'Street in Delft' is a remarkable picture for its time. Cut diagonally in half from bottom left to top right, the lower half is filled with the façade of a building and most of the upper half is taken up with sky. The house is built out of a series of rectangles for the windows and door, enhancing the picture's geometric effect, even though other details suggest a real house with people.

It is not such a great leap from Vermeer, Hopper and Morandi to pure abstraction. The Russian suprematist artist El Lissitsky used abstract geometric shapes in arrangements that suggest floating movement.

Piet Mondrian created a system of balanced but dynamic spaces by using black verticals and horizontal bars across a largely white background, interspersed by blocks of colour.

IMAGINARY LANDSCAPES

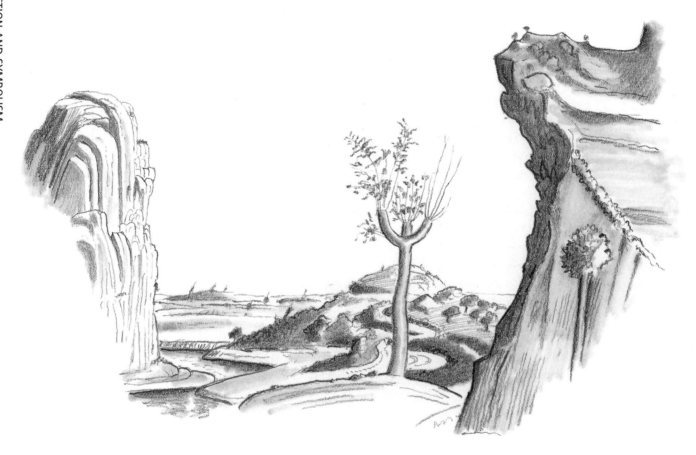

Background to Adoration
of the Shepherds – after Mantegna

The rocky backdrop is a typical Italianate landscape often found in pictures of the birth of Christ. The implication is that the birth of a saviour will bring back to life the barren, parched land. The passion of his death is foreshadowed in the cross-like tree set at the foot of the hill. The water of the river at the base of the rock indicates the water of life and also baptism. The two stony crags either side of the open space give an effect of the Old World being set apart by the new.

The landscape is based on natural forms, although these are fairly exaggerated. Even the tree is unusual in shape, so there is no danger of its not being read as a metaphor. Nature is brought into use in order to give a natural effect, but this is certainly an imagined, designed landscape.

Moses Saved from the Bulrushes – after Claude Lorrain

Coming one hundred years after Mantegna's landscape, Claude Lorrain's seems to be a view of a real place, the trees and buildings intended to add to our conviction that what we are looking at exists somewhere, perhaps around Rome. However, we are meant to believe this is the River Nile and that the future prophet Moses is being discovered in bulrushes along its banks; I have left out of the foreground the group of figures making this discovery. Apart from the palm tree set by the bank, the trees are of a European cast. In the distance is a distinctly Italianate bridge or viaduct. To modern eyes Egypt is largely conspicuous by its absence. In Lorrain's time, however, this would not have mattered, and tourists were so rare two hundred years ago that most people would not have known any difference. The landscape is secondary to the story, which contemporary viewers would have 'read' through the artist's use of symbolism.

The Ghent Altarpiece (central panel) – after H. & J. van Eyck

In the original there is an open garden-like landscape, comprising soft lawns, flowers, trees and bushes, which provides a backdrop to the main business of the painting – a coming together in Heaven of saints, angels and doctors of the church to worship God in the form of a lamb. In our copy, I have left out all the people and the central figure, and indeed the Holy Trinity shining their light from the sky onto the scene, because I want you to consider the landscape alone.

Bang in the centre is the high altar with a crucifix and a pillar either side, symbolizing Christ's martyrdom. In the front of the scene is an ornate fountain spurting water into an octagonal basin to symbolize the water of life. In the background, beyond the carefully trained and neatly trimmed trees and shrubs, we glimpse some impressive Gothic and Romanesque buildings. It is as though the full panoply of the medieval Church is peeping over the nearer hills so that we do not forget its association with the great ceremony going on in heaven. The inference, which would have been widely understood at the time, is that only the best aspects of the world are worthy of being with the presence of the Saints and God. This naturalistic world is marked by simplicity and restraint, with only the most desirable buildings and vegetation included in the picture. No accidental or badly designed areas are allowed in Paradise.

Part of the Procession of the Magi frescoes – after Benozzo Gozzoli

Gozzoli's Procession of the Magi fresco cycle was painted for the chapel of the Medici family's town house in Florence. In this copy I have again left out people and animals to concentrate on the landscape, which is not by any means a natural view of the countryside around Florence. To begin with there are no rocky outcrops like this in the area – in fact, not in any area, because Gozzoli has used a medieval convention and envisaged the landscape by draping cloth over scaffolding or boxes. He could easily have painted realistic rocks, but the convention of using traditional forms so his public would

not be disturbed by innovation outweighed the Renaissance desire to study nature. He has, however, put in plants found in the area, although idealized to an extreme. Some of the details are familiar – the castle in the background representing Jerusalem, for example, resembles the Medici Villa at Caffaggiolo – but overall the impression is of a formalized and carefully tidied-up landscape to suit the artistic design of the fresco cycle. Even the perspective is reduced, purposely so; Gozzoli would have been aware of the principles taught by Brunelleschi. Everything is secondary to the telling of the story.

The Garden of Earthly Delights – after Hieronymous Bosch

Painted at the time of the Renaissance, Bosch's original is an extraordinarily artificial construct, although it does include some natural features. As in the examples by the Van Eycks and Gozzoli, the trees and bushes are tidily clipped and controlled, the grass lawns are smooth and the few rock features are so obviously constructed that no-one could think them naturalistic. The water features are neatly dug ponds in someone's estate. But what are the other artefacts? There are extraordinary edifices spiking upwards across the horizon, and strange global devices scattered around the lawns and floating in the ponds. Some of them look like vast jungle plants of doubtful ancestry. But none of it seems real, and indeed the viewer is not expected to believe that it is in the normal sense. In the original the whole scene is teeming with people engaging in what appear to be either odd or dubious activities. Although everyone seems to be enjoying themselves, we viewers are left feeling uncomfortable. In his many didactic pictures, Bosch tried to warn of the dangers of putting the pursuit of pleasure above the pursuit of goodness. Everything in this garden looks pretty and pleasant on the surface. But note the sinister quality of those plant-like edifices, which look as though they might be capable of delivering a mighty lesson on the instigation of some higher authority.

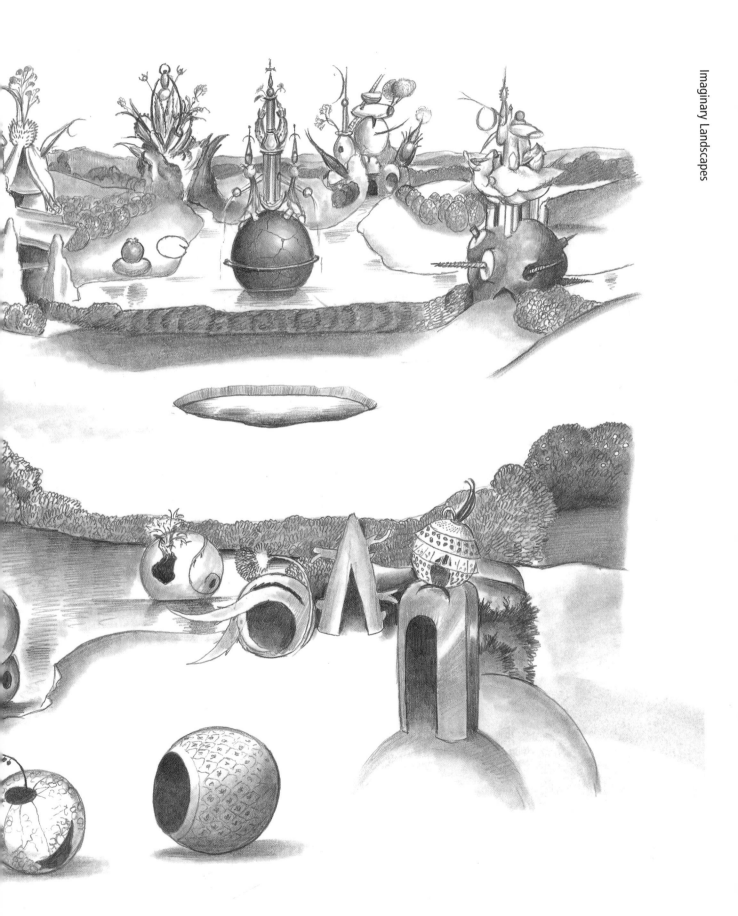

IMAGINATION, ABSTRACTION AND SYMBOLISM

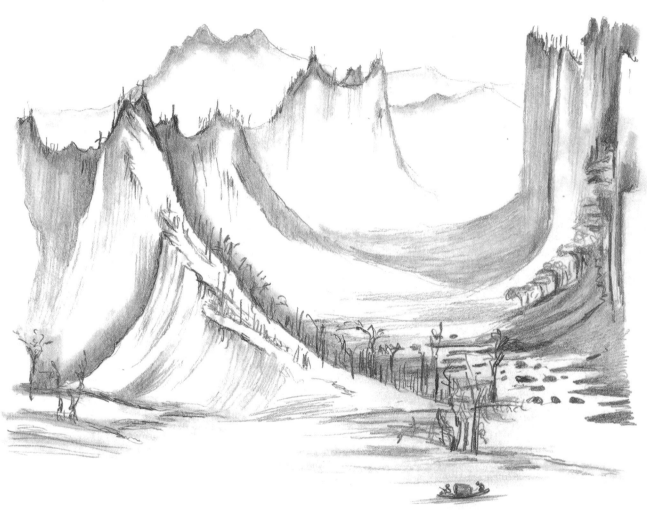

Fishing in a Mountain Stream – after Hsu Tao-Ning

This is the earliest example of an imagined landscape included in our selection (about 11th century). The style is markedly different and the technique astonishingly advanced for the period. No artist in Europe would have been expert enough to give an impression of receding space with anything like this effect. The size and spaciousness of the landscape with its vast perpendicular mountains and gaping gorge is almost breathtaking. The notable characteristic this landscape shares with the other examples is that it too is a depiction of perfection, with the artist shaping the various heights according to his design and editing out anything that upsets the unworldly harmony and beauty of the scene.

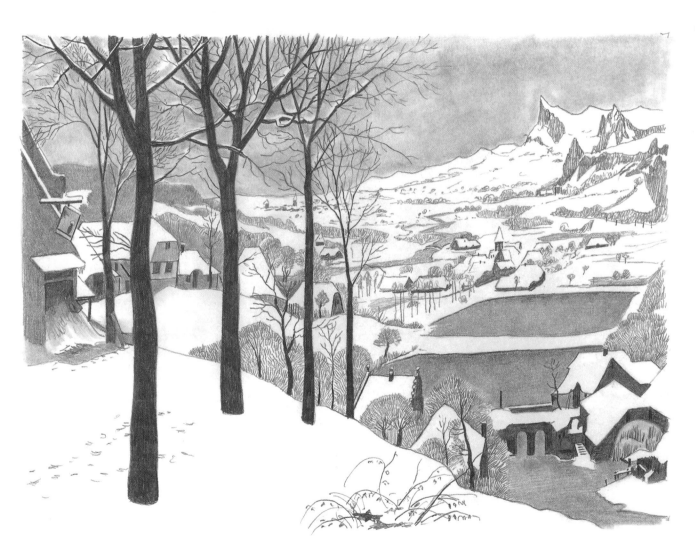

Hunters in the Snow – after Brueghel

Once again, I have left out the figures; in the original there are hunters in the foreground and myriad people active across the middleground. The landscape at least looks natural and you would be unlikely to think Brueghel was depicting an idealized scene. There are, however, a few pointers to indicate that this too is a constructed scene. Look at the alpine mountains in the background. They are cleverly done but not quite like any mountains you would see in the real world, especially being so closely tucked in against the rather flat Flemish landscape.

The Bow-Moon – after Hiroshige

The Japanese landscape painter Hiroshige took his forms from nature but was more interested in the spirit or essence of his scenes as works of art. He didn't want to produce simple facsimiles of what he saw. He looked for the key points and balance in elements of his choosing and then carefully designed the landscape to influence our view. Only the most important shapes and how they related to each other were shown. Usually their position and place was adjusted to imbue the picture with the most effective aesthetic quality. The landscape was really only a starting point for the artist, whose understanding, perception and skill were used both to bring the picture to life and to strike the right vibration in the onlooker. The experience was not left to accident.

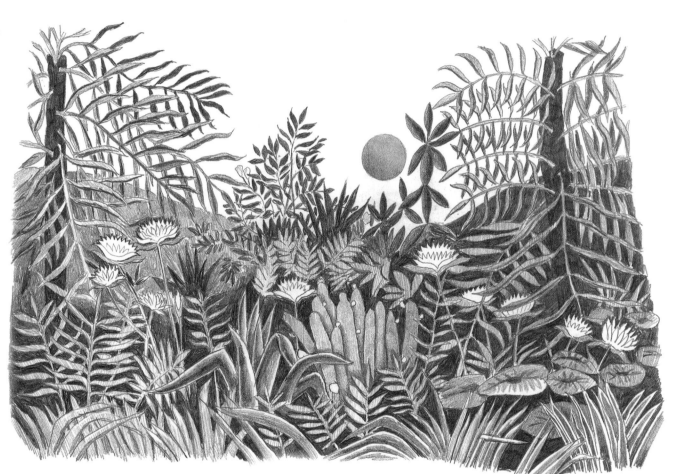

Virgin Forest at Sunset – after Rousseau
There is no disguising this is an imaginary scene.
The lush vegetation conveys the feel of the
jungle, although the plants themselves look very
much as though they have been copied from
the engravings that were current at this time in
geographical books and magazines. The artist
probably also supplemented his knowledge by
visits to the botanical gardens in Paris. In the
original, figures and animals are set within the
carefully composed disorder of luxuriant plants;
left out in this version. Although obviously the
view of an urban dweller and naïve in style, the
overall effect is very impressive.

Tower of Babel – after Pieter Brueghel

This is a marvellous piece of imaginative architecture-dominated landscape. The great mass of the tower with its multiplicity of structures rises out of a plain, although apparently constructed on a rocky outcrop. The amazing completeness of the architectural concept and the landscape laid out behind it, with a port and sea or lake to one side, is a brilliant evocation of the Biblical story.

IMAGINARY LANDSCAPES: PRACTICE

Now that you have studied a wide range of imaginary landscapes, it is time to consider trying it yourself. As with any type of landscape, you begin by deciding what to include. By this time you should have built up quite a stock of studies of details and features you have come across on sketching expeditions. Look through them and select details you think might work well together.

Shown below are several features that you would typically find in a landscape, either rural or urban. You will want to concentrate on producing a picture in your own style and including features you are familiar with, but don't be shy of using other methods and scenes by other artists to help you. Artists have done this down the ages to hone their skills. You will of course have to adapt any 'borrowings' to your own design, but that is not difficult. If you want to experiment at the extremes of imaginary landscapes, look at the work of the Surrealists and artists like Bosch for inspiration.

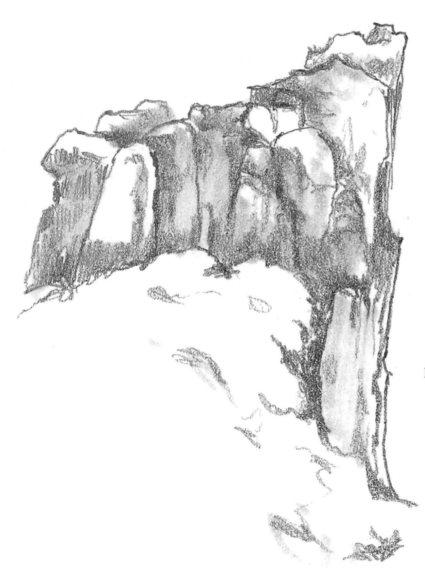

Rocks in the Chinese style

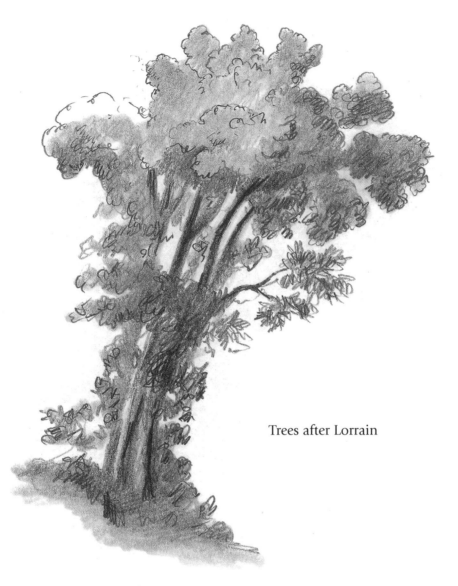

Trees after Lorrain

Water after Vermeer

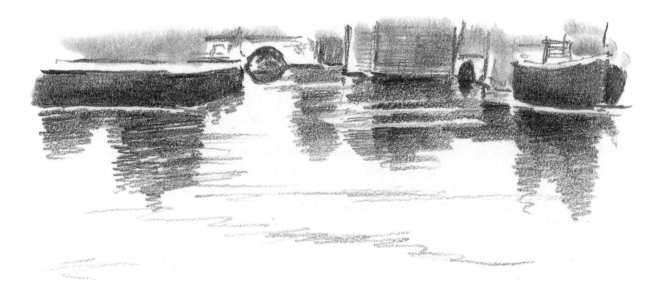

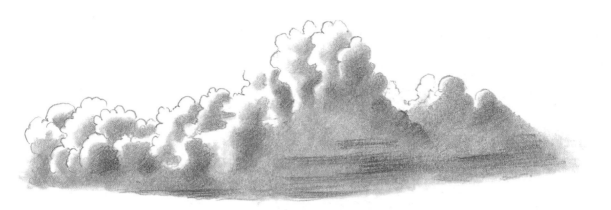

Clouds after Bellini

Buildings after
Utrillo

NOVEL APPROACHES

This is after the 16th-century Italian artist Archimboldo, who specialized in making pictures resembling portraits out of still-life objects. This piled-up stack of open and shut books draped by a background curtain produces an effect of a bearded man sitting for his portrait. It is definitely still life, but also becomes a portrait by virtue of a sort of optical illusion – a clever and very difficult approach to pull off.

Twentieth-century artists were interested in the still-life genre, but because of their desire to use a new language in art they produced some unusual variations upon traditional themes. This picture after Paul Klee of potted plants and a die on a paved floor gives a mysterious effect which is very different from the more photographic view of still-life objects.

GROTESQUES TO FANTASY

Leonardo da Vinci has left us many extraordinary examples of caricature which are undoubtedly not true to life but still recognizable. No one knows why the great man was so fascinated by this type of drawing, but perhaps it is not surprising he wanted to see how far he could go with it.

In the second half of the 16th century the Milanese painter Giuseppe Arcimbaldo took caricature in a different direction, producing fantasy portrait heads in which the features were composed of clusters of fruit and vegetables. Some later commentators considered him to be an ancestor of the Surrealists.

Examples from both artists are seen here.

The features of this man (original by Leonardo) are greatly exaggerated and can in no way be taken as realistic – nose protuding, mouth pushed up at the centre and down at the sides. The great lump of a chin completes the ludicrous effect, which glazed eyes and rather lumpy ears don't diffuse.

This second copy of a Leonardo is more
realistic apart from the protruding jaw which
is taken to unnatural lengths. The first face
looked rather stupid; this one looks more
intelligent and even kindly.

This extraordinary face by Arcimbaldo is reputed to be of the Hapsburg Emperor Rudolph II. Although made up of fruit and vegetables it is easily readable as a particular human face.

The drawing is an amusing conceit but one doesn't know whether it was meant to make fun of its subject or was just a curious exercise in ingenuity.

CARICATURE AS SATIRE

The work of the great caricaturists was born out of social and political turmoil. Hogarth, Rowlandson and Gillray, three of Britain's greatest exponents of caricature, came to the fore at a time of unprecedented change. All three were valued more for their caricaturing skills than their serious gifts, an oversight that was particularly hard on Hogarth, who was undoubtedly a major artist.

In Spain, Francisco Goya was also railing against the injustices and follies he saw around him. He chronicled the horrors of the occupation by Napoleon's armies in both paint and ink. In his smaller studies we get snapshots of the human condition in extremes of expression that ring true.

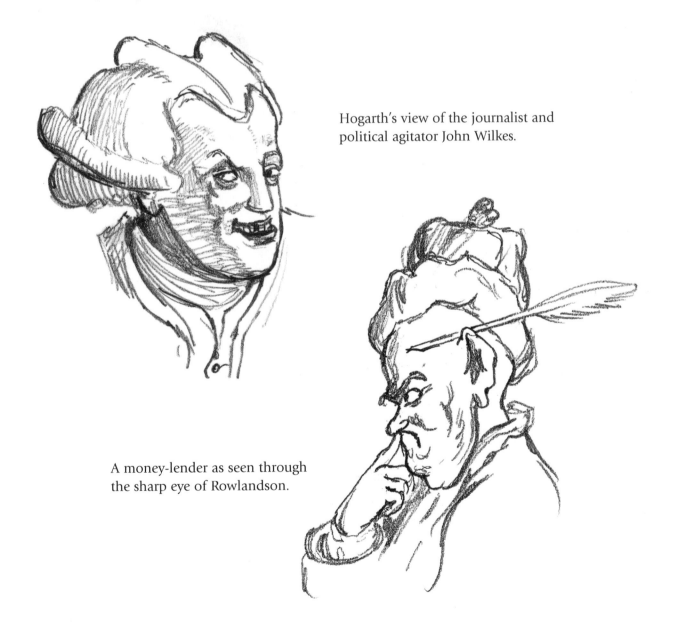

Hogarth's view of the journalist and political agitator John Wilkes.

A money-lender as seen through the sharp eye of Rowlandson.

In his series of drawings known as 'Los Caprichos', Goya castigated a host of iniquities. Here it is the Catholic Church, represented by two rather disreputable-looking monks.

At the end of the 18th century Napoleon became a target for English caricaturists, who, like most of their countrymen, feared what might happen once he had overrun mainland Europe. Initially portrayed by them as a tiny monkey-like character with a big hat, he evolved into a portly villain with a scowl and a big chin.

No one was safe from the caricaturists'
pen, not even the Duke of Wellington,
a great hero of the popular press thanks
to his victories in the Napoleonic Wars.
The treatment of him in these two
contemporary examples, after he had
swapped his uniform for a frock coat and
entered Parliament, is fairly good-natured.

Political leaders at
home came in for
just as much attack
from the caricaturists
as their foreign
counterparts.

 In these two examples (above) you see a
weasely-looking William Pitt the Younger by
Gillray. Fresh-faced in the first illustration (he
was after all only 24 when he became British
Prime Minister for the first time), he seems
to have matured a little in the second, with
clusters of freckles on the nose and cheek and
the makings of a moustache and beard.

Pitt's great political rival, Charles James Fox,
by Rowlandson.

CARICATURE AS ART

In 19th-century France political comment was often mixed with an illustrative kind of art which combined to make a rather strange brew. The result was certainly caricature but of a type that was more finished and obviously polished. The Salon culture of the French art world would have been horrified by less. The influence of the Impressionists would soon be felt, however, even in caricature.

Honoré Daumier made many drawings which hovered at the edges of caricature. The first of the two examples of his work shown here is from a French treatise on suffrage.

The second, taken from a journal, is of 19th-century France's leading literary figure, Victor Hugo, hence the immense brow.

Jean-Louis Forain was a regular contributor to journals as a caricaturist and graphic artist. This example of his work shows a departure in style from the satirical drawing usually seen in France up to this time. Very few lines have been used to depict the sleek, moustachioed bourgeois gentleman in evening dress.

A contemporary of Forain, Arthur Rackham became popular for his book illustrations, especially of children's stories. Rackham's imaginative approach went down well not only with children, who were sometimes almost frightened by them, but by their parents who particularly admired his finely drawn grotesquerie.

An early caricature by Impressionist
Claude Monet of his art teacher.

BUILDING A CARICATURE

The process of turning a perfectly normal looking person into a cartoon figure to accentuate their traits is the same whether the subject is familiar to millions of households or just one. It can be a fun exercise. The subject I have chosen here is my eldest son. His features are perfectly normal, but as I know quite a lot about him I can accentuate certain areas to bring out his personality to the casual observer. Let's begin the process.

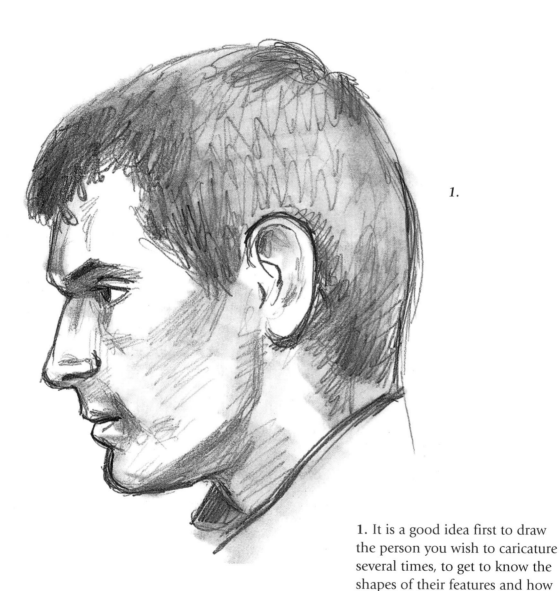

1.

1. It is a good idea first to draw the person you wish to caricature several times, to get to know the shapes of their features and how these relate to each other.

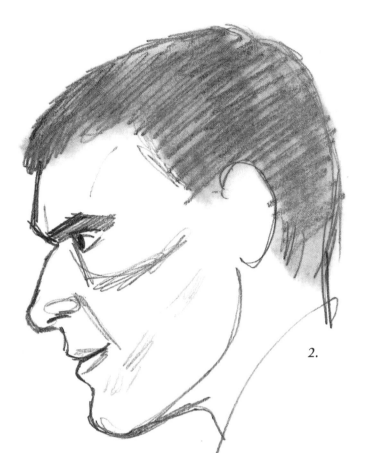

2. I have slightly exaggerated his way of staring intensely, his bony physiognomy, strong jaw. I've also tried to suggest his height of 1.9m (6ft 4in).

2.

3. Here I begin to produce something like a caricature. Notice how I have made him grin, although he wasn't doing this when I drew him. People who know him are familiar with his broad, up-turning grin, intense stare, large bony forehead, nose, cheekbones and jaw, and these are the characteristics I have tried to bring out.

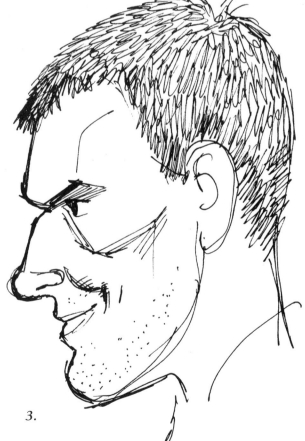

3.

IMAGINATION, ABSTRACTION AND SYMBOLISM

EXPERIMENTING

I could have taken that final illustration further and gone on until all superfluous lines had been deleted. You can do this more effectively if you know your subject well. You need knowledge to be able to build into your caricature attitudes, movements and favourite expressions in order to inject a bit of humour as well as get across a likeness with a minimum of detail.

Here are two examples for you to experiment with and see how far you can take the exaggeration before the subject becomes unrecognizable. Try to capture the obvious features first and then the general effect of the head or face.

Don't try caricaturing your friends, unless you don't mind losing them or they agree. If you can't get the subject you want to pose for you, try to obtain good photographs of them. These won't provide quite such good reference, but as long as you draw on your knowledge of the person as well, they should be adequate.

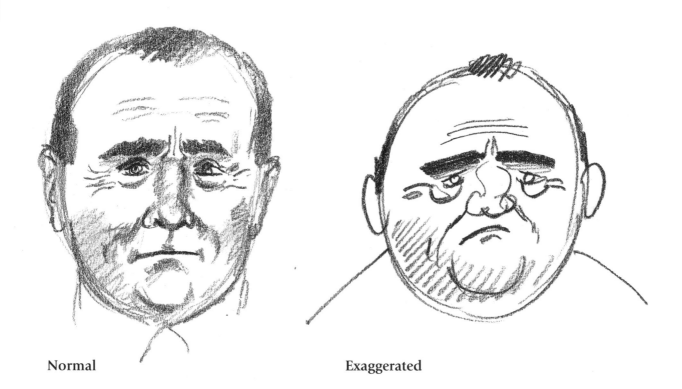

Normal Exaggerated

IDENTIFYING FEATURES:
1. Round head
2. Fat chin
3. Grim mouth
4. Heavy, anxious eyebrows
5. Little eyes with bags
6. Blobby or broken nose
7. Wrinkles and unshaven chin

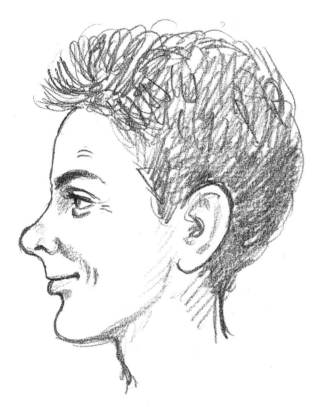

Normal

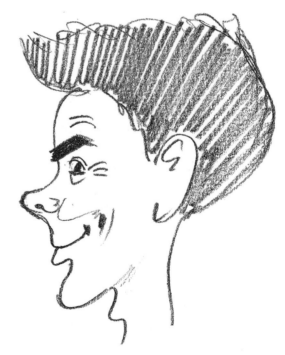

Exaggerated

IDENTIFYING FEATURES:
1. Round-ended, turned-up nose
2. Bright eye
3. Thick eyebrows
4. Big hair on top
5. Chin
6. Cheeky grin

SOCIAL MORES

Symbolism can be used to tell truths about society, individuals or a situation. The way the artist chooses to portray these truths will be down to his style and personal approach to drawing, as the following examples show. A good artist will make his values clear in his work, even if he has to present them in code, which is what symbolism provides, as the following examples demonstrate.

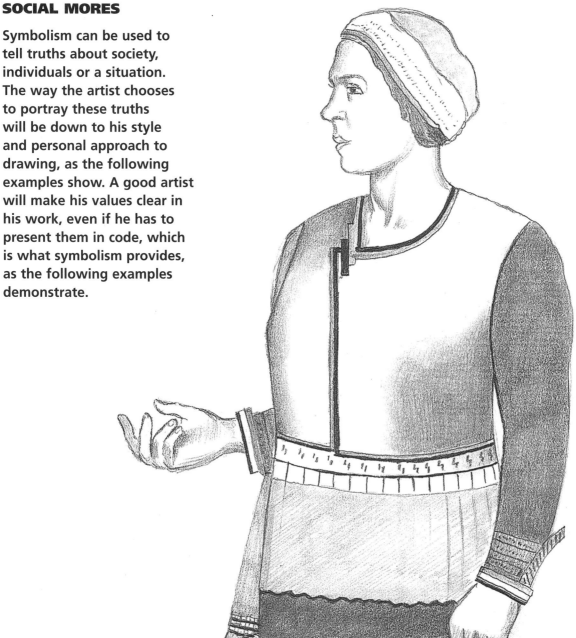

Kasimir Malevich was one of the leading exponents of Suprematism, an unrelenting geometric form of abstract painting popular in artistic circles in Russia soon after the Revolution. However, with the rise of Stalin and the beginnings of the official Social-Realistic school of art, Malevich's abstract ideals were suppressed as non-Communist. When Malevich painted the original of this portrait of his wife, he was contravening two of the main rules laid down for artists by the Soviet authorities. First, that a personal relationship should not form the basis of a painting (this was considered bourgeois); and secondly, that abstractionism was not an acceptable means of expression.

SYMBOLISM IN STILL LIFES

Many of the still life pictures that were painted during the 16th and 17th centuries were careful arrangements of symbolic objects, designed to tell some sort of story about the commissioner or to point out a particular moral to the onlooker.

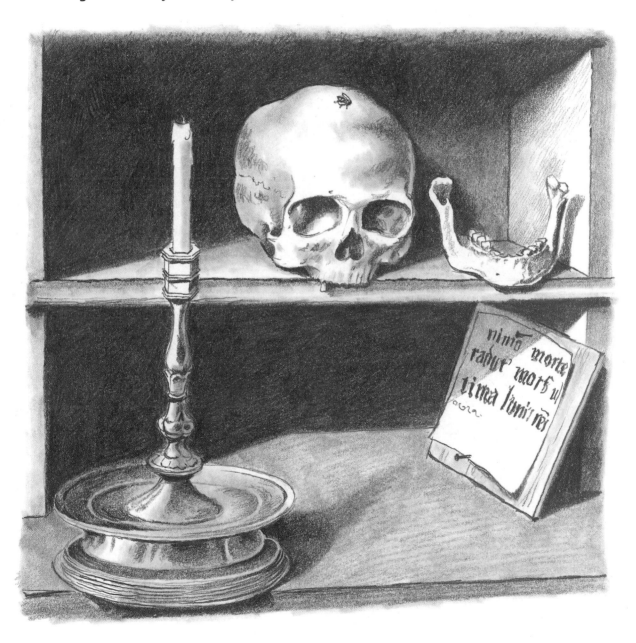

The most obviously symbolic pictures that were produced in the still-life genre were often concerned with the passing of time and approach of death. This still life after Bruyn the Elder (1493–1555) is a simple but effective composition with its blown-out candle, the skull with its jaw removed to one side and the note of memento mori on the lower shelf. The dark shadows under the shelf set the objects forward and give them more significance.

SYMBOLS AND ASSOCIATIONS

The face is the most obvious barometer of human feeling. However, it is possible to show moods or emotions in other ways – the position or movement of a body can be powerful indicators, for example – and not just rely on the obvious. An even more interesting approach is to let nature be a mirror, and transfer human emotions onto natural features. Consider the examples you will see over the following pages.

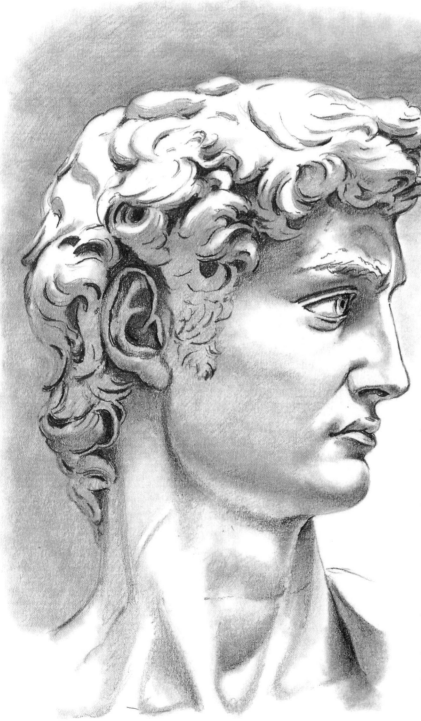

The head of Michelangelo's 'David' in Florence symbolizes the defiance of that city towards the hostile autocracies by which it was surrounded. A small but rich and inventive state, Florence was a free republic whose citizens and guilds had a voice in government. Michelangelo's statue of the shepherd boy who kills the giant warrior Goliath is a powerful symbol of the independence of that city and its determination to protect its status.

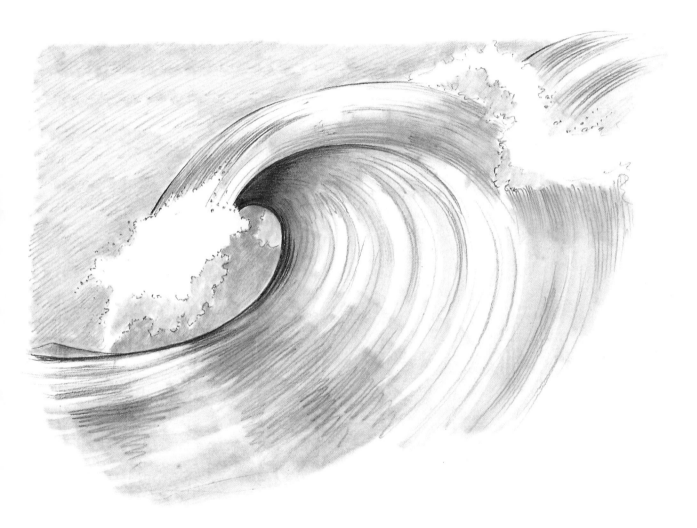

A breaking wave used as a metaphor for exhilaration is not new. In this example the impact might have been greater and the feeling of exhilaration emphasized if there was a figure of a surfer under the wave.

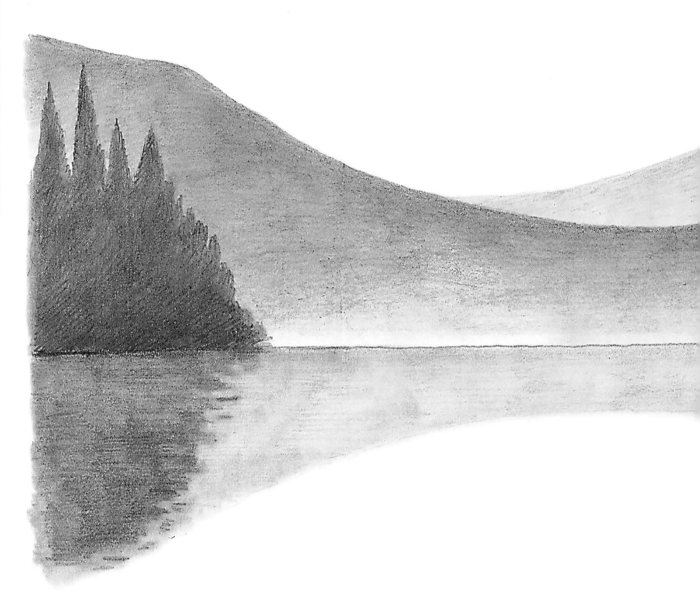

A beautiful still lake with reflections and calm skies seen in morning or evening light gives the feeling of serenity, especially with the small native boat being propelled smoothly, without haste, across the surface of the water.

This image symbolizes serenity partly by situation and partly by technique. The artist has made efforts to excise any disturbances from the picture.

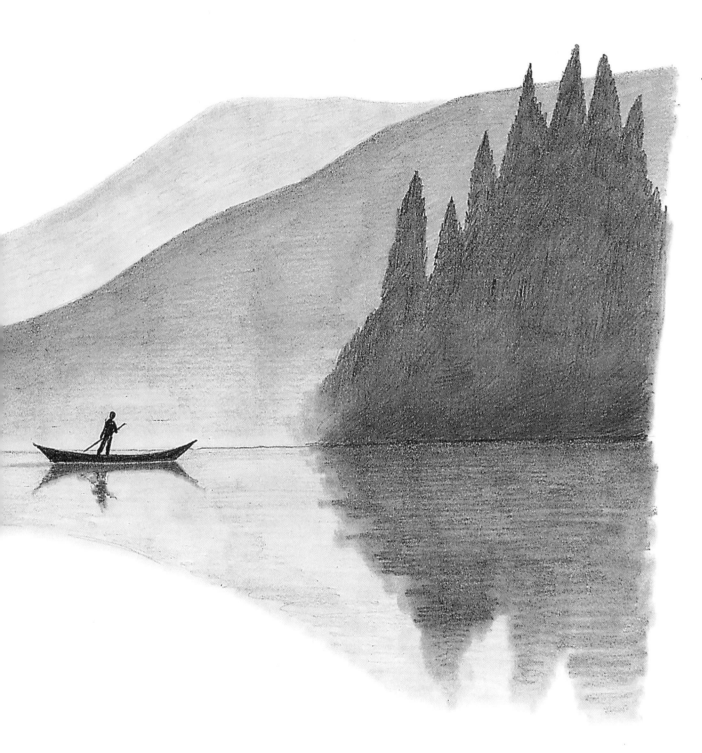

EXTREMES OF EXPRESSIVITY

Here we look at different ways of being expressive. The face as a measure of emotional expression is an obvious way to show the mood of a picture by association, but as you will see from these drawings, there are faces and faces. The galloping horse and jockey (overleaf) is a more abstract example of how to produce a visceral response.

Happiness

Intensity

Satisfaction

Despair

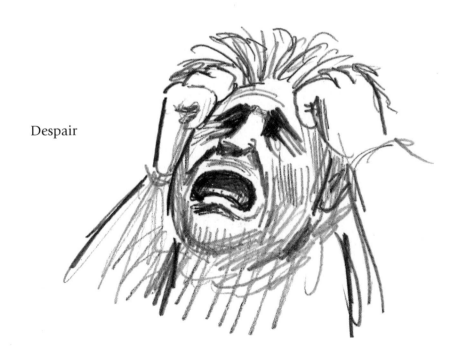

IMAGINATION, ABSTRACTION AND SYMBOLISM

This image is an attempt to convey the idea of
speed. The racehorse and jockey are glimpsed
pounding down a course, dirt flying up behind.
The idea is reinforced by how the image is drawn:
the rider with stirrups short, behind raised out
of the saddle, the horse's neck stretched, tail
streaming, powerful legs bunched up to take
the next stride. The economical use of lines also
suggests that the image is moving past us at speed.

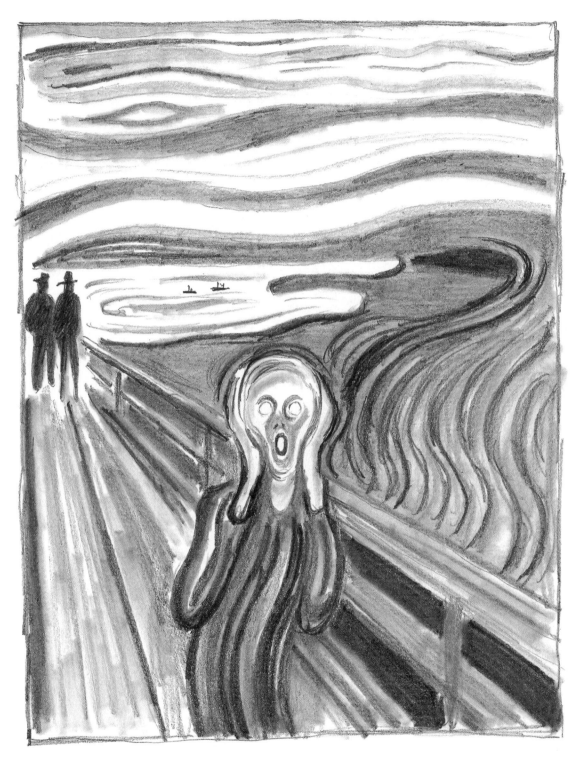

Marc Chagall

Edvard Munch's 'The Scream' is an expressive and subjective picture that is now read as a general statement about ourselves, particularly the angst and despair experienced by modern man.

The area depicted in the painting was favoured by suicides, and was close to slaughter-houses and a lunatic asylum where Munch's sister was incarcerated. The artist wrote of the setting: 'The clouds were turning blood red. I sensed a scream passing through nature.'

The original painting has a blood-red sunset in streaks of red and yellow, with dark blues and greens and blacks in the large dark areas to the right. The swirling lines and skull-like head with its unseeing eyes and open mouth produce a very strong effect.

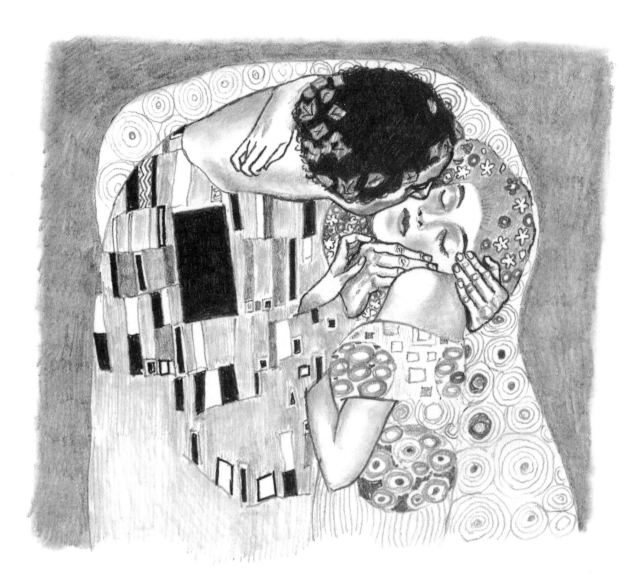

'The Kiss', by Viennese artist Gustav Klimt, shows the power of desire in a very graphic manner. The heavily ornamented clothing, while revealing very little of the flesh of the lovers, increases the tactile quality in the work. The firm grasp of the man's hands on the girl's face and head, her hands clinging to his neck and wrist, and her ecstatic expression tell us of the force and intensity of their sexual desire.

Expressing Yourself

All of the images we have looked at in this section try to convey to the viewer a feeling or idea that is not being expressed in words. Indeed, in many of the examples, it would be very difficult to express precisely or concisely the effect they have. One picture can be worth a thousand words. It is not easy to get across a concept by visual means, but with a bit of practice it is possible.

Try to produce such an image yourself. You can use or adapt the approaches or methods we've been looking at. When you've produced something, show it to your friends and listen to their reactions. If your attempt is suggestive of the idea you wanted to convey, they will quickly be able to confirm it.

Index